MASTERWORKS FROM THE INDIANA UNIVERSITY ART MUSEUM

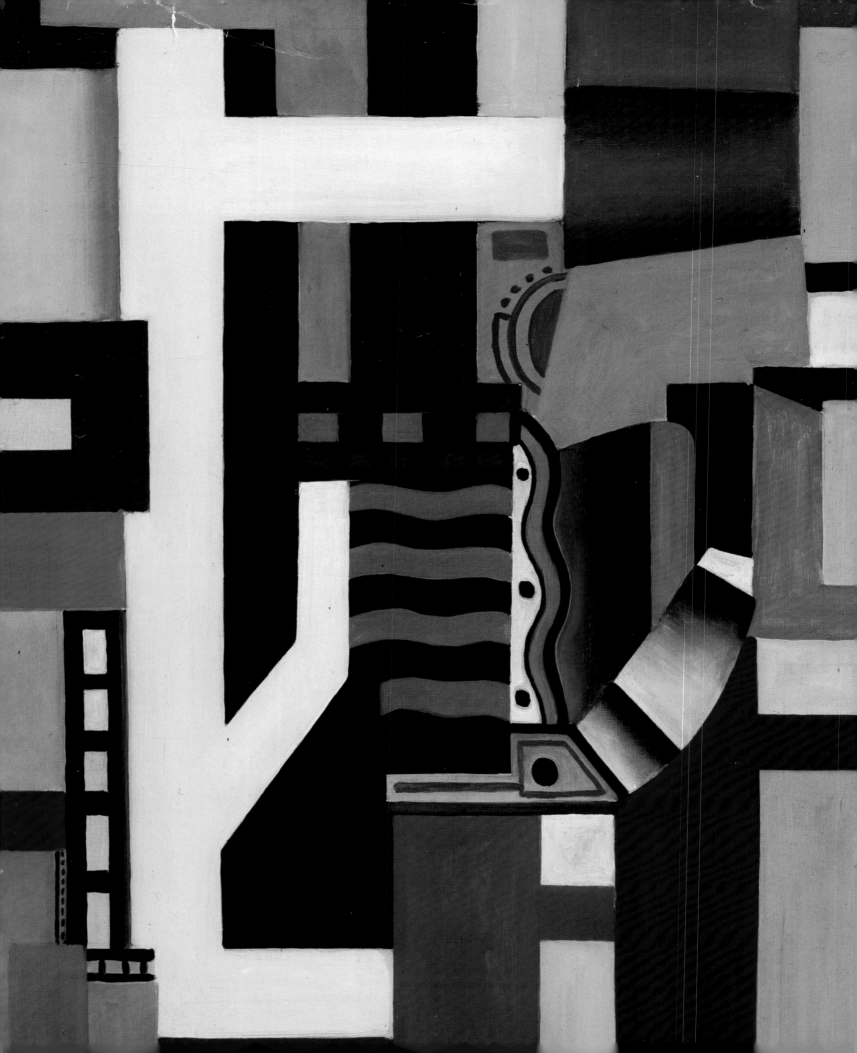

MASTERWORKS

FROM THE

INDIANA UNIVERSITY ART MUSEUM

ADELHEID M. GEALT

DIANE M. PELRINE

ADRIANA CALINESCU

JUDITH A. STUBBS

JENNIFER A. MCCOMAS

Edited by

LINDA J. BADEN

Photographs by

MICHAEL CAVANAGH AND KEVIN MONTAGUE

INDIANA UNIVERSITY ART MUSEUM
IN ASSOCIATION WITH
INDIANA UNIVERSITY PRESS,
BLOOMINGTON AND INDIANAPOLIS

This publication has been made possible with support from the
Samuel H. Kress Foundation, the Morton C. Bradley Endowment at
Indiana University, the David H. and Barbara M. Jacobs Charitable
Trust, Thomas and Caroline Tucker, and the IU Art Museum's Arc Fund.

Published by the Indiana University Art Museum in association
with Indiana University Press, Bloomington and Indianapolis.
Distributed by Indiana University Press, 601 North Morton Street,
Bloomington, Indiana 47404-3797.

Library of Congress Cataloging-in-Publication Data

Indiana University, Bloomington. Art Museum.
 Masterworks from the Indiana University Art Museum / Adelheid
M. Gealt ... [et al.] ; Linda Baden, editor ; photographs by Michael
Cavanagh and Kevin Montague.
 p. cm.
 Includes bibliographical references.
 ISBN 978-0-253-35069-5 (cloth) -- ISBN 978-0-253-21956-5 (pbk.)
1. Indiana University, Bloomington. Art Museum--Catalogs. 2. Art--
Indiana--Bloomington--Catalogs. I. Gealt, Adelheid M. II. Baden, Linda.
III. Title.
 N518.B4A58 2007
 708.172'255--dc22
 2007033018

1 2 3 4 5 12 11 10 09 08 07

Cover:
Stuart Davis
Swing Landscape, 1938
Art © Estate of Stuart Davis/Licensed by VAGA, New York, NY
(see page 340)

Frontispiece:
Fernand Léger
Composition, 1924 (detail)
© 2007 Artists Rights Society (ARS), New York/ADAGP, Paris
(see page 328)

Editing: Linda Baden and Janet Rauscher,
with the assistance of Sona Pastel-Daneshgar

Design: Brian Garvey

Photography: Michael Cavanagh and Kevin Montague

Printing: Metropolitan Printing Service, Bloomington, Indiana

This book is dedicated
to the founding directors of the
Indiana University Art Museum

HENRY RADFORD HOPE
1941 – 1973

AND

THOMAS TREAT SOLLEY
1973 – 1986

CONTENTS

A LASTING LEGACY

Like all dynamic entities, universities grow to reflect the character and values of the people they encompass. A deep reverence for art in all of its manifestations is a defining value of Indiana University that continues to shape our present and guide our future. The development at the IU Art Museum of a balanced, encyclopedic teaching and research collection, housed in an equally outstanding facility designed by I. M. Pei, is a testament to the core belief of IU's leaders and benefactors, faculty, staff, and students that the arts are essential components of a complete university education, worthy of their attention and support.

Although each individual work among these 160 masterpieces selected from the IU Art Museum collection is remarkable in itself, the true strength of the collection comes in the aggregate. Reflecting the broad sweep of humankind's artistic endeavors, spanning five millennia and every continent, the Art Museum's collection offers tremendous possibilities to teach and learn from original works of art of exceptional quality.

The universal nature of the collection takes on particular relevance as Indiana University builds on its strength as an international center of education. A collection of such scope affords students, faculty, staff, and the broader community opportunities to experience firsthand the highest physical manifestations of cultures from every corner of the globe.

Indiana University has been shaped in ways tangible and intangible by the generosity and foresight of many individuals. A touchstone of this commitment is the IU Art Museum collection that unfolds on the following pages. I have no doubt that these masterful works of art will continue to extend their influence, attracting scholars, students, and art lovers from near and far and affirming IU's commitment to the arts.

Michael A. McRobbie, President
Indiana University

FOREWORD AND ACKNOWLEDGEMENTS

Masterworks is dedicated to the founders of the museum's collection, Henry R. Hope and Thomas T. Solley. When I began my career at the museum, Henry Hope, our first director, had already assembled a small, but first-rate collection, which set the standard of excellence for all the acquisitions that followed. As head curator in the mid-seventies and eighties, I participated in the extraordinary period of collection growth that took place under Thomas Solley, the museum's second director. Since 1986, as the third director of the Art Museum, I have had many opportunities to teach and learn from the wonderful collection that is the legacy of these two great connoisseurs and benefactors.

Given my long history with the collection, I fully expected to sit back and enjoy this new volume as one might relish a quiet visit with dear old friends. There is some of that, of course—but I also have found myself thrilled anew by the richness and quality of the pieces presented here, intrigued and enlightened by the research of our curators, and, more than ever, filled with admiration for the generosity and foresight of the individuals and institutions who fostered such a remarkable gathering here in Bloomington of works of art of global significance.

To those extraordinary donors, both living and gone, I extend not only my personal gratitude and the museum's, but also the gratitude of all whose lives are enhanced by their visits to the collection, enlightened by their study of the artworks, or delighted by the beauty and complexity of the pieces they discover in this volume. The history essay that follows briefly tells the stories of many of these generous donors, and the entries celebrate many of their gifts.

This book has been crafted by the museum's publications team, a core group of four people with over one hundred years of combined experience at the IU Art Museum. The museum's photographers, Michael Cavanagh and Kevin Montague, have worked with the collection and its curators for twenty-six years. Their interpretations of these masterworks are themselves works of art, and I am proud to acknowledge and applaud their mastery. Another key member of the creative team, art director Brian Garvey, also possesses a deep appreciation for the collection, as his elegant design of this book reflects. Linda Baden, who edited this volume with the assistance of Janet S. Rauscher and who wrote the essay on the history of the collection, directs the publications area of the museum; *Masterworks* has been shaped by her collaborative approach to book-making and by her years of experience at the museum. At IU Press, Janet Rabinowitch, director, has been an enthusiastic and wise partner.

Curators Diane Pelrine, Adriana Calinescu, Judy Stubbs, and Jenny McComas deserve congratulations for their lively, informative, and nuanced discussions of the masterpieces in each of their collection areas. In my role as curator of the art of the West before 1800, I very much enjoyed the opportunity to revisit some of the masterpieces in my area and to read what my colleagues have to say about theirs. Many other were generous with their time and expertise: we extend our thanks to Louise Arizzoli, Marla Berns, David Binkley, Barbara Blackmun, John P. Bowles, Nanette Esseck Brewer, Gordon Brotherston, Jandava Cattron, Michael D. Coe, Bradley Cook, Harry Cooper, Kathy Curnow, Robert Eno, Christiane Gruber, Francesco Guidi, Brigitta Hauser-Schäublin, Ute Haug, Wolfgang Henze, Pascal James Imperato, Sumie Jones, Manuel Jordán, Alisa LaGamma, Ryan Lee, Patrick McNaughton, Herman and Linda Mast, Joanna Matuszak, Sona Pastel-Daneshgar, Constantine Petridis, Robin Poynor, Ned Puchner, Manfred Reuther, Christopher D. Roy, Evan Schneider, Roland Scotti, Thomas Shafer, Izumi Shimada, Zoë Strother, Angela Vanhaelen, Susan Vogel, Robert L. Welsch, Raymond Wielgus, Jiang Wu, the staff of the Museum of Modern Art Archives in New York City, and the staff of the Morgan Library and Museum Reading Room in New York City.

This publication—and the collection it represents—would not have been possible without the steadfast support of the leaders of Indiana University. From the early days with Herman B Wells at its helm, to the current presidency of Michael McRobbie, Indiana University has nurtured its Art Museum, and for that we remain most thankful. We also acknowledge with gratitude a longtime friend and benefactor of the museum, the late Morton C. Bradley, Jr., whose memorial fund has made this book possible. Finally, heartfelt thanks go to the Samuel H. Kress Foundation, the David H. and Barbara M. Jacobs Charitable Trust, and Thomas and Caroline Tucker for their generous support of this publication.

Adelheid M. Gealt, Director
Indiana University Art Museum

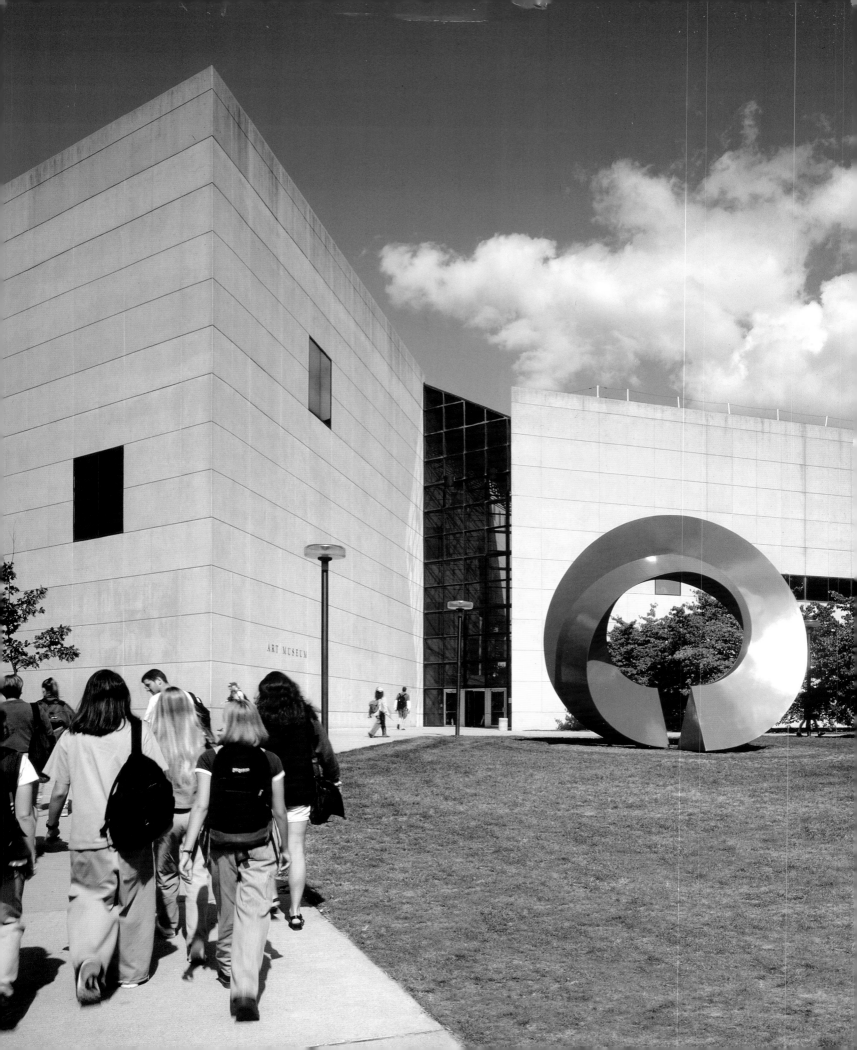

THE COLLECTION: A HISTORY

Linda J. Baden

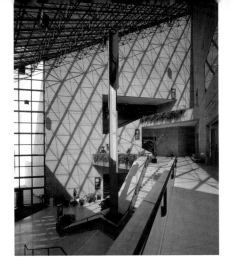

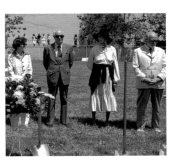

Groundbreaking ceremony for the new IU Art Museum building, June 14, 1978. *Left to right:* Betty Jo Irvine (director of the Fine Arts Library) Thomas T. Solley, and Sarahanne and Henry Hope

Herman B Wells, 1937

Henry Hope, 1960

The Art Centre Gallery in Mitchell Hall, 1957

By 1978, when a grassy football practice field was broken ceremonially for its new building, the Indiana University Art Museum was already well on its way to assembling a collection that would rival the best of any university art museum in the country. Situated strategically at the heart of the Bloomington campus, the dramatic new building—designed by the internationally renowned firm of I. M. Pei & Partners and dedicated in 1982—embodied Indiana University's commitment to teaching and learning from original works of art. This publication, inspired by the twentieth-fifth anniversary of I. M. Pei's masterful building, celebrates the IU Art Museum's collection and the vision and perseverance of the cadre of extraordinary individuals who brought it into being.

Herman B Wells (1902–2000), revered president and chancellor of Indiana University for more than sixty years, first envisioned the university as the "cultural crossroads of Indiana," with an art museum at its core. In 1941 Wells hired Henry R. Hope (1905–1989) to chair IU's art department and to create an art museum for the university; Hope had trained under museologist and educator Paul Sachs of the Fogg Art Museum at Harvard University. After diligent consideration of university art museum precedents, both public (Nebraska, Arizona) and Ivy League, Wells, Hope, and a handful of faculty advisors determined that the museum's collection would encompass the full spectrum of humankind's activities in the visual arts—"from antiquity to contemporary, from west to east," as Henry Hope put it—and that it should support the whole constellation of teaching and scholarship offered on the Bloomington campus.

Henry Hope's personal expectations for the "virgin soil" of the Midwest (as he described it in a letter to his mentor) were modest, and in the first fourteen years of his tenure, even those expectations seemed inflated. Great luck and Hope's quick and decisive action in 1941 had secured Stuart Davis's masterpiece, *Swing Landscape* (p. 340), as the museum's first acquisition, but the dream of establishing an important art collection at Indiana University languished during the war years. Plans to build a museum facility were set aside, and a variety of more modest schemes for collection displays were entertained and then shelved. The vision of an art museum at IU that would rival the great university collections established half a century earlier seemed overly ambitious, perhaps unattainable.

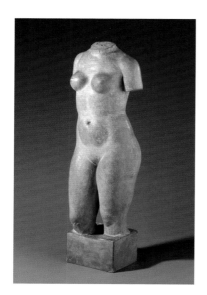

Aristide Maillol (French, 1861–1944). *Torso of a Young Girl*, ca. 1930. Terracotta. Gift of James and Marvelle Adams in honor of William Lowe Bryan, 55.4

Portrait Bust of James Adams, 1975. Mehri Danielpour (American, born in Iran). Bronze. Gift of Mrs. James Adams in honor of her husband, 76.126

Thomas T. Solley and Henry R. Hope, 1973

Then, in 1955, an unexpected gift was proffered. Two loyal alumni, James and Marvelle Adams, art collectors and longtime friends of President Wells, decided to give IU a terracotta bust by Aristide Maillol, one of the most important sculptors of the twentieth century. This remarkable vote of confidence reawakened Hope's passion for an art museum, as he recollected:

> This act was catalytic, stirring up excited thoughts followed by rapid action. The thoughts were that now for the first time since the end of the war I could revive my long-abandoned project of starting an art collection at the University…. If an alumnus would make a gift to his university of such an important and beautiful work, I reasoned, then there must be a base of support for an art museum that I had been totally unaware of. I was so moved that I was determined to make the future art museum one of our top priorities.[1]

The Adams' commitment heartened Hope and his wife Sarahanne (Sally), who were themselves important collectors of modern art. In addition to their energy and dedication, the Hopes subsequently gave many major works to the IU Art Museum collection, including Pablo Picasso's magisterial painting, *The Studio* (p. 338). Paintings and sculptures by the great modernists of the twentieth century, including Georges Braque, Jean Dubuffet, Marino Marini, Henry Moore, Jacques Lipchitz, and Aristide Maillol became the backbone of the museum's lauded collection of modern art. The Hopes also added important pieces from the ancient world, the South Pacific, and the Pre-Columbian Americas, along with Indian miniatures, Persian ceramics, Old Master etchings, and Baroque paintings.

Together, these early gifts and purchases made with a small university acquisitions fund (about 4,000 artworks in all) set the standard for what would become the museum's "golden age" of collecting under the directorship of Henry Hope's successor, Thomas T. Solley. The Hope family's generosity continued after Henry and Sally's deaths, with additional major gifts from their private collection entering the museum, including Henry Moore's *Reclining Figure* (p. 344) and Max Beckmann's *Hope Family* (p. 354).

At Henry Hope's instigation, Thomas T. Solley became the IU Art Museum's assistant director in 1968. Solley assumed the directorship upon Hope's retirement in 1971 and served in that position until 1986. His fifteen years of leadership transformed the IU Art Museum from a small, well-chosen teaching collection into one of the finest university art museums in the country.

A member of Indiana's prominent Lilly family and an architect trained at Yale, Solley had the perfect combination of background and determination to propel the museum into the future—a future that included a new museum facility. His architectural training gave him immediate access to the whole range of planning considerations; a lifetime of museum-going had engendered a very clear vision of what a good museum facility should be; and he had a solid understanding of IU's particular needs and strengths, honed during his years as an art history graduate student and later as

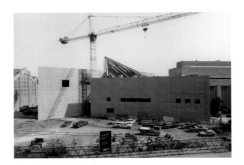

IU Art Museum under construction, ca. 1980

Tom Solley installing a display in the Raymond and Laura Wielgus Gallery

The Thomas T. Solley Atrium was named in 2002 in honor of the museum's former director

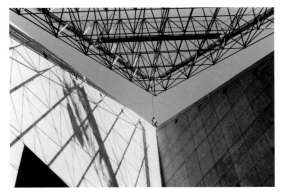

Atrium "space frame" lowered into place, 1981

assistant director. Under Solley's direction, the new Art Museum building was conceived, constructed, and installed, while the staff grew from three dedicated multitaskers into a "full-service" professional team with curators in several of the major collection areas, a full-time educator, a conservator, and specialists in design, photography, publications, fabrication, collections management, and administration.

Thomas T. Solley's name appears often in this volume. During his tenure, the collections grew from 4,000 to over 30,000 objects. Many of the masterworks presented here came to the museum under his aegis: some joined the collection as direct gifts from Solley or a member of his family (such as Mrs. Nicholas Noyes), while others entered as purchases he made to honor a relative. For each object acquired during Tom Solley's directorship, it is safe to say that—although the Solley name may not appear on every label—the Solley eye influenced the acquisition.

"Collecting is instinctive to man, or to certain men among mankind," Tom Solley asserted in a 1976 interview in Bloomington's local newspaper. As word of Solley's active acquisition program grew, dealers in New York, Chicago, Paris, and London took notice: "We get first crack now at a lot of things which heretofore might have been offered to institutions that have much more prestigious names than ours," Solley explained. "But they [the dealers] know that we have the funds and we're interested and we'll buy. So they offer it to us."

Tom Solley's remarkable eye and instinct for the art market during an exciting period of its development were invaluable assets in the process of collection-building. Yet, as he commented in his 1981 introduction to the museum's *Guide to the Collections,* "Cost and availability have also substantially affected the development of the collections, which were primarily acquired in the period following the Korean War, when the art market began its upward spiral which continues to this day. The Art Museum's particular strengths—in the arts of the ancient Western world; the Americas, the Pacific, and especially Africa; and the major formative movements of the twentieth century—are the happy consequence of these factors."

Hope and Solley—astute collectors and generous benefactors though they were—had significant allies in their campaign to build a great museum. First and foremost of these remained President Wells, who nurtured the museum in innumerable ways throughout his life and bequeathed his personal collection to it upon his death. James Adams, of that pivotal first gift, continued to support the museum in the crucial early years, primarily through gifts to the William Lowe Bryan Memorial Fund, which honored his friend, the president of IU from 1902 to 1937. Other collectors and benefactors made transformative contributions to specific areas of the collection: Raymond and Laura Wielgus, Burton Y. Berry, and Morton C. Bradley, Jr., are among the most prominent.

Equally important to the emergent collection was the interest and expertise of individual faculty members. Roy Sieber, a pioneer in the study of African art, helped shape the collections of African, South Pacific, and Pre-Columbian art and brought the Wielguses into the museum's fold; Diether Thimme, an ancient art scholar, print connoisseur, and collector, advised Hope and Solley on both ancient Western art and works on paper; Theodore Bowie, professor of Asian art, organized the first major international art exhibitions at IU and acted as curator of the Asian collection; Wolf Rudolph researched and published the Burton Y. Berry Collection; and Bruce Cole, currently chairman of the National Endowment for the Humanities, facilitated the gift to the museum of the renowned Middeldorf Collection. Other members of the School of Fine Arts faculty have researched and published aspects of the collection and have served on the museum's acquisition committee over the years, and several have donated their personal collections to the museum.

Thomas Solley retired in 1986, and Adelheid M. Gealt, then the museum's chief curator, was appointed interim director; the following year her appointment was made permanent. In the intervening two decades, Heidi Gealt has led the museum through a period of intense institutional advancement, which has seen the establishment of a National Advisory Board and the endowment of a number of curatorships, a conservation chair, undergraduate scholarships, and graduate fellowships. Under Gealt's leadership, the IU Art Museum has developed its public programming, expanded its innovative educational outreach, and solidified its role as a center for teaching and learning from original works of art for both the university community and the general public. The collection continues to grow judiciously, as curators seek to add to area strengths and fill gaps, while emphasis has been placed on curatorial programs, exhibitions, and research.

The museum's history can be sketched in broad strokes: a nascent period, during which the foundations for excellence were laid; a period of intense growth, which saw the coalescence of the collection and the physical facility in close to their present forms; and a period of maturation, during which the museum's infrastructure has developed in response to the previous decades of growth. While this picture suffices as a wide-angle view, the close-up is more nuanced. Each area of the collection has its own story to tell.

ANCIENT EGYPT, THE NEAR EAST, AND THE CLASSICAL WORLD

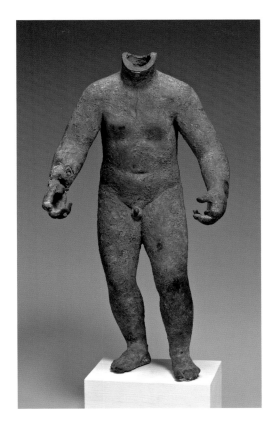

Italy, Pompeii. *Figure of Eros*. Roman Imperial period, 1st century AD. Bronze. William Lowe Bryan Memorial, 57.37

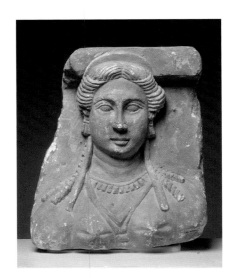

Egypt. *Bust from a Funerary Relief*. Roman period, mid-2nd century AD. Limestone. Gift of Frederick Stafford, 60.14

Assembled through purchase, gifts, and loans, the collection of ancient art has been developed to give the student and the general public a broad conception of the classical world of the Mediterranean, with examples of outstanding quality executed in a rich variety of materials. The collection spans some seven thousand years, from prehistory to the Byzantine world. The focus is not only on the major artistic developments—Greek art through the Hellenistic period and Italian art from the early Iron Age through the Etruscans, the Greek colonies, to Rome—but also on the cross-fertilization between Mediterranean cultures.

The museum's first acquisition of ancient art was a bronze figure of Eros, said to be from Pompeii, a gift of James S. Adams in 1957. The Adams gifts of Egyptian antiquities a year later formed the nucleus of that collection. In a time when issues of past ownership are closely scrutinized, the IU Art Museum is particularly fortunate that the provenance of the greater portion of the objects is well documented: they were either excavated by or acquired from the Egyptian government, coming to the collection via the Metropolitan Museum of Art, New York.

Along with the Adams gifts, the ancient collection was initiated with gifts from Frederick Stafford and Norbert Schimmel, two important collectors introduced to the museum by Matthias Komor, a New York dealer and friend of the museum in the formative years of the collection. The Stafford gifts of 1959 and 1961 include an intact, exceptionally fine pair of engraved Etruscan bronze handles from a *hydria* (water jar); only five others are known, and they are in fragments. A limestone portrait of a woman, from Roman Egypt, another important Stafford gift, has been illustrated and discussed in several scholarly publications.

In 1963, Henry Hope, acting on the advice of Diether Thimme, made the momentous decision to acquire the V. G. Simkhovitch Collection of Greek and Roman art. Among the more than 150 antiquities collected by the noted New York connoisseur, the marble sculptures—which include an outstanding group of Greek stelae (p. 94), Hellenistic statues, and Roman portraits—provided the monumental landmarks around which the museum's ancient collection subsequently developed: "Best of all for the museum," Henry Hope remarked in a 1970 *Art Journal* article, "was the incentive it gave us to fill in the gaps."[2]

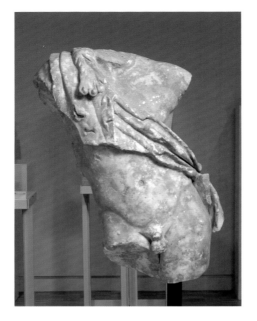

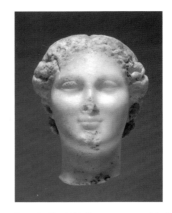

Roman. *Satyr in Repose, with Panther Skin.* Copy after a Praxitelean work of ca. 320 BC. Marble. Gift of Mr. and Mrs. James Adams and Dr. and Mrs. Henry R. Hope in memory of George Heighway, 64.104

Female Head. Hellenistic, second half of the 2nd century BC. Marble, traces of red pigment. V. G. Simkhovitch Collection, 63.105.24

Eastern Mediterranean. *Figurine of Athena.* Hellenistic, 3rd–1st century BC. Bronze. Burton Y. Berry Collection, 62.117.116

Burton Y. Berry, ca. 1975

Henry Hope and his wife Sarahanne helped "fill the gaps" of the ancient collection through personal gifts, which range from eighth-century BC Cypriote terracottas to Roman sculptures. One of the most important sculptures in the collection is the 1964 joint gift of the Hopes and the Adamses in memory of George Heighway (who was the first director of the IU Foundation and founder of the *Indiana Alumni Magazine).* This life-size marble torso of a satyr in repose is a remarkably fine Roman copy of a lost fourth-century BC original attributed to the Greek sculptor Praxiteles.

The museum's long and happy association with another alumnus, U.S. foreign-service diplomat Burton Y. Berry (1902–1985), also began during Henry Hope's tenure as director. In the early 1960s, learning from his old college friend Herman B Wells that a new museum was being planned, Burton Berry offered the museum the loan of his collection of Greek coins. Other loans from Berry of important ancient bronzes, gemstones, ceramics, and jewelry followed.

By the late 1960s, the art of the ancient Western world had emerged as one of the richest aspects of the museum's collection, a strength that was actively sustained by Thomas Solley. In the IU Art Museum *Annual Report 1979–80,* Tom Solley reported:

> From the magnificent Cycladic figurine given to the Museum in 1976 and the most important amphora by the Amasis painter, a gift of Mrs. Nicholas Noyes in 1971, to the rare Roman marble portrait busts of Septimius Severus and Julia Domna, the last decade has seen the Ancient Collection enhanced by many remarkable pieces representative of almost every culture and period of the Ancient world.

Three of the masterpieces Tom Solley singled out—the marble Cycladic figure (p. 78) and the imperial busts of Septimius Severus and his wife Julia Domna (pp. 106–109)— were gifts from Solley himself, and the amphora by the Amasis Painter (p. 82) was a gift from Solley's aunt, Marguerite Lilly Noyes. Schooled in the classical tradition, Solley had an affinity for the ancient world that is reflected in the brilliance of his purchases and personal gifts to the ancient collection.

Danaë Thimme, ca. 1990

Diether Thimme, ca. 1968

A Golden Legacy, special exhibition at the
IU Art Museum, 1995

Southern Balkans or western Anatolia.
Belt Buckle. Early Byzantine, 6th to 7th
century AD. Gold, bronze. Burton Y.
Berry Collection, 76.80.7

Thomas T. Solley also reported in 1980 that "two great gifts by the Honorable Burton Y. Berry in 1970 and 1976 have given the Museum one of the world's most important collections of Ancient jewelry." During Solley's tenure, the Berry loans were turned into major gifts. Some three thousand pieces were donated in 1970, in connection with the University's sesquicentennial. In 1976 Burton Berry decided to extend his gifts to the museum and donated more than two thousand objects, the remainder of his collection. This gift, including some five hundred gemstones and many jewelry items, added a range of classical art that constitutes an outstanding base for scholarly research, even as it enlivens the gallery. Since Berry's death in 1985, his tradition of generous support has been continued by his family: Azzedine Berry-Aaji and his wife Denise donated the Berry Collection of 145 textiles and laces and subsequently have augmented the study collection with various gifts, notably of gemstones and seals.

After the late 1980s, acquisitions continued, albeit at a slower pace, and mainly by gifts and bequests. Of note is a fine fifth-century BC Attic red-figure *kylix,* gift of Michelle and Shelley Michele Fratiani in 1998. In the same year, the Cycladic and early Greek holdings were augmented through the bequest of the Diether Thimme Collection by the estate of his wife Danaë Thimme, the IU Art Museum's first conservator. Also in the 1990s, the museum received gifts of Etruscan and Roman art from IU School of Music Professor Virginia Zeani in memory of Nicola Rossi-Lemeni. In 2000, the Department of Classical Studies at IU transferred over 400 objects, including Greek pottery, Roman sculptures, Egyptian papyri, and over 350 Roman coins, the fruit of years of collecting by faculty in the department.

Mostly, however, emphasis has been placed on research and on making the collection known through special exhibitions, publications, and through an international symposium on Ancient Jewelry and Archaeology organized by curator of ancient art Adriana Calinescu in 1991. Major exhibitions and publications of the Berry and Simkhovitch collections have brought these treasures to international audiences over the last two decades.

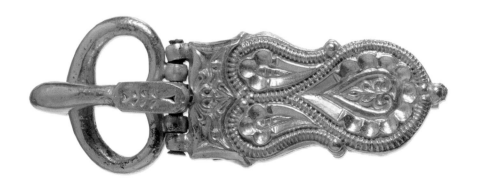

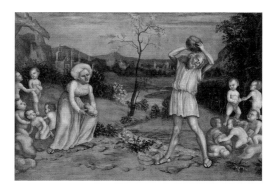

Nicola Giolfino (Italian, 1476–1555). *The Myth of Deucalion and Pyrrha,* ca. 1550. Tempera on panel. Samuel H. Kress Collection, 69.159

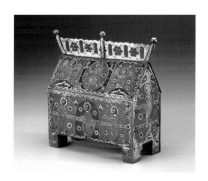

Limoges, France. *Châsse,* 13th century. Champlevé enamel, wood, gilt copper. 77.48

Giambattista Piazzetta (Italian, 1682–1754). *Shepherd Boy with Hat and Staff,* ca. 1720. Oil on canvas. 82.31

Italy. *Velvet Brocade Textile Fragment,* 15th–17th century. Silk. Gift of Gloria Middeldorf in memory of Ulrich Middeldorf, 87.26.2.177

From its beginnings in 1941, the IU Art Museum sought first-rate examples of the diverse artistic traditions that make up Western art from around AD 500 through the eighteenth century. Early friends, including James and Marvelle Adams, Henry and Sarahanne Hope, and Stanley S. Wulc, laid the foundation of the collection with important gifts. James Adams' fund to memorialize William Lowe Bryan enabled the purchase of eight extraordinary panels by the sixteenth-century Burgundian master, Felipe Vigarny. These panels, which illustrate the life of the Virgin, came to the museum in 1966 (pp. 240–43). That same year saw another significant addition: Hendrick de Clerk's *Finding of Moses* (p. 260), a rare example of Flemish painting before the time of Rubens.

Thanks to Henry and Sally Hope, the museum acquired one of the finest masterpieces by Jacopo Palma to be housed in a collection outside Venice: his *St. John the Baptist* (p. 250) is a grand figural composition full of portraits. Henry and Sally also donated the impressive Solimena (p. 278) and a beautiful copy of a Caravaggio masterpiece attributed to Pietro Paolini. The Friends of Art were also active in 1966, giving us a rare gem: an oil painting on copper by the North Italian master Luca Ferrari (p. 256). The Samuel H. Kress Foundation, which was so instrumental in the 1960s in helping American museums develop their European collections, donated a number of Italian medieval and Renaissance masterworks, including a rare central panel of a portable triptych from the shop of Taddeo Gaddi (p. 224); a masterpiece by the Sienese painter Matteo di Giovanni (p. 234); as well as a number of other important works, including Nicola Giolfino's *Myth of Deucalion and Pyrrha,* which is a rare surviving example of a bedroom decoration.

With Thomas Solley guiding the museum's development from the 1970s into the 1980s, every part of the Western holdings expanded and major works were added. In 1978 Solley donated German Renaissance panels by the Master of the Holy Kinship in memory of his beloved aunt, Marguerite Lilly Noyes (pp. 236–39). A number of other memorial tributes were made in her name at the time of her death in 1973. These included the beautiful *Virgin Adoring the Christ Child* by a fifteenth-century Florentine

master (p. 232) and one of the earliest paintings by the eighteenth-century Roman master Giovanni Paolo Panini (p. 276). Renaissance Florentine art was also augmented by the addition of a rare lid from a *cassone* (p. 230)—a relic of the historic moments that spawned the famous Pazzi Conspiracy of 1478, which resulted in the murder of a Medici heir. Our small, early head of a boy by the Venetian master Piazzetta (probably his son) is a charming addition to our eighteenth-century Italian holdings.

In addition to the acquisitions made possible by the generosity of Tom Solley and Mrs. Noyes, the friendship of Nicholas Acquavella brought the museum some lovely pieces, including *St. Catherine* by Francesco Zaganelli and a copy of Andrea del Sarto's *Barbarini Holy Family,* as well as a masterpiece by Luca Giordano (p. 252). The medieval holdings expanded to include remarkable Limoges enamel pieces—a cross and a *châsse*—as well as a rare intact portable triptych by Niccolò di Buonaccorso (p. 226). Lovely maiolica from Urbino, boxwood carvings from Germany, and exotic rock crystal from Milan enhanced the decorative arts collection. A 1974 gift from Mrs. Dale Cox of a fine example of the architectural work of Viviano Codazzi (p. 254) remains a collection highlight.

The museum's collection of Dutch paintings also expanded with the addition of works by Gerard ter Borch, Pieter de Ring, Cornelius Bega, and Emanuel de Witte, as well as a fine head by Pieter de Grebber, while our Italian Baroque holdings grew with the acquisition of the early Bernardo Strozzi image of *St. Dorothy* (p. 248). In this era, as well, the collection of French eighteenth-century masterworks deepened with the addition of the charming turn-of-the-century portrait of Mrs. Chinnery by Elisabeth-Louise Vigée Le Brun (p. 286) and Jean-Louis Laneuville's portrait of Jean de Bry (p. 282).

The years following Thomas Solley's retirement have seen the collection continue to grow, primarily through gifts. Honoring their long friendship and shared commitment to the teaching mission of the IU Art Museum, Gloria Middeldorf, widow of the late Professor Ulrich Middeldorf, a world-renowned art historian, worked with Director Heidi Gealt and Professor Bruce Cole to facilitate the gift of the Middeldorf Collection of medals, textiles, prints, and drawings. Outstanding pieces include Medici medals and a textile featuring the pattern of the Magi's cope in the masterful Bloemaert painting acquired in 1990 (p. 258). As Mrs. Middeldorf wished, the collection has stimulated important research and a forthcoming publication of the medals.

Herman B Wells bequeathed a number of masterpieces, including a charming Madonna and our first flower painting. Morton Bradley, Jr., whose major philanthropy was devoted to nineteenth-century American painting, also left us a number of interesting pre-1800 pieces, notably a Domenichino and a clown painting attributed to Claude Gillot. Most recently, it has been the generosity of Elisabeth P. Myers and the friendship of donors such as Robert and Sara LeBien that have enabled us to add a rare, early seventeenth-century masterpiece by Antiveduto Gramatica portraying the story of Judith (p. 246).

Henry Hope's acquisition of Stuart Davis's *Swing Landscape* set the standard for what has developed into a truly extraordinary collection of nineteenth- and twentieth-century art from Europe and America, now comprising approximately twelve hundred pieces. Hope negotiated the reallocation of the mural (which had been commissioned by the WPA Federal Arts Project for a public housing project in Brooklyn, New York, but never installed) to Indiana University in 1941, and it arrived early in 1942. Several other WPA allocations also formed the basis of the early collection in the 1940s, as was typical of many university art museums throughout the country.

Despite the brilliance of the Davis acquisition, the collection might have remained a modest pedagogical sampling but for the intervention of James and Marvelle Adams. Adams had wide-ranging interest in art, collecting works from many periods and places. His William Lowe Bryan Memorial Fund enabled the museum to purchase several important nineteenth-century French and American works, among them Charles-François Daubigny's *Morning* (p. 294), Ernst Barlach's seminal German Expressionist sculpture, *The Singing Man* (p. 332), and John Frederick Kensett's lovely *Water Scene*. James Adams' second wife, Elizabeth, bequeathed their collection to the IU Art Museum in 1981.

The museum's first director, Henry Hope, had a strong interest in French modernist painting and sculpture of the 1920s and 1930s, acquiring and donating works by Braque, Picasso, Maillol, and Lipchitz. Not only did he purchase important artworks, he also commissioned several, including the family portrait by Max Beckmann. From the 1960s on, the Hopes began to give items from their private collection to the museum, and our twentieth-century French collection largely exists because of their generosity. Sarahanne Hope Davis, Henry's widow, continued to make gifts into the 1990s, including important sculptures by Henry Moore and Alexander Archipenko (given in memory of IU's renowned metalsmithing pioneer and educator Alma Eikerman); a few more pieces were bequeathed upon Sarahanne's death in 2001.

The museum's modern and contemporary holdings grew even stronger in the 1970s and 1980s under the direction of Thomas T. Solley. Solley established relationships with dealers of German and Austrian art, such as Serge Sabarsky, and made German Expressionism an important element of the museum's collections. Solley sought out works by Emil Nolde, Ernst Ludwig Kirchner, Alexei von Jawlensky, and August Macke. His strong interest in Dada and Surrealism led to the purchase of the *Readymades* by Marcel Duchamp (pp. 324–27), a painting by Balthus (p. 336), and other works. Other major acquisitions, such as the Jasper F. Cropsey (p. 292) and the Gustave Caillebotte (p. 298) entered the collection as gifts from Thomas Solley or members of his family. Important pieces across the expanse of the modernist landscape were added, from a classic painting by Fernand

Unknown British artist. *Portrait of Viscount Weymouth*, ca. 1830. Oil on paper, gold fittings. Morton and Marie Bradley Memorial Collection, 2006.321

Gallery of the Art of the Western World, first floor

Morton C. Bradley, Jr., 1980

Morton C. Bradley, Jr. (American, 1912–2004). *Lotus*, 1974. Painted cardboard. Fabricators: Joe Parker and Linda Priest Photo: Rachel Huizinga

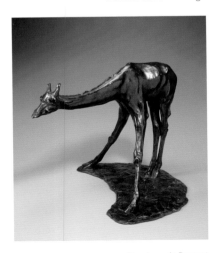

Rembrandt Bugatti (Italian, worked in France, 1884–1916). *The Drinking Giraffe*, 1907. Bronze. Arthur R. Metz Collection, Gift of the Arthur R. Metz Foundation, 94.82

Léger (p. 328) to works by the American masters Morris Louis (p. 356) and Jackson Pollock (p. 352). Thomas Solley developed other areas of the modern collection as well, building photography, works on paper, ceramics, glass, and metalwork collections that greatly enhanced the museum's scope and teaching capacity.

Complementing the museum's strength in nineteenth- and twentieth-century European painting and sculpture, the Morton and Marie Bradley Memorial Collection of American paintings from 1800 to the early twentieth century is a wonderful teaching resource for the university and very popular with visitors. Morton C. Bradley, a Massachusetts collector and conservator, donated the majority of the gifts in honor of his parents in the 1990s, although some gifts were made earlier, in the 1970s and 1980s. Bradley had strong family ties to IU—his father, Morton Clark Bradley, and his mother, Marie Louise Boisen, were born in Indiana, and both studied at Indiana University; his grandmother grew up in the Wylie House, which once belonged to Andrew Wylie, Indiana University's first president. Upon Morton Bradley's death in 2004, there was an additional bequest. Works by Hudson River School artists and other artists working in the New York/New England area are prominent in this collection. The Bradley Collection also includes numerous miniature portraits, some American, some European.

Morton C. Bradley was not only a collector and conservator of note; he was an artist whose extraordinary geometric sculptures came to Indiana University as part of his bequest. Several of these pieces have entered the IU Art Museum collection, while others have been installed in prominent locations on the Bloomington campus, including the IU Law and Business schools. Plans to publish and exhibit this important body of work are underway.

Finally, the Metz Collection, which entered the IU Art Museum as a gift from the Metz Foundation in 2003, provides a perfect complement to the Bradley painting collection with its outstanding selection of nineteenth-century Romantic bronze sculptures. Several Metz pieces are on view in the Thomas T. Solley Atrium of the Art Museum.

AFRICA, THE SOUTH PACIFIC, AND THE AMERICAS

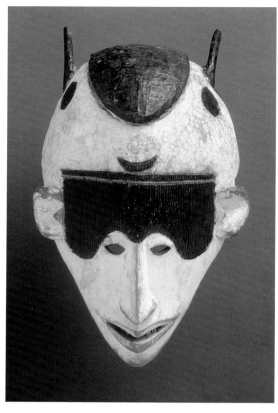

Igbo peoples, Nigeria.
Mask (Mwuo). Wood, pigment.
Gift of Frederick Stafford, 59.39

Roy Sieber and Laura and Raymond Wielgus

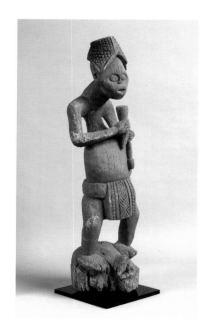

Bali-Nyonga kingdom, Cameroon.
Figure from a Meeting-House Post,
1909–14. Wood, pigment.
Gift of Rita and John Grunwald, 74.32

The museum's collection of art from Africa, the South Pacific, and the Americas is one of the country's richest, with more than 550 objects on display in the Raymond and Laura Wielgus Gallery and over 2,500 other items from these cultural areas accessible in an adjacent study-storage room. Aesthetically brilliant and classic objects combine with examples that go beyond expected styles and types to present a broad survey of the three world areas represented in the Wielgus Gallery. The internationally recognized collection draws anthropologists, art historians, and museum curators to Bloomington from throughout the United States and abroad.

The establishment of such a storied collection at Indiana University is the result of the influence, foresight, and extraordinary eye of the late IU professor Roy Sieber (1923–2001). Although a handful of very fine African, Oceanic, and Pre-Columbian objects had come to the museum in the late 1950s as gifts of the New York collector Frederick Stafford, when Roy Sieber joined the IU Fine Arts faculty in 1962, the collection contained only about fifty pieces, mostly bought by Henry Hope—"without specialized knowledge," as Hope was quick to admit. By 1970 (when Hope was about to retire), the collection under Sieber's guidance was already considered among the best in any university museum in the country.

Roy Sieber (who received the first PhD in African art history given in the U.S.) was recruited to IU because of the growing interest in African studies at the university. In addition to his ground-breaking research and exhibition experience, he brought a connoisseur's enthusiasm for objects and a growing coterie of collector friends. Encouraged by Sieber, many people enriched the collections over the years. Particular credit for their gifts and support should be given to Ernst Anspach, Herb and Nancy Baker, Richard Cohen, Allan Gerdau, Rita and John Grunwald, and Toby and Barry Hecht.

Undeniably foremost in the Sieber constellation were Raymond and Laura Wielgus, who made their first gift, a Costa Rican mace head, the year Roy arrived on campus. Many gifts were to follow, until, in 1975, a decision to sell their Biwat flute figure to the museum (p. 212) initiated a new stage in the Wielguses' involvement with the IU Art Museum. In 1986 this partnership was formalized, and in 1990 the agreement was expanded to include the Wielguses' entire African, South Pacific, and Pre-Columbian collection, an endowment, and the naming of the museum's gallery.

Costa Rica, Guanacaste-Nicoya zone (?). *Mace Head with a Human Face*, AD 1–500. Igneous rock. Raymond and Laura Wielgus Collection, 62.102

Affinities of Form: The Raymond and Laura Wielgus Collection of the Arts of Africa, Oceania, and the Americas opened at the Indiana University Art Museum in 1993 and subsequently traveled to venues in Maine, Texas, and Florida.

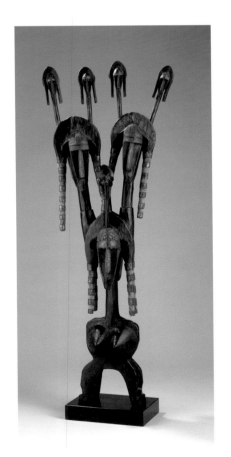

Bamana peoples, Sela Village, Mali. *Marionette Headdress*, early 1930s (?). Wood, brass, cloth. 77.87

The Wielgus Collection, meticulously assembled primarily in the 1950s and 1960s, includes major examples of ancient American sculpture and ceramics, Polynesian and Melanesian sculpture, and African sculpture and masks. Few private collections of African, South Pacific, and Pre-Columbian art are of such uniformly exceptional quality, marked by such authoritative connoisseurship—as the prevalence of Wielgus pieces among the masterworks presented in this publication demonstrates. In 1996/97 and again in 2000, a major exhibition of the Wielgus Collection, accompanied by an extensively researched catalogue, traveled to venues around the United States.

Thomas T. Solley became Roy Sieber's creative collaborator upon assuming the museum directorship in 1971. During the 1970s and 1980s, a number of major acquisitions added to the luster of the growing collection. In addition to the many Wielgus pieces that entered the collection through gift or purchase, several rare and beautiful African objects were purchased from the Frederick Pleasants estate (pp. 36, 56, and 62); other major acquisitions—a Baule gold pendant (formerly in the collection of André Derain) and a Bamana headdress among them—carried equally impeccable collection histories.

The strength of the museum's holdings of African, South Pacific, and Pre-Columbian art continues to attract collectors and donors. A recent gift from Tom Joyce of a large group of African currency and metalwork adds a new aspect to the African collection, certain to stimulate research and future publication. Jewelry and other objects from Somalia were important gifts from the Foundation for Cross Cultural Understanding, adding to the collection of Somalian basketry and pottery assembled for the museum by IU's John W. Johnson while on a Fulbright Fellowship there in 1988.

Roy Sieber's legacy of faculty involvement in the IU Art Museum continues to resonate. Last year Budd Stalnaker (1937–2006), who had taught textile design in the Hope School of Fine Arts, bequeathed his remarkable collection of African hats to the museum (p. 50), while Professor Emeritus Bill Itter continues to enliven the Wielgus Gallery with loans from his extensive collection of African ceramics.

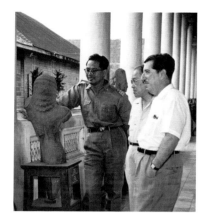

Professor Theodore Bowie with Thai officials in Bangkok to select pieces for the *Arts of Thailand* exhibition, held in the lobby of the IU Auditorium in 1960.

China. *Earth Spirit (Zhengmoushou).* Tang dynasty, 618–907. Earthenware with three color glaze *(sancai).* Gift of Margaret and Michael Chung, 2006.827

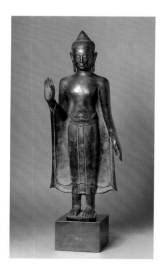

Thailand. *Buddha,* 13ᵗʰ–14ᵗʰ century. Bronze. Purchased with gifts in honor of Theodore R. Bowie, 79.78

Until the late 1950s—when the Art Museum acquired (through the William Lowe Bryan Memorial Fund) the superb Japanese lacquered wood sculpture of young Prince Shōtoku (p. 138) and an important group of Chinese bronzes, including the Shang dynasty *Liding* vessel (p. 128)—the Asian collection consisted of a smattering of Japanese prints and hanging scrolls. However, as Henry Hope recounted in his 1970 history of the IU Art Museum, these Bryan Fund acquisitions

> gave us confidence that we could build up an Oriental collection, not only in Japanese art, but also Chinese, Indian, and Southeast Asian. It seemed particularly fitting to do so in the late fifties because the University was building active exchange and area programs in the Oriental field—particularly in Thailand. It was in this regard that Professor Bowie organized the major exhibition of Thai art which after opening with much fanfare at Indiana [in the lobby of the IU Auditorium] went to the Metropolitan Museum in New York and to other American cities. I'm sure this helped to establish Indiana's reputation in collecting Oriental art."[3]

Henry Hope credits Professor Theodore Bowie with "constant searching" to grow the Asian collection, especially in Japanese art, noting in particular the acquisition of several beautiful screens, a major hanging scroll by Bunchō, and the gilded Amida Buddha (p. 136). Ted Bowie's ongoing relationship with Thailand (he subsequently organized a second exhibition for the Asia Society) resulted in a number of bronze and ceramic pieces, both large and small, entering the collection. A generous and comprehensive gift of over one hundred fourteenth- and fifteenth-century ceramics from Thailand was presented by Dean F. Frasché in 1967.

After Hope's retirement, the Asian collection found an equally ardent champion in Thomas Solley, whose interests ranged from Gandharan sculpture, to Cambodian bronzes, to ancient Japanese ceramics. Indian sculpture particularly appealed to Solley, and during the 1970s a number of significant pieces entered the collection, including the much-beloved bronze sculpture of Ganesha (p. 118), the beautiful stone Yakshi (p. 116), and the riveting Emaciated Buddha (p. 114).

The Asia collection continues to grow, with recent gifts from collectors and benefactors filling gaps and enhancing strengths. Robert and Sara LeBien, longtime leaders of the museum's National Advisory Board, purchased Quan Handong's *Oxen # 6* (p. 132) for the museum, and the artist Xiao Shunzhi donated his *Sweet Flower Soliloquy # 12.* Leonard H. D. and Marjorie J. Gordon recently enhanced the collection with three landscape paintings by the important Japanese artist Kanō Tan'yū (1602–1674). Margaret and Michael Chung gave us eighteen Chinese ceramics that date between the second millennium BC and the twelfth century.

Notes
1. Henry R. Hope, quoted in *Indiana University Art Museum: Dedication 1941–1982* (Bloomington: IU Art Museum, 1982), p. 10.
2. Henry R. Hope, "The Indiana University Art Museum," *Art Journal* 3, no. 2 (Winter 1970–1971): 173.
3. Ibid.

NOTES TO THE READER

The heading for each object presents the basic catalogue information for that work of art. If the name of the artist is known, that is given on the first line, followed by the artist's nationality and birth and death dates. When the individual artist is unknown, but the piece is attributed to an ethnic group or peoples (Yoruba peoples, Maori peoples), this information is given on the first line, along with the geographical region of origin. If only the general culture of a piece is known (Roman, Zapotec), that is given, along with the region of manufacture and the date range for the period or dynasty from which the piece arose. Sometimes, only the place of origin and period are known (Japan, Middle Jomon period). Finally, if the only identifier is the place of origin, that is given on the first line (Raivavae, Austral Islands).

Dimensions are provided in inches and centimeters, with height preceding width. For some three-dimensional works, only one measurement is cited, usually height.

The last line of the catalogue information names the collection or donor (if any) and gives the museum accession number. The numerals before the period indicate the year the object entered the museum's collection (only the last two digits were used prior to the year 2000); the number following the period indicates where the piece figured in the sequence of objects that entered the collection in that particular year.

We hope that readers of this publication will visit the Indiana University Art Museum galleries to view these masterworks in person. While the museum strives to exhibit almost all of these artworks regularly, not every work will be on view at all times. Occasionally key works are undergoing conservation or are on loan to other museums.

CONTRIBUTORS

Adelheid M. Gealt
Director and Curator of Western Art before 1800

Diane M. Pelrine
Class of 1949 Curator of the Arts of Africa, Oceania, and the Americas

Adriana Calinescu
The Thomas T. Solley Curator of Ancient Art Emerita

Judith A. Stubbs
The Pamela Buell Curator of Asian Art

Jennifer A. McComas
The Class of 1958 Curator of Western Art after 1800

Linda J. Baden
Associate Director, Editorial Services

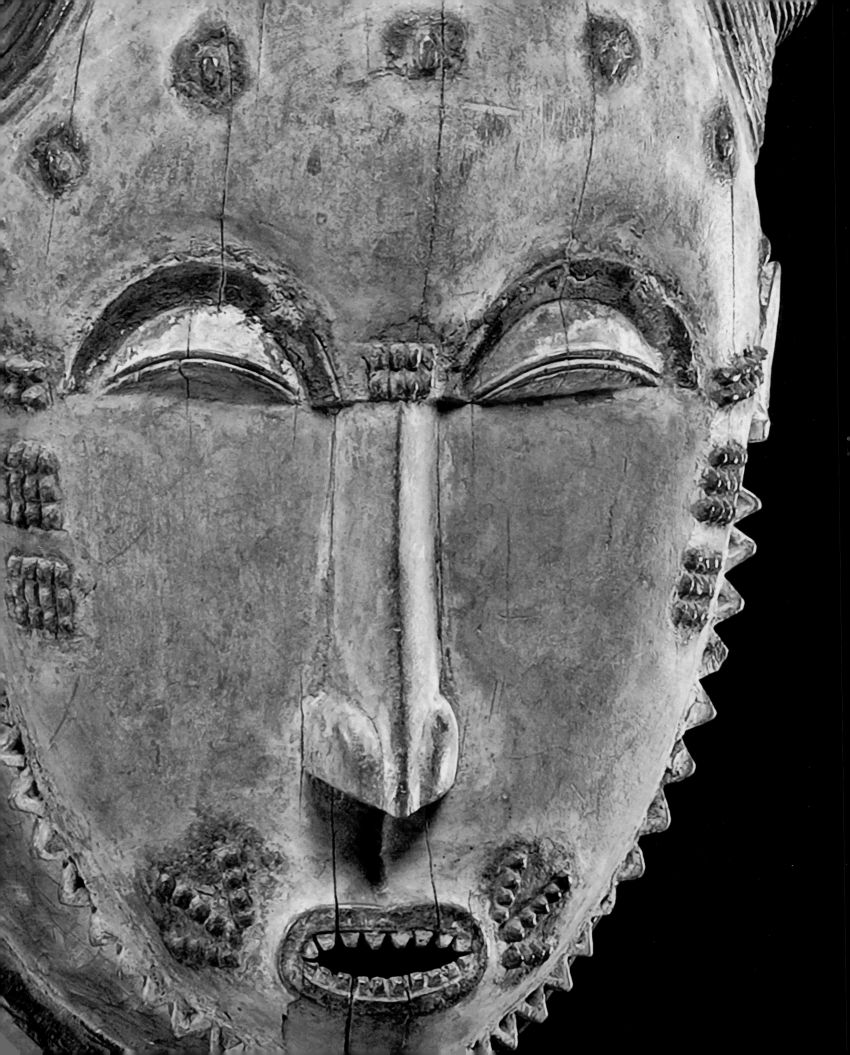

AFRICA

The sub-Saharan African collection is one of the museum's strongest and among the best in the country. Like nearly all museums showing African art, the IU Art Museum holds a collection that emphasizes the human form, a reflection of Western collecting interests. As a result, most objects in the collection are from western and central Africa, in the area of the Niger and Benue rivers and the Zaire River and its tributaries, where most of the groups that make masks and figures are concentrated. However, given the longtime involvement of Roy Sieber, who pioneered the study of non-figural forms such as textiles, jewelry, and household objects, it is not surprising that the collection includes numerous examples of those objects as well.

People who are unfamiliar with African art are sometimes puzzled by the object identification labels in this area, which lack the name of the artist who created the artwork. Instead, most of the objects are attributed to a peoples, or ethnic group—a cluster of communities that share the same language (but may speak different dialects) and culture. In the field of African art, ethnicity has become the primary identifier for objects that were made and used in local contexts. Because the names of individual artists and the specific locations where objects were collected usually were not documented, an ethnic attribution, or sometimes an attribution to a sub-group, is commonly the most precise designation that can be offered. These attributions are made on stylistic grounds, and, while ethnic borders are fluid, and artists from a single group may work in more than one style, most objects can be attributed by comparison with those for which more precise collection information exists.

When an object was made is also frequently unknown. Again, in most cases, that information was not documented when the object was collected. However, we know that most objects were not intended to last indefinitely and were regularly replaced. Furthermore, humidity, insects, and soil microbes hasten the decomposition of wood and other organic materials. A safe assumption, then, is that, without collection documentation or technical analysis to the contrary, objects were made less than a century before they were acquired. For the majority of American collections, including the IU Art Museum's, this means that most objects date to the late nineteenth or twentieth centuries.

Even though the people who acquired African objects for art collectors and museums most often did not obtain or record the makers' names, those artists were certainly acknowledged in their own societies. Indeed, throughout sub-Saharan Africa, artists—whether carvers, metalworkers, potters, or weavers—were recognized for their accomplishments, and their reputations sometimes brought commissions from far away, and enough work to fill the days.

For the most part, however, these creative endeavors were—and remain—part-time work; even today, in the face of rapid urbanization, farming continues to be the major occupation of people on the continent. But "part-time" does not mean that these artists were untrained or self-taught: artists learn their crafts in a variety of ways. Among the Bamana of Mali, for example, woodcarving is learned as part of a blacksmith's apprenticeship, which can last several years; in other areas, a man might learn to carve from a relative or friend under more informal circumstances. In some places, all members of a certain group might be expected to acquire skills in a particular craft as part of becoming an adult. For instance, all Ndebele girls in South Africa learned to do beadwork, though, as is the case in all creative endeavors, relatively few individuals would have the talent and acquire the skill to excel.

Although the terminology can be ambiguous, the objects that follow—and most that are on display in the gallery—are frequently called "traditional," to distinguish them from artworks made by African artists beginning in the twentieth century that are directed to a global art world and, usually, a commercial market. "Traditional" in this context tells us that the objects were intended to be used in local religious, cultural, or political practices. For museums, the term also is associated with ideas about authenticity: the IU Art Museum, like other art museums worldwide, collects objects that were actually used in those local contexts.

"Traditional," however, is not meant to suggest that art forms are unchanging over time or show no contact with outsiders. The museum's Chokwe chair is a perfect example: it represents a change in the form of seats used by leaders (elaborated stools had been used previously), and, although its inspiration came from European chairs, it would never be mistaken for one. As integral parts of their cultures, these traditional arts have been impacted by the dramatic transformations—colonialism, urbanization, and globalization among them—that Africa has experienced for more than a century. As a result, some of these arts have disappeared, but others continue to evolve to meet the current needs, desires, and aspirations of their makers and users.

Diane M. Pelrine
Class of 1949 Curator of the Arts of
Africa, Oceania, and the Americas

Dogon peoples, Mali

Male Figure
16th century (?)
Wood
H. 44 in. (111.8 cm)
Raymond and Laura Wielgus Collection, 87.12

Dogon sculpture became widely available in the 1960s, and its popularity increased dramatically; today, any collection of African art claiming to be comprehensive almost certainly includes a Dogon mask or figure. Few of those, however, have the size or presence of this example. Taller than most Dogon figures, this one, though damaged in places, has a sculptural quality indicating a masterful carver at work. The powerful columnar volumes of the arms, torso, and legs contrast with the flatness of the hands and beard and the delicacy of the chip-carved patterns on the torso and face, probably representing scarification, which are echoed in the serrated sides of the beard.

At first glance the figure's gender may be unclear, but what might be mistaken for female breasts are instead developed male pectoral muscles, and closer examination reveals that a penis, now missing, was originally carved. In addition, the figure is depicted with a full beard, a sign of a male elder. Such a man traditionally holds a position of power and respect within Dogon society, in recognition of the knowledge and wisdom gained over the course of a lifetime and reflecting a belief that elders have particularly strong connections with the world of the ancestors and other spirits.

The figure does not depict just any elder, however; it is likely a Dogon priest, or *hogon.* He stands with upraised arms, a pose frequently seen in Dogon sculpture and one associated with prayer, particularly for rain—so critical for successful harvests in this arid land. His only attire is a belt, the traditional way in which Dogon priests address the spiritual realm. The carved rings encircling the figure's wrists may depict iron bracelets, which are the purview of these priests and political leaders.

In contrast to Dogon masks, which appear in public masquerades, figures have been described most frequently in association with shrines and altars—private places not readily accessible to outsiders, including researchers. Consequently, our understanding of Dogon figures is more limited than what we know about masks. Located in family compounds as well as outside of villages, shrines are made for several purposes, including the honoring of ancestors, both real and mythic; the growth and strengthening of an individual's personal force; and the supplication of adequate rain. In many cases,

the owner himself may carve figures that are displayed on altars. However, certain shrines and altars, such as those commemorating the founders and important members of lineages and those honoring *binu* (mythic ancestors who lived before death came to humankind), demand figures carved by professionals. This figure was most certainly one of those.

Among the Dogon, professional carvers are most often blacksmiths. Historically blacksmiths had a privileged place in society: not only did they make the farming tools upon which people's existence depended, but their ability to master iron—a medium that could be transformed from a solid to a liquid—suggested a link with the spiritual world that fostered their roles as peacemakers among the living and as intermediaries between the living and world of the ancestors and deities that comprise the Dogon spiritual realm.

This figure has been associated with a style called Tintam, named after a town in the Bondum region of northern Dogon territory.[1] Tintam-style figures are distinguished by their lack of clothing, distinctive cap-like hairstyle, scarification marks on the torso, and a bulkiness missing in many other Dogon sculptures. Furthermore, unlike many Dogon figures, those in the Tintam style show little, if any, traces of sacrificial materials having been poured or rubbed on them.

The Dogon live in the dry and rugged area of the Bandiagara Escarpment of northeastern Mali. The climate there has allowed the preservation of wooden objects for periods unheard of in most parts of sub-Saharan Africa, so it is not unusual for figures to be more than a century old. The tentative sixteenth-century date for this figure is based on a carbon-14 test that was performed during the 1960s, which yielded at date of 1520 +/- one hundred years.

Further Reading
Ezra, Kate. *Art of the Dogon: Selections from the Lester Wunderman Collection.* New York: Metropolitan Museum of Art, 1988.

Note
1. Hélène Leloup et al., *Dogon Statuary* (Strasbourg: Éditions Amez, 1995), 163–65, pl. 103.

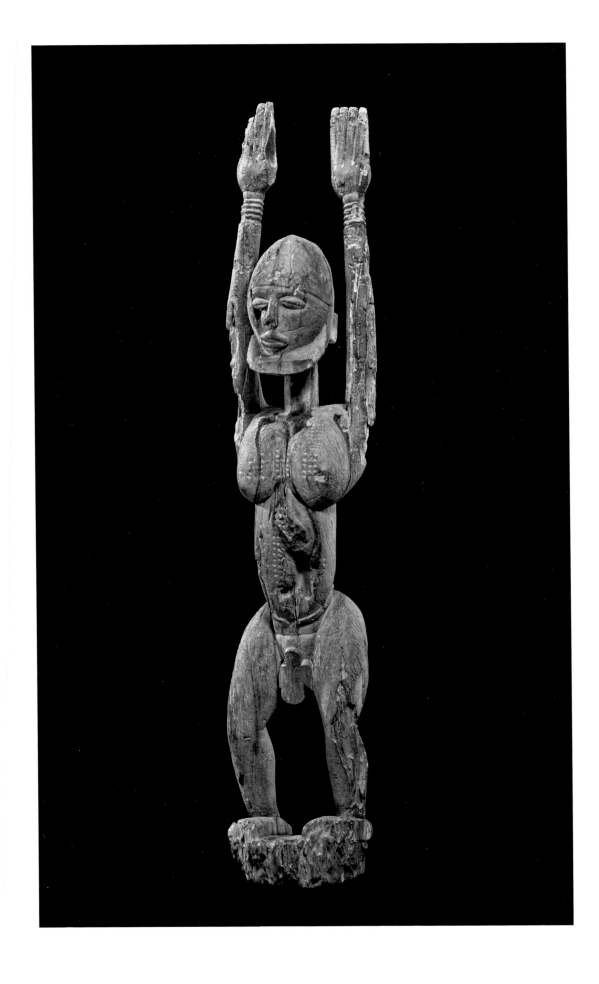

Bamana peoples, Mali

Antelope Headdress (Ci Wara or Sogoni Kun)
Wood
H. 20 in. (50.8 cm)
Raymond and Laura Wielgus Collection, 87.24.3

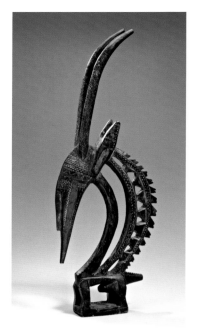

Ségou-style male antelope headdresses are readily identified by their long heads and intricate openwork manes. This gift of Frederick Stafford is one of the earliest additions to the IU Art Museum's African art collection.

Bamana peoples, Mali
Antelope Headdress (Ci Wara)
Wood, metal
H. 36 in. (91.4 cm)
Gift of Frederick Stafford, 60.10

Can anyone imagine a sculpture that more convincingly conveys the grace and delicacy of an antelope? Westerners most certainly appreciate the abstract simplicity of the form; research suggests that clarity of form and visual representation of the essence of the subject are also elements that Bamana viewers themselves value in sculpture.[1] Enhancing form with decoration—here, incised patterns on the neck and horns—and added elements (now missing, but indicated by the holes in the nose and ears for the attachment of red thread or metal rings) creates a sculpture that is *mafilè fén,* "something to look at," and *nye la jako,* "pleasing to the eye."

For Westerners, antelope headdresses from the Bamana have become icons of African art. Most often illustrated are those representing male antelopes with elaborate abstract manes that are associated with the area of Ségou, in the eastern Bamana region. However, other styles of the headdresses are also common, some more naturalistic; others, such as this example, less so. The verticality of this *ci wara* associates it with the eastern Bamana region, but its simplicity and degree of abstraction place it south of Ségou. In fact, it is very similar to another headdress collected in the 1930s in Kinian, a town in the region of Sikasso, over a hundred miles south of Ségou.

Bamana antelope headdresses appear primarily in two contexts. One was originally a men's association known as *ci wara* (literally, farming beast), which used spiritual practices to ensure successful agriculture. As part of those practices, dances were held in farming fields for association members, and antelope headdresses, also called *ci wara,* were worn. Taking its name from the mythic half-man, half-animal who taught the Bamana how to farm, *ci wara* over the years has transformed into a mostly secular performance celebrating good farming and farmers. Today, the term is most frequently applied to an especially proficient farmer or farming tool.

Antelope headdresses appear, too, in the context of *sogoni kun.* Like the term *ci wara*, *sogoni kun*, or little animal head, refers to a headdress, to the dancer who wears it, and to the performance in which it appears. Originating among the Wasulunke, who live southwest of the Bamana near the border of Mali and Guinea, *sogoni kun* spread among the Bamana, where it was incorporated into youth associations, groups of unmarried young men and women who undertake community service and organize village entertainment. Later, it also became a dance associated with itinerant performers, especially in urban areas. Frequently performed in conjunction with the agricultural cycle, *sogoni kun* has distinctive costumes, choreography, and music that set it apart from *ci wara.*

For all *ci wara* and many *sogoni kun* performances, the antelope headdresses appear in male/female pairs. Conventionally, the presence of a small antelope on the back of a larger one indicates a female (with her young), while the depiction of a large, intricate mane (such as the one above), signifies a male. Both of these features are absent from the museum's Wielgus example. Based on many years of studying regional variations in both *ci wara* and *sogoni kun,* however, Bamana expert Pascal James Imperato suggests that the figure may well be female, noting that while the ears on this antelope become small horns, the male counterpart would likely have a second pair of large horns.[2] However, Imperato goes on to point out that some *sogoni kun* were performed as single headdresses, not part of pairs, making the question of gender less relevant.

Whether *ci wara* or *sogoni kun,* this antelope was undoubtedly sculpted by a man from a Bamana blacksmith clan, for, in addition to working iron, smiths are the traditional woodcarvers. As an apprentice, a boy learns to carve wood before he is taught to forge iron, first mastering the carving of knife and hoe handles and then moving on to more complicated creations. As is the case all over sub-Saharan Africa, adzes of various sizes are the primary carving tools, and skills are mostly acquired through observation and trial and error. Though a few smith/carvers make a wide variety of iron and wooden objects, many specialize, and a man who shows great skill, such as the carver of this headdress, will earn a reputation that can draw clients from many miles.

Further Reading
Imperato, Pascal James. "The Dance of the Tyi Wara." *African Arts* 4, no. 1 (Autumn 1970): 8–13, 71–80; and "Sogoni Koun." *African Arts* 14 (no. 2, February 1981): 38–47, 72, 88.

Notes
1. See, for example, Patrick McNaughton, *The Mande Blacksmiths: Knowledge, Power and Art in West Africa* (Bloomington: Indiana University Press, 1988); and Kate Ezra, *A Human Ideal in African Art: Bamana Figurative Sculpture* (Washington, D.C.: National Museum of African Art, Smithsonian Institution Press, 1986).
2. Pascal James Imperato, personal communication, June 2006.

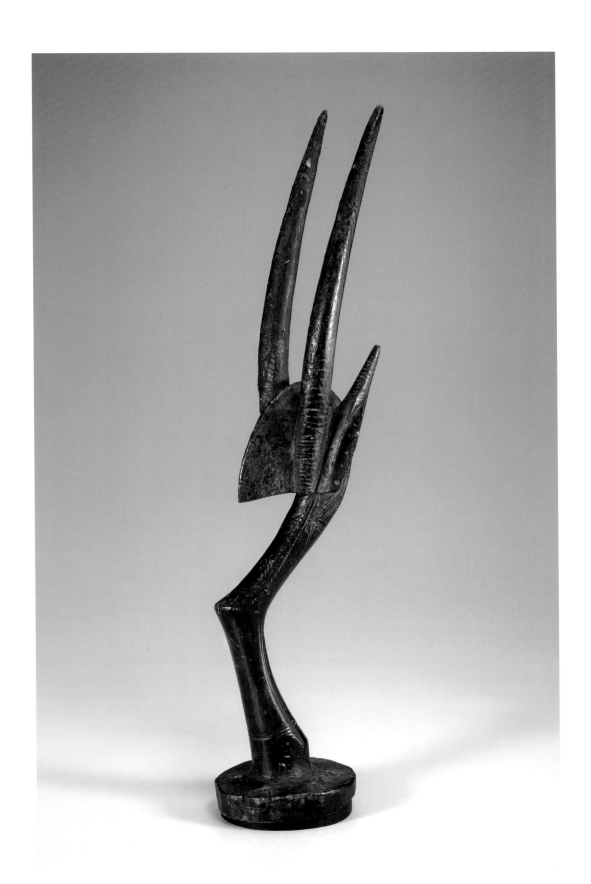

Mossi peoples, Burkina Faso

Mask (Karanga)
1900–1950
Wood, pigment, fiber
H. 70 in. (177.8 cm)
Gift of Rita and John Grunwald, 71.111

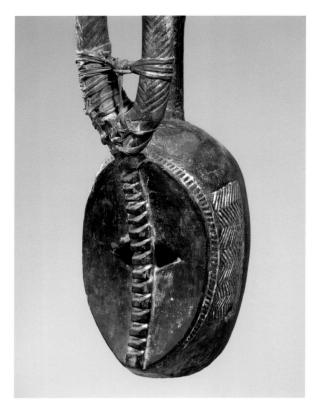

Detail of the head

Living in central Burkina Faso, the Mossi are an amalgamation of peoples, formed around 1500 when warrior horsemen from northern Ghana swept north, conquering the peoples living in the basin of the Red and White Volta rivers. In the society that was created—called Mossi—the conquerors and their descendants became the ruling class, known as Nakomsé, and the commoners, or Nyonyosé, were the subdued indigenous populations and their descendants. While the Nakomsé traditionally concern themselves with political matters, those pertaining to the spiritual realm are in the hands of the Nyonyosé. This division is reflected in Mossi art: figures associated with the installation and maintenance of chiefs and the king are owned by the Nakomsé, while the Nyonyosé have masks that honor nature spirits and ancestors, the focus of traditional Mossi religious practices.

This mask is of a type known as *karanga* (pl., *karansé*). Associated with the northern Mossi, a *karanga* consists of a face mask surmounted by an antelope head and horns with a plank-like superstructure behind them. Though the small head of the antelope is barely visible through the leather strips that repair a broken horn, the very long horns, which curve toward the plank at their tips, identify the animal as the Western roan *(Hippotragus equinus koba)*. Other masks have short, s-shaped horns, referring to a smaller antelope; both types depict animals that are totems of founding lineages of Nyonyosé in the area.

Mossi *karanga* masqueraders appear on several important occasions. At the burial of an elder from an important Nyonyosé family, they escort the body of the deceased to the grave and ensure that proper procedures are followed. Later, during annual funerary celebrations commemorating those who have died during the previous year, they appear again, this time performing for family members and guests by imitating the movements of the animals they represent. They also take part in annual rites to ensure the blessings of the ancestors on a community, and, during times of drought and poor crops, they are the traditional guardians of certain wild fruit trees that grow in the bush and are considered communal property of a village, ensuring that no one picks the fruit before it is ripe. In addition, Mossi masks also serve as portable altars, receiving sacrifices to ensure the goodwill of the ancestors.

The mask would have been the property of a Nyonyosé clan, rather than an individual, and the right to wear the mask would have been conferred upon a young man of the clan by one of the senior males. For a performance, the masquerader would don a costume consisting of shirt, pants, and a fringed fiber skirt with attached rattles. A cloth or fiber cap was sewn to the holes behind the base of the superstructure to help hold the mask in place, and, to keep it in position, the masquerader clamped in his mouth a stick that passed through the large hole toward the bottom of each side.

Blacksmiths are the traditional Mossi sculptors, and a member of one of those clans carved the mask out of a light, soft wood. Each year the pigments on the mask were renewed, after the mask had been soaked in a swamp or river for several weeks to kill any insects present. Some of the white pigment that once covered the face and the incised decoration is still evident, as are traces of red. With black, these are the primary colors not only of *karansé,* but also of masks from Burkina Faso generally. Geometric patterning, so effectively combined here in the form of cutouts and incisings, also characterizes most masks from this country. Perhaps most intriguing, however, are the visual similarities between *karansé* and the masks of the Dogon, neighbors to the west and descendants of people who fled into Mali from the Volta basin more than five centuries ago, when ancestors of the Nakomsé arrived. As Christopher Roy, an art historian whose research has provided much of our current knowledge of the arts of Burkina Faso, has noted, these masks are visual evidence of those historical links.

Further Reading
Roy, Christopher D. "Mossi Mask Styles as Documents of Mossi History." (2005) http://artqtserver.art.uiowa.edu:8080/Mask_styles/Index.html.
_____, and Thomas G. B. Wheelock. *Land of the Flying Masks: Art and Culture in Burkina Faso*. Munich: Prestel, 2007.

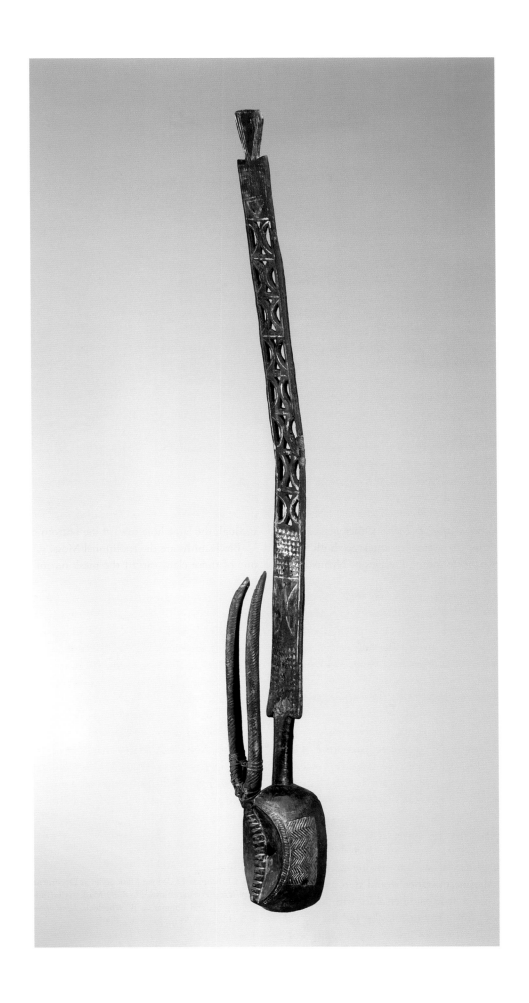

Dan peoples, Liberia/Côte d'Ivoire

Feast Ladle (Wunkirmian or Wakemia)
Wood
H. 20 in. (52.1 cm)
63.221

Though a large spoon with legs and feet belongs in a nursery rhyme or surrealist fantasy in the West, among the Dan peoples, who live in inland Liberia and western Côte d'Ivoire, it is an emblem of honor, a symbol of generosity, and the embodiment of spiritual power. The museum's feast ladle shows a liveliness, fluidity, and sense of proportion that also make it especially effective as a sculptural form. Associated with largesse and prosperity and, by extension, with the family wealth that makes such generosity possible, feast ladles such as this one were traditionally owned by a woman judged to be the most hospitable in her village or neighborhood.

Known as a *wunkirle* or *wakede,* that woman is chosen by her predecessor, whose feast ladle she frequently inherits. Her selection is public recognition that she is hardworking, industrious, and has excellent skills in farming and dealing with people—for only someone with those characteristics can fulfill the responsibilities of the position. A *wunkirle* is expected to provide food and gifts to those attending the festival that both commemorates her predecessor's death and marks the beginning of her new role. Thereafter, she is responsible for offering hospitality to all visitors to her neighborhood or village, whether individuals or groups. Itinerant musicians or other performers arriving for a community celebration, for example, can count on her for their meals.

In addition, the *wunkirle* prepares food for certain community events: during planting, she feeds the men who clear the fields; and, when circumcision rites are taking place, she ensures that the boys and their adult leaders have food brought to their camp. At feasts in her honor, the *wunkirle* may parade through her village or neighborhood with her ladle, using it to indicate where food should be distributed or to offer gifts of coins, peanuts, candy, or other treats to the crowd as a demonstration of her generosity. Competitions between neighborhoods may be held at major feasts for the title of most generous *wunkirle*. At those events, the woman and her assistants dance through town and distribute food and small gifts, with guests choosing the winner, who is honored in song.

According to traditional beliefs, the feast ladle embodies the spiritual power that allowed a woman to achieve her status, and before a woman can officially accept the position of *wunkirle,* that spirit must signal its acceptance of her in a dream. That same power ensures her success in fulfilling—and perhaps exceeding—the expectations associated with the role of *wunkirle.* In this respect, the ladles are the female counterpart of Dan masks (the exclusive domain of men), which also embody spirits, and sometimes a *wunkirle* with her ladle appears alongside masqueraders, throwing rice in front of them.

The museum's example shows one of the two most common forms for feast-ladle handles. The legs and feet are said to represent the people who arrive—usually on foot—for the *wunkirle* to feed. More frequently seen is a handle consisting of an elongated neck and female head, said to represent the original owner of the ladle and carved in a style resembling Dan female masks, which represent idealized beauty. Occasionally a handle might also end in a cow's or ram's head (a reference to the animals slaughtered for feasts), a fist (an allusion to the hand of the *wunkirle,* which opens in hospitality, or to her strong grip), a small rice bowl, or a non-figural design. Many of these ladles have bowls that are more like a scoop than the smooth oval of the legs-and-feet type. A few ladles with double bowls have also been documented.

Though some examples have extensive relief or incised decoration, surface embellishment of this ladle is minimal. Incised lines decorate the outer edge of the bowl, and additional incised lines circling the handle above the legs recall a woman's waist beads. The only other ornamentation is the depiction of brass anklets. Brass was considered the most prestigious and beautiful material for jewelry, and it was made into necklaces, rings, and a variety of arm and leg ornaments. Until the 1930s, both men and women wore brass anklets, but after that time they became almost exclusively women's jewelry. Worn in pairs as gifts from their husbands, the anklets became indicators of status: not only did their acquisition require resources, but, because their weight made activity cumbersome, they also suggested wealth that allowed the hiring of others to do work. The depiction of anklets on the ladle, then, can be related to the wealth and status of the *wunkirle* or to those to whom she provides hospitality, or they might simply be a way for the carver to associate the ladle itself with beauty and status.

Feast ladles are carved by the same men who sculpt masks and other wooden objects. The rich black surface for which Dan masks are known is characteristic of these ladles, too. This surface is traditionally created by soaking the object in river or swamp mud or by applying a dye made from boiling the leaves of a certain plant and then polishing it to a gloss with palm oil.

Further Reading
Fischer, Eberhard, and Hans Himmelheber. *The Arts of the Dan in West Africa.* Zurich: Museum Rietberg, 1984.
Johnson, Barbara C. *Four Dan Sculptors: Continuity and Change.* San Francisco: Fine Arts Museums of San Francisco, 1986.

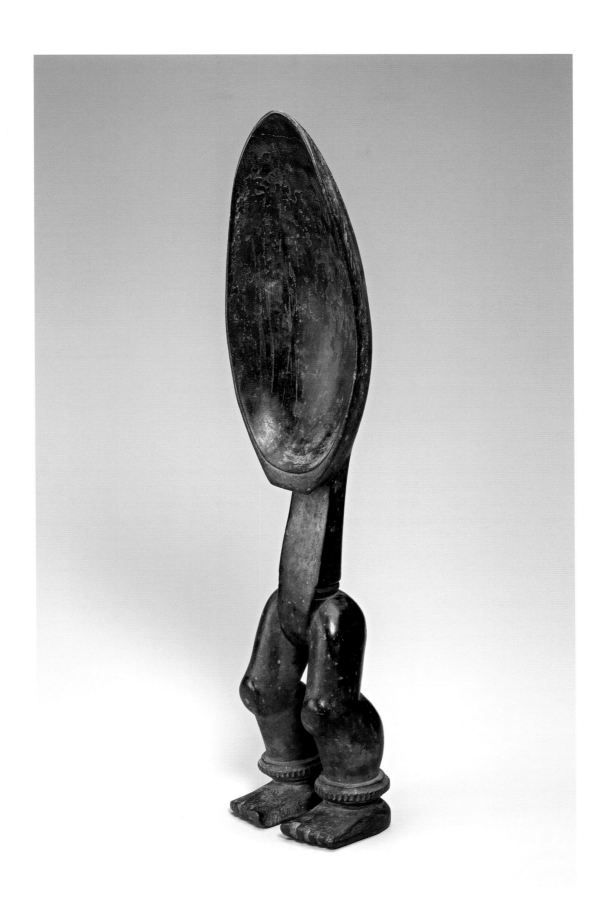

Baule peoples, Côte d'Ivoire

Mask (Goli Kpan)
Early 20th century
Wood, pigment
H. 19⁷/₈ in. (50.4 cm)
77.34.1

Masks and figures from the Baule, who live in central Côte d'Ivoire, were among the first African forms to capture Western attention at the beginning of the twentieth century, and this mask makes it easy to see why. Its self-contained oval form, framed by extensions at the top and bottom, contrasts with the fine, delicate surface carving of the facial features, coiffure, and scarification. The clean simplicity of the eyes, nose, mouth, and ears make the face easy to comprehend. These features are surrounded with subtle intricacy by the incised coiffure, the decorative serrations around the lower edge of the face, and the scarification marks on the temples and forehead, between the eyes, and around the mouth.

Among the Baule, scarification (no longer extensively practiced) and elaborate hairdos are considered signs of beauty and indications of civilized, socialized people. Detailed depictions of these enhancements on figural carving are much admired. Though we are tempted to view the serrations around the cheeks and chin as a beard, they are actually a decorative convention, appearing on masks that portray both men and women. Though the relief carving creates a lively surface, paint, which would have been regularly reapplied, also enhances it. On early examples such as this one, however, the color is frequently faded, a result of the use of natural pigments that were employed before enamel paint became available.

This mask was created for a masquerade performance called *goli,* an event held for entertainment and as part of funerals. In its full form, *goli* consists of four pairs of masqueraders who appear in succession and may be viewed by an entire community—men, women, and children. *Goli* performances contrast with other Baule masquerades, which have a sacred nature and traditionally are viewed only by adult males. In addition, two of the *goli* mask types are very different from other Baule masks, and the language of the masquerade songs is not Baule but Wan, the language spoken by their neighbors to the west, making it clear that *goli* did not originate with the Baule. Indeed, the Wan, too, have a masquerade called *goli,* which was the inspiration for the Baule version. By the end of the nineteenth century, some Baule villages were performing *goli,* and Susan Vogel, an art historian who has studied the Baule for over thirty years, has noted that the masquerade had spread to most Baule villages between 1900 and 1910. By 1970, *goli* had become the most widespread and popular Baule masquerade.[1]

Goli masks appear in a fixed order, usually in nearly identical pairs. Each mask type is considered fundamentally male or female, though each pair is considered to have male and female aspects, a belief that is a generally unspoken aspect of Baule worldview. The first type to appear is a wooden disk face, and the second is a helmet mask in the form of an animal head; both are male. The third type,

a horned face mask, and the fourth, of which the Art Museum's mask is an example, are female. Known as *kpan,* the fourth type can be recognized by its human face and crested coiffure. On the museum's mask, the short wrapped beard hanging from the chin indicates that it represents the male aspect of *kpan;* it would have been accompanied by another, very similar mask, representing the female aspect, which was beardless.

While all *goli* performances include the first two mask types, and the third appears frequently, *kpan* dances only at important events. It is the highest-ranking *goli* mask, and, in accordance with Baule custom, is therefore the last to appear. Appearing late in the day, the two *kpan* masqueraders hold flywhisks, emblematic of elderhood (unlike the others, who hold batons), and their dance is slow and stately, as befitting the dignity and honor that the Baule associate with exalted status. The other *goli* pairs appear together, but take turns dancing individually; the kpan pair, however, dances together.

Goli masqueraders all wear similar costumes, consisting of a netted shirt and pants, a raffia skirt, raffia fringes around ankles and wrists, and ankle rattles. In addition, long strands of raffia are wound around the rim of each mask, forming a long cape-like fringe that hangs from the mask to the wearer's waist and helps to hold the mask in position. An animal hide is attached on the top back of the mask—for a *kpan,* it is that of a leopard, an animal associated with royalty and power. Though narrow slits may be carved in the mask's eyes, the *kpan* masquerader does not wear the mask against his face, but rather tilts it slightly so that he can look out of the mask's mouth, allowing only very restricted sight. At the same time, like the Mossi masquerader (p. 32), he stabilizes the mask by holding in his own mouth a stick that extends across the width of the mask and through a hole near the bottom of each side.

This is one of the oldest *kpan* known in the West and one of the earliest *goli* published. It was exhibited in Paris in 1923 in *Art indigène des Colonies française d'Afrique et d'Océanie et du Congo belge,* an exhibition that was so popular that its original run was extended. Though no catalogue accompanied that show, two of its organizers, Henri Clouzot and André Level, published in 1925 a summary of it, *Sculptures africaines et océaniennes,* which featured the museum's mask on the cover.

Further Reading
Vogel, Susan Mullin. *Baule: African Art, Western Eyes.* New Haven: Yale University Press, 1997.

Note
1. Susan Mullin Vogel, *Baule: African Art, Western Eyes* (New Haven: Yale University Press, 1997), 169, 171.

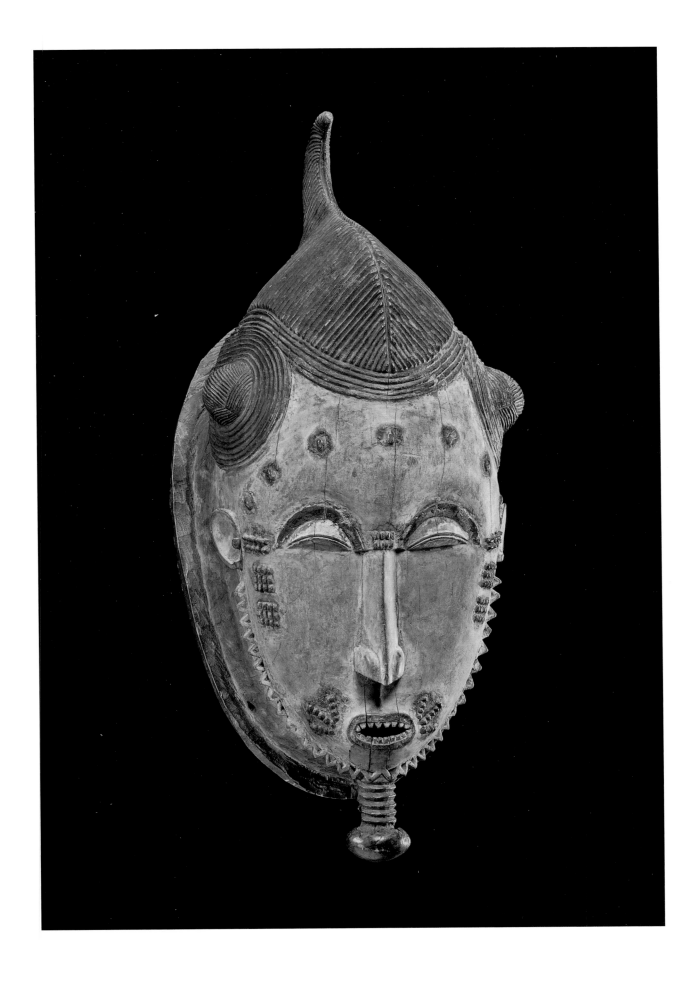

Yoruba peoples (Oyo subgroup), Nigeria

Staff for Esu/Elegba Cult (Ogo Elegba)
Before 1930s (?)
Wood, leather, cowrie shells, brass, bone, iron
H. 19 1/4 in. (50.7 cm)
Raymond and Laura Wielgus Collection, 87.24.2

Widely admired for the variety, quality, and quantity of their sculpture, the sixteen groups who make up the Yoruba peoples live in southwestern Nigeria and the eastern part of the Republic of Benin. Most members of their extraordinarily large pantheon of deities—estimates range from several hundred to well over a thousand—are worshipped in limited areas of Yorubaland, but a few are universally recognized with sculpture of a prescribed form. One of those is Esu (sometimes written "Eshu"), also known as Elegba, a deity, or *orisa,* who, paradoxically, creates confusion and disorder while at the same time offering the means for achieving balance and harmony.

Esu is a deity of contrasts and contradictions. Part of a praise poem honoring him vividly conveys this idea:

> Having thrown a stone yesterday,
> He kills the bird today.
> Lying down, his head hits the roof.
> Standing up, he cannot look into the cooking pot.
> Esu turns right into wrong, wrong into right.[1]

As an intermediary between the gods and people, he conveys offerings from the human world; before sacrifices are made to other deities, Esu's help is ensured by making an offering to him. As a trickster, he himself frequently makes sacrifices necessary, by tricking people into offending the deities and quarreling among themselves. In one often-told story, for example, Esu creates discord between longtime friends by donning a cap that is white on one side and black on the other. Each man—convinced of the color of hat worn by the stranger they see—accuses the other of lying. Esu is right at home in such chaos, whether among humans, or on a grander scale: in another story, he persuades the sun and the moon to exchange homes, thus reversing the natural order.

Not surprisingly, shrines dedicated to Esu, who is also associated with unrestrained sexuality, aggression, and power, are found at places of potential conflict—crossroads, markets, and the entrances to homes. Though some objects associated with the deity do not leave the shrines, staffs such as this one are taken out during celebrations honoring him, when they are carried in processions or hooked over the right shoulder of a male devotee as he dances. As befitting this *orisa* of contrasts and contradictions, his dance steps, consisting of high kicks and exuberant, flamboyant moves, are unlike usual Yoruba dancing.

Esu's position as an *orisa* of contrasts is also expressed in the staff itself: black and white are emblematic of this deity, and the white cowrie shells deliberately contrast with the darkened carving. Cowrie shells, valued by peoples all over Africa, were used at one time as currency and thus also serve as a reminder of Esu's involvement with economic affairs and the conflicts they often engender.

Other features, most notably the distinctive long-tailed hairdo, also announce that this is a sculpture for Esu. His priests wear a similar hairstyle, and among the Yoruba—as among many peoples throughout the world—long hair is associated with sexual license and aggressive behavior. In addition, the hairstyle is also an indication of loyalty and devotion. In a story recounted by an Esu priest to art historian Robert Farris Thompson, Orunmila, the deity associated with a particular form of Yoruba divination known as "Ifa," decided to determine his true friends by having his death announced.[2] When Esu heard the sad news, he dropped what he was doing—shaving his head—and rushed to Orunmila's house, with eyes streaming and a long tuft of hair still in place. Seeing Esu's state, Orunmila recognized him as a true friend, and proclaimed that he should always wear his hair that way as a sign of friendship. A small bone comb that is attached to a cowrie strand emphasizes Esu's vanity and the importance of this hairdo to him. The small calabashes carved along the top of the hair represent containers of herbal medicines, a reference to the deity's supernatural powers.

The figure blows a whistle, another indication of Esu. At the beginning of festivals honoring him, a similar whistle is blown to summon the *orisa,* and the blowing of whistles may announce the arrival of important people. In addition, the whistle reminds viewers of the contrary aspect of the deity's personality. Though children are told not to whistle for fear of provoking evil spirits, and whistling is forbidden in palaces because of sexual associations, Esu, ever the provocateur, disregards such social conventions and is perfectly happy to do so.

Further Reading
Drewal, Henry John, and John Pemberton III with Rowland Abiodun. *Yoruba: Nine Centuries of African Art and Thought.* Edited by Allen Wardwell. New York: Center for African Art in association with Harry N. Abrams, 1989.
Wescott, Joan. "The Sculpture and Myths of Eshu-Elegba, the Yoruba Trickster." *Africa* 32, no. 4 (October 1962): 336–54.

Notes
1. H. U. Beier and B. Gbadamosi, *Yoruba Poetry,* special edition of *Black Orpheus* (Ibadan, Nigeria: Ministry of Education, 1959), 15.
2. Robert Faris Thompson, *Black Gods and Kings: Yoruba Art at UCLA* (Los Angeles: UCLA Museum and Laboratories of Ethnic Arts and Technology, 1971), 4/3.

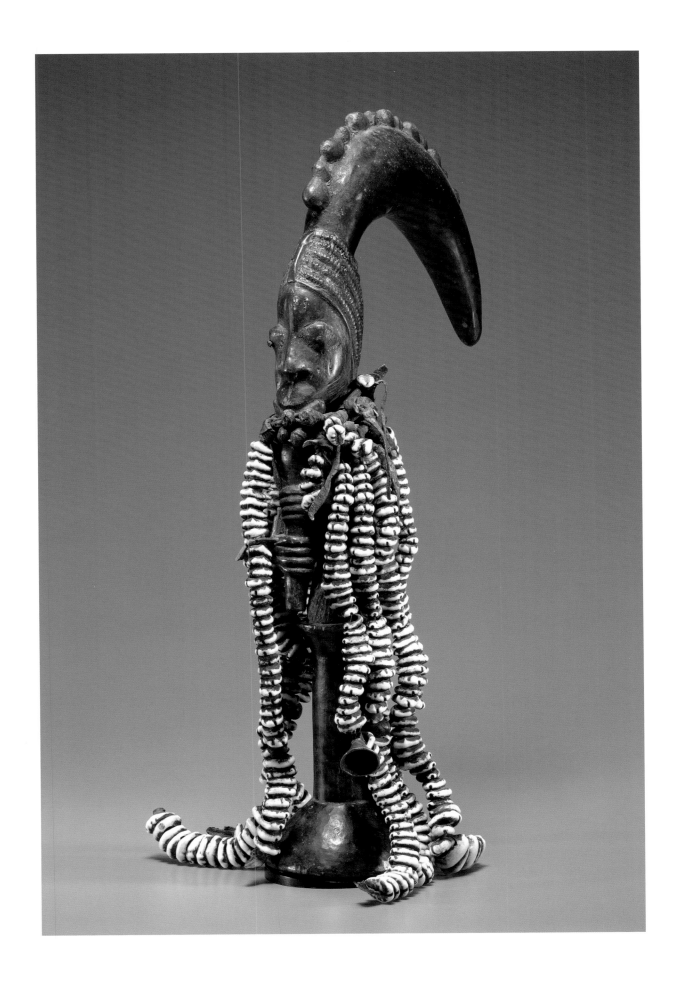

Yoruba peoples (Owo subgroup), Nigeria

Box
18th or 19th century
Ivory
L. 6 1/2 in. (16.5 cm)
77.28

Situated in the easternmost part of Yorubaland, Owo lies about halfway between Ife, from where all Yoruba are said to originate, and the Edo-speaking kingdom of Benin, which acquired many aspects of society, politics, and culture, including brass casting (see p. xx), from Ife. While the people of Owo are clearly Yoruba, the city's location and the oral traditions surrounding its history indicate a long and complex relationship with Benin, one that even today is not well understood. Ivory carving, historically one of Benin's premier arts, is one aspect of culture that demonstrates this relationship. Owo has long been recognized as a Yoruba center of ivory carving, though only in 1951 was a specific corpus of "Owo-style" ivories identified by the great African ethnologist and connoisseur William Fagg.[1] Many of those ivories formerly had been designated as Benin work, and Fagg's attributions were further evidence of long-standing interactions between the two kingdoms.

The interlace band that divides the lid of the Art Museum's box into two compartments and forms a ground line for the three figures is a motif associated with royalty both throughout Yorubaland and in the kingdom of Benin. The ground line and the relief carving itself situate the figures in space, but no details identify a particular place. In fact, the background is pierced with small holes, creating an abstract backdrop of light and dark contrasts. Visually, it resembles some ivory double-cylinder bracelets from Owo, Benin, and Ijebu (another Yoruba kingdom southwest of Owo), in which a figuratively carved outer cylinder surrounds a pierced inner one, forming a figure/background effect very similar to one on the museum's box. On both types of objects, the spotted effect of the background recalls depictions of the leopard, an animal associated with leadership and authority throughout the area. Though not as complicated as the double-cylinder bracelets, the box also resembles some of them in the positioning of the figures, which are arranged so that some of the composition will appear right side up when viewed from either of two directions.

The figures take up the full areas allotted to them (and, in fact, their heads press uncomfortably against the tops of their spaces), but the two compartments are unequal in size. In accordance with Yoruba and Edo conventions, the most important figure, which alone occupies one of the compartments, is larger than the other two. Interestingly, the end of the box on which he is carved is also slightly wider. This, of course, reflects the natural shape of an ivory tusk, which gradually tapers, but it also visually reinforces the prominence of this main figure. His importance is further emphasized by his fully frontal, symmetrical pose. This figure most likely represents the *olowo,* the king of Owo, based on his elaborate headdress and the *akato,* a band of coral beads that is worn across each shoulder.[2] In

his right hand, the figure holds a sword associated with chieftaincy in Owo. What he holds in his left hand remains a puzzle, not clearly resembling any iconography associated with the Yoruba or Benin kingdoms.

The lid's other compartment depicts two figures that appear to be engaged in combat. One of them, who wears a single coral band, has a sheathed sword at his side and holds a large club. The other, wearing a decorative collar or necklace and a small hat and holding an unsheathed sword ready for action, reaches over—with an extraordinarily long arm—to grab his opponent's leg.

The inside of the box is undecorated, but the outer sides and the bottom are incised. On all four sides of both the lid and the box, the incising takes the form of closely spaced parallel diagonal lines, which regularly change direction to form interlocking triangles. The bottom of the box is carved more simply, with two double-lined "x's" that mirror the two-part division of the lid. Though Owo ivories show a surprising variation in style and iconography, these embellishments highlight the interest in texture and pattern that is a common feature of much of their carving.

The carving of this box clearly represents a tremendous outlay of both skill and time, which further enhanced the value of already valuable material. Throughout sub-Saharan Africa, ivory is associated with wealth and prestige, and among the Yoruba, it is traditionally reserved for three groups: political leaders, elders of the Ogboni Society (an association dedicated to the earth goddess), and divination priests. An *olowo* or a member of his family could have owned the box, or it might have been a gift from the *olowo* to a subject as a sign of his favor. It may have held small gifts or stored personal belongings. Boxes such as this are also said to be used by the *olowo* as presentation containers holding offerings made to deities.[3]

Further Reading
Drewal, Henry John, and John Pemberton III with Rowland Abiodun. *Yoruba: Nine Centuries of African Art and Thought.* Edited by Allen Wardwell. New York: Center for African Art in association with Harry N. Abrams, 1989.

Notes
1. William B. Fagg, "Tribal Sculpture and the Festival of Britain—The Art Style of Owo." *Man* 51 (1951): 73–76.
2. Robin Poynor, personal communication, May 2006. Poynor, an art historian who has done extensive research on Owo Yoruba art, noted that the double *akato* could also indicate the *ojomo,* the second-most powerful member of the kingdom. Lesser chiefs wear one band, but only the *olowo* and the *ojomo* are permitted to wear one across each shoulder.
3. Rowland Abiodun, "The Kingdom of Owo," 105, in Henry John Drewal and John Pemberton III with Rowland Abiodun, *Yoruba: Nine Centuries of African Art and Thought,* ed. Allen Wardwell (New York: Center for African Art in association with Harry N. Abrams, 1989), 91–115.

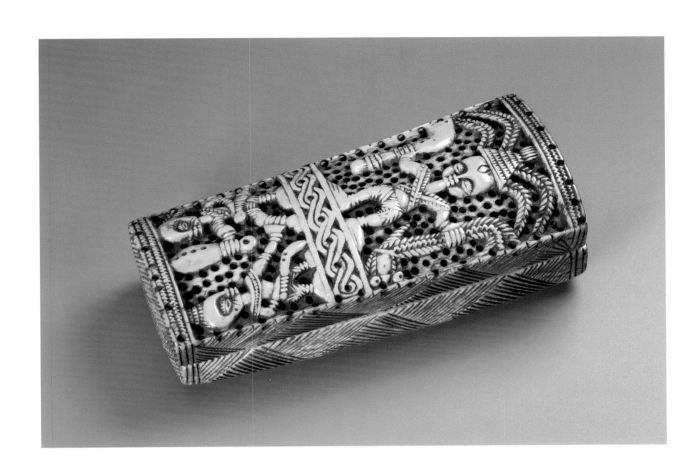

Edo peoples, Kingdom of Benin, Nigeria

Commemorative Head of an Oba
Middle Period, 1600–1700
Brass
H. 11¹/₂ in. (29.2 cm)
75.98

Metal sculpture from the historic Kingdom of Benin, one of the most powerful and long-lasting kingdoms in West Africa, is widely acknowledged to be among the finest from sub-Saharan Africa, and this commemorative head of an *oba,* or king, is an excellent example. Created when Benin flourished and trade with Europe increased the availability of brass, it is larger and heavier than heads ascribed to the early years of the kingdom, when metal was scarce, but it maintains a high quality of casting while avoiding the stiffness and extreme stylization that characterize many of the heads from the late eighteenth and nineteenth centuries.

Commemorative heads such as this honor individual kings, but, like most traditional portraits in sub-Saharan Africa, position and status, not physical likeness, are depicted. Here, the beaded crown and necklace indicate without a doubt that an *oba* is portrayed, for, as remains true to the present day, only the king wore a complete coral bead outfit for ceremonial occasions. Strings of beads also hang from the cap, and large beads embellish the ends of the strands of plaited hair or fiber. Clusters of larger beads decorate the cap, and a single bead hangs on the forehead. Three raised lines above each eye depict scarification; among the Edo-speaking peoples, this pattern denotes a male.

Just as the regalia and scarification indicate a position rather than an individual, so, too, does the face. The generalized and stylized features and the aloof, remote expression are common to all of the heads and can be related to important Edo beliefs. One is that the king is divine while alive, and when he dies he becomes an especially powerful force in the supernatural world. Because of his divinity, he remains unaffected by the mundane activities, petty concerns, and tribulations that occupy most people. Second, a primary attribute of the *oba* is the absolute authority that he holds over his subjects and can be passed down only to his heir. Thus, the king's position in the legitimate line of authority, predetermined by birth, is far more important than any of his personal characteristics.

In its original context, the specific identify of the king being commemorated would have been clear from the altar upon which the head was placed. When a new king was installed, one of his first tasks was to commission a head to honor his predecessor, who was usually his father. The completed head, with a large carved ivory tusk inserted in the hole in the top, was placed on a circular clay ancestral altar with other objects, such as small brass figures, bells, and wooden carvings. That altar, and those for earlier kings, were the focus of rites intended to ensure the help and protection of previous kings for the current *oba* and, by extension, for the kingdom as a whole.

Although most of the names of the kings of the current dynasty are known with at least approximations of the dates of their reign,

we do not know the name of the *oba* who commissioned this head or the name of the *oba* whom it honored. It, along with more than 160 other commemorative heads and hundreds of additional objects associated with the palace, was removed from Benin in 1897, when a British punitive expedition razed and sacked the city. These objects were shipped to England, where they were dispersed into private and museum collections throughout Europe and the United States.

Though often called Benin "bronzes," most of the commemorative heads that have been scientifically analyzed, including this example, have proven to be brass, an alloy of copper and zinc, rather than bronze, the major components of which are copper and tin. Whatever its actual components, copper-based metal is considered precious by the Edo, and, between the fifteenth and nineteenth centuries, it was reserved for use by royalty and those designated by the king. The metal's permanence makes it an especially appropriate symbol for a ruler, and the Edo say that untarnished brass is red, a color considered powerful and threatening to evil. In addition, the shiny surface of the metal is deemed beautiful (royal brasses were kept polished), important for a position that is supposed to have the best of everything.

The commission to make the head would have been given to a guild of brassworkers, a group of men who lived in a designated quarter of the capital, and who were considered special dependents of the king, for whom they worked exclusively. We can assume that a project of this importance would have come under the direct supervision of the guild elders, who were responsible for assigning projects to guild members.

The head was cast using the lost-wax, or *cire perdue,* method, a technique that Benin brasscasters are said to have learned from their counterparts in the Yoruba kingdom of Ife during the first half of the fourteenth century and that is still practiced in Benin City today. To make a sculpture, a brassworker shapes an exact beeswax model of the object to be cast over a clay core. The completed model is then covered with one or more layers of fine, smooth clay, followed by an additional layer or two of coarse clay. When the clay is dry, the mold is heated so that the wax melts and can be poured out and the molten brass poured in. After the metal cools, the layers of clay are removed, revealing the casting, which is then cleaned, filed, and polished.

Further Reading
Ben-Amos, Paula Girshick. *The Art of Benin.* Rev. ed. Washington, D.C.: Smithsonian Institution Press, 1995.

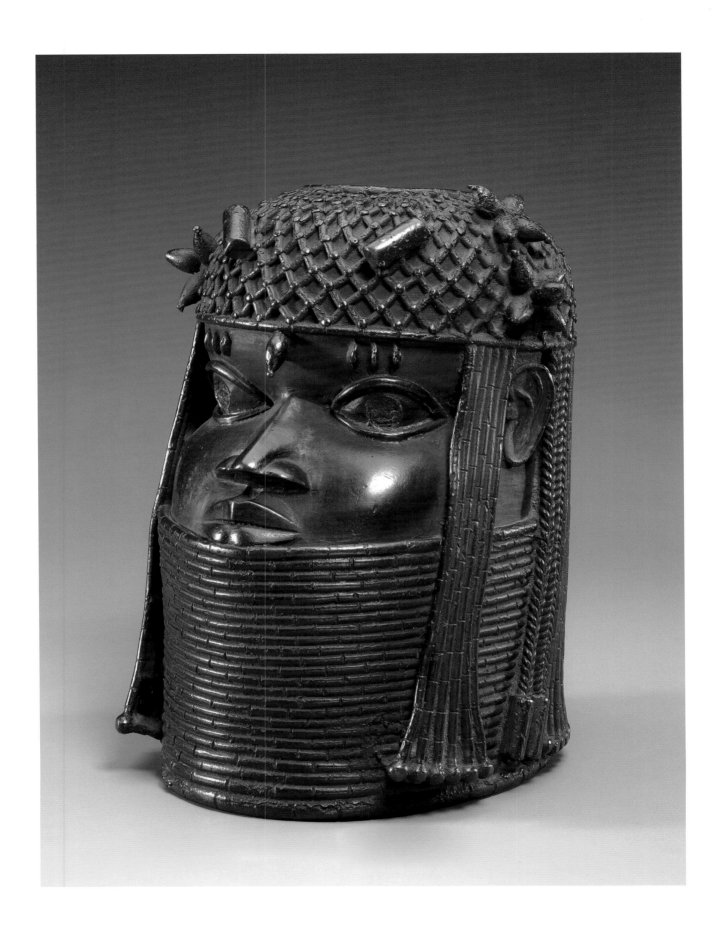

Igbo peoples, Anambra Valley, Nigeria

Shrine (Ikenga)
First half of the 20th century
Wood, pigment
H. 24 in. (61 cm)
70.50

Among the Igbo of southeastern Nigeria, the *ikenga* is a shrine that is both the symbol of an individual man's drive to succeed, as well as a means—as the focus of prayers and offerings—of ensuring that success. Sometimes called a shrine to a man's right arm or hand, in reference to accomplishment and action associated with those appendages, the *ikenga* emerges from a belief system holding that, while an individual's destiny is determined before birth, certain aspects of personhood are not. These aspects have ties to the spiritual realm and to a man's age set (other males of roughly the same age); they are associated with competition, aggression, and the will to succeed. A man might acquire a simple *ikenga* as a relatively young adult, but only when he has become a person of very high rank would he acquire one like this example.

The figure clearly portrays a man of status, one who has reached the highest level of Ozo, an Igbo men's society that recognizes success and accomplishment. By making increasingly larger payments to the society, a man moves through a hierarchy of grades and their associated titles. Most men could traditionally afford to enter the lower grades, but few could accumulate the resources necessary to attain the highest levels, which, while conferring social, political, and spiritual authority, also carried significant obligations and responsibilities.

In his right hand, the *ikenga* figure holds an iron staff reserved for the highest titleholders, and his three-legged stool is also the prerogative of the highest Ozo rank.[1] The marks on his forehead represent *ichi* scarification, a traditional indication of a senior Ozo titleholder. Even the ivory tusk trumpet that the figure holds in his left hand is a reference to Ozo. In addition to its association with the elephant (and by extension, to the animal's strength and power), an ivory trumpet heralds the presence of a titled man.

The relative naturalism of the figure belies a fantastic, marvelously intricate superstructure growing out of the head. Just as the figure clearly indicates a man of high rank, the superstructure comprises motifs referring to masculine power and authority. Curved forms on each side of the head recall ram's horns, one of the most common motifs associated with *ikenga*. Horns in general are synonymous with male power, and ram horns are considered an especially appropriate symbol for the unflagging determination necessary for success. Though the visual reference to ram horns is clear, the forms are by no means realistic depictions, for the ends of the curves swoop upward, forming loops that end in snakes' heads. The specific meaning associated with the snakes is not clear; however, in general, snakes for the Igbo are considered messengers between the spiritual and physical realms. The serpents alternate with anthropomorphized horned animal heads. These might be rams, though the shape of the horn more closely resembles depictions of antelope; in any case, the particular creature is not as important as the presence of the horns, again a symbol of masculine power.

In front of the curved horns and framing the figure's face, four spiky forms bristle toward the viewer. Similar motifs occur on some other *ikenga,* but what they depict and mean are not clear: they could refer to amulets worn for protection, or their aggressive forms may be a straightforward reference to the forceful attitude that the Igbo deem necessary for success. Surmounting all is a quadruped, which, like the horned heads below, has been anthropomorphized. It most probably represents a leopard, an animal both admired and feared and a symbol of the political authority associated with high-ranking levels of Ozo.

The skillful intricacy of its carving, which is created from a single block of wood, and its complex iconography make this an outstanding *ikenga*. Varying in form from highly abstract to the naturalism seen here, *ikenga* range from under twelve to at least seventy-eight inches in height. Larger ones generally belong to an age or lineage group instead of an individual. Minimum iconography consists of a head and horns: many abstract examples are little more. The more naturalistic carvings tend to be full figures, most often depicted holding a knife and a trophy head. Complex superstructures are not common, and those are most likely to be on the largest figures; however, the relatively small size of the museum's example indicates that it was a personal *ikenga,* making the elaborate superstructure unusual.

Small, simple *ikenga* traditionally have been available for purchase in Igbo markets, but larger and more elaborate ones were made on commission. As with most African sculpture, the name of the carver of this *ikenga* was not recorded. However, it is strikingly similar in both iconography and style to another, much larger, example, which was documented in the 1960s as the work of a carver (then deceased) from the north-central village of Nteje near the Anambra River, suggesting that it, too, was probably carved by this extraordinary sculptor.[2]

Further Reading
Cole, Herbert M., and Chike C. Aniakor. *Igbo Arts: Community and Cosmos*. Los Angeles: UCLA Museum of Cultural History, 1984.

Notes
1. Much of the iconographic interpretation presented here was originally summarized by Eli Bentor in a lecture, "*Ikenga* and the Building of Personhood," which was presented at the 1987 Evan F. Lilly Memorial Lecture Competition at Indiana University. A written copy of this presentation is preserved in the IU Art Museum Archives.
2. Herbert M. Cole and Chike Aniakor, *Igbo Arts: Community and Cosmos* (Los Angeles: UCLA Museum of Cultural History, 1984), 29.

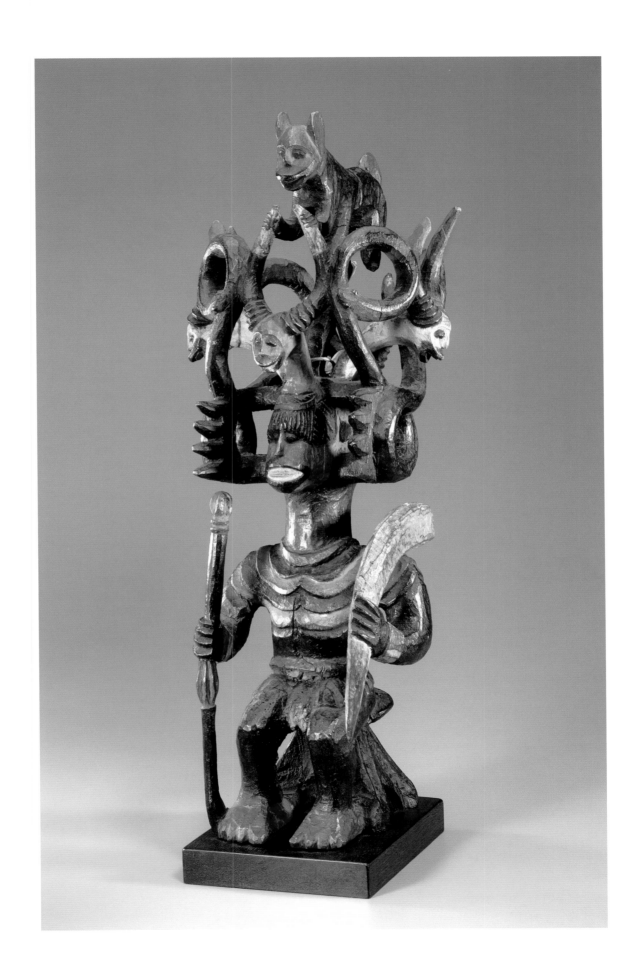

Ijo peoples (Kalabari subgroup), Degema area, Nigeria

Hippopotamus Mask (Otobo)
Collected ca. 1916
Wood, metal, incrustation, pigment
H. 18 1/2 in. (47 cm)
Gift of Raymond and Laura Wielgus in honor of
Rudy Professor Emeritus Roy Sieber, 96.49

This mask's name, *otobo,* means hippopotamus, an animal that Kalabari refer to as "the beast who holds up the flowing tide," and the mask's solid form and tusk-like canines clearly convey the strength and fierceness of its namesake. Befitting this powerful aquatic mammal—known for its aggressive and unpredictable movements on land—the *otobo* masquerader moves in a belligerent and forceful manner toward both the audience and other masqueraders. During a performance, the mask, which is positioned on top of the head, is decorated with feathers, fiber, leaves, and cloth, which are attached to the metal loops on the sides and top. In some communities, these added materials are so abundant that the carved mask is obscured. Though the color of the mask is similar to the gray-brown hide of a real hippopotamus, the features combine those of the animal with those of a human, reflecting a Kalabari belief that water spirits have both human and animal elements and can materialize in either form.

Masquerades representing water spirits are performed throughout the delta of the lower Niger River, but the best known are those of the Kalabari, one of the eastern subgroups of the Ijo, who dominate the area. Living in the eastern part of this watery world, the Kalabari traditionally have engaged in fishing and trade, though the discovery of oil in the region during the 1960s has brought new industry—as well as environmental problems and violence—to the area. While the masquerades may be seen as honoring the spirits, who were believed to be responsible for inventing masks and for ensuring the Ijo's food supply and their fertility, their secular aspect as entertainment that brings communities together has become increasingly important.

Eastern Ijo masquerades are held within the context of the Ekine (also called Sekiapu) Society. Both names connect the association with the performances: "Ekine" refers to a woman named Ekineba, who witnessed the singing, dancing, and drumming of water spirits and later taught them to people, and "Sekiapu" means "dancing people." Open to any adult male able to pay a small entrance fee and to demonstrate a basic level of dancing skill, membership in the society is considered an important attribute of a successful man. Although the Ekine Society is responsible for organizing the masquerades, among the Kalabari many masks are considered the property of "canoe houses," powerful lineage-based economic units that traditionally controlled trade within and outside the Niger River Delta. A canoe house gains great prestige for a spectacular masquerade.

Performances take the form of a multi-year cycle, which may last as many as twenty-three years from beginning to end. Over the years, Ekine presents a series of up to fifty different plays, each of which usually follows a simple plot designed to allow people to consider everyday life and its surroundings from a different perspective. Humans from various walks of life and fauna from the Kalabari world, such as the python, the tortoise, various mammals and fish, as well as composite creatures, are depicted. In addition to its own mask, each character has a distinctive costume, dance steps, and musical accompaniment. *Otobo* is seen near the beginning of the performance cycle and at its culminating event, called the *owu aru sun* (canoe of the water people), at which dancers from all of the plays appear.

Between 1914 and 1918, in response to a Christian revivalist, some Kalabari destroyed their masks and figures. A few, including the IU Art Museum mask, were saved and sent to England by P. Amaury Talbot, a British colonial officer and ethnographer. Like the museum's Montol figure (p. 48), it has frequently been included in major exhibitions here and abroad, testimony not only to its well-documented collection history but also to the mask's aesthetic quality. The strong geometry of both the whole and its parts, a characteristic seen less dramatically on other Kalabari masks, creates a forceful sculpture that particularly appeals to modern Western taste.

Further Reading
Anderson, Martha G., and Philip M. Peek, eds. *Ways of the Rivers: Arts and Environment of the Niger Delta*. Los Angeles: UCLA Fowler Museum of Cultural History, 2002.

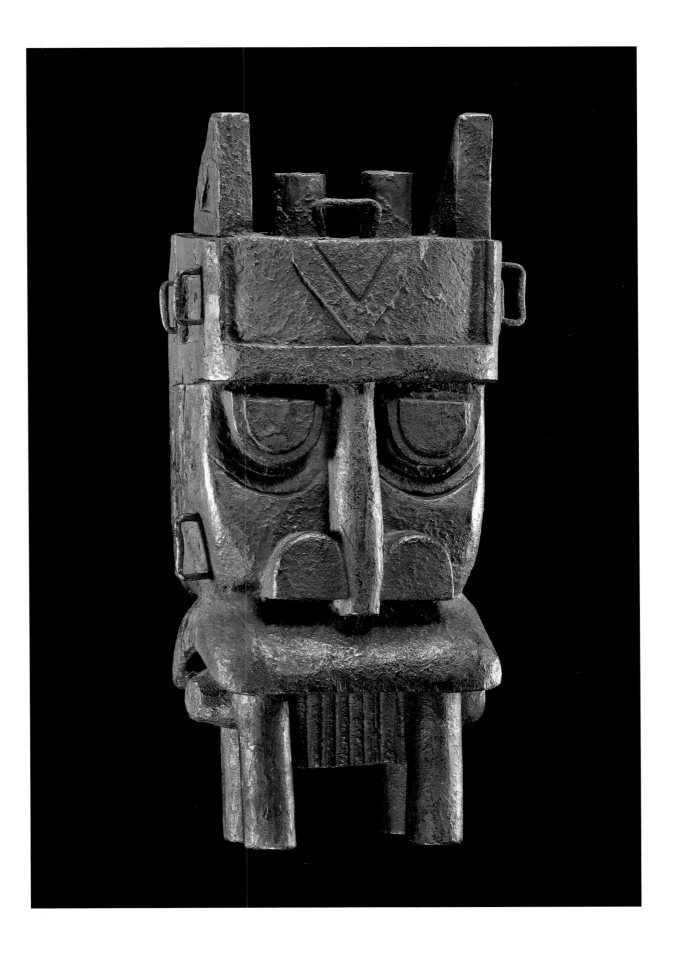

Montol peoples, Nigeria

Female Figure
ca. 1950
Wood, pigment
H. 15 in. (38.1 cm)
Gift of the Raymond and Laura Wielgus Collection

Though simply carved and modest in size, this figure is monumental in its presence. The raised head, tautly arched back, and sharply angled arms create tension and energy that are accentuated by the reddish-orange pigment covering the surface. Widely published, it is recognized as the most compelling figure known in the West by a carver from the Montol peoples, who live in eastern Nigeria, north of the Benue River.

Nearly all figures attributed to the Montol are standing, with simplified features and arms bent at the elbows or hanging at the sides. Many also have columnar torsos, broad shoulders, and hands with incised fingers that extend directly from the arms. However, the figures show considerable variation within those broad parameters, suggesting that many aspects of Montol carving were left to the preferences of individual carvers. In some cases, the variations may also reflect the fact that Montol figures were not necessarily made by professional carvers, but instead could also be made by amateurs: the appearance of the figure apparently is not as important as its existence.

Standing figures are traditionally used by neighboring peoples in the central Benue River area as part of men's associations concerned with healing and herbalism. These associations have been identified in at least thirteen ethnic groups, including the Montol, and all have names that are similar: among the Montol, the group is called Komtin, for example, and among the Goemai, who live to the southwest, it is known as Kwompten. Though particular practices vary, members use divination to determine the causes of certain illnesses, prescribe herbal remedies, and conduct curing rites. Sculpted figures, often in male/female pairs, are part of these practices, though their exact role is not clear. The recovered patient traditionally provides payment in the form of a celebratory feast at which songs and dances of the association are performed.

Roy Sieber, who taught African art history at Indiana University for nearly forty years, and who was instrumental in assembling the Art Museum's collections of African, South Pacific, and Pre-Columbian art, acquired this figure in Lalin, a small Montol village, during a research trip to northern Nigeria in 1958. (His findings were published in the groundbreaking *Sculpture of Northern Nigeria,* 1961, which remains a primary source for information about the art of the Montol and their neighbors.) At that time he was told that the figure had been purchased about eight years before at the market in Baltip, another nearby Montol village. Indeed, during his research Sieber found that it was not an unusual for sculptures to have been made in different towns from where they were used, or for a carver from one ethnic group to carve for people of another. While such interactions are taken for granted today, at the time, those observations were important contributions that helped to correct two Western misconceptions: that a carver in Africa worked only within his own community and that he worked only in a single style that was clearly identifiable with his ethnic group.

The figure was acquired from Sieber by Raymond and Laura Wielgus in 1960 and was included in an exhibition of their collection at the Museum of Primitive Art in New York that year. Its powerful visual presence drew the attention of ethnographer William Fagg, the doyen of African art studies in England, who included it in several seminal exhibitions and publications in the United States and Europe during the 1960s, a time when African art was gaining popularity. That exposure cemented its place in the African art canon.

Further Reading
Sieber, Roy. *Sculpture of Northern Nigeria.* New York: Museum of Primitive Art, 1961.

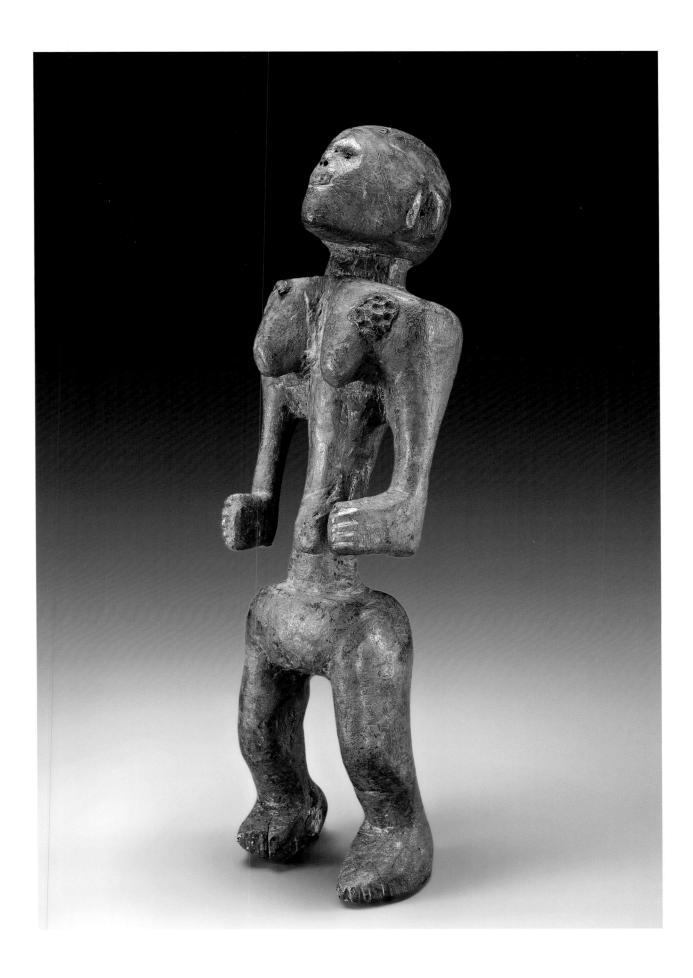

Grasslands, Cameroon

Prestige Hat
20th century
Cotton fiber, wood
Diam. 7³/₄ in. (19.7 cm)
Gift of Budd Stalnaker in honor of William and Diane Itter, 2004.27

Grasslands, Cameroon
Headdress
20th century
Feathers, fiber
Diam. 26 in. (66 cm)
Gift of
Budd Stalnaker,
2006.324

While the overall tonality of this Grasslands headdress is brown, a closer look reveals that, while some feathers are solid brown, many others have white spots or bands of cream, and small groups of beautifully subtle iridescent blue feathers liven the composition still further.

The Grasslands of western Cameroon is a region known for its diversity—in one province alone, over twenty languages were still spoken at the end of the twentieth century—while at the same time it is recognized for a surprising cultural homogeneity. Even the hat, a ubiquitous element of attire, makes this point very clearly: historically, throughout the area, free men were expected to cover their heads, and, as a result, an astonishing variety of everyday and ceremonial head coverings were created.

While common men might wear plain, unornamented hats, more exalted men, and sometimes women, turned to elaborate headgear as indicators of status and position, with decoration ranging from colorful stripes and embroidered and appliquéd patterns to added materials, such as beads, seeds, quills, elephant tail-hair, and coins. Fifty-five different hats and headdresses have been documented in the palace museum at Foumban, the capital of Bamum, a prominent eastern Grasslands kingdom, for example.[1]

Like many objects from the Grasslands, it is difficult, if not impossible, to correlate specific hat forms with particular locales. Extensive trade and gift-giving practices have ensured that objects, the techniques for making them, and, frequently, the makers themselves, have traveled widely. Such is certainly the case with hats like this delightfully flamboyant example. It was created from colorful cotton thread using a technique sometimes called knotless netting, in which threads are looped so that damage to an area will not result in the entire piece unraveling, Grasslands hats such as this are frequently described as knitted or crocheted, but this example and most older ones are neither: instead, each was made with a painstaking looping process requiring the entire strand of raffia or cotton to be pulled through each loop that was made. More recent hats, however, are frequently crocheted with a metal or plastic hook.

Some hats of this type are skullcaps or tall cylindrical hats with flat tops, with colorful stripes created as the hat was looped as the only form of decoration. Many others, though, including this example, have another kind of ornament added as the hat is made, in the form of burls, which are small, three-dimensional looped extensions, usually stiffened with pieces of wood so that they stand up from the surface of the hat. On some hats, each burl is relatively thick, and they are grouped on each side of the hat, recalling a style of coiffure created by similarly arranged tufts of hair. On this one, though, the burls are very thin and completely surround the hat, creating a lively, colorful textured surface.

The effect is similar to another type of Grasslands headgear, in which hundreds of feathers are individually attached to a fiber cap. Most frequently associated with the Bamileke (a collective name given by the Germans, who were the first Europeans to enter the area, to diverse peoples living south and east of the Northwest Province), feathered headdresses are also worn throughout the Grasslands.

Elaborated hats represent unusual outlays of resources, in terms of both the time and the additional quantities of materials—sometimes difficult to obtain—required to make them. Hats made of especially valuable materials that were controlled by the king *(fon)* became indicators of his favor, and certain distinctive styles became emblems of particular positions within the kingdom's hierarchy. Therefore, it is not surprising that these elaborated hats became associated with status and prestige.

These hats are from a collection of more than seventy, primarily from West and Central Africa, given to the museum by Budd Stalnaker, a fiber artist and professor emeritus in Indiana University's Hope School of Fine Arts. Stalnaker assembled most of the collection between 2000 and his death in 2006, from dealers visiting Bloomington. In addition to several other feathered headdresses and prestige hats from Cameroon, the collection includes examples in a variety of media of both frequently illustrated and less well-known traditions. Among the former are beaded hats from the Yoruba, prestige caps from the Kuba, and Zulu married women's headdresses; while the latter include headgear from the Dogon, the Mambila, and the Toma. The Stalnaker collection, combined with the small but fine group of hats already held by the museum, gives the African collection a significant strength in this richly varied and boldly dramatic realm of costume arts.

Further Reading
Arnoldi, Mary Jo, and Christine Mullen Kreamer. *Crowning Achievements: African Arts of Dressing the Head*. Los Angeles: UCLA Fowler Museum of Cultural History, 1995.

Note
1. Christraud Geary, *Things of the Palace: A Catalogue of the Bamum Palace Museum in Foumban (Cameroon)*, Studien zur Kulturkunde 60 (Wiesbaden: Franz-Steiner, 1983), 102.

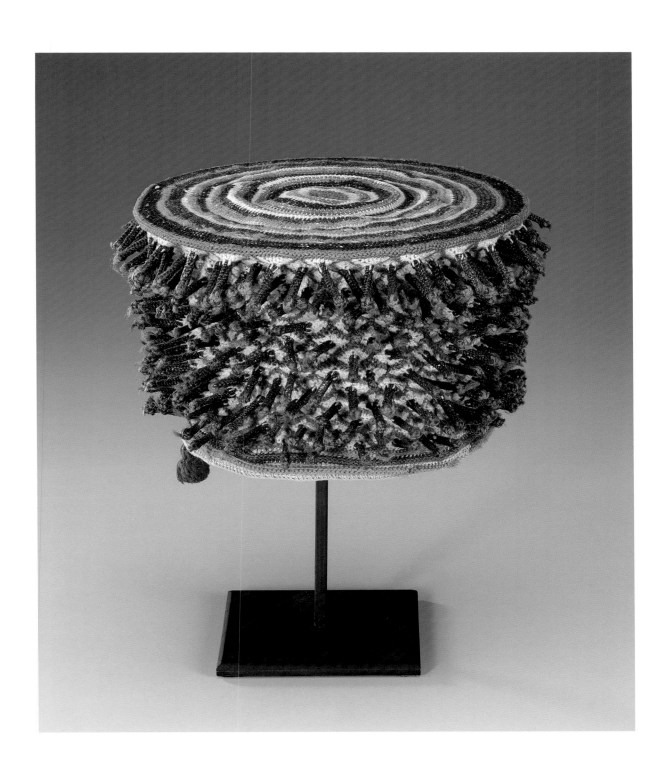

Kom kingdom, Cameroon

Bowl Figure
Early 20th century
Wood, glass beads, fiber, iron, raffia cloth
H. 36 in. (91.4 cm)
68.190

Objects from the treasury of the *fon* of Kom in Laikom, Cameroon. The IU Art Museum's figure is third from the left. Photo by Gilbert Schneider, courtesy of Evan Schneider.

Many small kingdoms dot the Grasslands of western Cameroon, an area known for its rich artistic production in a variety of media. Each of these kingdoms was historically ruled by a king, or *fon,* assisted by a complex hierarchy of titleholders and retainers. Much of the art from this area is traditionally connected with these leaders and their courts, in the form of spiritual and ritual objects and objects displayed as signs of rank, prestige, and wealth.

This bowl figure, once part of the treasury of the *fon* of the Kom kingdom, was kept at the palace in Laikom, the capital. Throughout the Grasslands, wooden bowls are displayed in the kings' audience halls, where they hold kola nuts and palm wine for guests, as signs of hospitality. Wooden bowls also may hold camwood, a cosmetic used ritually by the king, though this example does not show any evidence of the red powder. Befitting their association with royalty, these bowls are usually elaborately carved and decorated, frequently with symbols of the king, such as elephants and buffaloes. The most prestigious, however, incorporate human figures, as in this example.

The beaded decoration also marks the bowl figure as an object belonging to a *fon*. In the Grasslands, as in most parts of sub-Saharan Africa, glass beads were not made locally, but rather were imported from Europe, generally from Italy, Bohemia (now the Czech Republic), and the Netherlands. They were sometimes used as a medium of exchange, and, as trade objects, they were the purview of the kings, who controlled their distribution throughout the Grasslands. Cylindrical blue beads, especially prized, dominate this piece.

As can be seen on the inside rim of the bowl, the beads were sewn onto a coarsely woven cloth that was fitted over the carved figure and tacked into place. In the Grasslands, this was the usual way to cover a wooden object with beads, and it permitted the beadworker to apply beads in different patterns and directions, as in the chest area, which would not have been possible had the beads been simply wrapped directly around the wood. In addition, this method allowed the beads to be removed relatively easily from a damaged sculpture for reuse on another object.

The figure's attire and pose indicate that a high-ranking retainer is depicted. The knobs on the head refer to a prestige hat, and the semicircular pattern of beads on the chest depicts the decorative yoke of a robe—both elements of dress worn by titled men. White bands around the ankles, wrists, and neck indicate jewelry. The figure is seated, a posture allowed only rarely in the presence of the *fon*.

This figure was purchased by the museum from Gilbert Schneider, a Baptist missionary and anthropologist who spent sixteen years in Cameroon. For many years he lived not far from Laikom, and while there he developed a good relationship with Fon Lo-oh (ruled 1955–64) and was permitted to document the palace compound and its contents. During that time, the palace at Laikom burned, and Dr. Schneider played an important part in its rebuilding by assisting with the acquisition and transportation of materials to this isolated area. Upon completion of the new construction, and in appreciation of Dr. Schneider's help, Fon Lo-oh presented him with several gifts, including this bowl figure.

Stylistically, this bowl figure resembles five other figures from Kom, four of which are shown in a photograph (above) taken by Schneider in the 1950s. To the right of the museum's bowl figure in the photo is the well-known Afo-a-Kom, a beaded figure of a *fon* that was stolen from the palace, sold on the Western art market, and finally returned to Laikom in 1974. Research by Tamara Northern, who has studied the art of the Grasslands and these Kom figures for many years, has documented that the Afo-a-Kom is generally considered to be an effigy of Fon Yu (ruled 1865–1912) made during his reign. Trained as a carver during a period of exile before he became *fon,* Yu established a workshop of carvers with himself as the head after he became king. Early photographic evidence and oral history collected in Laikom suggests that the Afo-a-Kom was likely carved during the first decade of the twentieth century and that Fon Yu himself may have been the sculptor. A comparison between the body type and facial features of that figure and our bowl figure suggests a similar origin for the museum's piece.

Further Reading
Northern, Tamara. *The Art of Cameroon.* Washington, D.C.: Smithsonian Institution, 1984.

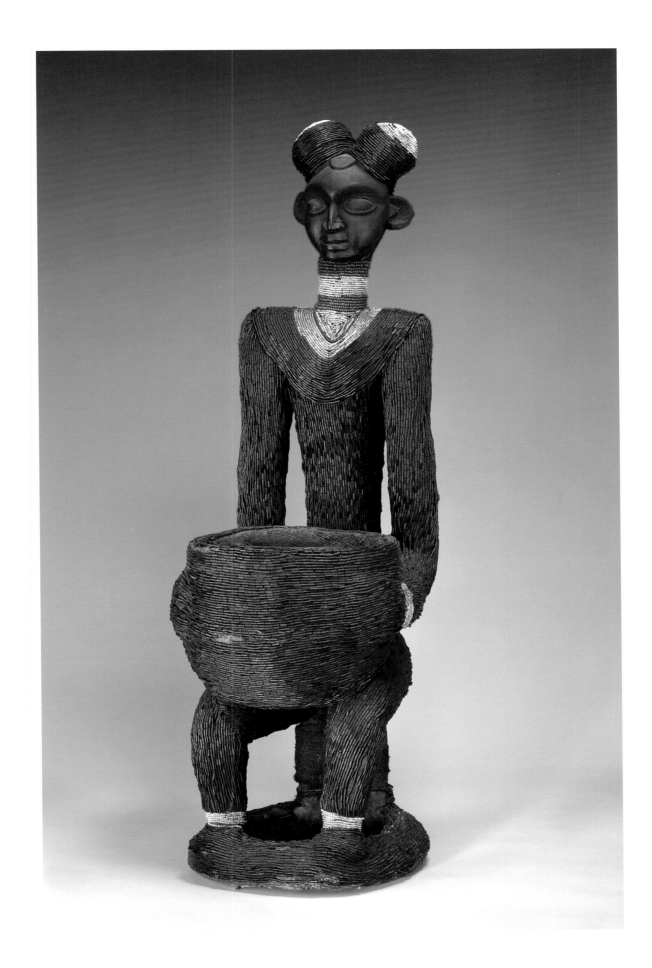

Fang peoples, Gabon

Reliquary Figure (Eyema Bieri)
19th or early 20th century
Wood, wicker
H. 17 1/4 in. (43.9 cm)
72.141

Fang reliquary figures are part of a wide tradition in Gabon related to a cult of the dead. Though practices varied, relics, especially skulls, of important deceased individuals were used in ceremonies connected with appeals to the spirits of the ancestors for guidance and assistance in leading successful lives and in rituals associated with the prevention of malevolent sorcery. The French banned the use of reliquaries in Gabon during the early twentieth century; ironically, at the same time, the figures associated with them, such as this example, were drawing the admiration of Parisian artists.

For the Fang, ceremonies connected with the relics were performed within the contexts of the extended family and men's societies. Cylindrical bark containers held the relics, which, in addition to skulls, might include leg and arm bones and vertebrae. One or two reliquary figures, in the form of a full figure or just a head, were placed on the top of each container. To hold the figures in place, some, including this example, have a shaft extending down the back, behind the legs. The shaft, which on this figure extends about five inches below the feet, would have been secured in the relic container or attached to the lid.

Though considered neither a portrait of an individual nor even a generic representation of an ancestor, the figure was placed on the container as a visual reminder of the founder of the lineage, and its presence was also believed to protect the relics from harm. Each reliquary was usually kept in a family shrine. Women and children were never allowed to see the relics themselves, but anyone could view the container and figure. On certain occasions, such as initiations, all of a community's figures might be brought together and manipulated as if they were puppets.

The muscular, tense body of the figure is characteristic of Fang reliquary figures, as are its symmetry, baby-like proportions, and expressionless face. James Fernandez, an anthropologist whose fieldwork has led to important publications about the Fang, has suggested that these features mirror significant ideas in Fang society.[1] For example, he notes that balance is considered important in all aspects of life. Furthermore, his research suggests that the Fang express vitality through opposition or contradiction. For example, a village traditionally consists of two rows of houses facing each other; men are associated with heat, day, the sun, and the sky, while women are allied with cold, night, the moon, and the earth. For the reliquary figures, the tense bodies oppose the inexpressive faces, and the child-like proportions not only contrast with the mature muscularity but also with the concept of the figure as honoring a deceased elder.

Reliquary figures can be divided into two broad regional sub-styles, northern and southern. The museum's *eyema bieri* is in the classic southern style: its head, body, and legs are approximately the same size; the figure is compact, with rounded, powerful forms; and the surface is black and lustrous, a result of having been rubbed with resin and palm oil. A southern-style *eyema bieri* usually looks more monumental than the northern-style figures, which emphasize more slender and elongated forms, smaller heads, and lighter surfaces. Both styles frequently include depictions of jewelry and/or scarification. Here, the sculptor has carved a belt and armlets on the upper arms.

This figure stands with legs slightly flexed—one way in which the sculptor created a impression of vitality within the figure—and with hands to chest, as if holding or offering something, which also enhances the sense of animation. The gesture is common to many reliquary figures, and is associated in a general way with the idea of offerings to the ancestors. Some hold nothing; others grasp a small bowl, an antelope horn, a whistle, or a weapon—all items connected with spiritual practices or protection. Excess wood between the hands on this example suggests that some object is intended, though the form is not fully realized: a cup or small bowl seems most likely.

This figure was in at least two notable collections before its acquisition by the IU Art Museum. Adolphe Basler's 1929 *L'Art chez les peuples primitifs,* which illustrated it, indicates that it was in the collection of Charles Ratton (1895–1986), a Parisian art dealer and one of the early proponents of African art. Another important connoisseur of African art during the first half of the twentieth century in Europe was Han Coray (1880–1974), who not only sponsored the first exhibition of Dada art in 1917, but also established the first major collection of African art in Switzerland between 1916 and 1928. Though a bank seized that collection for payment of debt in 1931, Coray went on to build another one. *Meisterwerke altafrikanischer Kultur aus der Sammlung Casa Coray,* published in 1968, illustrates the highlights from that collection and includes the IU Art Museum's *eyema bieri.*

Further Reading
Fernandez, James W., and Renate Fernandez. "Fang Reliquary Art: Its Quantities and Qualities." *Cahiers d'études africaines* 15, no. 4 (1975): 723–46.

Note
1. James W. Fernandez, "Principles of Opposition and Vitality in Fang Aesthetics," *The Journal of Aesthetics and Art Criticism* 25, no. 1 (Fall 1966): 53–64.

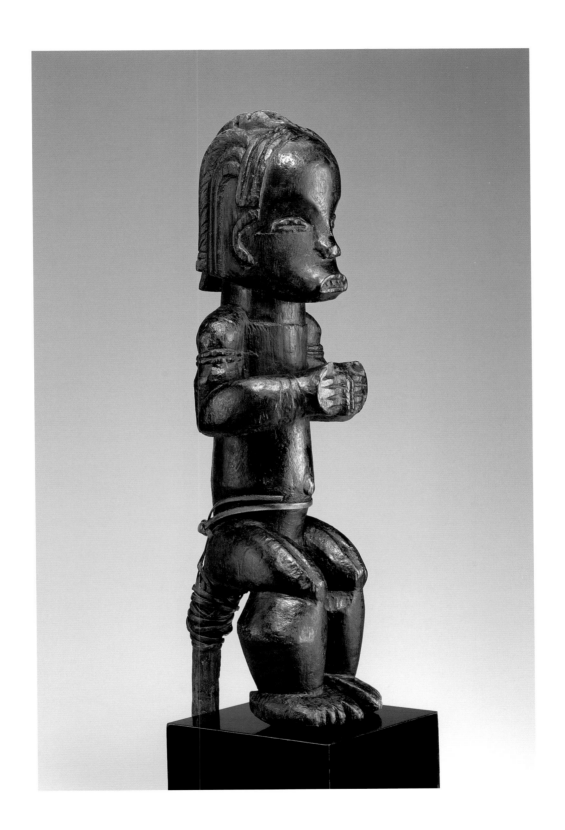

Punu or Lumbo peoples (?), Ngounié River area, Gabon

Musical Instrument
19th or early 20th century
Wood, fiber, pigment
H. 26 in. (66.6 cm)
77.34.3

Unlike many African musical instruments, which often are relatively rough, this one epitomizes refinement, with a grace and delicacy that is unsurpassed in its genre. The body of the lute-like instrument is smooth, showing no traces of the carving tool, as are the willowy sticks to which the strings are attached.

Even more exquisite is the carved head. Its appearance indicates that the instrument is from the area of the Ngounié River in southwestern Gabon, and it can probably be attributed to the Punu or the Lumbo, two very similar groups. Though the neck is stout, all of the other features are delicate, carved in the style of masks from that region. The elegant coiffure and serene face, as well, are characteristics shared with those masks. Finely incised lines indicate the hair, and its arrangement—a central crest flanked by braids—is the style depicted most frequently on the masks, a hairdo popular among women in the area at the beginning of the twentieth century. Like the masks, this face has features that depict an idealized female beauty: a rounded forehead, arched brows, coffee-bean-shaped eyes, a small nose, full lips, and a small, pointed chin. The face shows traces of kaolin, a fine white clay used as a pigment throughout sub-Saharan Africa, which traditionally also colored the faces of the masks.

We do not know whether the head has significance beyond adding to the instrument's beauty, value (the addition of such skillful carving most certainly would have come with increased cost), and, by extension, prestige. Though today appearing at a variety of events, masqueraders wearing the white-face masks originally attended funerary celebrations, where they were considered to embody spirits of the dead. In this area, the color white in general is associated with the spirits of the dead and the afterlife; perhaps the whitening of the face on the instrument indicates a similar association for this object. In addition, at least among the Punu, the presence of female figures on objects such as spoons may be reminders of the importance of an original female ancestor from whom all members of a lineage trace their descent.

Information about the specific contexts in which instruments such as this were played is limited. In Gabon, harps and similar instruments are traditionally played at ceremonies held by societies and cults dedicated to esoteric learning and healing. Such groups are numerous: some are large and widespread, while others are small and very localized. Perhaps the best known is Bwiti, a syncretic ancestor cult that began among the Fang at the beginning of the twentieth century and then spread to other peoples, including those in the Ngounié River area. However, it is unlikely that the museum's instrument was part of Bwiti, because it was probably in use before the cult had expanded to the Ngounié, according to Alisa LaGamma, an art historian who has done extensive research in the area.[1]

Often called a harp, this instrument is actually a pluriarc, or bow lute. Unique to Africa, the pluriarc is distinguished by the presence of multiple necks attached to a single body. Each of these necks holds a single string that lies parallel to the sounding board, unlike harp strings, which are perpendicular to it. Like the harp, however, it is plucked, rather than bowed. It is not a fretted instrument, nor does it contain tuning pegs, as does the European lute. The necks are inserted into holes drilled near the base of the resonator, and different tones are created by varying the lengths and curvatures of the necks. Because of the flexibility of the necks, however, the instrument is difficult to keep in tune. Found throughout sub-Saharan Africa, the pluriarc is most common in the central region; those used in Gabon likely originated to the south, in the vicinity of the Kongo and neighboring peoples.

The museum acquired this bow lute along with five other African, South Pacific, and Native American objects (see pp. 36 and 62) from the estate of Frederick Pleasants, former curator at the Brooklyn Museum. In 1954 and 1955, it was included in the major exhibition *Masterpieces of African Art* held there.

The Indiana University Art Museum has a few additional African musical instruments in its permanent collection, including a fine Kongo whistle. Also on the Bloomington campus, the Laura Boulton Instrument Collection at the William Hammond Mathers Museum of World Cultures contains a wide variety of instruments from Africa, as well as other parts of the world, and the Archives of Traditional Music preserves recordings of many African instruments being played.

Further Reading
DjeDje, Jacqueline Cogdell, ed. *Turn Up the Volume! A Celebration of African Music.* Los Angeles: UCLA Fowler Museum of Cultural History, 1999.
Brincard, Marie-Thérèse, ed. *Sounding Forms: African Musical Instruments.* New York: American Federation of Arts, 1989.

Note
1. Alisa LaGamma, personal communication, December 2005.

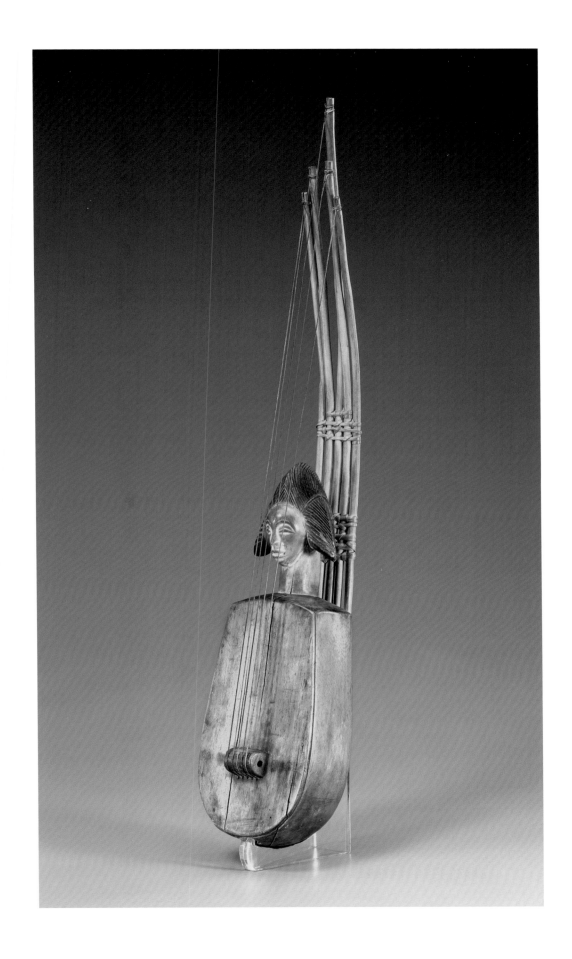

Bembe peoples, Democratic Republic of the Congo

Mask for Elanda Society (*'Amgeningeni* or *'Acwe*)
Hide, beads, feathers, quills, shells, buttons, fiber
H. 27 in. (68.5 cm)
65.38

An imaginative combination of materials makes this mask visually striking, as well as unusual in Western museum collections, which emphasize masks carved from wood. Worn by a leader of the Elanda Society, a men's association concerned with enforcing community laws and mores, the mask does not represent a specific being, but rather is said to be an *ebu'a,* "something hidden, unseen, unrecognizable, undefinable."[1] Elanda masks are typically made of hide that is covered with cowrie shells and beads (this one also has two buttons below the cowrie shells under the mouth) and surrounded by chicken feathers; the addition to the face mask of a chest piece makes this a particularly elaborate example.

Although some Bembe have migrated into Burundi and northern Tanzania, most live near the eastern border of the Democratic Republic of the Congo, in the vicinity of northwestern Lake Tanganyika. As a group, they are the complex product of interactions with several different peoples in the area, but most Bembe clans trace their origins to the Lega, their better-known neighbors to the northwest. Like the Lega, the Bembe are politically decentralized, and they practice Bwami, a voluntary association that simultaneously functions as a system of power and authority; a social and economic network for reinforcing kinship bonds, community unification, and redistribution of wealth; and a patron of the arts. However, unlike the Lega, for whom Bwami is the nearly exclusive reason for artistic production, the Bembe participate in a simplified form of the association and create masks and figures for other purposes as well. Among those is the Elanda Society, which the Bembe say is very old, and which may have originated with people who were in the area before even the Lega. Although Elanda was outlawed in 1940 by Belgian colonial administrators, like other African associations that faced a similar fate, it decreased in membership, but did not disappear, instead continuing its activities with more secrecy than before.

A young male typically joins Elanda after circumcision (traditionally Bembe men are circumcised when they are between eighteen and twenty years old) and when he is married or betrothed, but has not yet joined Bwami. While relatives may decide to join together, special circumstances may also prompt membership. These include instruction to do so by ancestors, either via a dream or sickness or by a dying father; pressure from relatives or community members; the breaking of a rule associated with Elanda; or the committing of an offense against one of its members. Initiations are held in secret, and there for the first time new members see the mask, accompanied by songs and dances, as well as learn the esoteric knowledge and rules associated with Elanda, pay required fees, and present gifts to senior members.

Each branch of Elanda has one mask, which is worn exclusively by the local leader of the society. It is accompanied by a costume consisting of a hat of chicken feathers, a python skin trimmed with feathers, small bags covering the hands, and as many as twenty-five genet and monkey skins. The masquerader carries a painted wooden shield and a painted wooden billhook. He is accompanied by percussion instruments and speaks in a harsh voice that differs from that used in ordinary speech. As he moves, he trembles and shivers. When it is not being worn, the mask and its costume are kept outside the village in a special building maintained by another high-ranking Elanda member.

A mask such as this one is the heart of a community's Elanda Society. Though worn only by one man, it is believed to offer all initiates protection from sickness and danger, and members are said to act on its behalf when acting as law enforcers. People who are not initiated into Elanda cannot view the mask—they can only hear its strange voice—and, as a result, they consider it frightening. For members, on the other hand, the mask is visual reminder of the fellowship and unity that the society brings.

Further Reading
Biebuyck, Daniel P. "Bembe Art." *African Arts* 5, no. 3 (Spring 1972): 12–19, 75–84.

Note
1. Daniel P. Biebuyck, "Bembe Art," *African Arts* 5, no. 3 (Spring 1972): 19. Virtually all information about the Elanda Society comes from anthropologist Daniel Biebuyck, who did fieldwork among the Bembe during the 1950s; that article is the basis for this presentation.

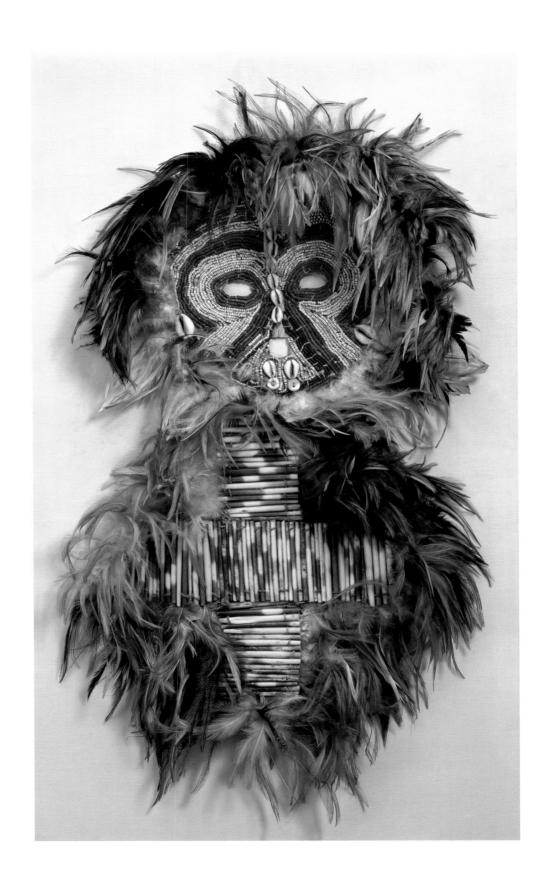

Pende peoples, Democratic Republic of the Congo

Divination Instrument (Galukoji)
Mid-20th century
Wood, fiber, feathers
H. approx. 9 in. (22.9 cm); H. of face 3 1/2 in. (8.9 cm)
Gift of Mr. and Mrs. Kelley Rollings in honor of Raymond and Laura Wielgus
98.178

The Pende, like many other peoples in sub-Saharan Africa, believe that certain individuals have the ability to communicate with spirits of the dead, who were given by the creator the power to ensure success and prosperity for those living in the physical world. In Pende society, two groups of people are credited with a special ability to communicate directly with those spirits and to convey their wishes and wisdom to the rest of the community. Members of first group are rare: generally women past menopause, who are chosen by the dead themselves. These diviners do not rely on elaborate ceremonies, nor do they charge for their services. Far more common is the diviner known as an *nganga-ngombo*. Usually male, the *nganga-ngombo* has learned how to communicate with the dead as part of his quest to harness the powers of the physical and spiritual realms for his own advantage.

Instead of receiving knowledge directly from the ancestors, the *nganga-ngombo* relies on the manipulation of an object to acquire information, and, for a price, he puts his knowledge to work for others. His motives are frequently suspect, however, and he is generally distrusted, to the extent that people may prefer a non-Pende diviner for serious problems, believing that he or she is more likely to be objective and not self-serving. As a result, Pende diviners compete fiercely for clients, both among themselves and with "foreigners," and a variety of divinatory methods and their accompanying devices have gone in and out of fashion as ways to convince clients that particular diviners can offer the best connection to the ancestors.

The *galukoji* is one of the most striking of these divination objects. First documented in 1928, it continued in use to the early 1950s, but it seems to have lost popularity shortly thereafter. As this example illustrates, the *galukoji* consists of a small wooden face at the front of a group of crossbars that are tied together at their ends and middles so that they can be compressed or extended. The face, usually 2 3/4 to 4 inches high, sports a coiffure or headdress made of rooster or guinea fowl feathers—this one appears especially luxurious—and carved features like those found on Pende masks.

The face on the museum's *galukoji* depicts both masculine and feminine elements, as defined by the Pende. In her masterful study of Pende masking traditions, art historian Zoë Strother describes gendered features and the ways in which they are portrayed.[1] Foremost among them is the forehead: masculine foreheads are depicted as bulging, while feminine ones are smooth and flat, as in this example. Likewise, cheekbones are prominent in masculine portrayals, while feminine ones have smooth cheeks. Other feminine elements are the gently curving hairline, the nose that does not turn up sharply at the end, and eyes that are half-closed. However, though the eyes are half-closed, they are also bulging, a masculine trait, as is the elongation of the face. Similarly, the upper lip on this face is flat, a feature many Pende associate with the feminine, in contrast to a masculine mouth, which is characterized by an upper lip that is pointed in the middle. The lips are brought together in a way that hides the teeth, though, a representation of the idea that men keep their lips together, even while smiling, while women are much more likely to show their teeth by laughing in public.

Just as the gender of this *galukoji* is ambivalent, the Pende diviner who used this instrument was most likely male (and therefore, in Pende thought, capable of violence in all forms), but ideally would have acted as a healer and a mediator, embodying social skills which the Pende associate with women. He would have been a figure that Strother describes as "the feminized male [who] represents a social ideal."[2]

There is some question about exactly how the *galukoji* functioned. Léon de Sousberghe, who worked among the Pende during the 1950s when the instruments were still in use, has described the diviner holding it on his lap, with a finger between the crossbars and the carved head at the top. At a critical moment in the divination process, the head of the *galukoji* would spring up toward the diviner's own head. For example, if the divination were held to determine the source of a theft, the *galukoji* would move at the mention of the name of the guilty party. However, the son of a diviner who had used a *galukoji* has also indicated that, at least in his area, the instrument did not identify an individual in such a direct and forceful manner. Instead, he says that the head jumped up to confirm that a client accepted various assertions made by the diviner during the session.[3]

Further Reading
Strother, Zoë S. "Smells and Bells: The Role of Skepticism in Pende Divination." In *Insight and Artistry in African Divination*, Edited by John Pemberton III, 99–115. Edited by John Pemberton III. Washington, D.C.: Smithsonian Institution Press, 2000.

Notes
1. Zoë S. Strother, *Inventing Masks: Agency and History in the Art of the Central Pende* (Chicago: University of Chicago Press, 1998), 108–16.
2. Zoë S. Strother, "Smells and Bells: The Role of Skepticism in Pende Divination." In *Insight and Artistry in African Divination*, ed. John Pemberton III. (Washington, D.C.: Smithsonian Institution Press, 2000), 105.
3. Léon de Souseberghe, *L'Art pene* (Brussels: Académie Royale de Belgique, 1959), 81; and Strother, "Smells and Bells," op. cit., 110.

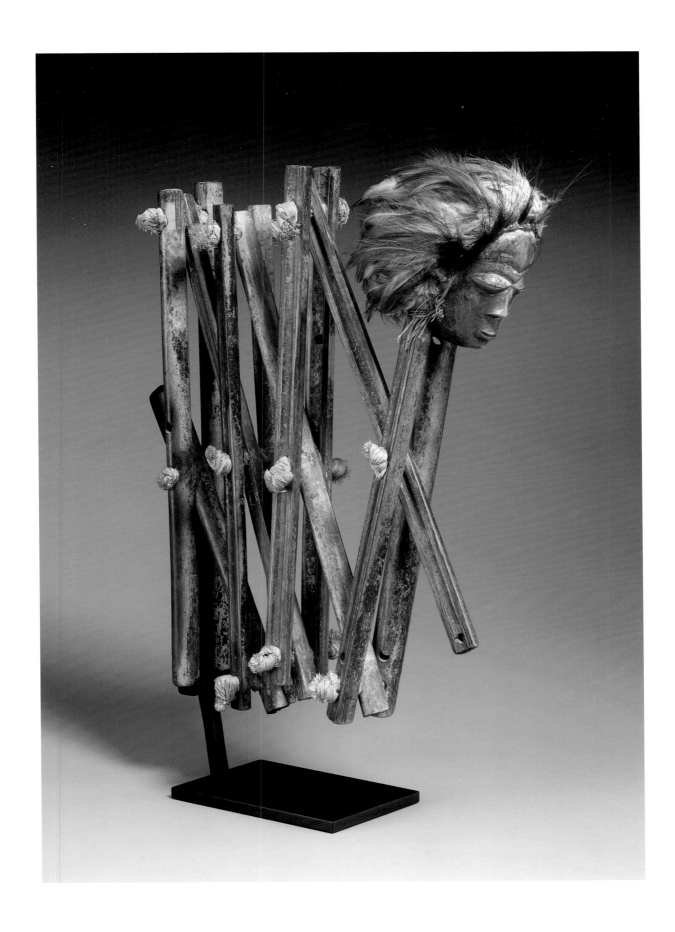

Kuba peoples, Democratic Republic of the Congo

Cup
19th or early 20th century
Wood
H. 10 ¹¹/₁₆ in. (27.2 cm)
77.34.2

Kuba peoples,
Democratic Republic
of the Congo
Cup
Wood, cowrie shells,
copper
W. 7 in. (17.8 cm)
Raymond and Laura
Wielgus Collection,
87.24.6

Cowrie shells, which are inlaid among the interlace patterns on this cup, not only create contrasting color and texture, but also indicate the high status of the cup's owner. First traded in Congo in the eighteenth century, cowries were used as currency during most of the 1800s. Copper, which covers the face on the handle, was the prerogative of the Kuba king.

This is surely one of the most masterful of the elaborately carved cups made by the Kuba, a name referring to a number of different but related groups living between the Kasai and Sankuru rivers, who traditionally acknowledge the leadership of the same king. Combining complex and intriguing imagery with a sure sense of form and proportion, the carver displays facility in creating the surface texture and patterning for which Kuba art is known: cross-hatching and raised and incised motifs contrast beautifully with smooth and broadly grooved surfaces.

These cups were traditionally used for drinking palm wine, a mildly intoxicating beverage fermented from the sap of the raffia palm tree, which the Kuba flavor with roots during fermentation. Imbibed by both men and women, palm wine traditionally plays an important role in Kuba social and ritual life, and Kuba folklore accounts for its origin. According to one version, a palm-wine lake was originally available from which all could draw their fill. One day, however, a woman polluted it and was then denounced by a fellow villager. The next day, the lake had disappeared, and in its place were growing four trees. A pygmy, one of the original inhabitants of the land in which the Kuba settled, discovered that one of the trees could be tapped for palm wine. He shared his knowledge only after becoming so publicly drunk that he was questioned by the village leader, who then decreed that palm wine should never be consumed in solitude, but instead should be enjoyed by people in groups.

In the nineteenth and early twentieth centuries, intricately carved cups came be to be used as marks of status. Kuba society is traditionally based on a complex hierarchy that involves men bettering their positions by acquiring titles, frequently through purchase. Ownership of objects that required great skill and time to create, and therefore could be acquired only at great expense, became one way to show directly and indirectly one's place in society. Commissioned, preferably from a highly reputed artist, a decorated cup might be one of several richly ornamented objects that a man might own as indications of his wealth and importance. Ironically, however, men of the highest status would not have used their cups in public, for they customarily ate and drank privately.

The cups, both with and without handles, can be divided into two categories. In the first are cups covered with incised geometric patterns similar to those found on Kuba textiles, beadwork, and other woodwork. Some of these have cowrie shells and/or copper sheets added to the surface to increase their value, as seen in another lovely cup in the museum's collection (above). Perhaps the most widely recognized form, though, are goblet-style cups in the form of human heads or heads on abbreviated bodies, such as this example.

Though sometimes described as "portrait cups," they are clearly not intended as naturalistic portraits, but instead suggest, through depictions of scarification and hairstyle, people of position within Kuba society.

Most noticeable on this cup is the horned coiffure. Emil Torday, who collected extensively among the Kuba at the beginning of the twentieth century, noted that cups frequently depicted a hairstyle that he said referred to buffalo horns and was worn by pregnant women and old chiefs.[1] However, more recently, the horns have generally been interpreted as those of a ram. The keeping of flocks of sheep was a prerogative associated with chiefs, and the attributes associated with a ram vis a vis the flock—dominance and assertiveness—parallel a chief's role with his people. Whichever animal is referenced (and perhaps both are possible), the zoomorphic quality of the head is emphasized by the animal-like ears, which are pointed and positioned high on the head.

The curve of the horns is echoed in the handle, a feature frequently absent on the head cups and rarely so elaborately conceived. It takes the form of female figure positioned elbows to knees and hands to face. (The figure's lower legs are lost below the knees.) Though the figure is simplified, the carver has clearly indicated the distinctive shaved hairline, angled just above the temples, which was popular among men and women during the nineteenth and early twentieth centuries.

Further Reading
Beumers, Erna, and Hans-Joachim Koloss. *Kings of Africa: Art and Authority in Central Africa*. Utrecht: Foundation Kings of Africa, 1992.

Note
1. Emil Torday, *On the Trail of the Bushongo* (Philadelphia: J. B. Lippincott, 1925), 100.

Luluwa peoples, Democratic Republic of the Congo

Female Figure (*Lupingu lwa Bwimpe* or *Bwanga bwa Bwimpe*)
Second half of the 19th century
Wood, incrustation, kaolin
H. 17 in. (43.2 cm)
Raymond and Laura Wielgus Collection, 75.91

Praised as one of the most beautiful of its type by the late William Fagg, who was one of the world's premier connoisseurs of African art, this figure represents Luluwa sculpture at its best, showing a complex harmony of form and surface effects.

The Luluwa, who live near the Lulua River in south-central Democratic Republic of the Congo, are particularly known for carved female figures that range in height from four to eighteen inches and are used in cults related to mothers and their newborns. Some, which depict a mother and baby, belong to Bwanga bwa Cibola, a women's association directed toward those who have had several miscarriages or whose newborns have died at birth or shortly thereafter. This figure represents another figure type, one that holds a small cup. These figures are part of Bwanga bwa Bwimpe, which had as its primary function ensuring the fertility of mothers and the health and beauty of infants. According to Constantine Petridis, who has done fieldwork among the Luluwa, this cult was particularly directed toward mothers who had given birth to a baby with pale skin. These children were considered especially beautiful, and, as result, the Luluwa believed, they and their mothers were likely candidates for attacks by envious people or sorcerers.[1]

The acquisition and maintenance of a figure such as this one was one way a woman could protect herself and her child from those wishing them harm. Through the addition of spiritually charged materials prescribed by a ritual specialist and periodically recharged, the figure became a conduit for invoking the assistance of the ancestors. Kaolin, a white chalk frequently used for ritual purposes in sub-Saharan Africa, was considered the most effective recharging material, and it is present in this figure's cup. Kaolin was also ritually rubbed on mothers and their babies. This figure's richly patinated surface suggests that the figure was much used and reflects the custom of rubbing a newborn, mother, and figure with red earth or powdered tree bark, palm oil, and water.

The figure's name, *lupingu lwa bwimpe* (literally, "figure of beauty") or *bwanga bwa bwimpe* ("charm of beauty"), refers to beauty in both a moral and physical sense, and the figures themselves suggest traits that were admired among Luluwa women. The large head, a common feature in African sculpture, emphasizes intelligence, and the long neck, muscular arms, and powerful calves indicate a capacity for hard work, a highly valued characteristic. The prominent navel, accentuated by concentric scarification, not only serves as a visual reminder of the link between mother and child and, by extension, successive generations of a family, but also is considered a mark of beauty in many African societies. The figure's extensive scarification reflects the Luluwa belief that such ornamentation made a woman beautiful, though by the nineteenth century this form of body decoration was much simplified on actual women. It is unclear whether the figure is depicted with an intricate coiffure or a wig-like headdress; in either case, its elaboration is another indication of a beautiful woman.

Petridis has suggested that relatively naturalistic and elaborately carved figures such as this one were made during a relatively brief period between the middle of the nineteenth century and the beginning of the twentieth, and he argues that their origin had more to do with Luluwa politics than with spiritual requirements.[2] At that time, in an attempt to emulate the Chokwe, who live to the southwest, some Luluwa leaders tried to consolidate power to create a centralized Luluwa state. Their political ambitions ultimately were not realized, but a more hierarchical society than had been typical among the Luluwa did come about. A visual indication of this new hierarchy was the acquisition of status symbols by the elite, and Petridis suggests that elaborately carved figures made for both Bwanga bwa Cibola and Bwanga bwa Bwimpe were among them. These figures, which were most certainly carved by the most skillful carvers, are much less numerous than those in a simpler, less naturalistic style. Petridis further postulates that they may have served not only as personal charms for the wives of high-ranking leaders, but also as figures used for the benefit of an entire community.

The museum's figure was likely made during the period suggested by Petridis. It was collected by Belgian colonial officer Sergeant Henri Joseph Lassaux in Luluabourg (now Kananga) sometime between his arrival in central Africa in 1894 and mid-1896, when he returned to Belgium.

Further Reading
Petridis, Constantine. "A Figure for *Cibola*: Art, Politics, and Aesthetics among the Luluwa People of the Democratic Republic of the Congo." *Metropolitan Museum Journal* 36 (2001): 235–58.

Notes
1. Constantine Petridis, "A Figure for *Cibola*: Art, Politics, and Aesthetics among the Luluwa People of the Democratic Republic of the Congo," *Metropolitan Museum Journal* 36 (2001): 244.
2. Petridis, op. cit., 242–43.

Chokwe peoples
Democratic Republic of the Congo/Angola

Chief's Chair (Ngunja)
1885–1930
Wood, antelope hide, brass
H. 31¼ in. (79.3 cm)
76.54

Detail of
chair stretchers

One of the most easily recognizable forms in African art is the chief's chair of the Chokwe peoples, who originated in central Angola, but, over the course of the last two centuries, have spread into southwestern Democratic Republic of the Congo and western Zambia. In the hands of skillful Chokwe carvers, a seventeenth-century Portuguese chair type became inspiration for a distinctive form of chief's chair that was an important part of Chokwe leadership arts from around 1885, the height of Chokwe expansion, until the 1930s, when use of the chairs ended.

Chokwe carvers did not make copies of these European imports; instead, they created chairs distinctly their own by adding carvings on the backs, legs, and stretchers and by elaborating the upholstery tacks into decorative patterns. The number of figures, as well as their placement and arrangement, vary from chair to chair. Although they do not form a continuous narrative, these carvings depict scenes from Chokwe history, religion, and daily life. Many of the carvings also seem to be visual metaphors for ideas and beliefs, particularly as they relate to leadership.

The seatback of the museum's chair shows a masquerader representing Cihongo, the primordial male ancestor and a symbol of masculine power and wealth. The Cihongo masquerade is traditionally associated with the chief and his lineage, making its prominent representation particularly appropriate. On the front legs are two more individual figures, one male and one female. As caryatids, they hold up the leader when he sits on the throne, suggesting that they may refer to the ancestors, from whom a leader derives his power, and may serve as a reminder of the importance of the continuity of the chiefly lineage.

Between the front legs, the two stretchers display multiple figures, an arrangement that is continued on the sides and back. The bottom stretcher shows a woman between two men, each pulling on her. This scene is frequently interpreted as a reference to Lweji, a seventeenth-century chief in present-day Angola, and her two brothers, who contested her right to rule, thereby starting the migrations that eventually resulted in the founding of the Chokwe people. Another plausible interpretation is that the figures are a metaphor for the struggle between male chiefs for power, with the winner taking his opponent's wife as a symbol of his victory. On the top stretcher, a woman holding a child, who appears limp and lifeless, faces a man who sits with his hands to his head, a pose associated with mourning and with the ancestors.

The upper stretchers on the sides and back depict creatures from the natural world that have metaphorical significance for the Chokwe and their leaders. On the viewer's left, two baboons face each other. The Chokwe consider these animals to be intermediaries between

people and the wilderness, and their depiction here indicates a leader's ability to play a similar role.[1] Hanging bats on the upper back stretcher also refer to special powers possessed by a leader: just as bats have an uncanny ability to move about with ease in the darkness, seeing when people are unable to do so, a successful ruler must be aware of all actions and words that affect a community, even those that individuals might try to hide. The birds on the right top stretcher are associated with fertility and, because of their migrations, with continuity, which a leader also claims to control. They also frequently refer to success in hunting and are viewed as intermediaries between the earthly and spiritual realms.

The stretcher below the baboons shows a boy's circumcision: held by an assistant, the lad faces the circumcision master, whose arms are broken in this example. Circumcision, necessary for Chokwe adult status, is traditionally performed in the context of a male group initiation, in which the initiates learn about practical and spiritual matters associated with being a responsible adult member of a community. On the lower back stretcher, one figure holds a small unidentified object, while the other beats a *chikuvu*, a flat drum played on a variety of occasions, both festive and somber. Frequently appearing on Chokwe thrones, the drum may symbolize the summoning call of a chief to his community, and the community itself.[2] Likewise, the two hunters on the stretcher below the birds may refer to prowess in that arena—Chokwe men are reputed to be great hunters. Alternatively, the fact that the men appear to be pointing their guns at each other may refer to the importance of resolving conflict through negotiation, a skill greatly valued in a leader.

IU Art Museum's example shows the chef's chair form at its visual best: there is a satisfying balance between the varied and well-carved rounded figures and the solid geometry of the functional part of the chair itself; neither dominates. In addition, the carver has created pleasing surface contrasts between the smooth figural carvings and the brass tacks, animal skin, and incised patterns on the chairback.

Further Reading
Jordán, Manuel A., ed. *Chokwe! Art and Initiation among Chokwe and Related Peoples.* Munich: Prestel, 1999.

Notes
1. Manuel A. Jordán, "Tossing Life in a Basket: Art and Divination among Chokwe, Lunda, Luvale and Related Peoples of Northwestern Zambia" (PhD diss., University of Iowa, 1966), 35–36.
2. Jordán, op. cit., 45; and Reinhild Kauenhoven-Janzen, "Chokwe Thrones," *African Arts* 14, no. 3 (May 1981): 71.

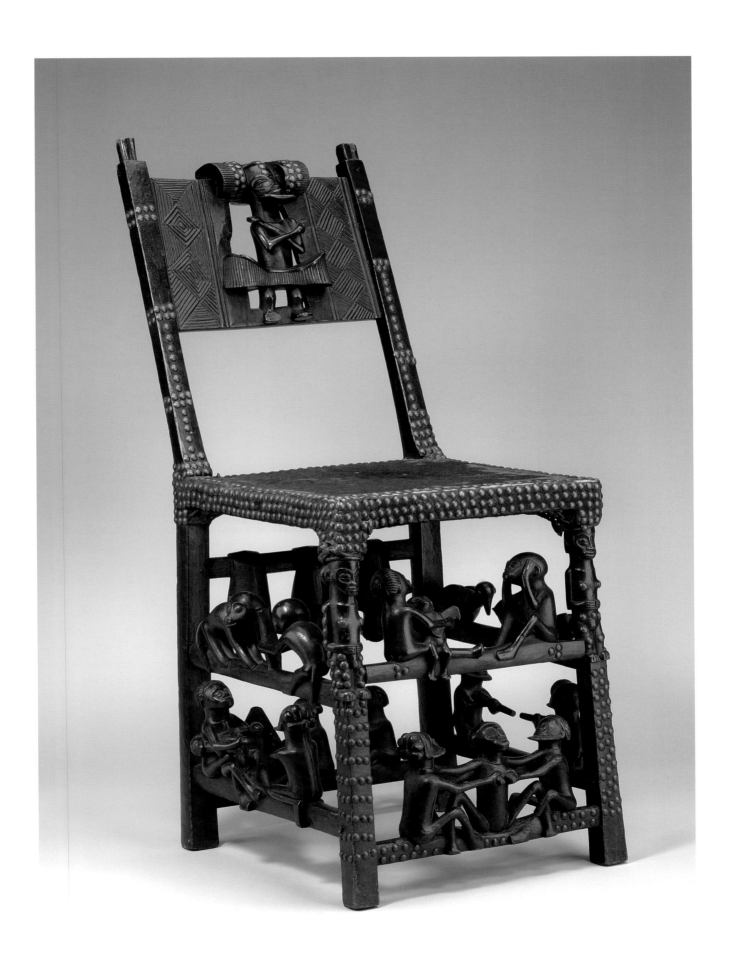

Ndebele peoples, South Africa

Wedding Train (Nyoka)
Early 20th century
Glass beads, cotton thread
Total L. 77 in. (195.6 cm)
Gift of Claire and Michael Oliver, 81.58

Full view

This *nyoka* would have been worn by a young woman at her wedding as part of an ensemble of other beaded objects including a veil, a married-woman's apron, and a cape made of goatskin (later frequently replaced by a blanket). The name *nyoka,* "snake," refers to the appearance of the train as it moves behind the bride while she dances. As an increasing number of women are married in Western dress, objects such as the *nyoka* have become rarer, and today much Ndebele beadwork is made for the art and tourist markets.

Unlike most other Ndebele beadwork, the beads of the *nyoka* are not attached to skin, fiber, or cloth. Though it appears to have been woven, no loom was used: beads are sewn together individually, a painstaking task for an object that is typically over sixty inches long. In addition to the motifs created by colored beads, small openwork squares or rectangles may punctuate the train, as in this example. Bead strings or a narrow band of beads are sewn to the top, to attach the train to the wedding blanket or to allow it to be hung from the bride's neck or head. Unlike the top edge of the *nyoka,* which is straight, the bottom frequently ends in a "v," a longer central flap, or another more intricate shape.

While we might be tempted to consider the dominance of white beads as related to the wedding train's use as bridal garb, it instead indicates the object's age. The oldest known examples of Ndebele beadwork date to the 1880s, and, no matter what their function, they are characterized by expanses of white beads broken occasionally by relatively small, frequently linear, geometric motifs created with translucent red, blue, green, and orange-yellow beads. Sewn with sinew, this early beadwork is made with so-called seed beads, frequently so small that a needle could not pass through them. The museum's *nyoka* is sewn with cotton thread, but in every other respect, it is typical of that old, and extremely rare, style. Later beadwork from the 1920s and 1930s shows a greater use of color and representational motifs; by the 1960s, a white background was unusual, and larger dark green, blue, and black beads dominate.

Bead color and patterns may be symbolic for other South African peoples, such as the Zulu, but Ndebele beadwork does not seem to have similar associations. Diane Levy, who has written on Ndebele beadwork, indicates that among several South African groups, the color white is linked with transitional, or liminal, states; she posits that such an association among the Ndebele could explain the predominance of white in beadwork, which often marked a change in a woman's status. She notes, however, that changes in color preferences over time weaken that argument, and suggests that the popularity of white beads in the nineteenth and early twentieth centuries could be because that was what was available.[1] Common Ndebele beadwork motifs today—houses, airplanes, and telephone poles—are drawn from a woman's visual experience and may reflect her desires and aspirations; however, researchers have found no indication that early, non-representational patterns have any symbolic meaning.

As elsewhere in southern Africa, Ndebele beadwork is a women's art. A girl traditionally learns beading from her mother or another female relative at a young age—as early as six or seven—and makes most of the pieces she wears, sometimes from old beaded objects that are taken apart. Some beadwork, though, is customarily given to her: for example, a female relative makes a bride's *nyoka.*[2] After the 1883 defeat of the Ndebele by the Boers in the Mapoch War and their subsequent dispersal to work on white farms, beadwork—and, later, house painting (which uses similar colors and motifs)—became a visually striking way of affirming Ndebele identity.

Further Reading
Powell, Ivor. *Ndebele: A People and Their Art.* Photographs by Mark Lewis. New York: Cross River Press, 1995.

Notes
1. Diane Levy, "Southern African Beadwork: Issues of Classification and Collecting," in *Art and Ambiguity: Perspectives on the Brenthurst Collection of Southern African Art* (Johannesburg: Johannesburg Art Gallery, 1991), 112.
2. Usually the paternal grandmother, according to Rhoda Levinsohn, *Art and Craft of Southern Africa* (Craighall, South Africa: Delta Books, 1984), 117.

ANCIENT EGYPT, THE NEAR EAST, AND THE CLASSICAL WORLD

The ancient masterworks selected here range in date from the third millennium BC to the third century AD. They are part of the museum's rich collection, which encompasses the ancient world from Iran to Europe. The collection comprises Egypt and the Near East, including Anatolia (present-day Turkey); the Middle East (the Levant); Iraq (Mesopotamia); Iran (Persia); as well as the classical Greek, Etruscan, Roman, and early Byzantine worlds. The collection's diversity is one of the advantages of a relatively small, but encyclopedic university museum, generously endowed by such connoisseurs as Burton Y. Berry, Thomas T. Solley, and Henry Hope.

The ancient cultures represented in the collection are remarkably varied, not only in their geography but in their world views as well. We notice the mysterious cult of death and the afterlife that pervades Egyptian art, distinct from the nature-based vitality prevailing in Near Eastern artifacts. The anthropomorphic mythical world of the Greeks, in turn, is different from the historical realism embraced by Roman artists. The Etruscans, who preceded the Romans in Italy, created one of the most original and enigmatic cultures of the ancient world. Remarkable for their exuberant religiosity are their luxurious tomb paintings and terracotta sarcophagi with smiling faces of the departed, as well as their fine, sensuous bronze works, including mirror engravings, which have influenced major modern artists such as Pablo Picasso.

One of the collection's strengths is Greek pottery, from the center (Attica, the region around Athens) and beyond (Boeotia, Laconia, East Greece, and South Italy). Black- and red-figure vases provide a comprehensive survey of the vase painters' art in sixth- and fifth-century BC Athens. The sensitive image of the boy called Apolexis represents an outstanding group of fourth-century BC Greek marble tomb reliefs.

A distinctive aspect of our collection is a fine group of ancient jewelry and gemstones. Numbering over five thousand pieces, many of great rarity, the collection illustrates in minute detail every aspect of ancient techniques and the ingenuity and exquisite craftsmanship of ancient gold- and silversmiths from earliest times to late antiquity. The jewelry collection is of international significance, fostering important research; it will continue to be a resource for future scholarship.

One leitmotif that recurs throughout our selection of ancient artworks is the artists' varied and masterful rendering of the figure, human or animal. The tension between the symbolic and the representational can be followed throughout the art of antiquity, and nowhere is this strife more evident than in the manner in which artists have dealt with the figure. We see the beginnings of ancient sculpture in the third millennium BC. In the Aegean island culture of the Cyclades, the sculptor known as the Goulandris Master used a linear, minimalist style to subdue the roughness of marble and to bring to life the abstracted contours of the female figure in our collection. The Egyptian Old Kingdom tomb statuette of a servant has a generic appearance dictated by a conceptual approach to the human figure, yet one cannot fail to recognize the hint of individualized humanity that glimmers in his alert gaze, intensified by colorful paint. Our earliest miniature masterpiece in gold, the Anatolian bull jewel, is an eloquent example of the manner in which the prehistoric goldsmith combined naturalism, abstraction, and suggestive exaggeration to express the rich Near Eastern tradition of animal-cosmic symbolism.

No group of artists was more concerned with the human figure than the Greeks, who endowed even their gods with human form and emotions. On the amphora by the artist known as the Amasis Painter, the god Dionysus seems to chat with a group of hunters in a convincingly lifelike fashion. Narratives on Greek vases are figurations of conflict and externalize emotion in scenes such as those of Herakles wrestling Triton, the battle of Theseus with the Amazons, or the punishment of Actaeon, in our selection. The Greek interest in depicting the human figure in activity is also reflected in the Boeotian terracotta group of the portly barber cutting a client's hair.

Some of the most exquisite representations of the human figure were created as adjuncts to utensils, as was the Ionian Greek youth who served as the handle of a bronze vessel. The Etruscan dancer, originally part of a bronze incense burner, and the Etruscan bronze mirror, engraved with a complex scene in which the mythological characters are identified by their Etruscan names, both arise from this tradition as well.

Historical portraiture, often used as propaganda, is characteristic of Roman art. The finely carved and highly polished portrait busts of Septimius Severus and Julia Domna convey the strength and authority of the imperial pair and were probably commissioned for public display.

Adriana Calinescu
The Thomas T. Solley Curator of Ancient Art Emerita

Anatolian, Hattian or Early Hittite
End of 3rd millennium BC

Bull Statuette
Gold, solid cast
H. 1 in. (2.4 cm)
Gift of Dr. Leo Mildenberg in honor of Burton Y. Berry, 2001.12

The power of this jewel-sized bull is concentrated in its large horns, which, together with its head, measure more than half the height of the animal. The compact body—a graceful, sculptural abbreviation of muscular rump and limbs—projects a contained energy, ready to discharge at any moment. A gift of Leo Mildenberg, a prominent connoisseur and collector of animal art, this miniature gold masterpiece is the earliest sculpture in our collection.

Careful, sensitive detailing renders the bull's head. The nostrils flare, the mouth parts slightly, and the eyes bulge above alert ears. The ridge of the eye socket extends along the muzzle, suggesting the underlying bone structure. There is a masterful contrast between the naturalistic rendering of the head and the abstracted body form.

The shape of the bull's body—a triangle on a narrow base—indicates that the statuette was most likely a finial of a large pin, perhaps used on a ceremonial garment and performing a religious function. The closest analogies seem to be the solid-cast bronze bulls, some of them fastened to the tops of poles (perhaps ceremonial standards), which were excavated from the rich burial grounds at Alaca Hüyük, in central Turkey, dating from around 2300 BC.

Those burials, found under the remains of a Hittite city, belonged to a people who spoke a language identified as Hattian in later cuneiform tablets of Assyrian merchants. The Hattians, who inhabited central Anatolia's mountainous region of Cappadocia centuries before the Hittites, were geographic precursors of the latter, but the groups' ethnic relationship, if any, is unclear. Hattian possessions included gold and silver jewelry, vessels, and ritual objects. They were accomplished metalsmiths who used sophisticated techniques, such as lost-wax casting. The propinquity between the Mildenberg bull and the early Alaca Hüyük animal figures is substantiated by the simplified, converging limbs and exaggerated heads with elongated muzzles and powerful horns, rendered in a manner that bespeaks an interest in natural forms.

Although we cannot discuss the beliefs and customs of the Hattians with certainty, we know more about the symbolism of the bull in Hittite art and mythology. A procession carved on orthostats (large, upright stone slabs) at Alaca Hüyük's imperial fortress culminates with the image of a Hittite king worshipping at the altar of a deity in the shape of a bull. The bull was an attribute of the principal deity of the Hittite pantheon, the Weather God of many names, commonly depicted in a chariot pulled by a bull team. The bull was believed to support the cosmos on the tips of its wide horns.

Further Reading
Akurgal, Ekrem. *The Art of the Hittites.* London: Thames and Hudson, 1962.
Frankfort, Henri. *The Art and Architecture of the Ancient Orient.* Pelican History of Art series. New York: Penguin Books, 1970.
Kozloff, Arielle, ed. *Animals in Ancient Art from the Leo Mildenberg Collection.* Cleveland, Ohio: Cleveland Museum of Art in cooperation with Indiana University Press, 1981.

Egyptian
Old Kingdom, Dynasty 5, 2565–2420 BC

Servant Figure
Limestone, paint
H. 7 7/8 in. (20.0 cm)
77.77

This statuette of a youthful servant is rare for several reasons: it departs from the frontal treatment characteristic of Egyptian sculpture; its execution is extraordinarily delicate and refined; the state of preservation of its painted colors is exceptional; and the vivid expressiveness of the figure's face is remarkable, as well.

Despite the fact that the man's arms and lower legs are lost, he clearly is shown in movement. His body leans forward and his knees are slightly bent, with the left one positioned forward. His arms would have reached forth, carrying most of the body's momentum. His stance indicates engagement in an activity, probably as a beer maker, bending over to strain mash with his hands through a sieve and into a waist-high vat.

While the figure is generic, the sculptor rendered the face with unusual sensitivity. We notice the wide cheeks and full lips, rimmed with a ridge, and the extended cosmetic line at the eyes' outer corner (an innovation of the Old Kingdom artistic canon). The eyes look ahead, into the distance, with a gaze that was supposed to go beyond this mortal world. Such a gaze was usual in sculptures of this genre, but this figure's eyes glimmer with an alertness that, together with the hint of a smile on the lips, subtly distinguishes his countenance from the run-of-the-mill type. The general conventions observed in our statuette became established in the art of the Fifth Dynasty of ancient Egypt; but, in this case, we may also speak of an individual sculptor's remarkable artistry. For, of all known servant figures of the period, this one is certainly among the finest.

The Old Kingdom period covered more than five hundred years (2700–2200 BC) and was considered by the Egyptians to be the golden age of their civilization. The Old Kingdom is known today as the Pyramid Age, a label referring to the construction of the largest known stone funerary monuments to kings. At the end of the Fourth Dynasty, private tombs of high dignitaries, called mastabas, proliferated around the king's pyramid, and the custom evolved of placing in them limestone statuettes of domestics, alongside those of the master of the estate and his family.

The servants were shown engaged in various tasks linked to the preparation of food and drink, and their function was to furnish the deceased with provisions for eternity. Bread and a drink similar to beer were staples of the Egyptian diet, and household occupations linked to them became professions with corresponding artistic types, such as our beer maker. Begun as a small, household operation, brewing evolved into a large-scale industry and became one of the economic activities that played an important part in the rise of Egyptian civilization.

The brewer prepared *henquet* (a beer-like beverage) by soaking half-baked bread in water and letting it ferment for several days; the resulting mash, with an alcoholic content of at least twelve percent, was trod underfoot and sieved into large vats to be bottled into smaller jars for storage. Interestingly, the hieroglyph that the ancient Egyptians used to denote a brewer bears a resemblance to our beer maker's pose. Here, the two distinctive activities of writing and of artistic representation have converged.

Further Reading
Aldred, C. *Egyptian Art in the Days of the Pharohs, 3100–320 B.C.* New York: Oxford University Press, 1980.
Robins, G. *The Art of Ancient Egypt.* Cambridge: Harvard University Press, 1997.

Egyptian
Third Intermediate period, Dynasties 21–22, ca. 1070–712 BC

Royal Head
Wood covered with gesso, gilding, and glass inlays
H. 3 3/4 in. (9.5 cm)
Jane and Roger Wolcott Memorial, 69.158

This small and exceptionally fine Egyptian head—made of stuccoed and heavily gilded wood—has broken off of a statuette. The figure wears an unusual royal headdress, rarely represented in sculpture, which has been called the Junior Blue Crown. The incised circlets of its surface decoration evoke the disk ornaments that adorn the *Kepresh,* or Blue Crown, a helmet-like headdress that is sometimes referred to in ancient texts as the War Crown, but which also appears as the blue-colored ceremonial regalia in Egyptian cultic representations from the New Kingdom (1550–1070 BC). The manner in which our figure's crown is held in place—by a brow band placed low on the forehead—and its snug fit, covering the whole skull, however, make it more similar to the traditional royal Cap Crown.

Encircling this royal skullcap is a diadem, now fragmentary. The diadem, or *seshed*-circlet, has square settings for inlays, some of which still hold their original red and green glass; its center square once bore a bronze uraeus, or rearing cobra, the symbol of the king. The cobra's double coil is modeled in relief on the crown's surface, with its tail extending all the way to the back of the head.

The idealized youthfulness of this unidentified, adolescent-looking king is conventional. However, his delicately wrought face—with its upward slant of eyes originally enlivened, together with the eyebrows, with colored inlays, and his full-lipped, almost smiling mouth—as well as his elongated skull and the crown with short, rounded tabs before the ears, are characteristic of the art of the early Third Intermediate period (Dynasties 21–22). Stylistically, this period returned to the forms of the New Kingdom's Dynasty 18, as illustrated in portraits of Amenhotep III and Tutankhamun.

The artistic creativity of the early Third Intermediate period (1070–712 BC), a poorly documented stage in Egypt's history, recently has been reassessed. Authority in the country was divided. The Dynasty 21 kings ruled northern Egypt from Tanis in the Nile Delta, while the High Priests of Amun, seated at Thebes, controlled southern Egypt. Intermarriages, however, were recorded, and princesses at Tanis are known to have married high priests at Thebes. The Dynasty 22 Libyan kings moved the capital to Bubastis and reestablished authority over the whole territory, yet they had to confront a century of rivalry from the coeval Dynasty 23, favored by the Theban priests. At last, following the short-lived Dynasty 24, the Dynasty 25 Kushite kings from Nubia would restore stability in Egypt.

Despite its divided and contentious state during the Third Intermediate period, Egypt was prosperous due to trade and wars with the Middle East. Excavations at the two royal capitals in the Nile Delta have uncovered evidence of immense wealth and prodigious artistic production. Finds at Bubastis include granite column fragments inscribed with lists of abundant temple offerings by King Osorkon I (ca. 980 BC), and Tanis has revealed rich finds of religious and funerary objects of gold and silver, including sculptures, jewelry, and vessels.

Royal sculptures in wood, a perishable material that would not have survived the humid climate, are absent from the Nile Delta sites. Thebes, on the other hand, had a brilliant tradition of wooden sculpture, dating at least since the reign of Amenhotep III (1391–1353 BC). At royal jubilee *(sed)* festivals, which celebrated and renewed the king's status, small-scale images of the king were produced as gifts to the participants. Egyptologist John Cooney has tentatively attributed the Bloomington head to the Theban School.[1]

Further Reading
James, T. G. H. *Ancient Egypt.* Ann Arbor: University of Michigan Press, 2005.

Note
1. John D. Cooney, "Three Royal Sculptures," *Revue d'egyptologie* 27 (1975): 91, pl. 6b.

Goulandris Master
Cycladic, 2700–2400 BC

Female Figure
Marble, traces of paint
H. 23 5/8 in. (60.0 cm)
Gift of Thomas T. Solley, 76.25

I love and admire Cycladic sculpture.
It has such great elemental simplicity. —Henry Moore

This female figure is a masterpiece of prehistoric art. Its stark simplicity and purity of form provoke a response of unmitigated pleasure and relate with ease to our modern aesthetic sensibility. Cycladic sculptures, it has often been said, mark the birth of Western art. Since the beginning of the twentieth century, major European artists such as Constantin Brancusi, Henry Moore, Amadeo Modigliani, and Alberto Giacometti have been fascinated and influenced by their stylized monumentality.

White marble figures—mostly female, like this one in the IU Art Museum's collection—are among the most important remains that have come down to us from the small pre-Greek communities that flourished almost five thousand years ago in the Cyclades, a group of islands in the Aegean Sea. The IU Art Museum's Cycladic figure has features typical of the genre: she is harmoniously balanced and was carved with admirable economy of detail. Her face is a blank expanse on which the semi-conical nose is the only feature. Her body is designed with a special feel for the geometry of the line and the curve. In the upper half of the body, with its long, conical neck, sloping shoulders, and folded arms, the emphasis is on linearity. In the lower half, the linear construction merges into the sensual curve of the thighs and the calves, with convex grooves defining the abdomen, knees, and ankles. The body is also subtly asymmetrical: the upper left side is narrower, and the left arm reposes at an angle above the right. This freedom from strict symmetry is a quality we have come to associate with the later Greeks of classical antiquity, and we view it as one of the secrets of their success.

The thinness of the figure when seen from the side reveals the sculptor's great mastery over the marble. The slender profile is less the result of aesthetic choice than the product of making good use of existing technology: this sculpture was hewn out of a rough slab of marble, probably split from a mountainside. The sculptor would have shaped the stone with rudimentary tools: a piece of charcoal for marking the outline and a wedge of emery (a hard, abrasive stone) for chipping away along the contours. Grooves and incisions were cut with a chisel, which could have been of bronze, emery, or obsidian (a hard volcanic glass). Chiseling was probably followed by painstaking rubbing with wet pumice to remove abrasion marks and achieve the surface finish.

Faint traces of red paint on the forearms of our figure indicate that she was adorned with bracelets. On fragmentary examples found elsewhere, details such as painted eyes, brows, ears, or hair strands— even facial markings indicating tattooing—have survived.

The figure's backward tilting head and downward pointing toes suggest a reclining rather than an erect posture. Indeed, in grave contexts, marble figures have been found placed on their backs among other funerary finds and were occasionally covered by weighty vessels. Tantalizingly, examples that bear signs of wear and tear during use in daily life have also been found among grave goods, evidence strengthened by the occasional find of such sculptures in the scant remains of Cycladic domestic settlements. The fact that a used figure was deemed worthy of accompanying the deceased seems to confirm an interpretation of such objects as status symbols. It has also been suggested that they played some part in the religious beliefs and rituals of the Cycladic people.

This much-published sculpture has been attributed to the Goulandris Master, an artist named after the collection in Athens that includes three examples by this craftsman's hand.[1] In all, fifteen figures by this master have survived complete, and they vary in size from small (six inches high) to nearly life-size. The carver's signature is the lyre-shaped head, sloping shoulders, small wide-spaced breasts, and the separated feet held at an angle.

There are no written records of the culture in which these sculptures were created, but aspects of it have been pieced together from the archaeological record. Most probably, the mild climate and geographical location of the Cyclades were propitious factors in the emergence of Cycladic culture. Clustered in the middle of the Aegean Sea, these islands are a stepping-stone between Asia and Greece. The sea-faring islanders established relations with their neighbors. They grew grapes and olives and exploited the natural resources of obsidian, emery, and marble; the mountains of Naxos and Paros were particularly rich in high-quality marble. They had potters, sculptors, and smiths, and their trade goods have been found outside the Cyclades: on Crete, at Troy, and on the Greek mainland.

Further Reading
Getz-Preziosi, Pat. *Early Cycladic Sculpture: An Introduction.* Malibu: The J. Paul Getty Museum, 1985.

Note
1. Jurgen Thimme, ed., *Art and Culture of the Cyclades in the Third Millennium B.C.* (Chicago: University of Chicago Press, 1977), cat. no. 167, pl. 5; Pat Getz-Preziosi, "Five Sculptors," in *Cycladica: Studies in Memory of N.P. Goulandris* (London: British Museum, 1984), figs. 3:3, 14c–16c; *Early Cycladic Sculpture: An Introduction* (Malibu: The J. Paul Getty Museum, 1985), figs. 64–65; *Early Cycladic Art in North American Collections* (Richmond: Virginia Museum of Fine Arts, 1987), cat. no. 85; and *Sculptors of the Cyclades: Individual and Tradition in the Third Millennium B.C.* (Ann Arbor: University of Michigan Press, 1987).

East Greek, Ionian, probably Samian

Handle in the Form of a Youth
ca. 540 BC
Bronze, solid cast
H. 6 $\frac{1}{8}$ in (15.5 cm)
Gift of the Honorable Burton Y. Berry in recognition of
Chancellor Herman B Wells' services to the University, 78.58

Many of the finest surviving Greek bronze statuettes are sculptural adjuncts to utensils. Here, a naked youth (kouros) arches his back to form a slender handle that is easy to hold, probably for a wine jug *(oinochoe)* or water jar *(hydria)*. As he bends backward with athletic plasticity, the youth extends his forearms to grasp the tails of two reclining lions, curved to fit the rim of the lost vessel. Three rivets once attached the handle to the vessel, one piercing the inner paw of each lion and one, still visible, placed beneath the toes of the youth's tightly held legs, which rest on the rounded petals of a decorative palmette.

The overall impression is of fluid curves and smoothly polished surfaces. The torso is long, with no suggestion of a waist and only an intimation of the semicircular rib cage breaking the gently swelling planes of belly and breasts. A horizontal ridge on either side of the genitals separates the slender upper body from the legs, narrow at the hip, bulging at the thigh, and with muscular calves. The youth's head, large in proportion to his body, rises sharply from a thick neck above the ridge of the collarbone. His face, wide at the brow, narrows to a jutting chin. His enormous, double-outlined almond eyes beam beneath strongly etched eyebrows, and his thick-lipped mouth opens in a smile; his delicate nose projects from a thick base amid the rounded cheekbones. The strong features of the face give it an intense and sensual presence. The forehead fillet holds back sweeps of hair that slant away from the central parting and are enlivened by incised individual strands. These locks swell above a smooth mass of hair that falls flatly on the back.

The lively suppleness of the youth's lithe body and the powerful expressiveness of his face bespeak the Ionian origin of this bronze. Its closest relatives are bronze kouroi from the sanctuary of Hera (Heraion) at Samos. During the sixth century BC, various workshops vied for originality in their bronze production. Perhaps this spirit of rivalry was best expressed in the production of exquisite handles for vessels and mirrors. Anthropomorphic handles were produced in centers of the Peloponnese (Sparta and Corinth) as well as in Attica, South Italy, and Etruria. But the rich island of Samos held a pioneering role in bronze smithing. Two Samian artists, Rhoikos and Theodoros, who were connected with the building of the Temple of Hera around the middle of the sixth century BC, are praised in ancient sources for introducing the hollow-casting technique of monumental bronze statues. Solid casting, as in our handle, also had an old tradition. The abundance of small Samian statuettes reveals a steady development that culminated in the third quarter of the sixth century with the appearance of young males of radiant expressiveness, of which this handle is a splendid example.

This object is among the generous gifts of Indiana University alumnus Burton Y. Berry. Berry's substantial contributions to the IU Art Museum can be attributed to his close relationship with President Herman B Wells. Their friendship began in the early 1920s, when they were in college at Indiana University together. Berry, a diplomat who traveled widely to Greece and the Near East, became a passionate collector of ancient art, renowned for his connoisseurship of small bronzes and jewelry.

Further Reading
Rudolph, Wolf W. *Highlights of the Burton Y. Berry Collection.* Bloomington: Indiana University Art Museum, 1979.

The Amasis Painter
Greek, Attic

Black-Figure Amphora Honoring Dionysos
550–540 BC
Clay, glaze, added red and white
H. (with lid) 14 5/16 in. (36.3 cm)
Gift of Mrs. Nicholas H. Noyes, 71.82

This amphora (a two-handled storage jar for wine or oil) is perhaps the finest classical vase in the Indiana University Art Museum's collection. It epitomizes the ancient Greeks' love of graceful, symmetrical arrangements in the elegant proportions that Athenian potters of the sixth century BC established for luxury vases, and it reveals to us the manner in which shape, function, and painted decoration can be perfectly harmonized. The handsome lid with a pomegranate top suits the vessel well, although it may or may not have been made for this amphora, since lids were often interchangeable.

The amphora's depiction of Dionysos in the company of mortals is most unusual. The god, who granted the gift of wine to humankind, is shown here on one of his visits to earth. He stands in the center of the scene—a bearded and majestic-looking figure with long hair, clad in a chiton with a mantle draped over his shoulder—and we recognize him by his specific attributes: the drinking horn he raises in his hand and the vine-leaf wreath on his head. Although no landscape elements appear in the scene, there is no doubt that the setting is rustic.

The tableaux on both sides of the vase carry almost mirror-image scenes. On each side, four men—on the front a mature, bearded man and three youths, and on the back (shown here) four youths—hold hunting spears and, accompanied by dogs, greet the god. The hunters are naked except for the chlamyses (mantles) on their shoulders, and their athletic nudity exemplifies the beauty of the male body, just as in the sculptures of kouroi (naked youths) of the period. They gesture with dignified animation, and the god himself seems to be conversing with them. Dionysos is honored here in his double capacity as god of viticulture and the hunt.

The Amasis Painter, to whom this amphora is attributed, was one of the foremost black-figure vase-painters of sixth-century Athens. He started working around 560 BC and had a long career of more than forty years. Unlike his great contemporary Exekias, who preferred to depict Dionysos in the company of gods, the Amasis Painter showed him in the company of mortals. Also unlike Exekias, who preferred monumental vessels, the Amasis Painter decorated a variety of shapes, from cups and *oinochoi* (pitchers) to *lekythoi* (oil flasks) and other small-size vases; but his favorite was the amphora, especially the panel-amphora, which allowed him to illustrate different scenes on the front and back panels. In the painter's oeuvre, therefore, our amphora has a place apart, as it offers a rare example of nearly identical compositions on both sides.

The Amasis Painter used the black-figure technique (silhouetting the figures in black paint against the original red color of the clay) with masterful control. Probably trained as a miniaturist painter, he excelled at detail: he rendered anatomical features with precisely incised lines, enhancing accessories with an economic application of color touches. He was an accomplished ornamentalist, as evidenced by the elaborate black and red palmette-lotus festoon above the figurative panel on this vase. And, he was blessed with a light touch and could be playful, as in his depiction on the front of the lively dogs, collared but not leashed.

The painter of our amphora—who never signed his vases—takes his name from the potter who inscribed a dozen known vessels with *AMASIS MEPOIESEN* (Amasis made me). The potter Amasis, whose name is Egyptian but whose subjects were purely Greek, either hired painters to decorate his wares, or the potter and painter were the same person. Athenian potters maintained their businesses in the *ceramia* (pottery) shops in the agora at the foot of the Acropolis. The potters' quarter occupied the area along the Eridanos stream, which provided the excellent orange-red clay for which Athenian pottery is famous. Made for local use or for export, vases were employed in rituals, as offerings to gods, or at symposia (male drinking parties). The all-male scenes on our amphora suggest that it was commissioned for the latter purpose.

Further Reading
Von Bothmer, D. *The Amasis Painter and His World. Vase-Painting in Sixth Century B.C. Athens.* Malibu: J. Paul Getty Museum; New York: Thames and Hudson, 1985.

Oltos
Greek, Attic (from Vulci, Italy)

"Bilingual" Eye-Cup
ca. 520 BC
Clay, glaze, added red and white
H. 5 1/4 in. (13.3 cm)
80.73

Detail of interior

The term "bilingual," when applied to Greek vase painting, describes the concurrent appearance of black-figure (black figures on a red ground) and red-figure (red figures on a black ground) representations. More than merely contrasting techniques, these styles are distinct artistic languages, each with its own grammar and vocabulary. The occurrence of the two modes of expression on our cup makes it an important artistic document from a period of changing artistic tastes. This cup comes from the renowned collection assembled by the second Marquess of Northampton (1790–1851) in Italy in the 1820s.

Oltos, the painter of this cup, used single figures to demonstrate his proficiency in both languages. In the tondo inside the cup, the messenger god Hermes runs briskly to the right and looks around, holding his *kerykeion* (a staff topped by intertwined snakes) in his right hand. He is painted in the earlier black-figure technique, as a silhouette surrounded by the natural orange-red color of the clay. On the exterior of each side, the Nereid (nymph of the sea) is depicted in red-figure technique (reserved in the natural color of the clay against the black-painted ground), but the dolphins in each of her hands were added in red over the black paint, a device used in the black-figure technique.

We know the name Oltos from two signed red-figure cups, one in Tarquinia, another in Berlin. The painter worked in the transitional period when the red-figure technique, freshly invented around 530 BC, began to rival black-figure, which had been the principal style of Attic vase decoration for more than a century. Both Hermes and the Nereid have athletic bodies shown in a similar fashion: frontal torsos are juxtaposed with heads and legs seen in profile—suggesting that the artist meant to facilitate the viewer's understanding of the two styles by drawing his figures in almost identical poses. As we compare the figures, however, we realize that Oltos was at his best in the black-figure technique and still tentative in red-figure.

Although Oltos belonged to the first generation of red-figure painters, he was initially trained as a black-figure artist. His Hermes is perfectly poised within the interior medallion and demonstrates the artist's masterful command of his graver: he rendered the god's moustache and the fringes of his beard with neat incised lines and detailed—also by incision—Hermes' eye, his forearm from elbow to wrist, and his lower legs from knee to ankle, using curved strokes to define the god's calf muscles and kneecaps. Oltos patterned the god's chiton with incised crosses to suggest its rich embroidery, and he highlighted Hermes' cloak folds, his pointed beard, and his flamboyant *petasos* (traveler's cap) and boot wings with added red color.

By contrast, the Nereid is devoid of internal definition. The painter used the relief-line—which was so important in red-figure for contouring the body against the black ground—only sparingly and omitted all details of anatomy. The embroidered *sakkos* on the Nereid's head, her bracelets, added in red, and the silhouetted panther on her short chiton are echoes from the black-figure technique. Absent from this rendition of the Nereid is any use of brushwork to articulate the female body in a lifelike posture, which would characterize the evolved red-figure mode. And yet, telling advantages of the new technique can be detected: the almond-shaped eye on the Nereid's profiled face looks more natural than the staring, frontal eye of Hermes, and the effect of the Nereid's body against the black ground is almost relief-like.

Our painter fitted the Nereid figure in the space between a startling pair of huge eyes, which he rendered in a combined technique: the eyebrows and the oculus are reserved, while red was added for the pupil and white for the circle around it. Fan-like reserved palmettes flank these apotropaic eyes. The eye-cup, decorated with a pair of eyes on each side of the exterior, was probably a creation of the vase painter Exekias, and it became fashionable in Attic black-figure ware around 530 BC. The eye-cup also seems to have been Oltos's favorite shape, one that he used with robust vitality in both modes of decoration.

Further Reading
Boardman, John. *Athenian Red Figure Vases: The Archaic Period. A Handbook.* New York: Oxford University Press, 1975.

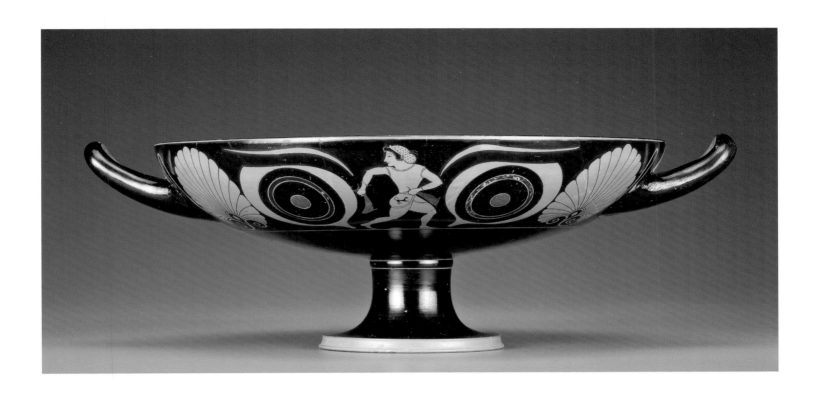

The Rycroft Painter
Greek, Attic

Black-Figure Hydria
ca. 520–510 BC
Clay, glaze, added red and white
H. 20 ¹/₄ in. (51.4 cm)
Gift of Thomas T. Solley, 77.33

The *hydria* (from the Greek word *hydor,* meaning water) is a vessel with three handles. The two horizontal handles—tilted upward on this example—were for lifting, and the vertical handle at the back (seen here rising above the rim) was for pouring. After filling their water jars at the fountain, women carried them on their heads, a tradition still alive in Greece and in the Balkans.

The anonymous artist who decorated this monumental *hydria* is called the Rycroft Painter, after a previous owner of a black-figure amphora by the same hand, now in the Ashmolean Museum, Oxford. Active in Athens when the red-figure technique was just coming into fashion in vase-painters' circles, the Rycroft Painter exemplifies the last high accomplishments of the black-figure tradition. This vase has been known since 1844, but it was attributed to the Rycroft Painter only after its acquisition by the museum in 1977.[1] It is the second vase by this painter in our collection.

The painter framed his compositions within panels on the vase's shoulder and front. Bordering the panels are carefully executed patterns of knotted fishnet, vine, and lotus-bud chains. Standing out prominently against the pitch-black surface of the vase, the panels are reserved in the color of the clay, a rare occurrence on a black-figure *hydria*. This detail reflects the influence of the novel red-figure technique. Another unusual touch is the painter's association, on the vase's angled shoulder, of a Dionysian subject with a decorative pair of eyes—the latter more at home on drinking cups, where such apotropaic eyes typically are flanked by palmettes, as on our Oltos cup (see p. 84).

The main subject is Herakles (Hercules), the mortal whose struggles—some of them atoning for the hero's violent nature—gained him immortality and made him a cult hero in the Greek world and beyond. He was especially popular in sixth-century BC Attica—so popular that, by the middle of the century, Athenian artists invented stories, like the one pictured here, that were not part of the traditional cycle of Herakles's Twelve Labors or the numerous other exploits recounted in extant literary sources.

Shown here in his guise as monster-slayer, Herakles wrestles with the fishtailed monster Triton, a non-canonical episode that could be seen as an elaboration on his fight, in the course of his eleventh Labor, with the sea-god Nereus, with whom he wrestled to find the way to the golden apples of the Hesperides. The Herakles-Triton fighting scene appears exclusively in Athenian art of the second half of the sixth century BC. The Athenians' sudden interest in the subject, it has been conjectured, could have been in response to a sea

victory, such as the seizure of the island of Salamis from the seaport of Megara or another Athenian success in the Aegean.

An internal stylistic reason might be also sought. Unlike Nereus, the protean sea-god who had the power to change his shape into various beasts and was a visually elusive figure, the lesser sea-god Triton fulfilled the artist's desire for a visual scheme in which two fighters could be shown intertwined in a compact, vigorous, and deadly embrace. The subject also allowed artists to explore a variety of wrestling poses and stances. (Much of what we know today about ancient wrestling positions is derived from painted vases.) Wrestling was a favorite sport, practiced by Athenian youth in the gymnasium's palaestra. The sport allowed all kinds of holds, with the ultimate aim of making the opponent touch the ground three times with his shoulders. The Triton episode was not Herakles's only wrestling match. As he rid the world of monsters, at those times when his weapons failed, he would wrestle, whether with the lion of Nemea, the Hydra of Lerna, or Antheus, the Libyan giant.

The Rycroft Painter articulated the clashing figures with consummate draftsmanship and selective use of color. He identifies Herakles by his quiver and his lion-head helmet and lion-hide cloak, which are lovingly detailed and elaborated with added red color. Red also enlivens the beards of the protagonists. Their struggle is conveyed by their emphatic gestures: the hero has straddled Triton's upper body from behind, firmly locking his right arm around the god's neck, and, with a mighty upward pull, he has immobilized the god's left arm with his other hand. To strengthen his hold, Herakles is forcefully pushing his left foot into the panel frame. The sea-god struggles to free himself from the powerful grip: he raises his right arm in dismay and has managed to bend his left arm from its helplessly upright position and grab his opponent's forearm. In the exertion, his elbow, like Herakles's foot, projects into the panel frame. Triton's laurel-wreathed head and his enormous serpent-body are contorted in pain. The white midriff muscle that curves and coils up to the dolphin-like tail—together with the scales, rendered by fine incision—emphasizes the twist of Triton's body, creating a masterful three-quarter view.

Note
1. J. R. Mertens, "A Black-Figure Hydria of Red-Figure Date," *Indiana University Art Museum Bulletin* 2/1 (1979): 6–15 (with a detailed description of the collecting history of the vase and an extensive bibliography).

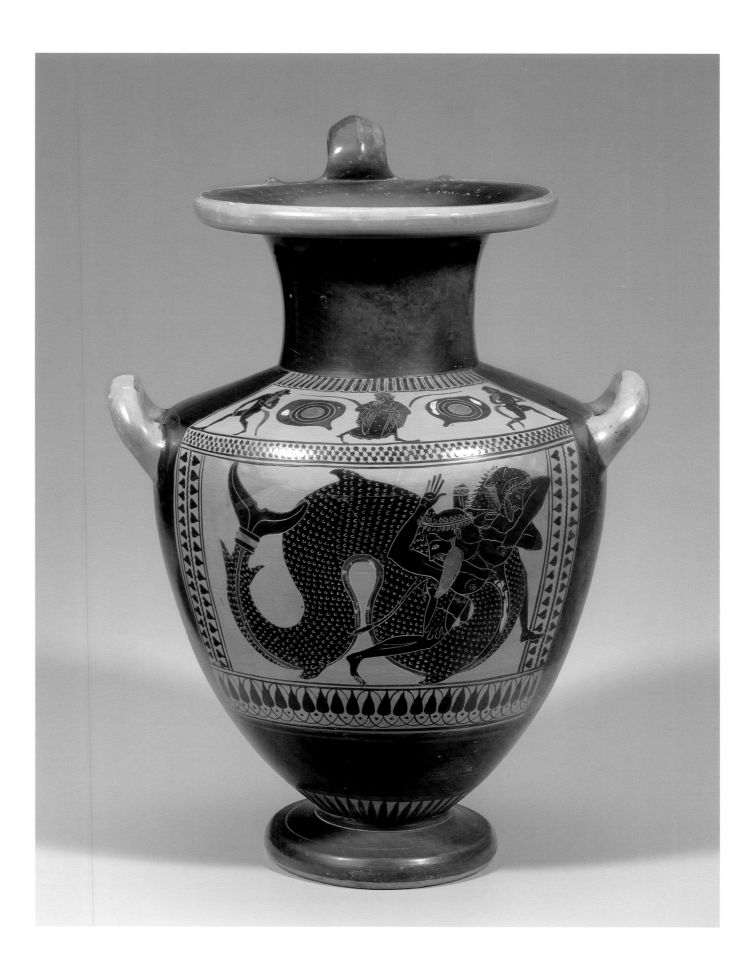

Etruscan (Italy)

Dancer
Early 5th century BC
Bronze, solid cast
H. 6 1/8 in. (15.5 cm)
Gift of Thomas T. Solley, 75.36.1

This vigorous masterpiece of small-scale sculpture conveys a sense of spontaneous movement in space. The statuette has no "front" view; its dynamic rhythm and flowing contours are best experienced when seen all around. The young dancer performs confidently on the small, circular top of a narrow tripod with curved legs. The artist seems to have delighted in rendering the sensual, swelling fullness of the dancer's body as—right foot firmly on the ground and left knee raised—he turns his head, following his extended left arm with a vivacious gaze. The lack of anatomical detail and the cursory execution of the dancer's body, from his broad chest and shoulders to his narrow waist, slender hips, and powerful thighs and calves, contribute to the impression of fluidity. This agile dancer was likely created to adorn a *thymiaterion,* or incense burner, a luxury utensil used at feasts and rituals. In his right hand (now broken) the dancer would have balanced a bowl for the burning of incense.

The nude dancing youth was originally a Greek motif, found painted on vases that the Etruscans eagerly imported. It is modified here by the Etruscan artist's interest in complex movement; the fluidity of the silhouette—the flowing lines—is what mattered to the artist, even if it meant distorting, elongating, and curving the limbs in unnatural ways. The figure appears similar to the dancing entertainers depicted in contemporaneous tomb paintings, such as those from the Tomb of the Lionesses at Tarquinia, in southern Etruria. The meaning of dancing figures on tomb walls, probably engaged in funerary rituals, often has been thought to denote an almost joyful sense of death—also conveyed by the smiling faces in Etruscan tomb art, such as the smiling married couple that reclines on the terracotta sarcophagus from Cerveteri, now in the Villa Giulia Museum. Whether an expression of emotion or a convention meant to enliven the representation of facial features, a lively smile also curves at the corners of our dancer's lips.

Our statuette was probably cast in a workshop at Vulci, the southern Etruscan town recognized for its outstanding manufacture, in the sixth and early fifth centuries, of luxury implements decorated with exquisite small sculptures: incense burners, tripods used as offering stands, and candelabra. Such furnishings were common household items, also used for feasts and rituals, as well as equipment for the tomb. The Etruscans furnished their tombs as elaborate dwellings for the eternity of the Beyond.

Further Reading
Brendel, Otto J. *Etruscan Art.* Pelican History of Art. New York: Penguin Books, 1978.
Haynes, S. *Etruscan Bronze Utensils.* London: British Museum, 1974.

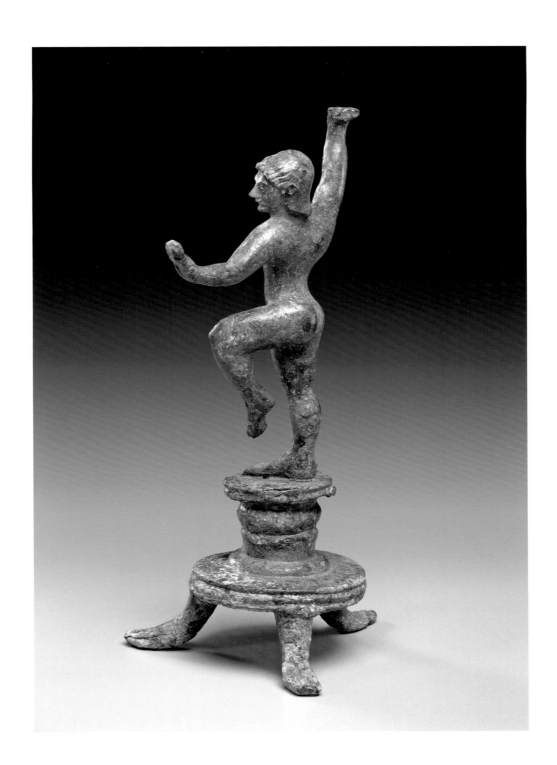

Greek, Boeotian

At the Barbershop
ca. 460 BC
Terracotta, paint
H. 5 ½ in. (14 cm)
79.82

This endearing barbershop scene is as charming now as it must have been more than twenty-four centuries ago.[1] Its protagonists are portly men, well past middle age. The customer, wrapped in a gown fastened at the shoulders to catch fallen strands, is slouched on a low stool and tilts his head to better allow the barber to accomplish his task. The day must be hot, for the barber is shirtless, and his potbelly protrudes above his ample apron. He is hard at work; the client's moustache and spade-shaped beard (one surmises) will be attended to next. This miniature sculptural masterpiece is a testament to the Greeks' delight in familiar subjects and their enjoyment of naturalistic detail in the representation of everyday life.

This work has been assigned to a Boeotian workshop. Boeotia was the home of Tanagra and Thebes, towns with centuries-old traditions of terracotta production, mostly votive figurines with religious, cultic, or funerary functions. Toward the end of the sixth century BC, a refreshing change occurred: the introduction of works with secular subjects, representing ordinary people engaged in daily activities. Cooks, bakers, carpenters, scribes, and musicians, for example, appear alone or in pairs, and sometimes in multiples. Such terracottas have been found mostly in tombs, but their specific function is not known. Perhaps the subjects represented their owners' occupations, and the placement of the figurines in tombs reveals a wish to take these familiar works along in the passage to the afterlife.

Several features make this barber group exceptional among Boeotian terracottas with everyday scenes. The matte colors, painted in tempera after baking, are excellently preserved. Black detailing enlivens the eyes and eyebrows and pink renders the flesh tones. Decorative touches embellish garments and furniture: the black belt or rope that holds the barber's apron; the stripe that runs along the front edge and down the sides of the customer's overalls, imitating a woven or sewn border; and the colorful stool, patterned in red and black.

Only two other barber groups are known, both of slightly earlier date. These early groups employ, in traditional sixth-century BC manner, mixed techniques: bodies were modeled freehand while heads were pressed in molds; the impression of incongruity between the carefully rendered facial features and the cursory, lumpy bodies is unavoidable. By contrast, this fifth-century example in the IU Art Museum's collection owes its exquisite sculptural quality to the coroplast's skillful use of the molding technique. Both the heads and the bodies, mold-pressed, have crisp contours, minimally enhanced with a finishing tool.

This small sculpture confirms existing information about the barber's profession in the ancient Mediterranean world. Scissors do not seem to have been used in antiquity, and the professional barber's haircutting tool was a set of very sharp "twin blades," which, unlike shears, were not pivoted. This instrument, which required great skill to use, often consisted of a flat metal piece doubled-up at the middle to form a rounded "handle" that would be cradled in the palm of the hand, freeing the thumb to move the top blade, and the fingers, the lower blade.

Barbers operated their business in the agora (marketplace), or in any crowded commercial quarter. Men, out for a stroll or on their way to daily business, stopped at the barber for a trim and a chat. In a way, the barber's shop was the public counterpart to the symposium, or the private male drinking party. Conversation ranged from trivial to serious subjects, from gossip to politics. The barbershop was the place to socialize and learn the latest news. Plutarch recounts the following anecdote about the manner in which the Athenians learned about their Sicilian expedition's disastrous defeat in 413 BC:[2]

> The Athenians, they say, put no faith in the first tidings of the calamity, most of all because of the messenger who brought them. A certain stranger, as it would seem, landed at the Piraeus, took a seat in a barber's shop, and began to discourse of what had happened as if the Athenians already knew about it. The barber, on hearing this, before others learned of it, ran at the top of his speed to the upper city, accosted the archons, and at once set the story going in the marketplace. Confusion and consternation reigned, naturally….

Unfortunately for the poor barber,

> it was decided that he was a story-maker, and was trying to throw the city into an uproar. He was therefore fastened to the wheel and racked a long time, until the messengers came with the actual facts of the whole disaster.

Plutarch's suggestion that the Athenians' disbelief at the news was caused by "the messenger who brought them" is telling of the low esteem in which barbers were held, due to their reputation for prattle and gossip.

Further Reading
Garland, Robert. *Daily Life of the Ancient Greeks.* Westport, Conn.: Greenwood Press, 1998.

Notes
1. First published in L. Pollak and A. Munoz, *Pièces de choix de la collection du Comte Gregoire Stroganoff à Rome* (Rome: [Impr. de l'Unione editrice], 1912), pl. 44:20. Acquired by Ernest Brummer (Volpi Sale, American Art, 31 March 1927).
2. Plutarch, *Lives,* trans. Bernadotte Perrin, Loeb Classical Library (Cambridge: Harvard University Press, 1996), vol. 3, Nicias 30.

The Painter of the Berlin Hydria
Greek, Attic

Red-Figure Volute-Handled Krater
ca. 450 BC
Clay, glaze, added red
H. 21 1/2 in. (54.6 cm)
Gift of Thomas T. Solley, 85.35

This handsome krater is a rare piece by a painter from whom few works have survived.[1] Both sides of the vase carry scenes related to war. The back depicts the moment of ritual libation, officiated by women before the warrior's departure to battle. The front (illustrated here) focuses on the climactic moment of combat. A Greek hoplite (foot soldier), at the center, plunges his long spear into the chest of an Amazon, a mythic female warrior from Eastern lands. The Amazon has launched her double-ended spear but missed. Her attendant flees, glancing back in fear. The scene is a self-quote, an excerpt from the painter's own multi-figure battle with Amazons *(Amazonomachy)* on a large calyx krater now in the collection of the Metropolitan Museum of Art, New York. The vase in the Metropolitan Museum's collection features an Amazon on horseback at its center; in the background, a Greek warrior fights another Amazon, both in poses identical to those of the protagonists on our vase. It has been suggested that the warrior on the New York krater may represent Theseus, the king of Athens, in a scene that refers to the legendary battle of the Athenians against the Amazons.

Amazon soldiers were said to have attacked Athens sometime before the Trojan War. When they arrived at the foot of the Acropolis, the fight turned into a battle for Athens. Theseus, leading the Athenians, repelled the female warriors, a heroic deed that conferred on him the status of the Attic hero par excellence. When admiring the krater's scene of a Greek warrior defeating the Amazon, the mid-fifth-century BC Athenian would have been reminded of Greek valor and the victories against the Persians at Salamis (480 BC) and Plataea (479 BC). It is no wonder that between 475 and 450 BC Theseus's *Amazonomachy* became an important subject in Athenian public art, probably inspiring vase painters as well.

Our vase is a typical product of its age and is instructive of Greek contemporary life. The painter rendered the details of the hoplite's armor accurately. Over his linen chiton, the soldier wears a leather corselet sewn with bronze scales and fastened over the chest with large shoulder straps. His Attic helmet, with hinged cheekpiece, is adorned with a high horsehair crest. Volutes decorate the side of the helmet, behind the ears. The warrior holds a round shield, and we see a fine three-quarter view of its back. A leather apron is attached to the shield to protect the bearer's thighs from arrows; on his shins he wears greaves. His sword is sheathed in the scabbard at his back, suspended from the baldric slung over his right shoulder.

The clothing of the Amazons and the weapons they bear combine features of Greek and Eastern gear. The wounded Amazon wears Persian patterned tights and a *kandys* (sleeved shirt), but over her Persian garment she is clad with a Greek *chitoniskos* (short tunic). Her shield emblem is a bearded snake, and on her apron, as on the hoplite's, is an apotropaic human eye, meant to protect from the evil gaze. She is heavily armed; besides the spear, she carries the Amazons' distinctive weapons: a battle-ax and a bow (only its end is visible at her hip, protruding from the unseen bow case attached to the back of her bandolier). The companion Amazon is dressed in a Greek chiton with a chlamys clasped over the right shoulder and wears the *kidareis,* a Phrygian peaked cap with long flaps. Her *pelta,* the typical crescent shield of the Amazons, made of animal skins stretched over a wicker frame, appears here disproportionately large, in symmetrical balance with the hoplite's shield.

The refined draftsmanship that describes all of the figures is remarkable. The combatants' three-quarter and turning poses, as well as their foreshortened limbs, demonstrate the painter's command of the red-figure technique. The Painter of the Berlin Hydria was a gifted member of a group of early Classical painters of large vases, whose foremost personality was the Niobid Painter. The important innovation of the painters in the Niobid group lies in the freedom with which they used space and in their dramatically composed epic scenes.

Further Reading
Von Bothmer, D. *Amazons in Greek Art.* Oxford: Clarendon Press, 1957.

Note
1. John Beazley named him the Painter of the Berlin Hydria after a *hydria-kalpis* in the Berlin Museum and attributed about a dozen vases to him in his *Attic Red-figure Vase-Painters*, second ed. (Oxford: Clarendon Press, 1963), 614–17. The list of attributions has grown to twenty known vases by this painter in Mathias Prange, *Der Niobidenmaler und seine Werkstatt* (Frankfurt am Main: P. Lang, 1989), 24–25 and 225–28. The Bloomington vase, no. GN 88 on p. 225, was attributed by Dietrich von Bothmer and Robert Guy, former curator at Princeton University Art Museum; Guy's successor, Michael Padgett, has also kindly provided pertinent information.

Greek, Attic

Gravestone of the Boy Apolexis
Late 5th–early 4th century BC
Pentelic marble
H. (as preserved) 18 in. (45.8 cm); W. 14 1/8 in. (35.9 cm); Th. 3 1/4 in. (8.3 cm)
V. G. Simkhovitch Collection, 63.105.33

A nude boy stands in profile with head inclined, facing right. His figure is carved in sunken relief, a technique that makes him seem to be contained in a three-dimensional space, as if he were placed within the doorway of a shrine. The architectural structure consists of Doric pilasters with projecting corners *(antae)*, crowned by a full pediment with roof ornaments *(acroteria)*. The boy's name, Apolexis (ΑΠΟΛΗΞΙΣ), is inscribed on the architrave above his head. We can tell that he is probably not older than three to four years from his chubby chin and plump body, soft with baby fat, as well as his hairdo of chin-length, wavy locks that radiate from a central braid running from the forehead to the back of his head. We do not know how the boy died, but the mortality rate for children was extremely high in the ancient world.

This memorial, commissioned by a private family, enriches our knowledge of Greek life through its very poignant evocation of the joys and carefree time of childhood. The boy is clutching his cherished toys. His gaze is bright: seen in profile, his large, expressive eye is directed at the plaything he clasps in his left hand. This object could be a small bird—whose head, now lost, would have been contained in the area filled by restoration—or a pouch carrying gaming pieces. The bird recurs as a common motif on gravestone slabs (stelae) for children. Besides being a beloved pet, the bird may have represented the soul of the departed; birds appear in flight within tomb scenes painted on funerary oil bottles *(lekythoi)* that were placed as offerings in Athenian graves.

The elongated object that the child holds in his lowered right hand—difficult to identify due to the fragmentary preservation of the gravestone—could be the muzzle of a dog jumping up to the child or the handle of a wheeled toy cart; both are common attributes of boys at play depicted on the small wine pitchers *(choes)* given as gifts to three-year-old children to mark their first coming of age, celebrated on the second day of the Athenian spring festival of Dionysus.

Dating of funerary stelae with any degree of specificity is difficult due to their conservative style and iconography. Proposed dates for the Apolexis stele vary from the late fifth through the middle of the fourth century BC. Several features favor dating the Apolexis stele early in the Classical series of tombstones of children. Apolexis's profile stance, for instance, is an early feature—three-quarter and frontal views of figures are developments that follow in the first half of the century—and so are the techniques of low relief sculpting within a recessed panel, as well as using the marble slab itself as the triangular ground on which to carve the pediment.

Carved marble stelae were erected by prosperous Athenian families. Unlike the Spartans, who did not make luxury grave monuments and did not record the names of the deceased (except in the cases of those slain in battle and of women who died in childbirth), the Athenians had a long tradition, dating from approximately 600 BC, of commemorating private individuals with figural monuments ranging from freestanding sculptures of young men (kouroi) and young women (korai) to carved stelae. Anti-luxury laws passed in Athens account for the decrease in grave monuments during the periods when such laws were in effect. Production of funerary stelae was scarce between 500 and about 430 BC, and picked up sometime after that date, continuing in abundance for about a century until 317/318 BC, when Demetrius of Phaleron passed his decree against erecting family tombstones.

The production of carved memorials may have resumed after 430 BC as an extension of the busy stone yard of the Parthenon (built between 447 and 432 BC). When the gigantic building enterprise of the temple of Athena Parthenos on the Acropolis wound down, masons as well as sculptors employed in its decoration were freed to take on private commissions. The lasting impact of the high Classical style of the Parthenon—with the pensive, rather solemn figures of its Panathenaic frieze (sculpted between 444 and 438 BC), and the mood of piety they exude—is discernible in the sensitive carving of this stele; indeed, the quietly posed small boys in the Panathenaic procession may have provided models for the rendering of the child.

Further Reading
Boardman, John. *Greek Sculpture. The Classical Period. A Handbook.* New York: Thames and Hudson, 1985.
Neils, Jennifer, and John H. Oakley. *Coming of Age in Ancient Greece: Images of Childhood from the Classical Past.* New Haven: Yale University Press, 2003.

Attributed to near the Hippolyte Painter
Colonial Greek (South Italian), Apulia

Situla with the Punishment of Actaeon
350–340 BC
Clay, glaze, added white, yellow, and red
H. to rim: 13 in. (33 cm)
70.97.1

The ceramic *situla,* a bucket shape unknown in mainland Greece, was probably a South Italian creation inspired by a metal prototype. The two upright, palmette-shaped decorative appendages jutting above the vase's rim are vestiges of a metal bucket's double handles. The vase's complex decoration, with elaborate palmette ornaments painted under the handles; its liberal use of color; and its multi-character scenes are qualities representative of the ornate style that flourished in Apulia by the mid-fourth century BC.

In this South Italian region, which extends along the coast of the Adriatic and Ionian seas, the Greeks had established colonies as early as the second half of the eighth century BC. Pottery imports from mainland Greece were held in high esteem, but by 420 BC a local school of red-figure pottery had developed at Taranto, the main city of Apulia. In the wake of the Athenian defeat in the Peloponnesian war in 404 BC, Athens lost its export markets, and South Italian pottery flourished. Apulian vase painters favored grand, multitiered compositions and mythological subjects often associated with theatrical performances.

Its fine quality of painting makes this vase one of the best among South Italian vases, and its unusual representation of the Actaeon myth makes it one of the richest in meaning. Several versions of Actaeon's story circulated in antiquity; most were morality tales repeated as warnings that human transgressions against the gods would not go unpunished. The hunter Actaeon died a violent death owing to the wrath of enraged Artemis, goddess of the hunt. She transformed him into a stag and set upon him his own hounds, who viciously tore him apart.

The artist who painted this vase did not indicate the cause of Artemis's ferocious vindictiveness. The instigator could have been Zeus, so incensed by Actaeon's desire for his aunt Semele that he incited Artemis to punish the youth, as in Hesiod's account.[1] Or, the antagonist could have been Actaeon himself, who provoked Artemis's anger by recklessly boasting of greater prowess at hunting than the goddess of the hunt herself, as alluded to by Euripides.[2] Most artists favored the dramatic moment in which Actaeon, metamorphosed into a stag, becomes the prey of his own hounds. The painter of this vase—and here lies the originality of this piece—instead chose to capture the elusive moment that preceded the hero's violent death. We witness the beginning of Actaeon's transformation, as the goddess, shown standing cross-legged on the right, pronounces her curse with a chilling gesture of her raised arm: antlers spring from her victim's head, one of his hounds jumps up, and the other—halted in mid-stride, one paw half-raised—looks up at him, sniffing the air. The alarmed gesture of the old woman on the left presages the violence to come.

A number of clues relate this scene to Actaeon's boast about his hunting skill. Both Actaeon and Artemis carry their hunting gear; Artemis is equipped with high-laced hunting boots, and a dappled fawn skin is draped over her shoulder; Actaeon wears a baldric with scabbard and sword. Artemis clearly has the upper hand; Actaeon's passive, seated posture contrasts sharply with the proud stance of Artemis. Actaeon's nakedness emphasizes his helplessness before the fully clothed goddess, richly adorned with jewels and a crown of rays and radiant in her elegantly embroidered chiton. The rustic setting represents the wilderness of Mount Cithareon, and the rock on which Actaeon sits is the famous rock that Pausanias, who saw it on the road to Plataea, called "Actaeon's bed," recounting that Actaeon "slept thereon when weary with hunting."[3] Here, the painter simply implies its existence under the hunter's outspread mantle, which is suspended next to him.

The painter presents the drama as a scene in a play. The characters are identified by their attributes, such as Actaeon's antlers, and they evoke postures codified on stage. In creating this tableau vivant, the painter grouped the protagonists in the lower register of the vase, and the audience of deities in the upper register. Apollo, Artemis's twin brother and protector, is identified by his swan and laurel branch. Pan, the god of woodlands and flocks, is shown both in his human aspect and as the goat-legged and horned Aegipan and holds his shepherd's reed pipes (syrinx) and staff. The old woman who gestures entreaty or distress in the lower register could be Autonoe, Actaeon's mother, or perhaps his nurse, a character absent from the myth but frequently included in stage performances.

Further Reading
Mayo, M. E., ed. *The Art of South Italy. Vases from Magna Graecia.* Richmond: Virginia Museum of Fine Arts, 1982.
Powell, Barry B. *Classical Myth.* 2nd ed. Upper Saddle River, N. J.: Prentice Hall, 1998.
Trendall, A. D. *Red Figure Vases of South Italy and Sicily.* London: Thames and Hudson, 1989.

Notes
1. M. L. West, *The Hesiodic Catalogue of Women* (Oxford: Clarendon Press, 1985), 87–88, fr. 217A.
2. Pausanias, *Bacchae,* trans. W. Arrowsmith, in David Greene and Richard Lattimore, *The Complete Greek Tragedies,* vol. 4 (Chicago: University of Chicago Press, 1992), 337–40.
3. Pausanias, *Description of Greece,* trans. W. H. Jones, Loeb Classical Library (Cambridge: Harvard University Library, 1935), bk. 9, 2.3.

Reported to be from Homs (ancient Emesa), Syria

Glazed Amphora
Late Parthian or early Sassanian, 2nd century BC–3rd century AD
Blue-green glazed clay
H. 12 3/16 in. (32 cm)
Gift of Mrs. Nicholas H. Noyes, 71.102

This rare amphora, the brilliant glaze of which has been perfectly preserved, is the finest of its kind. Few examples of this type of ceramic have survived, and, consequently, very little is known about them. Our vase can be situated within the complex Syrian culture that had absorbed Persian, Greek, Roman, and Egyptian influences. The Parthians' western advance out of Iran to Mesopotamia; their control, as early as 113 BC, of the Greek cities of Seleucia and Dura Europos (in eastern Syria); and their successive invasions of Syrian lands spread the Persian artistic influence. This Eastern influence was strengthened by the Parthians' Sassanian successors, who conquered Syria in AD 226. On the other hand, the Roman annexation of western Syria in 65/64 BC ensured the continuity of classical traditions in this already Hellenized region, which had been part of the Hellenistic Greek kingdom of the Seleucids. Of these influences, none dominates, as this amphora, an excellent example of the syncretism of Near Eastern and Classical traditions, demonstrates.

Indeed, in terms of its shape, the vase recalls the Persian amphorae with animal handles depicted on Achaemenian palace walls. Sumptuous counterparts of these carved amphorae have survived in precious metal, and our vase shares with them such traits as the ribbed body, the ridged collar, and the long, cylindrical neck. Some basic features, such as the ring foot, however, relate the vase to the Greek amphora, whose shape evolved in Hellenistic and Roman times to a more elongated form both in ceramic and metal vessels.

The specific form of our vase—featuring an elongated, yet angular, outline of body and handles—first appeared during Parthian times, along with the thick, blue-green glaze, which gives the vase its lustrous shine. The alkaline glaze, which includes ground quartz, soda alkali, and lime, with a copper-based pigment for coloring, probably originated in ancient Egypt. On this vase, the glaze was applied before firing, in two layers; the second layer, probably painted with a thicker brush, is much richer and drippier. The non-figural ornaments on the vase's body are innovations of the later Parthian period. Here they are particularly elaborate, from the tongue pattern and incised zigzag design above the collar to the deep, vertical incised lines on the body, which transform into a fan-shaped pattern under the handles, to the flattened relief knobs on and around the handles, to the unusual pattern of ovals finger-pinched onto the strip of clay that is applied around the upper body.

The most important element of the decoration, however, is the molded relief emblem on the vase's neck. In both technique and style, this detail relates to Hellenistic and Roman pottery. One is reminded of Hellenistic jugs *(oinochoai)* from Egypt, the bodies of which bear relief figures of Ptolemaic queens, or of luxurious Roman lead-glazed cups with molded figural scenes, which were produced all around the eastern Mediterranean during the first centuries BC and AD.

Singular, however, is the subject of the emblem. Several interpretations have been proposed. The emblem features a bearded male figure with curly hair and a high crown, wearing a tunic under a cloak fastened at the chest by a round brooch. He stands in the relaxed pose usually associated with libations. Indeed, he appears to be pouring a libation onto the ground from a shallow bowl in his right hand, while holding up a tall, curved horn, filled with a bunch of fruit, with his left hand. The figure could be Serapis, with his *modius* crown in the shape of grain basket; the shallow dish *(patera),* and the horn of plenty (cornucopia) would enhance the symbolism of abundance associated with the *modius.*[1]

Serapis, originally the Egyptian god Osiris-Apis (hence his name), was hellenized by the Ptolemies, the successors of Alexander the Great in Egypt, and represented in the guise of a bearded Greek god, associated with Zeus, Hades, and Asclepius. This deity, with roots in two cultures, continued to be popular in Roman times. The Roman emperor Septimius Severus (see p. 106) chose to portray himself as a follower of the god, emphasizing his birthplace in Africa and his promise of political rebirth for the empire by bringing the eastern and western realms together. Another interpretation identifies the emblem figure as the Sassanian king Shapur I (who wrested Syria from Roman domination in AD 256–58), wearing his globe-like crown and dressed in his cloak held by a large brooch on the chest.[2] Ironically, the thick glaze, which constitutes the visual delight of this vase, makes it difficult to discern the details of decoration with any accuracy.

Further Reading
Colledge, Malcolm A. R. *Parthian Art.* Ithaca, N.Y.: Cornell University Press, 1977.
Ghirshman, Roman. *Persian Art: the Parthian and Sassanian Dynasties, 249 B.C.–A.D. 651.* New York: Golden Press, 1962.

Notes
1. Richard Ettinghausen, "A Parthian and Sāsānian Pottery," chapter 31 in *A Survey of Persian Art from Prehistoric Times to the Present,* ed. Arthur Upham Pope (London: Oxford University Press, 1938), vol. 2, 656–58, pl. 182b; and vol. 6.
2. Arthur Upham Pope, *Masterpieces of Persian Art* (New York: Dryden Press, 1945), 53, pl. 34.

ASIA

The Asian collection at the Indiana University Art Museum covers a period of time from the second millennium BC to the present, and a geographic area from the Arabian Peninsula to Japan and from the central Asian countries of Afghanistan and Pakistan to the Southeast Asian nations of Thailand, Cambodia, and Vietnam. The vast continent of Asia includes the Indian subcontinent, the Euphrates basin, and the steppes of Russia and is home to a diverse array of peoples, languages, cultures, religions, customs, and histories. Asian peoples have been city builders, herdsmen, traders, marauders, seafarers, and mountain and desert dwellers. Some people practice monotheism, others worship a multitude of gods and goddesses, and still others have no deity at the center of their beliefs. Each culture creates objects that reflect its own blend of iconographical traditions, preferences, and styles.

Despite the enormous diversity that defines Asia, at particular moments in its history shared religions or cultures seem to have smoothed out differences. Religions such as Buddhism, Hinduism, and Islam brought a degree of hegemony to the artistic production of the countries that embraced them. Buddhism spread from India along two major trade routes: overland, through central Asia to China, Korea, and Japan, and following the river systems of Southeast Asia; and by sea, through the Indian Ocean and around the Malay Peninsula to Vietnam. Hinduism primarily followed southern routes, while in the seventh century, Islam swept through central Asia and into western China and traveled by sea to Indonesia.

Sometimes a culture could significantly influence others without sending even one soldier or capturing a single city. This seems to have been the case in Southeast Asia, where the cross-fertilization of Indian and indigenous cultures gave rise to such great architectural monuments as Angkor Wat. Similarly, at the height of its power during the Tang dynasty (618–906), China controlled a vast kingdom extending from Tibet to Korea—but its sphere of cultural influence was even greater and more enduring. Korea and Japan so thoroughly synthesized Chinese intellectual and religious traditions that sometimes it is difficult to determine the country of origin of a painting or sculpture once it has been removed from its original setting. Before developing scripts of their own, Koreans and Japanese used Chinese for their written communications, and the tradition of painting with a Chinese brush on paper or silk and using a carved seal to sign a painting survives even today.

Many of the issues that an historian of Asian art confronts are the same as for any other field of art, such as identifying the subject of the work, determining when or where a work may have been made, or confirming the identity of the artist. Some issues, perhaps not unique to Asian art, present particular challenges. In the West, a high value is placed on the originality and singularity of a work of art, making a one-of-a-kind painting or sculpture more valuable than a print, and the work of a known master more important than a wonderful work of art by an unknown craftsman. In Asia, while some artists have garnered special reputations, most are anonymous artisans. Religious art is usually unsigned, although sometimes a body of work can be attributed to a guild or group of artisans.

Tradition is often considered more important than originality, since it is tradition that gives a work religious or cultural meaning; and copying is a valued method by which to learn a skill or to preserve an artwork. Artists, particularly painters, do sign their works, but they may use many different names over the course of their careers. Each name change may signify a shift in the artist's style, status, or circumstances. Often, the key to identifying a particular artist is recognizing the combinations of signatures and seals on a painting. An artist might use several seals at the same time, or, like signatures, change them over time. Collectors, too, will affix their seals to a painting, giving researchers a valuable tool by which to trace a painting's history.

Finally, historians of Asian art face issues concerning the destruction, disappearance, and dispersal of works of art and the state of research. Some areas of Asian art have suffered more destruction than others. Central Asia, because of its location along major trade routes, has had a turbulent history, and much of its artwork has been disturbed or destroyed. What remains is frequently fragmentary. It is difficult to reconstruct Buddhist stupas or other monuments with any degree of accuracy, since so little remains. In Southeast Asia, many cities have been swallowed up by the jungle and remain to be uncovered. Other areas in Asia are difficult to access, either due to politics or geography. And it is important to remember that the study of Asian art in the West is a relatively recent field of inquiry, and there are far fewer scholars engaged in this research than in Western art. New finds come to light every time an airport or road is built, and the work of cataloging, categorizing, researching, and preserving is ongoing.

Judith A. Stubbs
The Pamela Buell Curator of Asian Art

Central Asia, Gandhara

Emaciated Buddha
2nd–3rd century
Green-grey schist with traces of gilding
H. 9 7/8 in. (25.0 cm)
79.53

Carved out of green-grey schist, this sculpture of the emaciated Buddha represents a relatively rare subject in Buddhist imagery; only about twenty are known worldwide. Now damaged, the Buddha originally would have been shown sitting in meditation with his hands on his lap. Behind his head is a round nimbus, an ancient solar symbol denoting enlightenment.

As the story of the Buddha's life is told, signs accompanying his birth presaged that Prince Siddhartha was destined to be either a great ruler or a great holy man. Sheltered from knowledge of the world by his father, Siddhartha grew up, married, and had a son of his own, largely within the confines of his palaces. On Siddhartha's first trip into the world outside the palace, he saw an old man. On his second excursion, he saw a sick man; on the third trip, a corpse; and on the fourth, a mendicant ascetic. Overwhelmed by the suffering in the world and filled with desire to comprehend it, Siddhartha decided to leave his family and the comforts of a privileged life. He spent many years wandering and studying with various holy men. During the period in his life portrayed here, Siddhartha engaged in rigorous meditation and severe fasting. His skeletal thinness, hollow belly, and sunken eyes convey his extreme denial of his physical body as he pursued his spiritual quest.

Although we have no documentation of its sculptor or place of origin, there is no doubt that this sculpture—judging by its style, stone, and subject matter—was made in the Kushan kingdom of Gandhara. The boundaries of Gandhara encompassed modern-day Pakistan, Afghanistan, and northeastern India. The Kushans, once a nomadic people, reigned over a remarkably diverse area, stretching from the Himalayan Mountains to the headwaters of the Indus River system, from the Hellenized kingdom of Bactria to the Indian subcontinent. They controlled not only large sections of the central Asian trade routes that linked the Roman Empire to China (sometimes collectively called the Silk Road) but also the upper reaches of the Indus River, which gave them access to major sea routes. Goods, peoples, ideas, and religions all traveled these routes. It is not surprising that the art produced in this period demonstrates both regional differences and eclectic combinations of iconography and style.

The Kushan kings ruled from two cities, Peshawar in Pakistan and Mathura in India, both of which were home to diverse populations—including Persians, Bactrians, Greeks, Achaemenid Persians, Parthians, and Indians—and the Kushan kings were tolerant of the religious beliefs of others, especially Buddhism. Although Prince Siddharta, the historical Buddha, is believed to have lived in modern-day Nepal and never journeyed as far north as central Asia, Buddhism was once a significant religion in the region.

The period of Kushan rule in Gandhara was a formative time in the development of Buddhist imagery, including a major change from representing the Buddha symbolically to presenting him personified. While the reasons for this change are not fully understood, a number of developments in the practice of Buddhism certainly influenced this shift. Particularly important was the growing influence of Mahayana Buddhism. Mahayana Buddhism asserted that one did not have to renounce life in the world and live a cloistered existence to practice Buddhism. This no doubt led to the popularization of Buddhism and sped its dissemination within and beyond the Indian subcontinent. The broad geographical range under Kushan control also played a role in the transformation of representations of Buddha by bringing together Buddhist practitioners and other groups of people, who, influenced by Greek and Roman culture, depicted their gods in human form.

While a variety of distinct artistic styles are associated with specific sites in the Gandhara kingdom, the greatest difference, both in material and style, is between works produced in India and those produced in central Asia. The IU Art Museum's emaciated Buddha was carved from hard, green schist, a stone found in the north, which is different in texture and color from the soft, mottled red sandstone quarried near the northern Indian city of Mathura. The way in which the figure is rendered, however, conclusively identifies this sculpture as from the northern part of the Kushan kingdom. The sculptor's attention to the planes of the face and the underlying muscular and skeletal structure of the body, although exaggerated, reveals the work's debt to the Greco-Roman tradition. Though we may never know precisely where this sculpture was made, it reflects a synthesis of disparate traditions. While the subject matter—Siddhartha, the future Buddha, seeking enlightenment through strenuous meditation—is Indian, the attention to anatomical structure and the stylized, wavy hair of Greek and Roman athletes and gods is derived from the Western Classical tradition.

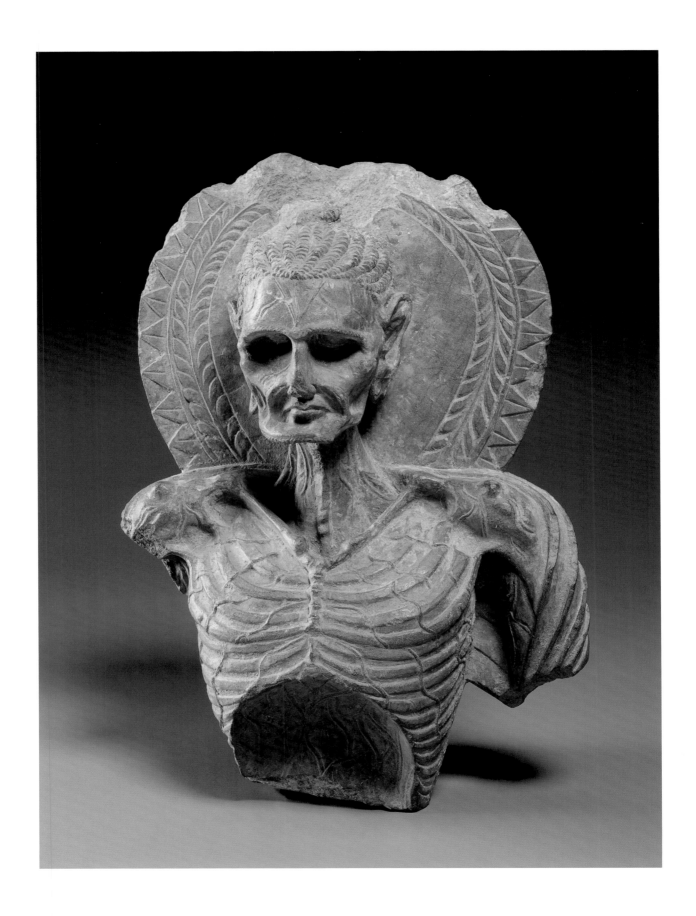

India, Uttar Pradesh

Yakshi
1st century BC
Sandstone
H. 16 ¼ in. (41.2 cm)
79.83

Yakshi (female) and *yaksha* (male) are ancient Indian deities endowed with powers of fertility and prosperity. In return for the devotion of their followers, these gods and goddesses provide material wealth and protection. Although their origins are obscure, they seem to have arisen in Indian worship and myth from a time before the Aryan invasion and the formation of the great Indian epics (ca. 1500 BC). Over time they were absorbed into the vast pantheon of deities in Indian religious traditions and relegated to the service of later gods and goddesses, both Hindu and Buddhist.[1]

This *yakshi* represents fertility and the boundless energy of nature. She is depicted as an ideal beauty with soft, voluptuous curves, full breasts and hips, and plump, pleasing limbs. The figure is adorned with sumptuous necklaces, earrings, and bracelets, and her hair is carefully arranged. She grasps the tree behind her with her right hand while her left arm and leg wrap around its trunk. If the sculpture had not been damaged, one of her heels would be lightly tapping the tree trunk. This is a representation of the classic pose of the *shalabhanjika,* or tree maiden, whose fecundity is so powerful that just the act of tapping the tree with her foot will cause it to burst into flower and fruit.

The carver of this image, one of many artisans who were involved in the construction of religious architecture, exerted his skill in achieving a perfect harmony between softly modeled forms and crisp details. This lovely *yakshi* may have been part of a larger program of sculpture at a Buddhist site of worship, or stupa. Figures like this one were carved on the railings surrounding the stupa or as part of the gateways—among the first images a pilgrim or traveler encountered. This sculpture, removed from the unknown site for which it was made, has lost its context. We know little of its history except that the stone, with its characteristic soft orange color and creamy white splotches, was quarried at Mathura in Uttar Pradesh. We can, however, recreate the figure's place within the typical decorative program of a stupa by looking at the railings of other shrines that survive, in whole or in part—such as Bharhut, dated to approximately the same time, or the Great Stupa of Sanchi, which dates somewhat later. Both of these sites have *shalabhajika* figures as well as other classes of *yaksha* and *yakshi* in addition to symbols of prosperity, such as wish-fulfilling vines, elephants, and lush plants borrowed from other religious and celebratory traditions. The message proclaimed in these sculptural programs is that rich gifts—spiritual gifts—are the rewards for those who believe in the Buddha and his teachings.

Note
1. For a detailed discussion of the origins of *yaksha* and *yakshi,* see Ananda K. Coomaraswamy, *Yaksas,* Part 1 (New Delhi: Munshiram Manoharlal, 1971).

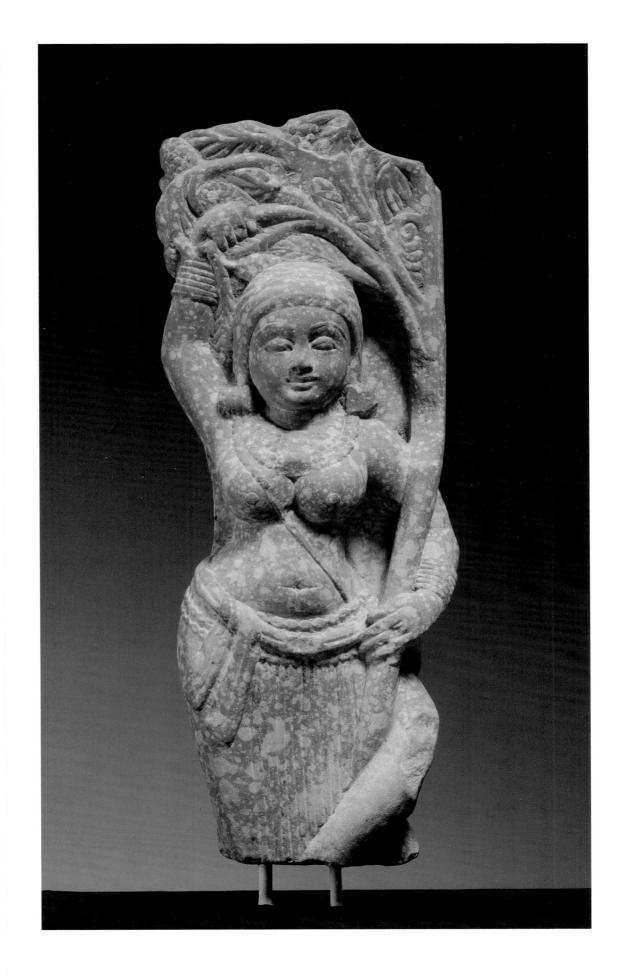

India, Tamil Nandu
Chola Dynasty, mid-9th–13th century

Ganesha
Late 12th–early 13th century
Bronze
16 x 9 1/2 in. (40.6 x 24.1 cm)
75.100

The IU Art Museum's cast bronze Ganesha, with its fine workmanship and exquisite detail, is certainly the product of an imperial Chola workshop. The Chola's concentration of power was in the south of the Indian subcontinent, centered in the city of Tanjore (Thanjavur) in the modern state of Tamil Nandu. The Chola monarchs were great patrons of the arts: some of the finest Indian sculptures ever made in stone and bronze date to their reign.

Chola artists achieved a perfect balance between giving images life and personality and preserving their iconic nature. In this sculpture of Ganesha, the artist used the subtle shift of weight to one foot and the delicate modeling of the chubby fingers to make the deity seem appealingly human. Sculptures such as this one were housed in temples devoted to Shiva but paraded through town on certain days. The upright structures on the left and right of Ganesha's platform would have supported a canopy, with poles slipped through the bronze rings to make the sculpture easy to carry.

While Ganesha seems to have been a late addition to the Hindu pantheon—not appearing in literature until the third century, absent from imagery until the fifth century, and achieving cult status only in the tenth century—elephant imagery is very old and pervasive in Indian culture.[1] Elephants, with their massive bodies and long life spans, embody strength and wisdom. They are also associated with rain and the life-giving waters of the monsoon. Images of elephants and other animals important in contemporary India (such as the Brahma bull) survive from the Indus Valley culture (2300–1750 BC) on small steatite seals. Elephants also figure in Buddhism, most notably in the story of the historical Buddha's remarkable birth. His mother, Queen Maya, dreamt that she was impregnated through her side by a white elephant, which signified her son's future greatness. Elephant-headed Ganesha certainly evolved from worship of the animal, but in Hindu mythology, he is the son of the great god Shiva and his wife Parvati.

In one version of the story, Parvati, lonely during one of Shiva's long absences, created a son and had him guard the door to her bath. When Shiva returned and found this strange young man blocking the door to his wife's chambers, he became enraged and cut off the boy's head. Parvati was furious and vowed to destroy the world unless Shiva corrected his mistake. Shiva sent his servants searching for a replacement head, and the first that they found was that of an elephant. Shiva placed the elephant head on the shoulders of the boy, adopted him, and gave him the name Ganesha, the Lord of Beginnings and Remover of Obstacles. Usually shown with four arms, Ganesha holds a hatchet and goad, symbols of cutting away illusion; a noose used to restrain passion; his own broken tusk; and a bowl of sweets.

Ganesha is, perhaps, the most loved and most widely worshipped of the thousands of Hindu deities. With his modified elephant head—his eyes are adjusted forward and framed by eyebrows, giving him a more human appearance—and his child-like body, Ganesha is both comical and appealing. His image appears in shop windows, at intersections, and in family shrines and temples.[2] He is the god of the sciences and writing. As befits his title, prayers to him are performed at the beginnings of new enterprises, journeys, weddings, and the start of each new day. On the fourth day of the month of Bhadrapada (August or September in the Indian calendar), public dancing, parades, and temple worship are held in celebration of this popular god.

Further Reading
Courtright, Paul B. *Ganesa: Lord of Obstacles, Lord of Beginnings.* New York and Oxford: Oxford University Press, 1986.
Narain, A. K. "Ganesa: A Protohistory of the Idea and the Icon." In *Ganesh,* ed. Robert L. Brown. Albany, N. Y.: State University of New York, 1991, 19–48.

Notes
1. A. K. Narain, "Ganesa: A Protohistory of the Idea and the Icon," in *Ganesh,* ed. Robert L. Brown (Albany, N. Y.: State University of New York, 1991), 19.
2. Paul B. Courtright, *Ganesa: Lord of Obstacles, Lord of Beginnings* (New York and Oxford: Oxford University Press, 1986), 4.

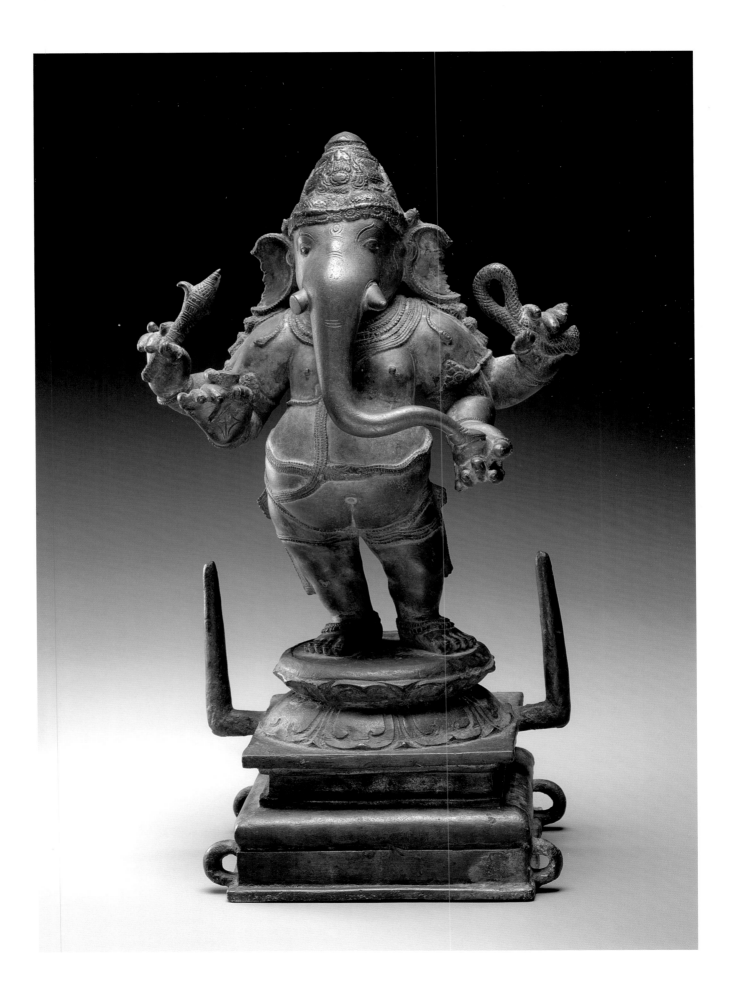

India, Deccan

Portrait of Aurangazeb as a Young Man
ca. 1650–55
Gouache on paper
3 $^{5}/_{16}$ x 2 in. (8.4 x 5 cm)
83.14

The Mughals ruled India from the time of Babur's conquest of Delhi in 1526 until the dynasty began to break apart after the death of Aurangazeb (1619–1707). Babur was a descendant of the Mongol Chingiz Khan on his mother's side and Timur the Turk on his father's side. His ancestry gave the dynasty its name: Mughal is a corruption of the word Mongol. The dynasty's familial relationship with Persia through Timur, who conquered the area that is now Iran, strongly influenced the arts of Mughal India. This painting reveals its debt to Persian court painting in its luminous colors and fine detail.

The subject of this exquisite painting is Prince Aurangazeb (1619–1707) as a young man. Aurangazeb is shown in the traditional pose of a Mughal ruler, wearing luxurious jewels and clothing, in an architectural setting painted with fine gold lines. The unknown artist beautifully rendered, with precise and tiny brushstrokes, the silky texture of Aurangazeb's beard and eyebrows, the gleaming surfaces of the pearls around his neck and on his turban, the gold-embroidered clothing, and sumptuous silk and gold prayer rug draped over the banister on which he leans. The smooth, lustrous surface of the miniature was achieved by burnishing, or rubbing, the painting from the back.

Although he followed the prescribed formula for painting members of the ruling elite, the artist nevertheless produced a lifelike portrait of the sitter. This miniature portrait was probably painted during one of the periods when Aurangazeb served as the viceroy of the Indian province of Deccan, the years 1636 to 1644 and 1653 to 1658. The painting might have been part of a collection of images bound in a book or given as a gift to a local ruler.

According to preeminent art historian Pratapaditya Pal, small paintings like these were inspired by Western miniature paintings introduced to India in 1615.[1] The soft green background, now slightly faded, was first made popular during the reign of Aurangazeb's grandfather, Jahangir (r. 1605–1627). Jahangir was a great connoisseur of the arts, especially painting. During his reign,

artists from all corners of India gathered in whatever city the court was located. His imperial painting workshops brought together all of the various artists and artisans required to produce a book or a miniature such as this one: calligraphers, painters, copyists, color grinders, and gilders. Many of the styles and conventions developed in his imperial painting workshops continued to be used throughout the subsequent reigns of his son Shah Jahan (r. 1627–1658), who is best known for building the Taj Mahal, and his grandson, Aurangazeb (r. 1658–1707).

In 1658 Aurangazeb made a bold and successful bid for power. Taking advantage of his father's ill health, he challenged and defeated his older brother and imprisoned his father for the remainder of his life. He ascended the throne in the city of Agra in that same year, taking *Alamgir,* World-Shaker, as his title. Aurangazeb was an austere, scholarly, and devout Muslim who limited his reading to religious works and devotional poetry. Although his military campaigns extended the reach of the Mughal Empire, his persecution of Hindus, his destruction of their temples and monuments, and his execution of a popular Sikh leader fueled revolts and rebellions among his subjects, ultimately leading to the empire's collapse not long after Aurangazeb's death in 1707.

Further Reading
Beach, Milo Cleveland. *The New Cambridge History of India: Mughal and Rajput Painting*, vol.1, part 3. Cambridge: Cambridge University Press, 1992.
Pal, Pratapraditya. *Court Paintings of India.* New York: Navin Kumar, 1983.
———. *Indian Painting.* Los Angeles: Los Angeles County Museum of Art, distributed by Harry N. Abrams, 1993.

Note
1. Pratapaditya Pal, *Court Paintings of India* (New York: Navin Kumar, 1983), 45.

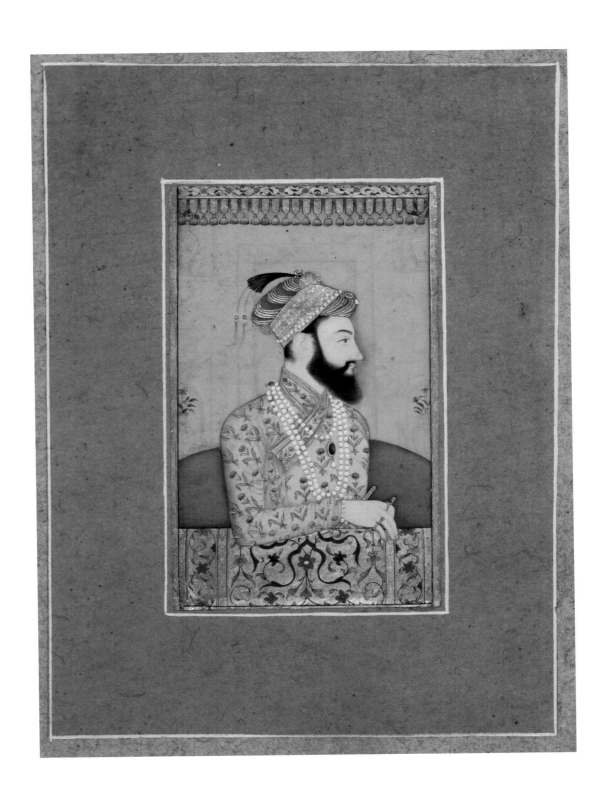

Middle Eastern
^cAbbasid Dynasty, 750–1250

Leaf from a Qu'ran Written in Kufic Script
9th–10th century
Ink and gold on parchment
6 ¹/₁₆ x 8 ⁵/₁₆ in. (15.3 x 21.1 cm)
63.41

In the Islamic tradition, the word of God, as revealed to the Prophet Muhammad (570–632) and preserved in the Qur'an, is sacred. Likewise, fragments of the Qur'an are sacrosanct and require preservation. Passages from the Qur'an were often written on parchment, as is our example, which contains Chapter 41, entitled "Adoration," verses 26–28. Also typical of an early Qur'an, our sheet consists of five lines. The verse, which begins on the recto side and continues on the verso, can be translated:

> [The disbelievers say: "Do not listen to this Qu'ran and shout away its reading]; [recto] you may haply prevail. We shall make the disbelievers taste the severest punishment, and retribute them for the worst that they [verso] had done. This is requital for God's enemies: Hell, where they will have their lasting home as punishment [for denying Our revelations].[1]

The written form of Arabic began to develop in the sixth through eighth centuries, following a long tradition of oral transmission of poetry and heroic epics. Even during the early years of Islam, the Qur'an, too, was preserved primarily through oral recitation. Finally, the need to accurately record this sacred text spurred its textual codification as well as the development of a script that was both legible and elegant.

The Indiana University Art Museum's folio page is written in a script that is commonly called kufic or kufi, a name derived from the city of Kufa, where innovations in perfecting the art of writing developed in the eighth century. Kufic script is characterized by its

angularity and by long horizontal lines, features that influenced the horizontal format of early Qur'ans, such as the one to which our page belonged. For a period of about three hundred years, kufic was the calligraphic style of choice for the majority of Qur'anic manuscripts.

Arabic belongs to a group of Semitic languages whose texts are written primarily with consonants. Thus, certain aspects of Arabic—such as vowel sounds, diphthongs, and the like—are not represented on the main line of the written text. With the rapid spread of Islamic culture to non-Arabic speaking peoples, the need arose to produce a text that could be read aloud accurately. This phenomenon eventually led to an innovation in writing: a system of dots and other diacritic marks appearing both above and below the line of text as an aid to pronunciation. In our fragment, vowels and other diacritic marks appear as gold dots. Additional marks, in the form of rosettes, indicate the end of each Qur'anic verse.

Further Reading
Déroche, François. *The Abbasid Tradition: Qur'ans of the 8th to the 10th Centuries AD*. Ed. Julian Raby, *The Nasser D. Khalili Collection of Islamic Art,* vol. 1. Oxford: Nour Foundation in association with Azimuth Editions and Oxford University Press, 1992.
Khatibi, Abdelkebir, and Mohammed Sijelmassi. *The Splendor of Islamic Calligraphy.* New York: Thames and Hudson, 1996.
Safadi, Yasin Hamid. *Islamic Calligraphy.* New York: Thames and Hudson, 1992.

Note
1. I am indebted to Professor Christiane Gruber for the translation of the text as well as information about Islamic culture and the manuscripts in the IU Art Museum collection.

Cambodia

Head of Vishnu
Pre-Ankor, 7th–8th century
Green sandstone
H. 4 in. (10.1 cm)
84.38

This head of the Hindu god Vishnu is but a fragment of what was most likely a standing figure attached to a wall or another architectural structure. In style and iconography the sculpture owes a debt to India, whose merchants, traveling the southern trade routes between China and the West, introduced not only the religions of Hinduism and Buddhism, but also Indian sculptural traditions, to Cambodia and other countries in Southeast Asia. Vishnu, the sustainer, is one of the most powerful gods of Hinduism, along with Brahma, the creator, and Shiva, the destroyer. The three are aspects of the great spiritual force as envisioned by Indian philosophers and mystics.

Only four inches high, the work commands attention despite its size. Seen from the front, the face is perfectly symmetrical and slightly heart-shaped. The height of the crown is equal to the length of the face, and the gently repeating curves of the brow, hairline, chin, and lips lend the whole balance and stability. The sculptor followed a canon of proportions that he could not alter, but the sensitivity of his carving is indicative of his skill.

What makes this head so dynamic is the way in which the sculptor treated the volume of the face and, more specifically, the way he dealt with the transitions between various facial planes, especially the front and side. The planes are so subtle that it is difficult to discover what marks the transition between the gentle welling of the cheek and the slight depression of the temple. Similarly, the brow line not only separates but also unifies the planes of the forehead and cheek before imperceptibly sinking—like a stream into sand—into the surrounding volumes. The slight flare of the elongated ears deflects the dominance of the head's cylindrical form, giving it a certain lightness and creating a dynamic relationship between the figure and the space that surrounds it.

The shallow carving of the eyes, nose, mouth, and brow line gives the features a subtle plasticity that is further enhanced by the play of light across the surface. Shadows seem to skim across the surface of the stone rather than dwell in its hollows. The result is a remote but gently animated expression of a being that, at least for a moment, is preternaturally serene. Time and the elements have further softened and blunted the surface of the stone, giving this head a suggestion of fragility and vulnerability that makes it even more appealing.

Further Reading
Bunker, Emma, and Douglas Latchford. *Adoration and Glory: The Golden Age of Khmer Art.* Chicago: Douglas Latchford in association with Art Media Resources, 2004.
Rawson, Philip. *The Art of Southeast Asia.* World Art Series. London and New York: Thames and Hudson, 1993.

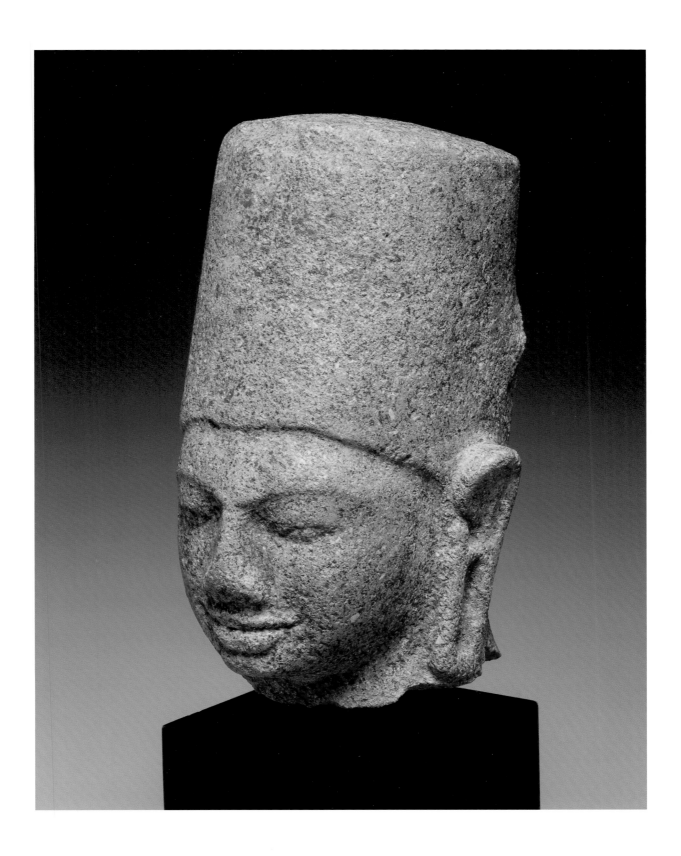

Cambodia, Khmer Culture

Prajnaparamita
13th century
Bronze
H. 13³/₈ in. (33.9 cm)
76.16

The exquisite balance between fine details and a simple, sensuous silhouette makes this bronze sculpture visually appealing, but its symbolic content makes it meaningful. The key to understanding this work lies in comprehending the Buddhist concepts it represents. This figure, identified by the seated Buddha perched above its multiple heads, represents the bodhisattva Prajnaparamita, who embodies the Buddhist concepts of wisdom *(prajna)* and perfection *(paramita)*. In Buddhism, wisdom is considered an intuitive comprehension of the true nature of reality. Wisdom is one of the six Buddhist virtues; the others are generosity, conduct, discipline, exertion, and meditation. Perfection—or, in a literal translation of the Sanskrit, "that which has reached the other shore"—expresses the state of enlightenment achieved by a bodhisattva.[1]

What is a bodhisattva? The word means "enlightened being," and although the idea of a bodhisattva exists in the earliest schools of Buddhism, it applied only to individuals seeking their own perfection. With the rise of the Mahayana school of Buddhism in roughly the first and second centuries, the idea of the bodhisattva came to mean a being who strives not only for his own enlightenment, but for all of humankind's. Mahayana Buddhism further distinguishes bodhisattvas of this world—beings of great compassion and spiritual attainment who serve as helpmates and models—and transcendent bodhisattvas, who have achieved Buddhahood, but who have elected to delay nirvana until all sentient beings have achieved a similar state of enlightenment. In practical terms, a bodhisattva helps the Buddhist believer in his or her quest for enlightenment by assuming the great burden of suffering that impedes the believer's spiritual progress.

In this sculpture, the bodhisattva Prajnaparamita is depicted with many arms and several heads. Prajnaparamita has attained the ultimate goal of Buddhist practice, and her wisdom is so vast and profound that it is difficult to comprehend. The multiplication of body parts visually embodies and symbolically represents her transcendent greatness and extraordinary power.

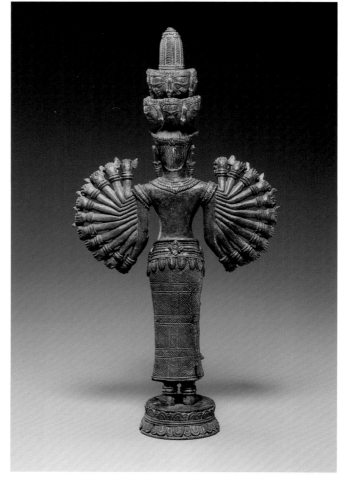

The figure viewed from the back

Note
1. Stephen Schuhmacher and Gert Woerner, eds., *The Encyclopedia of Eastern Philosophy and Religion* (Boston: Shambhala, 1994), s.v. "prajna," "paramita," "Bodhisattva."

China, Shang Dynasty

Ceremonial Tripod (Liding)
ca. 12th century BC
Cast bronze
H. 8 1/8 in. (20.7 cm)
William Lowe Bryan Memorial Fund, 58.41

Detail of vessel

The Chinese have been collecting and studying ancient Chinese bronzes since the eleventh century, and much of the vocabulary that scholars and collectors developed is still in use today. Bronze vessels are categorized primarily by their shapes. For example, this vessel is called a *liding* because it is a tripod *(ding)*. The vessel is described by the modifier *li,* which signifies that the vessel is lobed. (If the vessel were round, it would simply be called a *ding,* or if it were square, it would be called a *fangding.)*

Bronzes such as this one are artifacts of the Shang dynasty (ca. 1500–1050 BC), whose kings controlled a large area of northeastern China centered in the modern province of Henan. Information about Shang history and practices survives in the form of more than 200,000 inscriptions on oracle bones that have been excavated (or looted) from Shang sites. Oracle bones were made from the shoulder blades of oxen or of turtle shells, which were cleaned and then drilled with holes on the flat surfaces. A point was heated and applied to the depressions, causing the bones to crack. Shang kings or their diviners then interpreted these cracks. Questions—such as which ancestors or spirits should receive offerings, when rites should be performed, or whether a harvest would be abundant or poor—as well as the respective answers, are recorded on the bones.[1]

Shang society was hierarchical, with the king at the pinnacle and members of agricultural households and others, such as war captives, at the base. People believed in a complex world of spirits, which comprised a multitude of nature deities, royal ancestors, and others who might control the weather, harvests, and military campaigns. Much of the king's authority was derived from his kinship with his ancestors, who could intercede on his behalf and perhaps avert calamity. Ancestors were propitiated with elaborate rites, feasts, and sacrifices. If ancestors were displeased with the sacrifices made to them, they might fail to act on their progeny's behalf or even cause their descendants harm.

Bronze vessels such as this *liding* held food to be offered to ancestors. Bronzes were used in sets, either cast as a group or assembled. Some shapes, such as this *ding,* were used for stewing meats; others were reserved for alcoholic beverages, grains, and water. While some bronzes were used in rites performed on an ancestral altar, others were used in funerary contexts and buried with the dead.

The style of this *liding* places it in the late phase of the Shang dynasty, between the thirteenth and mid-eleventh centuries BC, before the kingdom was conquered by the vassal state of Zhou. Some of the identifying features of a late Shang bronze are the degree to which the decoration encompasses the surface of the vessel,

differentiation between foreground and background, and design motifs rendered in varying heights of relief. The decoration on this *liding* encompasses almost the entire surface of the bronze, with only a narrow band under the rim, the legs, and the bottom of the vessel left undecorated. Three stylized animal masks *(taotie),* the vessel's primary motifs, are located on the convex lobes above each leg, separated by pairs of upside-down animal forms. The spaces between the motifs are tightly packed with squared spiral patterns (thunder patterns) in low relief.

The animal masks, positioned over the legs with open jaws as if in the act of swallowing, can be read in two ways: as two animal heads seen in profile, forehead to forehead and nose to nose, or as one flattened animal head. In any case, the animals have ears, eyes, noses, eyebrows, and jaws, all constructed of the same thunder patterns used in the background. A great many Shang bronzes are decorated with such composite animal forms and masks. Identifiable creatures such as cicadas and even the occasional human also appear on bronze vessels.

What is the meaning of these patterns, if any? Totemic, shamanistic, and mythic theories have all been argued over the years, with limited success. We know that the use of animal forms on ritual objects was not a Shang invention, since such forms are also found on artifacts that date to Chinese Neolithic cultures. The carved stone objects of the Liangzhu culture, which flourished in the third millennium BC, make extensive use of animal masks, but chronology and geography make a direct link between this Neolithic culture and the Shang problematic.

Further Reading
The Great Bronze Age of China: An Exhibition from the People's Republic of China. New York: Metropolitan Museum of Art, 1980.
Thorpe, Robert L., and Richard Ellis Vinograd. *Chinese Art and Culture.* New York: Prentice Hall; and Harry N. Abrams, 2001.

Note
1. Robert L. Thorpe and Richard Ellis Vinograd, *Chinese Art and Culture* (New York: Prentice Hall; and Harry N. Abrams, 2001), 60.

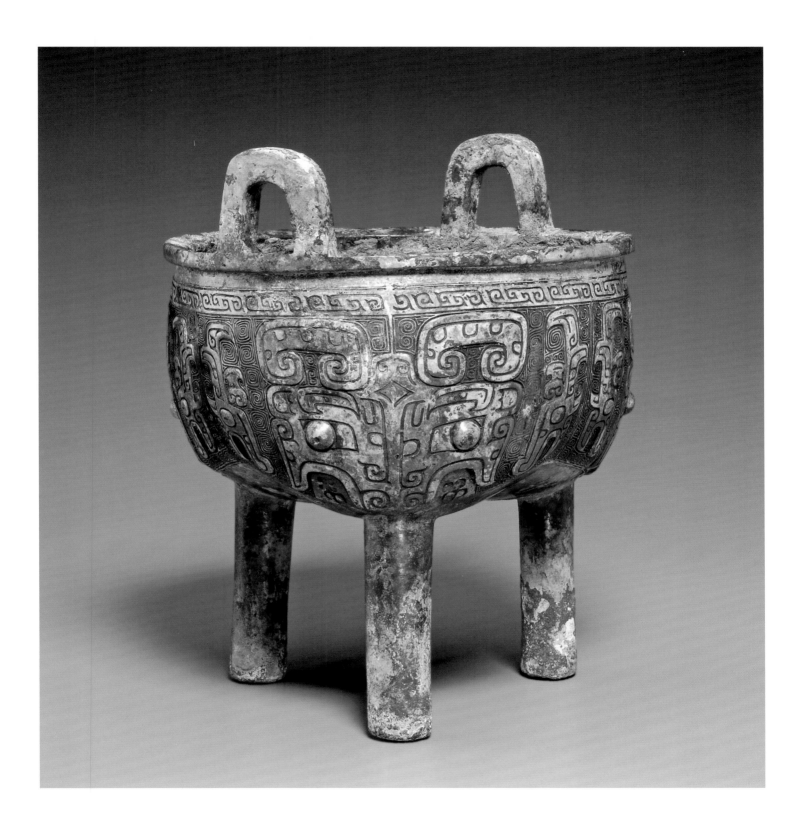

Feiyin Tongrong
Chinese, 1593–1662

Yinyuan Longqi
Chinese, active in Japan,1592–1673

Purity of the Moon, 1655
Ink on paper
16 3/16 x 38 3/8 in. (41.1 x 97.4 cm)
83.41

This painting is a spectacular tour de force of brushwork. The bold characters were executed in a quick and fluid style of calligraphy developed to write complicated characters more quickly. The same style also allowed for more personal expression, and thus it was considered more suitable for poetry and private correspondence than the precise, clerical script used to write documents. In order to write with such speed, the calligrapher must have complete mastery of brush, ink, and form. The calligrapher must also be focused and resolute—paper is an unforgiving medium, and a moment of hesitation will result in an unsightly blot of ink. Buddhist monks, particularly those who practiced Chan Buddhism (Zen in Japan), often employed this rapid style of painting and calligraphy because of the discipline it required. This painting—which is actually two sheets of paper joined together—consists of a pair of poems written by two Chinese monks, one living in China and the other in Japan.

Reading from right to left, the first poem is by the monk Feiyin Tongrong, the abbot of the Wangfusi Temple on Mt. Huangbo in Fujian Province, southern China. As Feiyin says in the inscription (and in his seal in the upper right corner), he was the thirty-first spiritual descendant of Linji Yixuan (d. 866), the founder of the Linji school of Chan Buddhism—perhaps better known by its Japanese appellation, Rinzai Zen.

Feiyin begins his poem with the title, "Purity of the Moon," written horizontally in large characters. The character for moon is ever so slightly tipped to its side, making it appear like a half moon clearing the horizon. Further to the left are two vertical lines of poetry, followed by three lines that identify Feiyin's credentials, affiliation, and date. The two large square seals are Feiyin's name *(Feinyin rong)* and sobriquet, Old Man of Mt. Jing *(Jingshan laoren).*

> *Purity of the Moon*
> The unchanging, pure nature of the moon is like the Bodhisattva of Compassion;
> One realizes this completely when the moon rises.
>
> *The thirty-first generation descendant of Lanji, Feiyin [Tong]rong, the old monk of Mt. Jing wrote this in the cyclical year yiwei [1655].*

Further to the left is a responding poem by Yinyuan Longqi (Japanese: Ingen), who was a thirty-second-generation descendent of Linji. His poem reads:

> Brilliant light illuminates the three thousand realms;
> Its perfect illumination stands me in good stead.
>
> *Yinyuan of Huangbo respectfully continued and wrote [this].*

The inscription is followed by two square seals, the first of which bears the two characters of Yinyuan Lonqi's name, and the second of which says "seal of Yinyuan" *(Yinyuan zhi-in).* An additional oval seal is located between the two poems and over the seam where the two sheets of paper are joined. It says, "True School of Linji" *(Linji cheng zong di san di yi shi).*[1]

Yinyuan took his vows at the age of twenty-nine and later succeeded Feiyin as abbot of the Wangfusi Temple. In 1654, a year before this pair of poems was written, Yinyuan, responding to requests from the Chinese community in Japan, left for Nagasaki, expecting to stay for three years. His plan was to establish the Huangbo sect (Japanese: Ōbaku) of Buddhist practice, train a successor, and return home. His sojourn turned out to be much longer. The China that Yinyuan left was in turmoil. In 1644, the last Ming emperor had hanged himself as the Manchu army entered the city of Beijing. This invasion ushered in only the second period in China's long history during which the country was ruled by a non-Chinese people. Southern China—particularly Fujian province, which was staunchly loyal to the Ming dynasty—proved more difficult to subdue, and did not come under Manchu (Qing) control until 1658.[2]

Whether driven by missionary zeal or political realities, Yinyuan never returned to China. In 1659, the Japanese emperor Gomizunoo? granted Yinyuan land on which to build a temple. Work was begun on the Mampukuji temple near Uji in 1661, and Yinyuan served as its abbot until 1664, when he appointed his disciple, Muan Xingtao (Mokuan Shoto), to succeed him. He died in Japan in 1673. This set of beautifully rendered poems is a rare document that records the transfer of Ōbaku Zen from China to Japan.

Further Reading
Shimizu, Yoshiaki, and John M. Rosenfield. *Masters of Japanese Calligraphy, 8th–19th Century.* New York: The Asia Society Galleries and Japan House Gallery, 1984.

Notes
1. Translations from the Chinese are from Yoshiaki Shimizu and John M. Rosenfield, *Masters of Japanese Calligraphy, 8th–19th Century* (New York: The Asia Society Galleries and Japan House Gallery, 1984), 160.
2. Jiang Wu, "Leaving for the Rising Sun: The Historical Background of Yinyuan Lonqi's Migration to Japan in 1654," *Asia Major* (Third Series) 17, part 2 (2004): 89–120.

Quan Handong
Chinese, b. 1956

Oxen, Series #6, "The Spirits of the South"
1994
Ink and color on paper
95 x 56 in. (241.3 x 142.2 cm)
Gift of Robert and Sara LeBien, 2006.518

Quan Handong was born in Guilin, a beautiful river town in the southern province of Guangxi in the People's Republic of China. In 1982 he received a BFA in Chinese painting from the Guangxi Art Institute, and he now lives in New York City, where he paints and works as a motion picture animation designer. Although he no longer lives in China, Quan holds the position of senior painter in the Guilin Chinese Art Academy, a group of artists who were drawn together in the early 1990s by a shared desire to explore traditional Chinese painting techniques as a means of examining contemporary issues of individualism, nationalism, and internationalism.

Unlike most of Quan's Guilin colleagues, who focus on the innate beauty of local landscapes—for which Guilin is justly famous—Quan has devoted much of his work to an exposition of the strength and power of mountain oxen. Quan says that the ox "is the kind of animal who is kind and gentle by nature, yet unyielding in front of challenges." Through the massing of the animals toward the lower part of this very large painting, Quan subtly suggests the power not only of the individual ox, but also of the herd. The simple repeated shapes and the alternation of light and dark create a dynamic surface that further underscores the nature of the ox, which is both powerful and pacific. The tension between physicality and abstraction, and between movement and stillness, adds to the painting's vitality.

The inscription at the top of the painting is read from right to left, top to bottom. It begins with a red oval seal whose characters can be read as "Mind's creative source." This is followed by four characters indicating the title of the painting, "The Spirits of the South." The title is followed by a prose passage:

> Mountain oxen roam the South. Lush autumn grass dances in the wind, like music from the heart of the hills. How peculiar are these mountain oxen with their long, curved horns! At once fierce and gentle, they draw from the broad sky and vast lands of the South the essence that makes their character unique. Faced with a sudden burst of engulfing flames from a man-made firestorm, they are unafraid. They crouch in the wild grass and then leap in the air. Swathed in flame, they run like soldiers on an ancient battlefield. The fire may burn their body but cannot bend their will. With mountain oxen about, the unforgiving Southern terrain becomes a rippling, soothing ocean.[1]

The inscription ends with the date, autumn 1994, and the signature of the artist (Handong, painter and calligrapher). Below are two seals: the round seal contains the character "Quan," and the square seal the character "Handong." Finally, to the far left is an additional seal that can be translated as "Externally follow Nature."

This last seal forms a pair with the seal that appears at the beginning of the inscription. Together, they refer to the writings and philosophy of the eighth-century Tang painter Zhang Zao (Chang Tsao). When asked from whom he had learned his painting technique, he replied, "Externally all Creation is my master. Internally I have found the mind's sources."[2] Although brief Chinese inscriptions such as these are notoriously difficult to translate because of the layers of meanings rendered by a single character, Zhang is certainly addressing the issues of the macrocosm and the microcosm—the universal and the individual. Quan addresses the same issues in the metaphoric possibilities of the individual ox and the herd and the gentle and the obdurate; he suggests that in an uncertain world we all will benefit from the spirit of the ox, who stands steadfast until all obstacles are dissolved.[3]

Notes
1. My thanks to Herman Mast for translating the inscription and conferring with Quan Handong about the meaning and references.
2. As quoted in Susan Bush and Hsio-yen Shih, *Early Chinese Texts on Chinese Painting* (Cambridge: Harvard Yenching Institute, 1985), 65.
3. Paraphrased from a gallery handout for an exhibition of Quan's work held in the Queens (N.Y.) Public Library in 2003.

南國精靈

山牛在南方的山地上
悠閒的散步 茂密
的飢草隨風狂舞
死如山地深愛的音
床如山牛這种古怪
精靈長々巷曲的
特角斗凶斗勇
又像和善良它們
吸取南方天闊
地的精華火鑄
猶特的性格一瞬
人鴉的大火襲來
面對猝然來临
河灭頂立灾它們
沒有惊盡懷慌
伏荒草坪中旋即一
軍而起獨着一身
火焰葉丽地奔馳
就像古代战墙的
勇士敘怒天火烧
断它們的筋骨
烧不弯那頑強的
意志有了山牛冷酷
的南为山地变成
了二牛鼓荡浪混情
的海洋

漢東畫并题目

Japan, Middle Jōmon period

Jar
ca. 2000 BC
Earthenware
H. 20 in. (51.0 cm)
62.189

In 1877 American scholar Edward Morse was traveling by train between Yokohama and Tokyo. Looking out the window near Omori, he noticed what he thought was an ancient shell mound. When he returned to excavate this mound, he found shards of pottery decorated with patterns that looked as if they had been made by pressing twisted cords into leather-hard clay. Morse described the pottery as "cord-marked," and it is the Japanese translation of his term that gives the pottery and the culture that produced it the name Jōmon. This astounding find ultimately changed previously accepted assumptions about the date and location of the world's first pottery-producing culture.

Until Morse's discovery and the study of Jōmon material, most scholars believed that the earliest cultures that manufactured pottery, dating to around 9000 BC, were located in the ancient Middle East and were closely associated with the development of agriculture. With the discovery in the 1960s of Jōmon pottery that dates to 10,700 BC, not only did scholars have pottery that dates earlier than examples found in West, but also works made by hunter-gatherers who would not engage in agricultural practices until the first millennium BC, some 9,000 years later. This startling discovery means that Jōmon pottery is the earliest known worldwide.

The Jōmon period was very long, extending from approximately 10,700 to 400 BC. It is divided into six time periods, each with its own characteristics of settlement patterns and pottery production. The Indiana University Art Museum's vessel dates to the Middle Jōmon period, between 2500 and 1500 BC. This pot, like all Jōmon vessels, was shaped by hand from coils of clay and fired in an open pit. The pleasing color variations on the surface are the result of the uneven temperature and oxygen levels in the open pit kiln. Although no two vessels are identical, this pot's flaring lip and undulating rim, with its exuberant forms, is typical of the middle Jōmon period. The flat-bottomed body of the vessel was decorated with cords pressed into the clay, and the rim was decorated with clay applied to the surface. The repeated, though not symmetrical, patterns on the body create a dynamic, rhythmic surface, and the raised designs and openings of the rim generate a lively play of light and shadow.

Without knowing where in Japan this particular vessel was found—or, more importantly, its exact location within a Jōmon settlement—it is hard to know its original purpose. Traces of soot on some vessels suggest that Jōmon pots of this shape were used primarily for food storage and for cooking. Some jars, however, were used for burials—deceased infants were sometimes placed in pots and buried beneath the entrance to a house. In some burials, two pots, with their bottoms removed, were used to bury a child. We know very little about Jōmon religious beliefs, but certain burial practices—such as those mentioned above and the figurines of humans, animals, or hybrid creatures found in increasing numbers in the middle Jōmon period—are indicative of ritual practices. Although we do not know this vessel's original purpose, there is power in its decoration. The vessel's sinuous, fleshy forms and its tactile qualities make it seem almost alive.

Japan
Heian period, 794–1185

Amida Buddha
12th century
Wood with lacquer and gold leaf
H. 32 1/2 in. (82.5 cm)

Imagine this sculpture in its original setting, on a carved wooden throne in the shape of a lotus blossom placed in a dimly lit temple, likely among a group of sculptures and other ritual objects. Covered in gold leaf, the figure would have glowed in the ambient light, making it seem as if it were miraculously lit from within. This figure is the Amida Buddha, or Buddha of the Western Paradise. He is sitting in a full lotus, or *nyorai,* a position indicating meditation. His hands are held chest-high, with the middle fingers curled to touch the thumbs. The figure seems detached, but not unwelcoming.

Buddhism is a discipline through which the practitioner achieves enlightenment. Strictly speaking, it has no figure of divinity. The Indian prince Siddhartha (563–477 BC), often referred to as the historical Buddha (also known as Shaka or Sakyamuni), came to the understanding that to live is to suffer, and that all things on earth are impermanent and sorrowful. What is born is destined to die. During the course of our lives, we become mentally and emotionally attached to material things as though they are substantial, enduring realities. As long as we retain our attachment to these illusions, we will be caught in a perpetual and unending cycle of rebirth and sorrow. With effort and training, the Buddhist practitioner learns to penetrate the illusory world of attachments and to achieve enlightenment.

Although the Amida Buddha occurs in painting and sculpture from the early years of Japanese Buddhism, he became the focus of his own devotional cult in the Heian period (794–1185). The reasons for his rise in popularity are complex but almost certainly related to a belief in *mappō,* which posits that as we move further away chronologically from the historical Buddha's achievement of nirvana, the world will face increasing turmoil and spiritual degeneracy—making it harder for others to follow the Buddha's example. Certainly, the Amida Buddha's vow that all who believed in him would be reborn in his Western Paradise at the moment of their death also contributed to his appeal. Unlike the Western concept of Heaven, Amida's paradise was a place of interim existence in which all impediments (i.e., attachments) were absent and the believer could continue to strive for enlightenment. Small, portable paintings of Amida were brought to the side of the dying so that the believers' last earthly vision was of the Amida Buddha and his celestial host descending from the sky, carrying a golden lotus throne on which to transport the believer to the Western Paradise.

The arts in Buddhism are, like texts, both objects for instruction and embodiments of ideas. A sculpture like this one is meant to be read and its lessons internalized. Posture, implements, hand gestures (mudra), and position within a group or within the context of a temple hall all contribute to a reading of a visual image that is dense with meaning. Each mudra, for example, carries a specific meaning. The Indiana University Art Museum's sculpture is a bit of an enigma. The hands take the position of the *an-i-in* mudra ("middle class, middle life"), one of the gestures of the nine Esoteric Amida Buddhas. This mudra signifies a particular state of the Amida's enlightenment, and, more broadly, the welcoming of the believer to the Western Paradise.[1] However, the usual position of the hands is in front of the chest, not out to the sides, as they are in this work. Perhaps this is a variation of the mudra, or maybe the arms were repositioned during one of the later repairs of the sculpture. Nevertheless, this is a solemnly beautiful figure. His solid body and the repeating, rounded forms of the face, chin, and chest, combined with the delicate drapery patterns, place this sculpture firmly in the elegant, courtly tradition of Heian sculpture.

Further Reading
Pilgrim, Richard. *Buddhism and the Arts of Japan.* 2nd ed., Chambersburg, Penn.: Anima Books, 1993.
Sauders, Dale E. *Mudra.* New York: Bollingen Series LVII, 1960; Princeton: Princeton University Press, 1985.

Note
1. Dale E. Sauders, *Mudra* (New York: Bollingen Series LVII, 1960; Princeton: Printceton University Press, 1985), 66–75.

Japan

Shōtoku Taishi at Age Two
Late 13th–early 14th century
Wood with pigments and lacquer
H. 27 1/2 in. (69.8 cm)
William Lowe Bryan Memorial Fund, 59.26

Shōtoku Taishi (574–622) was prince regent and the putative power behind the throne of Empress Suiko during the formative years when a nation-state was forged from Japan's semiautonomous regions and Buddhism was adopted as a state religion. He is thought of as a man of supreme gifts: a preeminent statesman, Buddhist scholar, and advocate of Chinese statecraft and learning (the Chinese system of government provided a model for Japanese emperors). Until 1984 Shōtoku's portrait was on every five and ten thousand yen note. Japanese schoolchildren still learn that he was the architect of Japan's first constitution in 604 and that he wrote scholarly commentary on several Buddhist texts.[1]

That Prince Shōtoku was involved in the political affairs of the court, could read and write Chinese (the Japanese did not have written language until sometime later), and was a follower of Buddhism is certainly true. What is equally true is that the process of mythologizing his life and accomplishments began as early as fifty years after his death.[2] Shōtoku quickly came to be regarded as a reincarnation of the historical Buddha. And, as with many great religious leaders, certain events in his life, whether factual, embellished, or invented, have acquired special significance. According to one of the legendary biographies, at the age of two Shōtoku turned to the east and began to chant the prayer *Namu Butsu,* or "take refuge in the Buddha." This story suggests the rich lore surrounding Shōtoku.

Depicting Shōtoku's reported recitation at age two, sculptures like this one were popular in Japan during the Kamakura period (1185–1336), and many examples survive in Japan. The IU Art Museum's figure is one of only a few in Western collections. Our sculpture is an early and particularly fine example of the type. The proportions are convincingly child-like, yet graceful. Eleventh-century advances in wood carving techniques—such as splitting the sculpture's main building blocks and hollowing out the core, as well as joining multiple blocks together—made sculpture less prone to cracking and allowed for more plastic modeling.

At first glance, Shōtoku appears to be kneeling, but he is actually standing on the hem of his stiff *hakama* (split skirt or pants). His eyes, made of crystal, are downcast and seem to be focused inward, making the figure seem eerily alive. Only traces of the original red paint on the *hakama* and flesh colors on the body survive. There is a space for relics in the core of the sculpture, but it is empty.

Devotion to Shōtoku and other charismatic figures increased during the Kamakura period, alongside the rise of Buddhist sects focused on bringing salvation to the masses. The formal practice of Buddhism in Japan had, in its beginnings, been the prerogative of the aristocracy, while the majority of the Japanese population continued to rely on shamans and ritual healers. From the eighth century on, an increasing number of unordained Buddhist monks espoused the worship of native gods and Daoist mysticism in combination with Buddhist practice. In the ninth century, Shingon and Tendai Buddhist schools promulgated the notion that native gods, *kami,* were emanations of Buddhist gods and vice versa, ultimately lending the unordained increased authority and orthodoxy. In the Kamakura period, many famous lay preachers traveled the countryside, giving sermons focused on the magical efficacy of Buddhism. The story of Shōtoku as the reincarnation of the Buddha, demonstrated by his precocious recitation of the *Namu Butsu,* was a perfect paradigm for teaching the masses, and so the cult devoted to him grew and prospered.

It is difficult to determine where the museum's Shōtoku sculpture was made. During the Kamakura period several sculpture workshops or schools flourished, such as the Kei school associated with the Kōfukuji temple in Nara and the In school in Kyoto, but sculptors also traveled to worksites throughout Japan. Membership in sculpture workshops was hereditary and was organized around a master carver, though promising outsiders could be adopted into the family. Without further documentation it is hard to assign a particular workshop or hand to this sculpture.

Further Reading
Kaminishi, Ikumi. *Explaining Pictures: Buddhist Propaganda and Etoki Storytelling in Japan.* Honolulu: University of Hawai'i Press, 2006.
McCallum, Donald F. "Tori-busshi and the Production of Buddhist Icons in Asuka-Period Japan." In *The Artist as Professional in Japan.* Edited by Melinda Takeuchi. Stanford: Stanford University Press, 2004.

Notes
1. Ikumi Kaminishi, *Explaining Pictures: Buddhist Propaganda and Etoki Storytelling in Japan* (Honolulu: University of Hawai'i Press, 2006), 31–32.
2. Donald F. McCallum, "Tori-busshi and the Production of Buddhist Icons in Asuka-Period Japan," in *The Artist as Professional in Japan,* ed. Melinda Takeuchi (Stanford: Stanford University Press, 2004), 36.

Japan

Portrait of Kōbō Daishi
14th century
Ink and color on silk
47 ³/₄ x 29 ⁷/₈ in. (121.2 x 75.8 cm)
66.13

This portrait of the Buddhist monk Kōbō Daishi (also known as Kūkai) is but a shadow of its former magnificence.[1] The silk has darkened and in places fallen away entirely; pigments have flaked; and some of the gold has rubbed off. Despite the losses, this painting has great importance: it is perhaps the only one of its kind in a Western collection, and it depicts one of Japan's most charismatic and influential Buddhist monks.

Kūkai was born in 774 to an old and venerable aristocratic family. Around the age of fifteen, he went to Kyoto to study with his uncle, the distinguished Confucian scholar Atō Ōtari, who was a tutor for the emperor's son. Three years later Kūkai entered the university to complete his education in Chinese classics, in preparation for a career in government. Then, seemingly disillusioned, he turned to Buddhism, left the capital, and spent several years seeking enlightenment while living a life of profound austerity. At some point in his studies, he encountered and was impressed by the precepts of Shingon Buddhism. In 804 Kūkai set sail for China to study Sanskrit and the mysteries of Shingon Buddhism from the revered master Huiguo.

After two and a half years in China and three months studying with Huiguo, Kūkai was ordained, becoming the eighth patriarch of Shingon Buddhism, a position he inherited from his master. He returned to Japan in 806, and three years later he was summoned to the capital, Kyoto, where he began his illustrious and influential career. In 816 Kūkai began to build a center for Shingon Buddhist practice on Mt. Kōya, one of the most sacred mountains in Japan.

Shingon Buddhism posits that enlightenment can be achieved through the performance of certain hand gestures, called mudras; the use of ritual implements; meditation; knowledge of secret formulas; and comprehension of the Five Wisdoms. By these means, the Buddha world could be experienced in this world. The practice of Shingon also involves visualizing the Buddha world by studying the Mandalas of the Two Worlds, which function as cosmic diagrams of the Universe— both the seen, or physical, world (the Womb World) and the ineffable, or metaphysical, universe (the Diamond World). Another important aspect of Shingon teaching is the transmission of essential secrets, those mysteries passed from mind to mind rather than through speech, creating a special bond between master and pupil.

In the IU Art Museum's portrait, Kūkai sits in the full lotus position on a low chair with his shoes on the floor to his left. In his right hand he holds a *vajra,* or lightning bolt, one of the sacred implements of Shingon Buddhism, symbolizing the Diamond World. In his left hand Kūkai holds a rosary, symbolizing the Womb World. The water jar to Kūkai's left is emblematic of the believer as the empty vessel who can be filled with truth, just as a jar can be filled with water. In the upper right corner is an image of the historical Buddha, Shaka. The references in this painting identify it as one of the portraits reportedly based on a painting of Kūkai kept in the Zentsūji temple built on the site of his birth, where, according to a thirteenth-century account, Kūkai is said to have had just such a vision of the historical Buddha.[2]

For Kūkai's followers, this portrait is more than an idealized likeness of the master. It is his embodiment, not only as the man and revered teacher, but also as the tangible symbol of the transmission of Dharma—the teachings of Buddha—from mind to mind, stretching in an unbroken line back to the historical Buddha. It is through the contemplation of such images that the abstract is made real. As Kūkai wrote:

> With the help of painting . . . their obscurities [esoteric doctrine] may be understood. The various attitudes and mudras of the holy images all have their source in Buddha's love, and one may attain Buddhahood at the sight of them. Thus the secrets of the sutras and commentaries can be depicted in art, and the essential truths of the esoteric teachings are all well set forth therein. Neither teacher nor student can dispense with it. Art is what reveals to us the state of perfection."[3]

Further Reading
Kitagawa, Joseph M. *On Understanding Japanese Religion.* Princeton: Princeton University Press, 1987.
Kūkai Major Works. Translated, with an account of his life and a study of his thought, by Yoshito S. Hakeda. New York: Columbia University Press, 1972.
Object as Insight: Japanese Buddhist Art and Ritual. New York: Katonah Museum of Art, 1996.
Shapers of Japanese Buddhism. Edited by Yūsen Kashiwara and Kōyū Sonoda, translated by Gaynor Sekimori. Tokyo: kōsei Publishing Co., 1994.

Notes
1. Kūkai is his religious name and Kōbō Daishi is his posthumous name, a Buddhist title of respect.
2. *Object as Insight: Japanese Buddhist Art and Ritual* (New York: Katonah Museum of Art, 1996), 56.
3. From Kūkai's *Memorial of the Presentation of the List of Newly Imported Sutras,* in *Sources of Japanese Tradition,* complied by Ryusaka Tsunoda, William Theodore De Barry, and Donald Keene (New York: Columbia University Press, 1959), 138.

Tani Bunchō
Japanese, 1763–1841

Scholar Gazing at a Waterfall
Ink on paper
66 ¼ x 30 ¾ in. (168.2 x 78.1 cm)
81.69

Tani Bunchō, an Edo-born contemporary of the printmaker Katsushika Hokusai, was a prolific painter as well as a teacher, author, and connoisseur. His father, a well-regarded poet, served as vassal to the high-ranking Tayasu family, descendants of the eighth Tokugawa shogun. As befitted his rank, Bunchō was educated in the Confucian classics. In the course of his education he also studied a variety of painting styles: the ink painting techniques of the officially sanctioned Kano school, traditional Japanese painting, Chinese painting, and even Western painting—all of which informed his work.

Bunchō was the protégé of Matsudaira Sadanobu, a very high-ranking official of the shogun. Under Sadanobu's instruction, Bunchō produced drawings of the coastlines of Izu and Bōzō, as well as a woodblock print catalogue of antiquities.[1] He is best known, however, as a Nanga painter.

Nanga painters modeled themselves after the Chinese literati in terms of painting style, subject matter, and, when possible, lifestyle. In fact, Nanga, which means "southern painting," is the Japanese equivalent of a term that was used by the Chinese Ming dynasty painter and theorist Dong Qichang (1555–1636) to distinguish amateur or literati painters (southern) from professional painters (northern). Amateur painters—for whom painting was an avocation—were predominately scholars and poets who often also were accomplished musicians and calligraphers. They painted landscapes and Confucian subjects such as the "Four Gentlemen" (bamboo, plum, orchid, and chrysanthemum), frequently making stylistic references to paintings of the past. Professional painters in China, by contrast, painting for money and on commission, were of a lower social rank than the literati, and their work was less valued, even though many were very accomplished painters. The terms amateur and professional also encompass stylistic differences. Broadly speaking, literati paintings are subdued in color and intuitive, while professional paintings are more colorful and descriptive, and they feature more meticulous brushwork.[2]

Chinese literati painting was introduced to Japan in the late seventeenth and early eighteenth centuries through the importation of painting manuals and, to a lesser extent, actual works brought by Chinese immigrants, merchants, and monks.[3] In Japan, early Nanga painters were primarily scholars of Chinese learning in and around Kyoto and Osaka, who had grown weary of Kano school painting and found these new painting styles invigorating. Tani Bunchō, considered the foremost artist of his day, was a third-generation Nanga artist who is usually discussed in terms of his roles as the first

Nanga artist in Edo (present-day Toyko) and as the teacher of artists such as Watanabe Kazan.

The subject of this undated work, one of two paintings by Bunchō in the IU Art Museum's collection, comes from the Chinese literati tradition. A scholar sits on a rock ledge framed by a twisted old pine tree, gazing at a waterfall. In Daoism (and Shinto), lofty mountains are considered points of contact between the world of the immortals and the world of humans. The painting's subtext is that spiritual renewal can be achieved directly, by experiencing nature, or vicariously, through painting. The painting style is bold and brash, with sharp, pleasing contrasts between light and dark ink and between line and wash. The painting surface pulses with life, but there is no believable three-dimensional space.

This lack of dimensionality is an unforgivable sin in a Chinese painting, where it would be considered a telltale sign of an inept painter. But Bunchō was a Japanese painter, not Chinese, and because he was working outside of the Chinese tradition, this "fault" should be reconsidered. In the Chinese literati tradition, painters employed styles and tropes of earlier Chinese paintings, building complex layers of visual signs. In many ways, Bunchō's work stays true to the spirit of this tradition. Bunchō did not draw strictly on Chinese sources, however: he also made reference to different schools of Japanese painting, such as Kano and the decorative flat surfaces of the art of Sōtatsu of Kōrin. Bunchō's painting is wonderfully eclectic in the very best sense of the word.

Further Reading
Addiss, Stephen. *Nanga Paintings*. London: Sawers, 1975.
Cahill, James. *Scholar Painters of Japan: The Nanga School*. New York: The Asia Society, 1972.
Japanese Quest for a New Vision: The Impact of Visiting Chinese Painters, 1600–1900, Selections from the Hutchinson Collections at the Spencer Art Museum. Edited by Stephen Addiss. Lawrence, Kans.: Spencer Museum of Art, 1986.
Yonezawa, Yoshiho, and Chu Yoshizawa. *Japanese Painting in the Literati Style*. Translated and adapted by Betty Iverson Monroe. Vol. 23 of *Heibonsha Survey of Japanese Art*. New York and Tokyo: Weatherhill Heibonsha, 1974.

Notes
1. Yoshiho Yonezawa and Chu Yoshizawa, *Japanese Painting in the Literati Style*, translated and adapted by Betty Iverson Monroe, vol. 23 of *Heibonsha Survey of Japanese Art* (New York and Tokyo: Weatherhill/Heibonsha, 1974), 110.
2. James Cahill, *Scholar Painters of Japan: The Nanga School* (New York: The Asia Society, 1972), 10.
3. Japan at this time was closed to outside influence, with the exception of highly restricted trade with China and the West.

Gibon Sengai
Japanese, 1750–1837

Chrysanthemum
Ink on paper
15 7/16 x 22 3/8 in. (39.3 x 56.8 cm)
68.208

From temple records and his many inscribed paintings, we can glean something of the biography of Gibon Sengai, a Zen monk whose calligraphy, playful paintings, and poetry are the delight of all who see them. We know from the Eishōji temple records, in the village now known as Mugegawa, on the main island of Honshu, that Sengai was born to a poor farming family named Itō, and that he had an older brother. These facts suggest that, like so many younger sons from poor families in both Asia and the West, Sengai was given to a monastery as a young child, to lessen the burden on his family and to provide him with an education and livelihood. At the age of ten, he was ordained at the Seitaiji temple near his village, and at nineteen, he left to study with the renowned Zen monk Gessen Zenne (1701–1781) at the Tokian temple in Nagata near Kamakura.

As part of his training, Sengai's teacher would have given him koan to study. These puzzling, sometimes nonsensical sayings—such as "What is the sound of one hand clapping?"—force the mind to break free from conventional thought patterns. Koan were used both by students, as aids to achieving enlightenment, and by teachers, who, upon judging the students' responses, would know whether each had achieved enlightenment or needed to meditate further. An early indication of what would become Sengai's gentle, mocking humor and self-deprecation is evident in his response to the koan, "Why did the Patriarch come from the West?," assigned to him by his master, Gessen Zenne. Sengai responded:

> Two thousand years since Sakyamuni
> [the historical Buddha] died,
> Billions of years before Maitreya
> [Buddha of the future] appears,
> Today I have had a chance meeting;
> As usual my nostrils hang over my lips.[1]

In his response, the most momentous event in a monk's life—achieving enlightenment—is respectfully deflated. Sengai may have had a mind-altering experience, but he is no more significant than before.

After Gessen's death, Sengai left the Tokian temple and traveled around central and northern Japan for a number of years. In 1788 Sengai accepted an invitation to move to the oldest Zen temple in Japan, the Shōfukuji in Hataka, on the southern island of Kyūshū. He was soon installed as its abbot. Sengai, from all accounts, was a humble man, well loved by his followers. He refused to wear the purple robes of office that were his due and always wore a plain black robe. A single bowl served him both for food and for begging. At age sixty-two he retired and spent the rest of his life promoting Zen through his painting and poetry.

The painting of chrysanthemums in the IU Art Museum's collection is typical of Sengai's work. It is deceptively simple—a few sprays of chrysanthemums entangled with a few stray strands of grass and a poem, which reads:

> Even though
> the flower has no ears
> it is called kiku

The word chrysanthemum, *kiku,* is a homophone for the verb *kiku,* to hear. With humor, Sengai gently leads the viewer to contemplate how thoughtlessly one accepts the reality of what one sees and experiences. In Buddhist thought, the phenomenological world is one of illusion. Only by detaching oneself from the ephemeral constructs of the world can one achieve enlightenment. A similar, startling humor is demonstrated in Sengai's calligraphy, "Bamboo, hard on the outside and nothing on the inside," also in the Indiana University Art Museum's collection.[2]

Sengai's calligraphy was much admired, even in his lifetime. People from both lay and monastic communities would arrive at his residence with gifts of paper, hoping that he would write something for them. And what was Sengai's response to his fame?

> To my dismay
> I wonder if my small hut
> is just a toilet—
> since everyone who comes here
> seems to bring me more paper![3]

Futher Reading
Addiss, Stephan. *The Art of Zen: Paintings and Calligraphy of Japanese Monks, 1600–1925.* New York: Harry N. Abrams, 1989.
Furuta, Shōkin. *Sengai, Master Zen Painter.* Translated, adapted, and with notes and commentary by Reiko Tsukimura. Tokyo, New York, and London: Kodansha International, 2000.
Suzuki, Daisetz T. *Sengai the Zen Master.* With editorial and prefatory notes by Eva van Hoboken, Sazo Idemitsu, Basil Gray, and Herbert Read. Greenwich, Conn.: New York Graphic Society, 1971.

Notes
1. Shōkin Furuta, *Sengai, Master Zen Painter,* translated, adapted and with notes and commentary by Reiko Tsukimura (Tokyo, New York, and London: Kodansha International, 2000), 16.
2. The Art Museum's accession number for this piece is 73.9.
3. Stephan Addiss, *The Art of Zen: Paintings and Calligraphy of Japanese Monks, 1600–1925* (New York: Harry N. Abrams, 1989), 179.

Donkyō (signed Unkei)
Japanese, d. 1810

Plum Branches
Ink on paper
26 7/16 x 11 1/4 in. (67.1 x 28.5 cm)
26 1/4 x 11 1/4 in. (66.6 x 28.5 cm)
Gifts of Charles Page, 69.31.1 and .2

Since 1969, when this pair of paintings was acquired, there have been various attempts to assign them a country of origin and to identify the painter. Was this talented artist Chinese, Korean, or Japanese? Artists from East Asian countries used similar painting techniques and materials, and they painted similar subject matter.

The eccentric and twisted branches of the plum tree, with new growth emerging from old limbs, created a challenge for painters, for an ill-formed line was not just an indication of poor draftsmanship, but of deficient moral character. The plum was often used as a metaphor for the Chinese Confucian bureaucrat. Just as the plum tree hidden behind the high walls of a residential compound reveals itself by its sweet scent, so, too, is the superior virtue of the Confucian bureaucrat revealed in even his smallest action. Also, the plum, which blooms in February, is considered stalwart and persevering—both good Confucian virtues—as it braves the winter while sending forth its delicate blossoms. Plum imagery also occurs in Buddhist traditions, where it symbolizes the enlightenment of the historical Buddha, Shakyamuni.[1] China, Korea, and Japan all produced painters who excelled at depicting plums.

The dealer who sold the paintings to the donor thought that they were Japanese, painted by a member the Kano school. The Kano school, whose beginnings can be traced to the fifteenth century, specialized in Chinese-style ink painting. The school produced many fine painters well into the nineteenth century. The dealer probably arrived at this attribution from information given to him when he bought the paintings or, if he could read Japanese, from the pamphlet and small packet of folded paper found in the box in which the paintings are kept.

The pamphlet, which appears to be an auction notice, includes a photograph, lot listing, and an attribution to Kano Un'en. The packet of paper contains two inscriptions of authenticity, ostensibly by Kano Tan'yū (1602–74), which also identify the artist as Kano Un'en. The paper on which the inscriptions are written is, however, suspiciously new, clean, and crisp. The calligraphy purportedly by Tan'yū, a master painter and calligrapher, is weak, and Tan'yū's red seal is badly cut and blurry. In other words, the attribution is unconvincing. A small, gummed label inside the box lid, written in English, reads "Ming," referring, no doubt, to the Chinese Ming dynasty (1368–1644). Although the painting was attributed to a Japanese painter at the time it was auctioned, at some other point in its history it was thought to have been Chinese.

Since the IU Art Museum purchased the paintings, various scholars have been consulted, the seals deciphered, the poems read, and the artist's style studied. One scholar determined the paintings to be Chinese; another suggested that they were painted by a Chinese monk named Yang Yunqing, who visited Japan in the fifteenth or sixteenth centuries. Another believed that they were Japanese, but could find no painter named (according to the way he read the seals) Yō Unkei.

I, too, was puzzled and I, too, asked various scholars to examine the paintings. Then I did what I should have done in the first place: dismissed everything that had been said and started from the beginning. On closer examination, I found that the auction record transcribed the second character of the painter's name incorrectly, creating the erroneous reading of the character as "un" rather than "kei." One of the aforementioned scholars correctly read the seals on the paintings as "Unkei." Unkei is one of the names used by a Japanese painter named Donkyō (d. 1810), who lived in Kyoto most of his life and painted in the style of the Chinese Ming dynasty painter Zhang Ruitu (1570–1641).

Donkyō's admiration and close imitation of a Ming painter's style obscured the attribution of this pair of paintings to a Japanese painter. Additionally, Japanese artists' habit of using a variety of art names or pseudonyms makes identifying an artist difficult. For the moment, until new evidence emerges, Donkyō painted this pair of beautiful plums. The next task is to find the source for the poems!

> Weird ethereal piping sweeps Jade Pass.
> My old friend a thousand leagues away—when will he return?
> Fan Lang wishes to convey tidings of south of the river.
> His face full of breeze and light is abloom with joy.
>
> Sparse clear silhouette conjoins with silvery sky.
> That jade's frozen figure: its quality the same.
> It is not that its deep roots make it hard to transplant,
> The moon goddess pushed it into a very chill palace.

Note
1. Helmut Brinker and Hiroshi Kanazawa, trans. Andreas Leisinger, *Zen Masters of Meditation in Images and Writings* (Zürich: Artibus Asiae Publishers, Supplementum 40, 1996), 41–45.

Soga Shōhaku (signed Kiyō)
Japanese, 1730–1781

Palm
Ink on paper
83 x 26 ¹/₄ in. (210.8 x 66.6 cm)
72.71.1

The blunt, bold brushstrokes, compressed angle of view, and dynamic contrast between the saturated black ink of the fronds and the pearl gray washes of the trunk and background make this painting of a palm tree seem to explode off the paper. This dynamism is further heightened by the calligraphy, which vibrates with suppressed energy, and the inky black strokes, which punctuate the surface. The eccentric and abbreviated cursive style of writing makes the inscription very difficult to decipher, but the last three characters, reading from right to left and from top to bottom, are "Kiyō ga" ("painting by Kiyō"), and the red seal that follows is variously read as "Jasokuken" or "Dasokuken."[1] Kiyō is one of several names used by the eighteenth-century artist Soga Shōhaku. According to scholars who have studied Shōhaku's oeuvre, this seal appears on works painted during the last decade of Shōhaku's life, when he was in his forties.

Although biographical information about Shōhaku is scant, we know that he trained with a minor member of the Kano school, Takada Keiho (1674–1755). The Kano school traces its origins to Kano Masanobu (1434–1530), a Japanese painter who emulated Ma Yuan and Xia Gui, two late twelfth- to early thirteenth-century Chinese painters. Subsequently, Kano Masanobu's son, Motonobu, and great-grandson, Eitoku, organized efficient workshop practices and developed large-scale, room-sized compositions of birds and flowers or Chinese sages. Although Kano school artists did, on occasion, use brilliantly colored pigments, the school is most associated with monochromic paintings, and its best painters are admired for their strong brushwork. We don't know when Shōhaku began his training with Keiho, but we do know, because of their relative ages, that Shōhaku's period of instruction could have been quite short, perhaps as short as five years. Keiho died when Shōhaku was just twenty-six.[2]

Judging from the great number of his paintings that survive, Shōhaku was prolific as well as innovative. He worked most of his life in Kyoto, although from the paintings still located in temples and shrines on the Ise Peninsula, we assume that he spent time there, as well. His family name was Miura, but at some point in his twenties he appropriated the name "Soga," suggesting that he felt or perhaps wanted to create a connection with the family of painters active during the Muromachi period (1392–1573), whose brushwork was strong and dynamic. Over the course of his career, he appropriated other titles, as well.

Soga Shōhaku belongs to a group of eighteenth-century Japanese painters called "eccentrics" by virtue of their idiosyncratic painting styles and, frequently, matching personalities. Literary sources written in the Edo period (1615–1868) refer to Shōhaku's odd behavior and painting style but also admit to his talent and admire his technique, as in this comment written by Japanese critic Okada Chūken (d. 1824):

> Soga Shōhaku: Native of Ise *[sic]*. He traveled about widely in the Kyoto and Setsu regions, and people regarded him as a lunatic. His paintings were multiform and free. In his "grass" style paintings, there are some where he applied ink to a straw (brush) and literally swabbed about. On the other hand, when it came to painting meticulous work, others could not equal him.[3]

Shōhaku derived the majority of his subject matter—sages, poets, and hermits—from Chinese paintings and literature. His figures are wild, often unkempt and deranged. Many of his paintings are very large, suggesting that he had wealthy patrons who were not offended by his unorthodox style. Shōhaku also painted landscapes as well as small paintings, such as our *Palm.*

Further Reading
Rosenfield, John M., in collaboration with Fumiko Cranston. *Extraordinary Persons.* Cambridge: Harvard University Art Museums, 1999
Soga Shōhakuten (Exhibition Soga Shōhaku). Edited by Tsuji Nobuo, Ito Shiori, and Sato Miki. [Tokyo]: Asahi Shimbun, Cultural Projects Division, 1998.

Notes
1. The first two characters in the first line of calligraphy may read "Miura," Shōhaku's family name.
2. *Soga Shōhakuten (Exhibition Soga Shōhaku),* ed. Tsuji Nobuo, Ito Shiori, and Sato Miki ([Toyko]: Asahi Shimbun, Cultural Projects Division, 1998), 189.
3. Money L. Hickman, "The Paintings of Soga Shōhaku (1730–1781)." (PhD diss., Harvard University, 1976), 23.

Sadaoka Gakutei
Japanese, 1786(?)–1868

First Companion of the Writing Chamber Ink
ca. 1827
Surimono; ink, metallic powders, and color on paper
8 ¼ x 7 ¼ in. (20.9 x 18.4 cm)
70.4.73

Sadaoka Gakutei (also called Yashima Gakutei), the illegitimate son of a samurai, was both a poet and a print designer who specialized in limited edition woodblock prints called *surimono*. These luxurious prints were commissioned for special occasions by private clubs and distributed to their members. The prints could commemorate events such as musical performances, poetry competitions, the debut or retirement of an actor, or the arrival of the New Year.

This exquisite print, originally one of a set of eight collectively entitled *Four Companions of the Writing Chamber,* was commissioned by the Ichiyō Poetry Circle *(Ichiyōren bumpō shiyū)*. The phrase "four companions" refers to paper, ink, the stone for grinding ink, and brush—in other words, the essential equipment for writing. The set of prints likely included poems and figures of four Chinese poets and four Japanese poets. Our print, *Ink,* depicts the Japanese poet Ono no Komachi, who was active in the mid-ninth century. Little verifiable information about Komachi's life survives (though legends abound) beyond the fact that she was an aristocrat in the Heian court (794–1185) and a poet of distinction, renowned even in her own time. Fewer than two dozen poems are firmly attributed to Komachi, most of which are collected in the *Kokinshū,* an early tenth-century imperial anthology of Japanese poetry.

In this *surimono,* Ono no Komachi is seated on the floor with a basin in front of her, a book in her hands, and many layers of clothing flowing around her. This scene represents the climactic moment of a legend dramatized in the Nō play *Sōshi Arai Komachi* (which translates as *Komachi Washing the Book* but is sometimes called *Komachi Clears Her Name),* attributed to the playwright Zeami (ca. 1364–ca. 1443). In this legend, Ono no Komachi and the courtier Ōtomo Kuronushi are pitted against each other in a poetry contest. To improve his chances, Kuronushi decides to spy on Komachi, hoping to hear her recite the poem on which she has been working. When he hears her composition, he cunningly plots to discredit and humiliate Komachi. Committing the overheard poem to memory, Kuronushi inscribes Komachi's poem in an eighth-century poetry anthology, the *Manyōshū*. At the next day's competition, after Komachi recites her poem,

> Sown by no one, from what seeds grow the floating grasses
> Luxuriating on the undulating ripples[1]

Kuronushi accuses her of plagiarism and produces his copy of the *Manyōshū* as proof. Komachi, bewildered, looks at the text and sees the poem she has just written. However, when she looks closely, she sees that the calligraphy is different from that of the other poems on the page. She says that she wishes she could wash the lines away. Her

wish can be understood in two ways: metaphorically, that her shame is erased, and literally, that the words disappear. A basin is brought to Komachi, and she dips the book in water.

Since Kuronushi has just written the poem, the ink, still wet, begins to dissolve. Komachi's reputation is saved.

At the top of Gakutei's print, to the left of the title, are two poems written, no doubt, by members of the Ichiyō poetry club. The first poem reads:

> The scent of plum blossoms,
> reflected in the water,
> permeates the book
> I wash in the undulating ripples
> > Kagakutei (pen name) Kōbun

The second poem reads:
> A warbler adds his song
> to the stream below
> the extraordinarily fragrant plum
> > Karindō (pen name)

The form—and often the pleasure—of a Japanese poem depend on complicated word plays and references. In Japanese, the last line of vertical script in Kagakutei's poem reads as *"nami no une une." Une une* are onomatopoetic words that create the sound and sense of lapping water. A contemporary audience would have immediately identified this line as borrowed from the poem attributed to Komachi in the Nō play noted above.

In addition to providing literary allusions that tease the intellect, these special edition prints are visually pleasing. Because these were privately funded and made in limited numbers, a great deal of money was spent on their materials and production. Professional printers carefully modulated the color gradation of the pink clouds and achieved flawless registration. Blind (or intaglio) printing as well as gold and silver powders give these prints an especially rich surface. Even the printed frame, decorated with repeating plum blossoms of shimmering silver and the character for literature, *bun,* of the Ichiyō poetry club, adds another layer of enjoyment to the experience of this print.

Note

1. Ono Komachi, *Poems, Noh Plays/Ono no Komachi*, trans. by Roy E. Teele, Nicholas J. Teele, and H. Rebecca Teele (New York: Garland Press, 1993), 102.

Tōshūsai Sharaku
Japanese, fl. 1794–95

The Actor Osagawa Tsuneyo II as Kojima
1794
Woodblock print; ink and color on paper
12 x 6 ¹/₈ in. (30.4 x 15.5 cm)
70.4.68

Sharaku is the most mysterious of all Japanese print designers. His prints appeared suddenly in May 1794, and just as suddenly they disappeared from view in January 1795. In a career that spanned less than a year, he produced about 150 prints, a few paintings, and preparatory drawings. He worked exclusively for the Edo publisher Tsutaya Jūsaburō (1750–1799), whose regard for Sharaku's talent is evidenced by his luxury editions of the artist's prints with expensive mica backgrounds. We know nothing about Sharaku's training or his activities before and after his brief foray into the world of woodblock prints. Scholars have combed Edo period (1615–1868) literature for references to Sharaku and have found very little with which to frame a biography. Tantalizing tidbits of information are scattered throughout a number of nineteenth-century texts—some suggest that Sharaku may have been a Nō actor—but the evidence is slim and, finally, inconclusive.[1]

This print is very rare—it may be one of only two worldwide, and possibly the only one in an American collection.[2] Recently cleaned and conserved, the IU Art Museum's example is published here for the first time. The subject is the actor Osagawa Tsuneyo II in his role as Kojima, the wife of Bingo Saburō, disguised as an assistant gardener. The print originally formed the right-hand part of a triptych, with the actor Ichikawa Komazō II in the role of Nitta Yoshida in the center and the actor Iwai Hanshirō IV as Chihaya on the left. The triptych dates to the eleventh month of Kansei 6 (December 1794) and was produced in conjunction with the Kabuki play *Matsu wa Misao Onna Kusunoki,* presented at the Kawarazaki theater in Edo (modern-day Tokyo).[3] The print is one of twelve that Sharaku designed for the play.

The triptych represents a departure in style from Sharaku's earlier works. The figure is set against plain paper rather than a mica ground, the result of a governmental ban on expensive or luxurious materials.[4] This is also the first set of prints in which Sharaku included a prop in the background—in this case a maple tree that serves to tie the three prints together.

Although some connoisseurs and scholars argue that Sharaku's prints diminished in quality after the eleventh month of Kansei 6, this print is a little gem. Sharaku drew Tsuneyo's strong face—with its large nose and long, pointed chin—with fine lines, giving the face an air of delicacy in contrast to the bold lines of the kimono and obi. One has a sense of the actor's own physiognomy as well as the personality he was depicting. In this respect, Sharaku's approach was markedly different from that of his contemporaries, who subordinated the physicality of the actor to the role he was playing. This is especially true of depictions of female impersonators *(onnagata),* whose masculine faces were softened to reflect the beautiful women whom they portrayed.

Some contemporary viewers thought that Sharaku's work was too realistic. For example, in Sasaya Kuninori's revision of the text *Ukiyo-e Ruikō,* first published in the late eighteenth and early nineteenth centuries, he writes, "Sharaku designed likenesses of Kabuki actors, but because he depicted them too truthfully, his prints did not conform to accepted ideas, and his career was short, ending after about a year."[5] Perhaps critics thought that Sharaku's designs were marred by his attention to the actor, rather than the role. For his admirers, it is just this tension between stylization and portraiture, fully realized in this print, that sets Sharaku apart from other artists of his time.

Further Reading
Henderson, Harold G., and Louis V. Ledoux. *The Surviving Works of Sharaku.* New York: E. Weyhe on behalf of the Society for Japanese Studies, 1939.
Lane, Richard. *Images from the Floating World: The Japanese Print.* Secaucus, N.J.: Chartwell Books, 1978.
Narazaki, Muneshige. *Sharaka the Enigmatic Ukiyo-e Master.* Translated by Bonnie F. Abiko. Tokyo, New York, and San Francisco: Kodansha International, 1983.
Thompson, Sarah E., and H. D. Harootunian. *Undercurrents in the Floating World: Censorship and Japanese Prints.* New York: The Asia Society Galleries, 1991.

Notes
1. Muneshige Narazaki, *Sharaku the Enigmatic Ukiyo-e Master,* trans. Bonnie F. Abiko (Tokyo, New York, and San Francisco: Kodansha International, 1983), 37–44.
2. Richard Lane, *Images from the Floating World: The Japanese Print* (Secaucus, N.J.: Chartwell Books, 1978), 126.
3. Ibid., 126, sidebar to fig. 123.
4. Harold G. Henderson and Louis V. Ledoux, *The Surviving Works of Sharaku* (New York: E. Weyhe on behalf of the Society for Japanese Studies, 1939), 23. See also Sarah E. Thompson and H. D. Harootunian, *Undercurrents in the Floating World: Censorship and Japanese Prints* (New York: The Asia Society Galleries, 1991), 59.
5. Muneshige Narazaki, op. cit., 43.

THE PRE-COLUMBIAN AMERICAS

The museum's Pre-Columbian collection offers a representative survey of the major cultures of Mesoamerica (the area from northern Mexico to the Gulf of Nicoya in Costa Rica) and Peru, and a sampling of objects from the so-called Intermediate Area, the region between Mesoamerica and Peru. Though relatively small, the collection contains typical forms represented by outstanding works of art.

Pre-Columbian art, also sometimes called "art of the ancient Americas," refers to artworks from the Americas before the coming of the Europeans in the sixteenth century. In spite of the allusion to Columbus, however, the end date for Pre-Columbian art is actually later than that explorer's fifteenth-century travels in the New World. Instead, by convention, the terminating date in Mesoamerica is 1519, when Hernán Cortes invaded the Aztec capital, Tenochtitlan (the site of present-day Mexico City); in Peru, it is marked by Francisco Pizarro's defeat of the Inca Empire in 1532.

Neither "Pre-Columbian art" nor "art of the ancient Americas" is an entirely satisfactory term. "Ancient" certainly suggests a period before European contact; however, accustomed to using the term in relation to the arts of Egypt, the Near East, Greece, and Rome, some may argue that placing objects created as late as the sixteenth century in that category renders it meaningless. Likewise, "Pre-Columbian" clearly indicates a pre-European period; however, in addition to the fact that "Pre-Columbian art" includes objects made for decades after Columbus's voyage, some people have objected to the use of a term that classifies artworks that span nearly three thousand years and many cultures in terms of a single relationship having nothing whatsoever to do with most of the artworks or the peoples who produced them. Nevertheless, as a generally accepted, if flawed, term of long standing, "Pre-Columbian" is used here.

Archaeologists have established chronological periods as a framework for organizing and understanding Pre-Columbian cultures. They conceive of Mesoamerica in three broad periods, which vary somewhat from area to area and are subdivided for specific cultures: Pre-Classic (also known as Formative), 1200 BC–AD 300; Classic, 300–1000; and Post-Classic, 1000–1521. Likewise, though archaeological fieldwork has been less extensive in most of the Intermediate Area and Peru than in Mesoamerica, scholars have generally found patterns that correspond to those to the north: cultures flourished at different times in different areas. In Peru, the periods are conventionally referred to as Early Horizon, 1000–200 BC; Early Intermediate, 200 BC–AD 600; Middle Horizon, 600–1000; Late Intermediate, 1000–1400; and Late Horizon, 1400–1532.

We tend to think of the Pre-Columbian epoch in terms of the rise and fall of individual cultures such as Teotihuacan during the Classic period or the Inca during the Late Horizon—but in most cases the situation is more accurately described as cultures that span the periods, waxing and waning in influence and power. Thus, for example, the Maya reached the high point of their expansion during the Classic period, but Maya culture existed in both the Pre-Classic and Post-Classic periods.

Similarly, a clear picture of Pre-Columbian Peruvian cultures requires the consideration of changes over time within regions, which consist of the northern, central, and southern coasts and highlands. In addition, though a particular culture was centered in a particular area, its reach frequently extended beyond. The Olmec objects included here very clearly illustrate that point: the Olmec heartland was on Mexico's Gulf Coast, but these objects were found in Olmec-influenced areas in the interior.

Many, if not most, objects that survive were part of burials, made either specifically for interment or as personal effects or regalia that had been important to the deceased when he or she was alive. In most cases, the objects belonged to the religious and political elite. These people were often one and the same, for rulers were considered the embodiments of gods, and priests played important roles in determining when and where battles would be fought and trading would take place.

Because most of these objects were buried, it is no surprise that those made of stone, clay, or metal have survived in the greatest numbers. Organic materials such as wood, fiber, and feathers have been preserved primarily in the dry burial caves of the Andes, making objects of less permanent materials that originated in the more humid region of Peru's north coast—such as the Moche ceremonial digging stick—rarities.

Most Pre-Columbian cultures had disappeared long before the arrival of the Spanish explorers, so much of our information about them comes from objects and architectural remains that were left behind, as interpreted by researchers such as archaeologists, art historians, and anthropologists. Unfortunately, most objects in art museum collections, including the IU Art Museum's, were not found in controlled excavations, and thus much information about them has been lost forever: even basic attributions to their culture of origin most often have been made on the basis of stylistic comparisons.

Diane M. Pelrine
Class of 1949 Curator of the Arts of
Africa, Oceania, and the Americas

Olmec style, Tlapacoya or Morelos, Mexico

Bowl
Early Formative period, 1200–900 BC
Clay, pigment
Diam. 7 1/4 in. (18.4 cm)
Raymond and Laura Wielgus Collection, 81.32.3

Rollout drawing of the bowl. Drawing: Brian Garvey

This well-preserved bowl is one of the most beautifully incised and proportioned of a group of early Formative-period cylindrical, flat-bottomed bowls found in central Mexico but clearly related to the Gulf Coast Olmec, the most widely recognized of Mesoamerica's Formative cultures. Created from gray clay and covered with a slip coating that fired white to buff in color, the bowl has thin walls masterfully incised with two identical heads in profile view separated by identical arrangements of v-shaped motifs.

The two faces are a version of the Olmec were-jaguar, a little-understood Olmec image. Seen in a number of variations, in a variety of media, it may refer to the mythological mating of a woman with a jaguar or to a totemic ancestor, or, by creating a visual and conceptual link with the jaguar—the most powerful creature in the Olmec physical world—it may simply be a convention indicating a powerful supernatural being. Whatever its significance, the motif is characterized by a downward-turning mouth, with upper lip pulled back as if snarling.

In the most extensive study to date of Olmec iconography, Peter David Joralemon identified 182 motifs related to the were-jaguar image on Olmec-style objects and then analyzed how those motifs were combined.[1] In that study, he identified the particular combination of features seen on this depiction—profile view, cleft head (on this example, the cleft is at the back of the head), almond-shaped eye with a round iris, a band through the eye, and an open toothless mouth with prominent gum ridges—as associated with a figure that he termed God VI, a designation he later changed to the Banded-Eye God. Joralemon associated this deity with spring and renewal, suggesting that the eye band could identify the image as an early version of Xipe Totec, the Aztec god of spring, who is depicted with similar bands. However, other deities were also depicted with eye banding, and therefore the band may not be the identifying feature for this image. Instead, the cranial cleft may be the more salient feature. That cleft has been interpreted as indicating an aspect of the Maize God that emphasizes the period of foliage growth, before a mature ear of corn is ready to be picked, and, alternatively, as a marker for one aspect of the earth—the earthquake—with the cleft representing a fissure in the earth.[2]

Pottery such as this has become part of a heated debate in the field of Olmec studies as to whether the Olmec should continue to be viewed as the "mother culture" of Mesoamerica, or whether it should more properly be considered as a "sister culture." According to the latter point of view, Olmec culture did not dominate during the Formative period or later, but instead it was one of several influences that contributed significantly to the development of Pre-Columbian thought and culture. Supporters of this theory point to the absence of certain kinds of ceramics, including finely made white-glazed bowls such as this one, in the Olmec heartland along the Gulf Coast, as well as complex iconography that is clearly connected to Olmec motifs such as the were-jaguar but different from anything that has been found along the Gulf.

This bowl and another very similar one were first published in Michael Coe's seminal *Jaguar's Children,* where he noted that the bowls were said to have been found together in the state of Morelos. However, Coe is convinced that, though the bowls might have been found there, they were most certainly made in Tlapacoya, a site south of Mexico City in nearby Puebla. Bowls of this type are said to have been found in both places, but Tlapacoya seems to have been the center of their manufacture. During construction of the Mexico-Puebla Highway in 1958, many fragments of similar bowls as well as complete vessels were found there, though not in an archaeological context. Raymond and Laura Wielgus purchased this bowl in 1962 from the dealer Everett Rassiga. Rassiga had acquired it from George Pepper, who had collected objects from that area during highway construction.[3]

Further Reading
Diehl, Richard A. *The Olmecs: America's First Civilization.* London: Thames and Hudson, 2004.

Notes
1. Peter David Joralemon, *A Study of Olmec Iconography.* Studies in Pre-Columbian Art and Archaeology 7 (Washington, D.C.: Dumbarton Oaks, 1971).
2. Karl A. Taube, *Olmec Art at Dumbarton Oaks,* Pre-Columbian Art at Dumbarton Oaks 2 (Washington, D.C.: Dumbarton Oaks, 2004), 97–98; and Kent V. Flannery and Joyce Marcus, "Early Formative Pottery of the Valley of Oaxaca," *Memoirs of the University of Michigan Museum of Anthropology* 27 (1994): 136–49.
3. Michael D. Coe, *The Jaguar's Children: Pre-Classic Central Mexico* (New York: Museum of Primitive Art, 1965), 28, and personal communication, May 24, 2007.

Olmec style, Santa Cruz, Mexico

Vessel in the Form of an Old Woman
Early Formative period, 1200–900 BC
Clay, pigment
H. 8 1/2 in. (21.6 cm)
Raymond and Laura Wielgus Collection

With its gaping mouth that forms a spout and a body that is simultaneously swollen and skeletal, this vessel presents a tremendously powerful image. It is believed to come from Santa Cruz, one of many sites in central Mexico where objects generally considered to be in Olmec style have been found. Located along the Cuautla River in the state of Morelos, Santa Cruz is a Formative site contemporary with Tlatilco in the central Valley of Mexico and is renowned for ceramics of laudable artistry and technical skill.

While female figures called "pretty ladies" are among the best-known objects from Mexico's Formative period and are the most commonly displayed Formative objects in museum collections, they are entirely different from this woman. These small, frequently solid clay sculptures were made in a large number of styles—most are frontal, symmetrical, generalized depictions—and they have been found in large numbers at many places, most famously at Tlatilco, but also at Teotihuacan, Monte Albán, Las Bocas: nearly everywhere early agriculturalists settled. The overwhelming majority of these "pretty lady" figures seem to depict younger people.

Images of old women are rare throughout Mesoamerica, and those in the form of vessels are even less common. Figures from Las Bocas in the Mexican highlands and also from La Venta, one of the major Olmec Gulf Coast centers, show similar wrinkled faces, pendulous but deflated breasts, prominent ribs, and thin limbs. Another example from Las Bocas is also in the form of a vessel, though the figure is seated rather than kneeling like this one.[1]

That kneeling posture is the traditional one taken by Mexican Indians for giving birth, suggesting that the very swollen stomach might indicate pregnancy. The pose is not exclusive to childbirth, however, and Olmec scholar David Peter Joralemon, who has studied the old-woman theme extensively, points out that the figure might portray an aged woman with an illness resulting in a bloated stomach or a priestess or other religious practitioner with a similar affliction. Here Joralemon is in the company of other scholars who have speculated that certain Formative period ceramic images in fact depict deformities or illnesses. Another interpretation proposes that this powerful sculpture, with enlarged stomach but otherwise skeletal body, depicts a person on the verge of death from starvation, her open mouth begging for food.[2]

The possibility that the figure combines the themes of old age and birth suggests yet one more intriguing interpretation: these two contrasting aspects of womanhood united in a single image may refer to a deity appearing throughout Pre-Columbian Mexican cultures. She is the mother of all gods and humans, who, along with her consort, determines exactly when each person will be born, and, in doing so, seals that person's fate. This deity was revered as older than creation and was associated with midwifery, making an image such as this one an entirely appropriate likeness.

This very commanding image also illustrates a more general theme that begins in the Formative period and continues thereafter in Mexico, right up to the time of the Aztecs. As a study in contrasts of the fleshy components of a living person joined to skeletal ones, it unifies in a single sculpture elements not normally found together in nature. Such conceptual complexities suggest sophisticated spiritual beliefs or philosophical perspectives that seem to have been an important part of ancient Mexican life.

Further Reading
Joralemon, Peter David. "The Old Woman and the Child: Themes in the Iconography of Preclassic Mesoamerica." In *The Olmec and Their Neighbors: Essays in Memory of Matthew W. Stirling,* 163–80. Edited by Elizabeth P. Benson. Washington, D.C.: Dumbarton Oaks, 1981.

Notes
1. See Peter David Joralemon, "The Old Woman and the Child: Themes in the Iconography of Preclassic Mesoamerica," in *The Olmec and Their Neighbors: Essays in Memory of Matthew W. Stirling,* ed. Elizabeth P. Benson (Washington, D.C.: Dumbarton Oaks, 1981), 163–80, especially figs. 1, 2; and Douglas E. Bradley and Peter David Joralemon, *The Lords of Life: The Iconography of Power and Fertility in Preclassic Mesoamerica* (Notre Dame, Ind.: Snite Museum of Art, 1993), cat. no. 7.
2. These and the interpretation in the next paragraph are suggested in Joralemon, "The Old Woman," op. cit., 177, 179, and in Michael D. Coe et al., *The Olmec World: Ritual and Rulership* (Princeton: Princeton University Art Museum, 1995), 328.

Oaxaca, Mexico

Bowl in the Form of a Head
Monte Albán I, 800–100 BC
Clay
H. 4 3/4 in. (12.1 cm)
Raymond and Laura Wielgus Collection, 81.32.4

The expressive quality and fine craftsmanship of this bowl are matched by very few ceramics from Monte Albán, the ancient ceremonial center in southern Mexico's state of Oaxaca. Like the best-known ceramics from Monte Albán, which are urns in the form of figures (p. 162), this bowl is grayware, and like the urns of similar date, it is a relatively simple, though enigmatic, image.

Both human and animal forms are depicted on ceramics from the Monte Albán I period, and it is not entirely clear which is portrayed here. While some scholars refer to this and similar depictions simply as old men or gods, Michael Coe, a leading authority on Pre-Columbian art, suggests that the face may represent one of two characters.[1] The first is the Old Fire God, a deity who may have originated with the Olmec, Mesoamerica's "mother culture," which dominated Mexico's Gulf Coast from around 1500 BC to around 500 BC. Centuries later, among the Aztecs (the dominant central Mexican culture when the Spanish arrived in 1519), the Old Fire God was associated with home hearths and the domestic side of fire. The wrinkled face and large holes for earspools are features characteristic of the Aztec version of that deity, although scholars are not certain how far back his lineage extends.

Coe suggests alternatively, that the face on the bowl might not be a human at all, but rather a monkey deity who was the patron of scribes, artists, dancers, and musicians among the Maya, another important Pre-Columbian culture that flourished around AD 300–900. Like the Old Fire God, this deity has not been found in Monte Albán, but his depiction on later ceramics tends to include holes for earspools and facial lines similar to those on this vessel. Yet another deity, also not known during Monte Albán I, but originating in Oaxaca, might be the subject: although not positively identified until a later phase in Monte Albán's history, a deity taking the form of an old man—complete with wrinkles—appears on funerary urns.[2]

The elegantly integrated knob of a horn projecting up from the top of the forehead adds a complicating factor to the identification. Horns and hats that look like horns have been identified by scholars as emblems of shamanism.[3] Believed to be the prominent spiritual practice throughout the early periods of Pre-Columbian Mesoamerica, shamanism was the foundation for the flowering of deities that later characterized Monte Albán and the rest of Mesoamerica, and it remained a vital and highly respected institution well into the modern period. Its practitioners were charged with healing and the spiritual and psychic well being of their communities, and they continued to work alongside the priests of more elaborated formal religions. The horn on this bowl may well refer to the power and authority of shamanism, even as the image may represent the early emergence of a deity. It might also be the insignia of an owner who was closely associated with the practice.

The style of many of the anthropomorphic ceramics from this period shows affinities with the Olmec. Scholars disagree as to whether the similarities between Olmec objects and those from other areas such as Monte Albán, in the southern highlands, should be explained as reflecting Olmec influence or as resulting from the physical settlement of people from the Gulf Coast, but Olmec culture is believed to have interwoven with the indigenous cultures of other regions, resulting in objects and practices that appear to be Olmec-related. In Monte Albán, for example, faces may have narrow, often slanted eyes and downturned mouths, the latter represented on this bowl.

As throughout the Pre-Columbian Americas, this bowl was made by hand, without the use of a potter's wheel, which was unknown. Its fine gray clay marks it as a ceremonial object, rather than utilitarian pottery, which was made of yellow and brown clays. The incised lines were no doubt the last details to be cut into the surface of the leather-hard clay before it was fired. Firing, probably in an open pit with grass and kindling, was at a relatively low temperature.

Further Reading
Boos, Frank H. *The Ceramic Sculptures of Ancient Oaxaca.* South Brunswick, N.J.: A. S. Barnes, 1966.
Miller, Mary. *The Art of Mesoamerica from Olmec to Aztec.* 3rd ed. London: Thames and Hudson, 2001.

Notes
1. Michael D. Coe, "The Art of Pre-Columbian America," in *African, Pacific, and Pre-Columbian Art in the Indiana University Art Museum* (Bloomington: Indiana University Art Museum, 1986), 13.
2. Frank H. Boos, *The Ceramic Sculptures of Ancient Oaxaca* (South Brunswick, N.J.: A. S. Barnes, 1966), 142–50.
3. See, for example, Peter Furst, "Shamanistic Symbolism, Transformation, and Deities in West Mexican Funerary Art," in *Ancient West Mexico: Art and Archaeology of the Unknown Past,* ed. Richard F. Townsend (New York: Thames and Hudson, 1998), 169–89.

Zapotec culture, Oaxaca, Mexico

Urn in the Form of a Seated Figure
Monte Albán II, 200 BC–AD 200
Clay
H. 11 7/16 in. (29.1 cm)
Raymond and Laura Wielgus Collection

As with the earlier bowl in the form of a head that is also from Oaxaca (p. 160), this urn figure can best be described as compelling but enigmatic. It is a type associated with the Zapotec people who built the ceremonial center of Monte Albán, the largest ancient American site in the state of Oaxaca. Beginning in the Formative period, the Zapotec of Monte Albán dominated the Valley of Oaxaca and beyond until the Post-Classic period, when the Mixtec, who had been living west of the valley, took control of much of it.

Ceramic figural urns, ranging from less than three inches tall to nearly life-size, are perhaps the best-known portable art from Oaxaca. Most have been found in tombs as part of elite burials, though some were also placed in the floors of ceremonial complexes and buried in boxes. Those in tombs were usually arranged in groups on the floor, with several smaller figures surrounding a larger one. The urns show no evidence of having held food, drink, human remains, or incense, although some have been found with offerings of small objects, such as carved jade.

By the Early Classic period (Monte Albán IIIa, ca. 200–400), what are considered typical Zapotec figural urns are readily recognizable: figures seated cross-legged, hands on knees, looking forward, wearing elaborate headdresses that became increasingly intricate over time. Zapotec figural urns from the Classic period are also made as if in two parts, with the figures attached to the fronts of the vessels, usually totally obscuring the containers when the figures are viewed frontally. In addition, during the Classic period, ceramicists began assembling urns from mold-made elements instead of modeling them entirely by hand.

While full-figure anthropomorphic containers are by no means unique to the Zapotec (see p. 158 for an Olmec example), this urn shares enough of the traits associated with Classic Zapotec urns to indicate that it is from the same tradition, but earlier. It was made from similar gray clay, and the figure is in a similar pose. Like other urns made before the Classic period, this one is entirely handmade, and the figure does not have an elaborate headdress. Moreover, here, the figure and urn are one and the same, a feature that was typical until the end of the Formative (Monte Albán II) period.

Who or what does this figure represent? In tombs, larger figures are believed to represent-deities, and the accompanying smaller ones, so-called "companions," are thought to represent priests, priestesses, and other devotees. Some figures and urn figures from the area have glyphs incised on the bodies or headdresses that allow identification, but none is present on this figure. For later figures, elements of the elaborate headdresses may point to a particular deity, but this one is plain, with no added ornaments. Furthermore, its unique facial features set it apart.

The figure, though, does have one feature often seen on those from the Classic period that can help in identification: the mouth mask. These masks were not worn to conceal the identity of the wearer, but rather were worn as references to specific deities. Based on the form of this mask, the eminent Pre-Columbian scholar Alfonso Caso, who excavated Monte Albán between 1931 and 1949 and also worked in other parts of Oaxaca, associates it with a serpent deity that he believed was an early manifestation of the feathered serpent, a deity known as Quetzalcoatl by the Aztecs, but who was also important among earlier Pre-Columbian peoples.[1] Frank Boos, who used the extensive work of Caso and Ignacio Bernal on Oaxaca urns to classify the gods represented on them, suggests however, that the distinctive eyebrows in conjunction with this mask indicate instead that the depiction refers to a goddess who is the female counterpart of Caso's male serpent deity.[2]

The difficulty in identifying the imagery is at least in part because the urn most likely did not originate in the site of Monte Albán or even from the Valley of Oaxaca. Rather, Caso believed that it was made in an outlying part of Zapotec Oaxaca, perhaps in the northern part of the state close to the border with the state of Veracruz.[3]

Further Reading
Boos, Frank H. *The Ceramic Sculptures of Ancient Oaxaca.* South Brunswick, N.J.: A. S. Barnes, 1966.

Notes
1. Correspondence from Alfonso Caso to Frank H. Boos, March 1966, and copied to Raymond Wielgus.
2. Frank H. Boos, *The Ceramc Sculptures of Ancient Oaxaca* (South Brunswick, N.J.: A. S. Barnes, 1966), 16; and Alfonso Caso and Ignacio Bernal, *Urnas de Oaxaca* (Mexico City: Instituto Nacional de Antropolgia e Historia, 1952).
3. Correspondence from Caso, op. cit.

Teotihuacan culture, Mexico

Seated Figure
Classic period, 200–650
Aragonite
H. 10 1/2 in. (26.7 cm)
Raymond and Laura Wielgus Collection, 76.8

"For Teotihuacan, simplicity and understatement expressed the power of the state and the quality of life of its inhabitants."[1] With this statement, noted Pre-Columbian scholar and Teotihuacan expert Esther Pasztory sums up the aesthetics that characterize the art of this major Classic site that lies about twenty-five miles northeast of Mexico City. An urban center with an estimated population of over 125,000 in AD 600, Teotihuacan was the sixth largest city in the world at that time. The name Teotihuacan means "place of the gods" in Nahuatl, the language of the Aztec people, who dominated the region centuries later and believed that the grandeur of the abandoned site—which includes towering pyramid-temple platforms, well-ordered streets, and administrative and residential compounds—could only have been created by beings far beyond mere humans.

In terms of visual expression, Teotihuacan's grandest achievement was its architecture, but this figure, a rare type in the Teotihuacan corpus, is a beautiful example on a more intimate scale of how, in this Spartan-like culture, art mirrored the structure and beliefs of society. Carved from stone and austere in form and decoration, the figure reflects the self-sacrifice, organization, and even rigidity that were characteristic of the great metropolis of Teotihuacan.

Teotihuacan figures range from monumental stone sculptures to small clay figurines. Between the two extremes in size, this figure also straddles the range of Teotihuacan style: it is more naturalistic than the extreme geometric severity of the larger stone work, but it possesses a stillness and sense of timelessness that is not seen in the almost lively informality of the so-called "portrait figurines," small clay figures that have mask-like faces similar to this one. In addition, some stone figures are very flat and two-dimensional, while others are much more naturalistically modeled. While the head and torso of this figure are flattened, the sculpture has been conceived of three-dimensionally, for the contours are rounded and the spine and buttocks are indicated on the back of the figure.

Most stone figures in Teotihuacan were carved from hard stone, such as greenstone. While aragonite, also known as Mexican alabaster, is softer than some other stones used for sculpture, it nevertheless would have presented challenges: like all stone carving at Teotihuacan, the figure was cut without the use of metal tools. Instead, sculptors used carving and chipping tools fashioned from bone, horn, and stone; drills from bird bone; and water and sand for abrasion. The deeper holes visible at the corners of the eyes and mouth may be the results of drilling that was done in creating those features, or they may have helped in securing inlays of stone or shell. Such inlays were commonly applied to stone masks, which were frequently made of alabaster-like stone, as were containers.

Nearly all other figures carved from semi-precious stone such as aragonite are standing, and nearly all other figures that are in the seated cross-legged pose are either small clay figurines or larger figures carved of rough volcanic stone.[2] The latter support round containers on their heads, which are believed to be braziers for burning incense offerings, and the figures that hold them are said to represent the Old God. This designation is particularly apt, as it can be interpreted as referring both to the antiquity of the image, which predates Teotihuacan, as well as to the apparent age of the personage depicted. Though nude like the museum's figure, the Old God characteristically has the wrinkled face of an old man and is so weighed down by his load that his back is hunched so that his chin almost touches his legs—dramatically different from the smooth face and ramrod-straight posture of this figure. While we do not know whether the cross-legged pose has similar meanings in these figures with very different appearances, Pasztory's research suggests that upturned hands, seen in this figure as well as in depictions of the Old God, generally refer to the divine hand from which gifts and abundance flow, and the gesture was favored for depicting both deities and members of the Teotihuacan elite.[3]

While we can be quite certain that this figure could be described as one for ritual use, we do not know the context in which it was found, and, because of its rarity, we cannot compare it with others that were found under documented conditions. Evidence suggests that larger figures may have been costumed in real clothing and jewelry and placed as major images in temples, and figures smaller than this one may have served as offerings on important ritual occasions.[4]

This figure was formerly in the collection of Mexican illustrator and writer Miguel Covarrubias (1904–1957). Perhaps best known in the United States for his writing and drawing for *Vanity Fair,* he also studied, wrote about, and collected Pre-Columbian art.

Further Reading
Pasztory, Esther. *Teotihuacan: An Experiment in Living.* Norman: University of Oklahoma Press, 1997.

Notes
1. Esther Pasztory, *Teotihuacan: An Experiment in Living* (Norman: University of Oklahoma Press, 1997), 160.
2. *Rediscovered Masterpieces of Mesoamerica: Mexico-Guatemala-Honduras* (Boulogne, France: Editions Arts, 1985), no. 152, illustrates a figure carved of black stone with traces of fresco that is similar to the IU Art Museum's example.
3. Esther Pasztory, "The Natural World as Civic Metaphor at Teotihuacan," in *The Ancient Americas: Art from Sacred Landscapes,* ed. Richard F. Townsend (Chicago: Art Institute of Chicago, 1992), 142.
4. Kathleen Berrin and Esther Pasztory, eds., *Teotihuacan: Art from the City of the Gods* (New York: Thames and Hudson, 1993), 176.

Maya culture, Petén (?), Guatemala

Pendant in the Form of the Sun God
Late Classic period, 600–900
Jadeite
H. 1³/₄ in. (4.4 cm)
Raymond and Laura Wielgus Collection, 77.91

Less than two inches tall, but monumental in its presence and complex in its significance, this beautiful example of Maya lapidary work depicts K'inich Ajaw, "Sun-Eyed Lord," the Maya sun god. Carved of jadeite, a material considered most valuable by Pre-Columbian peoples, and depicting a deity from the complex Maya pantheon, the pendant was most likely part of a necklace—perhaps the central element in a string of jade beads—or worn hanging from a belt. Maya men and women wore jewelry made from a variety of materials, including greenstone of all kinds, amber, pearls, shell, quartz, and obsidian, but pieces carved from jadeite were especially favored by priests and royalty for the prestige and for the life-affirming symbolism associated with the material. Furthermore, an association between rulers and the sun god would have made this pendant an especially prized ornament.

K'inich Ajaw is the god of the daytime sun and was perhaps also a manifestation of Itzamná, the principal creator deity. Artworks depict him with distinctive features: large, squarish eyes with pupils in the inner top corners; a prominent Roman nose; front teeth filed into a T-shape; and the *k'in* glyph, meaning "day" and "sun," on the forehead (as in this example) or body. Sometimes young, sometimes old, he has a counterpart, the Jaguar God of the Underworld, who represents the sun when it leaves the world of the living at dusk and crosses into the land of the dead. Though we are not sure whether these depictions refer to different aspects of the same deity or to distinct, but related beings, K'inich Ajaw himself was also associated with the jaguar, the most powerful animal in the Maya world, and he was sometimes depicted with a jaguar ear.

In spite of these complexities surrounding his exact identity, we can be sure that the sun god was important. Maya rulers identified themselves with him. Babies had beads dangled between their eyes to make them cross-eyed, and men filed their upper teeth into the shape of a "t," both attempts to emulate the Sun-Eyed Lord. In addition, his image appeared not only on personal objects such as this pendant but also on public sculpture.

Jadeite had a special connection with K'inich Ajaw. Its green color was associated with vegetation, especially the maize plant, which provided the Maya's most important food crop. Water, the sustainer of life, was also considered green. As the god of the daytime sun, K'inich Ajaw was responsible for ensuring its journey across the sky, a task that encompassed and allowed all other life-sustaining functions to be realized; hence, it is no surprise that durable green jadeite should be linked with the deity.

The Maya considered jadeite the ultimate precious material, and they particularly favored the apple-green color of this pendant. Indeed, the mineral was historically prized throughout Mesoamerica, and its association with ancient peoples such as the Olmec may have been one reason for its appeal to the Maya, who themselves collected antique objects. Like the Olmec before them, Maya and other Pre-Columbian peoples obtained jadeite in the form of pebbles, rocks, and boulders from the middle stretches of the Motagua River, Guatemala's longest river, which courses from the central part of the country east and northeast, emptying into the Gulf of Honduras.

The pendant is all the more remarkable because, like the stone figure from Teotihuacan (p. 164), it was created without metal tools. Although metallurgy was known in Mesoamerica from about AD 800, the Maya used metal primarily for jewelry and other luxury goods, employing bone, horn, and stone to make hammers, chisels, and drills and using sand as an abrasive. The harder and denser of the two minerals commonly known as jade (the other, nephrite, is not found in Mesoamerica), jadeite was especially difficult to work: string saws, tubular drills, and tools themselves made from jadeite were required, and only jade powder or quartz sand could satisfactorily grind and polish the material. With these implements, carvers painstakingly shaped the form of this pendant, incised its details, and polished its surface to a smooth, shiny finish.

Further Reading
Coe, Michael D. *The Maya.* 7th ed. London: Thames and Hudson, 2005.
Miller, Mary Ellen. *Maya Art and Architecture.* London: Thames and Hudson, 1999.

Maya culture, Petén(?), Guatemala

Polychrome Vase
Late Classic period, 700-800
Clay, pigment
H. 9 ³/₄ in. (24.7 cm)
73.10.1

Rollout drawing of vase by Diane Griffiths Peck.

The cylindrical shape of the vase, its color, and the arrangement of the decoration—a band of glyphs circling the top of the vase with figures below it—are all typical of Late Classic Maya ceramics; however, the number and complexity of the individual figures as well as the scenes in which they are arranged are exceptional.[1] Though much is still not understood about Maya imagery and iconography, painted ceramics such as this clearly convey the richness of imagination and thought that helped to make the Maya a dominant culture during Mesoamerica's Classic period.

Nearly all such decorated ceramics have been found buried in tombs, some deliberately broken shortly after they were made. As burial offerings, the vessels both honored the deceased and served, along with other burial goods, as useful accompaniments for the deceased's journey through Xibalba, the Maya Underworld. Their role in burials no doubt explains the imagery related to the Underworld that appears on many, including this vase.

The rollout drawing makes the images easier to discern. An Underworld palace is depicted on the left. On the far left, the patron god of the month of Pax sits with his hand on the wall. Associated with ritual bloodletting, he is identified by his missing lower jaw and jaguar-paw ear. The patches on his extended arm and thigh further indicate his divinity: these so-called "god markings" are a Maya convention for signifying deities. A group of musicians are below him, and, to their right, a figure covered with jaguar skin crouches before a large container with smoke rising from its contents. The Maya associated the jaguar with the Underworld, but the significance of this figure remains unclear.

Above are three figures. On the left, facing Pax, is God D, one of the three aged gods who rule over Xibalba. Above him hovers a moan bird, a messenger of the Lords of the Underworld. To the right, two similar figures play drums. Both wear headdresses edged with an interlace motif known as the mat symbol, indicating power and authority. These figures may be Hunahpu and Xbalanque, the Hero Twins, whose exploits in Xibalba are chronicled in the *Popol Vuh,* a sixteenth-century epic of the Quiché Maya of Guatemala that is believed to be part of a larger cycle of now-lost myths relating to the Underworld.

The two standing figures to the right are probably the focus of the vase, for they are shown larger than the other figures and are more richly costumed—two Maya conventions for signifying importance. The figures are dressed similarly, though not identically. These are the Hero Twins: on the left, Hunahpu can be identified by the black spots on his face and arms, while the patches of jaguar skin on the face and legs of the figure on the right signal that he is Xbalanque.

Each man holds what may be a blowgun up to his mouth, and the figures have dead birds tied at the backs of their waists; the Hero Twins were known for their prowess in killing birds with blowguns. Alternatively, the Twins may hold smoking tubes, a reference to their trial in the House of Gloom, when the Lords of the Underworld demanded that they keep their cigars lit throughout the night. The Twins outwitted the Lords with the help of fireflies; the insect-like creature between them, which unfortunately has been restored to such an extent that much of the original painting is obscured, may be one of those helpers.[2] The bat above the Twins is a clear reference to their harrowing stay in the House of Bats, where they underwent another trial presented by the Lords of the Underworld.

On the far right, two figures climb a tree. They are likely Hun Batz and Hun Chuen, mean and selfish half-brothers of the Hero Twins, who are tricked by the Twins into climbing a tree to get some birds at the top. Once there, they are turned into monkeys, who are identified with One Monkey, the patron deity of painters and scribes.

Like all Pre-Columbian ceramics, this vessel was made without the use of the pottery wheel. Decorated before firing, it was first covered with one or more coats of white slip (a mixture of very fine clay particles and water). Next, the outlines of glyphs, figures, and details were drawn with iron manganese paint and then filled in with colored slip. Firing was done with relatively low heat, 600 to 700 degrees centigrade. Though women may have shaped the vessels, men painted them. Like artists the world over, Maya painters ranged in talent, with relatively few producing truly exceptional examples of ceramics such as this one.

Further Reading
Miller, Mary, and Simon Martin. *Courtly Art of the Ancient Maya.* San Francisco: Fine Arts Museums of San Francisco, 2004.
Reents-Budet, Dorie. *Painting the Maya Universe: Royal Ceramics of the Classic Period.* Durham, N.C.: Duke University Press, 1994.

Notes
1. The band of glyphs that circles the top of the vase has not been interpreted, but it is most likely typical of other similarly placed texts of this period in relating when and for whom the vessel was made, its function, and, perhaps, the name of the painter.
2. Several smaller figures and motifs were repainted in a restoration completed before the vase was acquired by the museum, but the principal figures are intact.

Mixteca-Puebla style, Mexico

Polychrome Shell Pendant
Late Post-Classic period, 1200–1521
Marine shell, pigment
H. 2 ¹/₂ in. (6.3 cm)
80.65

The shell's female figure

This shell, a beautiful example of Post-Classic Mesoamerican painting, is appealing for both its miniature size and the vivacity of the depiction. Throughout Pre-Columbian Mesoamerica, marine shells were luxury items, traded from both the Gulf and Pacific coasts and presented as tribute to inland powers. Seashells were prized in their natural form, transformed into trumpets and vessels, incised or painted for ritual use or to increase their prestige value, and cut into plaques, beads, and pieces for inlay. Shells have been found in tombs and caches, and they were frequently fashioned into jewelry of various kinds. The association of shells with water made them a symbol of that life-giving substance and, by extension, a sign of fertility. This shell has been cut at the top and bottom to emphasize its spiral form, and all but one knob around the top has been smoothed down. That one, above the head of the figure on the left, has been pierced, presumably so that the shell could be worn as a pendant.

"Mixteca-Puebla" is a term coined by archaeologist George Valliant in the early 1940s to refer to two areas in southern Mexico—Mixteca, in western Oaxaca, and Puebla, to its north. Valliant believed that between the demise of Teotihuacan and the rise of the Aztec empire, a new culture originated somewhere in those areas, becoming an inspiration and influence on the development of Aztec civilization. The phrase has since come to be understood as more appropriately a reference to a widespread style and group of iconographic motifs that were most pronounced in the Mixteca and Puebla areas during the Post-Classic period.[1] The term is used particularly in reference to painting on manuscripts, ceramics, murals, and, in this case, shell.

The shell's painting is typical of the Mixteca-Puebla style and clearly relates to pictorial manuscripts of the same period. The figures are squat, with large heads and hands. Areas of flat, bright color are outlined in black, with no attempt at modeling. The composition encompasses multiple perspectives: for example, the standing figure's lower torso is depicted frontally, but his feet are in profile. Little attempt is made to represent space, though the setting is clear from the stepped frets, shown in profile on the right and frontally on the left, that frame the scene and are characteristic of Mixtec buildings.

The figure on the left wears a woman's cape but has no other distinguishing attributes. The figure on the right could be Xiuhtecuhtli, the god of fire, or a priest impersonator. Xiuhtecuhtli means Lord of Turquoise, but the name may be derived from the Nahuatl word for year, suggesting that he was also a god of time.[2] In Mixteca-Puebla-style painting, Xiuhtecuhtli's face is frequently yellow, as on this shell, and he is generally depicted with turquoise accessories, such as the necklace here. Turquoise was introduced to Mesoamerica from New Mexico during the Post-Classic period and

was identified with fire, perhaps because the center of an intense flame appears blue.[3]

The curved motif on the standing figure's back has been interpreted by some scholars as the snout of the fire serpent, Xiuhcoatl, lined with circles representing the stars of the Pleiades, a constellation important in Pre-Columbian Mesoamerica. Its sighting at midnight on the last day of a calendar cycle was believed to indicate the continuation of humankind and to signal that a new fire should be lit to ensure the arrival of the morning sun and the beginning of a new year.

Gordon Brotherston, a scholar of early Mexican codices who has studied the shell, offers an alternative reading of the painting, suggesting that associating the standing figure with Xiuhtecuhtli obscures rather than explains the scene.[4] He believes that the shell depicts tribute being collected, probably related to the tribute calendar, which was organized according to eighteen twenty-day feasts of the year. Tribute took various forms, including food, natural resources, and crafted objects, and its collection enabled dominant cultures not only to exert economic, political, and social control over their weaker neighbors but also to ensure a ready supply of both necessities and luxury goods for their own use.

On the museum's shell, the female figure holds what appears to be a *xiquipilli,* a cloth bag used to hold tribute, which she seems to be presenting to the standing male; he holds one hand outstretched to receive it, while the other hand holds a similar object behind him. Brotherston hypothesizes that the positions of the figures and various countable series of objects, such as the beads of the necklaces and the disks on the back of the male figure, are elements of a visual language that were intended to be read in the same way as the pictorial manuscripts that they stylistically resemble.

Notes
1. See H. B. Nicholson and Eloise Quiñones Keber, eds., *Mixteca-Puebla: Discoveries and Research in Mesoamerican Art and Archaeology* (Culver City, Calif.: Labyrinthos, 1994) for discussions and applications of the term.
2. Nahuatl is the language of the Aztecs, but it was (and is) spoken by others over a broad area of central Mexico.
3. Mary Miller and Karl Taube, *The Gods and Symbols of Ancient Mexico and the Maya* (London: Thames and Hudson, 1993), 174.
4. Gordon Brotherston, "Polychrome Pendant in the Indiana University Art Museum Collection," 1997 (gallery handout), and personal communication, May and June 2007.

Moche culture, Peru

Headdress Element in the Form of a Fox Head
400–800
Copper, gold wash, shell
L. 6 in. (15.2 cm)
Raymond and Laura Wielgus Collection, 2003.1

Justly famous for their magnificent ceramics, the Moche also have long been acclaimed as master metalsmiths, although only since the 1960s have large quantities of Moche metalwork been found. The dramatic finds at Sipán, where excavations began in 1987, brought information about Moche culture and art to a wide audience, and the abundant metalwork has added luster to their reputation as master craftsmen. The naturalism, delicacy, and fine craftsmanship seen in Moche ceramics is also evident in their metalwork, which was unsurpassed by any Pre-Columbian peoples before or after them. Moche techniques were also used by their north-coast descendants, the Chimú.

In making the fox head, a Moche artist attached pieces of metal to each other by means of tabs and slots, not by soldering or welding. His aim was clearly to create an image of a fox that was true to life: each whisker was attached individually, indications of nostrils were pressed into the nose, and shell was added to create more realistic teeth and eyes (pupils, probably of darker shell or stone, are now missing). The image must have been based on observation of the actual animal: the sense of realism is intensified by the tongue, which hangs between the teeth as if the animal were panting. When the head is moved, the tongue appears even more lifelike, for it is attached at the back of the head by means of a clever mechanism that allows it to sway freely.[1] The kinetic quality of the head was enhanced by the small hanging disks on the ears and chin; they would have also added an aural component to the display, for they tinkled when the head moved.

Although we can admire the artistry of the form as it now exists, the head was meant to look even more impressive: it would have shimmered in the light, for, though made of sheet brass, it was originally covered with a thin coating of gold. Moche metalworkers used a variety of techniques for gilding metal; on this example, a gold wash was applied to the copper using a sophisticated electrochemical plating technique, and then the surface was heated to permanently bond the two metals. Like many Moche objects that were gilded, however, most of the coating is now gone, the result of being buried.

Although the symbolism is not completely understood, the fox seems to have been important in Moche iconography. It was considered a lunar symbol because of its nocturnal habits, and it regularly appears in scenes of Moche warriors and runners, perhaps because it is an effective predator, while at the same time it is sly and clever enough to avoid being caught itself. Fox headdresses have been depicted in scenes of Moche runners; similarly, fox heads such as the museum's may have been parts of headdresses worn by real runners or attached to litters carrying important people.

As might be expected, metal creations such as this were objects of status and prestige. Among the Moche, they were owned only by those at the highest levels of society. In fact, this was true throughout the Pre-Columbian Americas, where metal was valued more for its appearance than for its utility. Fox heads such as this have been found over a wide area of Moche territory, from Loma Negra in the north, to Sipán in the central region, to the Huaca de la Luna in the Moche Valley toward the south.

Further Reading
Alva, Walter, and Christopher B. Donnan. *Royal Tombs of Sipán.* Los Angeles: UCLA Fowler Museum of Cultural History, 1993.
Benson, Elizabeth P. *Birds and Beasts of Ancient Latin America.* Gainesville: University Press of Florida, 1997.

Note
1. For a diagram of the tongue attachment, see Walter Alva and Christopher B. Donnan, *Royal Tombs of Sipán* (Los Angeles:UCLA Fowler Museum of Cultural History, 1993), 184.

Moche culture, Peru

Ceremonial Digging Stick
400–800
Wood, copper, resin
H. 54 in. (137.2 cm)
Raymond and Laura Wielgus Collection, 99.1

This ceremonial digging stick is a rare artifact as well as a powerful sculpture. It was carved from wood, a perishable material that survives for centuries only in dry climates and cave burials, and the ancient repair on the shaft suggests that it was an heirloom or other treasured object. Few images in the museum's collections are more compelling than this one of a jaguar clawing at the chest of a man whose head is thrown back in obvious agony.

The Moche, who flourished along Peru's north coast between the fifth and ninth centuries AD, are known for their realistic style, whether in ceramics, metal (see p. 172), or wood. The figures occupy the top of what looks like a digging stick, an implement used in farming throughout South America. However, the presence of the figures suggests that this is a ritual, rather than a utilitarian, object. Although we do not know the context in which this stick was discovered, similar pieces have been found in elite burials, which would seem to confirm its ceremonial use.

Both Mesoamerican and Peruvian Pre-Columbian cultures considered the jaguar an important animal. Admired for its strength and cunning and associated with waterways that sustained life, the animal has also been connected with the supernatural world, particularly the transformative powers of priests. The Moche closely associated the jaguar with at least two important deities: the creator god, and another, perhaps second aspect of the creator, who was depicted with feline fangs and a jaguar headdress.

Why the jaguar is depicted attacking a man is not clear. Elizabeth Benson, a noted Pre-Columbian scholar, suggests that the tableau may refer to the defeat of enemy warriors by the Moche.[1] After capture, defeated warriors were presented to the leader, who might also be the chief priest and who wore the costume of the feline deity. In addition, the warriors may have been sacrificed by jaguars, either real ones held in captivity or humans wearing jaguar costumes. In either case, the jaguar would have been identified with the Moche people and would have served as a symbol of their power and that of their gods in defeating all opponents.

The circular depressions on the jaguar (recalling its spotted pelt) and on the platform likely held shell or stone inlays. The use of such inlay was a popular technique all over Pre-Columbian Peru, not only creating dramatic color and light contrasts but also adding to the object's value, as semi-precious stones and shells were important trade items.

Further Reading
Reid, James. "Ancient Peruvian Wood Carving: Marvels of a Vanished World." *Tribal: The Magazine of Tribal Art* 9, no. 2 (summer 2004): 96–107.

Note
1. Elizabeth P. Benson, *A Man and a Feline in Mochica Art,* Studies in Pre-Columbian Art and Archaeology 14 (Washington, D.C.: Dumbarton Oaks, 1974), 25–29.

Lambayeque culture, Peru

Whistling Jar with Bridged Spout
800–1200
Clay, slip
H. 9 in. (22.9 cm)
Raymond and Laura Wielgus Collection, 75.99.3

The simple forms combined with expressive detail and a smooth, almost metallic surface make this vessel visually very appealing to contemporary viewers. Its form also suggests imagination, and some clever technology—the animal's head, as if raised in a howl, emits a sound when the jar is properly manipulated.

The specific animal is not clear: felines are most frequently depicted on Peruvian ceramics, but this animal's pointed snout suggests that it is a dog, fox, or other canine. In comparing this vessel with two similar ones said to represent sea lions (a food source for coastal peoples throughout the Pre-Columbian period), art historian Alan Sawyer suggests that "just as we call the animal a sea 'lion' and the Spanish call it a sea 'wolf' *(lobo del mar),* the ancient Peruvians may have thought of it as a sea 'fox' or sea 'dog.'"[1]

The term "whistling jar" refers to a vessel that makes a whistling sound when a person blows across the spout or when the vessel is partially filled with liquid and tilted. Whistling jars seem to have originated in Ecuador and were made as far north as Mexico, but those from Peru are best known. First made there around 1000 BC, the vessels frequently take forms—such as animals, birds, and musicians—that are enhanced by the aural feature.

The whistling mechanism is simple: a small hollow clay sphere, usually no more than an inch in diameter and pierced with a small hole, is positioned adjacent to a narrow clay tube, so that air flowing through the tube passes across the opening in the sphere and resonates to make a sound. Frequently constructed as a single piece, this apparatus may be placed inside or outside the vessel. On the Art Museum's example, the device is inside, probably within the animal's head. By blowing into the spout of a whistling jar, a person directs air into the whistle tube, creating a sound. For a double-chambered vessel such as this one, sound can also be created using a liquid: if a half-full container is tilted away from the whistle and then toward it, air is displaced quickly from the chamber and pushed through the tube, producing a wavering sound.

The jar clearly falls within the ceramics tradition of the north coast of Peru, with features that allow a more specific attribution to the Lambayeque, a culture of the north coast valleys that arose after that of the Moche and then, around 1200, was absorbed into the Chimú. Most noticeable is its sculptural quality, a trait emphasized by north coast artists, in contrast with the interest in surface color decoration that dominated in the south. Lambayeque ceramicists produced refined, elegant forms, and their workmanship can be identified in details such as the strap handle and the plain, elongated spout, both clear departures from their Moche predecessors, who favored stirrup-shaped handles with short, sturdy spouts. During the Lambayeque period, double-chambered pots such as this one, which had been rarely produced for the previous five hundred years, regained popularity. Press molds, first developed by the Moche, were further refined so that even relatively complicated pieces could be made using the molding process.

Unlike the Moche, who painted their pottery, fine Lambayeque potters specialized in carefully burnished blackware, in which the color was created during the firing process. Like other ceramics, those of the Lambayeque were fired in a shallow pit. To obtain the dark color, instead of an orange or buff that would otherwise occur, Lambayeque pottery was fired as usual, and then, while more fuel was added, it was covered with dirt, creating a dense smoke that drove carbon into the clay body, creating a dark and sometimes metallic appearance.[2]

We tend to think of clay vessels as functional, utilitarian objects, but that may not have been the case with this vessel, nor was it likely to have been made for burial, as some other Pre-Columbian ceramics were. Some researchers have suggested, instead, that vessels such as this were status objects, kept by wealthy individuals as emblems of their elevated positions within their society. Alternatively, some have proposed that the vessel's aural element indicates that it was not primarily for display, but instead it may have been used in a ceremonial context in which its whistling sound might have signaled contact between the physical and spiritual realms.

Further Reading
Donnan, Christopher B. *Ceramics of Ancient Peru.* Los Angeles: UCLA Fowler Museum of Cultural History, 1992.

Notes
1. Indiana University Art Museum correspondence from Alan Sawyer, March 12, 1976.
2. Christopher B. Donnan, *Ceramics of Ancient Peru* (Los Angeles: UCLA Fowler Museum of Cultural History, 1992), 20.

Sicán culture, Peru

Earspool
Late Middle Sicán period, ca. 1050–1100
Diam. 4 ¼ in. (10.8 cm)
Raymond and Laura Wielgus Collection

Viewl of the front

Showing an elaboration and attention to detail that indicate the work of a master goldsmith, this earspool is one of vast numbers of objects dug up in the middle La Leche Valley of Peru's north coast, particularly in the area of the sugar cane farm known as Batán Grande. Though the region has been a protected site since 1984 and part of the Pomoc Forest National Historical Sanctuary since 2001, from the 1930s until 1970, the family owning the land supported itself by selling these Pre-Columbian artifacts. Thus, valuable information about the objects' contexts was lost, resulting in their being misattributed and misunderstood.

Although nothing can restore information lost about this earspool specifically, long-term fieldwork since 1978 by Southern Illinois University archaeologist Izumi Shimada and the Sicán Archaeological Project today allows us to associate it with the height of the Sicán culture. A centralized theocracy, the Sicán culture flourished in the La Leche Valley beginning around 800 and continuing until around 1375, when it was conquered by the better-known Chimú, a culture to which much Sicán material has previously been attributed.

Sicán is best known for its metallurgy, particularly the extensive production of gold objects, which have been described as the epitome of Middle Sicán aesthetic expression.[1] Goldworkers were especially skillful in creating sheet metal, using a time-consuming process of alternate hammering and annealing (heating the metal to prevent stress cracks). The shaft and the disk of this earspool were made from sheets of gold, and the ornament also illustrates decorative techniques commonly used by Sicán smiths: small gold beads threaded on wire surround the disk, which has been decorated with repoussé—relief patterning created by hammering or pushing from the back of the sheet; motifs on the shaft, on the other hand, were finely incised into the front of the metal.

The central image is a bird sitting on a reed raft, holding a fish with one foot. Above the bird is a crescent-shaped motif similar to depictions of a feather headdress associated with the Sicán Deity, the god believed responsible for life itself, and with his physical embodiment, the Lord of Sicán, ruler of the culture. Additional boats or rafts containing figures with bird heads and human bodies circle this image. On the shaft, rows of similar composite bird/human figures with elaborate headdresses alternate with a wave motif.[2]

Anthropomorphized birds are depicted in the art of both the Moche (the culture that preceded the Sicán in this area) and the Chimú, usually as warriors, messengers, and assistants to rulers and deities. However, the Sicán Deity himself is usually depicted with bird-like features, and a tradition recorded in the Lambayeque Valley to the south by sixteenth-century Spanish priest Miguel Cabello de

Balboa reinforces the connection. That story recounts the founding of a dynasty in the Lambayeque and La Leche valleys by a man called Naymlap ("waterbird" in Muchik, a now-extinct language in the area), who traveled with a large retinue on a fleet of balsa rafts to the Lambayeque Valley. Once there, he established a palace, and, to affirm his divinity to his subjects, he instructed those closest to him to tell his followers when he died that he had transformed into a bird and had flown away.[3]

An earspool that appears to be this one's mate is in the collection of the Museo Nacional de Antropología y Arqueología in Lima, Peru, and is said to have been found at Batán Grande, the original attribution of this one, too.[4] Only a man in the highest echelons of Sicán society would have owned a pair of earspools such as this, which were worn by passing the shafts through pierced and stretched earlobes and securing them in place by a thread that was attached to a hole in each shaft and passed across the back of the head. In addition to their role as jewelry, multiple pairs of gold earspools are also among the grave goods found in elite burials.

Raymond Wielgus acquired the earspool in 1958 from New York collector and dealer Nasli Heeramaneck (1902–1971). Born in India, Heeramaneck was internationally recognized for his collections of Indian, Persian, and Pre-Columbian material.

Further Reading
Ancient Peru Unearthed/Sicán: L'or du Pérou antique. Calgary: Nickle Arts Museum, 2006.
Shimada, Izumi, and Jo Ann Griffin. "Precious Metal Objects of the Middle Sicán." *Scientific American* n.s. 270, no. 4 (April 1994): 82–89.

Notes
1. Izumi Shimada and Jo Ann Griffin, "Precious Metal Objects of the Middle Sicán," *Scientific American* n.s. 270, no. 4 (April 1994): 89.
2. According to Izumi Shimada, the headdresses and faces are indicative of Sicán style. Personal communication, September 2007.
3. Carlos Elera, "The Cultural Landscape of the Sicán," in *Ancient Peru Unearthed/Sicán: L'or du Pérou antique* (Calgary: Nickle Arts Museum, 2006), 65–66. Scientific testing of skeletons found in burials indicates that two major ethnic groups—one of them immigrants—comprised Sicán society, and archaeological evidence suggests that the immigrants occupied the highest level of society.
4. *Treasures of Peruvian Gold: An Exhibition Sponsored by the Government of Peru* (Washington, D.C.: National Gallery, 1965), cat. no. 84.

Wari or Tiwanaku culture, Peru or Bolivia

Lime Container
Middle Horizon, 600–1000
Wood, stone, shell, bone, reed
H. 3 ³/₈ in. (8.6 cm)
Raymond and Laura Wielgus Collection

This intricately made container was part of the paraphernalia used in the chewing of coca, a practice that has continued in South America for thousands of years. Although chewing coca increases endurance, allays hunger and thirst, and provides many vitamins, there is no evidence that it was done for those purposes during Pre-Columbian times. Instead, the only information we have—reports from the late pre-conquest Inca period—indicates that it was chewed for religious sacrifices and divination and was restricted to the nobility. We have no clear indications from Pre-Columbian times that this was a gendered activity, although later research among indigenous peoples suggests that it may have been reserved for males.

In English we refer to "chewing" coca, but, in fact, traditionally, the leaves are not masticated. Instead, a wad of dry leaves is placed in the cheek and sucked. The addition of a small amount of powdered lime, often made from burned shells, releases cocaine alkaloids from the leaves, resulting in a euphoria, but one that is significantly milder and without the serious, toxic effects created by ingesting processed cocaine.

Several accoutrements were associated with coca chewing, and the precious materials and skillful manufacture of many of those that survive support the belief that it was an elite practice. The coca leaves themselves were stored in small cloth bags, which in turn were kept in larger ones that also stored the other paraphernalia. Many bags of both types that survive are made with luxurious materials and intricate techniques. The powdered lime was kept in small containers and dispensed with tiny spatulas or spoons. Most of the latter, usually between three and four inches long, were cast from gold, silver, or copper with miniature figures of people, birds, and animals at the tops, sometimes with inlay for details such as eyes. The spoons and spatulas often were attached to the containers by a short cord. Though lime containers might be simple gourds, many were made from wood, stone, bone, clay, gold, or shell and were elaborately decorated. Most have a single hole at the top through which they are filled; on this example, that hole is plugged with a reed.

Most lime containers are from one to just over three inches tall, making this example relatively large. It is an unusual combination of a shell in the back with a carved wooden front. However, what makes the container so remarkable is the masterful shell and stone inlay. The multi-colored inlay creates the same lively effect that is displayed on textiles, the best-known Middle Horizon art form.

The image's face and ears resemble a bat, but whether that animal, some other fantastic one, or even a deity was intended, we are not sure. Depictions of bats, though not fully understood, appear with some frequency in the art of the ancient Americas. As Pre-Columbian scholar Elizabeth Benson points out, people frequently ascribe special powers to unusual animals, and certainly the bat—the only mammal that flies and a creature that sleeps upside down—fits in that category.[1] Among the earlier Moche, bats were associated with sacrifice and ritual, and if Middle Horizon peoples shared that thinking, then this was a particularly appropriate image for an accoutrement belonging to a religious practice.[2]

The container is similar to objects that have been attributed to both the Wari and Tiwanaku cultures, which flourished during Peru's Middle Horizon, 600 to 1000. The Wari empire, with a capital of the same name, began in the southern highlands, but spread over large areas of the coast and north. Its complex relationship with the Tiwanaku, a civilization centered in the area of Lake Titicaca, on the Peru/Bolivia border, continues to be debated. Though differences between the two cultures are clear in architecture and monumental sculptures, attributions for small portable objects such as this one are more difficult. The use of a seashell, for instance, might suggest that a coastal Wari origin is more likely; however, shells were widely traded inland as prestige goods. The well-preserved state of the wood and reed does perhaps add weight to a Wari origin; organic materials such as those are more likely to have been preserved in the drier coast and highlands than in the Titicaca basin.

Further Reading
Jones, Julie. *Rituals of Euphoria: Coca in South America.* New York: Museum of Primitive Art, 1974.

Notes
1. Elizabeth P. Benson, *Birds and Beasts of Ancient Latin America* (Gainesville: University Press of Florida, 1997), 52.
2. Elizabeth P. Benson, *The Mochica: A Culture of Peru* (New York: Praeger, 1972), 52.

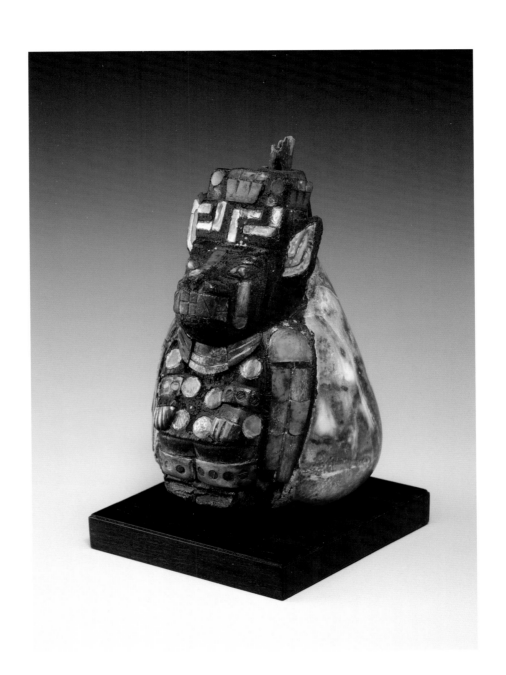

THE SOUTH PACIFIC

The islands of the South Pacific, also called Oceania, can be broadly divided into the regions of Polynesia, Melanesia, Micronesia, Australia, and Indonesia. Of those, Polynesia and Melanesia are best represented in the IU Art Museum by strong collections that highlight most of the major art-producing areas. The museum's Micronesian and Australian collections are smaller, as are those of the indigenous peoples of the Indonesian archipelago. Though these collections do not offer representative surveys as the Polynesian and Melanesian collections do, they nonetheless include some outstanding examples, such as the Batak priest's horn.

Polynesia (from the Greek for "many islands") refers to the islands within the triangle formed by the Hawaiian Islands to the north, Easter Island to the east, and New Zealand to the south. Each side of that triangle is over four thousand miles long, and within it are over one thousand islands, most of them uninhabited. Though the central Polynesian islands of Tonga, Samoa, and the Marquesas were occupied by the first century BC, people did not settle on others in the area—the Cook, Society, and Austral islands—as well as the outlying island groups, until between the fifth and ninth or tenth centuries AD.

Essential to understanding Polynesian art is knowledge of the importance of genealogy and the concepts of mana and tapu to Polynesian culture. Until European domination in the nineteenth century, Polynesian social and political institutions were complex, stratified systems based on genealogy. Though the degree of institutional elaboration varied among the islands, all Polynesians believed that individuals of the noble or chiefly rank could trace their ancestry back to the gods. Throughout Polynesia, various motifs, such as references to the human spine and vertebrae, were incorporated into artworks to reflect the importance of genealogy.

The elite ranks included artists, who frequently also were priests, and who were believed to have particular skill in dealing with mana, a supernatural energy or power possessed by all things, living and inanimate. A chief or priest had a great deal of the energy, while a commoner had much less. Mana was also responsible for making a tool or weapon work effectively and a plant bloom with beauty and vigor. Mana was inherited and could be passed through physical contact, so heirlooms, such as ornaments made of precious materials, contained mana from each of their previous owners. To protect this energy, a tapu, or restriction, assured that, by following a prescribed action or avoidance, mana would not be lost through corrupt or negative influences such as sickness or death or by contact with entities possessing less mana. Artists' tools and materials all contained mana, and, as the objects were created to the accompaniment of prayers and chants, some of the artists' own mana was transferred to the objects they created.

The islands of Polynesia have a relatively homogenous culture, but this is not the case in Melanesia ("black islands"), which comprises New Guinea and the nearby islands, most of which extend in an arc from the Admiralty Islands to New Caledonia. There, diversity is the rule and tremendous cultural and linguistic variation may be found even on a relatively small single island. While generalizations are difficult, in most of Melanesia, ancestors both of families and clans were of prime importance in religious life, for (as in many African societies) these spirits were believed capable of interceding in the physical world. These ancestral spirits have inspired some of the most powerful sculpture from the South Pacific, such as the museum's New Ireland and New Guinea figures. Artists also created masks, figures, and other objects connected with nature spirits that were embodied in animals and natural formations, such as rivers and mountains.

Unlike in Polynesia, where rank was inherited, a person's status in Melanesian societies was determined to a great extent by achievement, measured in arenas such as warfare, food acquisition or production, accumulation of wealth, and membership in the associations and cults that formed the political, social, and religious backbones of many communities. In many parts of New Guinea, for example, membership in a cult using objects such as the museum's Biwat figure for a sacred flute brought great prestige to an individual.

As with the African collection, and for similar reasons, neither the names of the artists who created the museum's South Pacific objects nor the dates they were made were recorded. However, the collection dates of some objects are known, and these suggest that they were made before Western influences subsumed much of the traditional cultures.

Diane M. Pelrine
Class of 1949 Curator of the Arts of
Africa, Oceania, and the Americas

Ha'apai island group, Tonga

Female Figure
18th century (?)
Whale ivory
H. 5 in. (12.7 cm)
Raymond and Laura Wielgus Collection

The rarity of Tongan figures, the high quality of the carving, the excellent condition, and the beautifully preserved patina combine to make this an outstanding work of art. The figure has a monumental presence, but it is small enough to be held in one hand, and the smoothly worn surface suggests much touching and attention.

Twenty-three single female figures of wood or ivory are attributed to Tonga today. Two of the six wooden figures have documentation associating them with Livuka, an island in Tonga's Ha'apai group. On the basis of stylistic similarities, the other wood figures are generally attributed to the same area, as are the seventeen ivory figures. Ranging in height from just over 1¼ to 5¼ inches, the ivory pieces are considerably smaller than the wood figures, which are between 7½ and 26 inches tall, but they share many of the same visual characteristics. These include simple, expressionless facial features; prominent ears; short or absent necks; well-developed breasts and buttocks; broad shoulders; straight, hanging arms; and slightly bent knees—all seen on this example.

The attribution question is complicated, however, by the fact that collection documentation for only three of these ivory figures definitively indicates Tonga. Of the rest, three of the ivory figures, as well as three suspension hooks that include figures in the Ha'apai style, were collected in Fiji, and the places of collection for the remaining eleven figures, including this one, are unknown. In fact, ivory figures such as this one could have been carved in Fiji or Tonga or both places; pre-European inter-island relations between Fiji and Tonga created a web of exchanges of goods and people, including craftsmen, resulting in similar objects being made and used in both places.

Though European reports beginning with James Cook in the eighteenth century note wood and ivory figures in Tonga, little information was recorded about them. The most extensive descriptions appear beginning in 1830, from missionaries recounting the actions of Taufa'ahau, a Ha'apai chief who later become king of Tonga and who burned, otherwise destroyed, or gave to Europeans objects associated with traditional religion as a sign of his new-found devotion to Christianity. The scanty information that survives suggests that figures, whether ivory or wood, represented goddesses or ancestors. Scholars today generally associate the ivory images in Tonga with Hikule'o, an important deity connected with harvest and fertility. Following local practices, similar figures in Fiji probably represented important ancestors.

Though some early literature refers to ivory (it is unclear whether it was carved) being wrapped in barkcloth and kept in shrines, most ivory figures, including this one, are pierced in the back of the head, suggesting that they were suspended, perhaps from a shrine's ridgepole or rafters. Their size—more than half are 3 inches or smaller—would also allow them to be worn as a charm or ornament by a chief or priest. This example has two suspension holes, one of which wore out, testimony to the figure's age and extended use.

The ivory is from the tooth of a cachalot whale. The teeth, which average nearly eight inches long, have distinctive outer and inner layers, seen here in the color variation most noticeable on the front of the legs. Before Europeans began trading with Polynesians, cachalot ivory could be obtained only from beached whales, making it a very rare, and therefore precious, material. With an increasing European, and later American, presence in Polynesia, ivory became more available, as the Westerners realized that ivory in the form of both whale teeth and walrus tusks was a valuable trade commodity.

Ivory's rarity was only one reason it was used for figures such as this; other factors making the material especially prized were its color—a creamy white that is transformed to a golden brown through smoking over a fire—and the smooth, shiny surface that can be achieved through polishing. Early European observers noted that among the Tongan elite, light, smooth skin was desirable, especially for women, who achieved the preferred effects by staying in the shade as much as possible, applying special lightening potions, and rubbing in oil for a glistening appearance and silky feel. Thus, an ivory figure exemplifies the ideal woman's skin color and texture.[1] Likewise, small hands (indicating that a woman did not have to work) and stocky proportions, including broad shoulders and large calves, were (and are) admired in Tongan women and are also reflected in the figures.

Further Reading
St. Cartmail, Keith. *The Art of Tonga*. Honolulu: University of Hawai'i Press, 1997.

Note
1. Jehanne Teilhet, "Ethnoaesthetics and Constructing the Social Identity of Tongan Women from a Female Image in the Wielgus Collection," lecture, Indiana University Art Museum, October 1993.

Austral Islands or Tahiti, Society Islands

Fly-Whisk Handle
Before 1818
Whale ivory, wood, sennit
L. 12 5/16 in. (31.3 cm)
Raymond and Laura Wielgus Collection

The intricate, delicate carving and the tawny, silky appearance of the ivory make this a sensuous, if somewhat enigmatic, object. The whisk itself, which was most likely made of fiber and attached to the narrow end of the handle, has long since perished. Oil, whether rubbed purposefully onto the surface or simply transferred from the hands of someone holding the whisk, has stained the white ivory; that transformation and the smooth, rounded surfaces indicate that the whisk was handled extensively, particularly along the wider section at the top.

One of only five known similar ivory handles, this one and another now in the Metropolitan Museum of Art were sent in 1818 from the Tahitian king Pomare II (1774–1821) to the Reverend Thomas Haweis (1734–1820). Haweis was one of the founders of the London Missionary Society, a mission responsible for the conversion of many Tahitians to Christianity. The third handle has been in the collection of the University of Aberdeen (Scotland) since 1823, a gift from a world-traveling alumnus. A fourth handle, said to have feathers attached to the bottom, is in the National Museum of Ireland, and the fifth, in the Masco collection, was unknown until 1983, when it appeared at auction.

All of the handles consist of carved pieces of whale ivory that have been lashed together with fiber, mostly narrow lengths of plaited sennit. The size of sperm whale teeth—the source of ivory throughout Polynesia before European contact—dictated this segmented construction. This example and the one in the Masco collection also contain sections of carved wood, presumably replacements for damaged pieces of ivory. Here, the bottom section is wood; on the Masco handle, the wood portion is in the middle.

In addition to the ivory examples, a few similar pieces are found in whalebone and in wood.[1] One whalebone whisk in the British Museum is very similar to the ivory ones in overall form and was included among the so-called "family idols of Pomare," objects the Tahitian king surrendered to missionaries upon his conversion to Christianity. One of the wood handles, likely collected on one of Cook's voyages, has a figure on the top and another on the bottom, both carved in the style of the Society Islands. Another, however, has a figure on the top in a style much more closely related to that associated with Rurutu in the Austral Islands, leading to speculation that objects of this type may have been among those that were made in the Austral Islands but traded to the Society Islands as part of exchanges that were well-established when Europeans first visited the islands.

At first glance, the Wielgus handle appears as an abstract form, with holes completely piercing the lengths of ivory at regular intervals. However, closer examination and comparison with two of the other examples indicate clear references to human figures. The Metropolitan and Aberdeen examples show in much less abstract form that at the top of the whisk is a figure in a backbend pose and suggest that the holes below are actually the spaces between abstract human figures positioned on top of each other. Similar "stackings" of human figures are also found elsewhere in Polynesia, and scholars understand such motifs to refer to ancestors and genealogy. The overall form of the handle also recalls a human spine and its vertebrae, another Polynesian symbol of lineage and genealogy.

James Wilson, one of the earliest Europeans to visit the Society Islands, noted that fly whisks were a common accoutrement of the islanders, and a fan or fly whisk (Tahitians used the same word for both objects) was among the insignia of a chief.[2] Later, the royal use of whisks was confirmed in an October 1918 letter to Haweis from Pomare, who thanks him for a watch, reports the burning of the king's "idols," and notes that "I also send you two little Fans [the whisks] which the Royal Family of these Countries were accustomed to fan themselves with. When the Day of the Festival arrived, and the king was prayed for, those were the Fans they used to fan away the flies, etc."[3] Even without this explicit documentation that this whisk handle had been owned by a king, we could suppose a prestigious origin, for throughout Polynesia ivory was a rare and precious material reserved for the noble class. Its value led Terrence Barrow, a longtime scholar of Polynesian art, to suggest that fly-whisk handles such as this one might have also been carried without the whisk attachment, as an indication of status.[4]

Further Reading
Stevenson, Karen. *Artifacts of the Pomare Family*. Honolulu: University of Hawaii Art Gallery, 1981.

Notes
1. For examples, see Steven Hooper, *Pacific Encounters: Art and Divinity in Polynesia 1760–1860* (Honolulu: University of Hawai'i Press, 2006), 176, 204–5.
2. James Wilson, *A Missionary Voyage to the Southern Pacific Ocean Performed in the Years 1796, 1797, 1798 in the Ship Duff, Commanded by Captain James Wilson* (London: T. Chapman, 1799), 357–58.
3. Maggs Bros. Booksellers, *Voyages and Travels*, vol. 4, pt. 9, *Australia and the Pacific*, Catalogue no. 856 (London: Maggs Bros. Booksellers, n.d.), 598–99.
4. Terrence Barrow, *Art and Life in Polynesia* (Rutland, Vt.: Charles E. Tuttle, 1973), 107.

Raivavae, Austral Islands

Drum *(Tariparau [Pahu-Ra])*
1800–1850
Tamanu wood *(Calophyllum inophyllum),* sharkskin, sennit
H. 54 in. (137.1 cm)
Raymond and Laura Wielgus Collection, 80.5.3

Detail of drum

"Virtuoso" is an apt word to describe the carver of this delightfully intricate drum. Though we will never know his name, we can be sure that, as a master craftsman in Polynesia, he was a member of the elite, who considered carving a sacred activity to be performed accompanied by prayers and chants. The coming of Europeans during the late eighteenth and early nineteenth centuries was disastrous for traditional Polynesian culture, but objects such as this one bear witness to a brief period between contact and acculturation in which skilled carvers reached new heights.

About a dozen similar tall Austral drums are known, and all are believed to have been carved on the island of Raivavae, although they apparently were traded over a wider area. Each is carved from a single piece of wood and has two hollow chambers. The upper one, over which a sharkskin tympanum is stretched, is the resonating chamber. Around the middle of the drum, rectangular wooden cleats secure the sennit cords that hold the tympanum in place. Their tension can be adjusted with the thick sennit tightening roll or, on this example, with the two sennit cords above it. Below the cleats, the second hollow chamber serves as a drum stand.

The drum's harmonious proportions and its tall, slender appearance appeal to Western contemporary taste, but what makes the drum so breathtaking is the elaborate carving that adorns it. The crisp and detailed workmanship indicates that metal tools were used; indeed, it is hard to imagine that a carver could have made this instrument with the stone, bone, shell, and teeth tools that were used before interactions with European explorers and traders made iron tools readily available. In fact, the oldest drums, collected during the 1770s have undecorated resonating chambers, and the motifs on the drum stands are larger and fewer in number.

On the resonating chamber, the carving takes the form of repeating rows of incised stylized headless humans with elbows on knees, toothed notches, and crescents. Each of the cleats has relief carvings of two triangular faces arranged chin-to-chin. Like the resonating chamber, the drum stand is covered with carving, but here much of the wood is pierced through, creating patterns of shadow and light over the surface. The motifs are similar, though more elaborated, to those on the resonating chamber: rows of clearly articulated figures with upraised hands, framed by bands of toothed notches, alternate with rows of crescents suggesting swags or waves. Below, just above the bottom of the drum, upside-down triangular faces alternate with equal amounts of void to form an openwork border. Finally, along the bottom are several rows of geometric carving, including small vertical lines, toothed notches, and circles surrounded by emanating rays.

Because the Austral Islands have been—and remain—one of the least studied island groups in Polynesia, we are not certain about the meanings, if any, associated with these motifs. Throughout Polynesia, the repetition of human figures is frequently associated with genealogy, and stylized headless humans with elbows on knees are also found on objects from the Cook Islands, particularly ceremonial adzes associated with Tane, an important Polynesian deity. The depiction of disembodied heads may relate to ideas about the sacredness of that body part, as the seat of a person's *mana*. Crescents have been interpreted in various ways: as a symbol of *mana* or as decorative elements inspired by the curved thighs of dancers, their skirts, or their chest ornaments.[1] Whatever their meanings, though, these motifs were not only confined to drums, but also decorated other wooden carvings, such as elaborately carved paddles, which became popular trade items.

The drums are usually called ceremonial, though their use was not documented on the Austral Islands at all. Instead, that designation has been based primarily on their similarity to drums in a Tahitian temple area depicted in a drawing by John Webber, the official artist on James Cook's third voyage to the South Pacific (1776–80). In that drawing, while others attend to sacrifices, two standing men use their hands to beat tall cylindrical drums that may have been imported from the Austral Islands. Those drums clearly differ from others in a sketch depicting a dance performance, where the drummers are seated and playing shorter instruments.

Further Reading
Moyle, Richard. *Polynesian Sound-producing Instruments.* Shire Ethnography, 20. Princes Risborough, Buckinghamshire: Shire Publications, 1990.

Note
1. Charles W. Mack, *Polynesian Art at Auction 1965–1980* (Northboro, Mass.: Mack-Nasser Publishing, 1982), 210; Roger Duff, *No Sort of Iron: Culture of Cook's Polynesians* (Christchurch: Art Galleries and Museums' Association of New Zealand, 1969), 30; and Douglas Newton, "Visual Arts of the Pacific," in *African, Pacific, and Pre-Columbian Art in the Indiana University Art Museum* (Bloomington: Indiana University Art Museum in Association with Indiana University Press, 1986), 64.

Marquesas Islands

Stilt Step (Tapuvae)
19th century
Wood
H. 17 ³/₄ in. (45.1 cm)
Raymond and Laura Wielgus Collection

Objects from the Marquesas Islands, a group of rugged volcanic outcroppings northeast of Tahiti and the Society Islands in central Polynesia, are nearly always easy to identify, and this stilt step, masterfully carved, very clearly shows the stylized depiction of the human form and interest in surface patterning that make the art so distinctive.

Marquesans call a representation of the human form, as well as a motif inspired by it (such as the face on the curved section at the top), a *tiki,* and these images appear on both sacred and secular objects in various media. Tiki is also the name of a deity who plays a prominent role in stories of origin in many parts of Polynesia; in the Marquesas, various myths credit him with teaching humans how to carve or with being the first deity for whom carved images were made. As the stilt step's larger figure illustrates, a Marquesan full-figure *tiki* has a large head (considered the most sacred part of the body) and a stocky body with hands to stomach and slightly bent knees: these features are also typical of Polynesian sculpture generally. The goggle eyes, flaring nostrils, and broad mouth with an indication of the tongue between the lips, however, are distinctly Marquesan.

A Marquesan stilt consists of two parts: a pole, between five and seven feet long, and a stilt step lashed to it. While some stilts, particularly those owned by young boys, were plain, many were decorated. The poles, about two to three inches in diameter, were usually carved with simple geometric relief patterns resembling those on Marquesan house posts. To help keep a step from slipping, the pole was wrapped with *tapa* (beaten barkcloth) approximately one third of the way up the shaft, and then the step was lashed in place over it. These lashings secured the step in two places: below the horizontal footrest (behind the head of the large figure on this example) and at the bottom (on this one, below the smaller figure). The braided fiber lashings were often dyed black and red and arranged in ornamental patterns, increasing the beauty of the stilt as well as the *mana* (the supernatural energy or force possessed by all things living and inanimate) associated with it, as the acts of braiding and lashing were accompanied by prayers and were considered to be sacred *mana*-enhancing activities.

Most artistic attention, though, was lavished on the stilt step, *tapuvae,* which is carved from a single piece of wood. Though the number, pose, and arrangement of figures varies, the most common form is a single standing *tiki* with hands on stomach, head attached to the bottom of the footrest, and buttocks and legs emerging from the part that was lashed to the stilt. This *tapuvae* shows such a *tiki,* and also includes a smaller crouching figure below. Here, a *tiki* face appears again on the relief carving that covers the footrest, which more commonly is filled with abstract motifs similar to those on the stilts.

Stilt demonstrations and contests, which often involved wagering by the audience, were popular in several parts of Polynesia, but the stilts themselves became an art form only in the Marquesas Islands. There, stilt games, along with singing and dancing, were one of the major entertainments at festivals marking special events such as weddings, milestones in the lives of children from important families, and the death of a chief or priest. Whether in the form of races, entertainment that included somersaults and other acrobatics, or competitions of skill, in which one man would try to knock down his opponent by balancing on one stilt while using the other to strike the stilts of his rival, stilt walking was believed to be a means of attracting the attention of deities, as well as a demonstration of the *mana* of individual participants and the families and groups they represented.

In addition to the *tapuvae,* the Raymond and Laura Wielgus Collection includes six other Marquesan objects: two bone ornaments, a stone figure, two headdresses, and an ivory-handled fan. Four of them were acquired in the 1950s from John J. Klejman, who moved to the U.S. from Europe before World War II, becoming one of New York's most prominent art dealers and one of the earliest selling African and South Pacific art, much of which he acquired in Europe. Other South Pacific objects that the Wielguses bought from Klejman include the Tonga figure (p. 184), the Maori pendant (p. 200), and the Erub mask (p. 218).

Further Reading
Kjellgren, Eric, with Carol Ivory. *Adorning the World: Art of the Marquesas Islands.* New York: Metropolitan Museum of Art, 2005.

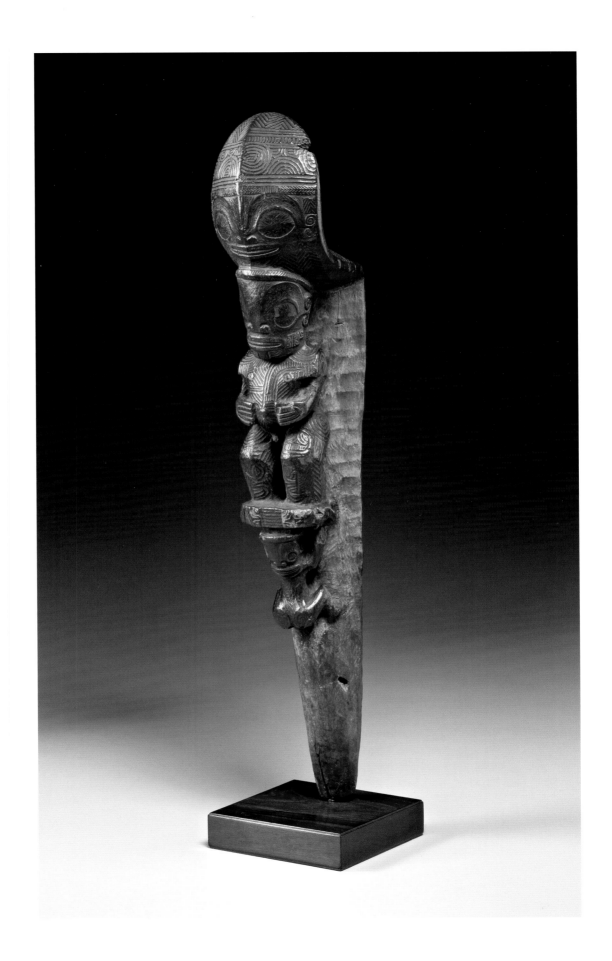

Easter Island

Chest Ornament (Rei Miro)
Wood, obsidian, bone
W. 15 in. (38.1 cm)
Raymond and Laura Wielgus Collection

While the graceful outline and delicate carving of this *rei miro* may make it more visually appealing to Western viewers than the *moai kavakava* (p. xx), like that figure, our understanding of the *rei miro* is limited by only fragmentary information about pre-European Easter Island, the result of a population being decimated before traditions were recorded. An indication of high rank, a *rei miro* was worn suspended around the neck from a cord, perhaps of braided human hair, by men and women at feasts and other important occasions. Status was important throughout Polynesia, where inherited rank not only determined the course of one's life but also was believed to indicate proximity to the gods, and particular materials and types of objects distinguished nobility from commoners. While people generally wore only one *rei miro,* the *ariki mau,* paramount chief of Easter Island, was said sometimes to have worn two of these ornaments on his chest and two on his shoulders.

Most *rei miro* were carved from toromiro, the same wood used for figures such as the *moai kavakava.* Eight to nine feet tall, *Sophora toromiro* is a slow-growing tree and was the only one still extant on Easter Island when Europeans first arrived (palm groves had once flourished, but had disappeared by the eighteenth century). Therefore, in spite of its tendency to grow crooked, it was, with the exception of occasional pieces of driftwood, the exclusive source of wood for carving. A few other examples of the *rei miro* are also found in stone, bone, and shell; some sources suggest that a woman's ornament was typically made of one of these other materials.

The ornament's defining characteristic is its crescent form. Most are symmetrical, with the crescent's points elaborated by carvings, usually in the form of human heads, as in this example. As this ornament illustrates, the faces have many of the typical characteristics depicted on full figures. Most noticeable are the mesmerizing round obsidian and bone inlaid eyes (some *rei miro* have simple carved eyes instead). This inlaid eye treatment is typical of nearly all Easter Island wooden figures, just as a similar technique was common to Maori sculpture (p. 198); in both cases, the added materials emphasize the eyes, drawing attention to the head, the most sacred part of the body. The overhanging brow, long nose, prominent cheekbones, and short beard are also quintessential Easter Island features and appear on many figures.

The back of the crescent is slightly rounded, but plain except for two raised lugs near the back of the top rim, which were drilled to hold the suspension cord. The fronts of some crescents are also plain, but many, including this one, are carved with an intaglio crescent that echoes the larger form, complementing it aesthetically.

The crescent form likely had multiple associations, creating an interesting contrast between the apparently simple form and its rich layers of meaning.[1] Some scholars have suggested that the *rei miro* may derive from shell breast ornaments and horizontal whale-tooth pendants worn in Fiji, Tonga, and Samoa, the area from which the rest of the Polynesian islands were populated. They also note that a similarly shaped wooden chest piece is part of the traditional Tahitian mourning costume. Linguistic support for this interpretation is found in the meaning of the word *rei,* used in Polynesia to mean "neck ornament," but originally referring to a whale tooth, and, on Easter Island, also meaning "mother-of-pearl shell." Another explanation of the form's meaning parallels interpretations of the crescent in Hawaii by proposing that the form may represent a human figure with upraised arms and, by extension, it may be a stylized convention for recalling the gods who were believed to hold the sky above the earth. Following that interpretation, the heads on the end of the *rei miro* can then be understood as an explicit restatement of the anthropomorphic symbolism.

Throughout Polynesia, the crescent also refers to the moon, and, perhaps most importantly, the form is understood as having that meaning in *rongorongo,* a system of pictographic symbols unique to Easter Island. Furthermore, elderly islanders at the end of the nineteenth century told one researcher that *rei miro* were sometimes called "moon ornaments," and that variations in the size of the crescent referred to different phases of the moon. On Easter Island and in the rest of Polynesia, time was organized according to the appearance of the moon, which was believed to balance the sun, creating harmony in nature.

Further Reading
Kjellgren, Eric. *Splendid Isolation: Art of Easter Island.* New York: Metropolitan Museum of Art, 2001.

Note
1. See Roger Duff, ed., *No Sort of Iron: Culture of Cook's Polynesians* (Christchurch: Art Galleries and Museums' Association of New Zealand, 1969), 58; Alfred Métraux, *Ethnology of Easter Island* (1940; reprint, Honolulu: Bernice P. Bishop Museum, 1970), 230, 232; and Jo Anne Van Tilburg, *Easter Island: Archaeology, Ecology, and Culture* (Washington, D.C.: Smithsonian Institution Press, 1994), 122.

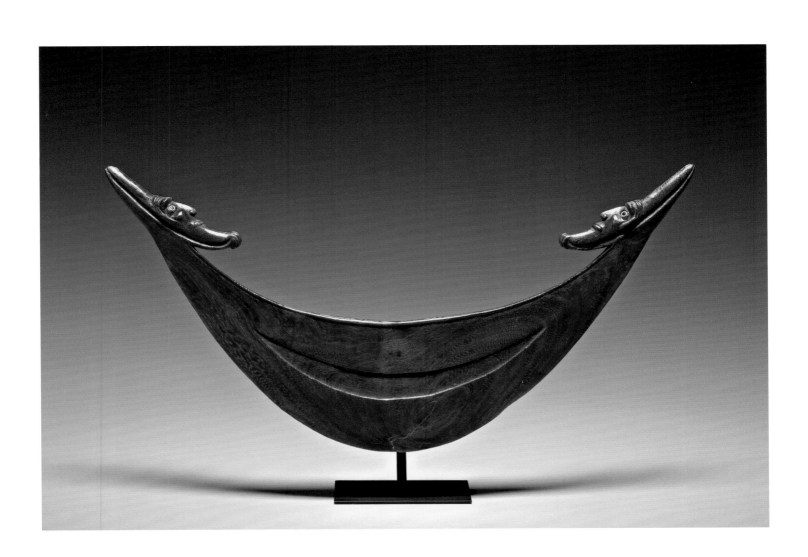

Easter Island

Male Figure (*Moai Kavakava*)
Early to mid-19th century
Wood, obsidian, bone
H. 15 in. (38.1 cm)
Raymond and Laura Wielgus Collection, 80.5.1

This drawing of the relief carving on the head of this *moai kavakava* clearly shows that the image combines human, lizard, and fish forms. Drawing: Brian Garvey

Though the monumental stone figures of Easter Island have for years captured the public imagination, another sculpture type, the *moai kavakava* ("statue with ribs"), leaves a remarkable impression not soon forgotten. Like almost all wooden Easter Island sculpture, it was carved from the toromiro tree, the only readily available source of wood on the island. Always male, *moai kavakava* have prominent rib cages, clavicles, and spines and sunken eye sockets that evoke skeletons, but their beards, glinting bone-and-obsidian eyes, and elongated fleshy earlobes place the images within the realm of the living. While it shares these typical characteristics, the museum's figure also displays a highly polished surface, precise details, and taut, strongly delineated features that create an expressive vitality, placing it among the most artistic *moai kavakava* known.

Information about what these figures represent and how they were used is fragmentary and speculative, a result of the decimation of traditional island culture that followed the arrival of Europeans in the eighteenth century. Already under pressure from major internal turmoil, including famine and war, Easter Islanders were subjected to the diseases, missionizing, and intervention in politics and commerce that marked Western presence throughout Polynesia. They also suffered a severe rupture with past traditions when, in 1862, slave ships raided the island, taking about a thousand people, including the paramount chief, to work on islands off the coast of Peru. Though the Peruvian government arranged for their return the next year, about nine hundred had already died, and most of the remaining perished en route. Fifteen survivors landed home, but they brought with them smallpox, and an epidemic followed that ravaged the remaining population, so that by 1872 it numbered just over one hundred. Although some anecdotal information and observations were recorded beginning in the eighteenth century, only in 1914 was a systematic study made of Easter Island culture; by that time, hundreds of objects had already been destroyed or removed from the island, and, more importantly, the artists and religious and political leaders who understood them were long gone.

The skeleton-like character of the figures suggests a connection with the world of the dead, and most scholars believe that *moai kavakava* represent ancestors or their spirits. In addition, the very prominent backbones carved on all *moai kavakava* recall the depiction of vertebrae on figures as a metaphor for genealogy in other parts of Polynesia, such as Hawaii. Other scholars, though, have suggested that the figures might be related to Makemake, a birdman deity who was the most important god on the island at the time of early European contact, and who was personified in oral traditions as a skull and as a man emerging from a skull. Adrienne Kaeppler, an anthropologist who has worked extensively in Polynesia, has

argued convincingly that *moai kavakava* may in fact relate to both traditions. Pointing out that fertility in its broadest sense is the basis of cults relating to Makemake, Kaeppler notes that the figures were likely parts of occasions that centered on families and their descent lines—i.e., human fertility.[1]

Many *moai kavakava,* including this one, have low relief carvings on the crowns of their heads, the part of the head considered most sacred throughout Polynesia. A variety of motifs occur, but on this figure, a creature with the face of a human, the body of a lizard, and the tail of a fish is depicted. Such combinations of forms are common in the art of Easter Island, and, though not fully understood, it has been suggested that this imagery may represent transformations taking place as a result of spirit possession or some other supernatural means.[2] On Easter Island, the lizard seems to have been associated with protection, and the ease and speed with which a fish could swim were much admired, particularly in relation to an important ceremony related to Makemake, in which competitors swam to a nearby island to retrieve a bird egg.

Moai kavakava are said to have been wrapped in barkcloth and displayed only on certain occasions, including feasts, harvests, and first-fruit celebrations. At those times, men (and perhaps women) brought out all the figures they owned, to be worn on the body (some figures have holes at the back of the neck for suspension) or carried in dances. These dances most certainly accompanied chanted prayers, and Kaeppler suggests that the figures can be viewed as expressing these prayers in permanent physical form.[3]

This figure is said to have come from one of the old whaling families of New Bedford, Massachusetts. Beginning in the 1790s, British and then American ships sailed the Pacific in pursuit of sperm whales—or, more precisely, their blubber and oil—and found the islands of Polynesia good stopping places for restocking their supplies and acquiring crew members. Souvenirs and curiosities brought back by some of these men were among the earliest Polynesian objects acquired by Americans.

Further Reading
Kaeppler, Adrienne. "Sculptures of Barkcloth and Wood from Rapa Nui: Symbolic Continuities and Polynesian Affinities." *Res* 44 (Autumn 2003): 10–69.

Notes
1. Adrienne Kaeppler, "Sculptures of Barkcloth and Wood from Rapa Nui: Symbolic Continuities and Polynesian Affinities," *Res* 44 (Autumn 2003): 17.
2. Jo Anne Van Tilburg, *Easter Island: Archaeology, Ecology, and Culture* (Washington, D.C.: Smithsonian Institution Press, 1994), 115.
3. Kaeppler, op. cit., 30.

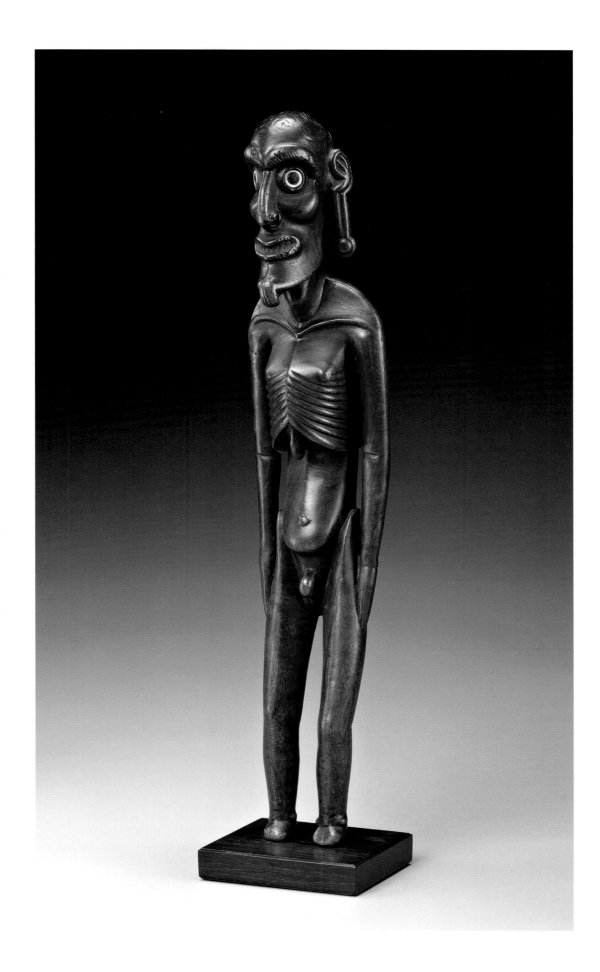

Hawaii

Pendant Necklace (Lei Palaoa)
1800–50
Walrus ivory, human hair, fiber
L. 13 7/8 in. (35.1 cm)
80.23

Visually, the *lei palaoa* is an object of contrasts: the hard, smooth piece of butter-colored ivory is set off by the dark, textured braids of multiple strands of human hair. Before European contact, a *lei palaoa* would have been worn by nobility of both sexes on ceremonial occasions, as personal display, or into battle as a symbol of genealogical lineage. A woman considered it her most valuable personal possession. For a man, it was second only to his feather cape or cloak, velvet-like garments made from thousands of feathers attached to a fiber base. As Kamehameha I (ca. 1758–1819) consolidated power to establish the Kingdom of Hawaii in 1810, he transformed the necklace into a symbol of his political power and authority. Under his successor, Kamehameha II, who became king in 1819, it became a status symbol that was no longer restricted to a particular group.

As elsewhere in Polynesia, ivory was a precious material for Hawaiians. Before European contact it was very rare, obtained only from beached whales. With the coming of traders and whalers in the nineteenth century, however, not only did the availability of whale ivory increase, but walrus ivory, taken by ships from the Arctic seas before they entered the South Pacific, was introduced. Similar in color to whale ivory, walrus ivory has a darker inner dentine core, which may appear crystalline, as in this example.

The hook form of the pendant is a least one thousand years old. Its origin and meaning are not known, though scholars have proposed several possibilities. Some have suggested that it refers to a ceremonial fish hook. Others believe that the form is a stylized head with a tongue, a reference to the belief that a deity accepted a sacrifice by drawing it in with its tongue; in fact, the Hawaiian word for the pendant tip is *lelo,* the word for tongue. In addition, the pendant form resembles the chin-mouth-tongue configuration of many Hawaiian figures representing deities, suggesting that the *lei palaoa* might have been considered conceptually much closer to sculptures such as the figure above.[1] Finally, some scholars view the hook of the pendant as an aesthetic counterpart to the crest, which they consider an extension of the backbone and a symbol of genealogy. Genealogy is an important aspect of the Polynesian belief system, for through its recitation, members of the nobility traced their ancestry back to the gods. Given the complexity and multivalent quality of much imagery throughout Polynesia, it is entirely possible that all of these interpretations are meaningful.

The sides of the pendant's shank are pierced so that the hair necklace can pass through. The earliest known necklaces, collected during James Cook's third voyage to the South Pacific (1776–80), consist of relatively few strands of twisted hair, but by the nineteenth

Likely collected by the naturalist on the H.M.S. *Blonde* in 1825, this figure was carved to honor a state, family, or personal god. Such figures were used in rituals that were believed to increase the *mana* of devotees while at the same time confirming the importance of their genealogies, two tasks that the wearing of the *lei palaoa* also accomplished.

Kona District, Hawaii
Figure
1800–25
Wood, fiber
H. 16 in. (40.6 cm)
82.41

century, they comprised many thick, braided coils. This example, for instance, consists of eight-ply braids, each made up of approximately ninety strands of hair. Thanks to an ingenious construction technique, however, they all still appear to pass through the hook. In fact, only a few plaits actually do; those are spread around the rest, which are tied very closely to the pendant. At the other end, the loops are bound with a fiber cord that emerges from the center of the braids and serves as a tie for the necklace.

Unfortunately, we know little about the origin of the hair used for *lei palaoa*. For Polynesians, the head was the most sacred part of the body, and therefore hair growing out of it was full of the supernatural energy called *mana* (see p. 183). Most likely hair for older necklaces came from noble women: early reports indicate that they cut their hair at marriage and after the birth of their first child, and an early nineteenth-century missionary noted that women in noble households spent a great deal of time braiding human hair for necklaces.[2] Whether these early necklaces contained the hair of more than one woman or whether hair strands might be added to a necklace over time is not clear. However, the large quantity of hair in later necklaces, as well as the wearing of those necklaces by a broader spectrum of people, suggest a shift in practice, so that the hair used in them was not exclusively from royal women.

Notes
1. J. Halley Cox, "The Lei Niho Palaoa," in *Polynesian Culture History: Essays in Honor of Kenneth P. Emory*, ed. Genevieve A. Highland et al. Bernice Bishop Museum Special Publication, 56 (Honolulu: Bishop Museum Press, 1967), 411–24.
2. Teri Sowell, "From Darkness to Light: Art and the Hawaiian Theory of the Body" (PhD diss., Indiana University, 1999), 65–66, 72.

Maori peoples (Rongowhakaata group), North Island, New Zealand

Canoe Bailer (Tiheru or Tata)
Early 19th century
L. 17 5/8 in. (44.8 cm)
75.67

Feathers and carved ornaments such as this typically decorated the fronts of Maori war canoes. For the Maori, a protruding tongue is a sign of aggressiveness. The figure-eight-shaped mouth, also carved on the bailer, is characteristic of Maori style.

Maori peoples, North Island, New Zealand
Canoe Prow Ornament
Wood, shell
L. 36 ¼ in. (92 cm)
65.35

This bailer is included among those Maori objects that are admired not only for the beautiful way in which they were made but also as evidence of a culture that transformed even seemingly mundane, utilitarian tools and equipment into aesthetic objects. Our appreciation is enhanced by the clear indications of extensive use: being dragged across the bottom of a boat has left one end chipped, and gripping the handle has polished it smooth and left it light in color.

Bailers such as this were an important piece of equipment for Maori war canoes.[1] As its name suggests, the war canoe (*waka taua*) transported men going to battle, but it was also used for coastal voyages and to return the bodies of important men who had died far from home. A war canoe could measure nearly one hundred feet long and almost six feet wide and was able to hold one hundred or more men. Its hull was built of up to three pieces of wood, the top strakes were carved with relief decoration, and the prow and stern were decorated with elaborate ornaments (above). Decking, sometimes spread with mats, covered the bottoms of these larger canoes, but one or two places were left exposed so that the boat could be bailed when necessary. Each of those spots was manned by one or two men with wooden bailers. The form of this bailer is typical; carved of a single piece of wood, it is in the form of a broad scoop with a handle projecting over it. The handle's placement is said to be ergonomic.[2]

Though the other war canoe equipment—stone anchors, plaited fiber sails, and wooden paddles—was generally relatively plain, bailers were elaborately decorated, and, like much Maori carving, they have multiple levels of visual interpretation. The overall form recalls a long-necked sea bird. However, a large figure-eight-shaped mouth, a hallmark of Maori woodcarving, is clearly depicted at the decorated end of the scoop, and above it, at the base of the handle, is carving that looks like the bottom of a nose. Though the round forms on each side of the mouth are placed in such a way that they may not readily be perceived as eyes on this example, their placement on other bailers suggests that they can be interpreted that way. An alternate reading of the composition views the handle as a continuation of the nose, leading to a head in profile at the end. That head is not the human, or *tiki,* form, but rather depicts a common but little-understood motif known as the *manaia,* which seems to combine elements connected with birds, lizards, and ancestors and is understood today as a guardian spirit. Some scholars argue that many of the stylized frontal faces in Maori art, such as ones with emphatic figure-eight-shaped mouths like the one on this bailer, are actually two *manaia* profiles put together.[3]

Canoe bailers figure in several Maori oral traditions. Kupe, the legendary discoverer of New Zealand, was said to have left behind his bailer, which became a rock at the mouth of Hikianga Harbor on the North Island's northwest coast. Paikea, another important figure from the legendary Maori homeland of Hawaiki, was nearly lost at sea with his brothers when a jealous half-brother put a hole in the bottom of a new canoe in which they were sailing and then hid the bailer, which could have kept the boat from being flooded; the only one of the brothers to survive, Paikea was borne on the back of a whale to Aotearoa, the Maori name for New Zealand.

During a visit to the museum in 1985, South Pacific art scholar Douglas Newton attributed this bailer to the Rongowhakaata group, who live in the vicinity of Poverty Bay on the east cape of the North Island. He noted that it is in a style associated with a Whanau-a-Apanui chief named Tukaki from the eastern Bay of Plenty, who is said to have traveled south centuries ago to a *wharewamamga* ("house of learning") on Tolaga Bay, where he learned the art of carving and developed a style that spread over a wide area of the east cape.

Further Reading
Starzecka, D. C. *Maori Art and Culture*. Chicago: Art Media Resources, 1996.

Notes
1. Though early European reports mention Maori outrigger and double-hulled canoes, by the end of the 1830s neither was used. In addition to war canoes, the Maori continued to make smaller and less decorated fishing canoes, and multipurpose canoes that were smaller still and unadorned. See Elsdon Best, *The Maori Canoe*. Dominion Museum Bulletin 7 (Wellington: Dominion Museum, 1925), 6.
2. Best, op. cit., 174.
3. For a good summary of Maori motifs and their meanings, see Roger Neich, "Wood Carving," in *Maori Art and Culture*, ed. D. C. Starzecka (Chicago: Art Media Resources, 1996), 82–90.

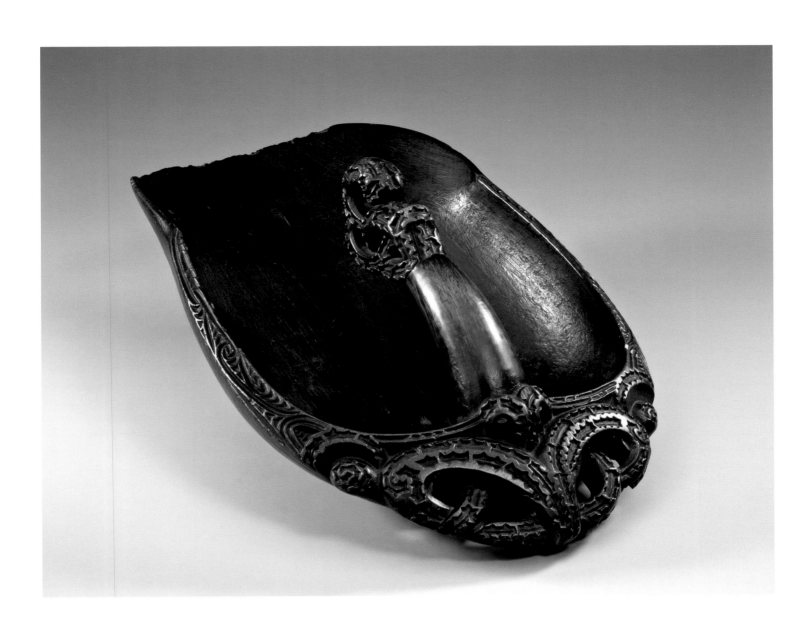

Maori peoples, New Zealand

Pendant (Hei Tiki)
19th century
Nephrite, haliotis shell
H. 9 in. (22.9 cm)
Raymond and Laura Wielgus Collection, 80.5.2

The large size, yet masterful carving make this *hei tiki* a remarkable example of Maori art in their most precious material, *pounamu,* a hard, green stone. Nearly all *hei tiki* are between two and seven inches tall, making this one of the largest known, but the sculptor has fashioned it with the same care and detail lavished on smaller pendants.

Worn suspended from a short flax cord around the neck, a *hei tiki* was considered the most precious ornament that a person could own. Its value came in part from the material from which it was made. The Maori call nephrite (a variety of jade) and bowenite (a type of serpentine) by the collective term *pounamu* ("green"). Because of its rarity, hardness, and mythological associations, *pounamu* was considered the most precious material available to the Maori at the time of the first European landing, that of James Cook, in 1769. Rare throughout the world, in Polynesia it is found only on New Zealand's South Island, and Maori histories describe hazardous journeys in search of *pounamu* and struggles to control its trade. For people who acquired metal only with the coming of Europeans, the *pounamu*'s hardness made it valuable for tools and weapons, and jewelry made from it was valuable in part because of the hundreds of hours required for its carving. Finally, in Maori stories of origin, personified *pounamu* is intimately connected with their journey from the mythic Hawaiki and settlement in New Zealand.

The pendants were also highly prized because of their connections to ancestors and the large amounts of *mana* they accumulated. For the Maori, as for people throughout Polynesia, *mana* was conceived of as a supernatural force or power that all things possessed and that could be transferred through physical contact. The hardness of *pounamu* and the length of time that a carver worked with a piece in making a *hei tiki* ensured that its *mana* was strong. That *mana* was increased by the association of the pendant with a particular ancestor, and the physical contact created when it was worn ensured that the *mana* continued to grow. Passed down through generations, an old *hei tiki* was considered especially powerful because of its acquisition of *mana* from intimate contact with a succession of owners.

A *hei tiki* was usually owned by an individual and inherited by a relative. Beginning in the nineteenth century, the pendants have been worn primarily by women, but European reports from the eighteenth century indicate that high-ranking men wore them, too. In former times, a pendant might also become more than a family heirloom: the leader of one community might present a *hei tiki* to the leader of another as a way to ensure good relations between the two groups.[1]

The meaning of the pendants' form is much debated. The name offers no clue, for *hei* means "to suspend," and *tiki* is a generic word referring to the depiction of the human form. The pendants were associated with ancestors, but they were not considered likenesses of them. Some people have suggested, though, that the bent position of the head, arms, and legs might refer generally to a deceased person, because the Maori traditionally flex a corpse before burial. The pose also has led other scholars to propose that the figure might depict a fetus, a woman during intercourse, or one giving birth, and, in fact, the pendants frequently have been associated with fertility. Many families have stories of women who became pregnant only after being given a *hei tiki,* and some women wore the pendant as an amulet to ensure easy childbirth.[2] However, while some pendants are female, others, including this one, have no indication of gender.

Whatever the interpretation of the unusual form, that form itself deviates little. As this example shows, it includes a large head turned and resting on one shoulder, arms bent so they are attached to the thighs, and legs splayed, but bent at the knees so that the lower legs join at the bottom, forming a crescent. Large round eyes, usually with a shell inlay around the pupils, and a figure-eight-shaped mouth recall Maori wood carving (see p. 198). Variations are seen in the shape of the head (some are more oval) and the side to which it is turned (unlike this one, most show the chin on the left shoulder), and a small number of pendants show one hand on the chest.

Like most *hei tiki,* this one is carved on only one side. Though all are relatively flat, the beautiful modeling and rounded forms of this example set it apart. Large pendants such as this example are believed to date to the nineteenth century, when Maori culture was undergoing dramatic changes and the availability of metal tools made carving easier and quicker. The superb craftsmanship of this *hei tiki,* however, testifies to its having been carved by a sculptor who was still a master of his medium.

Further Reading
Riley, Murdoch. *Jade Treasures of the Maori*. Paraparaumu, New Zealand: Viking Sevenseas, 1987.

Notes
1. Murdoch Riley, *Jade Treasures of the Maori* (Paraparaumu, New Zealand: Viking Sevenseas, 1987), 58.
2. Ngahuia Te Awekotuku, "Maori: People and Culture," in *Maori: Art and Culture*, ed. by D. C. Starzecka (Chicago: Art Media Resources, 1996), 43, 45.

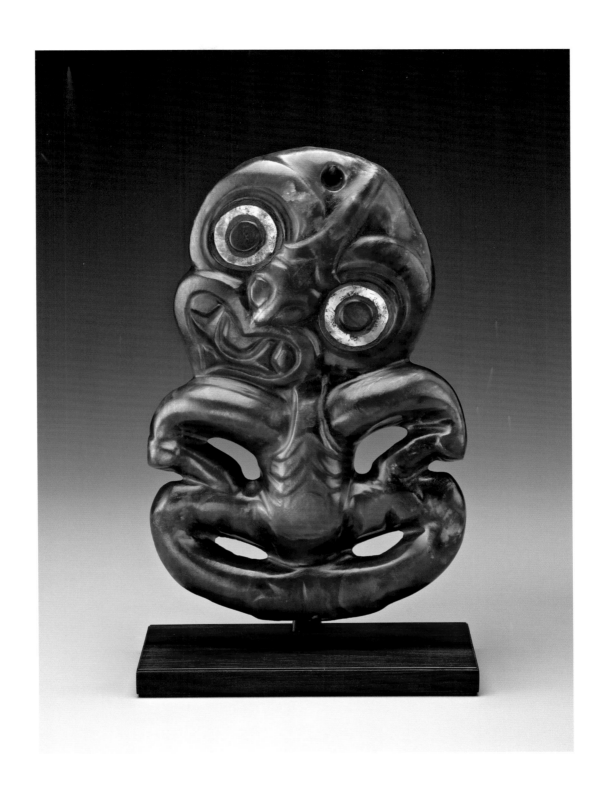

New Georgia group, Solomon Islands

Canoe Prow Ornament (Toto Isu)
19th century
Wood, shell, pigment
H. 5 1/4 in. (13.3 cm)
Raymond and Laura Wielgus Collection, 96.8

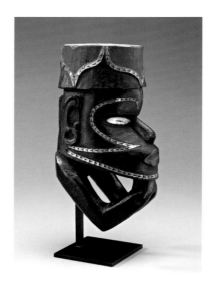

New Georgia group,
Solomon Islands
Canoe Prow Ornament,
(Toto Isu)
Wood, shell, pigment
H. 11 1/4 in. (28.6 cm)
75.51

Figures such as this one were standard parts of war and fishing canoes in the neighboring islands of New Georgia, Choiseul, Santa Isabel, and Ngella (Florida) until the end of the nineteenth century, when head-hunting ended in the area. Sometimes large enough to accommodate more than thirty men, these canoes were built in a graceful crescent shape, with tall prows and sterns, and were decorated with shells, feathers, fiber, and sculpture. While other sculptures were attached to the tops of the prow and stern, objects called *musumusu, nguzunguzu,* or *toto isu* were attached just above the waterline so that the faces looked forward.[1]

Ranging from four to nearly ten inches tall, the canoe prow ornaments most commonly take the form of a head with arms extended forward, hands touching the chin or holding a bird (a reference to successful navigation) or a small human head (a head-hunting symbol, as were the ornaments themselves). Most figureheads have a pierced projection from the back of the head to enable it to be lashed to the front of the canoe. Here, the projection and one of the holes is visible just above the ears; the black stain has rubbed off, revealing the brown color of the wood. Another prow ornament in the collection (above), also attributed to the southwestern area of the New Georgia group, offers a comparison that gives some sense of the stylistic range of these figures, which may vary considerably even within the same area. Those from the New Georgia group, though, generally have lower jaws that project outward, as both of these examples show.

Most of the heads, including the Wielgus example, depict accessories and enhancements that were commonly seen on the islanders themselves. Hats and headdresses were frequently worn, and some sort of headgear is depicted on nearly all of the carvings; the hat here may represent a European type popular in the nineteenth century. Both men and women wore large wooden earrings, sometimes up to four inches in diameter, and the ears of the Wielgus figure clearly have been pierced and stretched to accommodate such earrings. Finally, thin lines were painted on the face with lime as part of ceremonial dress, and the lines on the face of this prow ornament correspond roughly to the standard pattern, with markings across the forehead, over the cheekbones, and across the jawline.

Light and dark contrast created by white shell inlay against black wood is a hallmark of Solomon Islands art. On canoe prow ornaments, the shell is most often inlaid to form the whites of the eyes and the lines that correspond to face painting, as in this example, where the serrated edges and angles of the inlay pieces also contrast with the pleasantly rounded forms of the carving. Sometimes, the inlay is also used to decorate accoutrements, such as earrings or a hat

as in the prow ornament on this page. Nautilus shells were cut or broken into various shapes (each with its own name), then the edges were smoothed or serrated and the surfaces polished. A paste made from the parinarium nut was spread into grooves cut into the object, and then the inlay was pressed into the paste so that the pieces were even with the surface. In addition to canoe prow ornaments, other objects, including canoes, food bowls, and over-modeled skulls, were decorated in a similar fashion.

Customarily, these canoe prow ornaments are said to be protective, either shielding the canoe's passengers from trouble at sea or safeguarding them from human enemies. However, a recent publication by Deborah Waite, who specializes in the art of the Solomon Islands, suggests that an ornament also may have served as a signal to a war party's community about the outcome of a raid: if it were attached to the prow of the returning canoe, then the raid had been successful and the warriors were returning home unharmed. Its absence, on the other hand, indicated failure. As Waite points out, the prow ornaments may have had different uses from island to island and over time.[2]

Like the *hei tiki* (p. 200), which has become a national symbol of New Zealand, the *toto isu* has evolved into an emblem of the independent Solomon Islands. Appearing on currency as well as in advertising, the figures continue to be carved today, though most often as decorative items sold at markets to affirm national identity or as souvenirs of an exotic place.

Further Reading
Waite, Deborah. "*Toto Isu (NguzuNguzu)*: War Canoe Prow Figureheads from the Western District, Solomon Islands." *The World of Tribal Arts* 20 (Spring 1999): 82–97.

Notes
1. Different names were used in different areas: the prow ornaments were called *toto iso* in the Roviana Lagoon to the south of New Georgia Island, *nguzunguzu* in the Marovo Lagoon to the north, and *musumusu* on Choiseul. See Deborah Waite, "*Toto Isu (NguzuNguzu):* War Canoe Prow Figureheads from the Western District, Solomon Islands," *The World of Tribal Arts* 20 (Spring 1999): 82.
2. Waite, op. cit., 88, 91.

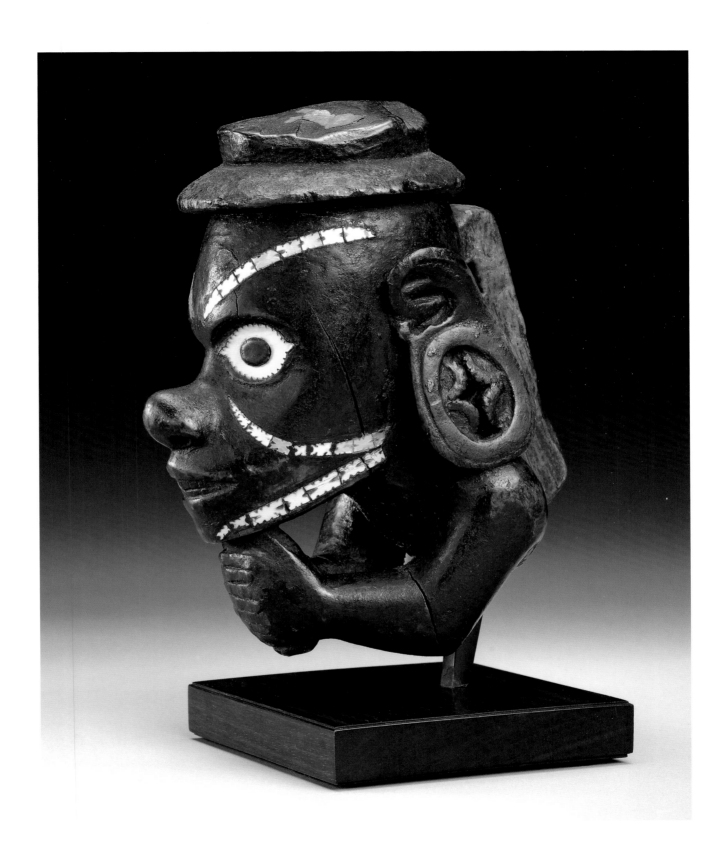

Neo village, Temotu, Santa Cruz Islands
Solomon Islands

Male Figure (Munga Dukna)
Wood, fiber, shell, turtle shell, turmeric
H. 13 ³/₄ in. (33.7 cm)
Raymond and Laura Wielgus Collection

The ability to bring its owner good fortune or disaster, health or illness, wealth or poverty were all believed to be within the power of the deity honored by this figure. Kept on an altar in a man's own home or in the communal men's house (a building that served as the social and spiritual center of a community), a *munga dukna,* "image of a deity," represented a man's tutelary deity and was treated with all of the respect and honor accorded a distinguished guest in a household. For example, before anyone else was served a meal, the figure was offered the best food, and it was regularly dressed with ornaments befitting an important man. When special assistance from the deity was desired, the owner addressed the figure in the same way he would appeal to a person of higher status.

This is a typical *munga dukna* figure: it is a standing male between ten and eighteen inches tall, wearing ornaments associated with prestige dress. What makes it remarkable as a Santa Cruz sculpture, though, is the quality of the carving, the clear evidence of use, and the survival of some of the added ornaments, which are usually missing on other figures. Aside from these qualities, the figure's very presence at the Indiana University Art Museum also makes it noteworthy, for, out of around fifty-five known figural sculptures from Santa Cruz Islands, the group lying southeast of the Solomon Islands, it may be the only freestanding *munga dukna* in a public collection in the continental United States.

As in much South Pacific sculpture, the carver emphasized the figure's head. The body, while powerful and solid, is simplified, and somewhat flattened. Pectoral muscles and genitals are depicted, as are elbow and knee joints, though the grooves marking them also served a practical purpose in keeping ornaments from sliding down the arms and legs. (Fiber cords are still in position at the knees, but the arms are bare.) As on most *munga dukna,* fingers and toes are indicated, although simplified.

An *abe,* a male headdress, is carved as an extension of the figure's head. Consisting of barkcloth over a circular wooden framework, the *abe* was worn by high-ranking males until the 1930s, when European brimmed hats, such as the one depicted on the canoe prow ornament from the nearby New Georgia group of the Solomon Islands (p. 202), became status symbols. Holes along the sides of the carved headdress originally held fiber fringe, imitating similar decoration added to ceremonial *abe.*

The carved headdress visually balances the angled face, which is rendered as a flat, tapering wedge punctuated by an overhanging brow and long nose. The turtle shell nose ornament, a miniature version of a type formerly worn by Santa Cruz men, conceals the mouth, which is little more than a slit carved below the face. Its position, together with the overall tapering form and angle of the

head, suggests a muzzle rather than a human mouth and chin, a stylistic convention seen elsewhere in the Solomon Islands, particularly the eastern group. Pointing to this and other eastern Solomon sculptural features, such as integral bases and figures, as well as likely interactions between Santa Cruz and the eastern group, William Davenport, the foremost scholar on the art of Santa Cruz Islands, has proposed that the style of *munga dukna* figures such as this one was influenced by eastern Solomon carving. He has associated the style particularly with Temotu, an islet just off the coast of northwestern Nendo, noting that many of the best-carved examples of *munga dukna* originated there. Though the figures are not thought to have been carved by men specializing in that activity, Davenport has noted that Temotu men, particularly those from the Neo area, were known as outstanding makers of outrigger canoes, thus especially skillful with carving tools.[1]

The figure was rubbed with a paste made of the powdered root of the turmeric plant and coconut oil. In the Santa Cruz Islands, turmeric paste is frequently used in spiritual contexts, especially those marking transitional states, such as weddings and maturity rites. Its application to *munga dukna* seems to be connected with the idea of the carving as an object simultaneously belonging to the physical/human world and related to the spiritual realm inhabited by the *dukna,* the deity. A particular property of turmeric makes understandable its association with ideas about transformations and transitions: usually a distinctive orange color, the powder turns purple under alkaline conditions.

Throughout the South Pacific, European missionaries initially encouraged the destruction of objects connected with local religion, but later sometimes collected them to be sold to fund mission activities. Such was the case on Nendo, where, in the 1920s, members the Anglican Melanesian Mission began selling figures given to them by recent converts to clients such as Captain Fred Jones, a European trader, who also acquired ethnographic material directly from the islanders. Jones sold objects to customers in England and New Zealand, including Harry Beasley, a London collector of ethnographic material from all over the world. Though much of Beasley's extensive collection is now in United Kingdom museums, some pieces, including this one, were sold privately.

Note
1. William Davenport, *Santa Cruz Island Figure Sculpture and Its Social and Ritual Contexts* (Philadelphia: University of Pennsylvania Museum of Archaeology and Anthropology, 2005), 30–32.

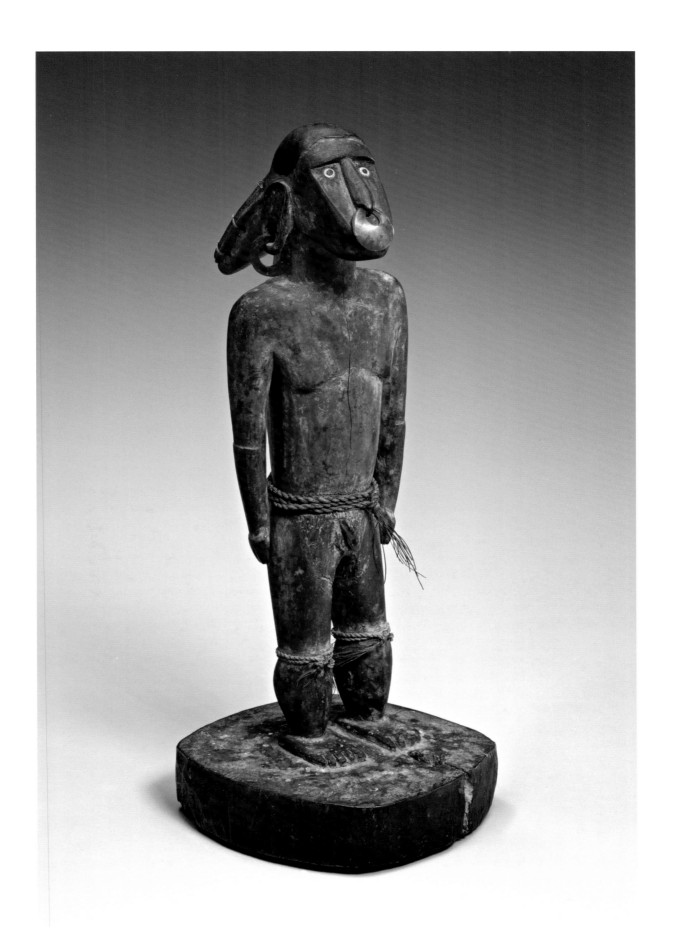

Northern Madak peoples, Malom village, New Ireland

Memorial Figure (Uli)
Before 1908
Wood, lime, pigment, shell, seasnail operculum, fiber
H. 55 in. (139.7 cm)
Raymond and Laura Wielgus Collection, 91.498

Powerful and enigmatic, the commemorative figures from New Ireland known as *uli* have attracted the attention of Westerners from the time they began arriving in Europe at the end of the nineteenth century. However, by the beginning of the twentieth century, when researchers tried to find out more about them, the tradition was already dying, and today *uli* have not been used for several generations. Therefore, although the intriguing appearance of these figures raises many questions about meaning and iconography, we have little firm information, and the two reports that describe the figures in their ceremonial context were based on activities in a single village on the north coast, away from where the figures originated in the mountainous area north of central New Ireland's Lelet Plateau.

An *uli* is central New Ireland's visual counterpart to the much more numerous *malagan,* colorful and complex sculptures that complete the funerary cycle honoring an important deceased community member. *Uli* were viewed at male rites concluding funerary celebrations that took place during the year following the death of a leader. Unlike *malagan* figures, which were made for one presentation and then abandoned, *uli* were displayed again and again: each time a newly carved *uli* was shown for the first time, older ones were gathered together, repainted, and displayed with it.

This figure is larger and more robust than many, but its form and features are typical of the genre, which is characterized by a large head, stocky body, and short, powerful legs. Much of the figure's impact derives from the broad face, which was originally painted white. Shell eyes create an eerily realistic, penetrating gaze and are set off by sweeping black triangles, a reference to face paint. The oversized hooked nose and wide grimacing mouth with pointed teeth add to the menacing expression. Also typical are the headcrest (probably referring to a feathered headdress worn by men during mourning), the fiber beard, and the cage-like rods that surround parts of the figure, reminiscent of similar structures on *malagan.* For viewers today, the dark, somewhat murky colors reinforce the figure's sinister expression, but when it was in use, it would have been regularly repainted, so that much of the figure would have been white.

All of the memorial figures appear to be hermaphrodites. Some scholars have suggested that they are associated with the moon, which New Irelanders traditionally consider as having a dual sexual identity.[1] However, they may represent males wearing strapped-on false breasts, as apparently was the custom on certain ritual occasions in parts of New Ireland. Alternatively, they may show exaggeratedly large male breasts, which were admired on the island. In either case, the meaning most likely referred to ideas connected with fertility—its

importance for the continuation of a people and a recognition of the importance and power of both male and female elements in ensuring it. The dual role that a leader plays as both defender and nurturer of his people may be expressed in the *uli* as well.

This *uli* stands with his arms across his stomach, but others have their arms straight down at their sides or raised above their heads, and some more elaborate *uli* also include small ancillary figures on the shoulders or torso or near the feet. Scholars have divided *uli* into different categories based on pose and the presence or absence of subsidiary figures or accoutrements, such as the bag used to collect and carry shell money hanging from this figure's left arm. Michael Gunn has proposed that these basic *uli* types—he identifies eleven—may have started the *uli* tradition as portraits of different leaders that served as the models for later representations.[2]

This figure was collected in New Ireland at Malom, a village on the central east coast, by Wilhelm Wostrack, a German district commissioner for southern New Ireland, in 1908. Stuttgart's Linden-Museum acquired it from him, and the figure later was also owned by the Swiss painter, sculptor, and collector Serge Brignoni (1903–2002) before being acquired by Raymond and Laura Wielgus in 1959 from Allan Frumkin (1927–2002), a dealer primarily of contemporary art, who also sold Oceanic and African art in Chicago during the 1950s and 1960s. During buying trips to Europe for prints, drawings, and paintings, Frumkin also looked for objects that might appeal to the handful of his clients who were also interested in ethnographic art, the Wielguses among them. Some of their finest objects were acquired from Frumkin; in addition to the *uli,* Frumkin also sold them the Austral Islands drum (p. 188), the Solomon Islands canoe prow ornament (p. 202), the Biwat flute figure (p. 212), and, from Africa, the Dogon and Luluwa figures (pp. 28 and 64) and the Bamana antelope headdress (p. 30).

Further Reading
Gunn, Michael, and Philippe Peltier, eds. *New Ireland: Art of the South Pacific.* Paris: Musée du Quai Branly, 2006.

Notes
1. Brigitte Derlon, "*Uli* Figures [2]," in *New Ireland: Art of the South Pacific,* ed. Michael Gunn and Philippe Peltier (Paris: Musée du Quai Branly, 2006), 174.
2. Michael Gunn, "*Uli* Figures [1]," in *New Ireland: Art of the South Pacific,* ed. Michael Gunn and Philippe Peltier (Paris: Musée du Quai Branly, 2006), 172.

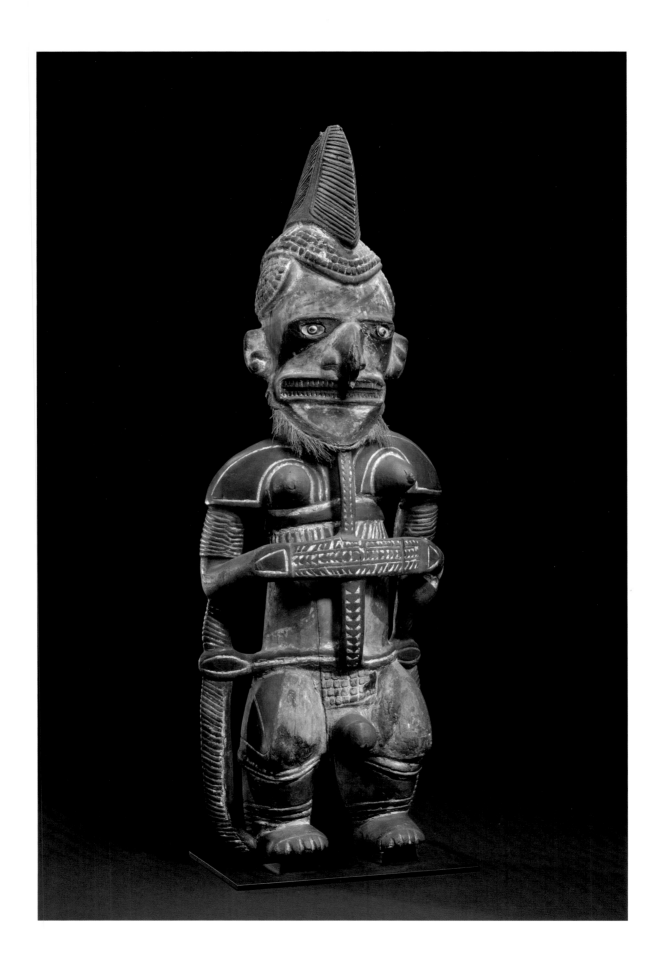

Lower Sepik River area, Papua New Guinea

Commemorative Figure
Before 1908
Wood, pigment, fiber
H. 80 in. (203.2 cm)
Raymond and Laura Wielgus Collection

This remarkably powerful figure is part of a broad tradition of commemorative figures, many life-size like this one, made by various peoples in the lower Sepik River area of Papua New Guinea. It was made to honor an ancestor, probably the founder of a lineage or a mythological ancestral hero, and its looming, formidable presence was a physical reminder of the importance of that ancestor. Kept inside a men's house, the figure was displayed at rites intended to invoke the help of the spirits of deceased community members for the benefit of the living. Together with other commemorative figures, it also was shown on other occasions, such as boys' initiations, when the power and importance of the ancestors were acknowledged. The powdery red pigment covering much of the figure emphasizes its spiritual associations: red is a color identified with ritual in New Guinea (and elsewhere) and frequently also with virility and male power.

The figure's size makes it imposing, but its head creates an unforgettable presence. Hanging over the plank-like chest, the face cast downward, it appears at once both skull-like and nonhuman. The outlines of eyes are only lightly inscribed in darkened sockets under the broad brow, and there is no illusion of flesh covering the elongated face, which narrows abruptly below the temples. This skeletal head emphasizes that the figure represents a deceased person and recalls a practice along some parts of the Sepik River in which actual skulls, sometimes incorporated into wooden figures, commemorated ancestors. Seen alone, the head might also be mistaken for that of some other creature entirely; the elongated jaw calls to mind the beak-like projections that characterize many figures and masks from the Sepik area (see p. 214, for example).

Carved costume elements and accessories indicate a proper, prosperous man. The figure's hat is a carved version of a basketry one. Two carved birds, one now missing and the other damaged, originally perched on its sides, likely a reference to clan or lineage totems. He wears a decorated loincloth; a net bag, known in Melanesian pidgin as a *bilum* and used by men and women over a broad area of New Guinea, hangs from his neck, covering his chest. Among men living along the Sepik, such bags frequently served as amulets, containing fragments of ancestral bones or other substances that were believed to protect the wearer. Two shell rings—popular ornaments—are attached to the carved bag, and additional relief carving evokes shells and seeds that often decorate such *bilums*. More shell rings are depicted on the arms, as are incised turtle-shell armlets, which were made on the northern New Guinea coast and traded into the interior. The curved piece over the figure's left shoulder may represent an adze, perhaps a ceremonial version of that basic wood-cutting tool.

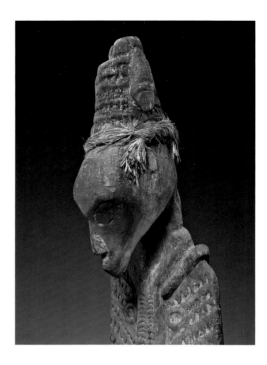

Detail of the head

The figure was collected at the beginning of the twentieth century, probably in 1908, by Captain H. Voogdt, a German ship captain and an employee of the New Guinea Company, a German trading business that administered the Protectorate of German New Guinea between 1885 and 1899. From the time of his first posting in the 1890s until World War I, Voogdt collected a large number of artifacts in what was then German New Guinea, while he sailed along the coast, picking up copra (dried coconut meat) from company stations, dropping off supplies and trade items, and recruiting men to work on the company's copra plantations. He sold most of the artifacts in Germany. In 1908, he and George Dorsey, curator of anthropology at Chicago's Field Museum of Natural History, traveled about seventy-eight miles up the Sepik River, the first Westerners since the 1880s to penetrate so far. Singarin village, about twenty-five miles from the mouth of the river, was one stop along their route, and Voogdt is said to have acquired this figure there. Although Dorsey himself collected many artifacts for the Field Museum on that trip, he also encouraged the museum to purchase from Voogdt over a thousand objects, most of which were also collected on the 1908 expedition.[1] In 1959, Raymond Wielgus acquired this figure by trade from the Field Museum.

Further Reading
Kaeppler, Adrienne, Christian Kaufmann, and Douglas Newton. *Oceanic Art*. New York: Harry N. Abrams, 1997.

Note
1. For an interesting account of these collectors and collections, see Robert L. Welsch, "One Time, One Place, Three Collections: Colonial Processes and the Shaping of Some Museum Collections from German New Guinea" in *Hunting the Gatherers: Ethnographic Collectors, Agents, and Agency in Melanesia, 1870s–1930s*, ed. Michael O'Hanlon and Robert L. Welsch (New York: Berghahn Books, 2000), 155–79, from which this summary is derived.

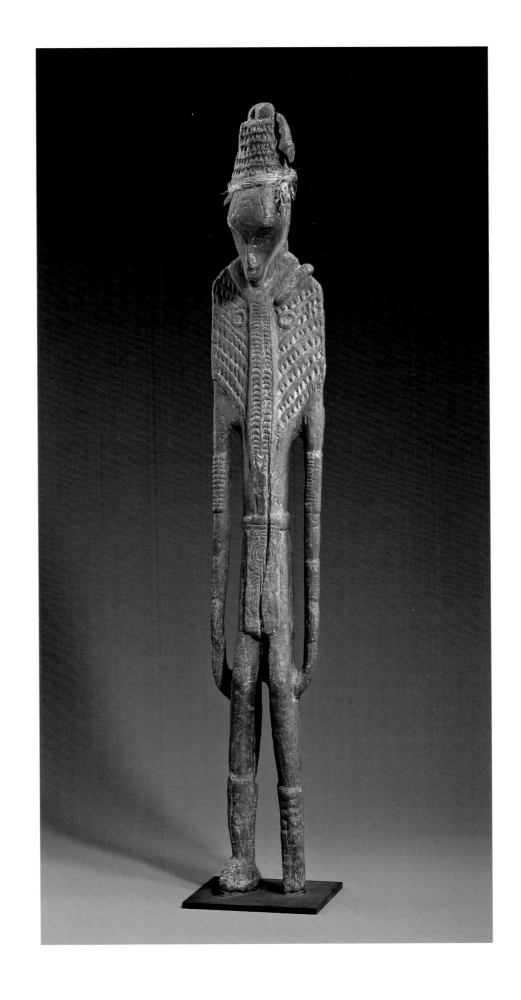

Kambot or nearby peoples, Papua New Guinea

Mask
Wood, rattan, clay, cowrie shells, nassa shells, boar tusks,
human hair, pearl shell, fiber
H. 21^1/$_2$ in. (54.6 cm)
Raymond and Laura Wielgus Collection

A dramatic combination of materials and textures, this mask epitomizes two tendencies in the art of New Guinea: the use of a variety of natural, locally available materials and the propensity for powerful, even flamboyant, imagery. It also underscores the limited understanding that Westerners have of many of the island's forms.

On this mask, clay has been modeled over an oval wooden foundation. The use of unfired clay or vegetal paste for overmodeling is a Melanesian technique most often associated with the preservation and display of the skulls of important ancestors, although a similar technique is also found in the mud masks of the New Guinea highlands. A basketry border surrounding the foundation probably held feathers, flowers, leaves, or other ephemeral materials and allowed the mask to be attached easily to other costume elements. Before the clay dried, shells, tusks, and human hair were embedded in it.

The shells and tusks not only create color and texture contrasts with the dark clay and hair; they also are traditional indicators of wealth and prestige. Three different kinds of shells reflect the traditional importance that shell in both natural and worked form has for the peoples of Oceania, not only as a material for decoration but also as a medium of exchange. Boar tusks, seen here as multiple nose ornaments and part of the headdress, were also highly valued in Melanesia, where traditionally a man's wealth was measured in part by the number of pigs he owned. In some areas, the two upper canines of a male pig were removed to encourage the growth of the lower ones, which would eventually curl into a circle that was prized as an ornament.

The known provenance for this mask goes back only to the 1950s, when it was in the collection of the prominent Brussels collector/dealer Joseph Van der Straete, so no documentation of its acquisition in New Guinea exists. However, it is attributed to the Kambot peoples (also known as the Tin Dama or Tindama), an amalgam of small groups who live on the Keram River, a southern tributary of the lower Sepik, and in the swamps around it. Lower Sepik cultures are many in number, but, because of longstanding interactions and the movement of objects, many figures and masks clearly share stylistic features, allowing scholars to refer generally to a lower Sepik style. Paradoxically, however, in the same region there are also objects very different in appearance from the standard fare, frequently originating from groups that remain relatively isolated, whether by choice or geography; this mask is one of those, and a long step from wood masks with convex oval faces and long beak-like noses for which the lower Sepik region is known.

To Westerners, the Kambot are traditionally best known for two unusual and spectacular types of objects: mosaic feather panels, kept inside the men's house and displayed on special occasions, and paintings on sago palm spathe, which were attached to the inside and outside of men's houses. In addition to those, the Kambot today are also known for their storyboards, a more easily transportable—and therefore marketable—form for the depictions of myth and legend as well as scenes of daily life. Masks are less well documented; however, one similar to the Wielgus example, purchased by the Australian Museum in 1938 and made in the same way (with boar tusks and various shells embedded in a clay surface that is surrounded by a basketry framework) was from Raten, a Kambot village. Flute ornaments and memorial plaques using the same materials and techniques are also identified with the Kambot and other nearby peoples in the area of the Keram River.

Though the mask differs from most others from the lower Sepik in appearance, it probably was made for similar uses. Likely it was part of a men's society or spirit cult and represented an ancestral or nature spirit.

Further Reading
New Guinea Art: Masterpieces from the Jolika Collection of Marcia and John Friede. 2 vols. San Francisco: Fine Arts Museums of San Francisco, 2005.

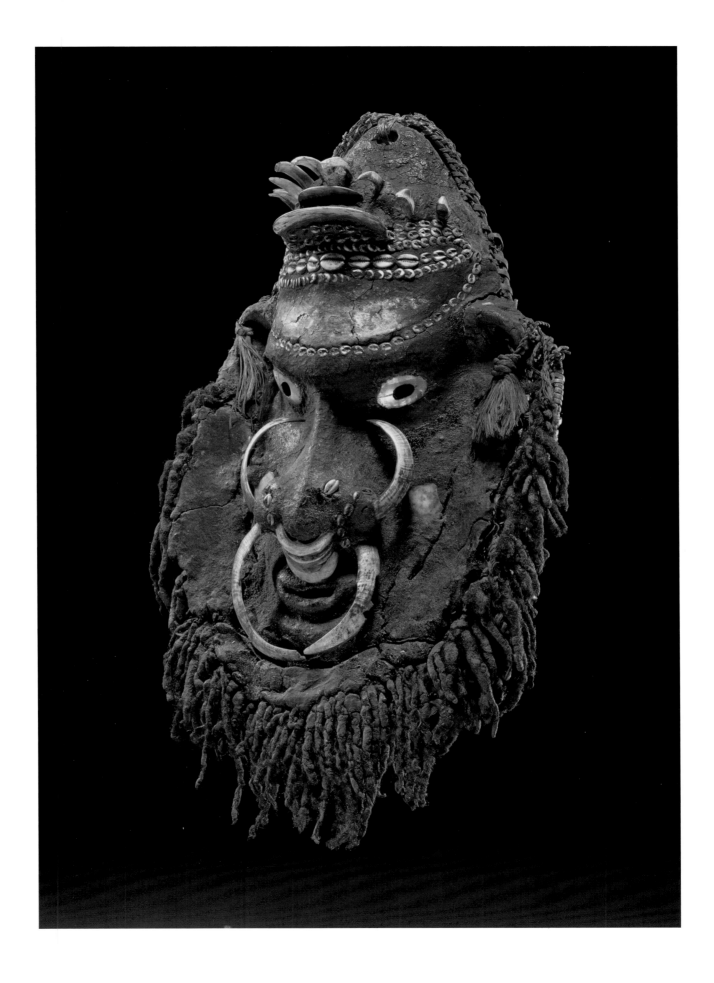

Biwat peoples, Papua New Guinea

Figure for a Sacred Flute (*Wusear*)
1900–20
Wood, shell, boar tusk, human hair, cassowary feathers, fiber, pigment
H. 20 1/2 in. (52.7 cm)
Raymond and Laura Wielgus Collection, 75.53

Living along both sides of the middle Yuat River, a tributary of the lower Sepik River, the Biwat (formerly known as the Mundugumor) are best known as one of the peoples featured in Margaret Mead's *Sex and Temperament* (1935), a book that argues that gender roles are culturally determined. There, Mead describes both Biwat men and women as assertive, violent, individualistic, and volatile, characteristics that seem to be corroborated—intentionally or not—by this figure's intense gaze, bristling feathers, and rigid bearing.

Carved to be placed in the end of a sacred flute (hence the peg under the feet), this figure is characteristic of Biwat figural carving style: an extraordinarily large head juts over a proportionally small torso and legs, while long arms and an enlarged phallus hang stiffly. The enormous head may reflect the Biwat belief that it is the most sacred part of the body; and the large penis, frequently seen on New Guinea sculpture, may refer to a commonly held idea that equates a man's aggressiveness with his virility and uses his genitalia as a symbol of both.

While the carved figure may depict idealized aspects of the male form, the added ornamentation—the tusk through the septum, the shell and fiber earrings, the feathers on the head, and the face painting—is realistic, showing the traditional manner in which a man might decorate himself. That these elements, as well as the human hair attached to the head, chin, and genital area, have survived is notable: added materials on many other figures are missing. Even the elements here, though, only hint at how the figure appeared in its original context: both a sacred flute and its stopper were covered with feathers, shells, and other valuable materials before they were displayed for the first time.

Like other cultures living in the vicinity of the Sepik River, the Biwat played transverse bamboo flutes, which were as long as eight feet and which were considered sacred objects to be viewed only by those initiated into the cults with which they were associated. In most parts of the Sepik, sacred flutes are traditionally communal property, but among the Biwat, they were owned by individuals, who kept them in their homes, offered them food and gifts, and addressed them by kinship terms. Sacred flutes were considered so valuable that they became family heirlooms; and, if a man could not acquire a wife through the preferred method of kinship exchange, he could obtain one by including a sacred flute as part of a bridewealth.

A sacred flute owner had the authority to initiate followers into its cult, a right that carried great prestige. It also required tremendous resources; not only did the owner have to pay for the flute and stopper to be carved, he also was responsible for all of the expenses associated with initiations, including the feasts that were provided for new initiates.

Margaret Mead, who worked with Reo Fortune among the Biwat for three months in 1932, associated elaborately decorated flutes and their stoppers with the *ashin,* or crocodile, cult.[1] At the inception of an *ashin* cult, an elaborately decorated flute and its stopper, called the child of the crocodile spirit, was "born" out of an enclosure where its mother, a water drum whose sound is described as the crocodile spirit, was hidden and played. For a brief time, the flute was displayed in all of its finery before the village, then it was removed to its owner's home, where it was wrapped and hidden, accessible only to cult initiates, who—contrary to practices throughout the rest of the Sepik—could include both males and females. Subsequent displays of the flute to initiate new members involved the building of a special ceremonial house for viewing of the flute, feeding of the crocodile spirit and her child, dancing, and feasting. Though the voice of the child of the crocodile spirit was also a critical component, the *ashin* flute might be so extensively decorated that it was impossible to play, in which case plain flutes would be blown.

This figure was illustrated in André Portier and François Poncetton's 1922 *Décoration océanien* (Paris: A. Calavas), one of the earliest publications dealing solely with Oceanic art. At that time, it was owned by surrealist Roland Tual, who began collecting African and Oceanic art shortly after the end of World War I. At the opening of his Galerie Surréaliste in 1926, Tual featured Polynesian and Melanesian objects, the first time a European gallery had exclusively exhibited Oceanic art.

Further Reading
McDowell, Nancy. *The Mundugumor: From the Field Notes of Margaret Mead and Reo Fortune.* Washington, D.C.: Smithsonian Institution Press, 1991.

Note
1. Mead noted that formerly many other cults had existed, and, though she witnessed an *ashin* cult initiation that she and Fortune commissioned, it is said to have been the last one held in the area. For her description of that *ashin* initiation, see Nancy McDowell, *The Mundugumor: From the Field Notes of Margaret Mead and Reo Fortune* (Washington, D.C.: Smithsonian Institution Press, 1991), 139–45.

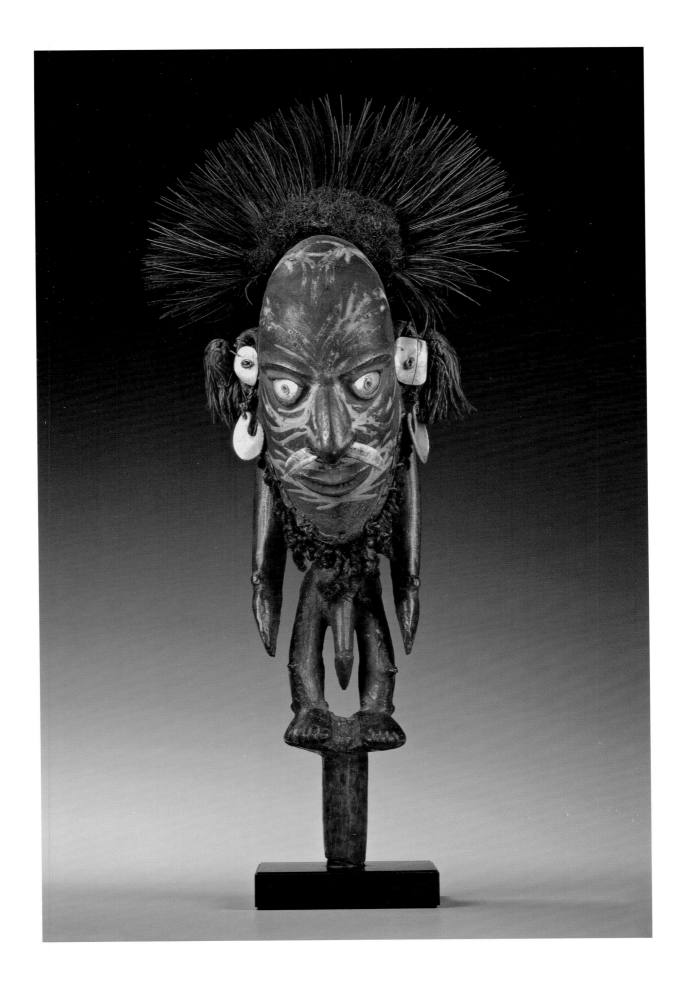

Iatmul peoples, Papua New Guinea

Mask (Mai)
Late 19th or early 20th century
Wood, pigment, cowrie shells
H. 25 in. (63.5 cm)
Raymond and Laura Wielgus Collection

Mai (also written *mei, mwai,* and *mwei)* masks are among the best-known objects made by the Iatmul, a group living along the middle Sepik River, whose complex, dynamic society has produced a prodigious number of masks, figures, and other decorated objects. Although called a mask, this sculpture has neither eye holes nor sufficient width to cover the face. Instead, it was originally attached to a large, full-length fiber cone that covered the masquerader and was decorated with a colorful array of shells, feathers, leaves, and flowers. Thus, like most of the masks from the South Pacific and Africa that are preserved in Western museums, this wooden part is actually only one small component in a complex ensemble.

These costumes, which usually appeared in two pairs, were worn by young men who made the masks "talk" via concealed bamboo tubes. *Mai* masqueraders appeared at dances that were junior analogues to those honoring ancestors, which were performed by senior initiated men. The masks represent ancestral spirits, which the Iatmul conceive of as brother-sister pairs, reflecting a complementary duality that the Iatmul see in the world around them. The mask pairs are owned by individual clans, and each mask has a personal name of one of the clan's ancestors. The literature also describes the *mai* mask used in other contexts: worn by a leader during the formal execution of captives, serving as a protective amulet during raids, and indicating the presence of spirits.[1]

Mai masks are long, narrow, and either covered with cowrie shells or painted in a pattern considered appropriate for a particular ancestor. This mask is especially narrow, which suggests that it is from the Nyaura (also written Niyaura), or western, Iatmul. The masks characteristically have exceptionally long noses, many of which end in a small animal or bird that has a totemic relationship with the clan owning the mask. According to Gregory Batson, an anthropologist who worked among the Iatmul, long noses are admired as signs of beauty in both men and women. In addition, he notes that they are also considered phallic symbols and, by extension, symbols of manhood and its associated qualities, such as aggressiveness.[2] Noses attached to chins, as in this example, are also said to be a reference to the first ancestors, who were unable to speak until their noses became detached. Finally, the nose-chin-mouth configuration also recalls the beak of a bird, a creature that is significant in the creation beliefs of peoples living along the Sepik.

In 1930, this mask was owned by Pierre Loeb (1897–1964), a Parisian art dealer who gave the Surrealists their first group show in 1925. Like the Surrealists, he also admired Oceanic art, and both collected and sold it. A 1930 exhibition of African and Oceanic art at the Galerie Pigalle in Paris, organized by Tristan Tzara, one of the founders of Surrealism, and Charles Ratton, a prominent art dealer, included twenty-two Oceanic objects from Loeb's collection, including this mask. This exhibition was one of three that year displaying the widest variety of Oceanic arts that had been seen in France up to then and featuring objects from New Zealand and New Guinea, both British colonies and therefore not especially well known in France. In keeping with the Surrealist interest in the expressive art of Melanesia, over two-thirds of the 138 South Pacific objects were from that region.

A 1949 photograph of an installation of Oceanic and modern art at Loeb's gallery may also show this mask. Although the darkness of the photo makes definitive identification impossible, the outline and visible details appear identical, and Loeb still owned the piece at that time. The mask is surrounded by a New Caledonia roof finial and a photograph, a drawing, and a sculpture by contemporary European artists. Such a combined display indicates the sympathetic relationship that many dealers, collectors, and artists saw between contemporary art and what they called the "primitive" arts of Africa and the South Pacific.

Further Reading
Bateson, Gregory. *Naven.* 2nd ed. Stanford: Stanford University Press, 1958.

Notes
1. Douglas Newton, *New Guinea Art in the Collection of the Museum of Primitive Art* (New York: Museum of Primitive Art, 1967), no. 59; and Brigitta Hauser-Schäublin, "*Mai*-Masken der Iatmul, Papua New Guinea: Stil, Schnitzvorgang, Auftritt und Funktion," *Verhandlungen der Naturforschenden Gesellschaft in Basel* 87/88 (1976/77): 119–45.
2. Gregory Bateson, *Naven,* 2nd ed. (Stanford: Stanford University Press, 1958), 163–64.

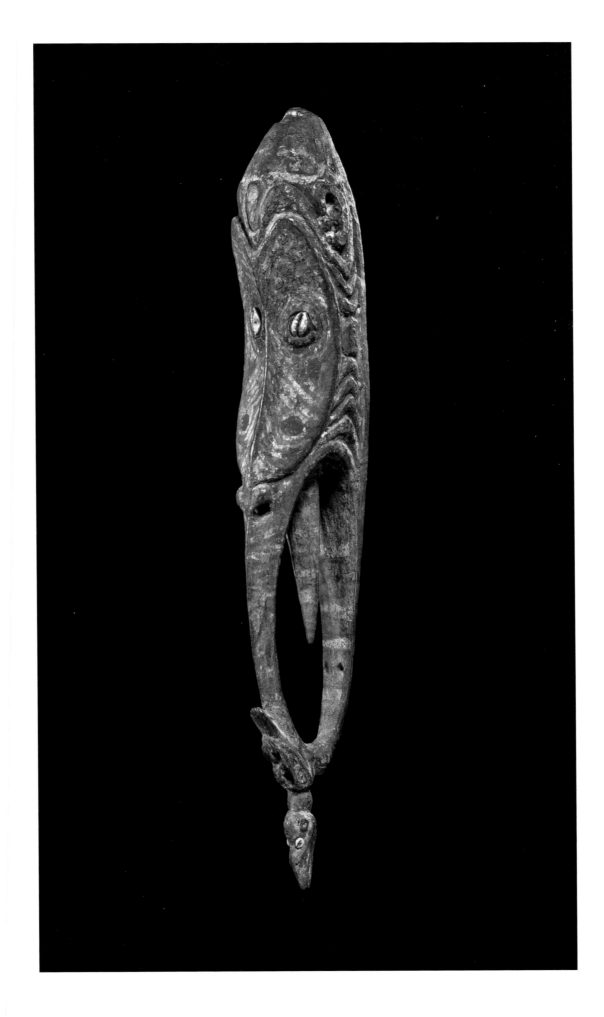

Asmat peoples, Papua, Indonesia

Seated Female Figure
Before 1913
Wood, pigment, seeds, fiber
H. 22 1/2 in. (57.2 cm)
Raymond and Laura Wielgus Collection

This figure has the distinction of being part of the first group of figures to enter Europe from the Asmat, peoples living in the southwestern part of New Guinea, in what is now the Indonesian province of Papua (formerly Irian Jaya). Collected by Antony Jan Gooszen, an officer in the Dutch Indies army who commanded exploration parties into the interior of southern New Guinea during 1907/08 and 1913, it was among more than nine hundred objects acquired there and given to Leiden's Rijksmuseum voor Volkenkunde (then the Rijks Ethnographisch Museum) in 1919. Like many museums that have multiple examples of one type of object, the Leiden museum later deaccessioned this and several other Gooszen objects.

Its importance as an early example of Asmat figurative carving aside, the figure is a dramatic sculpture: the subject looks human, but not quite; the forms are simple, yet powerful, and the repetition of shapes—the circle eyes, the crescents on the cheeks—enliven and unify the composition. Carved from a relatively soft wood, the figure was painted in the traditional Asmat color scheme of white, red, and black.

The distinctive elbows-to-knees-and-hands-to-chin depiction is frequently seen in Asmat art and is a posture that the Asmat say all people assume at birth and death. The pose is a significant aspect of the Asmat account of the creation of humankind, which also explains the close relationship that exists between people and trees. Details vary from place to place, but the basic story tells of a lonely creator, Fumeripitsj, who made wooden people for company. With their elbows and knees attached to each other, they were not very engaging company, but, when Fumeripitsj played a drum, the figures came to life, and, in dancing, their knees and elbows became separated. Symbolic reenactments of Fumeripitsj's creation take place even today during the consecration of a new men's house, a building within the community in which men gather for social and religious reasons. Scholars believe that figures such as this were displayed during those ceremonies.

In addition, the pose, particularly when combined with the insect-like head, recalls the praying mantis, a symbol of head-hunting because of the female mantis's inclination to eat the male's head during mating. Formerly a widespread and accepted way for the Asmat to avenge a death, head-hunting was also considered a way that a man could increase his own life force by following certain prescribed steps to assimilate some of the enemy's. Finally, the pose and beak-like mouth might associate the figure with the *amirak,* a malevolent female spirit living in rivers and streams that combines human features with those of a bird or snake.

Like the shields and monumental carved wooden poles for which the Asmat are known, wooden figures are carved for practices relating to the commemoration of ancestors. Each figure was traditionally given the name of a particular deceased person and served as a reminder to family members that the death must be avenged; according to traditional Asmat beliefs, enemies cause all deaths through physical or supernatural means, and a death that is unavenged leaves the spirit of the deceased in the world of the living instead of assuming its rightful place in the land of the spirits.

An ancestor figure such as this one was commissioned from a master woodcarver, *wowipitsj,* usually by the head of the family. Traditionally all men could carve utilitarian items, but master carvers—men with special talent—were called upon for special objects and admired and respected for their skill, as well as their special relationship to Fumeripitsj. However, even master carving was not a full-time profession, but rather an activity performed in addition to the tasks of daily life, such as hunting and fishing. In respect to a carved figure, greater importance was associated with the person commissioning it—that person, after all, was directly related to the person being commemorated—than with its maker. Traditionally a carver was compensated for an object only by being fed by the patron while he worked on it; today, of course, men can earn incomes by selling carvings to outsiders.

Further Reading
Smidt, Dirk, ed. *Asmat Art: Woodcarvings of Southwest New Guinea.* New York: George Braziller, 1993.

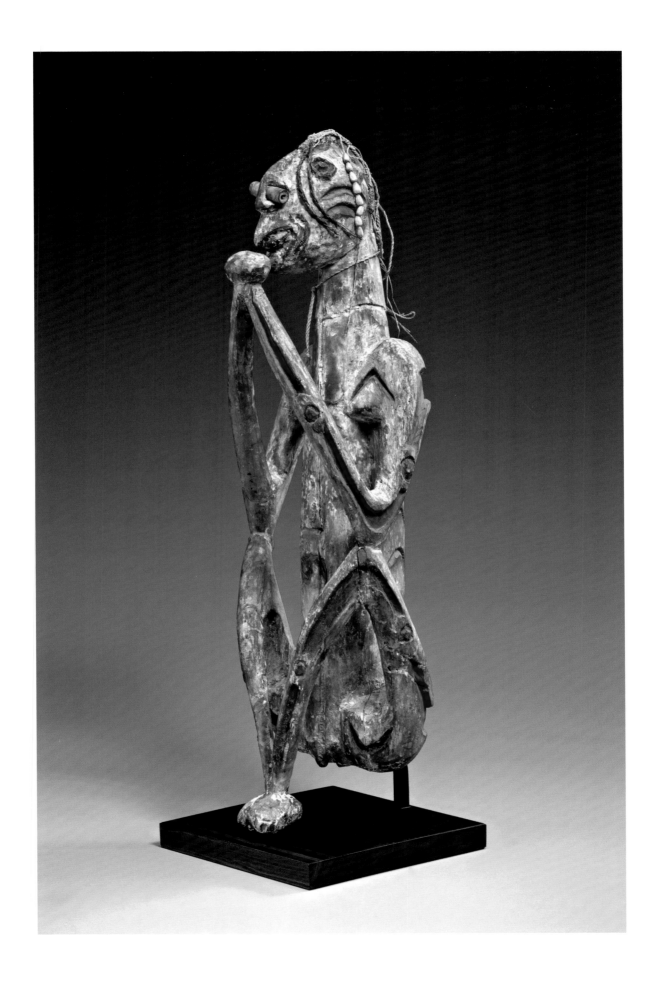

Erub Island, Australia

Mask
Turtle shell, clam shell, resin, sennit, wood, human hair, cassowary feathers
19th century
H. 20 1/2 in. (52.1 cm)
Raymond and Laura Wielgus Collection

Turtle-shell masks such as this example are a unique contribution to world art by islanders of the Torres Strait, the passage between New Guinea and Australia. More than 270 islands, occupying over 18,000 square miles, are located there, but fewer than 20 are inhabited, and turtle-shell masks or their depictions on rock paintings are associated with only about half of those. Though the masks have not been made or worn on the islands for more than a century, their unusual material, construction, and striking, if little understood, imagery place them among the most recognizable forms of Melanesian art.

Torres Strait art expert Douglas Fraser attributed this mask to Erub (Darnley Island), one of the easternmost islands, and one known for the large number of turtles that come to its shores.[1] Because of its size, the hawskbill turtle, which averages nearly three feet in length and more than 175 pounds, was particularly favored. Its beautiful shell, amber in color with light and dark streaks throughout, was cut, heated, and molded into masks, hooks, and ornaments. For large and three-dimensional objects, such as the masks, several pieces of shell were perforated along the edges and sewn together with fiber; on this example, stitching is most visible on the lengths of the cones on top of the head, at the temples, at the bridge of the nose, and on the chin. Additional stitches secure the human hair to the lower part of the face. Beeswax or a resin-like material bonded smaller elements, such as clamshell eyes and the lower part of the nose, to the mask. The same substance has been built up on the surface to form the eyebrows.

Turtle-shell masks depict human faces, such as this one, and local fauna, including birds, reptiles, and fish. While some masks are single images, others are composites that usually combine a human face with an animal. Though variations exist, the human faces have similar characteristics, whether they stand alone or are part of a composite. These features include an elongated face with a pointed chin, a long nose with pierced septum, and a mouth that includes the depiction of teeth, either incised onto the shell or cut through it, as here. Ears, when indicated, are separate pieces and frequently show the pierced and distended ear lobes that were common among both men and women.

On the face masks, which are especially associated with the eastern islands, human hair was generally attached around the lower part of the face, sometimes around the mouth, and at the top of the head. Like other added materials, the hair has not survived on many masks, but much of it is still intact here. Our example also has feathers from the cassowary, a large flightless bird native to New Guinea and northeastern Australia. Face masks are also usually surrounded by a flange; this one consists of separate pieces of turtle shell that have been decorated with both zigzag openwork (a common motif) and incised patterns. Additional incised motifs in the form of chevrons, another common decorative motif, ornament the cones on the top of the head and outline the face. On the ears, incised circles resemble the shell disks that islanders wore as ornaments. These patterns were rubbed with lime to contrast with the dark shell and make them more noticeable, though on most masks, including this one, only traces remain. Other color was frequently applied to the masks as well. When worn, they were decorated with feathers, shells, and seeds.

Turtle-shell masks were noted in 1606 by Diego de Prado y Tovar, second in command on the ship captained by Luis Vaez de Torres, after whom the Strait is named. However, researchers did not begin in-depth study of the islands until the end of the nineteenth century, and by that time contact with missionaries, who came to Erub in 1871, and traders had brought about such dramatic changes that turtle-shell masks were neither being made nor worn.[2] Consequently, detailed information about mask meaning and use is limited. The human faces are thought to refer to mythical ancestors, perhaps specific ones, who were believed to have traveled through the islands, teaching people both everyday survival skills and spiritual practices necessary to ensure their help and that of those ancestors to come.

Though particular practices varied throughout the islands, funerary rites and boys' initiations were major contexts in which masks appeared. Turtle-shell masqueraders danced during ceremonies held to ensure that the spirit of a deceased person left the community and traveled to the world of the ancestors. At initiations, senior men wore the masks with long grass costumes and danced at night to the accompaniment of drums and chanting, all intended to reinforce the lessons about manhood that had been presented to the boys.

Further Reading
Herle, Anita, and Jude Philip. "Custom and Creativity: Nineteenth-Century Collections of Torres Strait Art." In *The Oxford Companion to Aboriginal Art and Culture*, pp. 155–62. Edited by Sylvia Kleinert and Margo Neale. Melbourne: Oxford University Press, 2000.

Notes
1. Douglas Fraser, "Torres Straits Sculpture: A Study in Oceanic Primitive Art" (PhD diss., Columbia University, 1959), 89, 231.
2. The most extensive studies were carried out by the Cambridge Anthropological Expedition to Torres Straits, led by A. C. Haddon, in 1898–99, which resulted in a massive six-volume report published between 1901 and 1935.

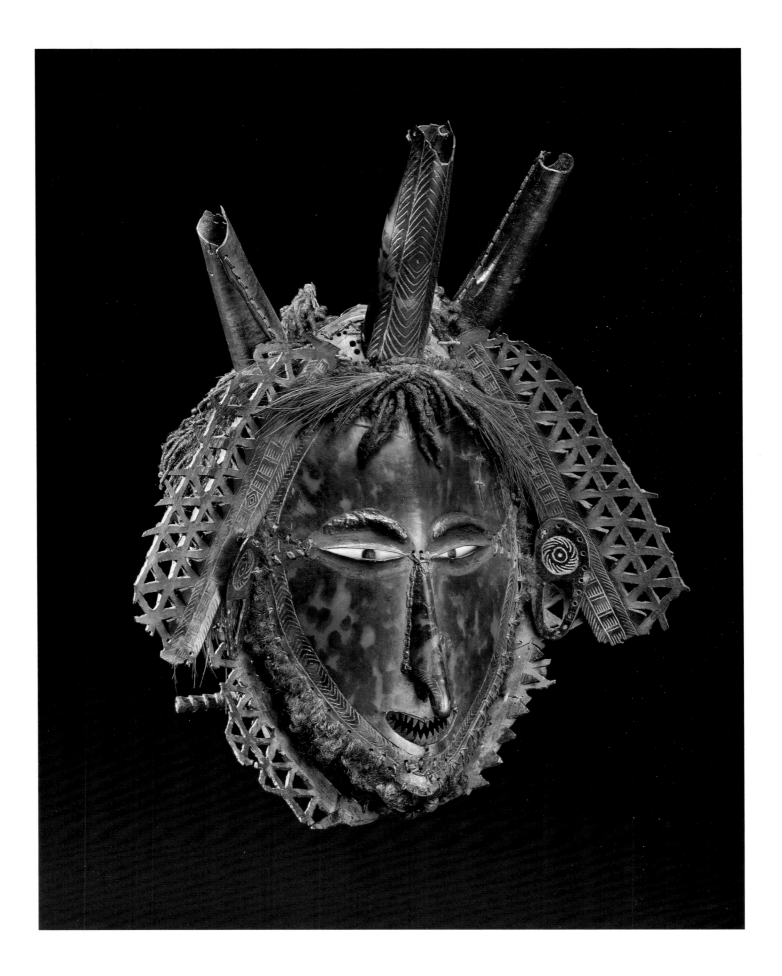

Batak peoples (Toba subgroup)
Sumatra, Indonesia

Priest's Horn (Naga Morsarang)
Wood, buffalo horn
L. 23 1/2 in. (59.2 cm)
77.13

This horn was owned by a *datu,* a powerful male ritual specialist trained in divination, healing, and sorcery among the Toba Batak. Living on the shores east, west, and south of Lake Toba in northern Sumatra as well as on Samosir, a volcanic island in the middle of the lake, the Toba are the largest of six Batak subgroups. Although the Toba are today mostly Christian, they have a rich indigenous religious tradition that shows Hindu influence resulting from first millennium trade with India or later contact with Hindu-Buddhist kingdoms on coastal Sumatra or Java.[1] Traditionally each Toba village had a *datu,* who determined auspicious days for undertaking particular activities, cured illnesses, and practiced sorcery both defensively and offensively for the benefit of the community. Many of these undertakings required the use of particular materials, medicines, or potions, which were kept in containers such as this.[2]

Hindu influence is evident in many objects and practices associated with a *datu,* including this beautiful horn. The wooden stopper is masterfully carved in the form of the head of a *singa.* A Sanskrit word meaning "lion," the *singa* in Batak mythology is a chimera that combines features of the elephant, buffalo, and serpent. The word is often used interchangeably with *naga,* a reference to Naga Padoha, a Hindu-related serpent deity of the underworld who is believed to support the earth. Appearing on traditional Batak houses, sarcophagi, and jewelry, the *singa* is a symbol of protection, fertility, and prestige. It is also depicted as a mount for deified ancestors, and the five figures carved on the head of this example may refer to the succession of priests intended to own the container or to mythological figures that appear on other paraphernalia owned by a *datu.* Though this horn does not have the decorative incising that embellishes the sides of some, the seated figure at the tip, a characteristic feature, is carefully carved, and the sculptor embellished the top edge of the horn with a carved snake chasing a quadruped.

A lizard is typically carved on the inside of the horn. It represents Boraspati Ni Tano, a deity concerned with fertility of agricultural fields, to whom sacrifices were made whenever people dug into the earth. This deity is also protective: in the guise of Boraspati Ni Huta he watches over villages, and as Boraspati Ni Rumah he protects homes. Depicted as a lizard, Boraspati appears on traditional homes and on the doors of rice granaries, as well as on paraphernalia associated with a *datu.*

Water buffalo horns are one of several types of medicine containers owned by Batak priests and are associated particularly with the Mandailing and Toba subgroups. Among the Karo Batak, smaller mountain goat horns with wooden stoppers carved with equestrian figures were most common. In all areas, medicine was also held in ceramic containers imported from China that were frequently closed with locally carved wooden stoppers. Still other containers were made from bamboo or lead.

The Art Museum's collection also includes three other types of objects associated with a *datu.* One of his most visible accoutrements was a staff, kept on behalf of the community and used in ceremonies intended to protect it, as well as in divination and in rites intended to bring rain. The staffs take two forms, and the IU Art Museum has an excellent example of the older type, called *tunggal panaluan,* which is characterized by a column of carved humans and animals (above). The museum also has objects containing the Sanskrit-derived writing that is unique among the Toba *datu.* One is a bark book *(pustaha);* these books, with accordion-style leaves and wooden covers, are said to contain names of earlier priests and calendars relating to divination, as well as prescriptions used by the *datu.* Similar texts are inscribed on water buffalo rib bones, which served as good-luck amulets, and two of these bones are also in the museum's collection.

Notes
1. Paul Michael Taylor and Lorraine V. Aragon, *Beyond the Java Sea: Art of Indonesia's Outer Islands* (Washington, D.C.: National Museum of Natural History, Smithsonian Institution, 1991), 108.
2. In addition to naturally occurring substances, small wooden weapons and tools that were sometimes part of a priest's rituals could also be kept in the horns. See Douglas Newton and Jean Paul Barbier, *Islands and Ancestors: Indigenous Styles of Southeast Asia* (Munich: Prestel, 1988), 224.

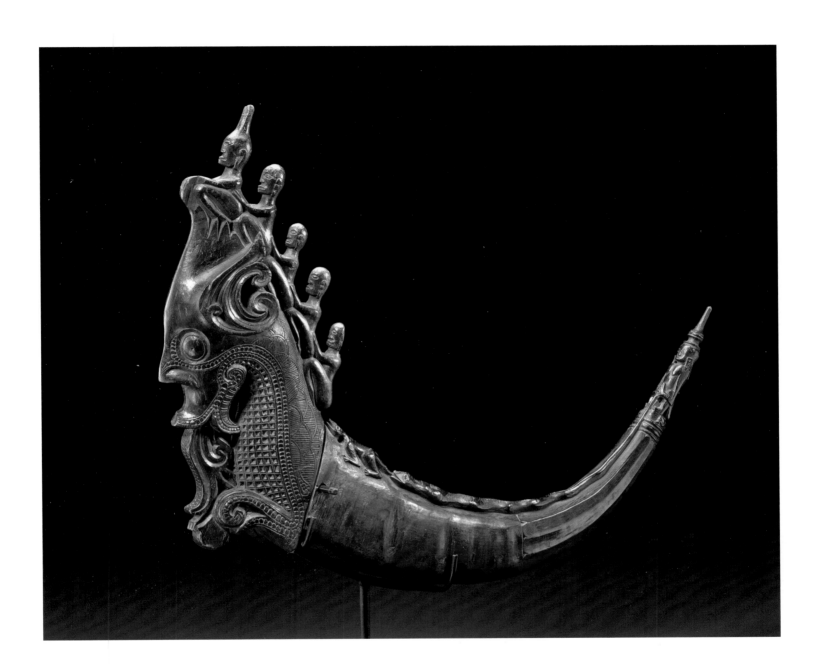

THE WEST BEFORE 1800

The masterpieces presented in this chapter are products of a European culture at first united by the Roman Catholic faith, later divided by differing beliefs, and finally, during the age of Enlightenment, dominated by a rationalism that did not entirely eclipse religion. By the time the Roman Empire collapsed in AD 476, it had been officially Christian for over a century; all pagan temples had been closed by St. Ambrose in 391. Battered by successive barbarian invasions, Rome declined, but survived. A skeletal ecclesiastical infrastructure held a disintegrating Europe together, unified by Catholicism and the Latin language.

Besides Jesus, Christians venerated a host of saints, including apostles and martyrs. Patrons of specific professions, saints also protected against diseases, and their relics attracted pilgrims. Rome, a key pilgrimage site, housed the bodies of St. Peter and St. Paul; Santiago, Spain, preserved St. James. Venice venerated the apostle Mark, while Jerusalem held the holy shrines of Jesus himself. Canonization sanctified such later leaders as Francis of Assisi (1228), Anthony of Padua (1232), and Teresa of Avila (1622).

All art was functional, serving primarily sacred purposes. The system of religious ritual, prayer, and relics inspired massive building programs and decorations involving murals, stained glass, sculptures, altar paintings, relic containers, and other liturgical objects. Private devotions also required art, including portable altarpieces, illuminated prayer books, and pilgrimage tokens, all of which depicted selected episodes from the lives of Christ, the Virgin Mary, or saints according to standard, time-honored formulas. Artistic production and civic life flourished under the economic and intellectual stimulus of pilgrimage, yielding thriving cities in the thirteenth and fourteenth centuries. Artisans trained in workshops, established themselves as masters, and, like other professionals, belonged to guilds. As economies revived, European merchants engaged in extensive trade and manufacturing, much of it involving the wool, silk, and textile industries. Europe remained a loose conglomeration of large and small city-states, ruled by emperors or kings, or governed as independent republics (such as Venice and Florence) dominated by the merchant elite. Each region had its styles and specialties, with Paris famed for its ivories; Limoges, its enamels; and Florence, its painters and sculptors.

By the fifteenth century, Europe was again transformed. In 1453 the Islam empire conquered Constantinople. Spain, under Ferdinand and Isabella, sponsored Columbus's journey to the New World in 1492. The cult of individuality, dormant since the collapse of Rome, revived, spawning renewed interest in portraiture. Donors now boldly presented themselves prominently in sacred paintings; individual painted and sculpted portraits abounded; and small medals featuring portraits and personal devices gained popularity, particularly in Italy.

Martin Luther's reforming fervor and the political ambitions of Henry VIII fractured Catholic unity in the sixteenth century. Iconoclastic Protestant outbursts destroyed masterworks in Germany, Holland, and England. While the Catholic Church reaffirmed the power of images and of faith in its Counter-Reformation imagery, the Protestant regions, notably Holland, had, by the seventeenth century, focused on secular subjects: still-lifes, landscapes, portraits, and scenes of everyday life (or genre) designed for use in the home and often acquired through the art market. New artistic centers, including Amsterdam and Leiden, joined such established centers as Venice, Florence, and Rome. Paris, under Louis XIV, became the leader in courtly refinement and fashion, while Rome became the destination of the best French artists, due to the establishment of the French Academy and the Prix de Rome.

France dominated Europe politically and culturally by 1700, setting fashion as well as social standards, while French artists, trained and inspired by the grand traditions of Italy, perfected the "rococo" style. England established its own robust artistic community, while the Grand Tour (focused on Venice, Florence, Rome, and Paris, among other stops) became de rigueur for English gentry. New excavations from the ancient sites of Pompeii and Herculaneum launched a craze for Greek and Roman antiquity, while—in this era of Enlightenment—rationalism placed secular art on center stage. Following the French example, academies began to replace workshops as training grounds for artists, and History painting, featuring epic narrative subjects and many figures, was regarded as the acme of artistic achievement.

By the end of the eighteenth century, two revolutions had fundamentally changed the political and, to some extent, the artistic landscape. America, aided by France, declared its independence from England in 1776 and established a new democracy. France began its own revolution in 1789, after which a new ruling class was established by the Emperor Napoleon in 1805. These shifts in power changed more than lives, greatly influencing artistic production. Francesco Solimena's allegories of Catholic power (for the Palazzo Reale, Naples) were later dismantled by Napoleon's agents, who occupied Italy. Elisabeth-Louise Vigée Le Brun, the first woman to become official painter to a French queen, escaped France at the storming of the Bastille, later finding refuge and patrons among England's gentry. The IU Art Museum preserves rare and important masterpieces that reflect these and many other seminal chapters in Europe's complex history.

Adelheid M. Gealt
Director
Curator of Western Art before 1800

Workshop of Taddeo Gaddi
Florentine, active ca. 1320–1366

Madonna and Child Enthroned with Donors, ca. 1330
Tempera on panel
17 3/8 x 7 9/16 in. (50.9 x 24.2 cm)
Samuel H. Kress Collection, 62.162

This magisterial Madonna, seated upon an elegant Gothic throne, comes from the workshop of the Florentine master Taddeo Gaddi. Pupil of the celebrated Giotto—who revolutionized Trecento Italian painting through his monumental, yet human and expressive characters—Taddeo created an independent style based on Giotto's groundbreaking models. He operated a large workshop, of which our panel is a product.[1]

Modeled on Taddeo's Berlin triptych (Gemäldegalerie; signed and dated 1334), our painting centers on the Virgin Mary. The Queen of Heaven, Mary is a regal presence on the throne, holding her son rigidly but without apparent effort. In a departure from the Berlin model, our version shows Jesus holding a goldfinch, a bird whose habit of feeding on thistles brought to mind Christ's crown of thorns and thus made it a symbol of his future Passion. Mary's throne, with its trefoil-shaped canopy, is crowned by a miniature piece of architecture resembling a small chapel or church. The architecture's delicate, almost flimsy structure contrasts with the Madonna's massive pyramidal solidity, which dominates the space with quiet authority.

At the base of the throne, on a deliberately smaller scale, are male and female donors, kneeling before the Madonna in prayerful adoration. Their ermine-trimmed red garments place them among the high-ranking merchants, bankers, and tradesmen who governed Florence and transformed her into one of Europe's leading cultural centers.[2] The husband crosses his arms, while his wife clasps her hands in prayer—both venerable attitudes of devotion. Despite the miniature scale and the generalized treatment of forms, these donors represent a genuine attempt at portraiture, as can be seen in the contrast of the husband's full face and fleshy presence with the delicate beauty of his wife.

This panel was once the center of a portable triptych. (For an example of an intact version, see the entry on Niccolò di Buonaccorso, p. 226). We can assume that our central panel, like its Berlin model, had a framing fillet occupied by saints (perhaps the twelve apostles). The wings likely portrayed the Crucifixion, on the right, and the Nativity or a group of saints on the left. We can also assume that our panel dates sometime after 1334 (the date of its prototype), but probably not much later.

Small enough to carry, with wings that could close, the portable triptych was a personal devotional object that could be used in various locations. The practice of daily devotions was an essential part of medieval life, with the day marked out by the times of prayer. Our triptych could have been used by the donors when traveling as well as within the home. Few Trecento homes survive, but the archives of Francesco Datini of Prato (1335–1410) include a room-by-room inventory that tells us that in the bedrooms were small images of sacred subjects. Even the guest room had a picture of th Virgin Mary in a little shrine. We also have pictorial evidence of prayers taking place before small icons, such as a fourteenth-century example showing St. Henry and his wife kneeling before a crucifix placed in a niche of his bedroom. The clergy too, made use of devotional images. A small fifteenth-century codex depicting the life of St. Dominic reveals the extensive use of altarpieces in Dominican monasteries. Illustrating Dominic's nine forms of prayer, it shows each one taking place in a different space and before a different altarpiece.[3]

The youth of this couple suggests that the altarpiece might have been commissioned to bless their union. Why would donors place themselves into the holy space of the altarpiece they commissioned? Given the small size and private nature of our example, the civic and public pride that influenced the depiction of donors in large public altars is unlikely to have been the motive. More probably, the couple, believing in the talismanic power of this holy image, were inspired to locate their proxies as close as was deemed proper to the source of divine intervention.

The painting retains the power to draw us into the Madonna's world, but today we admire it far more as a work of art than as a religious relic. The beautiful balance between thin and massive forms; the use of gold animated by sparing, yet effective punctuation of the surfaces to portray light passing through the open trefoils; and the massive, majestic Madonna transcend Trecento Florentine religious practices and enter the realm of artistic mastery.

Notes
1. See Andrew Ladis, *Taddeo Gaddi: Critical Reapraisal and Catalogue Raisonné* (Columbia: University of Missouri Press, 1982), no. 46. This entry is dedicated to Andrew Ladis, a brilliant scholar and friend to art history.
2. Iris Origo's classic book, *The Merchant of Prato, Francesco di Marco Datini, 1335–1410* (New York: Knopf, 1957), 288 ff. used the surviving documents of the Trecento Pratese merchant, Francesco Datini, to illuminate our understanding of the importance of dress. What our gentleman wears is a *gonellone,* a long robe worn by officials such as doctors or lawyers, and of these, the finest was *rosato,* or red, the aristocratic color. On his head, he wears a cap. His wife wears a scarlet gown trimmed in ermine, often signifying nobility.
3. I. Origo, op. cit., 250–56; George Kaftal, *Iconography of the Saints in Tuscan Painting* (Florence: Sansoni, 1952), no. 139; Leonard von Matt and M. H. Vicaire, *St. Dominic: Pictorial Biography* (London: Longmans, 1957), figs. 109–17, illustrating the *Codex Rossianus,* no. 3, in the Vatican Library, Rome.

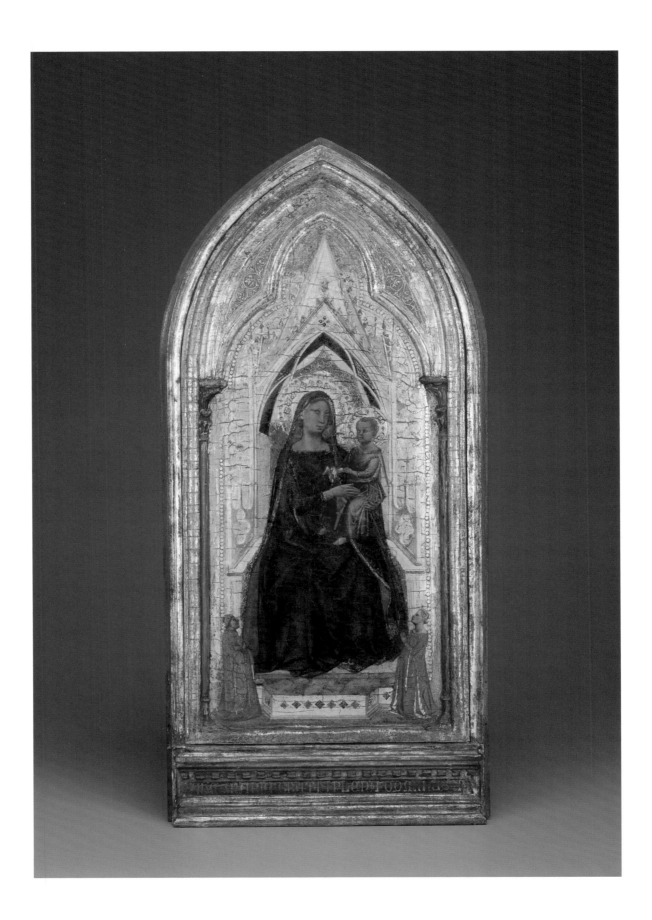

Niccolò di Buonaccorso
Italian, active Siena, ca. 1356–1388

Portable Triptych with Madonna of Humility, ca. 1370
Tempera on panel
23³/₄ x 21 in. (60.3 x 53.3 cm)
76.39

A graceful fourteenth-century Madonna looks out at us with gentle, yet guarded, tenderness in this extremely rare triptych. Painted by the Sienese master Niccolò di Buonaccorso, this three-part work is exceptional for surviving more than six hundred years intact. Both folding wings are present, as is the base and the flame-like moldings along the gables, placing this altarpiece among the less than one percent of extant Italian Trecento panel paintings.[1] It beautifully represents Niccolò's specialty, the kind of diminutive, intimate devotional art at which he excelled.

Probably the son and pupil of Buonaccorso di Pace (who was active from around 1348 to ca. 1362), Niccolò is listed in the Sienese painters' guild in 1355 and 1356. Later, in 1372, he appears in the record books as a prior of his district within Siena (the Terzo di Camollia). In 1381 Niccolò attained the position of *gonfaloniere* (standard bearer) within Siena's government. Active in decorating Siena Cathedral, Niccolò was paid by the Opera del Duomo of Siena for a (now-lost) panel of St. Daniel in 1383. By May 17, 1388, he was dead, buried in the Sienese convent of San Domenico.[2]

Niccolò's artistic identity was lost until the end of the nineteenth century, when the National Gallery in London acquired his *Marriage of the Virgin,* which remains his only signed work, bearing the inscription: NICHOLAUS: BONACHURSI; DE SENIS; ME P[I]NX[I]T. Eighteen panel paintings have since been assigned to Niccolò—all that remains of his thirty-year career. Our panel bears Niccolò's stylistic hallmarks: a miniaturist's aesthetic; fine, delicate figures with thin bodies and larger, oval heads; intricate decorative details; and a typically Sienese interest in spatial ambiguity. Also notable is his manipulation of scale: if our Virgin were to stand, she would be a monumental presence.

Working in a city dedicated to the Virgin Mary, Niccolò specialized in Marian subjects. Sienese artists invented the Madonna of Humility as a contrast to the enthroned Madonna (the *Maestà,* or Majesty).[3] Seated on the ground, sometimes on cushions, this humble presence granted the viewer a greater sense of intimacy with the Madonna.[4] The subject was ideal for small devotional panels, and our Madonna of Humility demonstrates Niccolò's talent for this theme.

Niccolò here offers a devotional summary of Christ's life, with the Annunciation, followed by his infancy (center scene) and death. Four saints serve as intercessors: presented in pairs, segregated by gender, they grace the wings. John the Baptist stands nearest the Madonna. He was the patron of hoteliers, cutlers, leather workers, and tailors. James the Less, an apostle martyred by the fuller's staff he holds in his right hand, was the patron of hat makers, silk merchants, and related medieval guilds. Catherine of Alexandria, identified by the wheel upon which she stands (the instrument of her martyrdom), was patron of education, as signified by her book. The saint holding the distinctive double-armed cross may be St. Helena, discoverer of the True Cross. She was the patron saint of needle makers, dyers, and nail makers. These saints may reflect the namesakes of the individual patrons or the guilds (i.e. tailors, fullers, leather workers) that commissioned the triptych.

Given its intimate subject and scale, our triptych may have been privately owned or used within a hospital. A crutch in the shield at the right of the base links the triptych to Santa Maria della Scala, the Sienese hospital, where the ill and dying were comforted with sacred images thought to have healing powers.[5] Easily portable, our altarpiece would have been carried from bed to bed.

Christ's disembodied face in the tympanum above the Virgin strengthens the argument for healing, since Jesus's visage is related to miraculous relics associated with the cult of the *Volto Santo* (the Holy Face, the sacred face of Jesus) that gained popularity during the Trecento. A relic known as Veronica's Veil, believed to bear the imprint of Christ's face from his Passion, had, by 1300, begun to draw thousands of pilgrims to Rome. Replicas of "the Veronica" or the Holy Face proliferated in paintings, pilgrim's badges, and as part of fourteenth-century passion imagery. Rarely part of portable triptychs, the *Volto Santo* on our panel connects the viewer to the curative, redemptive, and merciful power of that icon. Thus, our panel offers us an uncommon link to a bygone era, one that expected (and perhaps received) much from its images. The "true likeness" of Jesus, accompanied by his nurturing, protective mother, and aided by the intercession of four saintly beings, provided "solace and reminder," "a sweet comfort and consolation," and guidance to the believer's "true homeland," namely heaven.[6]

Notes
1. E. B. Garrison, *Italian Romanesque Panel Painting: An Illustrated Index* (Florence: L. S. Olschki, 1949).
2. Ettore Romagnoli, *Biografia cronologica de' bell'artisti Senesi,* 13 vols. (Florence: Edizioni S. P. E. S., 1976), vol. 3, 409–10; and Milanesi, *Documenti per la storia dell'arte Senese,* vol. 1, 31–32, cited in Pia Palladino, *Art and Devotion in Siena after 1350* (San Diego: Timken Museum of Art, 1997), 46 ff. See also H. B. Maginnis, "A Reidentified Panel by Niccolò di Buonaccorso, *Source* I (1982): 18–20.
3. For a discussion of this subject's Sienese origins, see Millard Meiss, *Painting in Florence and Siena after the Black Death: The Arts, Religion, and Society in the Mid-Fourteenth Century* (New York: Harper and Row, 1964), 132 ff.
4. Surviving evidence is fragmentary, but doubtless Simone Martini was among the pioneers of this subject. After all, his *Holy Family* (Liverpool, Walker Art Gallery) has the Madonna seated very low.
5. See Bruce Cole and Adelheid Gealt, "A New Triptych by Niccolò di Buonaccorso, and a Problem," *Burlington Magazine* 888 (March 1977): 184–87.
6. See Neil MacGregor, *Seeing Salvation: Images of Christ in Art* (New Haven: Yale University Press, 2000), 85 ff.

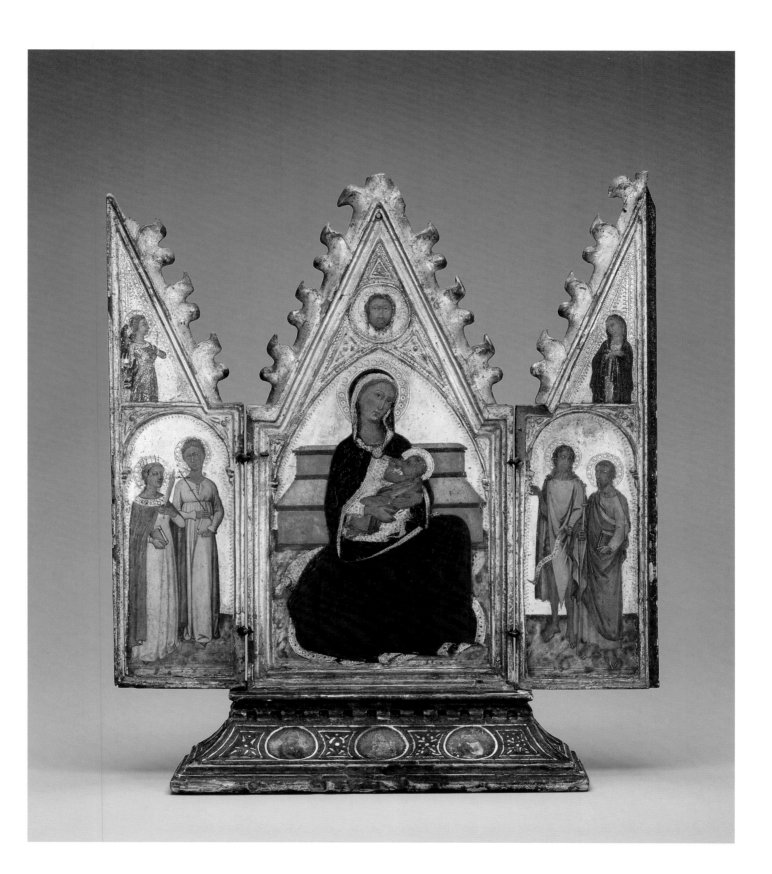

France

Crucifixion with the Virgin Mary and John the Evangelist, ca. 1350
Ivory
H. 5^{11}/$_{16}$ in. (14.5 cm)
72.100.3

This condensed, beautifully articulated image of Christ upon the cross is an exquisite example of the love of luxury, placed at the service of private devotion, that spawned a passion for ivory carving in medieval Europe. Ivory, from elephant or walrus tusks, had been prized since antiquity. Though not particularly abundant in the early Middle Ages, ivory from African elephants became increasingly available with the start of the Crusades (1095), and by the mid-fourteenth century (when our example was created) the African coast had a flourishing trade centered on the seafaring Swahili people. By 1255, Paris, already the wellspring of Gothic architecture, had emerged as a leading center of European ivory-carving, whose fine style set the standard for workshops elsewhere. A century later, when our example was made, workshops flourished outside Paris in centers such as Strasbourg, Troyes, Orléans, and Lyon.[1]

Our ivory panel is the right wing of what was once a diptych (a two-paneled image that folded together), with the left wing, attached by hinges (evident along our panel's left edge), long since lost. The crucifixion was a standard subject for the right wing, with Jesus generally portrayed so that he is oriented toward the left panel. The missing subject is a matter of speculation, but a good probability is that it featured a Madonna, as in at least three documented instances.[2]

The French carver who created our ivory emulated the swaying, elegant, and fluid forms favored in Gothic Paris; and the single trefoil Gothic arch enclosing the scene establishes a contemporary architectural context for this holy event, as well. Our master was a gifted carver, distinctive for the large hands, feet, and heads of his figures and the foliage finials decorating the top of the pinnacle. Starting with a flat panel, he cut away the ivory surface with skill and precision to render architecture and figures in relief. Sculpted in high relief, Christ—depicted with thin, angular arms, carefully articulated torso, and large, precisely modeled feet—is almost liberated from the background, while the Virgin and St. John are confined to a slightly more shallow space.

The death of Christ on the cross is the essential event of Christian dogma. Often depicted, this subject was central to Christian devotion, with medieval texts such as Jacobus de Voragine's *Golden Legend* (first published around 1275 and a medieval best seller) and Pseudo Bonaventura's *Meditations on the Life of Christ* (of roughly the same time) offering descriptive and meditative guidance. The presence of the Virgin and John the Evangelist became a standard feature, based on the Gospel of John (19:26–27), in which Jesus entrusts his mother to John's care. In our example, she reacts to the moment of Christ's death by spreading her hands in grief, her head turned toward her son, her body swaying away, while John the Evangelist weeps into his cloak (a quintessential gesture for this saint). In this graceful distillation, the figures of Christ, the Virgin Mary, and St. John interact in a silent ballet of suffering, grief, and mourning. Despite its simplicity, the image resonates with emotional intensity and visual subtlety.

Only two other panels, one in Cologne (Schnütgen Museum) and the other in the Montreal Museum of Fine Arts, have been ascribed to our carver, whose workshop is thought to have produced other panels featuring the Crucifixion now preserved at the Boston Museum of Fine Arts and the Lyman Allyn Art Museum in New London, Connecticut.[3]

Who originally owned our ivory will never be known—possibly it was a member of the increasingly prosperous merchant class, which contributed to Europe's flourishing economy and culture; perhaps a clergyman or nun; or maybe an aristocrat. Whomever the owner, it can be assumed that he or she used the carving for daily devotions. Small enough to be held in the hand like a book, the diptych from which our panel survives was, in a sense, a prayer book. Opened in a bedroom or private chapel, this rare and costly object was considered an appropriate vehicle to depict and praise divinity. Studied at close range, the polished ivory surface, with its soft forms reflecting suffused light, was a perfect inducement for the proper mental state of prayer. Through a charitable impulse, our ivory might have found its way into a cathedral sacristy. Certainly Europe's medieval cathedrals were full of such precious objects, as were royal treasuries.[4] The small scale and intimate nature of this delicate masterpiece affirm its function as a focus of worship in the hands of a devout individual.

Further Reading
Randall, Richard H. Jr. *The Golden Age of Ivory: Gothic Carvings in North American Collections.* New York: Hudson Hills, 1993.

Notes
1. See essay by Peter Barnet, "Ivory and Ivory Workers in Medieval Paris," in *Images in Ivory: Preciou Object of the Gothic Age* (Detroit Institute of Arts and Princeton: Princeton University Press, 1997), 3ff.
2. See Richard H. Randall Jr., *The Golden Age of Ivory: Gothic Carvings in North American Collections* (New York: Hudson Hills, 1993), no. 79 (the IU Art Museum ivory); Randall indicates that one left-hand panel from a dismembered diptych featured a Virgin between angels (Metropolitan Museum of Art). Another reconstructed diptych (see *Images in Ivory*, op.cit. nos. 22, 23), also features a Virgin. The Walters Art Gallery, Baltimore (71.276) preserves a German ivory of the fourteenth century with a crucifix on the right and a Madonna flanked by angels on the left; see Randall, op. cit. fig. 5.
3. Randall, op. cit., nos. 80–83.
4. Randall, op. cit.,15.

Apollonio di Giovanni
Florentine, 1415–1465

Lid from a Cassone with the Pazzi and Borromei Coats of Arms, 1463
Tempera on panel
21 1/8 x 72 in. (53.0 x 180.0 cm)
75.37

These charming putti, blowing on their trumpets while cavorting upon two dolphins, mark a happy moment in the life of the ill-fated Pazzi family, Florentine rival of the famous Medici, the de facto rulers of Florence.* Both banking families contributed to the artistic prestige of their native city, and both were powerful. The famous Pazzi Chapel, attached to Santa Croce and designed by Brunelleschi, represents that family's most celebrated artistic contribution to Florence, while Medici patronage was vast, including the churches of San Marco and San Lorenzo, as well as the Palazzo Medici, where Filippo Lippi painted the *Adoration* (which inspired the copy by the Lippi-Pesellino follower preserved in our museum; see p. 232).

Apollonio, established by 1442 as a member of the Arte dei Medici e Speziali (the Florentine guild that included doctors and apothecaries as well as artists), joined the professional painter's organization, the Compania di S. Luca, in 1443, then shared a shop with Marco del Buono. Apollonio was the more distinguished partner, whose shop book details commissions specific to his hand. Active for at least twenty years, Apollonio died in 1465, and his shop passed on to Marco, who continued to provide painted salvers, chests, and other decorative items for the brides, new mothers, and homes of well-to-do Florentines at least until 1480.[1]

Painted wedding chests *(cassoni)* with heraldic devices were often commissioned in anticipation of marriages among wealthy Florentine families. Apollonio's surviving shop book traces his orders from 1446 to 1463 and preserves 173 entries relating to commissions primarily for *cassoni* in conjunction with upcoming marriages. Most of the notable Florentine families are mentioned. One of the last entries, no. 170, dated 1463, documents our panel. It specifies an order on behalf of the *figliola di Giovanni di Buonromeo Borromei, a Giovanni di Antonio de' Pazzi.*[2] That is, for the daughter of Giovanni Borromei, who is to be married to Giovanni di Antonio de' Pazzi. This marriage would have far-reaching consequences and result in the Pazzi conspiracy, the most notorious assassination plot in Florentine history.

As early as 1461, the Pazzi, rivals to the Medici for power and wealth, planned a union through which Giovanni di Antonio de' Pazzi would be vastly enriched by the wealth obtained through his wife-to-be's future inheritance, since the Borromei were also rich bankers. Our wedding chest, with its putti astride two dolphins (the Pazzi coats of arms) clearly reflects this union. Unbeknownst to the Pazzi, the Medici (perhaps in response to this "merger") quietly inaugurated a law restricting inheritance to the male line, thus thwarting Pazzi ambitions. The Pazzi—an older family than the Medici, boasting a lineage back to the First Crusade—were doubtless outraged. Their resentment found an outlet a decade later, when

the Pazzi, not the Medici, became Pope Sixtus IV's bankers. These powerful allies—the Pope, Francesco Salviati (the archbishop of Pisa), and the Pazzi family—plotted their revenge against the Medici, and, in 1478, the Pazzi conspirators took action.

At eleven o'clock on Easter Sunday, April 26, 1478, Francesco de' Pazzi (the brother of Giovanni, the bridegroom), Bernardo Bandini Baroncelli, and two priests (Antonio Maffei and Stefano da Bagnone), all armed with daggers, entered the Duomo for Mass. At the sounding of the sacristy bell and the elevation of the host, they attacked Giuliano and Lorenzo de' Medici. Giuliano (lured from his sickbed to attend mass) died from nineteen stab wounds, while Lorenzo ("Il Magnifico") vaulted over the altar rail and took refuge in the new sacristy. As Pazzi loyalists tried to rally the Florentines with cries of *"Libertà,"* the populace (who had loved Giuliano) supported the Medici, who quickly took revenge. The assassins and conspirators, including the archbishop of Pisa, were caught, strangled or beheaded, and their bodies strung up in public.[3] The Pazzi family was disgraced, their names and coat of arms suppressed by order of the Signoria, so that the Pazzi family symbol, the dolphin, was blotted out or cut away wherever it was found.[4]

So how did our panel, emblazoned with Pazzi dolphins, survive? Was it hidden? We believe it was. A technical examination reveals the absence of the heavy gesso ground typical of external *cassone* panels. Iconographically, too, it is consistent with the inside of the *cassone* lid, and as a result, the zealous expungers of Pazzi coats-of-arms who roamed Florence after 1478 failed to see it, making this a rare and beautiful survivor of that violent moment in history.[5]

Notes
*This article is dedicated to Bruce Cole, former Distinguished Professor and Chair of History of Art at the Hope School of Fine Arts, and now Chairman of the National Endowment for the Humanities. He was instrumental in the acquisition of this important panel. My thanks also to Louise Arizzoli, for her help with the research on the Pazzi family.
1. See Ellen Callman, *Apollonio di Giovanni* (Oxford: Clarendon, 1974), 4–6.
2. See Callman, op. cit., 81; Callman does not supply a date, but the *Libro di Matteo[Marco]del Buono Giamberti e d'Apollonio di Giovanni, Dipontori,* preserved in the Biblioteca Nazionale Centrale of Florence (Ms. Magliabechiano XXXVII, 305), includes the date 1463. My thanks to Francesco Guidi for sharing this information.
3. No less a painter than Botticelli was commissioned in 1478 to paint the damnation or condemnation of the Pazzi in a fresco over the Porta della Dogana, which showed the traitors hanged. This fresco was destroyed in 1494, the year the Medici were expelled (albeit temporarily) from Florence.
4. Christopher Hibbert, *The House of Medici: Its Rise and Fall* (New York: Morrow Quill, 1980), 132–42.
5. See Ellen Callman, "An Apollonio di Giovanni for a Historic Marriage," *Burlington Magazine* 119, no. 888: 174 ff.

Lippi-Pesellino Follower
Florentine, active 1475–1500

Virgin Adoring the Christ Child with the Infant St. John and Three Angels
Tempera on panel
37 1/4 x 32 5/8 in. (94.0 x 81.3 cm)
Gift in memory of Marguerite Lilly Noyes, 74.19.1

This perfectly preserved image of the Virgin Mary adoring her newborn son offers a window into the artistic and religious world of fifteenth-century Florence at a creative high point. Our unknown master worked in the orbit of two celebrated Florentine painters: Fra Filippo Lippi (ca. 1406–1469) and Francesco di Stefano, called Pesellino (ca. 1422–1457). In 1932 the pioneering art historian Bernard Berenson named our artist "Pseudo Pier Francesco Fiorentino." More recently, and less poetically, he has been called the "Lippi-Pesellino Follower."[1] One of the finest surviving panels by this fairly prolific master, our tempera is linked to a *Madonna Adoring the Christ Child* by Fra Filippo Lippi, painted for the private Medici chapel in the Palazzo Medici Ricardi around 1459 (now in Berlin).

Lippi's panel promoted a new devotional subject in Florence, and our example reflects its spreading popularity among Florentine patrons. Bypassing the stable of the traditional Nativity, Lippi (and our artist) located the Madonna within a flowering garden, set against a backdrop of dark woodlands. These panels indirectly reflect the teachings of Antonino Pierozzi (1389–1459), once prior of San Marco, then archbishop of Florence, and later canonized as Saint Antonine, who advocated a form of religious meditation in what he called "the little garden of the soul," echoed here in the garden plot wherein Mary kneels and adores her child.[2] In 1455, Antonino was the religious instructor of Dionara and Lucrezia Tornabuoni, daughters of one of the oldest and most respected Florentine families; Lucrezia (who was married to Piero de' Medici, scion of the "first family" of republican Florence) probably influenced Lippi's original commission for the Palazzo Medici.[3]

Lucrezia Tornabuoni was, like first ladies of today, a leader. The "little garden of the soul" that Lippi visualized for her doubtless inspired imitation within Lucrezia's circle. Certainly the patrons who commissioned our version desired a similar guide to meditation, and they got an enchanting vision, made up of perfectly lovely blond beings occupying a decorous world. Any hint of suffering and penance has been subsumed within gentle sweetness. The patrons who commissioned this masterpiece were clearly loyal Florentines who venerated their city's patron saint and celebrated its name—the abundant blossoms in this garden remind us that Florence (Firenze) was, of course, the city of flowers.

Every flower in our master's garden offers spiritual nourishment. Lilies signified the Virgin's purity; roses (rich in symbolism) embodied both Christ and the Virgin, the sinless "rose without thorns." White roses symbolized her purity; red, her son's Passion. White carnations (dianthus, or "God's flower") connoted Christ's fidelity and Mary's love of God.

The patron saint of Florence, John the Baptist—the last of the prophets and the first of the martyrs—had, according to legend, visited the infant Jesus as a child. Behind him, the tree stump recalls John's words (Matthew 3:10): "And now also the axe is laid to the root of the trees: therefore every tree which bringeth not forth good fruit is hewn down, and cast into the fire." The stream probably alludes to the Jordan River, where John baptized Jesus. On the Virgin's left are three adoring angels, including one emulating Gabriel as he delivered his fateful message of the Annunciation (Luke 1:26-38): "Blessed art thou among Women"; although here his homage is directed at the infant.

In our master's version of the subject, symbols of penance abound outside the garden: nearly all of the trees are barren, several have fallen, and the soil is flinty. Huddled together, the wilderness saint (John the Baptist), the Virgin Mary, and the angels encircle the garden and its precious infant. Behind them, the white swan is a good omen, while the white wading bird above it may signal Christ's sacrifice, recalling Psalm 102:6: "I am like a pelican of the wilderness." The bird devours the snake (which seduced Eve), evoking Christ's triumph over Satan. A white deer crossing a bridge is a striking addition to Lippi's original iconography. A legendary foe of snakes, it may symbolize Christ or St. Giles, a popular medieval saint, the protector of cripples, and the possible namesake of the patron.

We can suppose that the patron of our panel was Florentine and probably a member of that vast network of Medici associates. Where did they place their version? Perhaps, like its Lippi prototype, it adorned a chapel within the family palace. Or maybe it was displayed in one of the smaller chapels of a Florentine church, to more publicly acknowledge a Medici affiliation. Could our version have been commissioned purely for a collection, as has sometimes been suggested? Probably not. The complex iconography involving incarnation, penitence, and meditation is too strongly devotional for such a secular purpose.

Notes
1. See Bernard Berenson, *Italian Pictures of the Renaissance: A List of the Principal Artists and Their Works, with an Index of Places: Florentine School* (London: Phaidon, 1963), 173 (cited as Jules Bache collection, New York). For the newer designation, see Marion Opitz, *Benozzo Gozzoli 1420–1497* (Cologne: Könemann, 1998), 44.
2. See Frederick Hartt, *History of Italian Renaissance Art: Painting, Sculpture, Architecture* (New York: Abrams, 1979), 229–30.
3. Antonino's *Opera a ben vivere*, written in 1455 for the two sisters, exists in one and two manuscripts respectively; see Peter Francis Howard, *Beyond the Written Word: Preaching and Theology in the Florence of Archbishop Antoninus, 1427–1459* (Florence: Olschki, 1995), 20. My thanks to Louise Arizzoli for her invaluable assistance with this research.

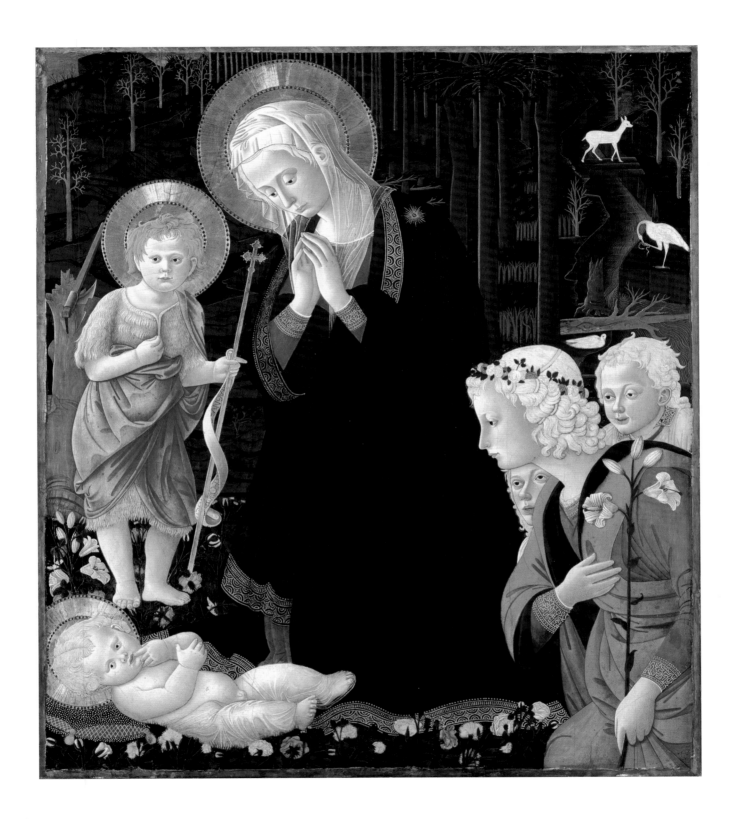

Matteo di Giovanni
Sienese, ca. 1430–1495

Judith with the Head of Holofernes (?), ca. 1491
Oil on panel
24 3/4 x 21 in. (62.9 x 53.3 cm)
Samuel H. Kress Collection, 62.163

This painting of a gorgeous heroine coolly holding the decapitated head of her victim is a fine, if fragmentary, autograph work by the Sienese master Matteo di Giovanni (ca. 1430–1495). Matteo's surviving oeuvre is primarily religious, including numerous enthroned Madonnas, and he is probably most famous for his haunting interpretations of the Massacre of the Innocents (Naples, Capodimonte; Siena, S. Maria dei Servi; Siena, S. Agostino), which demonstrate his ability to blend fictive illusionism with pictorial flatness, creating exquisite tension between vicious cruelty and decorative beauty. Still too-little appreciated (as is the Sienese school in general), Matteo di Giovanni was a painter of powerful originality, whose work demonstrates the independence of the artists of Siena, despite their proximity to their more famous Florentine contemporaries.

Painted on an arched panel, our heroine once belonged to a series of eight paintings depicting "virtuous" or "famous" men and women from antiquity, commissioned from diverse artists by the Piccolomini family of Siena, who probably used this and the other seven panels to decorate a long wall in the great hall of a palace or a villa.[1] Though undated, this commission was fulfilled sometime around 1490; thus our painting, which must have been completed before Matteo's death in 1495, probably belongs to one of the earlier examples from the series, perhaps 1491.[2]

Just who our heroine was meant to be is currently a matter of debate. She is generally identified as Judith, the famous heroine from the apocryphal Old Testament. When her city of Bethulia was besieged by an Assyrian army led by Holofernes, Judith, a rich and beautiful widow, adorned herself and entered the enemy camp. Holofernes, captivated by her beauty, hosted a banquet and planned her seduction. Instead, overcome by wine, he fell asleep, whereupon Judith decapitated him with his sword, placed the head in her maid's sack, and escaped back to Bethulia. Leaderless, the Assyrians were routed and Judith's people were saved.

Embodying virtue vanquishing vice, Judith became an immensely popular subject during the Renaissance, with numerous well-known examples produced in Florence. Donatello's celebrated Judith of 1457–60, done for the Medici (now Florence, Palazzo Vecchio), and Botticelli's Judith of ca. 1470 (Florence, Uffizi) are just two examples. The most common format was Judith shown holding Holofernes' head, as in Matteo's example.

Recent scholarship involving the series to which our Matteo belongs suggests another heroine. Given the largely Greek accent in the overall series (Alexander, Artemisia, and Eunostos), Matteo could have painted Queen Tomyris, who, according to Herodotus (1:214) ruled a central Asian nomadic tribe in ancient times. King Cyrus the Great, founder of the Persian Empire, had tricked the army led by Tomyris's son, leading to their slaughter and the son's suicide. In revenge, Tomyris led her army into battle, killed Cyrus, decapitated him, and, to further debase him, dipped the head into a bowl of human blood. Generally Tomyris is shown holding the head by the hair (often the crown is visible), and an attendant holds the bowl of blood.

Since our panel is cut down, it is difficult to determine if this is indeed Tomyris instead of Judith. Her headdress, with its jewel, though not a crown, suggests a woman of rank, perhaps a queen. But she also sports an elaborate coiffure, reflecting Judith's stated plan to make herself irresistibly beautiful. The tents in the background could be Persian or Assyrian. But they do not depict a vanquished army, as the Persians would have been by the time Cyrus was dead. The tents better describe the Assyrian army, still unaware that their leader had died, before the Bethulians routed them. Moreover, our heroine holds the head behind her (an awkward posture for dipping), and she looks into space, not at the bowl of blood (which might have appeared in a lost section of the painting) into which the head of Cyrus would be placed.

The definitive identification of our heroine must await further research. What remains certain is that this painting is one of Matteo di Giovanni's most important late works, and even in its fragmentary condition it is a masterpiece. The interplay between angular and rounded forms presents an engaging demonstration of stasis and action. Matteo's hallmark—balancing exquisite beauty with violent cruelty—is nowhere better manifest. Unique in his oeuvre, so far as we know, Matteo's heroine is the perfect femme fatale, the icy blond whose legacy lives on in modern film and literature.

Further Reading
Cole, Bruce. *Sienese Painting in the Age of the Renaissance*. Bloomington: Indiana University Press, 1985.

Notes
1. See Fern Rusk Shapley, *Paintings from the Samuel H. Kress Collection—Italian Paintings, Thirteenth to Fifteenth Century* (London: Phaidon, 1966), 157 ff.
2. The series was as follows: Luca Signorelli and the Master of the Griselda Legend, *Alexander the Great* (Barber Institute, Birmingham), *Eunostos of Tanagra* (National Gallery of Art, Washington, D.C.), *Tiberias Gracchus* (Budapest, Gallery); *Unidentified Woman—Artemisia?* (Poldi Pezzoldi, Milan); Francesco di Giorgio and the Master of the Griselda Legend, *Scipio Africanus* (Bargello, Florence); Neroccio de' Landi, *Claudia Quinta* (National Gallery of Art, Washington, D.C.); and Pachiarrotto, *Sulpicia* (Walters Art Gallery, Baltimore).

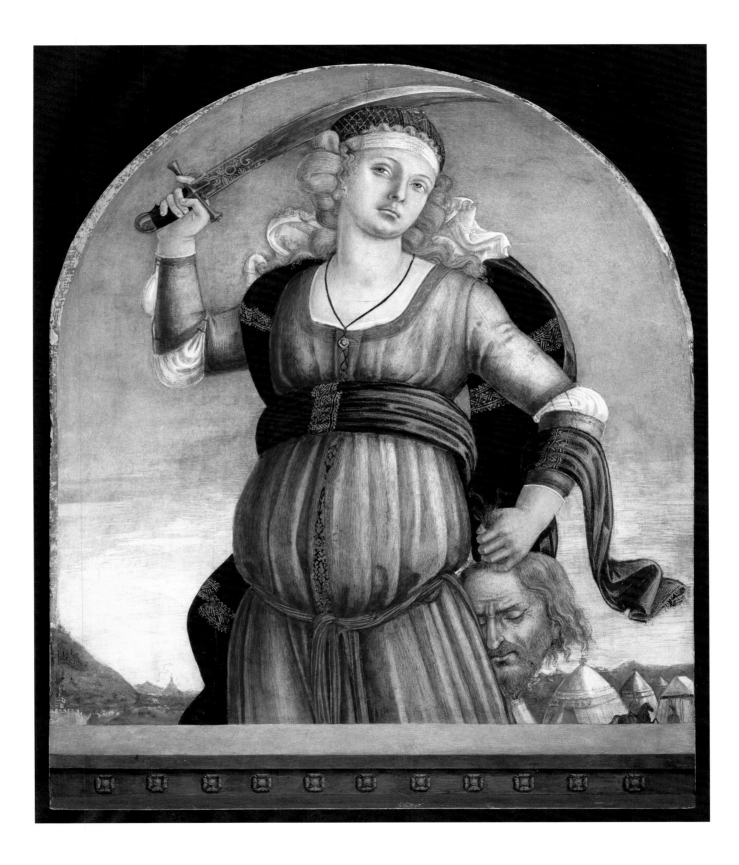

Master of the Holy Kinship
German, flourished Cologne, ca. 1475–ca. 1510

The Adoration of the Magi
Oil on panel
53 ³/₄ x 37 in. (136.5 x 94.0 cm)
Given in memory of Mrs. Nicholas H. Noyes, 78.62.1

Despite its visual integrity as a narrative scene in its own right, this panel originally formed the left wing of a three-part altarpiece; the right wing, depicting the Resurrection, is discussed in the following entry. The central panel depicted the Crucifixion and is now in the Musée des Beaux-Arts in Brussels.

This richly embellished *Adoration of the Magi* was painted in the late fifteenth century by an unknown master from Cologne, Germany. Named for his key surviving work, an altarpiece preserved in Cologne's Wallraf-Richartz Museum, the Master of the Holy Kinship is thought to have been born around 1450. He must have worked primarily in Cologne, and he probably died around 1515. Revealing familiarity with the Netherlandish tradition of Rogier van der Weyden, Justus van Ghent, and Hugo van der Goes, the Master of the Holy Kinship's style is characterized by solid modeling, unusual postures, large heads, and a love of crisply defined details and embellishments. Of his surviving paintings, ours is his only depiction of the Adoration of the Magi.[1]

The story of the Adoration is told in Chapter 2 of the Gospels of Matthew, which describes wise men from the East, who followed a star to the "house" where Jesus was and worshiped him. Jacobus de Voragine, the author of the medieval best seller *The Golden Legend,* characterized the kings as magicians (magi), wise men, and astrologers, and interpreted their gifts to Jesus: gold, to honor his sovereignty; frankincense, in homage to his divinity; and myrrh, which foreshadowed his death. By Voragine's time, the magi often symbolized the three ages of men and the three (known) parts of the world, with Caspar, from Europe, the oldest; Balthasar, from Africa, the youngest; and Melchior from Asia, middle-aged. Their remains, according to legend, were found by Constantine's mother, St. Helena. She gave the magi's relics to Milan, where they remained until 1164, when Frederick Barbarossa brought them to Cologne, establishing that city as a major pilgrimage site.

One of the oldest Christian cities in the West, Cologne had eleven gates (as had Jerusalem). One of those gates, Severins Tor, appears in the distance at the far left of our painting. In the foreground, the old Roman arches framed in green may reflect the type of architecture found in Cologne, originally a Roman colony that traces its history back to 38 BC. The stable, traditionally treated as a ruin symbolizing the fall of the old order and the rise of Christianity, sets off the Virgin and Child, who are "enthroned" within the central section, and isolates them from Joseph, who peers out with concern from an elaborate, arched doorway in the middle ground. To the right, the last of the shepherds who came to worship Jesus before the arrival of the wise men leaves his humble gift, a sheaf of grain, a portent and symbol of the Eucharist of the Last Supper.

Caspar, the oldest and first king, dressed in a royal robe of scarlet trimmed in white ermine, has offered his gift of gold, presented in a wonderfully wrought casket.[2] His hat, embellished with a crown (a configuration more frequently seen in earlier representations of the subject in Northern Europe), lies at his knees, just below his offering. His face has the specificity of a portrait, identifying him as the donor, who assumes Caspar's role, giving him special prominence and prestige.

Melchior, middle-aged, bearded, and swarthy, represents the Middle East. Draped in a brocaded robe, he prepares to offer his gift of frankincense. Balthasar, an exceptionally handsome young African king (perhaps a portrait?), is most distinctive. His opulent ensemble includes a crown surmounted by a gold seraph, set with a large ruby, and a chest-plate embellished with pearls outlining a fleur-de-lis of rubies. The fleur-de-lis here may refer to the sword lily, a symbol of Christ's Passion; this interpretation is strengthened by the blood-red color of the rubies.[3] Besides the kings, several other faces in the retinue are striking, particularly the young man in the dark cap staring directly out at us from the back of the group. Is this a portrait of our unidentified artist? The attitude and intense gaze have the hallmarks of self-portraiture, and certainly there was a tradition of such self-portraits within Adoration of the Magi scenes (as Botticelli's *Adoration* of ca. 1476 in the Uffizi documents).

The splendid fabrics, though demanded by the subject, are exceptionally elaborate and remind us that Cologne gained much of its wealth through the textile industry. The elaborate vessels and a host of descriptive details—including plants, animals, buildings, and birds (the owl, for example, was a well-known symbol of wisdom, but its nocturnal aspect signaled death; the swallow, Christ's Resurrection)—all suggest that our painting was a compendium of symbolic meaning, offering a lifetime of visual pleasure and spiritual enrichment.

Notes
1. See Rainer Budde, *Köln und seine Maler* (Cologne: i Dumont, 1986); Gisela Goldberg, "The Cologne School of Painting," *Apollo* 116 (October 1982): 214–25.
2. The dominance of his scarlet (and ermine) trimmed robe establishes his royal bona fides as much as his crown—red was such a rare and precious color at that time that it generally was reserved for royalty or the very rich; see Amy Butler Greenfield, *A Perfect Red: Empire, Espionage, and the Quest for the Color of Desire* (New York: Harper Collins, 2005), 25. This dress is similar to that worn by patrician donors in other images; see, for example, the donors in Taddeo Gaddi's *Madonna Enthroned,* p. 224.
3. Certainly there was a celebrated history of Franco-German alliances, one of which, the marriage between Isabeau of Bavaria and Charles VI, king of France, was made famous with the gift to Charles of the famous *Goldenes Rössel,* made in 1404. This piece of goldsmith's craft, which portrays a French king kneeling before the Madonna, shows him wearing a robe with fleur-de-lis designs. Here the single iris, blood-red, may refer to Christ's death. This handsome king may represent a portrait of an as yet unidentified African.

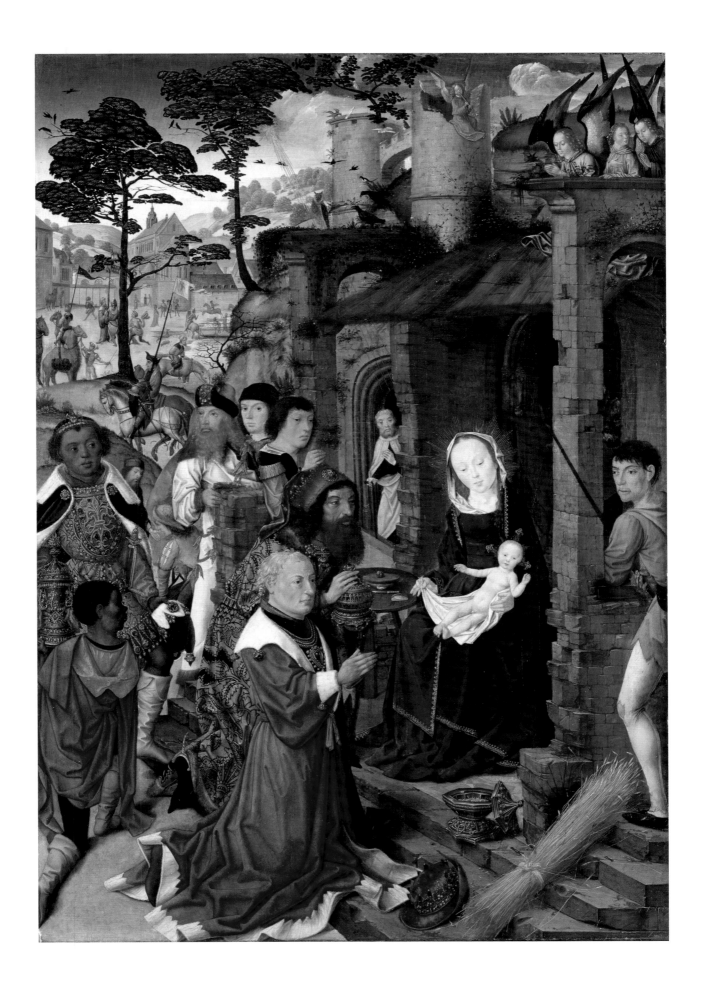

Master of the Holy Kinship
German, flourished Cologne, ca. 1475– ca. 1510

The Resurrection
Oil on panel
53³/₄ x 37 in. (136.5 x 94.0 cm)
Given in memory of Mrs. Nicholas H. Noyes, 78.62.2

This majestic panel, the right wing of a triptych, features Christ's Resurrection, the aftermath of the Crucifixion, which is the fragmented altarpiece's central panel (now in the Musée des Beaux-Arts, Brussels). As in the Adoration (the altarpiece's left wing; see previous page), the Master of the Holy Kinship gave this holy event a contemporary setting. The Rhine River, glimpsed in the distance in the Adoration panel, and flowing through the Crucifixion, is now dotted with the castles and fortresses of Cologne.

Step by step, the artist laid out the story of Christ's triumph over death in this panel, with the Resurrection taking center stage. Centrally placed, frontal, and hieratic, Christ (having risen on the third day) floats above his closed stone coffin, which is affixed with at least four unbroken wax seals, confirming its inviolate state. Draped in a scarlet robe, Jesus blesses the onlooker with his right hand and, in his left, holds a golden cross atop a rock crystal staff, from which flutters his white Resurrection banner, emblazoned with a red cross. The dead and verdant trees flanking Christ symbolize death and rebirth.

Although not described in the four Gospels, by the Middle Ages the Resurrection was a key tenet of Christian faith within the Western tradition. By the fourteenth century, its pictorial iconography was solidly established: Jesus standing above his closed tomb, surrounded by sleeping soldiers, holding a banner with a cross and draped in a red robe. Medieval literature, notably *The Golden Legend,* stressed the fact that Jesus "rose from a sealed grave."[1] This tradition, however, departed from the account of Luke (24:1–15), who describes the aftermath of the Resurrection, saying that the three Marys saw that the stone had been rolled aside and could not find Jesus. Later examples, nearer to the Master of the Holy Kinship's time, reverted to Luke's account, and showed Jesus rising from a tomb whose cover had been removed. The closed-versus-open tomb was one of the issues raised at the Council of Trent held between 1545 and 1563, which required Catholic artists to return to the older, closed lid model. Our artist, although he was working in a period when the open lid was popular, most likely adopted the closed stone coffin based on its longstanding tradition.

The Master's treatment of the soldiers is particularly striking. In addition to the fairly standard armed knights, our painting shows a less typical soldier: a Turkish mercenary, complete with yellow turban and green and red costume.[2] In the foreground is an even more unconventional soldier. Covered in a scarlet cloak (green is a more traditional color for soldiers' garments in Resurrection scenes), he stares into space, unseeing, as though in a trance. Something of a fop,

he is the farthest below Jesus visually. The presence of his red cloak further contrasts this lowly mortal with the divine, red-robed Jesus. The soldier's pagan status is reinforced by the gold brooch of Hercules and the Nemean lion adorning his hat. To Christ's left, another soldier, with shiny black armor articulating his long appendages and a back plate suggesting a carapace, adds a creepy, scorpion-like presence devoid of any spirituality. The sleeping soldier at the far left has the gentlest face; his attitude is the most graceful and his armor, with its golden leg guards, suggests not only a privileged status but also a greater spiritual warmth. Reflected in his helmet is the face of Jesus, which may identify this soldier as Longinus, who, out of pity, speared Jesus's side during the Crucifixion, and who, legend had it, converted on the spot.

Of all those surrounding him, only the angel watches with reverence and happiness as Jesus triumphs over death. Above them all—a vision of perfection—Jesus is no longer a mortal being: he floats above the tomb, even casting a shadow upon it.

The moment of the Resurrection is given its narrative context through the depiction of the preceding as well as succeeding events. The painter shows us the three Marys, who approach at the left of the panel. At the right, in the distance, we see Mary Magdalene kneeling before Jesus (the famous *Noli Me Tangere).* On the left of the panel, far in the distance beyond the Marys, we see Peter, having recognized the resurrected Jesus on the shore, leaping out of his boat and moving toward him, as described in John (21:1–8). Finally, concluding the story, Jesus's cross guides us to the upper right, where, blessing one last time, he ascends to heaven in a golden aura.

Notes
1. See discussion under "Adoration," Jacobus de Voragine, *The Golden Legend of Jacobus Voragine,* trans. Granger Ryan and Helmut Ripperger (New York: Longmans, 1941), 218.
2. This soldier deserves more study. The fact that he has literally "turned his back" on Jesus, and looks away, may be a reference to Muslims. It may not be coincidence that a Turkish soldier is included. After all, in 1453 Sultan Mehmed II conquered Constantinople, ending the Christian Byzantine Empire, an event that no doubt shocked the West, including Germany. By 1458 he was in Serbia and Bulgaria and doubtless was deemed a threat to Christianity. Such "infidel" (i.e., non-Christian) soldiers made regular appearances in German Resurrection scenes; see for example, the Master of the Lyversberg-Passion (Cologne, Walraff-Richartz Museum), in Frank G. Zehnder, *Katalog der Altkölner Malerei* (Cologne: Stadt Köln, 1990), 234.

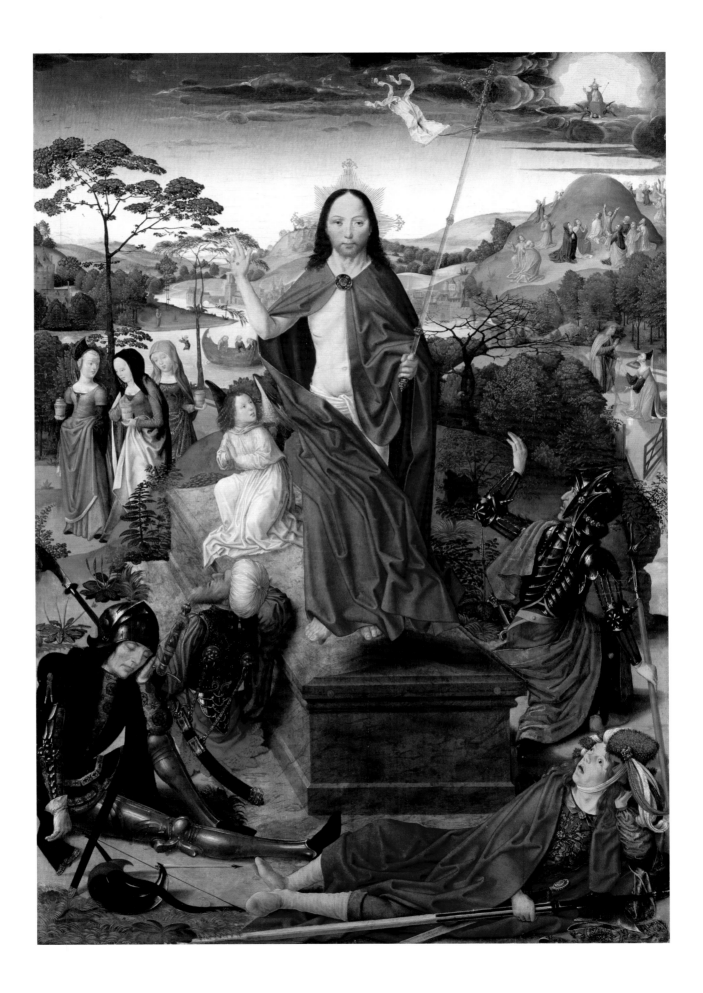

Felipe Vigarny
Burgundian, active Spain, ca. 1475–1542

Presentation in the Temple, ca. 1515
Polychromed relief: tempera and gold leaf on wood
48 x 30 in. (121.9 x 76.1 cm)
William Lowe Bryan Memorial, 65.50

This large, richly decorative relief by Felipe Vigarny reflects the Italian Renaissance style that supplanted the Gothic in Spain in the late fifteenth and early sixteenth centuries, during the Age of Exploration, a period of Spanish supremacy in European affairs. Vigarny (or "Bigarny," as the Spanish called him) was the pioneering Burgundian artist credited with introducing the Italian Renaissance style to the city of Burgos in the historic Castile region of Spain.

Within the dynamic yet conservative Spanish culture—where Gothic might be called "modern" and Renaissance called "ancient" or "Roman"—sculpture of all kinds was in high demand. Cardinals, bishops, and cathedrals required altarpieces (mainly in the form of the multi-paneled *retablos* that mixed relief sculpture with color and pattern to dazzling effect), while kings and queens (Ferdinand and Isabella) as well as high nobility required portraits, tombs, and devotional imagery. As a sign of wealth, those who could afford to do so imported their artists: German or Flemish sculptors generally worked in the Gothic mode, while Italian sculptors (or those trained in the Italian style) gained favor among patrons desiring the new Renaissance style (with its antique associations).

Born in France's historic Burgundy province, Vigarny trained in the capital city, Dijon, between 1485 and 1490. Home to the dukes of Burgundy from the early eleventh century until the late fifteenth, Dijon was a place of tremendous wealth and power and one of the great European centers of art, learning, and science. There, Vigarny probably absorbed the basic tenets of Italian (primarily Florentine) art, including figure type and architecture. His blond Virgin in her sweet, round-faced perfection, for example, is a near relative of our Lippi-inspired panel and likely traces her origins to the same fertile artistic ground (p. 232).[1]

We assume that Vigarny's style was established by the time he arrived in Burgos, a leading Spanish cultural center, in 1498. He rapidly gained acceptance there, with additional commissions coming from Toledo, Salamanca, and Palencia—where, in 1503, he produced sculpture for the high altar of the cathedral. Besides *retablos,* altarpieces, and choir stalls undertaken with various collaborators, Vigarny received royal commissions, including the fully round sculptures *Ferdinand the Catholic* and *Isabella the Catholic* for the Capella Real, Granada Cathedral.[2]

Our *Presentation* is one of eight panels from a Life of the Virgin cycle preserved at the IU Art Museum (see following pages), a cycle that was originally much more extensive, part of the multi-paneled and probably multitiered polychrome relief imagery that decorated an as-yet-unidentified chapel—perhaps devoted to Mary—within a Spanish cathedral. According to Luke (2:22–39), Mary and Joseph brought Jesus to the High Temple of Jerusalem to be "consecrated by the Lord," in accordance with Mosaic law requiring children to be redeemed with the payment of five shekels. This practice coincided with the Jewish rite of Mary's purification, which Christian tradition associated with "Candlemas," or the Feast of the Purification, in which a pair of doves was sacrificed. Luke also mentions the prophetess Anna, who, together with Simeon (traditionally depicted as the high priest), recognized Jesus as the Messiah. The Presentation had a long visual tradition by the time Vigarny executed his example, which he handled with clarity, balance, and a sense of decorum as well as decoration.

Here Simeon, robed as high priest, stands at the door of his temple and hands the infant Jesus back to Mary, who proffers, in return, the requisite turtledoves, which she holds in a basket. The prophetess Anna clasps her hands in reverence as she acknowledges the Messiah. Mary, richly dressed in an ornately patterned robe of blue and gold, gazes calmly at her child. Her right hand holds the stump of what is probably a candle, an allusion to the Feast of the Purification. Joseph, gray-bearded and balding, but still strong and manly, escorts his family. The hand that once held his staff is missing, and only the base of the staff itself remains. A young attendant (not a typical presence in this scene) stares mutely out at us. The entire proceeding takes place within an arcaded temple, whose marble walls and pillars are lovingly described, and whose bowed arches are a tribute to the artist's knowledge of Renaissance architecture. The windows are covered with gold leaf, articulated with a vine-pattern design, simulating the effect of light passing through stained glass. The whole represents a marvelous blend of sculpture, painting, and decoration, and its effect, despite its origins in an Italian style, is wholly and beautifully Spanish. It is testimony to Vigarny's abilities that he could adapt his French origins and Italian training to suit his Spanish patrons, with results so reflective of his adopted country. The IU Art Museum is fortunate indeed to have these rare examples of Spanish art in its collection.

Notes
1. Exactly which Italian Renaissance models were available to Vigarny remains an open question, but in the decades of his training many kinds of "portable" Florentine works—eg., Della Robbia ceramics, prints, as well as drawings and some paintings—not to mention Italian artists, could have made their way into Dijon. Certainly, the next generation saw Francis I inviting a host of Italian Mannerist masters, including Leonardo, Primaticcio, and others, to his court.
2. J. J. Martin Gonzáles, "Sculpture in Castille," in *Circa 1492: Art in the Age of Exploration* (Washington, D.C.: National Gallery of Art; New Haven: Yale University Press, 1991), 53, and "The Spain of Ferdinand and Isabella," figs. 1, 2 (for Granada Cathedral images).

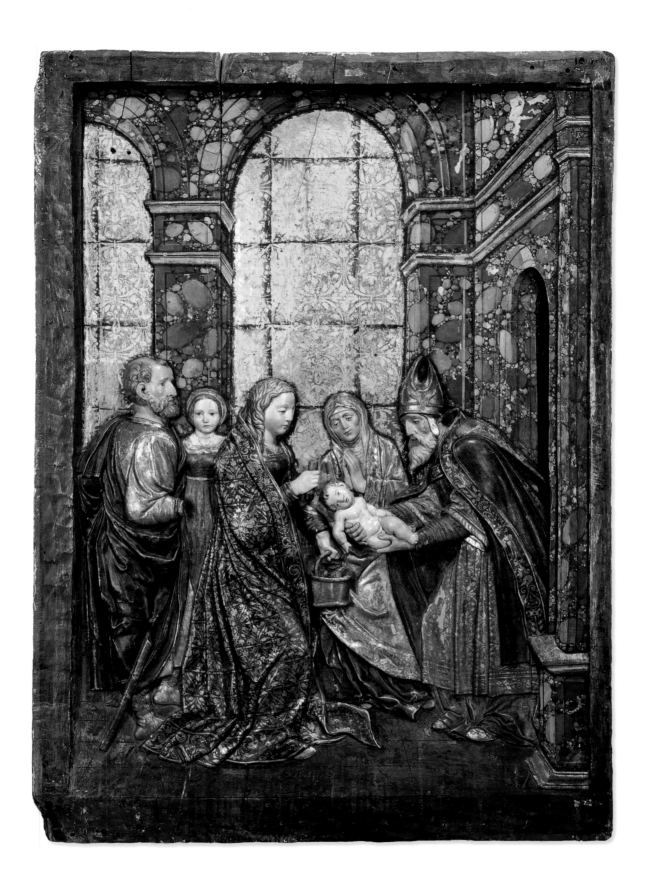

1.

2.

Felipe Vigarny
Burgundian, active Spain, ca. 1475–1542

Life of the Virgin cycle
Polychromed relief: tempera and gold leaf on wood
48 x 30 in. (121.9 x 76.1 cm)
William Lowe Bryan Memorial

1. *The Birth of the Virgin* [65.46]

2. *The Marriage of the Virgin* [65.47]

3. *The Annunciation* [65.112]

4. *The Visitation* [65.48]

5. *The Nativity* [65.113]

6. *The Adoration of the Magi* [65.49]

7. *The Flight into Egypt* [65.51]

3.

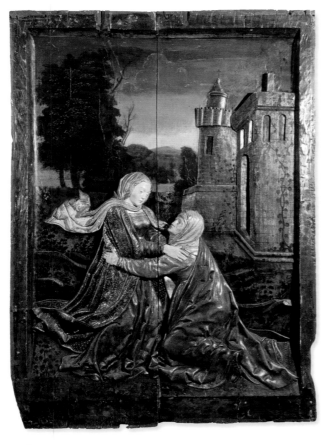

4.

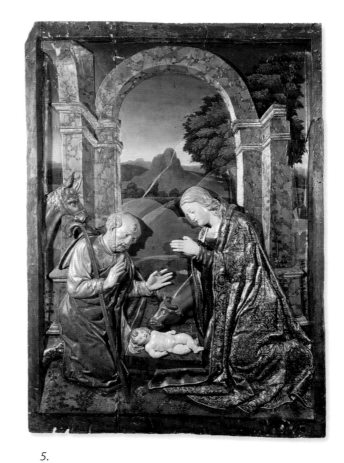

5.

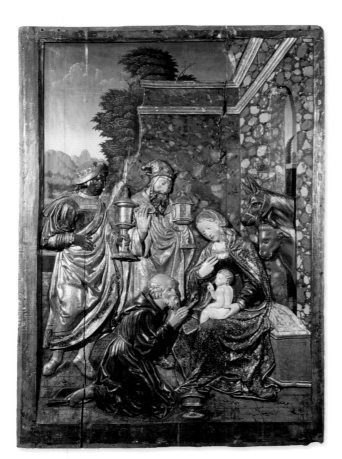

6.

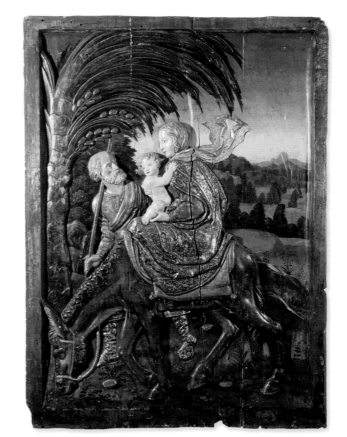

7.

Leone Leoni
Italian, 1509–1590

Charles V, ca. 1550
Bronze, gilding
H. 8 3/8 in. (21.3 cm); with base, 13 3/8 in. (34.0 cm)
70.47

Wearing a crown of laurel, the Emperor Charles V is immortalized in a small-scale bronze by one of Renaissance Italy's foremost sculptors, Leone Leoni, a gifted (though not quite as famous) rival to Benvenuto Cellini (1500–1571). Leoni's life, like Cellini's, is the stuff of novels. Trained as a goldsmith, Leoni was active in Venice around 1533, working for the celebrated humanist Pietro Aretino (a distant relative). Although the Ferrara mint, where Leoni had worked earlier, expelled him on a charge of counterfeiting, by 1537 he was working in the papal mint in Rome. There, in 1540, Leone stabbed a jeweler and received a sentence of the loss of his right hand, later commuted to slavery in a papal galley. Thanks to Admiral Andrea Doria in Genoa, Leone was liberated in 1541. Through Doria, Leoni entered the imperial mint of Milan in 1542, where he came to the attention of Charles V.

Holy Roman Emperor Charles V (1500–1558) ruled nearly all of Western Europe. With a principal court in Brussels, Charles claimed thrones in Milan, Madrid, and Naples, and he dominated Germany. Charles's extensive patronage included Titian in Venice as well Leoni in Milan. Initially Charles V commissioned medals of his wife, Isabella of Portugal (ca. 1545, Vienna, Kunsthistorisches Museum). In 1549 Leoni had an audience with Charles V in Brussels that resulted in commissions for portrait busts and statues of Charles V and his court, the most noted of which is the grand-scale *Charles V and Fury Restrained* (1549–55, Madrid, Prado). Orders also arrived from the emperor's sister Mary of Hungary, as well as from his son Philip II, for medals, portrait busts, and statues (large and small) of members of the imperial family. Chief among Leoni's later commissions were gilded bronze tomb sculptures of Philip II and his wives and a companion piece of Charles V and members of his family for the basilica of the Escorial, which Leone Leoni executed with his son Pompeo.

Our portrait bust has rightfully been called the most exquisite bronze portrait of its epoch, combining deep feeling with a jeweler's finesse.[1] Charles is presented as a modern-day emperor, consciously emulating ancient Roman rulers (such as Septimius Severus; see p. 106). Charles's portrait presents a similar demeanor—serious, yet energetic and commanding—and his head bears the ancient crown of laurel leaves awarded to victors in battle (likely an allusion to Charles's recent victory over Protestants at Mühlberg) rather than the contemporary imperial crown of the Holy Roman Empire. Underneath his "Roman cloak" Charles wears the armor that signifies his military accomplishments, a standard accoutrement for

his portraiture. Around his neck hangs the Order of the Golden Fleece, established by Charles's ancestor, Philip the Good, in 1430. Limited to thirty nobles distinguished for their continuation of the chivalric tradition, the order was disbanded at the death of Charles the Bold in 1477, then revived by Charles V's father, Maximilian.

Leoni's bust of Charles V depicts him as aging but still vigorous, with close-cropped hair and beard and a high-buttoned shirt beneath his armor. Although many paintings of Charles have survived, sculpture is scarcer, and bronze sculpture even more so. In addition to its medium, the small scale and refined execution of this bust distinguish it from other portraits of Charles. It reveals an intimacy rarely seen in Leoni's work, a struggle "between private feelings and public duty."[2] Slightly more than eight inches in height (without the base) the bust is clearly meant as a private possession, perfect for the Renaissance *studiolo* (study) which was then fashionable.

Who was the intended recipient of such an object, precious not only by virtue of its artistic mastery but also for the supreme political power it embodied? Leoni likely made it as a special gift for Charles on the occasion of their meeting in Brussels. It was not uncommon for artists to present gifts to patrons as tokens of good will and demonstrations of their talents, and Leoni would have been inspired to outdo himself for the Emperor. He succeeded. This bust is considered the first miniature portrait bronze of the Italian Renaissance.[3] It is certainly possible that Charles or members of his family ordered such miniature portraits, more costly than medals, less difficult to transport and replicate than large busts, for family members and diplomatic gifts. Since no documents enlighten us on this point, the original purpose remains unresolved. However its absolutely pristine condition (rare for an object that has survived for more than 450 years) demonstrates that the hands through which it passed all treated it with the care it deserved.

Notes
1. See Ralph T. Coe, "Leone Leoni's Miniature Bronze Portrait of Charles V: A Study of the Sixteenth-Century Heraldic Bust," *Indiana University Art Museum Bulletin* (Fall 1977): 36 ff.
2. Dorothy G. McGuigan, *The Hapsburgs* (New York: Doubleday, 1966), 70 (paraphrased in Coe, op. cit.)
3. Coe, op. cit., 43.

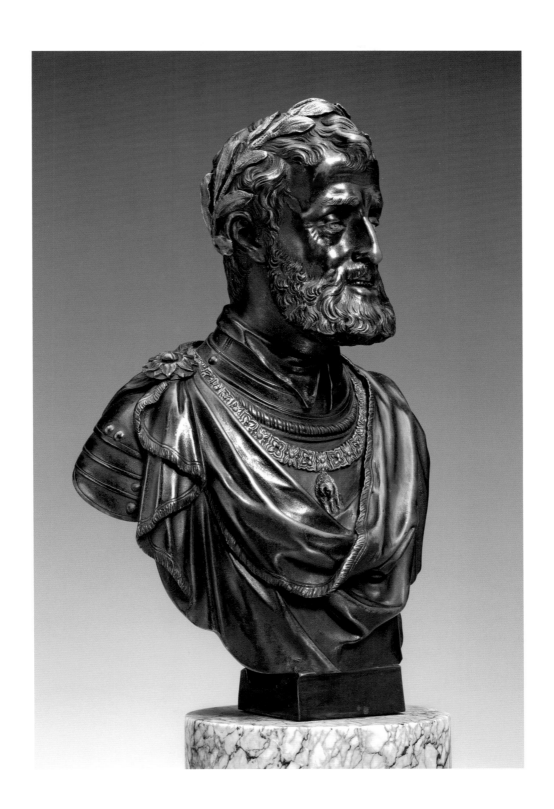

Antiveduto Gramatica
Italian, 1571–1626

Judith and Holofernes, ca. 1625
Oil on canvas
30 ⅝ x 35 in. (77.8 x 88.9 cm)
Museum purchase with funds from Robert and Sara LeBien, the Elisabeth P. Myers Art Acquisition Fund, and
the Estate of Herman B Wells via the Joseph Granville and Anna Bernice Wells Memorial Fund, 2003.148

This charming nocturne featuring the story of Judith and Holofernes is the creation of Antiveduto Gramatica, an important artist active in Rome during the first decades of the seventeenth century. According to Gramatica's contemporary, biographer Giovanni Baglione, Antiveduto's father had a premonition that his son would be born before his parents could reach Rome (from Siena), hence his unusual first name ("foreseen"). Trained in Rome, Antiveduto was prolific and precocious, producing small-scale religious subjects and portraits on copper. By 1593 he was a member of the Accademia di S. Luca, and in 1604 he joined the Congregazione dei Virtuosi. When Caravaggio arrived in Rome in 1592, he worked for some time in Gramatica's studio. Gramatica's patrons included Cardinal Alessandro Peretti, Cardinal dal Monte and Marchese Giustiniani. Sometime before 1620, Gramatica produced what is still considered his best-known work: *The Dream of St. Romauld* (Frascati, Eremo dei Camoldi). In 1624 Gramatica served briefly as *principe* of the Accademia di S. Luca, only to be dismissed for attempting to replace Raphael's painting of St. Luke with his own copy. Although most of his career was spent in Rome, we also know that he worked for Ferdinando Gonzaga of Mantua and was active in Turin and Naples.[1]

Although he was Caravaggio's teacher and elder, Gramatica is grouped among those who responded to Caravaggio's revolutionary and dramatic lighting. Nonetheless, Gramatica's style is independent, combining an eye for realism with a taste for idealism and delicate perfection, which ranks his paintings among the most appealing survivors of the early seventeenth century.[2]

Our painting portrays Judith, the heroine from the apocryphal Old Testament who emerged as a popular subject for Renaissance artists and patrons and remained so until the nineteenth century. Matteo di Giovanni's Judith is a fine fifteenth-century example of this subject, showing the heroine standing thoughtfully after completing the grisly act of beheading Holofernes (p. 234). Such meditative interpretations were supplanted in the seventeenth century by scenes of brutal violence. By 1598 Caravaggio had created his bloody and shocking scene of Judith in the act of loping off Holofernes' head, and slightly more than a decade later Artemisia Gentileschi followed suit with her version of the violent decapitation (both: Naples, Museo Nazionale Capodimonte). These large-scale, close-up views of beheading are extremely bloody, in sharp contrast to Gramatica's gentle interpretation.

True to the spirit of his era, Gramatica interpreted the story as a scene of action, but the violence is thoroughly muted, and the effect is both enchanting and decorative, with plenty of details to enrich our understanding of the story. The painting retains the nocturnal setting of Holofernes' seduction: a sliver of moon hangs in the sky, illuminating the tents of Holofernes' military encampment, while a large candle supplies light from within. Just inside the tent, Judith and her maidservant are departing with Holofernes' head secured within the servant's robes. Holofernes' decapitated body lies nude upon his bed in the background, the tent's folds discretely obscuring most of the gore. His armor, helmet, and scabbard lie strewn about the tent's floor, as Judith and her maidservant make their getaway. Young, beautiful, and innocent, this gentle Judith seems hardly capable of beheading a man, despite the sword—the instrument of murder—held in her right hand. Her attitude, dress, and demeanor are modest and mild and give no hint at what has transpired. Her beautiful blue gown is unstained, and her neatly coiffed hair remains remarkably unruffled by the violent act of butchery that she has just committed. Judith and her maidservant exit the tent in companionable conversation, like a pair of casual visitors instead of stealthy interlopers who have just murdered the general of an invading army. Gramatica's careful composition positions the tent to shield Judith from the army's view, while offering us, the onlookers, good vantage of the heroic act that saved her people.

Both the size and the subject matter of this work tell us that it was meant for private enjoyment and joined the personal collection of a Roman patron, most likely from the papal court. These collectors evidently preferred decorum to violence and admired the delicacy and intimacy of Gramatica's paintings.

Notes
1. Giovanni Baglione, *Le Vite de' pittora, scultori et architetti,* ed. Valerio Mariani (Rome: Calzone, 1935), 292–94.
2. Helmut Philipp Riedl, *Antiveduto della Grammatica (1570/71–1626): Leben und Werk* (Munich: Deutsche-Kunstverlag, 1998).

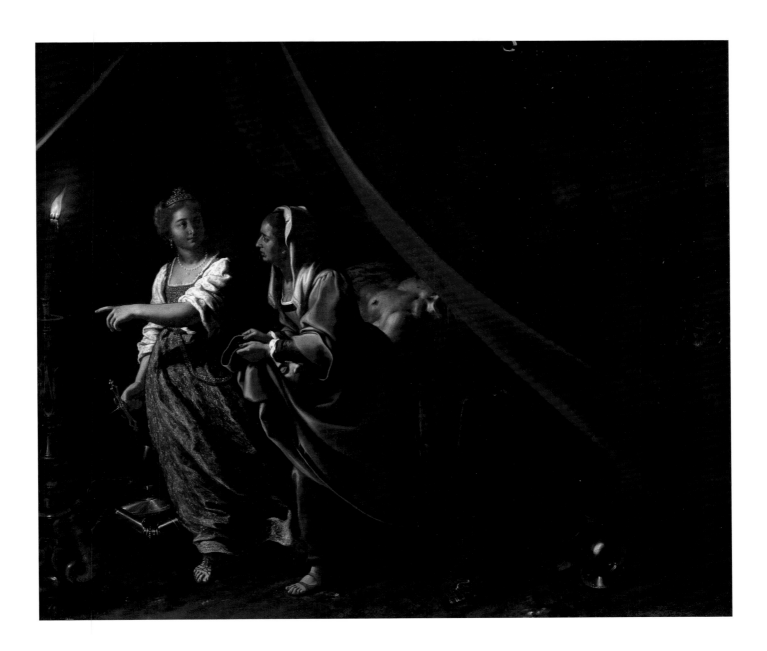

Bernardo Strozzi
Italian, 1581–1644

St. Dorothy, ca. 1615–20
Oil on canvas
56 1/2 x 35 1/8 in. (143.5 x 90.0 cm)
80.12

Set against a dark background, a monumental figure confronts us, her boldly defined form coupled with a preternatural delicacy of expression. This is an autograph work by Bernardo Strozzi, one of the greatest painters of his era, whose impact on Genoese and Venetian painting lasted into the eighteenth century.

Trained in Genoa between 1595 and 1597, Strozzi entered the Capuchin order, but he left the monastery in 1610 to care for his ailing mother. After her death, he joined another religious order, the Lateran Canons Regular, and in 1630 he traveled to Venice, where he became a monsignor. Called *il prete Genovese* (the Genoese priest), this cleric/painter became an influential master in Venice, receiving many official commissions for portraits and sacred subjects. Today Strozzi is most valued for his multifaceted artistic production, which includes monumental single figures such as ours, portraits, diverse religious subjects, and allegories, as well as unusual and important experiments in genre subjects. Unrivaled for his mastery of his medium, Strozzi at his best could make paint flow and ripple like water, reflect the delicacy of mist, or capture the tactility of flesh and fabric. His unusual blend of artistic traditions—Flemish, Italian mannerist, and Caravaggist—produced some of the most beautiful and brilliantly painted works of the seventeenth century.

Because of the presence of the child holding flowers, we can identify our subject as St. Dorothy, about whom few facts are known. Said to have been martyred in the fourth century in Caesarea, an ancient city in Asia Minor, St. Dorothy (identified by some as the daughter of a senator) was condemned to death by the Roman governor Fabricius around AD 303 for refusing to recant her Christian faith. She rejected a marriage offer, abstained from sacrificing to the gods, and was punished by torture—to no effect. Finally, her beheading was ordered, and she serenely explained to the watching crowd that she looked forward to deserting this cold world for a place without winter. A scribe, Theophilus, mockingly requested a basket of roses and apples from Paradise, and Dorothy promised this gift. The next winter, an angel, disguised as a boy, visited Theophilus and fulfilled Dorothy's promise of flowers and apples. Theophilus was himself converted and subsequently martyred. Dorothy's relics were preserved in the Roman church of St. Dorothy, while her cult flourished in Italy and northern Europe. She is the patron saint of gardeners, brewers, and newlyweds.

Often shown with fruits or flowers, here Dorothy embraces the young angel who will deliver the miraculous gift to Theophilus. Dorothy's beautiful face and her subtle expression, a combination of wistful melancholy and thoughtful determination, demonstrate Strozzi's distinctive contributions to the theme of martyred saints. The image resonates with references to past and future: Dorothy's youthful appearance, the matyr's palm she holds, and her sorrowful face reflect her earthly sufferings. The child-like angel holding the flower suggests St. Dorothy's arrival in Paradise and reminds us of the promise she made to Theophilus.

One prominent Strozzi scholar, Louisa Mortari, believes that our painting is one of Strozzi's earliest experiments with single figures of female saints that first developed his reputation, dating before 1620.[1] Mortari's suggestion places our work within Strozzi's years in Genoa, sometime after he left the Capuchin order in 1610. Genoa, a port city, was a rich republic dominated by aristocratic mercantile families, with the Balbi, Brignole, Doria, Durazzo, and Imperiali among the notable names. These families—together with religious orders including the Capuchins and the Franciscans, as well as the churches in the area—would have commissioned or purchased sacred images such as our St. Dorothy. Such subjects were equally popular among the clergy residing in convents, or for the private collections amassed in Genoese palaces. Based on St. Dorothy's role as patron saint, our painting might have been commissioned for a newly wed Genoese couple, or for a brewer or gardening family. Interestingly, unlike other subjects—including multiple versions of St. Francis and St. Catherine of Alexandria—only two examples of St. Dorothy by Strozzi survive: our painting and a much later scene of Dorothy's martyrdom executed for a Venetian church, which subsequently found its way to the collection of Walter Chrysler in New York.[2]

Further Reading
Gealt, Adelheid M. *Painters of the Golden Age*. Westport, Conn.: Greenwood Press, 1993
Haskell, Francis. *Patrons and Painters: A Study in the Relations between Italian Art and Society in the Age of the Baroque*. New Haven: Yale University Press, 1980

Notes
1. See Louisa Mortari, *Bernardo Strozzi* (Rome: De Luca, 1966), pl. 98. In the revised edition (Rome: De Luca, 1995), see no. 124.
2. See Mortari, op. cit., plate 401.

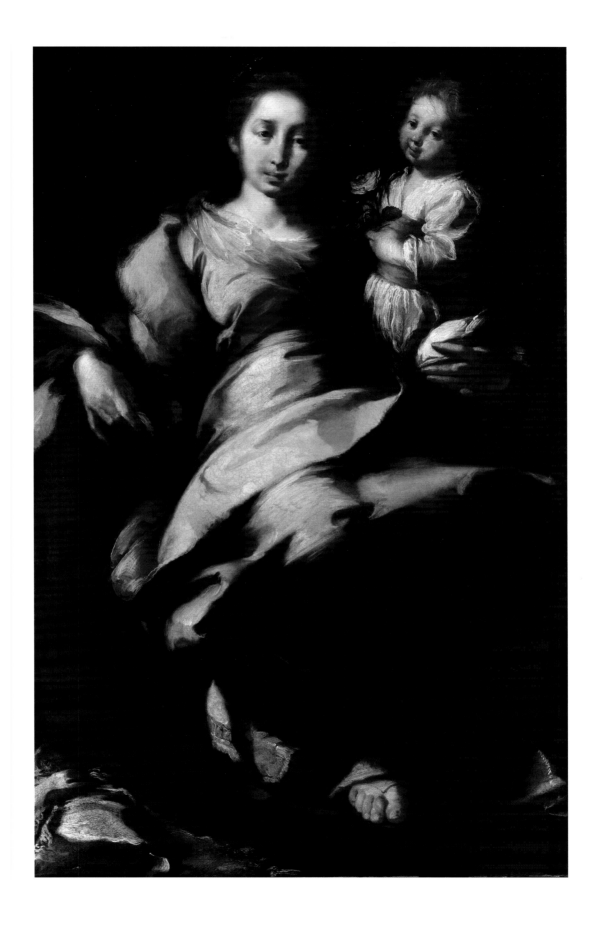

Jacopo Palma, called "Il Giovane"
Venetian, 1548–1628

St. John the Baptist Preaching, ca. 1620
Oil on canvas
63 ³/₄ x 94 ¹/₂ in. (162.1 x 238.8 cm)
Gift of Dr. and Mrs. Henry R. Hope, 64.129

Obscured by shadows, an intense St. John the Baptist delivers an inspiring sermon in this superb sacred narrative by Jacopo Palma, one of the luminaries of the last generation of Venetian sixteenth-century painters.[1] Called "Il Giovane" to distinguish him from his illustrious uncle, Palma "Il Vecchio" (ca. 1480–1528), young Palma worked in Titian's studio and was sent to Rome in 1567 under the sponsorship of Guidobaldo delle Rovere, Duke of Urbino. Back in Venice by 1570, Palma was honored with the task of finishing Titian's *Pietà* (Venice, Accademia), begun in 1573 and incomplete at the master's death in 1576. Palma Giovane's career spanned more than sixty prolific years, ending only with his death in 1628. More than two hundred of Palma's paintings survive in Venetian churches, and over one thousand graphic works (mostly drawings) are also preserved. Ours is the only known example of *St. John the Baptist Preaching* from Palma's hand to survive.

John the Baptist, "the desert saint," preached of Christ's coming and baptized him in the River Jordan. All church baptisteries were dedicated to John and were decorated with stories of his life. Independent paintings of Christ being baptized have a long history, while scenes of John the Baptist preaching, though less common, grew popular in the seventeenth century.[2]

Palma's painting is an early experiment with an independent easel picture depicting the subject, and it handles the theme brilliantly. Although deep in shadows and far to the right of the canvas, St. John dominates the scene. Easily recognized by his gaunt body, hair shirt, and attribute cross, John "enlightens" his audience—who are, appropriately, bathed in light. He preaches while seated instead of in his more customary standing pose. His outstretched hand and leg catch the light, guiding us toward the assembled audience, including the elder Pharisees and Sadducees whom Matthew (3:1–7) specifically mentioned in his account of the scene.

The gesture of the woman in the center of the composition, who gazes intently at John, and the twisting posture of the figure in the foreground draw our eyes toward a woman, a young man, and two young boys—clearly portraits of the picture's donors. Nearby, an older man gazes intently at us: this is Palma il Giovane himself, now an aging master, probably in his early seventies. The likenesses are masterpieces of portraiture, particularly the two enchanting boys at the far left. As they embrace, one peers warily out at the viewer, offering a youthful contrast to Palma's aged visage.

Still at the height of his artistry, Palma painted this work with verve and mastery. Broad and energetic brush marks define the edges of drapery, organize groupings, and lay down areas of color. Arms and legs, hands and feet are arranged so that they create visual alignments and parallels that play across the picture surface, while heads are grouped in twos or threes and likewise create interesting visual points and counterpoints within the image.

Beyond the certainties of subject and authorship (further confirmed by the presence of a signature "Pa(l)ma" in the lower right of the painting), this painting presents numerous questions regarding date, patron, and original location. Its great size and sacred subject suggest a still-unidentified Venetian church, confraternity, or charitable hospice. Appropriate to the sacred context of this picture, the female donor in our painting is attired in the customary veil worn by women when in church. Two Venetian churches, San Zacharia (dedicated to John the Baptist's father) and San Giovanni Decollato (St. John Beheaded), had interest in John the Baptist, but their decorations, like those of most Venetian churches, have been altered over the centuries. Other likely locations have disappeared: the church and hospital of San Giovanni Battista on Murano was destroyed in 1833, while San Giovanni Battista, once in the Campo Barbaro in the Giudecca, is also gone.

Dating remains speculative, but a comparable work by Palma, *St. Peter Sends St. Mark to Preach the Gospels in Aquileia,* dated 1625 and now in the Venetian church of San Polo, has similar use of light and dark, of landscape, and of the arrangement of forms. A date around 1620 makes sense for our painting, given the aging face that glances out so steadily from it. Painted in the final decade of Palma's life, it demonstrates that his powers remained undiminished.

Notes
1. For monographs on Palma, see Nicola Ivanoff and Pietro Zampetti, *Giacomo Negretti, detto Palma il Giovane* (Bergamo: Poligrafiche Bolis, 1980); and Stefania Mason Rinaldi, *Palma il Giovane, 1548–1628: disegni e dipinti* (Milan: Electa, 1990). 2. See Stefano Zuffi, *Gospel Figures in Art* (Los Angeles: The J. Paul Gety Museum, 2003); my own unpublished iconographic index reveals a number of seventeenth-century examples of the subject, including works by Mola (Museé du Louvre, Paris) and Stanzione (Museo Nacional del Prado, Madrid).

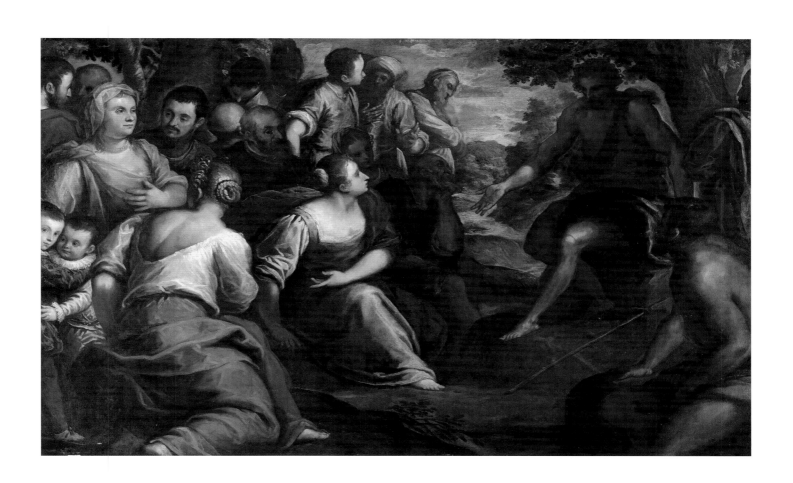

Luca Giordano
Italian, 1634–1705

The Flight into Egypt
Oil on canvas
61⁷⁄₈ x 90³⁄₄ in. (157.2 x 230.5 cm)
Gift of Nicholas Acquavella, 75.123

Luca Giordano was a celebrated and prolific Neapolitan artist of the seventeenth century, whose immense oeuvre—including church decorations, palace murals, canvases (both sacred and secular), and numerous oil sketches—is preserved in many major European and American collections. His ebullient and decorative manner gained him international fame, while his working speed earned him the nickname "Luca fa Presto." Contemporary reports suggest that his large studio produced nearly five thousand paintings in addition to his many mural cycles.

Active in Florence, Venice, and Rome, as well as his native Naples, Luca Giordano studied first with his father, Andrea Giordano, a minor Neapolitan painter. Luca likely studied with Jusepe de Ribera and Aniello Falcone before joining the Naples painters' guild in 1665. Widely admired, Giordano received patronage from Charles II of Spain, who made him his court painter in 1692. Ten years later, in Rome, Pope Clement XI received Giordano with honors. Capable of working in more than one style to accommodate his various commissions, Luca developed a heroic manner perfectly suited to the large-scale "history" paintings that he often produced. His *Flight into Egypt* is an excellent example of his work in this epic genre.

Luca took the popular theme of the Flight into Egypt in new directions. Only briefly mentioned in the Bible, depictions of the Flight generally were confined to two scenes: most traditional was the Holy Family and the donkey on their journey; scenes of the Holy Family resting, generally under a palm tree, or perhaps among ruins, also appear. Luca considered a more unusual aspect of the Holy Family's journey, showing them entering a boat and preparing to cross a river (or lake). A muscular boatman—a Christian reincarnation of Charon, who ferried the souls of the dead in Greek myth—helps remind the viewers of the future death of Jesus, who, according to Christian belief, through his sacrifice, saved the souls of all Christians. As angels hover around Joseph and Mary (who holds Jesus close to her breast), the family prepares to join the donkey already in the boat, as they continue on their long journey to Egypt.

With its dramatic, ominous sky giving way to a deep glow in the distance (something of a trademark in the artist's work), this masterful painting is a wonderful example of Luca Giordano's bold and haunting style. Set in a frieze-like composition, the monumental figure and the balanced, classical arrangement are thoroughly in keeping with the dignity of the subject, demonstrating perfectly Giordano's skills as a history painter in the grand manner.

Here he appears to have been challenging himself to maintain the coherence of his image, while giving each of the elements in his picture plenty of room to breathe. A subtle matrix of horizontals, verticals, and diagonals unifies the composition, while each figure is clearly readable. The play of gestures across the surface links each figure to the next: as the boatmen stabilize the craft, their strong arms lead us to the reaching seraphim, who reverently looks up at the Virgin. She, in turn, tenderly holds the baby Jesus, while resting her hand on Joseph's outstretched arm.

Just when the idea of showing the Holy Family crossing water originated remains a matter of speculation, although the earliest known engraving of the subject, dated 1582, by Jan Sadeler I after Martin de Vos, is—interestingly enough—from Holland, the land of canals and dikes. When and where Luca painted his masterpiece remain unknown, but it is tempting to propose that the picture might have been created around 1675, when Giordano was back in Venice adding scenes of the Life of the Virgin to the great church of Santa Maria della Salute. Certainly water and crossings in boats had particular meaning to a city built on marshland, dissected by canals, and navigated by gondolas. The moody landscape has elements of a Venetian sky, recalling those first explored by Titian a century earlier.

Finding inspiration in his reinterpretation of this classic New Testament story, Luca experimented with the subject a number of times. Out of his surviving oeuvre—more than five hundred paintings—at least four more Flights into Egypt feature the Holy Family entering or traveling in a boat.[1] None of the four repeat the same formula. Few achieve the dignity, majesty, and sheer scale of Giordano's Bloomington painting.

Note
1. Orreste Ferrari and Gisuppe Scavizzi, *Luca Giordano*, 3 vols. (Naples: Edizioni Scientifiche Italiane, 1966), fig. 257 (Washington, D.C.: Georgetown University); fig. 258 (Madrid, Coll. Santa Marca); fig. 417 (New York, Metropolitan Museum of Art); and fig. 612 (formerly Milan, Finarte). Ferrari and Scavizzi's work remains the standard sourcebook for Giordano.

Viviano Codazzi
Italian, 1604–1670

Rest on the Flight into Egypt
Oil on canvas
53³/₄ x 36¹/₂ in. (132.6 x 92.7 cm)
Gift of Mrs. Dale Cox in Memory of Forest Dale Cox, AB Economics, 1924 (born Bloomington),
and Arthur E. Middlehurst, BS Architecture, Cornell, 1919 (born Vincennes), 74.46

Amidst fragments of ancient Roman architecture, the Holy Family takes a momentary rest during their arduous journey into Egypt to escape the murderous wrath of Herod. This masterful creation comes from the hands of Viviano Codazzi, the foremost seventeenth-century specialist in architectural subjects, who inspired such eighteenth-century masters as Canaletto, Panini, and Piranesi.

Codazzi's career remains obscure. He probably trained in Rome, perhaps among the Dutch painters (Bamboccianti) active there, while he was certainly influenced by Agostino Tassi's *quadratura* wall and ceiling frescos, in which architectural or sculptural details are painted to give the illusion of reality. Active in Naples from 1634 to 1647, Codazzi supplied architectural backgrounds for other painters, including Massimo Stanzione and Micco Spadaro. Once back in Rome, he specialized in real and fantastic architectural subjects that appealed to leading Roman patrons such as Cardinal Bernardino Spada and Cardinal Flavio Chigi.

Our painting, with its dark brown and grey palette, is characteristic of Codazzi's Roman period, and thus it dates from sometime after 1647. Despite its biblical subject, the clear focus of his painting is a fantastic combination of architectural elements borrowed from a triumphal arch and the vaulted rooms of what may have been a basilica or a bath. Codazzi has animated the ruins with illumination, flooding the scene with strong light from the left and casting deep shadows on the right side of each form, thus throwing into sharp relief the edges of the broken columns and tumbling keystones.

In fact, light and shadow establish the sense that this ruin is collapsing before our eyes. A jumble of broken fluted columns in the shadows of the foreground guides us to the middle ground. At center stage in this masterful exercise in perspective, pairs of columns flank an arch; the columns display various degrees of destruction, with the leftmost column broken in half. The entablature has long since fallen down, attested to by the plants sprouting from the second column on the left. A fragment of the entablature remains above the columns at the right, but it is on the verge of destruction, the central keystone slipping out of alignment. Even the two intact columns are weakened, with chinks, like notches cut from timber, assuring their imminent collapse and rendering the Holy Family's temporary refuge more than a little precarious.

This variant of the Flight into Egypt, depicting the Holy Family resting among ancient ruins, is most likely Codazzi's invention. Certainly, ancient ruins were a fixture in Adoration of the Magi scenes, as our Master of the Holy Kinship exemplifies in the late fifteenth century (see p. 236). However, the Flight into Egypt generally focused on two typologies: the Holy Family en route with the donkey or resting under the palm tree (a reference to the apocryphal legend about the tree that bent down to supply them with food). Only one of the roughly thirty adventures experienced by the Holy Family in various apocryphal accounts specifies that they rested in a temple.[1] No prototype pre-dating Codazzi has yet been found.

For centuries, the ruined temple had a well-established meaning in the context of the Adoration, signifying the fall of the old pagan world and the rise of the new Christian civilization. Codazzi, who likely adapted this standard motif to the Flight into Egypt narrative, was working within a Roman cultural milieu that had long since developed a passionate interest in all things ancient and classical, inspiring the first of many waves of artistic "classicism." Everything—from subject matter, to style, to form—in the works of such celebrated masters as Nicholas Poussin (who spent his career in Rome) reflects this preoccupation with ancient times. It should also be remembered that Rome itself was littered with actual ruins, some of which were slowly being excavated.

Given this context, it is not surprising to find Codazzi "inverting" his approach to his story, enlarging and celebrating the pagan world and visually diminishing the Christian. His message is brilliantly mixed. Mary and Joseph appear tiny and vulnerable; the donkey, munching placidly on some grass, peers wistfully at them through the archway; while the strong, vivid, and pictorially dominant Roman architecture inevitably succumbs to destruction. This ancient world, ironically, is overpowered not only by time but by the Christian empire, dominated by the papacy, whose home in the Vatican established supremacy over Rome and whose administrators (including the client for this painting) eagerly acquired works of art celebrating ancient architecture, such as this one.

Further Reading
Marshall, David R. *Vivano and Niccolò Codazzi and the Baroque Architectural Fantasy.* Milan and Rome: Jandi Sapi, 1993.

Note
1. The subject has been little studied. The apocryphal books of James, the Infancy Gospels, and Arabic Gospels describe numerous adventures for the Holy Family during their sojourn into Egypt; the medieval sources—*The Golden Legend* and *The Meditations on the Life of Christ*—recount very few of these, and none describe the Holy Family resting among ruins. According to the Infancy Gospels, no. 22, the Holy Family stopped in the Temple of Sotinen and all of the idols crashed down—but Codazzi concentrates on architecture, which the Holy Family did not destroy. For the Flight's history, see Christopher Conrad, *Domenico Tiepolo, Die Flucht Nach Ägypten* (Stuttgart: Staatsgalerie, 2000); for the many episodes during the Flight, see Adelheid M. Gealt and George Knox, *Domenico Tiepolo, A New Testament* (Bloomington: Indiana University Press, 2006).

Luca Ferrari
Italian, 1605–1654

Venus Preventing Aeneas from Killing Helen of Troy
Oil on copper
10 ¹/₄ x 12 ³/₈ in. (26.0 x 31.4 cm)
Gift of Friends of Art, 66.77

An enraged hero is about to thrust a sword through the snowy breast of a hapless, though beautiful, maiden (Helen of Troy), only to be stopped by the equally beautiful goddess Venus. The dramatic moment is brought to life in this jewel-like miniature created by Luca Ferrari, active in Reggio Emilia, Modena, Carpi, Venice, and Padua. Luca is noted for his solid, crisply modeled figures, use of clear colors, and mastery of large, energetic compositions. Like other painters of his era, he favored images involving sensuous, yet doomed, heroines—such as Cleopatra or Lucretia—portrayed in mortal peril.

We know that Luca was familiar with mythological subjects derived from the *Iliad,* as he executed two *Iliad* scenes for the d'Este Villa Pisani. Luca also signed and dated frescoes based on the *Aeneid* (1650), relating the story of Antenore, the founder of Padua, for the Villa Selvatico-Emo Capodilista in Padua. At that time, he may have discovered the passage from the *Aeneid* that matches our image. It comes from Book II, which describes the awful events after the fall of Troy as told by Aeneas, the legendary founder of Rome:

> The graceless Helen in the porch I spied
> of Vesta's temple; there she lurk'd alone
> Muffled she sate, and, what she could, unknown:…
> Trembling with rage, the strumpet I regard,
> Resolv'd to give her guilt the due reward.
> 'Shall she triumphant sail before the wind,
> And leave in flames unhappy Troy behind?
>
> T''is true, a soldier can small honor gain
> And boast no conquest, from a woman slain:
> Yet shall the fact not pass without applause
> Of vengeance taken in so just a cause:
> The punish'd crime shall set my soul at ease,
>
> Murm'ring manes of my friends appease.
> Thus while I rave, a gleam of pleasing light
> Spread o'er the place; and, shining heav'nly bright
> My mother stood reveal'd before my sight
> Never so radiant did her eyes appear….
> She held my hand, the destin'd blow to break;
> Then her rosy lips began to speak:
> My son from whence this madness, this neglect
> Of my commands, and those whom I protect?
> Why this unmanly rage? Recall to mind
> Whom you forsake, what pledges leave behind…
> Not Helen's face, nor Paris, was in fault
> But by the gods was this destruction brought.[1]

The words resonate with our image. Grasping a sharp dagger, a young warrior (Aeneas), still armored from his battle with the conquering Greeks, prepares to stab Helen, whom Paris abducted, causing the Trojan War. Aeneas is stopped by Venus, his mother, whose soft grasp fends him off, the "destined blow to break." The words "Why this unmanly rage?" could be flowing from her lips. Venus appears to be wearing a laurel wreath, not commonly associated her but traditionally a crown of victory. The gods, as Venus says in the poem, were the only "victors" in the Trojan War, as they are, ultimately, the victors in all human affairs.

Young and beautiful, Helen wears a small crown, a reference to her marriage to Paris, prince of Troy. Certainly, as the *Aeneid* attests, she is a hapless victim here, incapable of defending herself. In the background, the flames of a burning Troy shoot into the sky over Aeneas's head. In Luca's hands, Helen has joined the ranks of the doomed heroines Lucretia and Cleopatra. But, unlike them, her life is spared—thus, the painting can be understood as a variant on Mars and Venus, wherein Love pacifies War. Here, maternal love pacifies vengeance.

In the absence of examples by other artists, for now Luca must be credited with being the first artist to paint this subject. This distinction may help explain the subject's popularity within Luca's oeuvre, as such a new invention must have been in considerable demand among his patrons. Ours is the smallest of four versions, likely a miniaturized version of a larger canvas now in the Art Gallery of South Australia in Adelaide. A third version, ascribed to a private Italian collection, suggests that this is *Nero Attempting to Kill Octavia, but Prevented by Poppea*.[2] A fourth version, not titled, exists in Chile.[3]

Notes
1. Virgil, *The Aeneid*, trans. John Dryden (1697; reprint, New York: Heritage Books, 1944), book II, lines 751–92.
2. See Adriano Cera, *La Pittura emiliana dell '600* (Milan: Longanesi, 1982), plate 12 under Luca Ferrari.
3. Museo de pintura de la Quinta Vergara, Quinta Vergara, Vino del Mar, Chile.

Abraham Bloemaert
Dutch, 1566–1651

Adoration of the Magi, 1624
Oil on canvas
72 ¹/₄ x 93 ¹/₄ in. (183.5 x 236.9 cm)
90.63

One of Christianity's most popular subjects—the visit of the three magi to the infant Christ child—has been transformed into a majestic history painting by the leading Dutch pre-Rembrandtist, Abraham Bloemaert. Influential as an artist as well as a teacher, Bloemaert initially trained with his father, Cornelis Bloemaert, then with other minor masters. From 1580 to 1583 Bloemaert was in Paris, absorbing French and Flemish art. By 1593 he had settled in Utrecht, the Catholic stronghold within Protestant Holland. Bloemaert became the city's leading teacher as well as the foremost Dutch Catholic artist of the century. In 1611 he was one of the founding members of the Utrecht Guild of St. Luke, and in 1618 he became its dean. Bloemaert's students included his four sons and many of the leading Utrecht Caravaggisti, including Hendrick ter Brugghen and Gerrit van Honthorst. Bloemaert's treatise *Fondamenten der Teeken-Konst* was used to train Dutch artists until the nineteenth century.

In 1624, the year our painting was produced, the artist was nearly sixty and at the height of his powers. He infused this venerable subject with monumentality as well as grace, individualizing his characters just enough to keep them from being stock types, but idealizing them sufficiently to endow them with the historic dignity that this revered subject required.

Bloemaert's interpretation of the subject forgoes the traditional attention to the magi's vast retinues and focuses on essentials, bringing us close to the action. Only a corner of the stable can be seen, as Mary dominates the left portion of the painting in queenly majesty, with Joseph hovering behind her. Grapevines, an allusion to the Eucharist, twine their way around the stable. The three magi fill the center of the canvas, leaving just a glimpse of their retinue. Much attention is lavished on their headgear: Melchior wears a broad-brimmed hat topped with a crown, while Balthasar, representing Africa, has a gorgeous turban adorned with jewels, and a proportionately smaller crown. Balthasar holds his myrrh in a *Buckelpokal,* a vessel featuring decorative bulges favored by silversmiths since the late Middle Ages. Behind him, holding his train, is another exotic figure, who may represent America.[1] The New World's placement as last in the hierarchy of world areas would be in keeping with seventeenth-century European views.

Holding the infant Jesus on her lap, a regal Madonna calmly observes her son receiving homage from Caspar, the oldest magus. He stretches his right hand toward the child and holds, in his left, a chalice full of gold coins. The chalice foretells the Eucharist, and it has been included in Adoration scenes since at least the sixteenth century.

Caspar's magnificent bishop's cope relates to a historic relic: the cope of David of Burgundy, bishop of Utrecht from 1456 to 1496, who gave the cope to St. Jans Cathedral in Utrecht. In fact, the cope

is the real "star" of the picture, suggesting its patron was a Utrecht Catholic. Bloemaert specialized in altarpieces for Catholics; some eighteen surviving works had this function. His patron would have appreciated the clear message regarding the allegiance of Utrecht and its bishop to the authority of the true Church (embodied here by Mary and Jesus). That theme doubtless resonated among Utrecht Catholics in post-Reformation Holland. A bishopric since the eighth century, Utrecht remained steadfastly Catholic despite the dominant Protestant, Calvinist faith.

A more famous version of our painting, minus the figures on the right, is signed, dated, and preserved in Utrecht.[2] Ours, with three figures added at the right, including the unusual exotic figure in the retinue and two more peasants, has been published as a studio copy, although its high quality is acknowledged, and some scholars identify ours as the first version.[3] The three additional figures may hint at the interests of the patron, or they may indicate that the Utrecht version has been cut down.[4]

The portrait within our painting—the man with the pointed beard—also raises questions. It has been suggested that he represents the donor of the painting. Given his presence in both versions, more probably he is the artist, but the issue remains unresolved.[5] What is undisputed is the very high quality of this painting, which offers a rare insight into Catholic patronage in Utrecht during the early decades of the seventeenth century.

Notes
1. Interestingly, the first American Indian known to be represented in European art, was included in an earlier Adoration of the Magi scene, attributed to the Portuguese master Vasco Fernandes (ca. 1475–1541/42) and now preserved in the Museo de Grão Vasco, Viseu (see Jay A. Levenson, ed., *Circa 1492: Art in the Age of Exploration* [Washington, D.C.: National Gallery of Art, 1991], no. 32). Indians of various kinds appear in sixteenth- and seventeenth-century European prints, drawings, and paintings, and their most common characteristic is a feathered headdress. Thus, the tawny skin, the exotic headdress, and the general features of this figure suggest that it is meant to represent a New World Indian. It should also be remembered that the Catholic Jesuits were among the early visitors to the New World, rendering the Indian of some significance to Catholic iconography.
2. Marcel Roethlisberger, *Abraham Bloemaert and His Sons: Paintings and Prints* (Doornspijk: Davaco, 1993), no. 545 (Utrecht, Centraal Museum).
3. See *Gods, Saints and Heroes, Dutch Painting in the Age of Rembrandt* (Washington, D.C.: National Gallery of Art, 1980), no. 6; and Roethlisberger, op. cit., no. 546.
4. There has been much discussion that the Utrecht picture is cut down, but Roethlisberger, op. cit., no. 545, disputes this. If he is correct, then this substantiates the notion that the patron of our version wanted a slight variation on the iconographic program, perhaps suggesting some connection (through trade?) with the New World.
5. Roethlisberger, op. cit., nos. 1, 2, illustrates engraved portraits of the fifty-year-old Bloemaert, but in his discussion of the Utrecht version, he refutes the identity of the face as that of Bloemaert.

Hendrick de Clerck
Flemish, 1570(?)–1630

The Finding of Moses, ca. 1629
Oil on panel
55 ¼ x 66 in. (140.3 x 167.6 cm)
Gift of Mr. Stanley S. Wulc, 66.24

This famous episode from the life of Moses was painted by one of the leading Flemish artists active before Rubens. Hendrick de Clerck spent most of his career as a court painter for the governors of the southern Netherlands. Appointed court painter in Brussels in 1594, he served Archduke Ernest from 1594 to 1596. Later, by arrangement with Emperor Rudolf II, he served Ernest's successors, Albert and Isabella. De Clerck's highly polished Mannerist style, with its elongated, graceful figures, was well suited to the courtly environs in which he worked. The majority of de Clerck's work remains in Belgium, making this example a welcome presence in North America, particularly for its important subject.

Moses' discovery in the bulrushes inaugurates the story of the life of the Old Testament lawgiver and leader. According to Exodus (2:1–10), Moses was born in Egypt during a time when the pharaoh, fearful of the Hebrews' proliferation, ordered the slaughter of all their male children. Rejecting such a fate for her three-month-old son, Moses' mother hid him in an ark made of bulrushes at the edge of the river and kept an eye on him. When the pharaoh's daughter and her maidens arrived at the river to bathe, they found the child. The pharaoh's daughter, though recognizing him as a Hebrew, decided to keep him, whereupon Moses' sister appeared and offered to find a nurse. That nurse was Moses' mother. Thus the two were reunited, and Moses was raised safe within the confines of the pharaoh's palace as the adopted son of the pharaoh's daughter.

Like other Old Testament stories, such as the Sacrifice of Isaac, the Finding of Moses was considered a prefiguration of New Testament events. When Herod sought to slay the new King of the Jews, he ordered all of the children of Bethlehem to be slaughtered, but the newborn Jesus and his parents fled to Egypt and safety. A popular seventeenth-century subject, depicted by notable painters including Nicholas Poussin (London, National Gallery), the Finding of Moses was appealing to courtly patrons, particularly in watery districts such as Venice and the Netherlands.

Rather than depict a single scene in the story, de Clerck presents "simultaneous narrative," an approach often used in the Middle Ages and the Renaissance. Far in the distance, at the right, Moses' mother can be seen placing her son in his little ark, while—still in the distance but somewhat closer to the main figures—the handmaidens of the pharaoh's daughter discover him among the bulrushes.

De Clerck chose to stress the opulent nature of the pharaoh's court. Directly before the viewer, the pharaoh's daughter, regal and commanding, sits as though enthroned at center stage, shielded from the sun by her gaily colored parasol. Richly adorned with ermine robe, gold crown, necklace, and matching bracelets, she wears an elaborately decorated antique fitted vest. (The prominence of the royal breasts underscores a key element of the story: that they will not nurse Moses, who is returned to his mother's bosom.) De Clerck depicts the pharaoh's daughter instructing Moses' mother and reminds us of her words in the Old Testament (Exodus 2:9): "Take this child away, and nurse it for me, and I will give thee thy wages." At the left, three of her handmaidens attend to her wishes, and to the right, Moses' sister and mother kneel in humility before the queen. However, de Clerck brilliantly underscored the importance of Moses' mother by giving her a yellow under-dress (similar to the pharaoh's daughter) and a bright red cloak, nearly the brightest color in the entire composition.

De Clerck's use of costume, ornament, and figure types is rooted in the Mannerist tradition of the sixteenth century. For example, the fitted girdle worn by the pharaoh's daughter, though based on antique models carried forward through the Italian Renaissance, is an adaptation of the kind of girdle shown in earlier Flemish paintings. The elongated handmaidens echo the Mannerist prints of Jaques Bellange, but all is stamped with de Clerck's own style.

The regal protagonist, combined with the picture's ornate appearance, as well as de Clerck's history of patronage, suggests the painting's origins within an as-yet unidentified Belgian royal palace, offering us a special glimpse into the courtly world of the Flemish late Renaissance by one of its presiding masters.

Jacob Backer
Dutch, 1608–1651

The Angel Appears to the Centurion Cornelius, ca. 1630
Oil on canvas
46 x 40 in. (117.5 x 101.6 cm)
Partial gift of Henry Radford Hope, 86.7

This portrayal of a rare subject from the Book of Acts is a youthful work by Jacob Backer, an important and successful Dutch portrait painter whose early history painting was deeply inspired by Rembrandt. Born in the port town of Harlingen, Backer first studied with Lambert Jacobsz. in Leeuwarden. Backer's early history paintings, including ours, suggest that he had close ties to Rembrandt's atelier in the early 1630s. A decade later, Backer established himself as a leading portrait painter in Amsterdam, and his reputation was such that when he died prematurely in his early forties, a commemorative medal was struck to honor him.[1]

Our painting is imbued with the flavor of Rembrandt's studio. The subject, an episode from the life of St. Peter, derives from the Book of Acts (10:1-4): There was in Caesarea, in ancient Palestine, a devout centurion who feared God, gave alms, and prayed regularly. He was visited by an angel, who instructed him to send for St. Peter. This the centurion did, and when they met, Peter recognized the faith of this devout gentile and baptized him into the Christian religion. Although a significant moment in the development of the Christian faith, the subject of this centurion (which parallels Christ's earlier meeting with a devout centurion) was infrequently portrayed. One suspects that Rembrandt (who explored New Testament subjects at this time, but as far as we know never examined this subject) probably inspired Backer to seek out this unusual episode from St. Peter's life.

Backer's Cornelius may have resonated with pious Dutch patrons, who, though largely Protestant, certainly read their Bibles and desired images that retold biblical stories in a manner that connected their present to this holy past. With limited visual currency, the story of Cornelius may have been viewed as untainted by Catholic dogma, and therefore it appealed to an Amsterdam client; conversely, its Petrine subject might have interested a Catholic, quietly practicing his faith within the Protestant city.

Backer adopted Rembrandt's realist manner to tell the story. The angel, despite the aura of light, manifests the fleshy solidity of a young Dutch apprentice, here dressed up in a white gown and golden shawl and given a pair of wings. We know that the Dutch preferred realistic, concrete descriptions of tangible objects, including still-lifes, landscapes, and architecture, and this preference influenced history painting. Hence, Backer's image of a divine presence remains rooted in the ordinary world, only slightly removed from its source: a model atop a stand in the studio. Like Rembrandt himself in the late 1620s

and early 1630s, Backer paid particular attention to accoutrements, in this case the golden shawl.

Backer elected to show the centurion kneeling before the angel (perhaps to stress his piety and possibly the "fear" which Acts says he experienced at this vision), a detail not present in the few other known examples of this subject.[2] As well, he is dressed, curiously enough, not as a Roman, but as person from the East, complete with turban and an embroidered jacket, upon which he wears a metal gorget signifying his military status. Although Backer, like most Dutch people, was well schooled in the Old and New Testaments and surely knew that his centurion was a Roman, he seems to have intentionally identified the centurion as a Jew and not a gentile, thus reversing the meaning of the story (in which Peter, a Jew, first embraces gentiles into the new religion). Or was Backer simply appropriating available props from Rembrandt's studio and using them to endow his centurion with an aura of exotic antiquity?

Regardless of why the centurion looks orientalized, this early masterpiece by Jacob Backer is a significant example of Rembrandt's impact upon young Amsterdam artists around 1630. Moreover, it forms an unusual link with the eighteenth century. Sometime after 1785, the noted Venetian draftsman Domenico Tiepolo retold the story of early Christianity in a series of more than three hundred large drawings. Domenico devoted three drawings to the story of Peter and the centurion, describing the angel appearing to Cornelius in a composition similar to Backer's. Perhaps it is only coincidence, perhaps not. Domenico had an interest in the school of Rembrandt, and Backer's work may, in some unknown way, have found its way into Domenico's path. Certainly the two artists shared an interest in this unusual biblical episode.[3]

Notes
1. Werner Sumowski, *Gemälde der Rembrandt-Schüler* (Landau: Edition PVA, 1983); and Adelheid M. Gealt, *Paintings of the Golden Age: A Biographical Dictionary of Seventeenth-Century European Painters* (Westport, Conn.: Greenwood Press, 1993), 15.
2. An engraving by Philip Galle after Johannes Stradanus from *Acta Apostolorum* (Antwerp, 1575) shows Cornelius seated as the angel arrives; Bernard Salomon in the *Biblia Sacra* of Lyons (1588) made a woodcut with this pose.
3. See Adelheid M. Gealt and George Knox, *Domenico Tiepolo, A New Testament* (Bloomington: Indiana University Press, 2006), nos. 243–47. Domenico's two scenes of Lamentation in this series are based on Rembrandt's *Descent from the Cross,* now London, National Gallery, which once belonged to Consul Smith in Venice.

Matthias Stomer
Dutch, ca. 1600–after 1652

The Mocking of Christ, ca. 1640
Oil on canvas
51 x 72^1/$_{16}$ in. (130 x 183 cm)
Evan F. Lilly Memorial Fund, Gift of Thomas T. Solley, 82.47

This *Mocking of Christ* by torchlight is a masterpiece of sacred narrative by one of Holland's most steadfast representatives of Caravaggism, Matthias Stomer. The best of the second generation of Caravaggio enthusiasts originating in the Catholic stronghold of Utrecht, Stomer followed in the footsteps of Dirck van Baburen, Hendrick ter Bruggen, and Gerrit van Honthorst. Likely born in Amersfoort, near Utrecht, Stomer was strongly influenced by Honthorst, who was active in Rome from circa 1610 before returning to Utrecht in 1620. Stomer likely came into contact with Honthorst's work at the latter's academy in that city.

By 1630 Stomer was in Rome, the wellspring of Caravaggio's influence. Three years later he moved to Naples, where he stayed until around 1640. Pushing ever southward, he went on to Sicily, where his only surviving signed and dated work, the *Miracle of Saint Isidorus Agricola,* was completed in 1641 for the church of the Agostiniani, in Caccamo. Between 1646 and 1649, Antonio Ruffo, Duke of Messina, acquired three of Stomer's pictures. By the 1650s, we surmise, Stomer had moved north, since an *Assumption of the Virgin and Three Saints* was painted in 1652 for S. Maria Assunta, in Bergamo. This is the last scrap of information about the artist that survives. Stomer was rediscovered in the twentieth century thanks largely to the noted scholar Benedict Nicolson.[1]

Adopting Caravaggio's dramatic lighting, Stomer painted with a crisp and proficient modeling. His format generally involved figures gathered around a central light source. Religious subjects predominate. These are the essentials of our painting, which conflates two episodes of Christ's Passion, his mocking and his later crowning with thorns. The story of Christ's mocking, which took place shortly after his arrest, derives from the Gospel accounts of Matthew (26:67), Mark (14:65), and Luke (22:63). His hands tied, Jesus was blindfolded, spat upon, struck with fists, and taunted. The crowning of thorns marked the last stages of his trial after his condemnation. As chronicled in Matthew (27: 27–31), Mark (15:16–20), and John (19:2–3), Jesus was given a scarlet mantle, and a plaited crown of thorns was placed upon his head. His tormentors beat him, then knelt in mock homage to him. Thereafter, he was shown to the populace (the Ecce Homo), taken away, and crucified.

Stomer staged the scene at night, the traditional timing of Christ's arrest in the Garden of Gethsemane. A youth blowing a horn into Jesus's ear represents a dimension of his initial torture that gained favor among artists during the late Middle Ages and the Renaissance, who showed drums, cymbals, and pipes blaring. Seventeenth-century Dutch painters, including Honthorst, introduced the hunting horn, suggesting that Jesus was a captive prey tortured by those who had hunted him. Christ's tormentors in Stomer's painting are not only the Roman soldiers who abused him after his condemnation and set the crown upon his head, but also the local populace, who, the Gospels tell us, initially taunted and mocked him after his arrest.

While stressing Christ's mocking, Stomer introduces the crown of thorns, which he shows on Christ's head, signifying that later stage of Christ's trial. In the foreground, dramatically silhouetted against the light, a bearded older man—baton in hand after beating Jesus—kneels in a parody of homage before Jesus as described in the Crowning. He is representative of the local populace who wished Jesus dead. In the background, a powerful soldier strips away Jesus's gown, revealing his nakedness, while also catching and surrounding Christ's figure in light and hinting at his burial cloth.

Honthorst's *Christ Crowned with Thorns* (ca. 1622), now in the Rijksmuseum in Amsterdam, served as Stomer's basic model, which he inventively adapted, adding a subtle interpretation all his own. The urchin blowing the hunting horn has become, in Stomer's hands, half-naked, uncouth, and very poor. By contrast, the older youth holding the torch (not found in Honthorst's version) is the boy's antithesis in every way. His rich and elegant blue costume lends a striking note of color to this monochromatic scene, while his refined appearance reflects a more delicate nature. The older boy's doubts about his actions are reflected in his anxious expression, which is tinged with compassion as well as sorrow. Although based on the featherbrained fop made famous by Caravaggio, in Stomer's interpretation the youth is transformed from a vapid sensualist into a character who exhibits conscience. As he prepares to doff his hat, his gesture of homage hints at greater sincerity than that of his companions, injecting a quality of vulnerable humanity into an otherwise cruel and inhuman episode.

Note
1. Benedict Nicholson, "Stomer Brought Up-to-Date," *Burlington Magazine* 119 (1977): 230–43; see also Nicholson, *The International Caravaggesque Movement: Lists of Pictures by Caravaggio and His Followers throughout Europe from 1590 to 1650* (Oxford: Phaidon, 1979).

Pieter de Ring
Dutch, ca. 1615–1660

Still-Life with Lobster, ca. 1650
Oil on canvas
35¼ x 45 in. (89.5 x 116.8 cm)
73.22

This gorgeous still-life, known as a *Pronk,* was painted by one of the great practitioners of the genre, Pieter de Ring. A pupil of the eminent still-life painter Jan Davidsz. de Heem (1606–1684), de Ring also specialized in still-lifes. While de Heem worked in Antwerp after 1640, de Ring may have trained with him while the former was active in Leiden from around 1626 to at least 1631. De Ring remained in Leiden, helping to found the St. Luke's guild there in 1648. He is mentioned again in guild records in 1649, but during the 1650s, his most productive decade, his name is absent. His death in the city in 1660 is documented in burial records and with a commemorative medal.

De Ring specialized in still lifes containing fruit, with the most lavish of them, the *Pronk,* including an abundant array of food and wine. Still-lifes emerged as independent images, often with moralizing overtones, in the sixteenth century.[1] By the early seventeenth century, independent still-lifes featuring fruits, vegetables, game, or flowers proliferated in Italy, Spain, and Flanders, while Holland invented the *ontbijte*—breakfast or "snack" pieces, depicting simple edibles, such as herring, bread, or cheese. The precursor to the *Pronk,* the *ontbijte* often depicted some luxury foods, notably olives or white bread, and sometimes included commonplace fare, including cheeses and rough brown bread. *Ontbijte* had complex associations, not only with the senses, but also with ideas of feasting versus fasting, admonishments regarding over-indulgence, or messages about moral choices and the brevity of life.

By the middle of the seventeenth century, Dutch burghers had accumulated new levels of wealth through banking, trade, and commerce, while still-lifes became more opulent in the hands of such pioneers as Jan Davidsz. de Heem. Inspired by Flemish traditions, de Heem evolved sumptuous arrangements of meats, fish, fruits, and drinks displayed on precious imported porcelain and glass. To what extent these luxurious still-lifes retained their mixed and moralizing message is unclear. Opinion is divided about how much meaning is imbedded: some suggest that grapes, wineglasses, and bread continue to evoke the Eucharist, while other elements, such as watches, suggest *Vanitas,* or intimations of mortality.[2] Others disagree, suggesting that such ideas were likely not the primary intention of the painter.[3]

What, then, are we to make of our masterpiece by Pieter de Ring? Certainly it speaks of abundance, with its massive bunches of green grapes, its juicy plums dangling from their stems, its ripe, sliced melon and pellucid cherries. Some of these fruits, such as the cherries and plums, were from orchards in the region and were relatively easy to obtain and afford, but the melons, oranges, and grapes were imported luxuries in mid seventeenth-century Leyden. What of the seafood? Oysters, lobsters, shrimp, and crab were cheap and abundant in de Ring's Holland—thus, these are not the delicacies they are for us today. As part of the banquet, they may have conveyed the idea of the freshness of all the food and the immediacy with which it must be eaten, reminding us that perfect ripeness quickly turns to rot, and that the moment must be seized.

The presence of white bread, grapes, and wine served in costly and beautifully wrought glass beakers may whisper of the Eucharist, but it speaks more loudly of luxury and wealth. Moreover, the ripened melon, with its open form, sitting just beside the oysters (famous as an aphrodisiac) expands the repertoire of subject matter to include sexuality, an aspect of life the Dutch often celebrated in their paintings. Absent from this assembly are the "leveling" foods—the cheeses, smoked herring and coarse breads—that were common fare for all the Dutch. Our picture is less egalitarian, directing itself to refinement and wealth, an aspect enhanced by the sumptuous cloths, the fine glassware, and the Chinese export (perhaps Ming) chafing dish.

An exotic element is introduced by the glint-eyed African Grey parrot that pecks at one of the cherries. Besides evoking foreign lands and exotic trade, this creature is the embodiment of the mimic—perhaps the artist's way of reminding viewers that everything they see so convincingly placed before them has been copied from nature. The artist is the ultimate mimic, who transforms what he sees into a visual and intellectual banquet, and who celebrates his presence within the painting by placing, as his signature, an allusion to his name: the ring, tucked behind the oranges at the left.

Further Reading
Gealt, Adelheid M. *Painters of the Golden Age.* Westport, Conn.: Greenwood Press, 1993.
Kinder, Terryl. "Pieter de Ring: A Still-Life Painter in Seventeenth-Century Holland." *Indiana University Art Museum Bulletin,* 1979.

Notes
1. Sybille Ebert-Schifferer, *Still-Life: A History* (New York: Abrams, 1999), cites, among other independent still-lifes, that by Barthel Bruyn the Elder, on the back of a portrait of a woman, now in Otterloo, Kröller-Müller Museum, 33–34.
2. See Ebert-Schifferer, op. cit., 154.
3. See Simon Schama, *The Embarrassment of Riches: An Interpretation of Dutch Culture in the Golden Age* (New York: Knopf, 1987), 162.

Gerard ter Borch
Dutch, 1617–1681

Portrait of a Lady, ca. 1655
Oil on canvas
11^1/$_2$ x 9^5/$_8$ in. (29.2 x 24.4 cm)
77.78

This candid likeness of a Dutch lady is by one of Holland's most gifted painters, Gerard ter Borch. Celebrated for his genre subjects, ter Borch is especially admired for his talent at rendering textures, most notably satin, in paint. As a portrait painter, ter Borch is justly famous for his brilliant interpretation of his sitters, whom he depicted with a blend of honesty and sympathy, endowing them with a vivacity and presence that belie the small scale of his canvases.

Born in Zwolle, the capital of Overijssel province along the Ijssel River, Gerard trained first with his father, Gerard ter Borch the Elder. Gerard then moved to Haarlem, studying with Pieter de Molijn before joining the Haarlem Guild in 1635. Later in 1635 Gerard went to London, where he absorbed the courtly portrait style of van Dyck, after which he traveled extensively. Ter Borch moved to Deventer in 1654, having married Geertruyt Matthys. After gaining citizenship in 1655, ter Borch rose through the social and political ranks to become a *gemeeensman,* or common councilor, in 1666.

An active and respected member of Deventer's conservative regent class, ter Borch became its recorder, producing some sixty surviving portraits of the city's social and political elite. His social stature and that of his clientele in Deventer seems to have inspired a subtle shift in ter Borch's portraits, rendering them more formal and austere, a demeanor enhanced by his sitters' propensity to dress in black.[1]

We have no date for our portrait, but the sitter's costume is typical of the fashion that developed in the 1650s and continued through the 1660s, as demonstrated by a ter Borch portrait dated 165[2] now in Madrid.[2] Given the date of her costume, we can conclude that our sitter was a member of Deventer society. Presented against a stark background, she wears a conservative black and white costume—appropriately austere, yet subtly sumptuous. The fitted black satin dress is embellished with elaborate and costly tucks and stitches, while the cuffs are made up of no less than four layers of white silk organza. Her collar is double: a gauzy capelet tied with four discreet bows overlays a shoulder-covering white collar. Tucked in her carefully dressed hair, adorning her throat and ears, and looped about her delicate arm are pearls, time-honored emblems of perfection and another subtle sign of wealth.

A notable accoutrement is her fan, a luxury item. Clasped between the ring-adorned thumb and forefinger of her right hand, the folded fan was a valued "gestural icon" associated with purity and cleanliness. The fan could hint at flirtation or signal anger, happiness, or a host of other meanings.[3] Of the eleven or so surviving portraits by ter Borch of women holding fans, most show the closed fan held in the right hand, as in our example.[4] However, singular within this group of ter Borch portraits is the directional gesture of our sitter's fan, pointing to the left. This gesture alone would suggest a pendant portrait to our lady's left—which is, indeed, the case.[5]

Our sitter's husband presently resides in the Indianapolis Museum of Art. We know nothing about either member of this married pair, apart from their obvious status as upper-class members of Deventer society in the late 1650s. The existence of a second pair of portraits suggests extended family—to whom the paintings were given.[6]

Imbedded within this pared-down presentation is a wealth of human characterization, which, above all else, renders this work a masterpiece. As our subject calmly (and perhaps with resignation) presents herself for scrutiny, she is certain that her toilette and demeanor are flawless. She expects that her face will be presented with no attempt at idealism or flattery. No cosmetics brighten her pale complexion, nor has the artist attempted to straighten her uneven nose. Her mouth, though closed, appears about to break into a smile, hinting not only at a warmth of character, but perhaps at one small vanity, an attempt to hide her uneven, and perhaps overlarge teeth. This human imperfection, this mixture of solemnity and mirth, these eyes which are steady, cautious, and careworn, present emotions marvelously contained, yet almost bursting forth. This woman is no mere stereotype: she reveals a complex humanity that is almost shocking, coming as it does within such a conservative, reserved context. This paradox renders ter Borch's portrait so compelling: only real genius can reveal so much and so little all at the same time.

Notes
1. James Laver, *Costume and Fashion, A Concise History,* 4th ed. (New York: Thames and Hudson, 2002), 108, notes that Holland's burgher population tended to assume the conservative black and white dress, the origins of which were, ironically, Spanish. Spain was of course the country from which Holland fought for its freedom for so long. Deventer evidently favored a particularly sober version of this conservative tradition—and ter Borch's portraits are distinctive for this quality, compared to those of his contemporaries working in other cities, such as van der Helst or Maes.
2. Arthur Wheelock, *Gerard ter Borch* (Washington, D. C. : National Gallery of Art, 2004), 58. The cartwheel of folded linen making up a collar that was popular in Holland during the first half of the century had died out by the 1640s, and by mid century we find the simpler arrangement of a white collar draped over the shoulders of a black dress.
3. David R. Smith, *Masks of Wedlock: Seventeenth-Century Dutch Marriage Portraiture* (Ann Arbor: UMI Research Press, 1982), 81 ff.
4. S. J. Gudlaugsson, *Geraerd ter Borch*, 2 vols. (The Hague: M. Nijhoff, 1959–60), pl. 159.
5. The convention of portrait pairs dates to the Renaissance, with such famous examples as Piero della Francesca's portrait of Federigo de Montefeltro and Battista Sforza, now Florence, Uffizi. The placement of the husband in the left panel goes back at least as far as 1506, with Raphael and his portraits of Agnolo Doni and Maddalena Strozzi Doni, now Florence, Pitti.
6. Gudlaugsson, op. cit., cat. 133, 134 (II).

Cornelis Bega
Dutch, 1631–1664

Tavern Scene, 1661
Oil on canvas
19 3/4 x 18 in. (50.2 x 45.7 cm)
73.13

In this gem of genre painting by the Haarlem master, Cornelis Bega, five peasants take their ease in a country tavern. One of the most important painters of rustic genre scenes, Bega came from a family of artists. His father, Pieter Jansz. Begijn (or Begga), was a goldsmith, and his grandfather, Cornelis Cornelisz. van Haarlem, was a painter. Reared and trained in Haarlem, Bega is considered Adriaen van Ostade's best pupil. At some point, Bega might have gone to Rome, but by 1654 he was registered in the Haarlem painter's guild and was active there for ten years until his premature death from the plague in 1664. He is buried in St. Bavo's church.[1]

Given his brief career, Bega's oeuvre is relatively small, but its high quality demonstrates his independent contributions to genre painting. Like van Ostade, Bega painted peasants eating, drinking, or amusing themselves in barnyards or country taverns. By the 1660s he was concentrating on tavern scenes, featuring the lower-class characters favored by van Ostade. But Bega's interpretation is less raucous than his master's; his figures are more solid and have greater specificity. Moreover, Bega's peasants are contemplative, and the whole presentation tends to be more evocative.

Painted at the height of his career, just three years before his death in 1664, our painting is a masterpiece of distilled form coupled with amplified content. The dark interior of Bega's tavern is described in a muted, monochromatic palette. In the murky light we can barely make out its dingy walls and humble furnishings. An empty barrel serves as a crude side table, home to a crumpled cloak and an incongruously luxurious blue, salt-glazed pitcher. In this demonstration of Bega's skill at still-life painting, objects lie strewn about, including a playing card—a remnant of a bygone game.

Four figures engage in amicable conversation. One holds a brazier, preparing to light his pipe. His voluble companion holds a tankard in one hand and a glass in the other, his contented expression reflecting the benefits of the drink he has already imbibed. Between them, a man leans in, eager to catch every word; another man with a pipe looks away. In a dark corner, a fifth man, his back turned to the viewer, relieves himself against the tavern's wall.

The casual assembly gradually reveals its rich messages. Faces and hands, carefully picked out with light, allude to the five senses. The beer and tobacco suggest taste, while the smoke and urine bespeak smell. The men's conversation evokes the sense of hearing. Many objects are handled. And, despite the dim light, seeing is emphasized by the gazes of the men as they interact with each other. Thus each of the five senses—taste, smell, hearing, touch, and sight—are acknowledged.

Bega also alludes to time in several ways. His characters represent diverse ages, with the central figure embodying youth and the man just behind him, old age. Moreover, actions are depicted at various stages of time: drinks already emptied, conversations underway, pipes about to be smoked suggest past, present, and future. All of this is presented within an unambiguous social milieu that nevertheless poses an ambivalent moral message.

Gambling, drinking, and smoking were longstanding taboos among the Dutch. Countless moralists denounced these vices and used sermons, pamphlets, prints, and paintings to preach against their evils. However, by the time Bega painted this subject, these social prohibitions had become more relaxed. In moderation, beer, for example, was a dietary staple considered to have beneficial properties, and local breweries were integral to the Dutch economy. Smoking, too, had gained fairly widespread acceptance by the 1660s and 1670s. In fact, as Simon Schama points out in his ground-breaking study of Dutch culture, tobacco was a thriving industry among the Dutch and was viewed as having beneficial relaxant and medicinal properties.[2]

Bega's peasants, then, may not be raucous ne'er-do-wells about to drink and smoke themselves into a stupor, but hard-working, sociable men, who have earned the right to relax and converse in the tavern, enjoying the benefits and pleasure of beer and tobacco. These poor peasants may represent the virtue of frugality (albeit enforced), and their convivial mood, the merits of companionship. But what are we to make of the ace of spades lying in the foreground? After all, gambling was a vice universally condemned. Bega's peasants ignore the card and do not appear to be gambling. Hence, Bega's message about his characters appears to be more accepting than judgmental, more positive than negative. Though his men are rustic, they are not uncouth; instead, they enjoy life's simple pleasures in a picture that is a delight itself.

Notes
1. Mary Ann Krisman-Scott, "Cornelis Bega (1631/2–1664): as Painter and Draughtsman" (PhD diss., University of Maryland, 1984).
2. See Simon Schama, *The Embarrassment of Riches: An Interpretation of Dutch Culture in the Golden Age* (New York: Knopf, 1987), 196 ff.

Juan Francisco Carrión
Spanish, 1626–1680

Vanitas, 1672
Oil on canvas
40 ³/₈ x 34 ¹/₈ in. (102.6 x 86.7 cm)
Gift of Henry D. and Sidney Hill, 59.46

This sober assembly of books and papers, arranged on shelves dominated by a skull and an hourglass, represents *Vanitas*—the transience (or vanity) of life—conveyed primarily through the symbolism of books. The only known signed and dated work by Juan Francisco Carrión, the painting documents the name of the artist, his Spanish origins (by inference from his Hispanic name), and his period of activity during the last quarter of the seventeenth century. Little else is known about this Carrión, who signed his masterpiece on the piece of paper found in the left-hand corner of the painting (*Carrión fecit* [Carrión made this]). We assume that he is identical with the author who signed the poem beneath the skull.[1]

Clearly a gifted painter, Carrión adopted the venerable convention of fictive bookshelves, which he applied to his *Vanitas* theme. The shelf-like arrangement and the skull have a long tradition stretching back to Roman paintings and reemerging in Christian art. *Vanitas* still-lifes, combining tangible reality with messages about mortality, grew immensely popular during the seventeenth century throughout Holland, Italy, and Spain.

Painted in 1672, our example builds on conventions established by such earlier masters as Juan de Zurbarán, Sánchez Cotán, and Juan van der Hamen. Carrión placed particular emphasis on writing in its many forms: documents (perhaps letters, treatises, and the like) are placed above twelve haphazardly arranged bound books—open and closed, spines visible or not. The handwritten poem, which practically dangles from the mouth of the skull just above it, compels our attention. Adapting the familiar "As I am so you shall be" message promulgated since the Middle Ages, Carrión delivers a powerful, if commonplace, truth:

> Oh You who look at me
> Look well and live well
> You know not how or when
> You will also look like me
> Look well and with attention
> At this portrait or figure
> All things end at the grave.
> —Juan fran Carrio f

While little is known about Carrión, much more is known about Francesco de Quevedo (1580–1645), whose work is central to our still-life. Quevedo was celebrated as one of the greatest writers in Spanish history, much admired for his versatility (he wrote satires, poetry, picaresque novels *[Buscón]*, and a number of religious tracts),

and his grasp of contemporary Spanish ideas ranked with Cervantes. Born eight years before the defeat of the Spanish Armada, Quevedo studied theology and traveled extensively in Italy (especially Naples, then a Spanish possession) as he observed his beloved Spain decline socially, politically, and economically. Alternately in and out of favor with Philip IV, Quevedo spent long stretches imprisoned in the Torre de Juan Abad. His religious tracts urged an authentic Christian life as an antidote to Spain's deterioration.

Quevedo's stoic Christian meditation on the inevitability of death, *La cuna y la sepultura (The Cradle and the Grave),* published in 1634, appears in our painting, as does his *Virtud Militante, contra las Quatro Pestes Del Mundo, Inuidia, Ingratitud, Soberbia, Avarizia,* published in 1634, here presented in a condensed reference: *Pestes de Quevedo (Plagues by Quevedo).*[2] *La Corte santa (The Holy Court),* by Nicolás Causino, published between 1670 and 1677 in a Spanish translation by Aragón, augments Carrion's message. Thus, the still-life rehearses a history of famous moral and religious tracts in Spain. As Carrión reinforced the onlooker's comprehension of death's imminence, he depicted written guides to a proper mode of life.

Carrión's poem stresses the primacy of sight, supreme among the five senses for writing, reading, painting, and seeing. Seeing ends with death, as the skull's empty eye sockets remind us. The painting celebrates the value of writing and reading as refuges from more "senseless" or profane pursuits. Writers and painters will, like all men, be stopped by death, but their work survives, granting them immortality—and, in this case, moral authority.

Carrión, both poet and painter in this complex performance, sets a sober, yet compelling tone, reflected within his choice of a dark, earth-toned palette and the stark alignment of forms. Despite his sobering reminder of death, Carrión disputes the commonplace theme of the vanity of writing. Using words and image, he presents the stages, states, and limits of that endeavor, but he suggests that the hand, guided by the eye and the mind, can, in fact, conquer death. Carrión's fate bears out his thesis: this painting, all that survives by the artist, was the means to his immortality.

Notes
1. See Enrique Valdivieso, *Vanidades y Desengaños en la Pintura Española del Siglo de Oro* (Madrid: Fundación de Apoyo a la Historia de l'Arte Hispánico, 2002), 89; and Edward J. Sullivan and Nina A. Mallory, *Painting in Spain, 1650–1700, from North American Collections* (Princeton: The Art Museum, Princeton University, in association with Princeton University Press, 1982), no. 10.
2. See Donald W. Bleznick, *Quevedo* (New York: Twayne, 1972).

Emanuel de Witte
Dutch, 1617–1691/2

Church Interior with Figures, 1685
Oil on panel
18 1/8 x 15 in. (46.0 x 38.1 cm)
84.21

This glimpse into a Gothic cathedral is by Emanuel de Witte, one of the most important Dutch specialists in architectural subjects. Born in Alkmaar, in northern Holland, de Witte lived between 1640 and 1651 in Delft, where he trained with Evert van Aelst, a still-life painter. By 1652 he had settled in Amsterdam. The Dutch biographer Arnold Houbraken described de Witte as possessed of a difficult personality, whom success eluded. To personal tragedies (he lost his first wife around 1650) were added financial struggles. In 1658 he had a commission from the king of Denmark, but by 1660 he was in such dire straits that he had indentured himself to an Amsterdam notary, who was to receive all of de Witte's future work in exchange for room and board and eight hundred guilders a year. De Witte broke that contract, enduring numerous legal disputes and further financial difficulties. His wife set a daughter to stealing; both were caught and punished. De Witte disappeared, and six weeks later was fished out of a canal with a rope around his neck, having committed suicide.[1]

In 1651, while still living in Delft, de Witte began painting church interiors, joining Gerrit Houckgeest and Hendrick van Vliet in this new development. Perhaps the lure of a new market with no competition in his genre inspired de Witte's move to Amsterdam the following year. Besides numerous views of the Oude Kerk and the Nieuwe Kerk, de Witte also produced imaginary interiors, loosely based on combinations of these two historic Amsterdam churches. Of the roughly 256 surviving autograph works by de Witte, 22 depict imaginary Catholic churches, of which only six portray a Gothic interior. Ours is de Witte's most elaborate version of a fictive Gothic Catholic church.

Placing us at the crossing of the nave and transept of this venerable cathedral, de Witte shows us a gentleman discussing what may be a future baptism with two monks (probably Capuchins) as he points to the baptismal font. Above them, we find what appears to be a coat of arms that includes a garment, perhaps alluding to Jesus or John's seamless tunic worn in childhood, accompanied by shields and other coats of arms.[2] At the right, a family considers a tomb beneath a sculpture of the Virgin Mary, while in the background we see a sculpture of a crucified Christ flanked by John the Evangelist and Mary, executed in a late Renaissance style. Well in the background is the high altar, before which the priest conducts the Mass. The whole is described using strong contrasts of dark and light, one of de Witte's preferred compositional devices. This dramatic contrast, together with de Witte's wonderful interplay of symmetry and asymmetry, transforms his visual description into a masterful exercise in artistic composition.

This painting's fascinating blend of reality and fiction, with its strong accent on Catholicism—a minority religion that ran counter to the spartan ethos of the predominantly Protestant culture of Amsterdam—raises the question of patronage. Who would have desired such a picture? Certainly, architectural subjects gained popularity throughout Holland during the seventeenth century. Churches, primarily Protestant edifices, doubtless reflected Dutch piety as well as their preference for solid, concrete descriptions of the world around them. De Witte, who had the architectural field to himself in Amsterdam, may have tried different methods of attracting buyers. Was his portrayal of a Catholic church intended to recall the time before the iconoclastic anti-Catholic revolt that broke out more than a century before, in 1566, and resulted in the suppression of Catholic churches and the destruction of notable altarpieces by Pieter Aertsen in the Oude Kerk and Nieuwe Kerk? Was it painted to appeal to a Catholic who desired some affirmation of a bygone era? Though in the minority, Catholics were tolerated and practiced their faith privately. By 1653 the Catholics in Amsterdam had a "house church" on Jodenbreestraat that served eleven hundred worshippers. In 1662 the Carmelites obtained a chapel and operated in a "house church" on the Nieuwe-Zijdsvoorburgwal, which took up the first floor of two adjoining houses.[3]

If not painting for one of Amsterdam's Catholics, was de Witte hoping to attract a connoisseur, who might have admired his skillful re-creation of a historic, bygone reality? We shall never know. However, what is certain is that despite his importance as a leader in architectural painting, de Witte could not overcome his personal and financial burdens. The structure and discipline he could impose on his work did not translate easily into his life. The vicissitudes of the art market, and those of life, doomed him to failure.

Notes
1. Arnold Houbraken, *De groote schouburgh der Nederlantsche konstschilders en schilderessen* (1718–21; reprint, Amsterdam: B. M. Israel, 1976); Ilse Manke, *Emanuel de Witte, 1617–1692* (Amsterdam: M. Hertzberger, 1963); and Walter A. Liedtke, *Architectural Painting in Delft: Gerard Houckgeest, Hendrick van Vliet, Emauel de Witte* (Doornspijk: Davaco, 1982).
2. My thanks to Professor Angela Vanhaelen for her help. She notes that five different paintings (four by de Witte) feature this motif, which she believes is a coat of arms.
3. Manke, op. cit., 47.

Giovanni Paolo Panini
Italian, 1691–1765

Landscape with Ruins, ca. 1715/18
Oil on canvas
28 1/2 x 39 in. (72.4 x 99.1 cm)
Given in memory of Marguerite Lilly Noyes, 74.19.2

This imaginary scene of ancient Roman ruins is an early work by the artist destined to become the most celebrated "view painter" of eighteenth-century Rome, Giovanni Paolo Panini. Born in Piacenza, the youthful Panini originally contemplated a priestly vocation, but instead he turned his talents to architectural painting. Possibly a student of Ferdinando Galli Bibiena and Giovanni Battista Galluzi, by 1708 Panini had produced a treatise on perspective, and his career as a fresco decorator of villas and palaces owned by the Roman aristocracy had begun.

The easel pictures that were to gain him such fame are documented as beginning in 1719, the year of his admittance to the Accademia di S. Luca in Rome. Active as an architect and designer of fireworks, temporary architectural decorations, stage designs, and furniture, Panini is best remembered for his painted views of Rome and her monuments, both ancient and contemporary. Like Hubert Robert (his brilliant French counterpart, whom he inspired), Panini produced both actual views *(vedute reale)* and imaginary scenes *(vedute ideate).*

Our painting shows Panini's obvious inventiveness with *vedute ideate* at the start of his career, coinciding with the excavations of the ancient city of Herculaneum around 1718, which spawned the eighteenth-century enthusiasm for antiquarian imagery that Panini did so much to satisfy.[1] Panini's patrons eventually became anyone interested in Rome or the antique, particularly European and British "Grand Tourists." Notable among Panini's patrons were the fourth earl of Carlisle, who in 1740 ordered a set of Roman views (Castle Howard Collection); Frederick the Great of Prussia, who commissioned a panoramic view of Rome in 1749 (now Postdam, Stiftung Preussische Schlösser); and the duc de Choiseul, who ordered the famous *View of Ancient Rome* around 1755 (now Stuttgart, Staatsgalerie).

In a slightly misty light, some real and some fanciful ancient Roman ruins appear before the viewer. In the niche at the left, Panini conflates two famous antique sculptures: although similar in scale and musculature to the Farnese Hercules (Naples, Museo Nazionale), Panini's figure blows on a pipe like the Borghese Faun (now Paris, Museé du Louvre). The Farnese Hercules, rediscovered in the sixteenth century, was preserved in the Palazzo Farnese in Rome until 1787 and was praised by the English poet and politician Joseph Addison as one of the "four finest Figures that are now Extant"; while the Borghese Faun ranked among the most admired statues in Rome in the early seventeenth century.[2] Beyond the sculpture, adjacent to a tall cypress tree that marks the middle ground, an ancient Roman cinerary urn sits atop a stone base, against which is propped the torso of a broken Roman sculpture, reminiscent of the so-called Pasquino, an antique fragment found in Panini's time at the Piazza Navona.[3]

Center stage, a graceful Roman colonnaded rotunda, loosely based on the Temple of the Vesta at Tivoli, basks majestically in the light, its broken entablature displaying a single surviving relief sculpture of a pagan sacrifice. Within the temple precincts, a goddess stands on her pedestal, possibly a variant of the Capitoline Flora, another famous ancient sculpture.[4] The whole architectural assembly is safely ensconced within a stone garden wall, suggesting a private refuge for peaceful contemplation of the past.

At the right, on the steps of a fragmentary colonnaded porch beyond which a distant landscape can be glimpsed, a turbaned cavalier views the pool of water where a bather dries himself in the sun. Arrayed around the grand yet decayed ancient monuments, couples flirt and larger groups converse or look about. They are visually diminished, insignificant, overpowered by the artist's vision of the ancient past, considered greater—literally and figuratively—than the present. This was Panini's youthful vision. He went on to celebrate the accomplishments of his own day with epic scenes of modern Rome together with other grand images of antiquity. Those later scenes tended to be presented as clear-eyed reportage, with none of the sentimental nostalgia for a bygone era that seeps through the very pores of our dream-like painting.

Notes
1. See Ferdinando Arisi, *Gian Paolo Panini e I fasti della Roma del Settecento* (Rome: U. Bozzi, 1986), no. 64, 4p4; and Francis Haskell and Nicholas Penny, *Taste and the Antique: The Lure of Classical Sculpture, 1500–1900* (New Haven: Yale University Press, 1981), 74 ff.
2. See Haskell and Penny, op. cit., 229–30 and 212–13.
3. Haskell and Penny, op. cit., 292.
4. Haskell and Penny, op. cit., 216–17. The identity of Panini's goddess is unclear.

Francesco Solimena
Italian, 1657–1747

Allegory of the Four Parts of the World, 1738
Oil on canvas
50 x 72¹/₂ in. (127.0 x 184.2 cm)
Gift of Dr. and Mrs. Henry R. Hope, 74.83

These grand and handsome figures—representing Europe, Asia, Africa, and America—were painted by the presiding genius of eighteenth-century Neapolitan painting, Francesco Solimena, for one of Europe's most powerful rulers, Charles III (1716–1788).* When he was seventeen, Francesco, the son and pupil of the gifted painter Angelo Solimena, moved to Naples, where the paintings of the reigning Neapolitan artist of the day, Luca Giordano (see p. 252), inspired him. After Giordano departed for Spain in 1692, Solimena took on the mantle of undisputed leader of the Neapolitan school, a position he held until his death. His elegant, sculptural style, with its solid figures, bold drapery, and refined but strong faces, perfectly suited the needs of his patrons, who included the aristocracy and clergy of Naples, as well as of much of Europe. Solimena died wealthy and ennobled, with the title of baron.

The patron of our painting, Charles III, son of King Philip V of Spain, became duke of Parma in 1731, king of Naples in 1734, king of the Two Sicilys in 1735, and king of Spain in 1759. In Naples, Charles showered the seventy-seven-year-old Solimena with commissions ranging from royal portraits to battles scenes and sacred subjects. Not surprisingly, when Charles planned his marriage, he turned to Solimena.

In 1738, the twenty-two-year-old Charles married fourteen-year-old Maria Amalia of Saxony. Solimena, chief decorator of their nuptial chambers in the Palazzo Reale in Naples, decided to celebrate Charles III's famous piety. Considerable evidence about the now-lost bedchamber decor survives, and it suggests that our painting decorated the antechamber's ceiling.[1] Bernardo de Dominici, that essential contemporary source for Neapolitan painting, mentions Solimena's commission.[2] In 1739, two painters, Ludovico Mazzanti and Carlo Roncalli, stated that Solimena's ceiling was on canvas and not the more common fresco, which has led modern scholars to conclude (on the basis of size, medium, subject, and degree of finish) that our painting was the original work for the ceiling of the nuptial antechamber.[3] Solimena's preparatory sketch survives.[4]

Solimena's allegory identifies Europe with Catholic Rome. Elevated above the other regions of the world, Europa rests her left hand on the dome of the temple/church as she reaches with her right to receive the papal tiara and St. Peter's keys, the symbols of Catholic authority. Apollo, the sun god—a reminder of Europa's pagan origins—charges across the sky in his chariot, shining his light down upon her. Asia, seated below her, offers incense. Meanwhile, Africa, personified by the river god of the Nile (based on Bernini's famous sculpture of 1648 in the Piazza Navona, Rome), ignores them and gazes in the direction of the New World. Two heroic nude women represent America (perhaps North and South). These figures wear

feathers, hold sheaves of grain (signifying America's fruitfulness), and are armed with bows and arrows. Embodiments of natural humanity unspoiled by civilization, these figures appear benign, although one thrusts an arrow toward the Papal crown, perhaps to recall the Jesuits who had died trying to convert Native Americans.[5] In creating this scene for the King of Naples (and ultimately Spain), Solimena was, not surprisingly, championing Europe as the world's leader, leaving no doubt that the rest of the world looked up to her.

Robust, yet refined, the painting attracted attention. The Scottish painter Allan Ramsay commented on it in a letter written from Naples as Solimena worked on the commission. Seventeen years later, Charles Nicholas Cochin, the celebrated connoisseur and art advisor, mentions the painting in his accounts of his travels through Italy.[6] Today, the nuptial antechamber in the Palazzo Reale is bereft of its decor, raising the question of when our painting was removed. We know that Charles left to assume the Spanish throne in 1759, placing Naples in the hands of his son, Ferdinand (1751–1825).[7] By 1808 Napoleon (who had successfully invaded Italy in 1797) made his general, Joachim Murat, King of Naples, and Murat probably removed Solimena's masterpiece from the Palazzo Reale. By that time, Solimena's celebration of Catholic supremacy and Bourbon political dominance was obsolete, given Napoleon's avowed secularism and anti-Bourbon position. Fortunately for us, the painting was not destroyed, and it found its way to Bloomington, a precious relic of a momentous historic wedding.

Notes
*My thanks to Louise Arizzoli for her indispensable help with the research on this entry.
1. See Hugh Honour, *The European Vision of America* (Cleveland: Cleveland Museum of Art, 1975), no. 128.
2. Bernardo de Dominici, *Vite dei Pittori, Scultori e Architetti napolitani* (Naples: Nella stamperia dei Ricciardi, 1742–45), III, 609.
3. See Nicola Spinosa, *Pittura napoletana del Settecento dal Barocco al Rococò* (Naples: Electa, 1988), 118–19.
4. Solimena, oil sketch of an allegory of four parts of the world, sold at Christie's London, March 24, 1972, no. 57. Ergman collection, Paris.
5. In 1664 François de Creux published *Historiae Canadensis,* which included an illustration for the Jesuit missionaries who died converting the Iroquois between 1646 and 1650; see Hugh Honour, op. cit., no. 108.
6. Alastair Smart, *The Life and Art of Allan Ramsay* (London: Routledge and Kegan, 1952), 34, quotes his letter to Cunyngham, 2 August, 1737: "Solimena is employed to paint an hymeneal ceiling against the King's marriage, which is looked for some time next winter…."; Christian Michel, *Le Voyage d'Italie de Charles-Nicolas Cochin* (1758; reprint, Rome: Ecole française de Rome, 1991), 142.
7. Interestingly, upon arriving in Spain, Charles III immediately hired the celebrated Venetian painter Giambattista Tiepolo to decorate his new throne room with a visual paean to his rule. Tiepolo also stressed Charles's piety in his *Triumph of Spain,* ca. 1765, by placing a figure of Faith above the personification of Spain. See Michael Levey, *Giambattista Tiepolo* (New Haven: Yale University Press, 1986), 257 ff.

Joseph Chinard
French, 1756–1813

Portrait Bust of Baron Dominique-Vivant Denon, 1792
Terracotta
H: 28 in. (71.1 cm)
61.35

The confident, smiling expression on his face belies the precarious situation in which Dominique Vivant Denon (1747–1825) found himself in 1792, the year Joseph Chinard sculpted this bust. A diplomat, writer, artist, and administrator, Denon was born to a family of the minor aristocracy and became a trusted member of King Louis XV's court. In 1772 he embarked on a diplomatic career, spending most of his time at the Court of Naples. In August 1792 French nationals were expelled from Venice, where Denon had been living for four years. Denon returned to Paris in December, and upon his return—apparently worried because of his noble background—he changed the spelling of his name from the aristocratic de Non to the more plebian-sounding Denon.

Denon quickly re-established himself in French society during the Revolution, and in 1798 Napoleon selected him as one of thirty-six scholars to accompany his military expedition to Egypt. The scholars traveled up the Nile recording and illustrating Egyptian architecture and customs and collecting ancient artifacts. Denon's popular illustrated account of his Eygptian travels, *Travels in Upper and Lower Egypt* (1802), contributed greatly to the "Egyptomania" that influenced French interior design and decorative arts in the early nineteenth century.[1] After being appointed director of French museums by Napoleon in 1802, Denon spent thirteen years transforming the Louvre into a major national museum, and—less admirably—played an active role in the pillaging of European art collections during Napoleon's conquests. (These confiscated works became prized possessions of the Louvre.) Following Napoleon's defeat at Waterloo in 1815, Denon, bitterly opposed to the increasing demands for restitution of these looted artworks, resigned his post.

During his tenure as Louvre director, Denon hoped to oversee a revival of sculpture within French art. The Neoclassical elegance of Chinard's sculptural works, and his sensitivity to his sitters' personalities, had earned this sculptor the favor of both Napoleon and Denon. In addition, Chinard's support of the French Revolution and his adherence to Enlightenment ideals had made him popular in France. Indeed, Chinard had served two months in 1792 in the notorious prison of Castel Sant'Angelo in Rome for creating sculptures considered to be anti-Catholic by the papal authorities. Chinard exhibited his work at the Paris Salons under Denon's direction, and in 1806 Denon commissioned him to contribute sculptural elements to the Arc de Triomphe du Carrousel near the Louvre.

Unfortunately, the circumstances under which Chinard sculpted this bust of Denon are unknown. Both men had ties to the French Academy in Rome, and they may have met through mutual connections there. The autumn of 1792 was tumultuous for both men,

with Denon's expulsion from Venice and Chinard's imprisonment in Rome from September to November. It is probable that Chinard sculpted this bust early in 1792, when both men were still living in Italy. An inscription on the bust uses the original spelling of Denon's name, indicating that this bust may indeed predate Denon's return to revolutionary France and subsequent name change.[2]

Chinard's bust of Denon flatters the sitter, presenting the details of his dress and hairstyle with careful realism and his facial features and expression with sensitivity. Denon possessed, by all accounts, a vivacious and charming personality, and his famous wit is apparent. The imprint of Chinard's fingers in the clay can be seen throughout the surface of the sculpture; indeed, the use of terracotta for this portrait gives it a sense of warmth and spontaneity often missing in the formalism of Neoclassical art. Nevertheless, Denon's carefully curled coiffure and the drapery partially covering his high-collared coat reflect the precedent of ancient Roman portrait busts. After completing formal studies in sculpture in his native Lyon, Chinard had worked from 1784 to 1787 in Rome, where he saw ancient sculpture and was exposed to the work of the two most important Neoclassical artists of the day: the painter Jacques-Louis David and the sculptor Antonio Canova. One of the most talented French portraitists of the eighteenth and early nineteenth centuries, Chinard earned renown for his intimate, realistic portrait busts, often of colorful personalities such as Vivant Denon.

[J. A. M.]

Further Reading
Alexander, Edward P. *Museum Masters: Their Museums and Their Influence.* Nashville, Tenn.: American Association for State and Local History, 1983.
West, Alison. *From Pigalle to Préault: Neoclassicism and the Sublime in French Sculpture, 1760–1840.* Cambridge: Cambridge University Press, 1998.
Wilson-Smith, Timothy. *Napoleon and His Artists.* London: Constable, 1996.

Notes
1. Vivant Denon, *Voyage dans la Haute et la Basse Egypte* (Paris; P. Didot, 1802). The book was published in English the following year as *Travels in Upper and Lower Egypt, in Company with Several Divisions of the French Army, During the Campaigns of General Bonaparte in that Country* (London: Printed for T. N. Longman and O. Rees; and Richard Phillips, by T. Gillet, 1803).
2. The bust is inscribed in the clay on the left shoulder: "De Non age 45 ans" (Denon's birthday was January 4, 1792).

Jean-Louis Laneuville
French, 1748–1826

Portrait of Jean de Bry, ca. 1793
Oil on canvas
25 ³/₄ x 21 ⁵/₁₆ inches
77.54.1

This crisp, penetrating portrait of French lawyer and statesman Jean-Antoine-Joseph de Bry was for many years thought to be a work by Jacques-Louis David, the major proponent of Neoclassicism in French art. It was not until 1976 that the Wildenstein Gallery reattributed this unsigned painting to Jean-Louis Laneuville, a student and friend of David's.[1] Works by Laneuville are rare, and this artist was nearly forgotten by the late nineteenth century. All of his extant works are portraits in which he adopted David's highly finished and uncluttered Neoclassical mode. These psychologically intense portraits evoke the personality and humanity of Laneuville's prominent sitters.

Jean de Bry, the son of a textile merchant from Picardy, was deeply involved in both revolutionary and Napoleonic-era politics. In 1792 he became a deputy to the National Convention, the revolutionary-era government that ruled from 1792 to 1795. During this period, de Bry served as president of the National Convention, and he may have had his portrait painted to mark this high point in his political career.

In Laneuville's portrait, de Bry's penetrating blue eyes confront the viewer, while his unsmiling expression and strong grip on the prominent roll of legal documents suggest that he is a man of consequence. With eyes that follow the viewer through the gallery, de Bry's portrait evokes the atmosphere of surveillance and suppression surrounding the French revolutionary government. Laneuville's decision to paint de Bry's head and hand slightly over scale in proportion to his torso contributes to the sense of dominance and power in the portrait.

Seated sideways in a simple chair, de Bry is dressed stylishly in the relatively austere fashion of revolutionary-era France: a red double-breasted waistcoat, a high-collared, tight-fitting frock coat, black lace cravat, and crisp white shirt. Although he does not wear the formal wig associated with the ancien régime (out of fashion by the 1790s), he does powder his long, wavy hair. Gold hoop earrings provide a flamboyant accent to his restrained, tasteful outfit. Many men of this time used their attire to express their patriotism, and de Bry's political ideals are hinted at in the red, white, and blue color scheme of his costume, evoking the colors of the new French flag.

Just as revolutionary fashion was simplified, yet imbued with symbolism, Neoclassicism, characterized by its simplicity and clarity, was a politically charged artistic style in revolutionary France. Neoclassical artists such as David and Laneuville tried to evoke the monumentality, seriousness, and uncluttered characteristics of ancient Roman sculpture in their painting. Turning their backs on the frivolity and playfulness associated with the Rococo style of the eighteenth century, Neoclassical artists favored a smoothly finished paint surface and stable, balanced composition to suggest the control and rationality of Enlightenment ideals.

While little is known of Jean-Louis Laneuville's life, it is likely that he shared the revolutionary sympathies of his sitters. As a student of David, an ardent supporter of the Revolution, Laneuville would have interacted with a circle of antiroyalist, republican artists in the close-knit, intimate atmosphere of David's studio. His portrait commissions appear to have come primarily from leaders of the Revolution, including some of the most outspoken supporters of the Reign of Terror. His best-known portrait—painted in 1793 or 1794, at the height of the Terror—depicts a revolutionary leader, Bertrand Barère de Vieuzac, resting his hand on a sheaf of documents that call for the deposition of the monarchy (now Bremen, Kunsthalle).

Intriguingly, the expensively tailored vests and frock coats, high quality fabrics, and careful hairstyling and personal grooming apparent in Laneuville's portraits of revolutionaries—along with their upper-class act of commissioning portraits—conflicted with their call to eschew the aristocratic lifestyle and the importance it placed on material possessions. The portrait of Jean de Bry reflects, therefore, the climate of conflicts and contradictions in 1790s France. Laneuville's controlled and highly finished image of a fastidious man offers little hint of the terror and bloodshed roiling French society under de Bry's government.

[J. A. M.]

Further Reading
Le Bourhis, Katell, ed. *The Age of Napoleon: Costume from Revolution to Empire, 1789–1815.* New York: Metropolitan Museum of Art, 1989.
Oppenheimer, Margaret. *The French Portrait: Revolution to Restoration.* Northampton, Mass.: Smith College Museum of Art, 2005.
Rosenberg, P., ed. *French Painting, 1774–1830: The Age of Revolution.* New York: Metropolitan Museum of Art, 1974.

Note
1. Dossier on the painting from the Wildenstein Gallery, IU Art Museum, registrar's files. In 1889, when this painting was exhibited at the Exposition Universelle in Paris, it was already thought to be a work by David. It appears as number 240 in the catalogue of the *Rétrospective de l'art français* with the attribution to David. The reasons for the misattribution of this work in the late nineteenth century are not clear, but the style of the work aligns it with the rediscovered oeuvre of Laneuville. The newer attribution to Laneuville was accepted and published during a recent exhibition of French revolutionary-era portraiture at the Smith College Museum of Art.

THE WEST AFTER 1800

The history of nineteenth- and twentieth-century art is characterized by its diversity of styles, motives, and theories; thus, when he began to assemble the modern collection at Indiana University, it was Henry Hope's aim to introduce university students to this material through the development of an encyclopedic collection. Comprising approximately twelve hundred pieces, the collection has particular strengths in nineteenth-century American painting, German Expressionism, French painting of the 1920s through the 1940s, and modern sculpture.

The nineteenth century saw the emergence of many new artistic impulses, as traditional forms of art patronage (the Church, the State, and the aristocracy) gave way to the rise of a commercial art market. The growth of the middle class in European and American cities spurred a demand for landscapes and genre paintings, which were typically purchased from large exhibitions and private art galleries.

Nationalist sentiments also characterize the painting and sculpture of the last two centuries. The IU Art Museum's large holding of mid- to late-nineteenth-century American paintings, a collection dominated by Jasper Francis Cropsey's *American Harvesting,* reflects American artists' search for a distinctive American style of painting, while Henry Fuseli's painting *Prospero, Caliban, and Miranda in Shakespeare's The Tempest* reflects British pride in England's literary heritage.

A growing freedom to experiment also led to a variety of artistic movements, beginning with Neoclassicism and Romanticism in the early nineteenth century. Alexander Nasmyth, for example, represented a romanticized vision of nature in his *View of Glen Coe, Argyllshire.* In France, artists increasingly turned to plein air painting and the depiction of everyday life. In the mid-nineteenth-century artists such as Charles-François Daubigny gathered in the village of Barbizon to paint outdoors, directly from nature. The Impressionists revolutionized painting techniques while recording everyday life in Paris and the nearby town of Argenteuil, as in Monet's *Le Bassin d'Argenteuil.* American artists, many of whom studied in Europe, enthusiastically adapted the Impressionist style, developing a distinctively American approach, as can be seen in Edmund C. Tarbell's *Girl Mending.*

The start of the twentieth century coincided with the rise of the modernist avant-garde. Artists such as Maurice de Vlaminck and Emil Nolde rejected the notion that art must objectively portray reality; Vlaminck's *Still-Life* and Nolde's *Nudes and Eunuch* are characterized by a liberated approach to color, form, and perspective. Although Paris remained the epicenter of the avant-garde before World War II, artists throughout Europe engaged in an active dialogue with each other through loan exhibitions and art journals, especially prior to World War I. Major avant-garde groups could be found in Germany, Russia, and Italy. These artists were supported and promoted by dedicated art dealers and collectors in these countries. A range of important work by the German Expressionists can be seen at the IU Art Museum, which has examples of paintings by Blaue Reiter artists Alexei von Jawlensky and August Macke and Brücke leader Ernst Ludwig Kirchner, as well as Expressionist sculpture by artists such as Ernst Barlach. Picasso's Surrealist *Studio,* Braque's Cubist *Napkin Ring,* and Léger's abstract-geometric *Composition* reveal the range of styles that arose and evolved in France between the wars.

Perhaps the most significant development in twentieth-century art was the emergence of non-representational—or abstract—art, lacking an easily identifiable subject. Non-representational art was first developed by Wassily Kandinsky in Germany and Arthur Dove in the United States. They used color, form, and technique to involve the viewer emotionally and intellectually with their art. After World War II, as the center of the art world in the West shifted from Paris to New York, non-representational art became the hallmark of the Abstract Expressionists such as Jackson Pollock and Color Field painters such as Morris Louis.

The wars, events, and social issues of the twentieth century have also occupied artists. Marino Marini's *Horseman* is a poignant comment on wartime, while Jean Dubuffet's paintings, such as *Business Lunch,* challenge the viewer to consider those marginalized on the fringes of mainstream society, particularly the mentally ill. Robert Colescott's *Lightening Lipstick,* the most recent painting discussed here, presents a frank look at racial issues in the contemporary United States. Today, the art world is defined by a multiplicity of viewpoints, media, and aesthetic approaches. Artists use sculpture, assemblage, painting, and video, and a variety of aesthetic styles, techniques, and subjects to challenge the eye and intellect of the twenty-first-century viewer.

Jennifer A. McComas
Class of 1958 Curator of Western Art after 1800

Elisabeth-Louise Vigée Le Brun
French, 1755–1842

Portrait of Mrs. Chinnery, 1803
Oil on canvas
35 x 28 in. (91.4 x 71.1 cm)
75.68

This portrait marks a connection among three remarkable eighteenth-century women: the sitter, a highly cultivated Englishwoman, Margaret Chinnery (1764/5–1840); the famous French writer, Madame de Genlis (1746–1830); and the celebrated French painter, Elisabeth Vigée Le Brun (1755–1842). Self-educated, Margaret Chinnery was, from youth, devoted to the writings of Madame de Genlis, one of the most famous and prolific writers of her day. In 1790 (as Madame de Genlis fled revolution-torn Paris), Margaret married William Chinnery (1766–1839), a rising member of the British treasury.[1] In 1802, a visit to post-revolutionary Paris brought Margaret Chinnery and Madame de Genlis together, and the author presented her admirer with her book on mythology bound in red morocco leather. A year later, when Vigée Le Brun came to England, she painted Margaret Chinnery holding that treasured volume.[2]

Born in Paris, Elisabeth-Louise Vigée Le Brun was, like many other notable women artists, the daughter of a painter. Louis Vigée, a minor portrait painter, trained his talented daughter who, at the age of twenty-one, married the art dealer Jean-Baptiste Le Brun. By 1779 Vigée Le Brun had achieved an unprecedented success for a woman artist, becoming official painter to Queen Marie Antoinette, whom the artist praised: "I don't think that Queen Marie Antoinette ever missed the opportunity of saying a kind remark to whoever had the honor of meeting her…."[3] In 1789, when the Bastille was stormed, Vigée Le Brun disguised herself as a peasant, and, with her six-year-old daughter, fled Paris, traveling to Italy, Austria, and Russia. Vigée Le Brun's return to post-revolutionary Paris in 1801 was brief and painful. She left for London in 1802, where she settled into damp quarters on Maddox Street, complaining about the English weather and praising English cleanliness and hospitality.

One of her earliest English clients was the Chinnery family, whose country home in Gilwell became a pleasant refuge from London's oppressive climate. Margaret Chinnery, fluent in both French and Italian, devoted herself to the arts. The Chinnery concerts, highlights of the London social scene, featured the celebrated musician Giovanni Battista Viotti (1755–1824). Viotti had arrived in London in 1792 and lived with the family from 1799 until his death. Vigée Le Brun's memoirs recount an enchanting blend of family hospitality and marvelous music.[4]

Vigée Le Brun, who had helped change French portraiture by encouraging a more natural approach that dispensed with formal wigs, attitudes, and dress, here applied her formulae to an English subject, characterizing Margaret Chinnery with her signature attributes of ideal femininity: large luminous eyes, cupid's bow mouth, and soft, curling hair. Mrs. Chinnery gave the artist's visual language a distinctly English accent. Though dressed in the fashionable high-waisted empire style launched in France and crowned by Vigée Lebrun's favorite veil, Mrs. Chinnery remains indisputably British. Instead of bows and flourishes, we find delicacy and tidiness; instead of overt sentimentality, we discover a thoughtful, good-humored nature. Mrs. Chinnery's charming face, bearing the sweet expression so characteristic of Vigée Le Brun's women, retains an English quality, one based on the fundamental good sense that makes Jane Austen's heroines so appealing.

Demonstrating her taste for order, Margaret looks up from her text, yet marks her place. She may have been reading aloud during her sitting, and turns to the artist to discuss the book's contents with intelligence and confidence.[5] Her gaze is the most intelligent, direct, and clear-eyed of Vigée Le Brun's many portraits. Mrs. Chinnery's toilette suggests a preference for discipline: her curls, though plentiful, are neat and restrained; her necklaces are perfectly arrayed; and her veil is discrete and dignified. Even the tassels that embellish the empire waist of Mrs. Chinnery's velvet gown hang with careful regularity.

Still, the features of Mrs. Chinnery that Vigée Le Brun singles out to "praise" were aspects of the feminine that she had admired since her days with Queen Marie Antoinette, as a quote from her description of the Queen bears out: "She had superb arms, perfectly formed hands….Her expression was intelligent and sweet; her nose fine and pretty, her mouth was not wide."[6] Nearly forty when the portrait was painted, Margaret retains a typical extended youth supplied by Vigée Le Brun, but a certain plumpness hints at the beginnings of middle age. Certainly these were Margaret's happiest years. By 1812 her husband William would be disgraced for embezzling funds from the British treasury, and her daughter Caroline had died. Joining her exiled husband in Paris in 1819, Margaret no longer found comfort with Madame de Genlis, but the Chinnerys remained attached to Viotti until his death in 1824.

[A.M.G.]

Notes
1. William's brother George Chinnery (1774–1852) was a noted painter.
2. A valuable resource on the Chinnery family and Madame de Genlis can be found in Denise Yim, *The Unpublished Correspondence of Mme de Genlis and Margaret Chinnery* (Oxford: Voltaire Foundation, 2003).
3. S. Evans, *The Memoirs of Elisabeth Vigée-LeBrun* (Bloomington: Indiana University Press, 1989), 33.
4. Ibid.
5. Various sitters devised ways to while away the hours. Vigée-Lebrun sang duets with the Queen, ibid.
6. Evans, op. cit., 32.

Henry Fuseli
Swiss, active England, 1741–1825

Prospero, Caliban, and Miranda in Shakespeare's The Tempest, Act 1, Scene 2
ca. 1806–10
Oil on canvas
36 x 28 in. (90.1 x 69.8 cm)
79.70

In his numerous interpretations of Shakespearean subjects, Henry Fuseli specialized in the most fantastic and dramatic moments of the repertoire. After moving from his native Zurich to London in 1764, he became a passionate devotee of the Drury Lane Theatre, often opting for the uncomfortable, cheap seats near the stage over the more prestigious boxes located above the stage on the sidelines. Sitting close to the stage afforded the artist a visceral experience of the drama and provided him the opportunity to study not only the technique of Shakespearean actors, but also the evocative scenic and lighting designs.

Although the popularity of Shakespeare's plays on the London stage had risen steadily throughout the eighteenth century, the transformation of Shakespeare into an icon of the emerging Romantic movement began most conspicuously in German-speaking central Europe. In Germany, Sturm und Drang (Storm and Stress), a literary and musical movement promoting emotionalism over rationalism and classicism, was largely responsible for the attention given the English playwright. As Shakespeare became an important symbol of Sturm und Drang, the English playwright was widely translated into German and performed in German-speaking Europe during the late eighteenth century. The German philosopher Johann Gottfried Herder praised Shakespeare's plays for yielding to an "impetuous force of nature, a barbaric sublimity, an instinctive and primordial creative energy."[1]

Written in 1611, *The Tempest* is filled with characters and situations evoking the sublime and the supernatural. The play's cast of wizard, fairy, and grotesque slave ensured that it was one of Shakespeare's most popular. The plot, which revolves around a magically induced shipwreck and enchanted love affair, enabled producers to take advantage of a wide variety of mechanical stage effects to entice spectacle-seeking audiences to the theater. Fuseli's painting depicts a moment from Act I, Scene ii of the play, in which the wizard Prospero, protecting his daughter Miranda from the advances of his slave Caliban, threatens the slave with his magical powers. Despite Prospero's imposing gesture, it is Caliban's twisted figure, flooded in strong light, that dominates the composition.

Though Caliban was often portrayed as a subhuman beast, Fuseli's depiction of the character evokes the tragic figures of Sturm und Drang literature. That Fuseli's sympathetic portrayal of the slave Caliban dates from the same time that the British government outlawed the slave trade within their empire (in 1807) may not be coincidental. While this wild and abject figure appealed to the Romantic imagination and had contemporary resonance, Caliban's

pose is also derived from the ancient Roman statuary in Rome's Piazza del Quirinale. On the advice of Sir Joshua Reynolds, the director of London's Royal Academy of Fine Arts, Fuseli had journeyed to Rome in 1770 to further his artistic training. There, from classical Roman statuary and from Michelangelo's Sistine Chapel frescoes, he learned how to create powerfully expressive, monumental human figures, seen from a low vantage point. His use of muted, shadowy color in his paintings may be a response to Michelangelo's darkening frescoes.

Fuseli's taste for the more supernatural and magical Shakespearean plays made him a perfect match for a society entranced with the "gothic" in art and literature. His work became widely known through his participation in the Shakespeare Gallery, an enterprise conceived of by London printseller John Boydell in 1786. Boydell commissioned original paintings on Shakespearean subjects, and reproductive engravings after the paintings, to capitalize on Shakespeare's popularity. Fuseli contributed nine paintings to the gallery's first exhibition in 1789, including a similar scene from *The Tempest*.

Fuseli's reasons for the producing the IU Art Museum's painting are more obscure. Fuseli scholar Gert Schiff believes that the painting was the model for a book illustration, although no such illustration has been documented.[2] The painting was sold at Christie's in London in 1842, and an intriguing handwritten annotation in the auction catalogue notes that the work was painted for John Knowles, Fuseli's first biographer.[3] So perhaps this painting was simply a commission from Fuseli's good friend. It is a characteristically Fuselian interpretation of Shakespeare, one in which the many aesthetic and intellectual currents of the artist's time coalesce in his dramatic style.

Further Reading
Myrone, Martin. *Henry Fuseli.* London: Tate Publishing, 2001.

Notes
1. Quoted in Maria Grazia Messina, "Shakespeare and the Sublime," in Jane Martineau et al., *Shakespeare in Art* (London and New York: Merrell, 2003), 62.
2. Although Schiff overlooked this painting when compiling his monumental Fuseli catalogue raisonné of 1973, the 1979 invoice for the painting from the Shickman Gallery notes Schiff's thoughts on the dating and purpose of the painting (IU Art Museum curatorial files). The painting is included in the Italian-language catalogue raisonné of Fuseli's oeuvre: Gert Schiff and Paolo Viotto, *L'opera completa di Johann Heinrich Füssli* (Milan: Rizzoli Editore, 1977), 103–104.
3. Sale of April 22, 1842, *Valuable Collection of Pictures by Italian, Flemish, Dutch, and English Masters, The Property of that Excellent Judge and Connoisseur, The Late John Knowles, Esq.,* Christie's, London (lot 49, sold as *Prospero controuling Caliban with his Wand, Miranda is seen seated in the cavern*), annotated copy, Royal Academy, London.

Alexander Nasmyth
Scottish, 1758–1840

A View in Glen Coe, Argyllshire, 1814
Oil on canvas
35 x 27 in. (88.9 x 68.8 cm)
Anonymous gift, 91.190

Alexander Nasmyth was born in Edinburgh, and after an extensive artistic education there and in London and Rome, he embarked on a varied career in Scotland as a painter, landscape gardener, engineer, and stage designer. Best known for his paintings of Scottish scenery, Nasmyth has been called the "father of Scottish landscape painting." During the eighteenth century, landscape had developed into an important genre in British art, fueled by the growing popularity of tourism. The practice of sketching outdoors from nature was pioneered by English artists in the early nineteenth century, and landscape painting increasingly dominated exhibitions during Nasmyth's lifetime.

During the Romantic era, tourists and artists in the United Kingdom attached a new importance to the depiction of their native landscapes. The production of identifiably Scottish landscape views reflected efforts to forge a Scottish identity that was distinct from that of England. The Scottish Lowlands and the major cities, Glasgow and Edinburgh, had become increasingly Anglicized during the eighteenth century, and they were rapidly industrializing during Nasmyth's lifetime. Consequently, the more remote Highlands became pivotal to the construction of a Scottish identity in which rural Gaelic traditions and picturesque scenery were employed to challenge English cultural hegemony in Scotland.[1] In this context, *A View in Glen Coe, Argyllshire* appropriately emphasizes the grandeur of Scottish scenery.

However, Nasmyth's landscape art, in general, was rooted in eighteenth-century English aesthetics. His green and brown-toned palette and diffused light sources are reminiscent of the work of Claude Lorrain, the seventeenth-century French painter whose arcadian views of Italy captivated the English during the eighteenth century. Meanwhile, Nasmyth's imaginative approach to topography reflects his activity as a landscape designer but also responds to influential eighteenth-century aesthetic theories. Edmund Burke's characterization of the Sublime (vast, wild, terrifying) in his *Philosophical Enquiry into the Origins of Our Ideas of the Sublime and the Beautiful* (1756) encouraged artists to portray landscape vistas that were especially awe-inspiring, while the Reverend William Gilpin published guides in the 1780s that explained ways to identify a Picturesque (i.e., rugged and uncultivated) landscape. Part tourist guides, part drawing manuals, Gilpin's books directed readers to visit the picturesque sites of Britain, but also encouraged them to "improve" upon nature in their drawings of these places.

A View in Glen Coe, Argyllshire, painted in 1814, is a particularly good example of Nasmyth's practice of rearranging or editing nature to render it more picturesque or sublime. Glen Coe, a narrow valley containing a gorge and waterfall and ringed with mountains, rises above Loch Leven near the western coast of Scotland. The first road was built through the glen in 1785, enabling tourists and artists in search of picturesque scenery to easily access the area. Nasmyth depicted the glen in several paintings, and the site became a mainstay of Scottish Romantic painting in the nineteenth century. However, while artists of the later nineteenth century strove for precise topographical accuracy in their depictions, Nasmyth increased both the height and cragginess of the mountains, deepened the gorge in the foreground, and compressed the space to emphasize the narrowness of the glen. Through his editorial changes to the landscape, Nasmyth created a wilder and more rugged landscape dominated by dramatic, Alpine peaks. Yet, despite his changes, Nasmyth's painting recognizably depicts a group of mountains in the glen known as "The Three Sisters." Although he viewed the landscape through the lens of Picturesque and Sublime aesthetics, Nasmyth used these English artistic formulae to call attention to the majesty of Scotland's distinctive topography.

Nasmyth took liberties with his portrayal of Glen Coe, but it was crucial that the landscape remain recognizable, for the glen had specific Scottish cultural and historical associations. Most viewers in the early nineteenth century would have been aware of Glen Coe's tragic history. In February 1692, Glen Coe was the site of an attack by supporters of the English King William III on members of the Macdonald clan, for their tardiness in taking an oath of loyalty to the king. The massacre was considered a watershed event in Scottish history, and accounts of the event originally published between 1695 and 1704 were reprinted in Edinburgh in 1818.[2] During the next few years, Nasmyth exhibited this or another painting of Glen Coe numerous times throughout Britain, attesting to the popularity of the subject. In conjunction with its spectacular topography, the history of Glen Coe conferred special status on the site, and gave it a prominent role in the nineteenth-century construction of Scottish identity.

Notes
1. John Morrison, *Painting the Nation: Identity and Nationalism in Scottish Painting, 1800–1920* (Edinburgh: Edinburgh University Press, 2003). See especially chapter 3, "The Lure of the Highlands," 47–76.
2. Charles Leslie and George Ridpath, *Memoirs of the Lord Viscount Dundee and the Highland Clans, Together with an Account of the Massacre of Glenco* (Edinburgh: D. Webster, 1818).

Jasper Francis Cropsey
American, 1823–1900

American Harvesting, 1851
Oil on canvas
35 1/2 x 52 3/4 in. (90.1 x 133.9 cm)
Gift of Mrs. Nicholas H. Noyes, 69.93

Landscape was the focal point of the Hudson River School, the first recognizably American school of painting. The North American landscape provided artists of the mid-nineteenth century with a means to distinguish their art from that of Europe. When Jasper Francis Cropsey, one of the leading members of the Hudson River School, exhibited his large canvas *American Harvesting* in 1851 at the American Art-Union (an exhibition society in New York City), the work, with its idyllic depiction of rural farm life, was lauded for presenting a scene perceived as typically American. *American Harvesting* was reproduced in the Art-Union's annual bulletin of 1851, and high-quality engraved reproductions were issued, which ensured the image a wide circulation. Cropsey's popular work was further disseminated through numerous copies, including a chromolithograph issued by Currier & Ives.

Although the painting's exaltation of the native landscape greatly appealed to American sensibilities, in its execution Cropsey had used and manipulated an aesthetic language borrowed from European art theory. Indeed, as artistic training was limited in the United States during Cropsey's youth, his studies took place in Europe. Shortly before painting *American Harvesting,* he spent two years in France and Italy, where he visited exhibitions and absorbed European artistic traditions. Cropsey's meticulous attention to detail and smooth paint surface reflect European academic techniques. His contact with the American artist Thomas Cole further solidified Cropsey's adherence to European aesthetics. Although considered the "father" of the Hudson River School, Cole developed his style in England and France, where he was exposed to the aesthetic trinity: the Picturesque, the Beautiful, and the Sublime. These categories were defined by eighteenth-century English theorists such as Edmund Burke and William Gilpin, and they proved enormously influential on the depiction of landscapes for decades.

All three aesthetic categories play prominent roles in *American Harvesting.* The Picturesque, which refers to irregular, mysterious landscapes, is reflected in Cropsey's handling of the painting's foreground, with its overgrown woods, rough tree stumps, and dark tonalities. The large expanse of farmland in the middle ground is carefully separated from this picturesque wilderness by a wooden fence. This section of the painting, an idealized vision of a rural arcadia, is based on the aesthetic concept of the Beautiful. The seventeenth-century French artists Claude Lorrain and Nicolas Poussin, whose Italianate landscapes presented harmonious, cultivated, and tamed visions of nature, had popularized the concept of the Beautiful. Finally, in the background of Cropsey's painting, a chain of craggy mountains refers to the category of the Sublime, used to describe the most overwhelming and breathtaking elements of the landscape. For American artists, the Sublime was considered the aesthetic mode that best expressed their native landscape, with its mountain ranges, vast plains, wide rivers, and sparse population.

By using the European aesthetic categories of the Picturesque, Beautiful, and Sublime, Cropsey created an idealized vision of American rural life in *American Harvesting*. Although viewers might assume that the painting depicts a specific locale in upstate New York, Cropsey presented a landscape that was generalized enough to represent the nation as a whole. Such a vision was popular and marketable in mid-nineteenth-century America. Significantly, the painting's first owner, who purchased the work in 1852, was a merchant from Brooklyn, one of the nation's fastest growing cities, where industrialization and building projects were proceeding at a rapid pace.

During a period of such rapid changes, urban residents felt a sense of nostalgia and sentimentality for the rural landscape. Cropsey, who had been born in Staten Island, was well aware of the concerns facing the urban inhabitants of Brooklyn and Manhattan, who began to visit the scenic Hudson River Valley as tourists in the 1820s. Attractive to artists, as well, were the Romantic literary associations that the region had acquired with the publication of Washington Irving's *Rip Van Winkle* and *Legend of Sleepy Hollow* and James Fenimore Cooper's *Last of the Mohicans.*

Hudson River School artists commodified this landscape for tourists and provided them with a preconceived framework for viewing nature. The production of these paintings was ultimately driven by urban taste for idyllic, rural American scenes. A painting such as *American Harvesting* could perhaps convince the viewer that the American landscape and way of life retained an element of arcadia even in the face of immense social, economic, and demographic changes.

Further Reading
Burns, Sarah. *Pastoral Inventions: Rural Life in Nineteenth-Century American Art and Culture.* Philadelphia: Temple University Press, 1989.
Novak, Barbara. *Nature and Culture: American Landscape and Painting 1825–1875.* New York: Oxford University Press, 1980.
Talbot, William S. *Jasper Francis Cropsey, 1823–1900.* New York: Garland, 1977.
Wilton, Andrew, and Tim Barringer. *American Sublime: Landscape Painting in the United States, 1820–1880.* Princeton, N. J.: Princeton University Press, 2002.

Charles-François Daubigny
French, 1817–1878

Morning, 1863
Oil on canvas
25 3/4 x 19 1/4 in. (65.4 x 48.9 cm)
William Lowe Bryan Memorial, Gift of James Adams, 59.47

Landscape painting in France changed radically during the nineteenth century, and Charles-François Daubigny played an important role in these transformations. In seventeenth- and eighteenth-century French painting, imaginary Italianate landscapes often served as backdrops for narratives drawn from classical literature or mythology. These scenic views, while pleasing to the eye, were highly artificial, their elements arranged and framed according to academic models. Actual landscape elements were often eliminated, combined, or invented to create a more harmonious composition, and the eighteenth-century aesthetic theories of the Sublime and the Picturesque encouraged artists to rearrange nature on their canvases for dramatic effect.

The rise of the Romantic movement in the nineteenth century provoked a fundamental reconsideration of the role of landscape within painting. While literary sources had traditionally inspired landscape painting, the overwhelming importance of music within Romanticism—especially Beethoven's stormy compositions—convinced French artists to approach the landscape differently than their predecessors had. Just as music could be appreciated for its own ineffable qualities, artists reasoned that landscape could be valued for its intrinsic nature rather than as a setting for human events.[1] English landscape paintings by artists such as John Constable provided one important model for spontaneous, direct observation of nature for French artists. The Romantic veneration of nature—and, more practically, the development of commercially prepared oil paints in tubes—inevitably led to the rise of plein air painting, the practice of painting outdoors. In the open air, artists had to work quickly and spontaneously, intuitively responding to the scene before them.

In the 1840s and 1850s a group of artists including Daubigny, Jean-François Millet, and Théodore Rousseau began gathering in the village of Barbizon, where they devoted themselves to plein air painting. Despite its idyllic setting in the Fontainebleu Forest, Barbizon was not far from Paris, an important consideration for these artists, who had not completely broken with the academic establishment, and who continued to exhibit at the Salon. Although the group advocated the modern practice of plein air painting, these artists also found inspiration in Dutch seventeenth-century landscape paintings, which seemed to provide a more natural, less stylized, vision of landscape than did the French academic tradition.

Daubigny, despite having trained in the studios of several eminent French artists, was perhaps most influenced by the Dutch landscape paintings he copied in the Louvre. He also became a close friend of the older artist Camille Corot, one of the pioneers of plein air painting. Daubigny, however, was one of the first artists to bring his canvases to near completion outdoors, rather than returning to the studio to carefully add details and smooth out his paint surface.

Morning was painted in the area around Barbizon.[2] The placid, unpeopled scene offers no suggestion that this area of France—the Ile-de-France—was the nation's most populous region. The painting's straightforward depiction of a rutted lane leading to a country cottage in the woods would have been unthinkable without Romanticism and its transformative effects on landscape painting. Devoid of narrative, *Morning* simply reflects the physical and visual qualities of the landscape as they appeared to Daubigny as he painted.

Daubigny's rapid brushwork and his interest in the changing qualities of light made him an influential model for the later generation of Impressionists but disconcerted many of his contemporaries. Despite the artist's mostly successful showings at the Paris Salon, some critics accused him of careless technique.[3] However, Daubigny was more interested in capturing the essence of the landscape than in faithfully reproducing every detail. *Morning's* tonal quality, muted but harmonious palette, and balanced, closed composition suggest a musical composition as much as a description of nature. Unlike the Impressionists, Daubigny did not heighten his colors with white or use unnaturally bright tones within his work. His earth-based palette instead reflects his close observation of nature and weather, in contrast to the stylized and idealized landscapes of previous centuries.

Notes
1. Kermit S. Champa, "The Rise of Landscape Painting in France," in *The Rise of Landscape Painting in France: Corot to Manet,* ed. Kermit S. Champa (Manchester, N.H.: The Currier Gallery of Art, 1991), 30–38.
2. Robert Hellebranth, *Charles-François Daubigny, 1817–1878* (Morges: Editions Matute, 1976), 142. Hellebranth's catalogue raisonné places the painting geographically in the part of the Ile-de-France region that is bounded by the Seine and Marne rivers.
3. *Morning* was exhibited at the Paris Salon of 1863 (no. 512, *Matin,* p. 64): Pierre Sanchez and Xavier Seydoux, *Les catalogues des salons des beaux-arts,* vol. 7 (Paris: L'Echelle de Jacob, 1999–).

Claude Monet
French, 1840–1926

The Port of Argenteuil (*Le Bassin de Argenteuil*), **1874**
Oil on canvas
21⁷/₈ x 26¹/₄ in. (55.6 x 66.7 cm)
76.15

In 1871 Claude Monet and his family settled in Argenteuil, a Parisian suburb located along the Seine River, northeast of the city. They would remain there until 1878, and the years spent at Argenteuil were some of the most productive and innovative of Monet's career. The town was central to the development of Impressionism during the 1870s, and Monet was often joined there by fellow painters Alfred Sisley, Camille Pissaro, Gustave Caillebotte, Pierre-Auguste Renoir, and Edouard Manet. The life and scenery of the town were instrumental in forming the shared aesthetic concepts of the Impressionists: they captured the effects of light on the water and on Argenteuil's gardens with short brushstrokes and luminous colors, suppressing detail in favor of atmosphere.

Monet and the Impressionists elevated the town of Argenteuil to the status enjoyed by Barbizon, a small village located thirty miles from Paris in the Fontainebleu Forest, where the previous generation of artists—Charles-François Daubigny, Théodore Rousseau, and Jean-François Millet—had settled in the late 1840s in order to paint rural peasant life. The Impressionists in Argenteuil continued the tradition of painting in a small town outside of Paris, but they explored a different aspect of their chosen town, focusing on the modern pursuits of the urban middle class and portraying them in bright, sun-drenched colors.

Just fifteen minutes by rail from Paris's Saint-Lazare train station, the village of Argenteuil was strongly connected to life in the city. Although proud of its medieval origins, the town embraced modernity during the mid-nineteenth century, welcoming developers and industrialists and capitalizing on new trends in recreational activity, particularly boating, to attract urban day-trippers. Argenteuil held its first sailboat regatta in 1850, and during the 1860s boating became increasingly popular with middle-class Parisians, who converged on the town on Sundays. Also popular with urban visitors were pastoral promenades along the shores of the Seine at Argenteuil and at Petit Gennevilliers, across the river.

Monet was no stranger to watery landscapes, having grown up in Sainte-Addresse, a suburb of the port city of Le Havre, on the English Channel. There, and during summers spent on the Normandy coast, he had painted merchant ships and fishing boats. It was not until his move to Argenteuil, however, that Monet displayed an interest in boating as a leisure activity. In Argenteuil he joined in the activity on the river, and had a *bateau-atelier*, or "studio boat," built in 1874. Like his mentor Charles-François Daubigny, who had been traveling on the Seine and Oise rivers in a studio-boat since 1857, Monet took his boat on painting excursions on the Seine.

During the early 1870s Monet painted a remarkable series of views of the Seine in Argenteuil—many from the boat, which provided an intimate vantage point of the river and its banks. In the *The Port of Argenteuil,* Monet instead chose an elevated viewpoint from which to paint. The studio boat is prominently moored, however, at the lower right of the composition. *The Port of Argenteuil* portrays the Seine basin, where the river expanded to its greatest width and depth. The area was flanked by the riverbank promenades and hosted the majority of weekend boat races. Indeed, Monet's painting reveals the Seine basin as a hub of recreational activity, dotted with sailboats and promenaders. Monet's series of Seine paintings in Argenteuil also show his interest in exploring variations on a theme. His explorations of themes would culminate in his well-known studies of haystacks, water lilies, and the facade of Rouen Cathedral, which he painted numerous times under varying daylight conditions.

By the 1920s, *The Port of Argenteuil* had entered the collection of Adolph Lewisohn, a wealthy New York industrialist who had emigrated from Germany in 1867 and had become an early and important collector of French Impressionism in America. When highlights of his collection were published in 1928, the book's author, Stephan Bourgeois, described *The Port of Argenteuil* as a "brilliant early work" and captured in vivid prose the appeal that this painting still holds for viewers today: "In spite of the great calm reigning in the landscape, the scintillating vibration of light and heat permeates the whole scene with animation. The delight of a radiant summer day, exhilarating all the senses, was caught by the artist in the agile touches of his brush."[1]

Further Reading
Brenneman, David A. *Monet: A View from the River.* Atlanta: High Museum of Art, 2001.
Moffett, Charles S. *The New Painting: Impressionism 1874–1886.* Washington, D.C.: National Gallery of Art, 1986.
Tucker, Paul Hayes. *The Impressionists at Argenteuil.* New Haven: Yale University Press, 2000.

Note
1. Stephan Bourgeois, *The Adolph Lewisohn Collection of Modern French Paintings and Sculptures* (New York: E. Weyhe, 1928), 74.

Gustave Caillebotte
French, 1848–1894

Yerres, Effect of Rain, 1875
Oil on canvas
31 5/8 x 23 1/4 in. (80.3 x 59.1 cm)
Gift of Mrs. Nicholas H. Noyes, 71.40.2

Andō Hiroshige
Japanese, 1797–1858
Takanawa Ushimachi, from
*One Hundred Famous Views
of Edo,* 1857
Color woodblock print
68.75.3

An avid rower and boat enthusiast, Gustave Caillebotte enjoyed painting the river near his family's country estate in Yerres, not far from Paris. While many of his paintings depict athletic rowers, *Yerres, Effect of Rain* offers a more contemplative perspective on the river. Rather than presenting a landscape bathed in bright sunlight, as is typical of many Impressionist canvases, Caillebotte instead evokes the heavy grayness of a rainy day on the river in muted, subdued hues.

Yerres, Effect of Rain was the artist's first work to focus on water as the predominant compositional element. The rippling circles caused by raindrops on the surface of the water suggest a steady shower, and they provide a sense of rhythm and abstraction. The canoe (perhaps Caillebotte's) on the far shore of the river is beached, awaiting better weather. Canoes or skiffs of this type, manned by bourgeois urbanites enjoying their leisure in the suburbs or countryside, appear frequently in Caillebotte's paintings. However, this unusual work, unlike most in Caillebotte's oeuvre, includes no human figures, but focuses instead on the forms and textures of the landscape.

Although Caillebotte's masterful command of perspective and draftsmanship derive from his brief period of study at the Ecole des Beaux-Arts, his work differs sharply from his academic models. For example, *Yerres, Effect of Rain,* with its formal division into three distinct sections, unusually flattened perspective, strong diagonal lines, and cropped row of poplar trees in the background, reflects Caillebotte's interest in Japanese prints.

Japanese color woodblock prints—many depicting landscapes—had been widely available in France for several decades when Caillebotte painted this scene. The Japanese landscapes most attractive to European artists became important influences on the development of Impressionism in France. Artists such as Caillebotte were particularly drawn to the strong, unmodulated colors, unorthodox use of perspective, odd foreshortening, and surprising use of cropping found in woodblock prints by Andō Hiroshige (1797–1858).

A comparison of Caillebotte's *Yerres, Effect of Rain* with Hiroshige's print *Takanawa Ushimachi* captures this mid-nineteenth-century artistic dialogue between Japan and France. Hiroshige's print, which depicts boats on Edo Bay from beneath the large, cropped wheel of an oxcart, reflects European influence in its use of perspective to suggest a large, deep space. The colors, however, are brighter and more saturated than was typical in Western painting, and the large cropped wheel in the foreground is disproportionately oversized,

with Hiroshige choosing to ignore perspective and scale in favor of visual drama. Strong diagonal lines lead the viewers' eyes back and forth across the composition. Like the print, Caillebotte's painting is clearly divided into three zones, separated by diagonal lines that draw the eye back and forth across the image. The middle ground of each image is a large expanse of water. Likewise, Caillebotte's stylized ripples on the surface of the lake are reminiscent of Hiroshige's treatment of water.

The son of a wealthy textile merchant, Caillebotte had been at the forefront of the Impressionist group, using his inheritance to finance exhibitions and publications and to purchase works by his artist friends. *Yerres, Effect of Rain* dates from Caillebotte's most prolific period as a painter. After 1882, with the dissolution of the Impressionists as a cohesive group, Caillebotte's output of paintings diminished. In the late 1880s Caillebotte turned his attention to the boating activities that he had so often painted, designing and building several racing yachts. When Caillebotte died prematurely in 1894, his strikingly original paintings were underappreciated, and few sold at a posthumous exhibition. Today Caillebotte is viewed as a pivotal member of the Impressionist movement. Works such as *Yerres, Effect of Rain* responded imaginatively to new concerns and aesthetic influences in mid- to late-nineteenth-century France.

Further Reading
Broude, Norma, ed. *Gustave Caillebotte and the Fashioning of Identity in Impressionist Paris.* New Brunswick, N.J.: Rutgers University Press, 2002.
Gustave Caillebotte, 1848–1894. Paris: Réunion des Musées Nationaux, 1994.
Johnson, Deborah. "Confluence and Influence: Photography and the Japanese Print in 1850," in *The Rise of Landscape Painting in France: Corot to Manet,* ed. Kermit S. Champa. Manchester, N.H.: The Currier Gallery of Art, 1991.
Varnedoe, Kirk, and Thomas P. Lee, eds. *Gustave Caillebotte: A Retrospective Exhibition.* Houston: The Museum of Fine Arts, 1996.

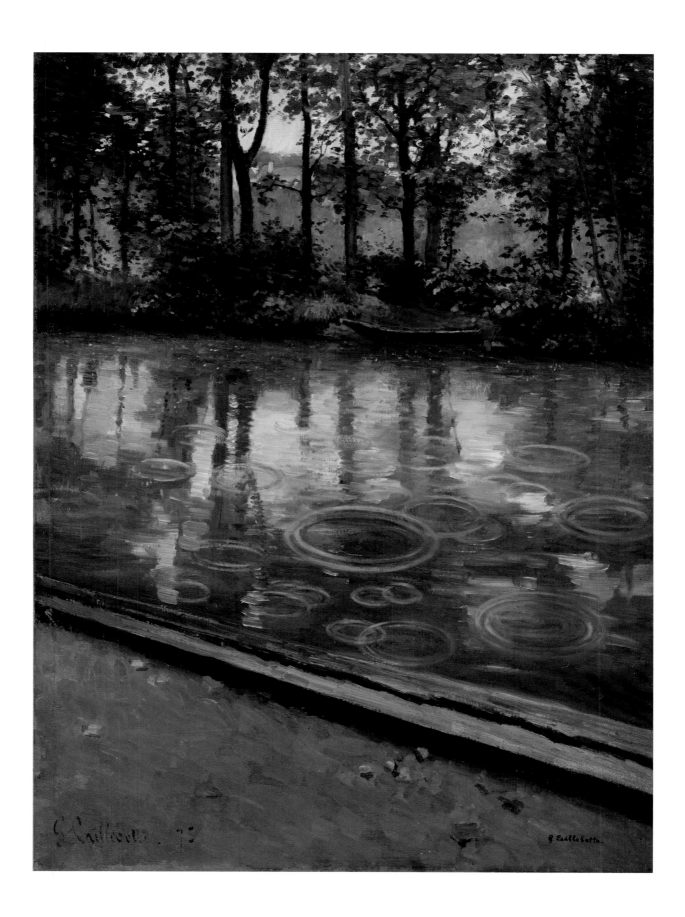

Theodore Clement Steele
American, 1847–1926

The Boatman, 1884
Oil on canvas
37 1/2 x 35 1/2 in. (95.2 x 115.5 cm)
Gift of Hubert L. Collins, M.D., and his wife Cordelia A. Collins, R.N., 2005.31

Aside from five years in Germany, Theodore Clement Steele spent most of his life in Indiana, working in Indianapolis, Nashville, and Bloomington. Although best known for his Impressionist landscapes of the rural Indiana countryside, Steele embraced Impressionism relatively late in his career, in the 1890s. *The Boatman*, reflecting the conservative style taught at European art academies, is, however, Steele's most important work from his student years in Munich.

Steele enjoyed a successful career as a portraitist in Indianapolis during the 1870s, but opportunities for further artistic training and advancement were limited. Until the late nineteenth century, American artists had little choice but to travel to Europe for rigorous training in draftsmanship and painting, and many chose the highly regarded German academies. By the 1870s the Royal Academy of Fine Arts in Munich had become the most popular choice for American students because of its prestige, quality of instruction, and large enrollment of non-German students. In 1880, after raising funds with the help of friends and patrons in Indianapolis, Steele and his family traveled to the Bavarian capital, where he enrolled at the Royal Academy.

Students at the Royal Academy undertook a rigorous course of study, focusing on figure drawing. Steele enrolled in the life drawing class of Gyula Benczúr, an Hungarian instructor reputed to be the most demanding drawing professor at the academy. In Benczúr's life-drawing class, students drew exclusively from models employed from the local population. The emphasis was on drawing their heads, concentrating on line and contour. Steele commended this method of teaching, writing, "This system of drawing touches me just where I am the weakest and will no doubt be of the greatest benefit."[1]

Steele's work at the academy, like that of his colleagues, reflects little of the social reality of late-nineteenth-century Germany. Political unification, rapid industrialization and urbanization, and the anti-Semitism that was increasingly poisoning German culture made little impact on the artistic output of the conservative academy, and it was only in the 1890s that alternative, "modern" styles and modes of instruction became common in Germany.

In the academy of the 1880s, the artistic traditions of sixteenth- and seventeenth-century Germany and Holland were emulated: Dürer's and Holbein's attention to line and contour, and the bravura brushwork and chiaroscuro of Rembrandt and Frans Hals were especially valued. Students at the academy attended lectures on art history and anatomy, and, although Steele, with his bad ear for German, admitted to learning little from the art history lectures, he absorbed these artistic traditions through his visits to the Alte Pinakothek Museum, where he copied the Old Masters. The anatomy lectures had a greater impact on him, as he was able to observe anatomical charts, drawings, and, in all probability, actual dissections of cadavers, a standard feature of nineteenth-century art academies.

The academy's attention to anatomy, art history, and draftsmanship converged in the final project undertaken by advanced students: the completion of a large-scale exhibition work. Steele's painting *The Boatman*, his final exhibition piece, was displayed during the summer of 1884 at the academy's annual student salon. This highly polished, carefully rendered work was awarded the coveted silver medal by the school's faculty. Although the academy hoped to purchase the painting for its own collection, Steele declined the honor, and in 1885 he brought the painting home to Indiana, where it probably entered the collection of his patron, Hermann Lieber.

The muted palette of grays and browns and strong chiaroscuro in this image of an elderly rower seated in a small boat are suggestive of the work of the seventeenth-century Dutch masters who were emulated at the academy. The wiry old man leans back, his face turned away from the viewer, the strain of his labor reflected in his prominently veined, muscular arms and knobby hands. Although ostensibly depicted in motion, the figure seems curiously still. The backlighting of the painting suggests an artificial source of interior light. Steele worked from a model in the studio, prepared his figure studies, and completed his painting entirely indoors. His decision to depict his model as a peasant boatman reflects the popularity of rustic, peasant subjects in German genre painting of the period as well as the emphasis placed on noncontroversial, marketable subjects by academy professors.

Further Reading
Gerdts, William H. *Theodore Clement Steele: An American Master of Light.* New York: Chameleon Books, Inc.; published in association with Evansville Museum of Arts & Science, Evansville, Indiana, 1995.
Krause, Martin. *The Passage: Return of Indiana Painters from Germany, 1880–1905.* Indianapolis: Indianapolis Museum of Art in association with Indiana University Press, 1990.
Lenman, Robin. *Artists and Society in Germany 1850–1914.* Manchester and New York: Manchester University Press, 1997.
Quick, Michael, and Eberhard Ruhmer. *Munich and American Realism in the Nineteenth Century.* Sacramento, Ca.: E. B. Crocker Art Gallery, 1978.

Note
1. Letter to Dr. William B. Fletcher, February 1881. Quoted in Judith Vale Newton and William H. Gerdts, *The Hoosier Group: Five American Painters* (Indianapolis: Eckert Publications, 1985), 58.

José María Velasco
Mexican, 1840–1912

Valley of Mexico from the Tepeyac (Valle de México desde el Tepeyac), 1895
Oil on canvas
18 x 24¹/₂ in. (47.5 x 62.2 cm)
Morton and Marie Bradley Memorial Collection, 75.117.1

José María Velasco was born in Temascalcingo, a town not far from Mexico City, to a family of rebozo (shawl) weavers. Velasco knew from an early age that he wanted to be an artist, and he enrolled in the Academy of San Carlos in Mexico City in 1858, at the age of eighteen. Studying there with the Italian painter Eugenio Landesio, Velasco decided to specialize in landscape painting. Landesio taught Velasco to observe nature carefully and to practice a meticulous style of draftsmanship. Velasco also had a strong interest in the natural sciences, and he considered geological and botanical knowledge just as crucial for a landscape painter as knowledge of human anatomy was for painters of the human figure. Along with his fine arts training, Velasco enrolled in courses in zoology and botany. He later became the president of the Mexican Society of Natural History and in 1906 was commissioned to paint murals for the National Institute of Geology in Mexico City.

Velasco had put his studies of botany and natural science to good use in 1869, illustrating a volume on the flora of the Valley of Mexico, and from the 1870s this valley around Mexico City became one of the most important and popular subjects in Velasco's oeuvre.[1] In the 1890s he painted nine practically identical views of the Valley of Mexico. All depict a path leading to the Villa de Guadalupe (where Velasco lived), with figures—different in each painting—in the foreground. The Lake of Texcoco, snow-capped mountains, and volcanoes form the background. Mexico City is laid out on the flat valley floor in the middle ground. Although characterized today by sprawl and congestion, Mexico City in the 1890s, as portrayed by Velasco, blended subtly into its natural surroundings. Velasco's notes indicate that he painted two of the nine paintings outdoors on-site, and that the others were copies made in the studio. Like many nineteenth-century painters, Velasco often painted copies or variations of his most popular works for various buyers.

On the inventory Velasco compiled of his paintings, he described the IU Art Museum's painting, which he titled *Valley of Mexico from the Tepeyac,* as portraying a shepherd with three sheep descending the shaded foreground path. He noted that he painted it outdoors, on the hill of Tepeyac, which overlooks the Valley of Mexico.[2] Two similar paintings, modeled on the IU Art Museum's, were painted in 1895 and 1900. The IU Art Museum's painting is the only one of Velasco's nine similar 1890s views of the Valley of Mexico to depict a shepherd in the foreground.

Despite Velasco's note that he had painted *Valle de Mexico desde el Tepeyac* "on-site," according to his great-granddaughter, he actually altered the perspective and many other elements of the landscape on his canvas.[3] His interest in accurately representing geology and topography merged in these paintings with his desire to create idealized, almost classical, landscape vistas. Velasco emphasized the clarity of the atmosphere by portraying even distant features of the landscape with sharpness and precision. Rather than allowing the background to recede into a haze, Velasco, with the aid of binoculars, painted every element of the vista with the same meticulous attention to detail. The stillness and quietude of this landscape encourage a meditative mode of contemplation, perhaps reflective of Velasco's strong sense of God's spirit in nature.

Velasco was celebrated for his landscapes, winning numerous awards and exhibiting his work not only in Mexico, but also in Europe and the United States. Today, Velasco is perhaps best known as one of Diego Rivera's instructors at the Academy of San Carlos. The majority of Velasco's paintings remain in Mexico, as his work was declared Mexican national patrimony in 1943. Although a number of private collectors from the United States and Europe purchased or commissioned work from Velasco in the late nineteenth century, *Valley of Mexico from the Tepeyac* is a rare example of a Velasco painting in a United States public collection.

Further Reading
José María Velasco 1840–1912. San Antonio: Instituto Cultural Mexicano; Austin: Museum of Art of the University of Texas, Austin, 1976.
Moyssén, Xavier. "Cuadros de José María Velasco en colecciones europeas y norteamericanas." In *Mexico en el Mundo de las Colecciones de Arte,* ed. María Luisa Sabau García. Mexico, 1994.

Notes
1. José María Velasco, *La flora del Valle de México* rev. ed. (1869; facsimile edition) with an introductory text by Elías Trabulse (Toluca: Instituto Mexiquense de Cultura, 1991).
2. "Original Landscape Paintings by José Maria Velasco," in María Elena Altamirano Piolle, *National Homage: José María Velasco*, vol. II (Mexico City: Museo Nacional de Arte, 1993), 514.
3. Piolle, op. cit., 412.

Edmund C. Tarbell
American, 1862–1938

*A Girl Mending,** 1905
Oil on canvas
30 1/8 x 25 1/4 in. (76.5 x 64 cm)
Morton and Marie Bradley Memorial Collection, 75.122

In a 1906 interview, Edmund C. Tarbell selected two recently completed paintings as his most successful works to date: *A Girl Crocheting* and *A Girl Mending*.[1] Illustrations of these two paintings were also paired in a 1909 article on Tarbell's recent work by the artist Kenyon Cox, who suggested that some of Tarbell's finest draftsmanship was to be found in his rendering of the head of *A Girl Mending*.[2] When *A Girl Mending* debuted at the critically acclaimed *Ten American Painters* exhibition in 1906 at New York's Montross Gallery, one critic wrote, "If it contained nothing besides J. Alden Weir's portrait of 'A Gentlewoman' and Edmund C. Tarbell's 'A Girl Mending,' the show would have been noteworthy."[3]

A Girl Mending is indeed among the most important paintings donated to the Indiana University Art Museum by one of its great benefactors, Morton C. Bradley, Jr. Bradley, a Boston art collector and restorer, had family ties to Andrew Wylie, the first president of Indiana University. Between 1957 and his death in 2004, Bradley donated a vast collection of nineteen- and early-twentieth-century American art to the museum. He scoured estate auctions, antique shops, and galleries in the Boston area to amass his collection, acquiring works by a range of New England artists, such as Tarbell.

Tarbell, whose family had roots in Massachusetts dating back to the mid-seventeenth century, was born in West Groton. He decided to become an artist at the age of ten and studied at the Boston Museum School and in Paris at the Académie Julian. Although Tarbell adopted the fashionable Impressionist style in France, he was also profoundly affected by the seventeenth-century Dutch paintings he saw in European museums. The style of his mature work from the early twentieth century has, in fact, been dubbed "Vermeerian Impressionism."[4]

At the turn of the last century, artists and collectors in New England led a revival of interest in the Delft painter Johannes Vermeer (1632–1675). Vermeer's work represented for them the values and culture of the so-called Dutch Golden Age of the seventeenth century, which was seen as analogous to the Protestant, mercantile culture of colonial New England.[5] Tarbell was attracted to Vermeer's work primarily because of the Dutch artist's handling of natural light, in which he bathed each object and thus bound together his compositions. Tarbell strove as well to make natural light the unifying element in his paintings of interiors. Kenyon Cox linked the aesthetics and attention to light in Tarbell's and Vermeer's work in his 1909 article: "There is the same simplicity of subject, the same reliance on sheer perfection of representation—the same delicate truth of values, the same exquisite sensitiveness to gradations of light."[6]

A mood of calm orderliness and domesticity defines the work of both Tarbell and Vermeer, and there are revealing compositional parallels between their paintings as well. In 1905, Tarbell began a series of paintings of solitary women in tasteful interiors, engaged in domestic tasks such as crocheting, mending, sewing, or reading. In *A Girl Mending,* the model, dressed in a lilac kimono, sits next to an antique gateleg table, concentrating intently on her work. An open door in the background leads to a hallway containing Asian art objects. The expanse of white wall behind the woman's head is unadorned but enlivened by the play of light from the windows and hallway.

Although the soft edges bespeak its Impressionist roots, this interior evokes Vermeer's paintings of simple, elegant rooms in which solitary women are engaged with letters, jewelry, and musical instruments. Often the figures in Vermeer's paintings are placed near a corner, and windows usually frame the left side of the composition—the same arrangement found in Tarbell's painting. The open door is another motif Tarbell borrowed from Dutch painting, particularly that of Pieter de Hooch. The maps, paintings, and recurring studio props that appear in Vermeer's paintings are echoed in Tarbell's frequent depiction of the gateleg table and Asian objets d'art, such as the porcelain vase, in his interiors. These objects add aesthetic interest to the scene and are also subtle markers of class and wealth—both Vermeer's Delft and Tarbell's Boston prospered through capitalist trade ventures in Asia, which ensured a luxurious lifestyle for the upper class.

Tarbell established himself as the leading Boston artist during his lifetime by inscribing his vision of upper-class life within the tradition of old master painting, and by fusing the spontaneity of Impressionism with careful attention to detail and craftsmanship.

Notes

* In the IU Art Museum's previous collection catalogue, this painting was published as *Portrait of Mrs. Rice,* ca. 1910. Subsequent research has shown the date to be 1905 and has not revealed evidence to confirm the identity of the sitter. The painting was published in 1906, 1907, 1912, 1915, and 1918 with the title *A Girl Mending.*
1. Adrian Margaux, "My Best Picture: No. VII—The Choice of Eminent American Painters," *Strand Magazine* 32 (December 1906): 566–67.
2. Kenyon Cox, "The Recent Work of Edmund C. Tarbell," *Burlington Magazine* 14, no. 70 (January 1909): 259.
3. "A Brace of New York Exhibitions," *Brush and Pencil* 17, no. 4 (April 1906): 141.
4. This term was coined by Patricia Jobe Pierce to describe Tarbell's style. See Pierce, *Edmund C. Tarbell and the Boston School of Painting 1889–1980* (Hingham, Mass.: Pierce Galleries, Inc., 1980), 90, 112–15.
5. Arthur K. Wheelock, Jr., and Marguerite Glass, "The Appreciation of Vermeer in Twentieth-Century America," in *The Cambridge Companion to Vermeer,* ed. Wayne E. Franits (Cambridge: Cambridge University Press, 2001), 163–64.
6. Cox, op. cit., 259.

Maurice de Vlaminck
French, 1876–1958

Still-Life, 1905
Oil on canvas
21 7/8 x 25 5/8 in. (55.6 x 65.1 cm)
Jane and Roger Wolcott Memorial, Gift of Thomas T. Solley, 77.2
© 2007 Artists Rights Society (ARS), New York/ADAGP, Paris

Alexei von Jawlensky
Russian, active Germany,
1864–1941
Still-Life with Red Cloth,
1909
Oil on academy board
James S. Adams Collection,
Elizabeth G. Adams
Bequest, 81.31.21

Maurice de Vlaminck is regarded as one of the most important exponents of the short-lived Fauve movement. Vlaminck's exuberantly colorful paintings—the antitheses of traditional academic art—reflect his claim that an artist's work should mirror his personality. Proud of his working-class background, Vlaminck cared little for tradition and bourgeois manners. He was known for his dramatic personality, anarchist leanings, and anti-intellectual stance.

Vlaminck seems to have first considered taking up painting as a profession in 1900, when he met fellow artist André Derain, also a resident of Chatou. The two began painting together, and Derain introduced Vlaminck to Henri Matisse. Vlaminck did not publicly exhibit his paintings until the 1905 Salon d'Automne, an annual exhibition of modernist art in Paris. It was at this exhibition that Vlaminck, Matisse, and the other artists in their circle were dubbed "les fauves" (the wild beasts) by art critic Louis Vauxcelles. Despite his use of the epithet "wild beasts," Vauxcelles supported modernist art and would have appreciated the intense colors of the Fauve canvases: the high-keyed paintings of Vincent van Gogh, Georges Seurat, and Paul Gauguin had been exhibited in France throughout the 1890s, and critics saw Fauve painters as following the example of these modern masters. However, Fauve paintings also exuded an aura of youthfulness, partly through a greater simplification of form. Characterized as enfants terribles by critics who were less sympathetic to the movement than Vauxcelles, the young Fauve artists, like avant-garde artists throughout Europe, were indeed strongly interested in children's art and folk art. These interests are reflected in Vlaminck's reliance on primary colors and simple forms.

The IU Art Museum's painting is one of relatively few still-lifes by Vlaminck, who is best known as a landscape painter. However, he painted a number of still-lifes during the height of Fauvism in 1905 and 1906, the period when his use of color was at its most uninhibited. This *Still-Life* juxtaposes complementary colors—bright reds and contrasting greens—to infuse brilliance and excitement into ordinary subject matter. With its short brushstrokes and mosaic-like patchwork of pure color, the painting reflects the impact of Post-Impressionists van Gogh and Seurat, both of whom had received retrospectives in 1905 at the Salon des Indépendents in Paris. In his memoirs, Vlaminck wrote of his strong reaction to van Gogh's paintings: "I was so moved that I wanted to cry with joy and despair."[1]

Vlaminck was befriended by the art dealer Ambroise Vollard, who purchased all the works from his studio in 1906 and honored him with a one-man exhibition in 1910.[2] Vlaminck, a previously unknown artist, could now financially support himself through his painting, and his work could be seen regularly at exhibitions throughout Europe, thanks to Vollard's generous policy of lending work from his gallery. The international artistic atmosphere fostered by such progressive dealers as Vollard encouraged the development of the related Fauve, Expressionist, and Neo-Primitivist styles that emerged in the years prior to World War I in France, Germany, and Russia.

This cross-cultural artistic dialogue can be observed through a comparison of Vlaminck's *Still-Life* of 1905 with Alexei von Jawlensky's *Still-Life with Red Cloth* of 1909, also in the IU Art Museum's collection. Jawlensky, a Russian artist who lived in Munich and was associated with the Blaue Reiter Expressionist group, enthusiastically adopted a Fauve approach to painting after participating in the 1905 Salon d'Automne, where the Fauves made their debut. The similarities between the two still-lifes are striking—both employ the color red as a dominant compositional element, use a similar tipped-up perspective and compressed space, and employ a similar assortment of flowers, vases, and cups as subject matter.[3]

Further Reading
Herbert, James D. *Fauve Painting: The Making of Cultural Politics*. New Haven and London: Yale University Press, 1992.
Rabinow, Rebecca A., ed. *Cézanne to Picasso: Ambroise Vollard, Patron of the Avant-Garde*. New York: Metropolitan Museum of Art, 2006.
Vlaminck and His Fauve Period. New York: Perls Galleries, 1968.

Notes
1. Quoted in Ellen Oppler, *Fauvism Reexamined* (New York and London: Garland Publishing, 1976), 111.
2. Jacquelin Munck, "Vollard and the Fauves: Derain and Vlaminck," in Rebecca A. Rabinow, ed., *Cézanne to Picasso: Ambroise Vollard, Patron of the Avant-Garde* (New York: Metropolitan Museum of Art; New Haven and London: Yale University Press, 2006), 124. The exhibition, *Peintures et faïences décoratives de Vlaminck*, was held March 15–26, 1910. It is possible that the IU Art Museum's *Still-Life* was included in this exhibition. Catalogue numbers 7, 18, and 35 are all titled *Nature morte*.
3. Similarities between Vlaminck's 1905 still-lifes and Jawlensky's work were also noted by John Elderfield in the 1976 Fauve exhibition at the Museum of Modern Art: John Elderfield, *The "Wild Beasts": Fauvism and its Affinities* (New York: Museum of Modern Art, 1976), 143. The year before it was acquired by the IU Art Museum, this Vlaminck *Still-Life* was displayed in this exhibition. It is reproduced on page 146 of the catalogue.

Robert Henri
American, 1865–1929

Portrait of Edith Haworth, April 1909
Oil on canvas
31 ⁷/₁₆ x 25 ¹/₂ in. (79.9 x 64.8 cm)
76.55

Modernity and the urban experience were important themes for Robert Henri, whether he was painting portraits or scenes of city life. His stylistic spontaneity (achieved through quick execution and sketchy, bravura brushwork) and portrayal of contemporary people, scenes, and events infuse Henri's work with the spirit of early twentieth-century America. The leader of a group of American artists known as the Ashcan school, Henri stressed the need to directly confront urban life and to move away from the idealized imagery promulgated by academic teaching. At the same time, an almost romantic excitement for modern life, with its complexity and rapid pace, characterizes much Ashcan painting.

Born during the final year of the Civil War and dying the year of the stock market crash, Henri lived during an era of rapid change and modernization in the United States. Railroads and industry transformed the American landscape, while waves of immigrants gave new character to the nation's growing cities. American urban culture, defined largely by New York City, took on a new identity during this period—often called the progressive era—and fostered the growth of social reforms; the expansion of an urban infrastructure built on mass transit, consumer culture, and architectural innovation (such as skyscrapers); and the development of modern art.

Although Henri received a traditional academic education at the Pennsylvania Academy of Fine Arts and in Paris at the Académie Julian and with the French academician William-Adolphe Bougeureau, he rebelled against academic structure and establishment in the early twentieth century, instead promoting artistic independence and modernization. In 1908 Henri, although a member of the National Academy of Design in New York, helped to organize an independent exhibition at the Macbeth Galleries. The artists in the exhibition became known as the Eight, and the group was later labeled the Ashcan school for their preference for gritty, urban, working-class subjects. Many of the artists associated with the Eight began their careers as newspaper illustrators and thus lacked an extensive background in the traditional fine arts. Rejecting aestheticism and refinement in their painting, they brought a journalistic awareness of everyday life to their work. Henri's break with academic traditionalism proved inspirational to the American organizers of the 1913 Armory Show, the first large-scale exhibition of European modern art in the United States. Henri also disseminated his ideas by teaching in Philadelphia and New York.

Henri's portrait of Edith Haworth, which was painted in just one and a half hours, presents Haworth, a fellow artist, as a modern, self-assured woman. Haworth was one of Henri's students, probably at the New York School of Art, where he taught from 1900 to 1908.[1] After Henri opened his own school in 1909 (the Henri School of Art) Haworth became the monitor of the portrait class.[2] She was bound for Europe in April of 1909 when she stopped into Henri's New York studio to say good-bye and found herself the subject of a portrait by her former teacher.

Henri had a special affinity for the genre of portraiture. He forged relationships with his sitters, to whom he affectionately referred as "my people," and he sought to express something individual about each sitter's personality in his paintings. Although he often found sitters during his travels in Europe and the United States, he also engaged his friends, family, and acquaintances such as Haworth as models on a regular basis. While Henri had focused on life-size, full-length portraits in a style derived from old masters such as Velazquez during the first years of the twentieth century, his increased teaching responsibilities around 1909 led him to adopt a smaller format and more informal style of portraiture, as well. The loose, slashing brushstrokes and Haworth's casual pose reflect Henri's spontaneity in creating this painting. Haworth glances over her shoulder and seems to be shifting her pose; her movement and informality suggest the rapid pace of modern life and Haworth's own busy life as integral elements of her personality.

Further Reading
Zurier, Rebecca, et al. *Metropolitan Lives: The Ashcan Artists and Their New York.* Washington, D.C.: National Museum of American Art, in assoication with W. W. Norton, 1995.

Notes
1. Marian Wardle, ed., *American Women Modernists: The Legacy of Robert Henri, 1910–1945* (New Brunswick, N.J.: Rutgers University Press, 2005), 201.
2. Bernard B. Perlman, *Robert Henri: His Life and Art* (New York: Dover Publications, Inc., 1991), 91.

Aristide Maillol
French, 1861–1944

Ile de France, 1925
Bronze
H. 65 in. (165 cm)
Given in memory of Henry Radford Hope (1905–1989) by his wife,
children, and grandchildren, 89.14
© 2007 Artists Rights Society (ARS), New York/ADAGP, Paris

Born in southwest France near the Spanish border, Aristide Maillol hailed from a peasant background and grew up in a rural culture isolated from cosmopolitan Paris. Against the wishes of his family, he made his way to Paris at the age of twenty to begin his artistic career. First working as a painter and tapestry designer, he turned to sculpture in the late 1890s due to deteriorating eyesight. Disenchanted with the academic sculpture of late-nineteenth-century France, Maillol belonged to a generation of young artists eager to create a modern sculptural aesthetic. Although Maillol remained committed to depicting recognizable forms, his engagement with avant-garde painting during the 1890s prompted him to approach sculpture with a fresh, modern eye. Unlike his predecessors, Maillol was more interested in form than narrative or literary allusion: "My point of departure is always a geometric figure…because those are the shapes which stand up best in space."[1]

Maillol's sculpture is defined by stability and equilibrium, which he achieved through a strict adherence to geometric precepts. Through this architectonic interpretation of the human body and the simplification of its forms and gestures, Maillol created sculpture that was both modern in its emphasis on form, and classical in its symmetry and balance. Maillol's reliance on geometry can be seen clearly in *Ile de France,* in which the form of the striding woman is inscribed within an invisible triangle or rectangle (depending on the angel from which the sculpture is viewed).[2]

Maillol's sculptures of female nudes—the predominant theme in his oeuvre—blend classical and modern aesthetics in other ways as well. On a trip to Greece in 1908, Maillol found the ancient Greek celebration of the idealized nude figure congruent with his own sculptural preferences. Likewise, he felt a sense of timelessness in Greek sculpture that he too sought in his own work. To achieve this enduring quality, Maillol abandoned all references to historicity, anecdote, or overt symbolism, instead drawing inspiration abstractly from the landscape—primarily the Mediterranean coast, but also the region around Paris, where he had a summer home. The *Ile de France* takes its name from the place of its creation, the geographical region encircling Paris. Because the nude is a bather, holding a towel behind her back, Maillol may have intended a reference to the Seine River, which flows through this region.

Maillol had begun work on the *Ile de France* as early as 1910, at first conceiving of the piece as the torso of a girl walking in the water. By 1925, he had finally completed the full-length version of the sculpture. In the bronze cast, the nude woman strides forward confidently, much as the *Ile de France* region could be characterized as confident and proud of its cosmopolitanism, historical prominence, and cultural importance.

Maillol's sculpture played a significant role in the development of the collections of the Indiana University Art Museum. In January 1955, James S. Adams, an Indiana University alumnus, purchased a terracotta torso by Maillol from the Curt Valentin Gallery in New York and presented it to the university's fine arts department. This impressive donation spurred Henry Hope, the department's chairman, to begin seriously seeking out major pieces in order to build a museum collection. Of the Maillol torso donated by Adams, Hope later recalled: "This gift, which would be welcomed by any museum, had a personal meaning to me, for it turned out to be the torso version of Maillol's *Ile de France,* the full figure in bronze being in our private collection.[3]

The life-size bronze *Ile de France* was one of Hope's major sculpture acquisitions for his private collection. The bronze, purchased from Curt Valentin in 1948, is the fourth of seven casts of the *Ile de France* made at the Paris foundry of Alex Rudier.[4] Hope had seen the sculpture while in Paris in 1948, and Valentin agreed to acquire it for him. It was featured in an exhibition of the Hopes' collection at the Cincinnati Museum of Art in 1949, and then placed in the Hopes' garden. Sarahanne Hope, Henry's widow, donated the sculpture to the Indiana University Art Museum in 1989. Today it stands in the museum's atrium, gazing at the spot where Henry Hope died in 1987 while giving a speech during a celebration of his and Sarahanne's contributions to Indiana University.

Further Reading
Aristide Maillol, 1861–1944. New York: Solomon R. Guggenheim Museum, 1975.
Lorquin, Bertrand. *Aristide Maillol.* Geneva: Skira, in association with Thames & Hudson, London, 1995.
Solley, Thomas T., and Constance Bowen. *The Hope Collection: Selections from the Twentieth Century.* Bloomington: Indiana University Art Museum, 1982.

Notes
1. Quoted in John Rewald, "Maillol Remembered," in *Aristide Maillol, 1861–1944* (New York: Solomon R. Guggenheim Museum, 1975), 16.
2. Noted by Kathleen A. Foster, "Maillol: Sculpture and Drawings in the Indiana University Art Museum," brochure (Bloomington: IU Art Museum, n.d.).
3. Henry R. Hope, "The Indiana University Art Museum," *Art Journal* 30, no. 2 (Winter 1970–71): 170.
4. Letter from Curt Valentin to United States Customs, September 14, 1948. Curt Valentin Papers, Museum of Modern Art Archives, CV.III.B.9.

Ernst Ludwig Kirchner
German, 1880–1938

Boats on the Elbe near Dresden, 1910 (reworked ca. 1920)
Oil on canvas
24 ³/₈ x 34 ³/₄ in. (62 x 88 cm)
Jane and Roger Wolcott Memorial, Gift of Thomas T. Solley, 75.34
© Ingeborg & Dr. Wolfgang Henze-Ketterer, Wichtrach/Bern

Ca. 1920 photograph of *Boats on the Elbe* in its original state. Courtesy of the Kirchner Museum, Davos, Switzerland.

Ernst Ludwig Kirchner was a recent graduate of the architecture program at the Königliche Technische Hochschule in Dresden when he, along with fellow students Erich Heckel, Karl Schmidt-Rottluff, and Fritz Bleyl, founded the group they named Kunstlergruppe Brücke (Artists' Group Bridge). The Brücke, with Kirchner as its leader, was a major force in the development of German Expressionism.

Although Kirchner lived in Dresden until 1911, the city appears infrequently in his paintings of this period, as he preferred the informality of his studio and the Saxon countryside to the city's grandeur. Prior to its destruction in World War II, Dresden was thought of as the "Florence on the Elbe" for its baroque skyline and graceful streets. When Kirchner did paint the city, the Elbe River often served as a focus for his works, as in *Boats on the Elbe*.

The outbreak of World War I changed the course of Kirchner's life dramatically. Already showing signs of mental instability, he was declared unfit for the battlefield but suffered a war-induced nervous breakdown nevertheless. Kirchner's condition led him to relocate in 1917 to Davos, Switzerland, which was known for its sanatorium and health-care facilities. In the early 1920s Kirchner, perhaps due to these changes in his life, not only began developing a new style, but also revisited many of the works he had painted before the war, photographing them and, in some cases, partially repainting them. Of his prewar paintings, Kirchner most extensively reworked *Boats on the Elbe*.[1] A photograph taken prior to the repainting reveals that he added the figure of the boatman and changed numerous details throughout the composition. The result of Kirchner's re-working of the painting is a more animated composition, focused on the life and movement of the river. The existence of an early photograph of *Boats on the Elbe* provides a rare glimpse into the working methods of an artist and his reevaluation of early work.[2]

International modernism had played an important role in the development of Kirchner's style around 1910. The vividly contrasting colors and large, flat shapes offset by heavy black outlines used by Edvard Munch impressed Kirchner greatly. These stylistic elements are especially prominent in the early version of *Boats on the Elbe,* which focuses on the rough forms of boats and houses but includes no human figures. Although, like Munch, Kirchner incorporated a large amount of black into *Boats on the Elbe,* he also admired Matisse's use of bright color. Yet, the vivid colors in *Boats on the Elbe,* though a response to the exuberance of Fauvism, are more acidic and

jarring than anything produced by Matisse and his circle. *Boats on the Elbe* reflects a synthesis and exaggeration of the styles of Munch, the Fauves, and other modernists. The early version of *Boats on the Elbe* has a distinctly sketchy quality, reflecting Kirchner's technique in 1910 of painting with oil paint heavily thinned with turpentine.[3] This method allowed him to brush large amounts of pigment onto the canvas quickly, achieving a sense of spontaneity and immediacy in his work. This sense of sketchiness is somewhat reduced in the painting's final version due to the added layers of paint and more carefully delineated details.

Kirchner continued to paint prolifically during the two decades he spent in semi-seclusion in Switzerland. However, when the Nazis seized 639 of his works in Germany—displaying 32 pieces in the infamous *Degenerate Art* exhibition of 1937—Kirchner's mental condition worsened, and in 1938 he committed suicide. *Boats on the Elbe,* still in Kirchner's possession at the time of his death, was first exhibited publicly in 1950 in Switzerland. Its extensive compositional and stylistic evolution make it unusual in Kirchner's oeuvre as a work that fully bridges his Dresden and Swiss periods.

Further Reading
Lloyd, Jill, and Magdalena M. Moeller, eds. *Ernst Ludwig Kirchner: The Dresden and Berlin Years.* London: Royal Academy of Arts, 2003.

Notes
1. Donald Gordon, *Ernst Ludwig Kirchner* (Cambridge, Mass.: Harvard University Press, 1968), 463, n. 59.
2. I would like to thank Dr. Wolfgang Henze, curator at the Ernst Ludwig Kirchner Archiv in Bern, and Dr. Roland Scotti of the Kirchner Museum in Davos for their help in locating this photograph, which has never been published before.
3. Gordon, op. cit., 64.

August Macke
German, 1887–1914

Forest Stream (Waldbach), 1910
Oil on canvas
24 ¹/₄ x 24 ¹/₈ in. (61.5 x 61.2 cm)
Partial gift of the Robert Gore Rifkind Collection, 78.67

August Macke painted this brightly colored image of a forest stream near the Bavarian lake, Tegernsee, where he lived during 1910. Working intensively for a year in the rural environs of the Tegernsee, Macke developed his own style, its vibrant palette and forms evidence of the impact of Fauvism. Macke had studied at the academy in Düsseldorf in 1904 and with the painter Lovis Corinth in Berlin in 1907, but his trips to Paris in 1905 and 1909 had the greatest impact on his approach to form and color in painting. In Paris, and again at a 1910 exhibition in Munich, Macke was able to view the work of Henri Matisse and the Fauves, whose bold colors and simplified forms appealed to him. Like most of Macke's works painted during the Tegernsee period, *Forest Stream* has a balanced composition, a harmonious palette, and a stable, geometric structure. The forked branches of the trees echo the fork of the stream, which bisects the image. Foliage, moss, and underbrush are indicated by broadly brushed patches of yellow, green, and orange, which suggest the mass and volume of the bank of the stream.

Despite his avant-garde style, Macke chose traditional subject matter in his paintings, focusing on landscape, still-life, and portraiture. This painting of a forest landscape is heir to a tradition reaching back to the work of the early-nineteenth-century German Romantic artists, yet it provides a fresh, modern vision of nature. While nineteenth-century industrialization and urbanization brought about the formation of the modern German state, launching the nation into world-power status, modernization also engendered deep feelings of nostalgia for the past and for the rural landscape. Numerous Romantic paintings, by artists such as Caspar David Friedrich, had presented the forest as a mysterious, evocative locale, sheltering ruins of Gothic churches or prehistoric burial mounds. By the early twentieth century, however, the quiet and solitude of the forest was perceived as a wholesome antidote to the hectic pace of urban life. Influential health and youth movements—which advocated nudism, vegetarianism, and long walks in nature—construed the German forest as a site of health and well-being. Fueled by the popular youth movement known as the Wandervogel, which encouraged urban youths to pursue outdoor activities to reconnect with the natural world, hiking in the woods had become an increasingly popular pursuit in early-twentieth-century Germany.

Macke, only twenty-three years old in 1910, would have been aware of this youth movement's tenets and other similar currents in German culture at the time. Macke's landscape paintings, as products of this cultural milieu, typically depict a benign and harmonious vision of nature. Indeed, *Forest Stream,* with its close-up, cropped view of the stream, recalls not the Romantic artist's awe of nature, but a hiker's point of view. Rather than affording an expansive, panoramic view over the woods, Macke's almost claustrophobically cropped composition reminds one of the more limited perspective that a hiker, intent on footing and following a trail, has of the forest.

The Bavarian lake district, where the Tegernsee is located, is easily accessible from Munich and had become a popular resort area in Macke's time. Surrounded by the Alps and dotted with picturesque villages, southern Bavaria was also home to several artists' colonies, such as Dachau and Murnau. In these colonies, artists worked en plein air (outdoors), producing quickly painted canvases that captured their internal responses to the landscape. Although Macke developed his distinctive style independently, it paralleled the aesthetic experimentation of Wassily Kandinsky, Alexei von Jawlensky, Gabriele Münter, Franz Marc, and other Munich-based Expressionist artists who spent summers in Murnau. In 1911 these artists, some of whom had been painting together informally since 1908, banded together to form the group known as the Blaue Reiter (Blue Rider), one of the primary proponents of German Expressionism. Macke, who had made Franz Marc's acquaintance in 1910, was invited to contribute to the *Blaue Reiter Almanach,* a compilation of theoretical writings by both German and foreign artists on art and spirituality. Although Macke did not share Kandinsky's belief that art was a conduit of spirituality and mysticism, he exhibited with the Blaue Reiter in 1911 and 1913. *Forest Stream,* however, was first shown in a solo exhibition devoted to Macke in Frankfurt in 1913. *Forest Stream* appeared with paintings by other Blaue Reiter artists in 1915 at the avant-garde Sturm Gallery in Berlin. This was a posthumous exhibition for Macke, who had died at age twenty-seven on a battlefield in France near the start of World War I.

Further Reading
Auguste Macke und die Frühe Moderne in Europa. Münster: Westfälisches Landesmuseum für Kunst und Kulturgeschichte; Bonn: Kunstmuseum, 2002.
Zweite, Armin. *The Blue Rider in the Lenbachhaus, Munich.* Munich: Prestel, 1989.

Emil Nolde
German, 1867–1956

Nudes and Eunuch (Keeper of the Harem) *(Akte und Eunuch [Haremswächter])*, 1912
Oil on canvas
34 3/8 x 28 3/8 in. (87.3 x 72 cm)
Jane and Roger Wolcott Memorial, Gift of Thomas T. Solley, 76.70
© Nolde Stiftung Seebüll

In contrast to the lavish and erotic paintings of harem scenes popular in the nineteenth century, Emil Nolde's *Nudes and Eunuch (Keeper of the Harem)* portrays figures with roughly delineated bodies in awkward poses. The figures' striped and patterned pants reveal Nolde's interest in the bold and simple design characteristic of Expressionist graphics. In choosing to paint an "exotic" scene, Nolde revealed his interest—shared with the Expressionist Brücke group (he formally joined the Brücke group in 1906, a year after it was founded)—in the art of non-Western cultures, particularly those of sub-Saharan Africa and the South Pacific, where Germany had several colonies. Indeed, Nolde visited German New Guinea in 1913 to see Oceanic art.

Nolde was born into a conservative and deeply religious family in the north German province of Schleswig-Holstein near the Danish border, and his embrace of cutting-edge modernism and non-Western art could not have been predicted. He had trained as a woodcarver and furniture designer before turning his attention to painting. After studying painting in Munich and Paris around the turn of the century, Nolde developed his intensely personal and distinctive style, characterized by his use of bright color, simplification of form, energetic brushwork, and exotic subject matter. Through vigorous brushwork and garish color combinations, as seen in *Nudes and Eunuch,* Nolde and the other Expressionist artists sought to infuse their work with the dynamism and energy they perceived in non-Western art.

A consideration of *Nudes and Eunuch's* reception and treatment during the Weimar Republic (1918–33) and the Third Reich (1933–45) sheds light on the complexity of twentieth-century German reactions to Expressionism. When Nolde painted *Nudes and Eunuch* in 1912, Expressionism was flourishing in major German cities, promoted by artists' societies, exhibitions, and journals. Before World War I, *Nudes and Eunuch* appeared in several important exhibitions, and by 1918 it was in the collection of Herbert von Garvens-Garvensburg, a distinguished author, collector, and gallery owner in Hannover.[1] In 1925 *Nudes and Eunuch* was purchased by the Staatliche Galerie Moritzburg in Halle. Alois Jakob Schardt, the director of the Galerie Moritzburg, devoted himself to building a stellar collection of contemporary German art during the Weimar years. Despite his devotion to the modern style of Expressionism, Nolde was politically conservative. When the Nazi Party came to power in 1933, Nolde, swayed by the party's commitment to German nationalism, joined the party—a decision he later regretted, as his own work was attacked by Nazi ideologues. He was astonished when the Nazis declared German Expressionism "degenerate." In the summer of 1937, Nazi officials, following the orders of Minister of Propaganda Josef Goebbels, destroyed collections of modern art by confiscating works they considered "degenerate." The Staatliche Galerie Moritzburg lost about two hundred modern paintings, Nolde's *Nudes and Eunuch* among them.

After enjoying his status as one of Germany's most important contemporary artists, with his work sought out by collectors and curators, Nolde suddenly found himself an artistic pariah. Not only was he forbidden to paint, but more than one thousand of his works were confiscated by the authorities. In the notorious *Degenerate Art* exhibition that opened in Munich during the summer of 1937, *Nudes and Eunuch* was prominently displayed, accompanied by a highly racist wall text. The purpose of the *Degenerate Art* exhibition was to mock modern art and to indoctrinate viewers into believing that such art was worthless, morally degenerate, and un-German.

After the close of the exhibition, *Nudes and Eunuch* languished in storage in Berlin for two years, until Nolde's brother-in-law, a Danish art dealer, schemed to retrieve some of Nolde's paintings from the Nazi government. Hitler's government attempted to sell the confiscated paintings for valuable foreign currency whenever possible, and because Nolde's brother-in-law was a Danish citizen, he was eligible to purchase "degenerate" paintings from Germany. (Because his last name was Vilstrup, his connection to Nolde was not directly evident.) Thus, with Nolde's consent, Aage Vilstrup purchased eleven confiscated paintings. He surreptitiously returned some to the artist, and sold the rest from his gallery in Denmark.[2] *Nudes and Eunuch* was sold to a Danish private collection, and in the postwar years was included in both Danish and German exhibitions that acknowledged Nolde's preeminence within the Expressionist movement. A gift to the IU Art Museum in 1976, *Nudes and Eunuch* is perhaps the most historically important work within the museum's strong German and Austrian Expressionism collection.

Further Reading
Barron, Stephanie, ed. *"Degenerate Art:" The Fate of the Avant-Garde in Nazi Germany.* Los Angeles: Los Angeles County Museum of Art, 1991.

Notes
1. The painting appeared in a solo exhibition devoted to Nolde at the Neue Kunstsalon in Munich in 1912, as well as in the first exhibition of the Neue Münchener Sezession in Munich in 1914.
2. Martin Urban, *Emil Nolde: Catalogue-Raisonné of the Oil-Paintings* (New York: Harper & Row, 1987–90), 12. I would like to thank Dr. Manfred Reuther, director of the Nolde-Museum, Stiftung Seebüll Ada und Emil Nolde, for confirming and clarifying aspects of this painting's World War II-era provenance for me in November 2004.

Alexei von Jawlensky
Russian, active Germany and Switzerland, 1864–1941

The Old Man (Yellow Beard), 1912
Oil on canvas
20 1/2 x 19 1/8 in. (52.1 x 48.6 cm)
Jane and Roger Wolcott Memorial, Gift of Thomas T. Solley, 75.14
© 2007 Artists Rights Society (ARS), New York/VG Bild-Kunst, Bonn

Alexei von Jawlensky believed in the mystical power of color. A blue aura encircles the head of Jawlensky's *Old Man,* while his yellow beard, green hair, and red face pulsate with pure, saturated color. In 1911 Jawlensky, who had previously painted mostly landscapes and still-lifes, turned his attention exclusively to the human form, particularly the face. These large figural paintings featured bright, nonnaturalistic colors. As he later wrote in his memoirs:

> I used a great deal of red, blue, orange, cadmium yellow and chromium-oxide green. My forms were very strongly contoured in Prussian blue and came with tremendous power from an inner ecstasy.…It was a turning point in my art. It was in these years, up to 1914 just before the war, that I painted my most powerful works.[1]

Painted in 1912, *The Old Man* belongs to the period Jawlensky himself considered one of his most important and creative. He worked on a series of large, colorful, icon-like heads in 1912, creating a variety of archetypal figures and faces. Painted in the Bavarian village of Oberstdorf, *The Old Man* is one of three paintings of a local gardener. In each work, this humble subject is transformed into an almost shamanic figure, radiant with the power of color, his rugged features acquiring a sense of wisdom and gravity.

Like his friend Vasily Kandinsky, Jawlensky was born in Russia to an upper-class family. After a stint at the St. Petersburg Academy of Art, he decided to leave behind a military career and move to Munich with his partner Marianne van Werefkin for further artistic training. Munich, which rivaled Paris as an artistic center, led the way in the formation of a Central European avant-garde when, in 1892, a group of progressive artists seceded from the conservative Münchener Künstlergenossenschaft, the city's primary exhibiting organization, in order to promote contemporary trends in art. Also in the 1890s, independent art schools, studios, and artists' groups were changing and modernizing the city's artistic scene. One of these schools was run by the Slovenian artist Anton Ažbe, who promoted a bold approach to the use of color in painting, instructing his students to apply unmixed colors to their canvases. In 1896 Kandinsky and Jawlensky both enrolled in Ažbe's school, where they became close friends.

Trips to France in 1905 and 1906 also proved important for the formation of Jawlensky's style. On these trips, he would have been exposed to the most avant-garde currents in French art; Matisse and the Fauves made their debut in 1905, and a major Gauguin retrospective was held in 1906. The strong, non-naturalistic hues, heavy outlines, and flat patches of color that characterize Fauvism and French Symbolism soon began to appear in Jawlensky's paintings.

Jawlensky spent the summers of 1908 and 1909 in Murnau, a small town in the Bavarian Alps, painting with Werefkin, Kandinsky, and Kandinsky's partner Gabriele Münter. In their landscapes, portraits, and still-lifes, the two couples developed the Expressionist style now associated with the Blaue Reiter (Blue Rider) group. The Blaue Reiter was founded by Kandinsky and Franz Marc in 1911, and although Jawlensky chose not to join the group formally, he participated in their exhibitions. As an exhibiting society, the Blaue Reiter maintained an exclusive focus on cutting-edge modern art. The group promoted artists whose work was stylistically forward-looking and nontraditional, but also concerned with the inner life and feelings of the individual artist.

In cultivating their inner lives through their art, the Blaue Reiter artists displayed great interest in the spiritualist theories of the early twentieth century, and in late 1911 Kandinsky's important treatise, *Concerning the Spiritual in Art,* was published. The Russian Orthodoxy that had shaped the childhood of the group's Russian members played a decisive role, as well, in their conception of art and color. Orthodoxy, noted for its use of religious icons, attached great importance to images and symbolic colors; thus the Blaue Reiter artists saw links between art, color, and spirituality. The icons of Russian Orthodoxy certainly provided a model for Jawlensky's heads, with their spiritual intensity, symbolic colors, and penetrating eyes. While gold was often favored as the background color in Russian icons, blue had a special significance to the Blaue Reiter. A deep Prussian blue, considered a spiritual and noble color, figures prominently in work by Kandinsky, Marc, and Jawlensky. This deep blue frames Jawlensky's *Old Man,* while providing a vivid contrast to the bright colors of his face.

Further Reading
Jawlensky, Maria, Lucia Pieroni-Jawlensky, and Angelica Jawlensky. *Alexei von Jawlensky: Catalogue Raisonné of the Oil-Paintings.* London: P. Wilson for Sotheby's Publications, 1998.
Zweite, Armin. *The Blue Rider in the Lenbachhaus, Munich.* Munich: Prestel, 1989.

Note
1. Translated in Clemens Weiler, *Jawlensky: Heads, Faces, Meditations* (New York: Praeger, 1971), 98.

Arthur G. Dove
American, 1880–1946

Connecticut River, 1912–13
Pastel on linen
17 3/4 x 21 5/16 in. (45.1 x 54.0 cm)
Jane and Roger Wolcott Memorial, 76.23

As one of the first American abstract painters, Arthur Dove contributed greatly to the development of American art. Born in upstate New York, Dove attended Cornell University, but he had little formal artistic training. He began his career as a magazine illustrator in New York, before traveling to France in 1908. During the eighteen months he spent in France, Dove was exposed to the new styles of Fauvism and Cubism, and he returned to the United States in 1910 with a fundamentally changed conception of painting. Shortly after his return, Dove created his first abstract works, a series of six oil studies, simply titled *Abstractions.* Around this time he also met the photographer and art dealer Alfred Stieglitz, whose support and influence encouraged Dove to continue his radical artistic experimentation.

Stieglitz gave Dove his first one-man exhibition in 1912, a show of his new abstract works in pastel, collectively titled *The Ten Commandments,* which depicted the essentialized forms from nature that provide the basis of Dove's abstract style. In the pastels in this show, Dove developed the essentialized natural forms that would become the basis of his abstract style, which he continued to develop and refine over the next decade in such works as *Connecticut River.* The composition of *Connecticut River* is a close translation of Dove's 1910 oil study *Abstraction No. 1.* In both works, river, trees, and other landscape forms are recognizable but highly stylized. The palette of *Connecticut River* is confined to earth tones (ochers, browns, greens, and blues) applied with Dove's handmade pastels, with the forms defined by sinuous black outlines.

In 1910 Dove moved with his wife and newborn son to a farm near Westport, Connecticut, but despite his choice to live outside of New York City, he remained closely attuned to the intellectual trends and artistic theories of the day. Westport was home to numerous writers and artists, including the novelist Sherwood Anderson and the photographer Paul Strand. Dove also read Stieglitz's journal *Camera Work,* which promoted avant-garde aesthetics and theories. Stieglitz published an excerpt from Wassily Kandinsky's 1912 essay *On the Spiritual in Art* in English translation soon after it was published, but he and Dove also read the treatise in the original German.[1] Kandinsky and his Blaue Reiter Expressionist group in Munich had a strong impact on the emergent American avant-garde. A painting by Kandinsky was first exhibited at the New York Armory Show in 1913, and his writings, which explain how abstract art can express inner feelings and spirituality—a concept previously considered the domain of musical composition—struck a chord with many of the artists in Stieglitz's circle.

A search for archetypal forms that could express both nature's appearance and the artist's inner life occupied Dove in works such as

Connecticut River. In one of his letters, to the collector Arthur Jerome Eddy, Dove explained how one of his paintings evolved:

> I chose three forms from the planes on the side of the trees, and three colors…From these was made a rhythmic painting that expressed the spirit of the whole thing. The colors were chosen to express the substance of these objects and sky."[2]

Dove sought to reconcile the material and spiritual worlds through the abstraction of natural forms, and throughout his career, his abstractions were rooted both in his experience of nature and in his desire to create a modernist American art. Just as the nineteenth-century Hudson River School painters turned to landscape to express a sense of national identity, so too did Dove and other members of the American avant-garde utilize the organic forms of nature in their quest to create a distinctively *modern* art with an American flavor. The American landscape, first interpreted by the artists of the Hudson River School based upon the Transcendentalist theories of Walt Whitman and Henry David Thoreau, found a modernist reinterpretation in Dove's paintings.[3] Transcendentalist beliefs that God is present within nature found a counterpart in the organic forms, curving lines, and rhythmic energy of Dove's compositions which suggest that nature as a living force is a manifestation of the spiritual.[4] Paintings such as *Connecticut River* portray Dove's subjective and spiritual interaction with nature, an experience considered restorative by many in the face of the rapid urbanization and industrialization of early-twentieth-century America.

Further Reading
Balken, Debra Bricker. *Arthur Dove: A Retrospective.* Andover, Mass.: Addison Gallery of American Art, Phillips Academy, 1997.
Haskell, Barbara. *Arthur Dove.* San Francisco: San Francisco Museum of Art, 1974.
Kirschner, Melanie. *Arthur Dove: Watercolors and Pastels.* New York: George Braziller, 1998.
Morgan, Ann Lee. *Arthur Dove: Life and Work, with a Catalogue Raisonné.* Newark: University of Delaware Press, 1984.

Notes
1. Melanie Kirschner, *Arthur Dove: Watercolors and Pastels* (New York: George Braziller, 1998), 14–15.
2. Quoted in Frederick S. Wight, *Arthur G. Dove* (Berkeley and Los Angeles: University of California Press, 1958), 30.
3. Sherrye Cohn, *Arthur Dove: Nature as Symbol* (Ann Arbor: UMI Research Press, 1985), 2.
4. Cohn, op. cit., 93.

Kurt Schwitters
German, 1887–1948

Merzbild 13A. Der kleine Merzel, 1919
Mixed-media assemblage
16 x 12 in. (41.9 x 32.4 cm)
Jane and Roger Wolcott Memorial, Gift of Thomas T. Solley, 75.39
© 2007 Artists Rights Society (ARS), New York/VG Bild-Kunst, Bonn

Faced with a lack of both money and art materials in ravaged post-World War I Germany, Kurt Schwitters began creating art with found materials—ticket stubs, newspaper advertisements, and even objects such as coins and washers. As he later recalled:

> When the war ended I felt the need to express this great sense of liberation and joy. To save money, because Germany had become a very poor country, I saved everything I came across. You can express your joy even with rubbish! Anyway, everything was in tatters, and we had to build things up again from the fragments.[1]

The German economy was in a shambles, the government was unstable, and hundreds of thousands were dead on the battlefields. Germany was also subjected to the crushing terms of the 1919 Treaty of Versailles, which required the nation to pay large war reparations. For Schwitters, then, the use of found objects, junk, and garbage to create works of art was not only liberating in an artistic sense, but it was also analogous to Germany's postwar challenge of rebuilding a ruined, fragmented nation.

For Schwitters, however, the creation of collages was not driven solely by practical considerations. Collage (the pasting together of flat materials) and assemblage (relief or sculptural collage utilizing three-dimensional objects) had become important forms of artistic expression for the early-twentieth-century avant-garde. Pioneered by Pablo Picasso and Georges Braque within the context of Cubism, collage was enthusiastically adopted by the artists associated with the Dada movement in Berlin. Performances, provocations, and unorthodox artistic techniques characterized the creative output of the Dada artists, who wanted to force people to question authority and the status quo. World War I, and the disgust that many artists felt over its carnage and irrationality, was the catalyst for the creation of the Dada movement.

Immediately following the war, Dada appeared in Berlin, where it became highly politicized. The Berlin Dadaists used photography, mass-media imagery, and especially photomontage (photographic collage) to critique contemporary society. Schwitters met Raoul Hassmann and Hannah Höch, two prominent Dadaists who pioneered photomontage, and he attempted to join "Club Dada," as it was known in Berlin. Rejected because of his lack of political engagement, Schwitters decided to create his own, single-artist movement, which he named Merz.

Collage and assemblage were the defining features of Merz. Schwitters created the word *Merz* by excising this syllable from an advertisement for the Kom*merz*- und Privatbank (Commercial and Private Bank) that he used in his first collage. Although the word Merz was invented, it carries myriad linguistic connotations for German speakers. The use of language and linguistics was important to Schwitters, who was also a writer, and who placed typographical fragments in many of his collages. Merz is pronounced exactly the same as *März,* the German word for the month of March, and thus, connotes the idea of growth and rebirth. Yet Merz also rhymes with *Schmerz,* the German word for "pain," and sounds similar to the French *merde,* signifying waste.[2] Like collage itself, whose layered and fragmented components suggest multiple meanings, the word Merz allows for infinite interpretations.

Numbered 13A, the *Merzbild* (Merz picture) at the IU Art Museum, is one of Schwitters's early collages, created in 1919. Schwitters produced two series of Merz works in 1919 and 1920. Those labeled with the letter "B" were large collages composed of flat items such as paper, tickets, newspapers, and fabric, while those including an "A" in the title were assemblages, constructed with three-dimensional materials. *Merzbild 13A* belongs to the assemblage series and is composed primarily of painted fabric scraps, some of which are nailed to the support, as well as pieces of cork, washers, and coins. While the Dadaists' caustic social critiques were occasionally echoed by Schwitters in his own work, this piece, diminutively subtitled "the little Merzel," shows that he had a greater concern for aesthetics and formal values. The harmoniously layered geometric shapes building up this collage suggest the formal influence of Cubism and Russian Constructivism.

World War II interrupted Schwitters's artistic endeavors as he immigrated first to Norway and then to England, where he died in 1948. The Merz collages and assemblages regained international attention in the 1950s with a series of important exhibitions in New York and Europe. *Merzbild 13A* was featured prominently in many of these exhibitions before entering the IU Art Museum's collection in 1975.

Further Reading
Elderfield, John. *Kurt Schwitters.* New York: Museum of Modern Art, in association with Thames and Hudson, London, 1985.
Schmalenbach, Werner. *Kurt Schwitters.* New York: Abrams, 1967.
Waldman, Diane. *Collage, Assemblage, and the Found Object.* New York: Abrams,1992.

Notes
1. Quoted in Guglielmo Gigliotti, "Kurt Schwitters' Reliquary of Rubbish Recreated," *Art Newspaper* (February 2001), 28.
2. Isabel Schulz comments on these linguistic similarities in "'What Would Life be Without Merz?' On the Evolution and Meaning of Kurt Schwitters' Concept of Art," in *In the Beginning was Merz—From Kurt Schwitters to the Present Day,* ed. Susanne Meyer-Büser and Karin Orchard (Hannover: Sprengel Museum and Hatje Cantz Verlag, 2000), 245.

Marcel Duchamp
French, 1887–1968

Readymades, 1913–21
Edition 8/8, 1964
Mixed media
Partial gift of Mrs. William Conroy, 71.37.1–.13
Gift of Mr. Arne H. Ekstrom, 71.96
© 2007 Artists Rights Society (ARS), New York/ADAGP,
Paris/Succession Marcel Duchamp

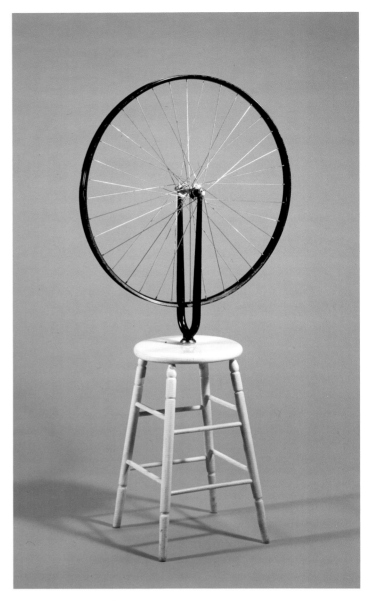

Bicycle Wheel. Metal, wood [71.37.1]
right: *Fountain.* Porcelain [71.37.7]

While early-twentieth-century artists such as Kurt Schwitters and the Cubists often included found objects in their work, Marcel Duchamp took this practice further, presenting mass-produced items as art objects. Known as Readymades, these objects, which were produced between 1913 and 1921, challenged traditional definitions of art and continue to be the subject of artistic controversy. Most of the objects originally designated as Readymades have been lost or destroyed, so it is through later replica editions, such as the set at the Indiana University Art Museum, that Duchamp's important contribution to modern art can be appreciated.

The IU Art Museum owns one of only two complete sets of the 1964 edition of the Readymades (see following pages) A joint project on the part of Duchamp and his Milan dealer Arturo Schwarz, the 1964 edition marked the fiftieth anniversary of the creation of the first Readymades. Duchamp selected fourteen of the most important of his early Readymades for inclusion in the new edition, which was limited to eight of each object, all of which were signed, numbered, and dated by the artist.[1] Despite Duchamp's—and the Readymades'—importance to twentieth-century art, the 1964 edition found only two purchasers. One set was purchased by the National Gallery of Canada and another by the Cordier & Ekstrom Gallery in New York. In 1971, the IU Art Museum's director acquired the set from Cordier & Ekstrom.[2]

The works in the group can be roughly divided into two subgroups: the "pure" Readymades and the "assisted" Readymades In the first category are objects that Duchamp simply purchased and signed without additional manipulation. Examples of "pure" Readymades are *In Advance of a Broken Arm,* a snow shovel that Duchamp purchased at a hardware store and hung from the ceiling, and the notorious *Fountain,* a porcelain urinal turned on its side and signed "R. Mutt." The assisted Readymades might best be described as assemblages; in these pieces, Duchamp combined several found or purchased objects to create sculptural pieces. The best-known example is the *Bicycle Wheel,* in which Duchamp screwed a bicycle wheel to the seat of a wooden stool. Some of the assisted Readymades are, however, quite elaborate constructions. *With Hidden Noise* is constructed of a ball of twine sandwiched between brass plates, on which nonsensical sentences are inscribed. Inside the twine, a small object rolls around, producing a sound if the piece is handled. The identity of the object inside the twine is a mystery—in the original piece of 1916, Duchamp asked his American patron Walter Arensberg to secretly select the item and place it in the twine. For the 1964 edition, Duchamp's wife selected the object.[3]

Although Duchamp had experimented with the idea of the Readymades in prewar Paris, it was in New York that he first displayed his Readymades as art objects. Exempted from military duty for health reasons, Duchamp left war-torn France and arrived in New York in 1915, where his reputation for artistic radicalism had preceded him. His Cubist painting *Nude Descending a Staircase* had been subjected to ridicule when it was displayed in the city in the 1913 Armory Show, the first major showing of European modernism in the United States.

Duchamp, along with Francis Picabia and Man Ray, founded the New York branch of the international Dada movement, which rejected artistic rules and traditions. To test the limits of authority and preconceived notions of art, Duchamp, using the pseudonym R. Mutt, submitted *Fountain* to an unjuried exhibition at the Society of Independent Artists in New York in 1917.[4] When the exhibition

continues on page 326

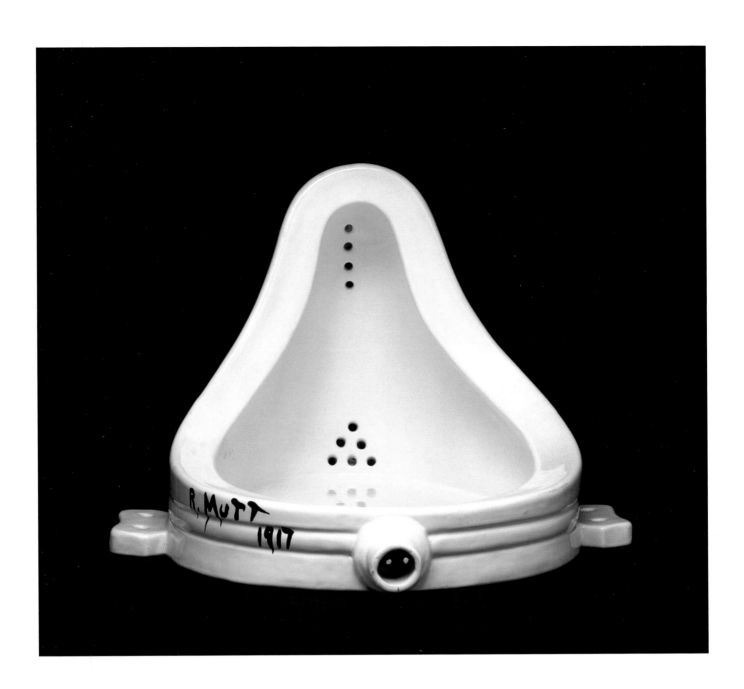

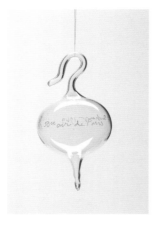

Paris Air. Plexiglas [71.37.11]

Why Not Sneeze Rose Sélavy? Marble, paint, metal, wood [71.37.13]

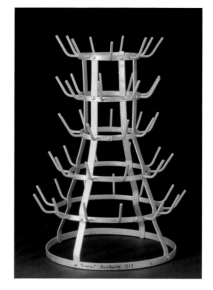

Bottle Rack. Galvanized iron [71.37.3]

Trap. Wood, metal [71.37.9]

With Hidden Noise. Twine, brass, bolts [71.37.6]

Comb. Steel, wood, felt [71.37.5]

committee rejected the submission, Duchamp and a friend wrote a passionate defense of the eponymous R. Mutt that is almost a manifesto of his theory and conception of the Readymades:

> 1. Some contended it [*Fountain*] was immoral, vulgar.
> 2. Others, it was a plagiarism, a piece of plain plumbing.
> Now Mr. Mutt's fountain is not immoral, that is absurd, no more than a bath tub is immoral. It is a fixture that you see every day in plumbers' show windows. Whether Mr. Mutt with his own hands made the fountain or not has no importance. He CHOSE it. He took an ordinary article of life, placed it so that its useful significance disappeared under the new title and point of view—created a new thought for that object. As for plumbing, that is absurd. The only works of art America has given are her plumbing and her bridges.[5]

While the last sentence in Duchamp's statement is humorous, it implies that Duchamp believed that the mass-produced everyday objects of modern life had inherent aesthetic value by virtue of their modernity.

Duchamp's impact on twentieth-century art was enormous. Ideas he pioneered, such as assemblage, iconoclasm and provocation, and conceptualism, have characterized much of the production of modern and contemporary artists, as the definition of "art" continues to expand.

Further Reading
D'Harnoncourt, Anne, and Kynaston McShine. *Marcel Duchamp.* New York: The Museum of Modern Art, 1973.

Notes
1. Some of the items, such as *Fountain,* were specially constructed for this edition, as the mass-produced objects of the 1910s were often no longer available in the 1960s.
2. Additional information about the sales of the 1964 edition can be found in Francis M. Naumann, "Marcel Duchamp: Money is No Object. The Art of Defying the Art Market," *tout-fait: The Marcel Duchamp Studies Online Journal* (April 2003). www.toutfait.com.
3. *The Almost Complete Works of Marcel Duchamp* (London: Arts Council of Great Britain, 1966), 124.
4. For an excellent overview of this event, see William A. Camfield, "Marcel Duchamp's Fountain," in *Marcel Duchamp: Artist of the Century,* ed. by Rudolf Kuenzli and Francis M. Naumann (Cambridge, Mass.: MIT Press, 1989).
5. Marcel Duchamp, editorial in *Blind Man,* no. 2 (May 1917). Reprinted in *The Almost Complete Works of Marcel Duchamp,* op. cit. 126.

The Three Stoppages. Wood, Plexiglas, glass [71.37.2]

Apolinere Enameled. Metal, paper.
Gift of Mr. Arne H. Ekstrom [71.96]

Hat Rack. Wood [71.37.10]

Fresh Widow. Wood, leather, paint [71.37.12]

Traveler's Folding Item. Leather, iron [71.37.8]

In Advance of the Broken Arm. Aluminum, sheet metal, wood [71.37.4]

Fernand Léger
French, 1881–1955

Composition, 1924
Oil on canvas
50 9/16 x 38 3/4 in. (128.4 x 98.4 cm)
Jane and Roger Wolcott Memorial, Gift of Thomas T. Solley, 75.41.1
© 2007 Artists Rights Society (ARS), New York/ADAGP, Paris

1925 photograph of the Pavillon de l'Esprit Nouveau, in which *Composition* is visible. The photograph was originally published in 1925 in the journal *L'Architecture Vivant.*

Fernand Léger's 1924 painting *Composition* made its first public appearance in 1925 at the internationally acclaimed Exposition des Arts Décoratifs in Paris. Unlike most of the pavilions at the exposition—which featured lavish, elitist interiors in the burgeoning Art Deco style—*Composition* hung prominently in the Pavillon de l'Esprit Nouveau, designed by the radically modernist architect Le Corbusier. In this pavilion, Le Corbusier applied his streamlined, utilitarian Purist style to a domestic setting. For unknown reasons, *Composition* hung only briefly, soon replaced by a different painting by Léger *(Le Balustre),* but its appearance in the pavilion can be confirmed by a photograph published in 1925 in the journal *L'Architecture Vivante.*[1]

When selecting a painting for inclusion in Le Corbusier's pavilion, Léger faced the challenge of choosing an image that would harmonize conceptually with the architect's vision. Although Le Corbusier did not commission paintings specifically for the pavilion, it is possible that Léger had actually conceived of *Composition*—one of his only completely abstract paintings of the postwar era—with the pavilion in mind.[2] Significantly, although the painting is dated 1924, Léger had nearly finished *Composition* as early as 1922—the year that the Exposition des Arts Décoratifs was originally scheduled to open.[3] The painting originally had a prominent zigzag pattern in the center that Léger painted over in vivid orange in the final version of 1924. Other small details were changed between 1922 and 1924, perhaps as a response to the evolving aesthetic of Purism, which reached its pinnacle in Le Corbusier's pavilion.

Characterized by geometry, simplicity, and mathematical proportions, Purism represented an aesthetic return to order, structure, and classicism after the chaos of the First World War. Purism also reflected a fascination with machines, mass-produced materials, and functionality. Both Léger's *Composition* and Le Corbusier's pavilion were structurally defined by geometry, straight lines, and flat areas of color. Striving to make his vision economically accessible, Le Corbusier did not design furniture specifically for his interior, but instead chose items that were mass-produced by firms such as Thonet-Mundus, a Viennese manufacturer of bentwood chairs. Works of art also played an important role in the pavilion, with sculptures by Henri Laurens and Jacques Lipchitz and paintings by Léger, Amédée Ozenfant, and Le Corbusier himself featured. *Composition* hung above a leather armchair, and the austerity of the painting's flat, interlocking shapes and earth-tone-dominated palette, combined with its simple black frame, harmonized perfectly with the utilitarian, Purist setting. Pavillon de l'Esprit Nouveau advocated a close interaction between architecture, interior design, and painting with which Léger completely agreed. Its aesthetic vision resulted in a *Gesamtkunstwerk* ("total work of art") that one scholar calls "the definitive monument of the immediate postwar era in France."[4]

After the close of the exposition, *Composition* continued to play a role in the avant-garde art world. Almost immediately, the prominent Berlin art dealer Alfred Flechtheim acquired *Composition* for his own collection. Until 1933, when he fled Nazi Germany and settled in England, Flechtheim was the most important dealer of contemporary French art in Germany. He opted not to sell *Composition,* but he did display it in his Berlin gallery in a 1928 exhibition devoted to Léger, and he sent it to important exhibitions in Rotterdam and Zurich.[5] Upon his death in 1937, Flechtheim left part of his estate to the Mayor Gallery in London, and *Composition* consequently entered the collection of the gallery's director, the Belgian-born curator and critic Edouard Léon Théodore Mesens. In 1947 Mesens mounted an important Cubist exhibition, in which *Composition* was featured as a variation of the style. The IU Art Museum acquired the painting several years after Mesen's death in 1971. Although its placement in Le Corbusier's pavilion was perhaps the perfect environment for *Composition,* it easily stands on its own as a major masterpiece within Léger's oeuvre.

Notes
1. *L'Architecture Vivante* (Fall/Winter 1925–1926): 50.
2. Angelica Rudenstine, *The Guggenheim Museum Collection: Paintings 1880–1945* (New York: Solomon R. Guggenheim Museum, 1976): 470.
3. Carol S. Eliel, *Purism in Paris, 1918–1925* (Los Angeles: Los Angeles County Museum of Art in association with Harry N. Abrams, Inc., 2001), 49. See also *L'Architecture Vivante* (Summer 1927): 34, where a photograph of *Composition* in an earlier state is published. It is identified here as a "study" from 1922.
4. Eliel, op. cit., 65.
5. 1928, *Fernand Léger,* Galerie Alfred Flechtheim, Berlin (cat. no. 25). February 1932, *Internationale Schilderijen Tentoonstelling van Moderne Meesters,* De Bijenkorf, Rotterdam (cat. no. 7); and, April 30–May 23, 1933, *Fernand Léger,* Kunsthaus Zurich (cat. no. 104).

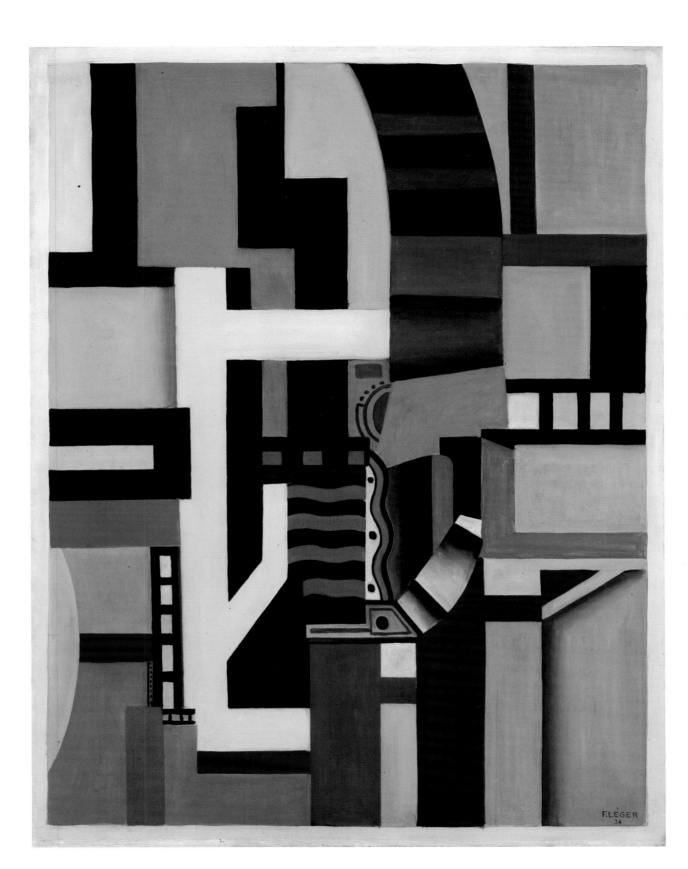

Jacques Lipchitz
Lithuanian, active France and the United States, 1891–1973

Harlequin with Guitar, 1926
Bronze
H. 13 1/8 in. (39 cm)
Gift of Dr. and Mrs. Henry R. Hope, 84.11
© Estate of Jacques Lipchitz, courtesy, Marlborough Gallery, New York

Born in Druskieniki, Lithuania, Jacques Lipchitz illegally crossed the Russian border in 1909 and made his way to Paris at the age of eighteen. Because he was a Jew, he was barred from entering the art academies of the Russian Empire, so he arrived in Paris with no artistic training but with ambitions to become a sculptor. In Paris, Lipchitz became involved with the development of Cubism, working closely with Pablo Picasso, Diego Rivera, Henri Laurens, and Juan Gris. Cubism encouraged Lipchitz to experiment with shape and space in his work.

In the mid-1920s Lipchitz's blocky Cubist figures gave way to a lighter, more open style, still reflecting the visual language of Cubism, but involving a greater engagement with the use of negative space within sculpture. Lipchitz called these small pieces, most of which, like *Harlequin with Guitar,* were made in 1925 and 1926, the "transparents," and later recalled that his creation of the transparents was "a fantastic experience…suddenly, I found myself playing with space, with a kind of open, lyrical construction that was a revelation to me."[1] Lipchitz was interested in architecture and commissioned the avant-garde architect Le Corbusier to design his house in a Parisian suburb in 1925. Fittingly, it was in the open, airy, modernist space of this house that Lipchitz created his transparents. The intertwining of three-dimensional form with open space in architecture may have provided some of the impetus for Lipchitz's creation of the transparents.[2]

Alan Wilkinson, a leading Lipchitz scholar, considers the transparents to be "Lipchitz's most original and influential contribution to modern sculpture."[3] Because of their small size, intricacy of detail, and numerous open spaces, Lipchitz found casting the pieces to be a challenge. He first made a model for each sculpture from cardboard and wax, and then had a single bronze cast (whereas most bronzes are cast in multiple) of each piece made at the Valsuani Foundry in Paris, using the lost-wax casting method, in which the original wax model is melted as molten bronze is poured into the sculpture's mold.[4]

In his transparents, Lipchitz often turned to the commedia dell'arte subject matter that was popular with the Cubists. Of the sixteen bronze transparents of 1925–26 exhibited in his 1930 retrospective in Paris, seven, including the *Harlequin with Guitar,* portray commedia figures.[5] A form of popular theater dating to late Renaissance Italy, the commedia enjoyed a resurgence in the early twentieth century as avant-garde directors and performers turned to

its masks and stylization to revitalize the theater.[6] Commedia dell'arte performers, although portraying stock characters (Harlequin, Pierrot, Columbine, and others.), were renowned for their improvisatory skills on the stage, which might explain their appeal not only for the avant-garde theater, but also for the Cubist artists, who were experimenting with a new visual language. Lipchitz's *Harlequin with Guitar* (named for the trickster character of commedia dell'arte) fuses two favorite Cubist subjects—the commedia figure and the musician. In a typically Cubist manner, the guitar has become the lower half of Harlequin's body, while the diamond pattern, made by thin, criss-crossing strips of bronze, suggests the brightly checked outfit traditionally worn by the character.

Lipchitz fled Nazi-occupied France for the United States in 1941. The same year, Curt Valentin, one of the few dealers who promoted modern European sculpture in America, became Lipchitz's dealer in New York, introducing his work to a select number of collectors and critics.[7] Henry Hope, the chair of the Indiana University fine arts department, purchased *Harlequin with Guitar* in 1954 from Valentin. The same year he included it in a major Lipchitz retrospective at the Museum of Modern Art, for which he authored the catalogue.[8]

Notes

1. Quoted in Alan G. Wilkinson, "Introduction," *Jacques Lipchitz: The Cubist Period (1913–1930)* (New York: Marlborough Gallery, 1987), 4.
2. M. Hammacher, "Jacques Lipchitz, 1891–1873: A Concise Survey of His Life and Work," in Alan G. Wilkinson, *The Sculpture of Jacques Lipchitz: A Catalogue Raisonné* (London: Thames and Hudson, vol. 1, 1996), 15–16.
3. Wilkinson, *Jacques Lipchitz: The Cubist Period,* op. cit., 4; and Wilkinson, *Catalogue Raisonné,* op. cit., 226.
4. Alan G. Wilkinson, *Jacques Lipchitz: A Life in Sculpture* (Toronto: Art Gallery of Ontario, 1989), 25.
5. Jeanne Bucher, *Cent Sculptures par Jacques Lipchitz* (Paris: Galerie à la Renaissance, 1930). This retrospective ran from June 13 to 28, 1930. *Harlequin with Guitar* is cat. no. 74.
6. In 1911 the Ballets Russes, under the direction of Sergei Diaghilev, performed *Petrushka,* a new ballet with music by Stravinsky in Paris. The plot revolved around a melancholy fairground puppet reminiscent of the commedia character Pierrot. A few years later, in 1917, Picasso designed the sets and costumes for another commedia-inspired ballet, Jean Cocteau and Erik Satie's *Parade.*
7. Phoebe Wolfskill, "Lipchitz and His Dealers," in eds., *Lipchitz and the Avant-Garde: From Paris to New York,* ed. Josef Helfenstein and Jordana Mendelson (Urbana-Champaign: Krannert Art Museum, 2001), 134.
8. Henry R. Hope, *The Sculpture of Jacques Lipchitz* (New York: Museum of Modern Art, in collaboration with The Walker Art Center, Minneapolis, 1954). Letter from Henry Hope to Curt Valentin, March 23, 1954, Curt Valentin Papers, Museum of Modern Art Archives, CV.III.35.

Ernst Barlach
German, 1870–1938

Singing Man, 1928, cast 1938
Bronze
20 x 24 in. (50.8 x 61 cm)
William Lowe Bryan Memorial, 57.36
© Ernst Barlach Lizenzverwaltung Ratzeburg

Expressionist sculpture is often overlooked in studies on German art. However, it flourished during and after the First World War, when a wide range of German artists turned to sculpture to express the pain, suffering, and frustration wrought by the war. Several sculptors in particular rose to prominence, among them Wilhelm Lehmbruck, Gerhardt Marcks, and William Wauer. Works by each of these artists can be viewed at the Indiana University Art Museum. Perhaps the most important Expressionist sculptor, however, was Ernst Barlach, whose *Singing Man,* conceived in 1928, is one of the best-known examples of German Expressionist sculpture.[1] Barlach's sculpture was integral to Expressionism, and he was also a prolific draftsman and printmaker.

Although Barlach studied art during the late 1880s and early 1890s in Hamburg, Dresden, and Paris, it was only in 1906 that he devoted himself to sculpture, after a journey through the western reaches of the Russian empire (today Poland and Ukraine). Impressed by both the landscape and its peasant inhabitants, Barlach began creating figural sculptures that reflect universal human conditions and emotions. His depictions of mothers, musicians, and warriors often evoke timeless, archetypal figures. As in Expressionist theatrical aesthetics, Barlach's Expressionist sculptures, while rooted in figural imagery and concerned with the human condition, are not naturalistic. An Expressionist playwright as well as a sculptor, Barlach found models in stylized historical forms of theater, such as medieval morality plays.

While early Expressionism was international in outlook, during and after World War I artists became more concerned with their German heritage and with German artistic models. The model of German Gothic religious art led them to imbue their sculptures with an urgent sense of spirituality. Although the example of the Gothic was most enthusiastically received during and immediately after the war, Gothic art had been of interest to Expressionist artists since at least 1908, when the art historian Wilhelm Worringer published an influential dissertation.[2] Entitled *Abstraction and Empathy,* this work argued that artistic styles stemmed directly from the *Zeitgeist* of various times and cultures. Thus, according to Worringer, abstraction and stylization in art (including Gothic art) reflected feelings of insecurity and unrest in the society that produced such art. Worringer's theories inspired Expressionists to look seriously at German Gothic art as a model for the art of their own unsettled times.

In the 1920s Barlach was considered the modern "Gothic" artist par excellence. The emotional power and spirituality of his work led to several commissions for World War I memorials, some of which were placed in churches. The gestural quality of *The Singing Man,* the exaggeration of the figure's limbs, and his almost prayer-like demeanor were all stylistic characteristics that Barlach perceived in German Gothic art. Although not overtly religious, *The Singing Man,* with closed eyes and upturned face, conveys Barlach's interest in humanity's striving toward spirituality. With the figure swathed in a shapeless garment, the focus is on the singer's face, with its expression of intense concentration—or perhaps spiritual ecstasy. *The Singing Man's* expression is indeed so open to interpretation that the German playwright Bertolt Brecht, upon seeing this sculpture exhibited after World War II, wrote, "The Singing Man…is singing by himself, but apparently has listeners. Barlach's sense of humor sees to it that he is a bit vain, but no more than is compatible with artistic performance."[3]

Although Barlach preferred wood carving (used frequently in medieval sculpture, and considered most expressive in the early twentieth century) above all other sculptural techniques, he cast a number of his works, including *The Singing Man,* in bronze in 1930, at the prompting of his dealer Alfred Flechtheim. Flechtheim showed the new casts in an exhibition devoted to Barlach at his galleries in Berlin and Düsseldorf. As a tribute to the artist, and due to the popularity of *The Singing Man,* additional casts were made immediately after Barlach's death in 1938. The IU Art Museum's cast appears to be from the 1938 edition.[4]

Notes
1. The sculpture was not cast in bronze until 1930. There are fifty-seven casts of *The Singing Man,* with only eighteen dating from Barlach's lifetime. See Ernst Barlach, *A Selftold Life,* trans. Naomi Jackson Groves (Waterloo, Ont., Canada: Penumbra Press, 1990), 89.
2. Wilhelm Worringer, *Abstraktion und Einfühlung: Ein Beitrag zur Stilpsychologie* (Munich: R. Piper, 1908).
3. Bertolt Brecht, "Notes on the Barlach Exhibition," in Daniel C. O'Neil, trans., *Ernst Barlach* (Northampton, 1960), 36.
4. *Bronzen von Ernst Barlach* (Berlin and Düsseldorf: Galerie Alfred Flechtheim, 1930.) James Adams, who purchased *The Singing Man* from a New York gallery in 1956 and donated it to the IU Art Museum in 1957, believed that this cast came from the original 1930 edition. He wrote to Henry Hope that, "Your cast of 'Singing Man' was made and exhibited during Barlach's lifetime. I'll send you a letter from his foundry. It is one of the first castings—I think there are ten in all, most in museums." From a letter from James Adams to Henry Hope, January 13, 1957, Indiana University Art Museum curatorial files. Unfortunately, Adams does not specify in his letter from which gallery he purchased the sculpture, nor has the letter from Barlach's foundry materialized. However, the foundry mark on the IU Art Museum's cast differs from the foundry mark used in the 1930 casting. Whereas the 1930 foundry mark reads, "H. Noack, Berlin Friedenau," the IU Art Museum's cast, and the casts from the 1938 casting, reads simply, "H. Noack, Berlin."

Georges Braque
French, 1882–1963

The Napkin Ring, 1929
Oil and sand on canvas
15 ¹/₂ x 47 ¹/₂ in. (39.4 x 120.7 cm)
Gift of Dr. and Mrs. Henry R. Hope, 69.56
© 2007 Artists Rights Society (ARS), New York/ADAGP, Paris

Originally painted for Braque's dealer Paul Rosenberg, *The Napkin Ring* was one of the first major artworks acquired by Henry Radford Hope, the founding director of the Indiana University Art Museum. In 1941, shortly after receiving his PhD from Harvard, Hope joined the fine arts faculty at Indiana University. Following his marriage to Sarahanne Adams McClennon of Indianapolis in 1944, the couple began collecting modern art seriously. In the summer of 1944 they purchased Braque's *Napkin Ring* and Picasso's *Studio* from Paul Rosenberg's New York gallery. *The Napkin Ring* held a special place in the Hopes' collection, and Henry Hope had a particular interest in Braque. In 1949 he organized the first major retrospective of the artist's work in the United States; the exhibition was shown at the Museum of Modern Art in New York and at the Cleveland Art Museum.[1]

Georges Braque best known for his close association with Pablo Picasso. In the years before World War I, the two artists developed the Cubist style together. The war severed the artistic relationship between the two, as Braque, a French citizen, was conscripted into the French army, while Picasso, as a Spanish national, was able to continue painting without interruption during the war years. Seriously wounded during the war, Braque did not resume painting until 1917; by then, Picasso's interests had diverged from the Synthetic Cubism that the two artists had developed between 1912 and 1914. Braque continued to paint in variations of this Cubist idiom for the duration of his career.

The flattened objects, clear outlines, and natural palette of *The Napkin Ring* derive from Synthetic Cubism, yet the forms are less fractured and deconstructed than in Braque's prewar work. Seeing himself as the heir of Paul Cézanne and Jean-Siméon Chardin, Braque especially favored the still-life, perhaps because the genre gave him great flexibility to explore the shapes and textures of simple objects and the spatial relationships between them. The tray of fruit, pitcher, and glass depicted in *The Napkin Ring* reappear in various arrangements throughout Braque's oeuvre. Painted primarily in dark green, blue, and earth-based pigments mixed with sand, the dry, grainy surface of the image is reminiscent of fresco. Braque was the son of a painter-decorator—a house painter—and learned illusionistic techniques, such as creating false wood grain, from

his father. Creating a fresco-like appearance with sand was another decorative trick that Braque learned from his father's trade and applied to easel painting.

Paul Rosenberg, who became Braque's exclusive dealer in 1922, commissioned Braque to paint four narrow, horizontal still-lifes for his house in Paris. The paintings were also copied as mosaics to adorn Rosenberg's dining room. One of the still-lifes painted for this project was *The Napkin Ring*. A few months after the Nazi takeover of France in May 1940, Rosenberg, who was Jewish, fled to the United States, taking most of his family with him. He left most of his collection and gallery stock in French bank vaults, and he was unable to access these works for the duration of the war (indeed, most of his collection was looted by the Nazis). However, he did manage to have some of his collection, including much of the stock from the London branch of his gallery, shipped to the United States; *The Napkin Ring* was among the pieces shipped to New York.[2] Henry Hope later recalled that Rosenberg was not eager to part with this painting, only agreeing to sell it in the summer of 1944 after hearing from his son Alexandre, who was active in the Free French Forces, and from General de Gaulle, that Paris would soon be liberated from German control.[3]

Further Reading
Leymarie, Jean. *Georges Braque*. New York: Solomon R. Guggenheim Museum, 1988.
Wayne, Kenneth. *Picasso, Braque, Léger, and the Cubist Spirit, 1919–1939*. Portland, Maine: Portland Museum of Art, 1996.
Wilkin, Karen. *Georges Braque*. New York: Abbeville Press, 1991.

Notes
1. Henry Hope, *Georges Braque* (New York: Museum of Modern Art and Cleveland: Cleveland Museum of Art, 1949), cat. no. 59.
2. Hector Feliciano, *The Lost Museum: The Nazi Conspiracy to Steal the World's Greatest Works of Art* (New York: BasicBooks, 1997), 72. The fate and recovery of Paul Rosenberg's collection is covered extensively in Feliciano's investigative book.
3. Thomas T. Solley and Constance Bowen, *The Henry Hope Collection: Selections from the Twentieth Century* (Bloomington: Indiana University Art Museum, 1982), 10.

Balthus (Count Balthazar Klossowski de Rola)
French, 1908–2001

The Window, 1933
Oil on canvas
63 5/8 x 45 in. (160.6 x 114.2 cm), 70.62
©2007 Artists Rights Society (ARS), New York/ADAGP, Paris

The Window was included in Balthus's first solo exhibition of seven paintings held in 1934 at the Galerie Pierre in Paris. *The Window* confronts the viewer with a terrified young woman who leans against a windowsill, her left breast bared and her right arm raised—presumably to fend off an intruder or rapist. When standing before the nearly life-size painting, the viewer finds him or herself in the position of the woman's unseen attacker.

Windows are a prominent motif in Balthus's work, and it has been suggested that Balthus's intent here was to parody the German Romantic motif of women meditating at open windows.[1] However, while the women in Romantic paintings often enjoy expansive vistas, the window in Balthus's image, hemmed in by the cluster of tall buildings, becomes a place of fear, danger, and claustrophobia.

Despite the surreal sense of terror that pervades the image, the scene portrayed in *The Window* was firmly grounded in reality. The room depicted was Balthus's attic studio on Paris's Rue de Fürstenberg, with the building's courtyard visible below. The look of fear on the model's face was also real, although dramatically provoked by Balthus: when the model, fifteen-year-old Elsa Henriquez, arrived at Balthus's studio, he reportedly lunged at her and acted as if he intended to tear off her blouse.[2]

At an unknown date, Balthus made significant changes to the painting. In the original version, Balthus distorted Elsa's features, and her blouse fully covered both breasts. As the changes he made contribute a greater sense of danger and eroticism to the painting, it seems likely that he made them early, prior to the painting's 1934 exhibition.

According to Balthus's biographer, the only positive adjective Balthus used to describe his painting was "Mozartian."[3] Indeed, references to Mozart recur throughout Balthus's memoirs, and a consideration of his reverence for the Austrian composer illuminates Balthus's attitude toward art. Balthus recounts listening to recordings of Mozart daily, striving to attain the same degree of perfection in his painting that he perceived in Mozart's music:

> I rate Mozart above all other composers in the whole world…He has always been my model, someone who helped me see the essence of things…This kind of simplicity must be attained in painting…When listening to Mozart, I feel an entire gamut of emotions…He tapped a universal, gigantic reservoir. I've often modestly aspired to dip into the same well.[4]

Balthus's musical sense of composition is evident in *The Window*. Constructed of interlocking shapes and harmonious, muted colors, the painting's visual structure is architectural, balanced, and symmetrical, much like a Mozart composition. This carefully designed structure offsets the tension embodied by the model's off-balance pose and fearful expression.

An important influence on Balthus's painting also can be found in Italian Renaissance painting, particularly that of Piero della Francesca. In 1926 Balthus had visited Italy, spending an extended period in Arezzo, where Piero's most celebrated fresco cycle, *Legend of the True Cross,* is located. Piero's work is characterized by its mathematical sophistication and sense of calm stillness—attributes that Balthus sought in his own work. He also sought to connect himself to the Renaissance masters by referring to himself as an artisan. Lamenting the lack of knowledge of traditional painting techniques among contemporary artists, Balthus stressed the importance not only of selecting canvases, pigments, and brushes, but also of the manual labor involved in preparing a canvas and planning a painting.[5] This sense of craftsmanship, combined with a classical, "Mozartian" visual structure, defines Balthus's style.

Born Balthazar Klossowski, Balthus once famously declared, "Balthus is a painter about whom nothing is known."[6] Despite his cultivation of a reclusive, aristocratic aura, much is now known of Balthus and his contradictory identity. The grandson of an Orthodox cantor from Breslau, Balthus vehemently denied his Jewish heritage. Shunning the bohemian lifestyle associated with the modern artist, he adopted a title and aristocratic surname, basing his claim on his father's ties to minor Polish nobility. Refusing to grant interviews throughout his life, he nevertheless decided to publish his memoirs in his final years. Critical reception of Balthus's work has been similarly contradictory. While achieving great acclaim in recent decades, his arguably most vibrant paintings—works such as *The Window*—were virtually ignored by most critics when they were created in the 1930s. Today these paintings are seen as psychologically penetrating, technically superior, and brilliantly individualistic.

Notes
1. Sabine Rewald, "Balthus Lessons," *Art in America* (September 1997): 92.
2. Jean Clair, ed. *Balthus* (New York: Rizzoli, 2001), 230.
3. Nicholas Fox Weber, *Balthus: A Biography* (New York: Alfred A. Knopf, 1999), 489.
4. Balthus, *Vanished Splendors: A Memoir,* trans. Benjamin Ivry (New York: Harper Collins, 2002), 35–36.
5. Claude Roy, *Balthus* (Boston: Little, Brown, and Co., 1996), 250.
6. Roy, op. cit., 6. This famous quotation is repeated throughout the literature on Balthus.

Pablo Picasso
Spanish, active France, 1881–1973

The Studio, June 1934
Oil on canvas
50 ³/₈ x 62 in. (128 x 159.4 cm)
Gift of Dr. and Mrs. Henry R. Hope, 69.55
© 2007 Estate of Pablo Picasso/Artists Rights Society (ARS), New York

Along with Georges Braque's *Napkin Ring,* Pablo Picasso's *Studio* was one of the first major paintings acquired by Henry Radford Hope, former chair of Indiana University's fine arts department and first director of the Indiana University Art Museum. In the summer of 1944, Hope and his new wife Sarahanne purchased both paintings from the New York gallery of Paul Rosenberg, a French dealer who had come to the United States during the war. Rosenberg had acquired *The Studio* from Picasso exactly ten years earlier, after its completion during the summer of 1934. Decades later, Hope remembered being immediately attracted to the painting when he saw it in Rosenberg's gallery.[1] The Indiana University Art Museum collection of work by Picasso encompasses numerous graphic works as well as two oil paintings, and is particularly strong in work from the 1930s.[2] During the 1930s Picasso's range of motifs and subjects reflected his interests in Spanish culture (for example, the bullfight), and in classical mythology (especially the figure of the Minotaur), as well as his often turbulent relationships with women. *The Studio* explores the artist's creative process and the role played by the female model in this process.

The exuberant colors and bold shapes of *The Studio* reflect Picasso's continued reliance on the synthetic Cubist vocabulary he had developed with Braque before World War I. Yet, while many of Picasso's initial experiments with Cubism were primarily formalist abstractions, *The Studio* is a personal—and indeed self-conscious—artistic statement. The figures in the painting are undoubtedly meant to be read as Picasso himself, standing at his easel, and his mistress Marie-Thérèse Walter. Laden with symbols of fertility and sexuality, *The Studio,* despite its Cubist structure, recalls the thematic concerns of Surrealism, a major current in the art and literature of 1930s Paris. Marie-Thérèse, only seventeen years old when she became Picasso's mistress in 1927, personified Surrealist writer André Breton's concept of the child-woman, or femme-enfant. The antithesis of the threatening femme fatale, the femme-enfant was exemplified by her ability to arouse erotic feelings through her youth, her presumed innocence, and her naïveté. Picasso, who was still married to his first wife, the dancer Olga Koklova, wished to conduct his affair with Marie-Thérèse discreetly, and by portraying her as his model, he could explore their relationship in his art without publicly acknowledging her as his lover.

The highly gendered motif of the artist and his model (invariably, the artist/creator was portrayed as male, and the inspirational model as female) played an important role in Picasso's work during the 1930s. Between 1927 and 1937, Picasso even devoted a suite of seventy-three prints, the *Suite Vollard,* to the topic. *The Studio,* featuring the artist and his model, was created when Picasso was deeply immersed in this subject through his work on the *Suite Vollard.* Although the artist who recurs throughout the images of the *Suite Vollard* is a sculptor, the thematic parallels with *The Studio* are clear. Limply reclining, with her breasts and stomach exposed, the lavender-fleshed figure of Marie-Thérèse is the ideal representation of woman as passive muse. The horizontality and curvilinear, organic forms of the right side of the canvas give way to the vertical, geometrically structured left side of the composition, the section in which the artist (Picasso) stands and paints at the easel. Picasso also injects a humorous note into the image by revealing that the artist is painting a cluster of flowers rather than his voluptuous model. Nevertheless, the biological, fertile connotations of the flowers can easily be read as a reflection of female childbearing abilities; indeed, Marie-Thérèse gave birth to the couple's daughter Maya a little over a year later, an event which ironically coincided with the end of her relationship with Picasso. A monumental and personal exploration of the theme of the artist and his model, *The Studio* is one of Picasso's major works dealing with this motif.

Further Reading

FitzGerald, Michael. *Picasso: The Artist's Studio.* Hartford, Conn.: Wadsworth Atheneum Museum of Art, in association with Yale University Press, 2001.
Freeman, Judi. *Picasso and the Weeping Women: The Years of Marie-Thérèse Walter & Dora Maar.* Los Angeles: Los Angeles County Museum of Art, 1994.
Hope, Henry R. "Picasso in the 1930s." In *Pablo Picasso: Images of the 1930s.* Fort Lauderdale, Fla.: Fort Lauderdale Museum of the Arts, 1980.
Muller, Markus, ed. *Pablo Picasso and Marie-Thérèse Walter: Between Classicism and Surrealism.* Bielefeld: Kerber, 2004.

Notes
1. Thomas T. Solley and Constance Bowen, *The Hope Collection: Selections from the Twentieth Century* (Bloomington: Indiana University Art Museum, 1982), 9–10.
2. Other works by Picasso from the 1930s in the collection of the IU Art Museum include: fifty prints from the *Suite Vollard* (1927–37); the major etching *Minotauromachia* (1935); a portfolio of thirty-one aquatints known as *Buffon* (1936); the aquatint *Dreams and Lies of Franco* (1937); and an oil painting *Still-Life with Pitcher and Candle* (1937). The last was also donated to the museum by the Hope family.

Stuart Davis
American, 1892–1964

Swing Landscape, 1938
Oil on canvas
86 3/4 x 173 1/8 in. (220.3 x 439.7 cm), 42.1
Art © Estate of Stuart Davis/Licensed by VAGA, New York, NY

Swing Landscape ranks as a seminal work in the oeuvre of American painter Stuart Davis. The imposing size of *Swing Landscape* and its pulsating, vibrant palette reflect the original intent to hang the mural in an architectural context: the Williamsburg Housing Project in Brooklyn, New York. Davis received this commission from Burgoyne Diller, the supervisor of the Mural Divison of the Federal Art Project (FAP). Part of President Franklin D. Roosevelt's Works Progress Administration (WPA), the Federal Art Project provided employment to artists, musicians, and actors, in part through an ambitious program of mural and public art projects.

Despite Davis's great artistic achievement, *Swing Landscape* was never installed in the housing project. The Williamsburg mural project was experimental, even controversial, from the beginning, as Diller commissioned artists who championed abstract styles of painting. The Williamsburg murals, in fact, are believed to be the first nonobjective murals ever painted in the United States.[1] However, the WPA primarily supported social realist, figurative, styles. With few easily recognizable motifs, *Swing Landscape* verges on pure abstraction, and it was probably deemed too modern for its intended audience.[2] Although Davis must have been disappointed that his mural was ultimately rejected by the FAP, this decision saved *Swing Landscape* from almost certain destruction. Murals by Ilya Bolotowsky, Balcomb Greene, and others were installed in Williamsburg, only to suffer neglect and overpainting. Rediscovered in the 1980s, some were removed to the Brooklyn Museum of Art. Others, however, had been damaged beyond repair.

Davis would have disagreed that abstract art was irrelevant to the Williamsburg audience. His involvement with the 1913 Armory Show in New York, which introduced European modern art to a wide American audience, and the year he spent in Paris in the late 1920s, convinced him that the abstract art pioneered by Pablo Picasso and Fernand Léger was the style best suited to modern life. In his few extant notes on the Williamsburg mural commission, Davis wrote:

> [Modern] art reflects the colors and shapes of the time. It has a new sense of space and color which reflect the broader view and experience of modern man which modern technological advance has made possible. The train, auto, and airoplane [sic], have made a new sense of space and color. Abstract art reflects this new experience. Abstract art has affected the design of all modern objects…Now the gov't has made a start in bringing this abstract art directly to the people in modern homes.[3]

As *Swing Landscape*'s title indicates, modern American music—specifically jazz and swing—had a great impact on Davis's concept of modern art. During the 1920s, Davis frequented the clubs of Harlem and Hoboken, where he absorbed the sounds of ragtime and jazz. A jazzy rhythm is visible in the arrangement of colors and forms in *Swing Landscape*. For Davis, music had the ability to transcend time and place, and it provided an ideal model for modern mural art, which he felt should remain relevant for future generations.

After its rejection of Davis's mural for Williamsburg, the FAP was faced with the task of finding a home for the monumental painting. Following brief exhibitions at the Federal Art Gallery in New York in 1938 and the Cincinnati Modern Art Society in 1941, it was allocated to Indiana University. Henry Hope, the newly appointed chair of the fine arts department at Indiana University, was aided in his successful negotiations for the mural by Peggy Frank, the director of the Cincinnati Modern Art Society, who played a key role as a liaison between Hope, the administration of the WPA, and Stuart Davis himself. *Swing Landscape* arrived in Bloomington early in 1942: it was Henry Hope's first acquisition for the nascent museum.[4] Called by one critic "one of the most exhilarating and lyrical walls in the United States," Stuart Davis's *Swing Landscape* is intimately tied to the development of the Art Museum at Indiana University, and it remains an anchor of the museum's collection.[5]

Notes
1. Stephen Wallis, "A New Deal for Artists," *Art & Antiques* (June 1996): 62.
2. The new Davis catalogue raisonné also suggests that the mural may not have been installed due to architectural changes in the building: Ani Boyajian and Mark Rutkowski, eds., *Stuart Davis: A Catalogue Raisonné*, vol. 3 (New Haven: Yale University Art Gallery, in collaboration with Yale University Press, 2007), 293.
3. Stuart Davis, "Synopsis on Abstract Art in Williamsburg Project, October 1937," Stuart Davis Papers, Fogg Art Museum, on deposit at Houghton Library, Harvard University. I would like to thank Harry Cooper, curator of modern art at the Fogg Art Museum, for sending me a copy of Davis's notes.
4. The story behind *Swing Landscape*'s acquisition by Indiana University in 1942 was reconstructed through letters and documents held at the Archives and Rare Books Dept., University Libraries, University of Cincinnati. Correspondence between Stuart Davis, Henry Hope, Peggy Frank, and V. Roger Wood of the Federal Works Agency, Works Progress Administration for the City of New York, was consulted. On January 26, 1942, Wood wrote to the Cincinnati Modern Art Society, "It is in order for you to forward the Stuart Davis mural 'Swing Landscape' to the University of Indiana."
5. Bennett Schiff, "Stuart Davis was modern right down to his very roots," *Smithsonian Magazine* (December 1991): 66.

Jean Dubuffet
French, 1901–1985

Business Lunch (*Dejeuner d'affaires*), May–June 1946
Oil and sand on canvas
35 x 45 1/2 in. (88.8 x 115.5 cm)
Gift of Dr. and Mrs. Henry R. Hope, 69.157
© 2007 Artists Rights Society (ARS), New York/ADAGP, Paris

"Paris is teeming with art exhibits, most of them contemporary, and as a whole they are very fine," Henry Hope, the founding director of the Indiana University Art Museum, told a student reporter in August 1948 after returning from a two-month-long visit to Europe.[1] Among the paintings Hope may have seen in a still-war-ravaged Paris were the works of Jean Dubuffet, a former wine merchant who had decided to embark on a career as an artist in 1942. In 1947 or 1948 Hope became the proud owner of *Business Lunch*, one of Dubuffet's recent paintings. Hope purchased the painting from Pierre Matisse, whose gallery had enthusiastically promoted Dubuffet's work in the United States, beginning with a one-man show in the winter of 1947.[2]

Business Lunch, a humorous depiction of five dining businessmen, relates to Dubuffet's cycle of paintings, *Mirobolus, Macadam & Cie.*, which he worked on in 1945 and 1946. Although the work was not painted in time to be included in the May 1946 exhibition of this cycle at the Galerie René Drouin in Paris, its style clearly conforms to that used in other paintings from the cycle.[3] Painted with a technique Dubuffet called *haute pâte*, or "high impasto," these paintings are built up of a mixture of oil paint thickened with sand or other additives. The coarse surfaces of these paintings are often reminiscent of rough street pavement, hence the word "macadam" (road-paving material made of crushed stones and tar) in the series title.

A conservator who examined the painting described Dubuffet's technique for constructing *Business Lunch*. It is built up in numerous layers, beginning with a white ground covered by a multicolored layer of traditional oil paint. Dubuffet then covered this layer with a very thick, chalky, plaster-like material of black and brown pigments, and incised hieratic figures in this rough ground, giving them a graffiti-like quality. Some of his slashing cuts through the impasto were deep enough to reveal the colors beneath. Dubuffet finished the painting with a layer of smooth, glossy black paint, topped by one of matte black paint generously mixed with sand.[4] While Cubists such as Georges Braque and Pablo Picasso had often mixed sand into their paint in order to achieve a grainy texture, Dubuffet's use of materials typically considered foreign to the art-making process became one of the defining features of *Art brut*, a French term coined by Dubuffet to connote the rawness, roughness, and primitivism of artworks outside of the fine art tradition.

While folk art, "primitive" art, and children's art had been of interest to European avant-garde artists since the beginning of the twentieth century, Dubuffet was particularly interested in art created by social outsiders and the mentally ill, including patients in asylums. Although he had sporadically painted and drawn during the 1920s and 1930s, Dubuffet seriously turned to art as a profession in 1942 when living in Nazi-occupied Paris. During the Nazi era, thousands of mentally ill patients in Germany were euthanized because of their perceived lack of human value, and modern artists, such as the Expressionists, were equated with the insane in Nazi propaganda.

Dubuffet's very different—and sympathetic—perception of the art created by the mentally ill may be seen in this context. His interest in the subject was sparked by the book *Bildnerei der Geisteskranken (Artistry of the Mentally Ill)*, published in 1922 by the Heidelberg psychiatrist Hans Prinzhorn. Dubuffet read this book, which asserted that the artworks created by asylum patients were aesthetically valuable, in 1923, and its thesis still resonated with him when he painted works such as *Business Lunch* at the end of World War II. In 1945 Dubuffet traveled to Switzerland, where he began collecting art made by mental patients and schizophrenics. He donated his large collection to the city of Lausanne, Switzerland, in 1971, and it can be seen there today in the Musée de l'Art Brut. Dubuffet was particularly attracted to drawings made by Swiss mental patients, seeing in them a romanticized "authenticity" and naïveté missing from avant-garde modernism. His development of the simplified, hieratic, outline style seen in *Business Lunch*—and its satirical treatment of the conformist manners of the bourgeoisie—is a response to these works from outside the traditions of Western art.

Further Reading
Demetrion, James T. *Jean Dubuffet 1943–1963: Paintings, Sculptures, Assemblages.* Washington, D.C.: Hirshhorn Museum and Sculpture Garden, in association with The Smithsonian Institution Press, 1993.
Franzke, Andreas. *Dubuffet.* Trans. Robert Erich Wolf. New York: Abrams, 1981.
Jean Dubuffet: A Retrospective. New York: The Solomon R. Guggenheim Foundation, in association with New York Graphic Society Ltd., 1973.

Notes
1. "Hope Says Europe Wears Menacing Look," *Indiana Daily Student*, August 11, 1948. Hope Clippings File, Indiana University Archives.
2. Pierre Matisse Papers, Dubuffet Accounts 1943–1960 (B8,1), J. Pierpont Morgan Library, New York.
3. Max Loreau includes *Business Lunch* with the *Mirobolus, Macadam & Cie* cycle in his catalogue of Dubuffet's oeuvre: Max Loreau, *Catalogue des travaux de Jean Dubuffet: Mirobolus, Macadam et Cie.* (Paris: Société française des Presses suisses, 1966), 94.
4. IU Art Museum conservation files, from a 1983 examination report.

Henry Moore
English, 1898–1986

Reclining Figure, 1946/47
Hornton stone
15 x 28 in. (38 x 71.1 cm)
Given in memory of Dr. Henry Radford Hope by Sarahanne Hope-Davis, 95.8
Reproduced by permission of the Henry Moore Foundation

The reclining figure was the signature motif of Henry Moore's oeuvre, appearing both in his early, intimately scaled stone pieces and in the monumental bronze public sculptures of his later career. Born in Yorkshire, England, in 1898, Moore attended the Leeds College of Art after serving in World War I and then received a scholarship to the Royal College of Art in London. While in London, Moore made frequent visits to the British Museum, where the comprehensive collections of non-Western art influenced his approach to art-making. Moore particularly was impressed by Mesoamerican sculpture's "stoniness…its truth to material [and] its tremendous power."[1] Moore also traveled to Italy in 1925, where he was attracted to the work of Giotto, Masaccio, and Michelangelo. Although he attempted to keep Western art traditions from impacting his own work, the influence of these Renaissance masters—particularly the late works of Michelangelo—nevertheless found expression in Moore's sculpture.

The IU Art Museum's *Reclining Figure* of 1946/47 clearly reveals Moore's gradual succumbing to the Italian artistic tradition. Douglas Lewis, emeritus curator of sculpture and decorative arts at the National Gallery of Art in Washington, D.C., notes that the pose of the *Reclining Figure* mirrors that of Michelangelo's figure of Dawn in the Medici Chapel in Florence's Church of San Lorenzo—one of the late works by Michelangelo that had impressed Moore during his Italian sojourn of 1925.[2] It is also probable that Moore was familiar with ancient Greek and Roman sculptures in which major rivers, such as the Nile and the Tigris, are personified as colossal reclining figures.[3]

One of Moore's artistic mantras was "truth to material," and he advocated using materials that expressed a sense of geography or a specific environment. As an English sculptor, Moore often sought out native stones for his carvings. Hornton stone, the material from which *Reclining Figure* is carved, is a type of limestone quarried in Oxfordshire. Hornton stone is known for its distinctive and varied coloring, and its connection to English art and architecture is strong: it had been used in the building of Canterbury Cathedral, St. Paul's Cathedral in London, and the universities of Oxford and Cambridge.

Working primarily with a claw chisel, a tool in use by sculptors for over two thousand years, Moore carved the stone in accordance with the modernist principle of "direct carving." Direct carving, a corollary to the modern vision of "truth to materials," was a response against the nineteenth-century practice of making several preliminary models for a sculpture in clay or wax, and then authorizing numerous editions in bronze or marble. Moore and other twentieth-century artists preferred to create one-of-a-kind sculptures, in which the nature of the material itself was emphasized. In the late 1930s, Moore began experimenting as well with the incorporation of negative space in his sculptures, opening up holes and crevices in the pieces. The openings between the *Reclining Figure's* arms, legs, and torso provide a sense of lightness and create shapes reminiscent of the biomorphic forms favored by the Surrealist artists with whom Moore frequently exhibited during the 1930s and 1940s.

In 1946 Moore was the subject of a major retrospective at the Museum of Modern Art in New York. After visiting the exhibition, Henry Hope, director of the Indiana University Art Museum and an important collector of modern art (he already owned Moore's abstract, biomorphic sculpture *Four Forms* of 1936), asked Moore's American dealer, Curt Valentin, whether it might be possible to acquire one of Moore's reclining figures as well.[4] Moore was currently working on the *Reclining Figure,* and when he completed the piece in the spring of 1947, Valentin contacted Hope, describing the sculpture as "the finest piece you could buy."[5] Although Hope had wanted a larger sculpture, he nevertheless took Valentin's advice and purchased the *Reclining Figure* in early 1948.[6] The sculpture resided in the Hopes' Bloomington garden for the next twenty years. In 1968, it was moved inside, where the family continued to enjoy the sculpture in their home until 1995, when Sarahanne Hope-Davis, Henry's widow, donated both of the family's Moore sculptures to the IU Art Museum.

Further Reading.
Compton, Susan. *Henry Moore.* New York: Charles Scribner's Sons, 1988.
Henry Moore: The Reclining Figure. Columbus, Ohio: Columbus Museum of Art, 1984.
Kosinski, Dorothy. *Henry Moore: Sculpting the 20th Century.* New Haven: Yale University Press in association with the Dallas Museum of Art, 2001.

Notes
1. Henry Moore, "Primitive Art," first published in *The Listener,* April 24, 1941, reprinted in *Henry Moore: Complete Sculpture: 1921-48*, ed. David Sylvester (London: Lund Humphries, 1988), vol. 1, xxxvii.
2. Douglas Lewis, "A Masterwork and Its Maquette," *Indiana University Art Museum Insider* (Spring 1999): 3.
3. At least two such sculptures are in the collections of the Vatican: *Colossal Statue of the Nile River,* Braccio Nuovo, Vatican Museums, and *Statue of the Tigris River,* Museo Pio Clementino, Vatican Museums. Moore would also have seen figures like this among the Parthenon marbles at the British Museum.
4. Thomas T. Solley and Constance L. Bowen, *The Hope Collection: Selections from the Twentieth Century* (Bloomington: Indiana University Art Museum, 1982), 12–13.
5. Letter from Curt Valentin to Henry Hope, December 11, 1947. Curt Valentin Papers, Museum of Modern Art Archives, New York. CV.III.35.
6. Letters from Henry Hope and Curt Valentin, January 22, 1948, and January 24, 1948. Curt Valentin Papers, Museum of Modern Art Archives, New York, CV.III.35.

Diego Rivera
Mexican, 1886–1957

Danzante, 1947
Oil on canvas
59 1/2 x 49 1/2 in. (151.1 x 125.7 cm)
Gift of Samuel and Cecyle Stone, 78.30

Don Jesús Robles, who worked as a brickmaker and handyman for Diego Rivera, posed for this portrait at Rivera's home in the Mexico City suburb of Coyoacán.[1] Wearing an elaborate feathered headdress and fringed cape, Robles plays a *concha,* a lute fashioned from armadillo shell. Robles's lute is inscribed with the words "Corporación de Concheros," identifying him as a member of a society of religious dancers. The *concheros* are confraternities dedicated to preserving traditional dances, music, and costumes. Their ritual dances, often performed during the fiesta of Our Lady of Guadalupe (Mexico's patron saint), can be traced back to the era of the Spanish conquest of Mexico. Although the dances combine both Spanish Catholic and pre-Columbian elements, they originally commemorated the conversion of the indigenous people to Catholicism.

In the mid-twentieth century, the *conchero* associations, in which membership was hereditary, flourished around Mexico City, as well as in Guanajuato, Rivera's birthplace. The armadillo shell lutes and feathered headdress, cape, and beads, which were reminiscent of ceremonial Aztec costumes, are accessories integral to the *concheros'* dances.[2] In 1948, Rivera introduced Robles to the daughter of the Illinois couple who had purchased *Danzante* the previous year. Robles informed her that he was the leader *(capitán)* of the *conchero* association in his village, where he returned every year to lead the dances and festivities.[3]

Rivera is best known for his work as a muralist. Aside from well-known mural projects in the United States—such as those for the Detroit Institute of Arts and New York's Rockefeller Center (destroyed in 1934)—Rivera painted numerous murals for buildings in Mexico. His portrait of Robles was painted while he was beginning work on a major mural for the Hotel del Prado in Mexico City. This mural, *Dream of a Sunday Afternoon in the Alameda,* reflects Rivera's love of portraiture. Arrayed against the backdrop of Mexico City's leafy Alameda Park is a panoramic presentation of figures from recent Mexican history and from Rivera's life. He had received the commission for the mural in March of 1947 and most likely painted *Danzante* in the same month.[4]

Rivera enjoyed a multifaceted artistic training, beginning with a standard academic course of study in Mexico City. From 1911 to 1920 he lived in Paris, where he was in constant contact with the avant-garde and painted in the Cubist style. Seventeen months in Italy in 1920 and 1921, however, marked a turning point in his career. Rivera recognized that the Renaissance frescoes in churches and civic buildings could serve as models for the creation of a modern, socially conscious, public art.[5]

The Italian frescoes Rivera had studied featured clarity and legibility of style, an emphasis on linearity, bright and sumptuous coloration, and the precise rendering of detail. Not only Rivera, but many other realist painters of the 1920s and 1930s revived these elements of early Renaissance painting, and its characteristics are evident in *Danzante.* Rivera imbued his portrait of Robles with a sense of monumentality and gravity, which derives from the oversized depiction of his hands, the sensitive portrayal of Robles's serious face, and the simplification of form. The linear quality of the composition reflects Rivera's talents as a draftsman, which he had honed through the meticulous planning of his large murals. The rendering of the feathers of Robles's headdress is precise and detailed, almost to the point of stylization, while every detail of his costume clearly marks him as a *conchero* dancer.

Although Rivera accepted many portrait commissions from the upper classes, non-commissioned portraits of figures from the peasantry and working classes had played an important role in his work for decades. Active in leftist politics his entire life, Rivera had a vested interest in painting sympathetic and respectful portraits of the proletariat. In many of these works, and in his portraits from the 1940s and 1950s in general, specifically Mexican themes played a prominent role.[6] In *Danzante,* Rivera focused on Robles's efforts to keep ancient traditions alive and flourishing. By titling the painting *Danzante,* a word that specifically refers to a religious or *conchero* dancer, Rivera transformed Robles from an individual personality into an archetype of Mexican folk culture.

Notes
1. Identification of the sitter provided by Diego Rivera in a letter of authentication, dated April 9, 1947. Additional information from a letter from the donor, Cecyle Stone, dated February 14, 1986. IU Art Museum curatorial files.
2. Michael Stephens, *Mexican Festival and Ceremonial Masks: An Exhibition of Masks from the Victor José Moya Collection* (Berkeley, Calif.: Lowie Museum of Anthropology, University of California, Berkeley, 1976), 14–15; and Martha Stone, *At the Sign of Midnight: The Concheros Dance Cult of Mexico* (Tucson: The University of Arizona Press, 1975).
3. Letter from Cecyle Stone, dated February 14, 1986. IU Art Museum curatorial files.
4. Dating is based on a letter of authentication from Rivera to the painting's purchasers, Samuel and Cecyle Stone, dated April 9, 1947. The Stones' customs declaration form for the importation of the painting into the United States is dated April 11, 1947. IU Art Museum curatorial files.
5. Laurance P. Hurlburt, "Diego Rivera (1886–1957): A Chronology of His Art, Life and Times," in *Diego Rivera: A Retrospective* (Detroit: Founders Society, Detroit Institute of Art, in association with W. W. Norton, 1986), 47; and Luis-Martín Lozano, "Diego Rivera, *Classicus Sum,*" in *Diego Rivera: Art and Revolution* (Mexico: Instituto Nacional de Bellas Artes; Landucci Editores, 1999), 150–51.
6. Rita Elder, "The Portraits of Diego Rivera," in *Diego Rivera: A Retrospective,* op. cit., 199.

David Smith
American, 1906–1965

Pillar of Sunday, 1945
Painted steel
H. 31 in. (78.7 cm), 69.151
Art © Estate of David Smith/Licensed by VAGA, New York, NY

By 1965, when he died in an automobile accident, David Smith was regarded by many as the foremost American sculptor of his day. Smith was born in Decatur, Indiana, and raised there and in Paulding, Ohio. His small-town, Midwestern upbringing limited his familiarity with modern art. Despite an education at Ohio State University and the University of Notre Dame that was notably lacking in attention to the arts (Notre Dame offered no art classes at the time), Smith quickly made up for lost time when he moved to New York City in 1926 to attend the Art Students League. In New York, he immersed himself in the world of modern art, visiting galleries and studying European modernism in museums and in magazine reproductions. The welded metal sculptures of Picasso and the Spanish sculptor Julio González particularly appealed to Smith, who was beginning to recognize his own talents for sculpture. Smith realized that the welding skills he had obtained while working at the Studebaker plant in South Bend, Indiana, during the summer of 1925 might be put to artistic use.

Smith began making welded sculptures in 1933. Not only were his sculptural technique and use of materials such as steel unorthodox, but his very approach to conceptualizing a sculpture was unusual. Smith, who began his art studies as a painter, always approached his sculpture with a painter's eye, attempting to fuse the two-dimensionality of a picture plane with the three-dimensionality of a traditional sculpture. Similarly, he was more interested in abstract and symbolic forms than in the sculptural mainstay of the human figure. As Edward Fry remarked in the catalogue to the 1969 retrospective of Smith's work at the Guggenheim Museum in New York, Smith's sculptures, many of which have a strongly frontal orientation, suggest the primacy of the two-dimensional picture plane over the sculptural attributes of mass and volume.[1]

Pillar of Sunday, composed of flat, interlocking forms, exemplifies this aspect of Smith's work. Indeed, in the catalogue to Smith's solo exhibition at the Buchholz-Willard Gallery in January 1946, art historian W. R. Valentiner singled out *Pillar of Sunday* as an "excellent example of a three-dimensional conception developed from flat steel plates."[2]

During World War II, a shortage of metal and a wartime welding job had prevented Smith from creating many sculptures. Immediately after the war, however, from 1945 until 1950, Smith produced a large number of works, many influenced by Surrealism, with its focus on the inner workings of the human mind. In fact, *Pillar of Sunday* was featured in the 1947 exhibition *Abstract and Surrealist American Art* at the Art Institute of Chicago.

Most of Smith's immediate postwar works were relatively small in size and often were embedded with autobiographical references. The sculptures created around the same time as *Pillar of Sunday* contain romanticized, autobiographical, or mythological references and titles, such as *Reliquary House* (1945), *Deserted Garden (Landscape)* (1946), and *Song of the Landscape* (1950). With a shape that could be interpreted as totemic or tree-like, *Pillar of Sunday* reflects Smith's interests in nature, the mythic, and the ancestral. The images attached to the vertical trunk of the sculpture refer to Smith's recollections of Sundays spent in Paulding, Ohio, during his youth. Born into a strict Methodist family, Smith recalled that his mother was a "pillar of the church," providing a humorous gloss on the sculpture's title, *Pillar of Sunday*.[3] At the bottom of the sculpture is a depiction of a Sunday chicken dinner, and adjoining it is a bird-like woman singing in the church choir. Due to the totemic format of the piece, the commonplace Sunday rituals of dinner and choir-singing take on the aura of ancient, tribal religious rites. Indeed, Smith noted that as a child, the Christian sacrament of communion and the chicken dinner following the church service were "one and the same."[4] In another fusion of Christian and ancient traditions, Smith identified the bird-like figure perched atop the sculpture as a symbol of the soul, borrowed from ancient Assyrian sculpture.[5]

The 1969 David Smith retrospective at the Guggenheim sparked a strong interest in his work among collectors. The acquisition of a piece by Smith was particularly desirable for the Indiana University Art Museum, as Smith had been a visiting professor at Indiana University during the 1954/55 academic year. In 1969 the IU Art Museum purchased a small Smith sculpture of 1958, exchanging it three years later for *Pillar of Sunday*, which had been called an "extraordinary symbolic work" in the 1969 Guggenheim catalogue, and which the Marlborough-Gerson Gallery was willing to sell only to a museum.[6]

Notes
1. Edward Fry, *David Smith* (New York: Solomon R. Guggenheim Museum, 1969), 11.
2. W. R. Valentiner, *The Sculpture of David Smith* (New York: Buchholz-Willard Gallery, 1946), 3. Exhibition held January 2–26, 1946. *Pillar of Sunday* was cat. no. 29.
3. Alain Kirili, "Virgins and Totem," *Art in America* 71 (October 1983): 157.
4. Karen Wilkin, *David Smith: The Formative Years* (Edmonton, Alberta: Edmonton Art Gallery, 1981), 14.
5. Ibid.
6. Fry, op cit., 11. Indiana University Art Museum Policy Committee Meeting minutes, December 8, 1971. The Smith sculpture originally purchased by the IU Art Museum, *Structure #39* of 1958, was exhibited in the IU Art Museum's exhibition *Noguchi, Rickey, and Smith* (Bloomington: Indiana University Art Museum, 1970), of November 8–December 13, 1970.

Marino Marini
Italian, 1901–1980

Horseman (Il cavaliere), 1947
Bronze
63 7/16 x 61 in. (161.1 x 154.9 cm)
Gift of Dr. and Mrs. Henry R. Hope in memory of James Adams, 76.137
© 2007 Artists Rights Society (ARS), New York/SIAE, Rome

One of Italy's most important twentieth-century sculptors, Marino Marini had a deep understanding of Italian artistic traditions. Born in Pistoia, Tuscany, Marini studied at the Accademia di Belle Arti in Florence. In the late 1920s he traveled frequently to Paris, where he came into contact with artists such as Pablo Picasso, Henri Laurens, Georges Braque, Jacques Lipchitz, and Aristide Maillol—all of whom melded classical artistic traditions with modernist aesthetics. In a 1958 interview, Marini pointed to his own experience of growing up in Tuscany, which was home to the ancient Etruscan civilization, as an essential influence on his approach to sculpture:

> Here in Italy, our whole being is still impregnated by our artistic past…I myself was born in Tuscany, where the discovery of Etruscan art during the last fifty years has been an outstanding event. It is for this reason that my art relies more on themes taken from the past— such as relationships between man and horse—than on modern subjects.[1]

Marini's sculpture is characterized by archetypal, almost mythic, themes and figures that recur throughout his career. The theme of the horse and rider plays a dominant role in his oeuvre, first appearing in a 1936 cycle of horsemen. Although Marini cited the ancient equestrian monument to Marcus Aurelius on Rome's Piazza del Campidoglio as one of his favorite works, his horsemen do not recall monumental or memorial statuary.[2] While they are classically proportioned and balanced in keeping with Italian artistic traditions, they are also streamlined and simplified according to modernist aesthetic values: Marini was careful to avoid any resemblance to official Italian sculptures and monuments during the 1930s and early 1940s, while Italy was governed by Mussolini's fascist regime, instead emphasizing his affinities with Etruscan and early Roman sources.[3]

World War II profoundly affected the character of Marini's horse and rider sculptures. Whereas his horsemen of the 1930s had appeared heroic and regal, his postwar horsemen became disoriented and sorrowful. In 1950 Marini told the American collector James Thrall Soby that his new approach to the horseman theme stemmed from his experience of watching Lombard peasants flee wartime bombings on their frightened horses.[4] Marini himself had been profoundly affected by the war when his apartment and studio in Milan were bombed in 1942, destroying many of his works and forcing him to seek refuge in Switzerland. These postwar horsemen were tragic figures, helpless in the face of modern warfare.

In the 1947 *Horseman* in the IU Art Museum's collection, Marini's nude rider sits on the horse with his arms hanging limply, and his face turned upwards with an expression of hopelessness. The horse appears agitated, with ears flattened and neck outstretched. As Marini explained, "My statues of riders express the anguish of my age. With every new work…the riders, increasingly less powerful, have lost their former domination over animals."[5] Marini considered the equestrian motif to be so powerfully symbolic of suffering and despair that he turned to the theme again in 1959 when creating a memorial to the horrors of war for The Hague.

Marini's sculptural talents were recognized in Italy as early as 1929, when he was appointed to a teaching position at the Scuola d'Arte della Villa Reale in Monza, Lombardy. In the 1930s he participated in the Venice Biennales and other major exhibitions in Milan and Rome, winning first prize for sculpture at the second Rome Quadriennale in 1935. In 1940 he became professor of sculpture at the prestigious Accademia di Belle Arte di Brera in Milan. Widespread American recognition of Marini came starting in 1950, when the dealer Curt Valentin gave him a one-man show at the Buchholz Gallery in New York City.[6] The IU Art Museum's director, Henry Hope, had a close relationship with Curt Valentin, who sold him *Horseman* in 1951.[7]

The IU Art Museum's *Horseman,* a cast bronze sculpture with residues of a plaster and wax patina, is one of an edition of three casts and the artist's proof. As a collector, Henry Hope was in good company—the other casts in this edition quickly entered the collections of John D. Rockefeller III in New York and the Tate Gallery in London. By working the surface of each individual sculpture with a chisel and applying a whitish patina of plaster and wax to the surface after casting, Marini ensured that each cast in the edition was unique.[8] Marini's surface treatment of the IU Art Museum's bronze resulted in mottling and pitting, in which the artist's hand provides an expressionistic touch of pathos to the classical subject matter.

Notes
1. From a 1958 interview with Marini: "The Beginning of My Career," reprinted in Patrick Waldberg, G. di San Lazzaro, and Herbert Read, *Marino Marini: Complete Works* (New York: Tudor Publishing Co., 1970), 490.
2. James Thrall Soby, introduction to *Marino Marini* (New York: Buchholz Gallery, 1950), 1–2.
3. From a 1958 interview with Marini, "The Beginning of My Career," in Waldberg, op. cit., 490.
4. Soby, op. cit., 3.
5. From a 1958 interview with Marini, in Waldberg, op. cit., 492.
6. *Marino Marini,* (New York: Buchholz Gallery, February 14–March 11, 1950).
7. Curt Valentin Papers, (New York: Museum of Modern Art Archives, CV.III.35): letter from Curt Valentin to Henry Hope, March 22, 1951.
8. Soby, op. cit. 3; and Ronald Alley, *Catalogue of the Tate Gallery's Collection of Modern Art other than Works by British Artists* (London: Tate Gallery and Sotheby Parke-Bernet, 1981), 487–88.

Jackson Pollock
American, 1912–1956

Number 11, 1949
Duco and aluminum on canvas
45 x 47 ¹/₂ in. (114.2 x 120.6 cm)
Jane and Roger Wolcott Memorial, Gift of Thomas T. Solley, 75.87
© 2007 The Pollock-Krasner Foundation/Artists Rights Society (ARS), New York

Thanks to a 1949 article in *Life Magazine* entitled "Is He the Greatest Living Painter in the United States?" and to Hans Namuth's 1950 series of photographs and films of the artist at work, Jackson Pollock was catapulted to celebrity status at the very moment that he was creating his iconic "drip paintings" in a Long Island barn. There was little in Pollock's background or artistic training to suggest that he would become an icon of modern art. Raised in California, Pollock moved to New York City in 1930 and enrolled at the Art Students League under Thomas Hart Benton, who scorned European modernism in favor of stylistically conservative Regionalist painting. Pollock later met John Graham, a Russian émigré artist, who introduced him to Picasso's Cubist innovations, while the Jungian psychoanalysts Pollock consulted between 1938 and 1943 opened his mind to the subconscious worlds explored by the Surrealists. Indeed, Pollock's work of the early 1940s explicitly addresses the concepts of symbols and the psyche in a quasi-Cubist style.

Pollock's style abruptly changed in the mid-1940s after he married fellow artist Lee Krasner and moved to a run-down farmhouse near East Hampton on Long Island. When the artist Allan Kaprow wrote in *ArtNews* that Pollock had "destroyed painting," he was referring to Pollock's almost complete break with Western artistic tradition at this time.[1] Pollock's new paintings were created by dripping and dribbling liquid enamel paint directly from cans onto a canvas laid on the floor and manipulating the paint with sticks or stiff brushes. Pollock said of his working method in 1946, "On the floor I am more at ease. I feel nearer, more a part of the painting, since this way I can walk around it, work from the four sides and literally be *in* the painting."[2]

Although the influential art critic Clement Greenberg defined Pollock's new method of painting as "American," "rough," and "brutal" in a 1947 review, many of the paintings—particularly those from 1949, when Pollock worked on a relatively small scale—exhibit decorative and lyrical qualities.[3] For example, *Number 11* is characterized by richly layered webs of patterns and colors. Patches of mustard yellow, sea green, and rust brown emerge through a tangled skein of thin, white, spidery lines. In the postwar period, New York had just emerged as the artistic capital of the Western world, with its culture much enriched by the émigrés who had fled Europe before and during World War II. In an attempt to distinguish the art produced by native-born American artists from their European counterparts, Greenberg and other critics characterized American art as masculine and powerful, in contrast to perceived European qualities of decorativeness and intellectual sophistication.[4] As one recent author notes, Pollock, who

found it commercially viable to emphasize his spurious western, "cowboy" origins (he was born in Wyoming, but moved with his family to southern California as an infant), fully participated in this "masquerade of masculinity."[5] Namuth's photographs of Pollock energetically flinging paint onto his canvases also played up the perception that Pollock's working methods were highly active, masculine, and anti-intellectual.

Pollock painted *Number 11* at the height of his experimentation with the drip paintings, and he exhibited it in his third solo show at the Betty Parsons Gallery in New York in late 1949.[6] The previous year, in order to emphasize their apparent lack of subject, Pollock had begun titling his paintings only with numbers. Pollock thus encouraged viewers to focus on the purely aesthetic qualities of his abstractions. By the mid-1950s, Pollock's drip paintings were in demand by collectors and were already seen as an important milestone within the historical trajectory of Western abstract art. The collector and writer Bernard Harper Friedman noted that in 1955, when he had the opportunity to invite Jackson Pollock to his New York apartment, he proudly hung *Number 11,* a recent purchase, on a wall near works by Arp, Schwitters, Mondrian, and Klee.[7]

Although he experienced success in the early 1950s with shows at New York galleries and the sale of one of his paintings to the Museum of Modern Art, Pollock's battles with depression and alcoholism interrupted his development as an artist in the mid-1950s. He died in an alcohol-induced automobile accident in 1956 at the age of forty-four.

Notes
1. Allan Kaprow, "The Legacy of Jackson Pollock,"*ArtNews* 57, no. 6 (October 1958): 26, 56.
2. Quoted in Kirk Varnedoe and Pepe Karmel, eds., *Jackson Pollock: New Approaches* (New York: Museum of Modern Art and Harry N. Abrams, 1998), 46.
3. Clement Greenberg, "Review of Exhibitions of Jean Dubuffet and Jackson Pollock," *The Nation* (1 February 1947). Reprinted in *Clement Greenberg: The Collected Essays and Criticism,* ed. John O'Brian, (Chicago and London: University of Chicago Press, 1986), vol. 2, 125.
4. Clement Greenberg, "Review of Exhibitions of Mondrian, Kandinsky, and Pollock; of the Annual Exhibition of the American Abstract Artists; and of the Exhibition *European Artists in America*," *The Nation* (7 April 1945). Reprinted in O'Brian, op. cit., vol. 2.
5. Jeremy Lewison, *Interpreting Pollock* (London: Tate Gallery, 1999), 69–71.
6. November 21–December 10, 1949, *Jackson Pollock, Paintings,* Betty Parsons Gallery, New York City
7. Bernard Harper Friedman, *Jackson Pollock: Energy Made Visible* (New York: McGraw-Hill Book Company, 1972), xii.

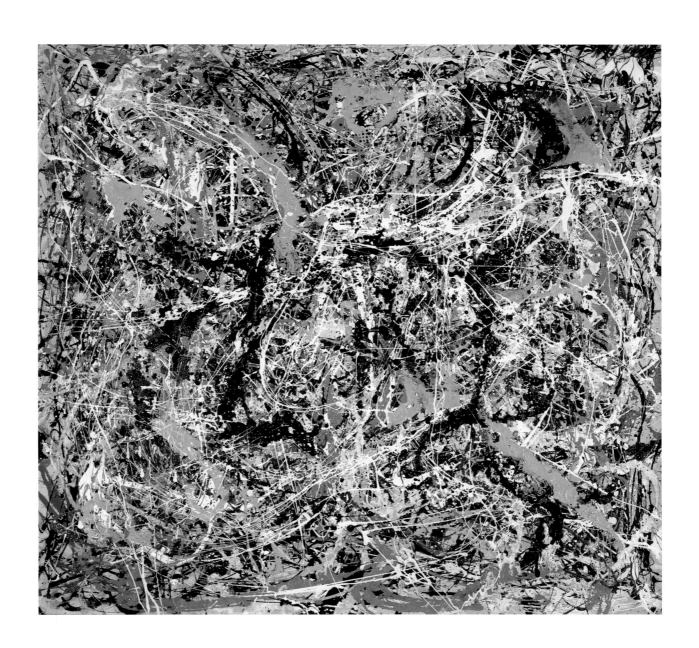

Max Beckmann
German, also active in the Netherlands and United States, 1884–1950

Hope Family Portrait, 1950
Oil on canvas
80 ¼ x 35 in. (204.0 x 89.0 cm)
Gift of the Hope Family, 2002.73
© 2007 Artists Rights Society (ARS), New York/VG Bild-Kunst, Bonn

Henry Radford Hope, director of the IU Art Museum from 1941 to 1967, and his wife Sarahanne were dedicated art collectors. Among the artists with whom they were personally acquainted was Max Beckmann, who painted this portrait of the Hope family just a few months before his death.

Born in Leipzig, Beckmann studied at the Kunstschule in Weimar and in Paris and Florence. Throughout his career, he was intrigued by the challenges posed by the human figure, and this motif dominates his work. Although he worked in an Impressionistic manner prior to World War I, the traumas of the war led to changes in his style. The characteristics of late Gothic German and Netherlandish painting—heavy black outlines, the use of awkward perspective, and compressed space—became the hallmarks of Beckmann's style after the war. During the 1920s, Beckmann was recognized as one of Germany's foremost painters.

In 1925 Beckmann took a teaching position in Frankfurt, where he became friendly with Bernard Heiden, whose family collected modern German art. To escape Hitler's regime, Heiden and his wife Cola immigrated to the United States in 1934 and eventually they found themselves teaching in the music school at Indiana University. Beckmann also left Germany before the war and spent the war years in Amsterdam. The Heidens asked Henry Hope to offer Beckmann a position at Indiana University in 1947, and, although Beckmann declined, he maintained a relationship with his friends at Indiana University. In April 1948 he visited Bloomington to judge a print and drawing exhibition. The visit won him a portrait commission from Henry Hope in the spring of 1950.

The *Hope Family Portrait* depicts Henry and Sally Hope with their children. On the choice of Beckmann for their portraitist, Henry Hope later reminisced that "for years, Sally and I had wanted to get a portrait of our family….Max Beckmann had almost come to teach at Indiana University. So it was not difficult to get him to accept the commission to paint the portrait....He made several sketches and took photographs of us all…There is a wonderful discernment about that picture."[1]

Another statement of Hope's reveals that Beckmann was chosen for both aesthetic and practical reasons: "The choice of Beckmann was made for two reasons: 1) I admired the several portraits he did in St. Louis and the group portrait[s]…done in Amsterdam…. The other reason was that we were close friends of Curt Valentin [Beckmann's dealer in New York] and he offered to make the arrangements for us."[2]

The painting, with its vertical format, constricted space, and densely stacked figures, is typical of Beckmann's multi-figure compositions. Beckmann painted the portrait largely from memory, with the aid of a few sketches and photographs made at the beginning of April 1950. Beckmann, in fact, seems to have experienced some difficulties with the composition. By the end of May 1950, however, the artist was finally satisfied with the portrait, writing, "I believe Hope is finished. It would be too beautiful to be true."[3]

In the Hope portrait, Beckmann used unusual poses and props. Peter, the oldest boy, is obscured behind Henry, while the youngest daughter, Sarah Jane, sprawls on the floor in the foreground.[4] Henry holds a sculpture in one hand, pointing to it as if it were an important item from his collection. However, according to Hope, "Beckmann told me he put that there to suggest that I was an art historian and collector. It is no specific object."[5] Because none of the family members make eye contact with each other, the figures seem detached and isolated despite being crowded together. This suggestion of isolation recurs in many of Beckmann's portraits.

When the painting was completed in September of 1950, Beckmann delivered it to Curt Valentin's gallery in New York. Valentin immediately lent the portrait to a contemporary painting exhibition at the Whitney Museum of American Art, before delivering it to the Hopes in Bloomington.[6] The family was so pleased with the portrait that they had it reproduced on their Christmas cards that year.

Further Reading
McComas, Jenny. *Max Beckmann and the Hope Family Portrait.* Exhibition brochure. Bloomington: Indiana University Art Museum, 2003.
Rainbird, Sean, ed. *Max Beckmann.* London: Tate Publishing, 2003.

Notes
1. Quoted in Thomas T. Solley and Constance L. Bowen, *The Hope Family Collection: Selections from the Twentieth Century* (Bloomington: Indiana University Art Museum, 1982), 15.
2. From a letter of Hope's, December 12, 1969. Quoted in Erhard and Barbara Göpel, *Max Beckmann: Katalog der Gemälde*, 2 vols. (Bern: Verlag Kornfeld, 1976), 501. There is correspondence concerning the price of the portrait and arrangements for Beckmann's visit to Indiana in the Curt Valentin Papers, Museum of Modern Art Archives, New York, CV.III.5.
3. Beckmann, *Jägebucher 1940–1950* (Munich: Langen-Müller, 1955), 374. My translation.
4. The practical reason for this compositional choice is that Peter, who was away at boarding school in Connecticut, did not sit for Beckmann. Per letter from Peter McClennen, November 19, 2002, Indiana University Art Museum curatorial files.
5. From a letter of Hope's, December 12, 1969. Quoted in Göpel, op. cit., 501.
6. Letters from Curt Valentin to Henry Hope, fall 1950. Curt Valentin Papers, Museum of Modern Art Archives, New York, CV.III.35.

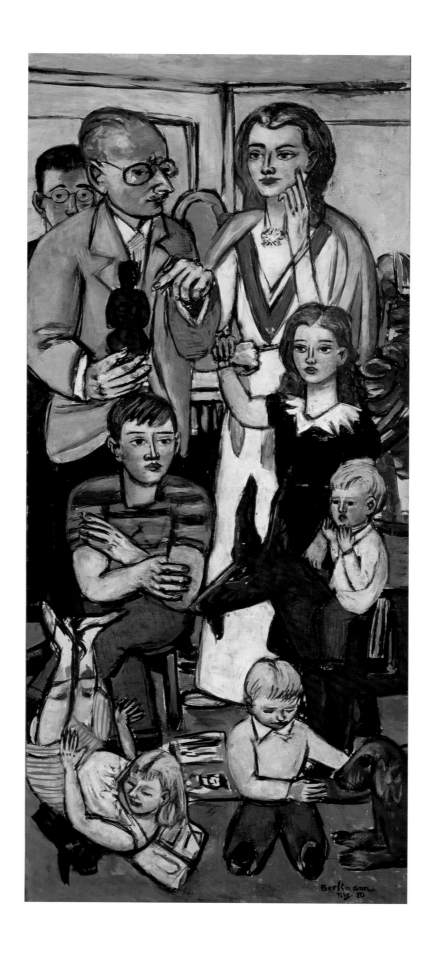

Morris Louis
American, 1912–1962

Beth Aleph, 1959–60
Acrylic on canvas
95 ³/₈ x 140 ³/₈ in. (242.2 x 356.5 cm)
Jane and Roger Wolcott Memorial, Gift of Thomas T. Solley, 75.46
© 1959 Morris Louis

Born in Baltimore to Russian Jewish immigrant parents, Morris Louis spent most of his life in the Washington, D.C., area. Geographically removed from the New York City, the epicenter of post-World War II American art, Louis developed a personal artistic style distinct from the New York avant-garde. Yet Louis was not isolated from the avant-garde developments of the 1950s and 1960s. He enjoyed friendships with many leading art world figures, including artists Helen Frankenthaler and Kenneth Noland and critic Clement Greenberg, who had championed the work of Jackson Pollock in the early 1950s.

Louis's early artistic experiences were similar to those of many other important artists of his generation. After studying at the Maryland Institute of Fine and Applied Arts in Baltimore he found employment with the Federal Art Project of the Works Progress Administration. He painted murals first in Baltimore, and then, in the late 1930s, in New York City, where he attended experimental workshops conducted by Mexican muralist David Alfaro Siqueiros. Louis also made frequent visits to the Museum of Modern Art, where, like many other American artists, he was drawn to contemporary European art, such as the paintings of Max Beckmann.

As American art found its own voice after World War II, Louis began to develop the meditative, richly colored paintings for which he is now famous. A visit to Helen Frankenthaler's New York studio in 1953 was an eye-opener for Louis, who adopted Frankenthaler's technique of staining unprimed canvas with thinned paint to achieve wash-like, almost transparent configurations of pure color. Louis began pouring thinned acrylic pigment onto the canvas, which he manipulated to achieve the desired flow and direction of the paint. Together with the younger painter Kenneth Noland, Louis developed this poured-paint technique during a series of "jam painting" sessions, inspired by the experimental, collaborative gatherings of jazz musicians.

Characterized by orderly abstract forms and an emphasis on color as an expressive force, *Beth Aleph* is a striking example of Louis's mature style. Louis's sensitivity to color was cultivated in part through his study of Matisse and the Impressionists, artistic precursors for whom color was also a defining feature of their painting. As the critic Clement Greenberg wrote,

> [Louis] began to feel, think, and conceive almost exclusively in terms of open color…Color meant areas and zones, and the interpenetration of these, which could be achieved better by variations of hue than by variations of value. Recognitions like these liberated Louis's originality along with his hitherto dormant gift for color.[1]

The Hebrew title, *Beth Aleph,* was assigned to this painting by Louis's widow after the artist's death, and her intriguing choice of title enables us to see another layer of meaning in Louis's painting. *Aleph* and *Beth* are the first two letters of the Hebrew alphabet, and in *Beth Aleph*, the curved, tapering stripes of color evoke the calligraphic strokes of a fountain pen. Calligraphic or hieroglyphic markings were intrinsic to Abstract Expressionism, appearing in the work of Jackson Pollock, Lee Krasner, and Franz Kline. Likewise, from the 1930s on, abstracted Hebrew letters and script played a role in Louis's work. Although the artist himself was not religious, Louis's wife taught classes at a local synagogue. He would have thus understood that the Hebrew script, according to Jewish mystical tradition, was considered a vehicle for meditation and spiritual contemplation, much as color was for him and other American artists such as Noland and Mark Rothko.[2] The sinuous, calligraphic areas of color and the meditative quality of Louis's paintings may thus have inspired his widow to bestow titles composed of Hebrew letters on paintings such as *Beth Aleph* after his death.

Louis's paintings are often considered a bridge between the Abstract Expressionism of the 1950s and the Color Field painting of the 1960s. His work combines characteristics of these related modernist tendencies, both of which were cultivated and promoted by his friend and mentor Clement Greenberg. Despite the presence of possible hidden references evoked by the titles of his works, paintings such as *Beth Aleph* are also emphatically modernist in their insistence on the preeminence of their materiality and formal qualities. The thin paint soaking into the weave of the canvas emphasizes the flat surface and non-illusionistic qualities of the painting. And most importantly, in Louis's paintings, color—and the joy of working with color—is the primary subject.

Further Reading
Elderfield, John. *Morris Louis.* New York: Museum of Modern Art, 1986.

Notes
1. Quoted in John Elderfield, *Morris Louis* (New York: Museum of Modern Art, 1986), 13.
2. Mira Goldfarb Berkowitz, "Sacred Signs and Symbols in Morris Louis: *The Charred Journal* Series," in *Complex Identities: Jewish Consciousness and Modern Art*, ed. Matthew Baigell and Milly Heyd (New Brunswick, N.J.: Rutgers University Press, 2001), 197–98.

Isamu Noguchi
American, 1904–1988

Pisa, 1966
Marble
H. 14 $^{15}/_{16}$. in. (37.9 cm), 73.15
© 2007 The Isamu Noguchi Foundation and Garden Museum,
New York/Artists Rights Society (ARS), New York

A global perspective lies at the heart of Isamu Noguchi's sculptural oeuvre. Born in Los Angeles to an American mother and Japanese father and raised in Japan, Noguchi attended high school in Indiana, art school in New York, and, thanks to a Guggenheim Fellowship, participated in the bohemian artistic life of Paris in the late 1920s. In 1930 the Trans-Siberian Railroad took him to China, and he returned to Japan for a brief visit. Although New York was Noguchi's primary home for much of his life, he also established a residence and studio in Mure, on Shikoku Island, Japan, in 1969. Inspired by his extensive travels, Noguchi was drawn to both eastern and western artistic traditions. He participated in European modernist movements, such as Surrealism, and also found himself drawn to the traditions of Zen Buddhist aesthetics and Italian Renaissance sculpture.

While Noguchi is best known for his incorporation of Japanese aesthetics into his work, he was also strongly affected by the art and raw materials—particularly the stone—of Italy. Noguchi first visited Italy in 1949 after receiving a Bollingen Foundation grant to travel the world studying "environments of leisure," such as parks, plazas, gardens, and temples. On this visit, he was struck by the organic relationship between architecture and nature at ancient sites such as Paestum, and he strove to achieve a similar integration in his own sculpture. In 1962 Noguchi returned to Italy as a visiting artist at the American Academy in Rome, and, at the suggestion of the sculptor Henry Moore, he visited the Henraux marble quarries near Pietrasanta in Tuscany. Working with stone from this quarry—located near the site where Michelangelo had acquired marble for his sculptures—was a formative experience for Noguchi, even at this relatively late stage in his career. After discovering the Henraux quarries, Noguchi set up a summer studio in nearby Querceta, and returned there from New York for the remainder of the decade.

Noguchi had been introduced to marble-carving by the Romanian sculptor Constantin Brancusi, for whom he had worked as an assistant in Paris in 1927, and the stone became his favored medium while working in Italy during the 1960s. In Italy he was able to explore all of the properties of marble, a crystalline and luminous stone that can range in color from white to black to pink to green. Noguchi, who associated materials and sculptural techniques with specific geographical environments, felt that carving stone, particularly marble, was appropriate to his work in Italy, with its long sculptural tradition reaching back to antiquity. *Pisa*, which Noguchi carved in 1966, was made while the artist was working in Querceta. Named after the famous Tuscan city of Pisa, the sculpture is intimately tied to Noguchi's experience of working in Italy and his love of marble.

Noguchi carved *Pisa* from a pinkish-brown marble striated with lighter and darker veins. *Pisa,* with its highly polished surface and bent, tubular shape, might be associated with the Minimalist tendencies of 1960s art, but it also reflects Noguchi's identification with the spiritual and aesthetic traditions of Zen Buddhism, which occupied him even while working in Italy. While visiting Japan in 1931, Noguchi had met and briefly stayed with his uncle, a Zen monk, and visited Zen gardens and temples in Kyoto. Noguchi identified more strongly with his Japanese heritage after Japanese-Americans were interned during World War II, and his approach to carving became increasingly influenced by his study of Zen. Writing of his love of stone in the 1960s, he commented that, "I try to look in a rock and find…the spirit of a rock," suggesting that it was necessary to meditate and reflect on his materials in accordance with Zen ideas about the sacredness of nature.[1] In a work such as *Pisa,* in which the stone is minimally shaped and altered, Noguchi may have been experimenting with the Zen concept of *wabi,* or "less is more." As Thomas Solley and Daniel Mato stated in the catalogue of an exhibition held at the Indiana University Art Museum in 1970:

> With the minimum appearance of effort [Noguchi] creates an effect that expands beyond the immediacy of the sculpture to refer to basic integral forces in nature. Translated into the calm movement of *Pisa,* these forces flow with a sculptural wholeness integrating the transition of form and material into a unity with its surrounding space.[2]

Further Reading
Altshuler, Bruce. *Modern Masters: Isamu Noguchi.* New York: Abbeville Press, 1994.
Ashton, Dore. *Noguchi East and West.* New York: Alfred A. Knopf, 1992.
Grove, Nancy, and Diane Botnick. *The Sculpture of Isamu Noguchi, 1924–1979: A Catalogue.* New York: Garland Publishing, 1980.
Noguchi, Isamu. *A Sculptor's World.* New York: The Isamu Noguchi Foundation, 2004.

Notes
1. Quoted in Valerie J. Fletcher, *Isamu Noguchi: Master Sculptor* (New York: Whitney Museum of American Art, 2004), 141.
2. Daniel Mato and Thomas T. Solley, *Noguchi, Rickey, and Smith* (Bloomington: Indiana University Art Museum, 1970), 8.

Joseph Cornell
American, 1903–1972

Spirit Level, 1969
Mixed media
8 $^7/_8$ x 14 $^{15}/_{16}$ in. (22.5 x 37.9 cm), 70.54
Art © The Joseph and Robert Cornell Memorial Foundation/
Licensed by VAGA, New York, NY

Rich with evocative associations of ballet and opera, the European Grand Tour, childhood, and the night sky, Joseph Cornell's box assemblages have a sense of magic and preciousness that gives them an enduring appeal. Despite the fact that Cornell was a self-taught artist who rarely traveled beyond the borders of New York State, he was a voracious reader who was interested in contemporary art movements and described himself as an "armchair voyager." His boxes reveal an inner world that was shaped by his belief in the compatibility of art and science, by nostalgia, and by a deep affinity with the picturesque. Evoking the cabinets of curiosities of past centuries, Cornell's constructions often combine elements from fine art (reproductions of Old Master paintings), popular culture (film stills, references to penny arcades, Victorian kitsch), and the natural world (shells, driftwood, celestial charts). To obtain the objects used in his assemblages, Cornell scoured junk shops, antique and print shops, and used bookstores in Manhattan.

Cornell's earliest artistic productions were collages, which he showed to the art dealer Julien Levy in 1931. Levy was struck by the collages' affinity with Surrealism, and he showed Cornell's work at his New York gallery the following year in the exhibition *Surrealisme.* From two-dimensional collage, Cornell made the leap to three-dimensional assemblage, and his first box construction, *Untitled (Soap Bubble Set),* was completed in 1936.

While Levy and other critics attempted to categorize Cornell as a Surrealist, it was a classification he himself did not fully accept. Although he was interested in the collages of Surrealist artist Max Ernst, the most profound influences on his work were the Readymades and other assemblages created by Dadaist Marcel Duchamp (see pp. 324–27). In fact, Cornell and Duchamp enjoyed a close friendship during the years of World War II, when Duchamp was living in New York. The "object" was a preoccupation of Duchamp and the Dadaists, who transformed ordinary objects into high art through creative manipulation. Duchamp created sculptural assemblages with similarly ordinary items, a concept that Cornell adopted for his boxes.

Created near the end of Cornell's life, in 1969, the Indiana University Art Museum's *Spirit Level* is a rectangular wooden box with a window-like glass front. It contains two horizontal metal rods from which are suspended two cordial glasses holding greenish-yellow marbles. A yellow cork ball, placed on these rods, is free to roll back and forth. Two metal rings hang from a third metal rod

at the top of the box, and an astronomical chart is affixed to the background. A piece of driftwood with white nails pounded into it lies on the floor of the box, next to a small starfish and some navy blue sand. The objects in *Spirit Level* reappear in boxes made throughout Cornell's career, particularly in his series known as *Soap Bubble Sets* and *Celestial Navigation Variants.*

Iconographically, *Spirit Level* belongs to both of these overlapping series, which, as Lynda Roscoe Hartigan writes, reflect Cornell's "lifelong preoccupation with the relationship between science and imagination, knowledge and wonder."[1] Fascinated by the constellations and by antique celestial navigation charts, Cornell included such charts and maps in many of his boxes. In *Spirit Level,* the yellow cork ball placed before the astronomical map appears as a sun or planet. Likewise, the yellow marbles in the cordial glasses seem to symbolize small planets or stars; while the starfish, driftwood, and sand evoke the moon's dominance over the ocean's tides. They perhaps also recall that for most of human history, the navigation of the seas was predicated on seafarers' ability to read the stars and constellations.

Looking through the "window" of glass at the front of the box, the viewer is granted a view into the enormity of the universe yet simultaneously is shielded from it. In this respect, Cornell's glazed boxes function like the windows that often frame expansive landscape vistas in German Romantic painting, psychologically distancing the viewer from the unknown. Although Cornell never physically traveled to distant places, boxes such as *Spirit Level,* with their references to navigation, stars, and planets, reflect Cornell's intellectual interest in exploration, discovery, and travel.

Further Reading
Blair, Lindsay. *Joseph Cornell's Vision of Spiritual Order.* London: Reaktion Books, 1998.
McShine, Kynaston, ed. *Joseph Cornell.* New York: Museum of Modern Art and Prestel, 1996.
Seitz, William C. *The Art of Assemblage.* New York: Museum of Modern Art, 1961.
Waldman, Diane. *Collage, Assemblage, and the Found Object.* New York: Abrams, 1992.

Note
1. Lynda Roscoe Hartigan et al., *Joseph Cornell: Shadowplay…Eterniday* (London: Thames and Hudson, 2003), 66.

Robert Colescott
American, b. 1925

Lightening Lipstick, 1994
90 x 114 in. (228.6 x 289.6 cm)
Acrylic on canvas
Museum purchase with funds from Lawrence and Lucienne Glaubinger, the Arlene and Harold Schnitzer CARE Foundation,
the Elisabeth P. Myers Art Acquisition Fund, and the Joseph Granville and Anna Bernice Wells Memorial Fund, 2005.2
© Jandava Cattron and Robert Colescott

Big, bold, and brimming with grotesque figures and hot, saturated colors, this late masterpiece by Robert Colescott has incredible wall power.* Since its installation in the museum's galleries, *Lightening Lipstick* has been cited frequently by visitors as either their most or least favorite work. Such a sharp dichotomy would not surprise its creator, whose works received much the same reaction when they were displayed in 1997 at the 47th Annual Venice Biennale—where he was the first African American artist to receive a solo show. Colescott knows how to capture his viewers' attention and how to make them think, particularly about issues of race and sexuality.

Colescott isn't afraid to face prejudice head-on. His breakthrough works from the 1970s featured shocking re-castings of art historical masterpieces in blackface. Colescott's use of minstrelsy and offensive pop icons—such as Aunt Jemima—was not always appreciated within the black community: some felt that the artist was only helping to perpetuate negative stereotypes. In his later works, Colescott moved beyond parody to create complex narratives that were more personal, expressionistic, and not as easily deciphered.

In this work, Colescott chose a traditional motif—a woman at her toilette—to address a sensitive racial issue within both the black and Latino communities: a preference for lighter complexions over dark. *Lightening Lipstick* examines how the perception of skin color in the United States and the Caribbean informs identity and class, and how our categorization of others may not match their idea of themselves. A light-skinned woman looking at her darker reflection exclaims in Spanish, "Soy Latina!" ("I'm a Latina"), while the face in the mirror responds, "Negrita!" ("Black woman").

The right half of the canvas, dominated by the central character's oversized head, is amplified by zones of activity on the left-hand side. A "color wheel" charts skin tone from one to six, beginning with a very dark-skinned African man shown over an enslaved woman and ending with a fair-complected Howdy Doody-like caricature. Evoking racist evolutionary theories based on physiognomy, "casta paintings," and a wheel of fortune, the chart suggests that one's color is a matter of sexual chance.[1] The image is filled with visual puns. The word "lightening" refers to skin-tone change (either genetically or cosmetically), but it is echoed by the lightning bolt and light bulb.[2] The bright red lipstick emphasizes the sexuality of the main female figure and her alter ego. By using bright colors, humor, and satire, Colescott creates a multilayered composition that is both playfully cartoonish and addresses the social ramifications of imperialism, slavery, lust, and rape on future generations.

Mixed race unions appear throughout Colescott's oeuvre. While he claimed that "in affairs of the heart I don't think there is race," he explored the issue of multiracial identity and the stigma attached to the offspring of miscegenation through the recurrent character of the tragic mulatto.[3] As a descendent of Creoles (people of mixed European and black heritage) from New Orleans, he was well aware of the role that skin-tone played in American society. The central map of the Gulf Coast in *Lightening Lipstick* recalls Colescott's ancestry. By making the main character a Latina, he moves the subject beyond personal narrative to create an allegory for the racial genealogy of all Americans.[4] Colescott's view of history—in which the "key to the future is a knowledge of the past"—not only exposes racism, but offers a path to healing.[5]

Colescott began his career questioning the validity of "masterpieces" by dead white men as representative of Western art, but he went on to create a more diverse form of history painting that delves deeply into our social psyche. His use of irony, pop culture references, text, appropriation of art historical prototypes, and painterly, cartoon-like style set the stage for the postmodern art of the generation that followed. By taking a stance on complex issues—such as racial blending and cross-racial impersonation—Colescott challenged these younger artists to go beyond outrage over media stereotypes to examine contemporary issues of identity.

Notes
*Entry written by Nanette Esseck Brewer, the Lucienne M. Glaubinger Curator of Works on Paper, IU Art Museum.
1. Colescott's move to Arizona in 1985 led to an interest in "casta paintings," eighteenth-century portraits of people of mixed ethno-racial heritage in colonial Latin America. Such paintings generally included sixteen scenes of family groups in a taxonomic progression from "pure" Spaniards to lower-caste black and Indian unions.
2. The lightening-through-makeup is seen as self-loathing, the light bulb as symbolic of a lynching noose, and the lightning bolt as an ominous sign of the annihilation of the black identity. Susan Gubar, "Minstrelsy's Racechanging Numbers: A Postscript to Racechange and the Fictions of Identity" in *Modern Fiction Studies* 49, no. 3 (Fall 2003): 622–23.
3. "Robert Colescott: Urban Artist in the Desert," *Arizona Alumnus* 67, no. 1 (Fall 1989): 10.
4. As Colescott said, "Consider the intricate network of human relations and interdependencies that have existed since dim pre-history (it's no coincidence that the darker Europeans live closer to Africa). Then consider that most people of either race go around acting like we're not even related. It adds up to a historic absurdity of tragic dimensions." *Robert Colescott: Recent Paintings* (Roswell, N. M.: Roswell Museum and Art Center, 1987).
5. Colescott created a series of paintings with this title in the 1980s.